Architecture of the Middle Ages

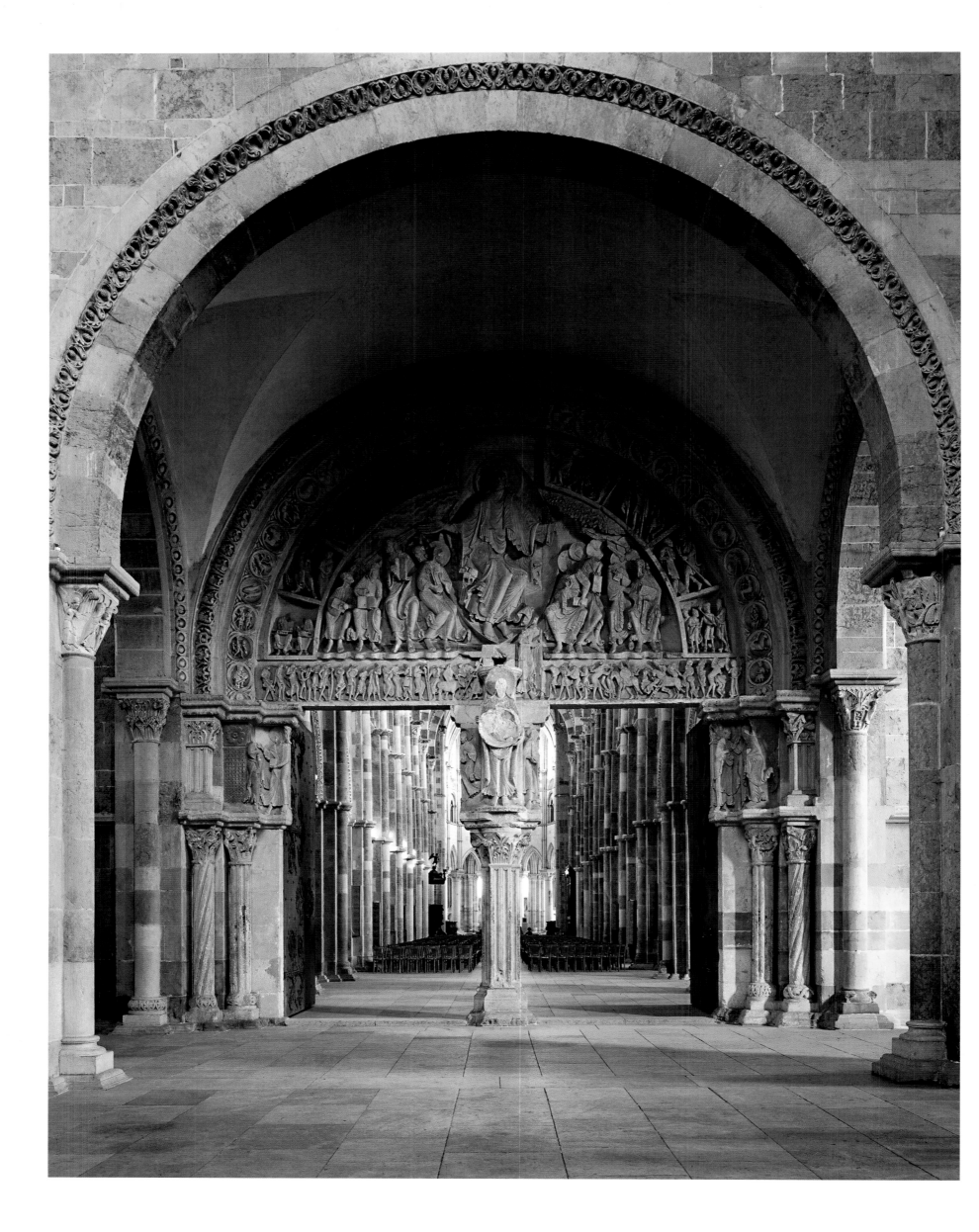

Ulrike Laule

Architecture of the
Middle Ages

Editor: Rolf Toman

Photography: Achim Bednorz

Feierabend

© 2004 Feierabend Verlag OHG
Mommsenstr. 43
D-10629 Berlin

Layout: Rolf Toman, Thomas Paffen
Production management: Erill Vinzenz Fritz, Stephanie Leifert
Picture editor: Petra Ahke
Coordination, editing, and typesetting of the English edition: APE Int'l, Richmond, VA
Translation from German: Tammi Reichel
Lithographs: Fröbus GmbH, Köln
Printing and binding: Stalling GmbH, Oldenburg

Printed in Germany
ISBN 3-89985-053-X
61 09021 1

Contents

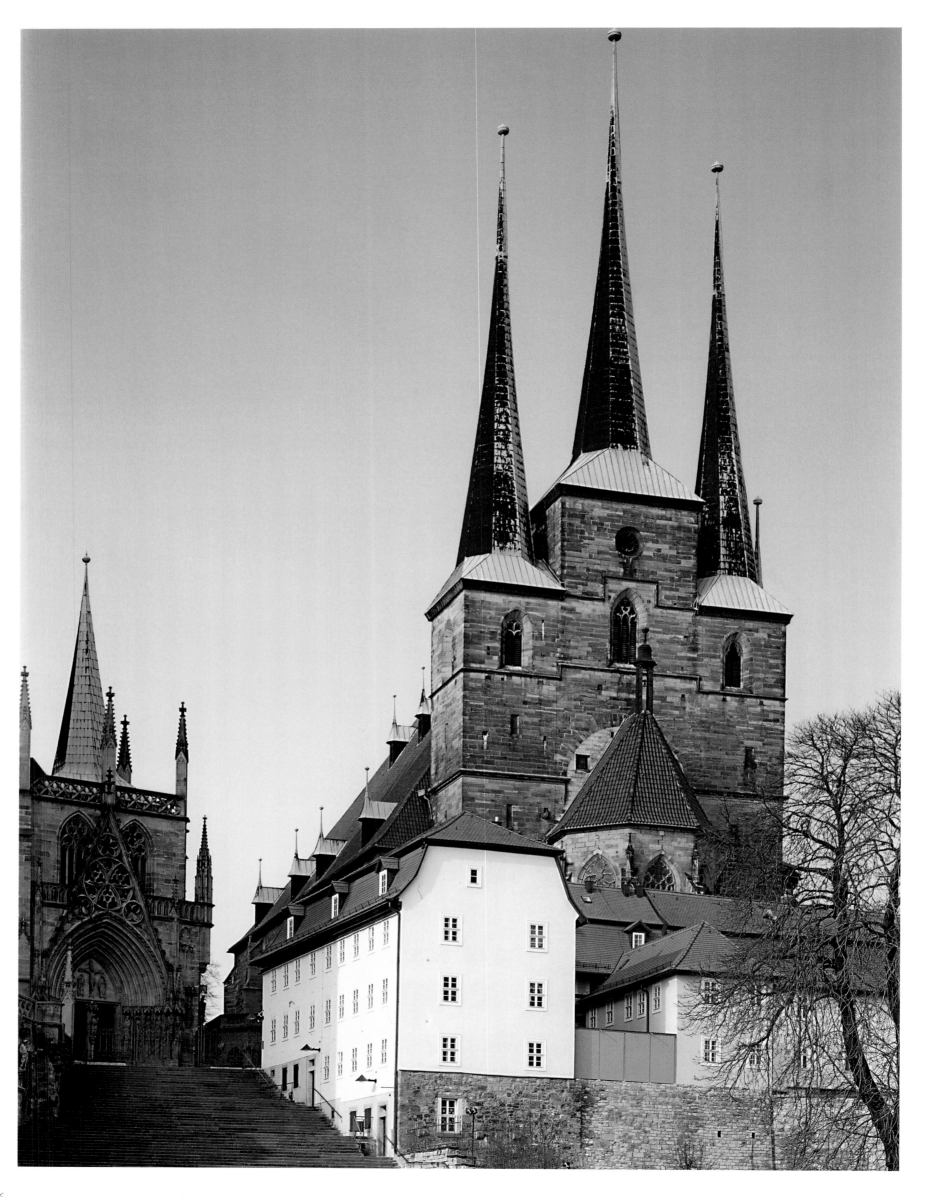

Introduction by the Editor

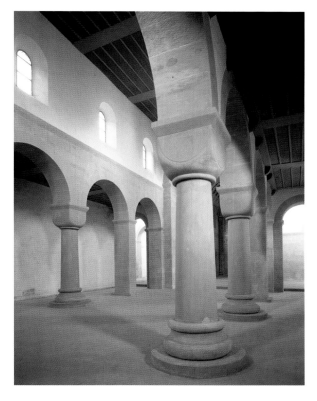

The topic of this book is the architecture of the Middle Ages. Central to this are buildings of the High and late Middle Ages, or more precisely, Romanesque and Gothic sacred architecture of the period from 1000 to 1520. The discussion of pre-Romanesque architecture is brief due to the fact that preserved examples of buildings from the time before A.D. 750 are scarce and don't lend themselves to a photography-based book. Examples from Carolingian and Ottonian times (750–1000) are limited, as well. We will, of course, cover significant buildings from that time, such as the chapel at Charlemagne's palace in Aachen, as well as crypts and the development of the westwork. But a truly close, visual examination can only begin with late Ottonian and early Romanesque sacred buildings.

There are an abundance of secular architectural monuments from the High and late Middle Ages, including donjons, castles, city manors, city halls, hospices, city ramparts and gates, bridges and other functional structures. However, the chapter treating secular architecture is relatively short. We limited ourselves to pointing out the huge number, variety and polymorphism of these architectural projects, since delving deeper into the development of each type of structure would have exceeded the scope of this book.

The focus of this volume is the architectural photography of Achim Bednorz. The concept of an illustrated book with only introductory texts was a challenge for the author, Ulrike Laule, who was given very limited space to elaborate on Romanesque and Gothic art and building styles, and at least basically outline their development in the various European regions. She certainly has proven her abilities in this area in other publications. In order to help the reader become acquainted with technical architectural terms, a graphic overview of forms and shapes precedes each of the two main sections. Architectural illustrator Pablo de la Riestra, himself an art historian and well acquainted with the problems of conveying architectural and historical context, created illustrations comparing Romanesque and Gothic building forms. Highlighting the differences in medieval sacred architecture also brings out its common elements. The main problem for the editor was to select from the huge variety of historical monuments and to bring together the various elements—photos, drawings, and texts—into one book. It easily could have grown to three times its size—but the publisher would not have gone along with that...

One more word about the topic itself: The Gothic cathedral is widely considered to be the zenith of medieval architecture. This judgment is based on the feats of structural engineering it represents and the general impression of space evoked by its width and height, the impressive vaulting, the tinted light from the enormous windows, and numerous other esthetic elements. While in no way seeking to downplay the impressiveness, even the wonder (Bourges!) of the Gothic cathedral, I must still confess a secret preference for rural Romanesque architecture. This predilection accounts for the fact that the chapter on Romanesque architecture, at least the photographic component, is as long as the chapter on the Gothic period—which could be considered quite an imbalance, since the Gothic lasted almost twice as long as the Romanesque. While there is no "justification" for this preference, I will try to explain it. The appeal of a time gone by—for me and for many others—lies in its remoteness, its other-ness, in that sense of "once upon a time." In this respect, a Cistercian monastery nestled in some quiet valley, with its simple, unadorned, modest-sized church space whose meditative aura can still be felt, is more unfamiliar than an urban cathedral. The latter's architectural superlatives are, in a sense, already modern in their tendency toward exaggeration. Thus I have mixed feelings, for example, when I stand before the facade of the Strasbourg cathedral. Its wealth of forms and ornamentation is astonishing and impressive (see illus. p. 148 bottom). Along with the wonder, however, is a sense of almost being crushed beneath the abundance of elements. One is almost tempted to turn away from it. Only by observing the elements individually and analyzing the whole from a comfortable distance am I able to return to a sense of wonder. My experience with the abbey church of Le Thoronet (see illus. pp. 70/71), on the other hand, is entirely different. It feeds my fantasies about a different, monastic way of life, and enhances my reflections on life then and now; in short, it provides more of an existential experience that has more to do with life than with art. Knowing why the early Cistercian buildings were so sparse and unadorned, and why the great Cistercian abbot Bernard of Clairvaux banned ornamentation from the abbey churches, only makes it better.

So you see, this book admittedly has a subjective side, even if you don't notice it at first glance.

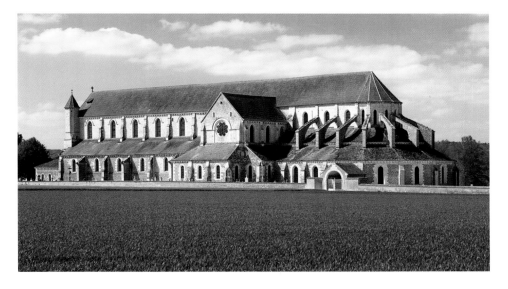

ABOVE:
Kleinkomburg, St Ägidius, 12th c.

Pontigny, former Cistercian abbey church of Notre-Dame, exterior, last third 12th c.

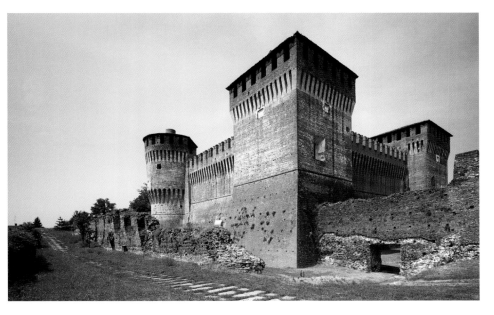

Soncino, Castello, one of the best preserved fortified buildings in Lombardy, created in 1473 under the patronage of G. M. Visconti

PAGE 6: **Erfurt, St Severi,** view from the west (nave 1280–1340)

PAGE 2: **Vézelay, Sainte-Madeleine,** main portal, 1125–1130

Early Medieval Architecture

When discussing building styles, art history typically refers to the entirety of building forms, elements and motifs that characterize the architecture of a certain period and thus make it dateable. The preserved and excavated legacies of an era make it possible to reconstruct the progeny and development of a style. The precondition for a style's existence is always a new esthetic ideal, a changing feel for space, which may result from changes in devoutness, a restructuring of liturgical rites, a change in the dominant cult, or from a new spiritual mindset. Thus new architectural elements emerged—such as the crypt or westwork in Carolingian times, and later the ambulatory with radiating chapels or the double-tower facade—as well as changes in esthetic ideas resulting from the rearrangement and reinterpretation of certain forms and motifs. A new style always evolves out of the changing, reshaping, and reinterpretation of an existing one as it is adapted to new circumstances. Because of this, a given style's evolution can be traced through early, high, and late stages that distinguish when a new form begins to evolve and an old one is still recognizable. This is especially true for early medieval art and architecture, which represented the European (or occidental) counterpart to Byzantine culture.

Tribal migrations that began around A.D. 375 with the invasions of the Huns and Alans reshaped all of Europe and resulted in the Romans being driven out of their northern provinces. In 476 Rome itself was conquered by the German chieftain Odoacer, and again in 493 and 497 by the Ostrogoth King Theodoric the Great, while the Eastern Roman Empire endured under Emperor Justinian (527–565) to once again encircle almost the entire Mediterranean Sea.

At the same time the Franks had spread from Frisia towards the south and east. Their king, Clovis, managed to triple the size of his empire by the time of his death in 511. In the end, his sons ruled almost all of central Europe. Charlemagne, who had become King of the Franks in 771, expanded his territories further east and south. The Frankish Empire eventually reached from the Ebro River in Spain to the Saale and Elbe Rivers in Germany, from the Atlantic Ocean to Bavaria and Friaul, and on the Italian Penisula included Tuscany, the Vatican, and the Duchy of Spoleto. His coronation in 800 made the Frankish king Emperor of the Holy Roman Empire. The fact that the pope had crowned Charlemagne emperor reinforced the alliance between church and empire, as expressed by the notion of the divine right of kings. Charlemagne unified the occident in religion, politics, and culture. His political program, known as the *renovatio imperii*, was a simultaneous expression of his claim and of its legitimacy. It brought about the reformation of the Western Roman Empire and the revitalization of academics and the arts referred to as the Carolingian Renaissance. This and the rivalry with the Byzantine Empire, the principle power to the southeast, shaped the art and architecture of the imperial court and its surroundings. Charlemagne imported spolia from Rome and Ravenna—the latter being the burial place of Theodoric, who had conquered Italy on behalf of Constantinople (see illus. right and on pp. 10/11). Both cities had become Frankish when Charlemagne assumed the protectorate of the church-state in 774. He also adopted building styles and motifs from the Byzantine Empire and Rome. The Christian imprint of the empire and the multitude of examples, however, reshaped them and fused them into a single style characterized by its own individual esthetic. Later occidental styles ultimately evolved from this Carolingian art and architecture.

The most famous examples of early Carolingian architecture are the palace of Aachen, whose chapel still stands (illus. p. 12), the small private chapel of the magnificent suburban villa that Bishop Theodulf, friend and counselor of Charlemagne, had built in Germigny-des-Prés, and the Lorsch Abbey gatehouse (illus. p. 13). What they all share in common is rich ornamentation, variety in their floor plans and elevations, a wealth of individual spaces that combine to

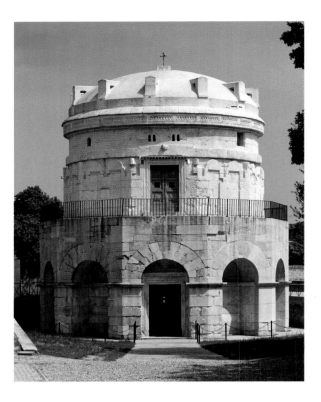

Ravenna, Mausoleum of Theodoric, rotunda from the 1st quarter of the 6th c.

form a whole, and especially the usage and free recombination of models drawn from late antiquity.

Along with central-plan buildings, basilicas emerged, for example in Steinbach bei Michelstadt and in Seligenstadt, both in Germany. Both were commissioned by Einhard, son-in-law and biographer of Charlemagne, and are cruciform, columned basilicas with truncated crossings and simple east choirs. Sankt Georg in Reichenau-Oberzell (890–896) also belongs to this tradition. The abbey church of Sankt Johann in Müstair (illus. below left) is thought to have been sponsored by the emperor himself. It is a flat-ceilinged hall church with three apses of equal height that are decorated with scene paintings and—exceptionally—it has two corridor-like "aisles," separated from the nave by walls, through which one entered the church. The prototypes for this hall design with one or three apses, found mainly in the Swiss Alps or foothills of the Alps, are also seen in the eastern Mediterranean region.

On the Iberian Peninsula, where the Asturian kingdom was the last Christian bastion against the Muslim Umayyad Emirate of Córdoba, we find more examples from the Carolingian period. Examples still standing today include Santa Maria de Naranco (illus. pp. 14/15), a former palace hall, and San Miguel de Liño (illus. p. 9 bottom right), near Oviedo. Their rich ornamentation and complex structural proportions hardly deviate from the central plans used in northern regions. It is noteworthy that in the mid-ninth century, a barrel vault was already being used in the nave. Its reinforcing arches are located in a common axis with the columns of a blind arcade arrangement on the side walls.

A similar blind arcade arrangement can be found in the crypt of Saint-Laurent in Grenoble (illus. p. 9 bottom left), although here the columns are spolia and architraves alternate with arches above the capitals. The barrel vault resting upon them has no transverse arches.

Roman city basilicas from the ninth century, for example San Giorgio in Velabro and San Prassede, stand firmly in the late antique tradition and are three-aisled, transeptless churches with a flat ceiling and a semi-circular apse. Their columns support arches or an architrave.

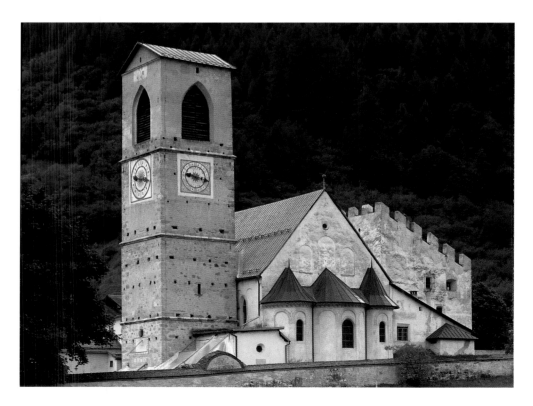

Müstair, Graubünden, abbey church of St Johann, southeastern view, ca. 800

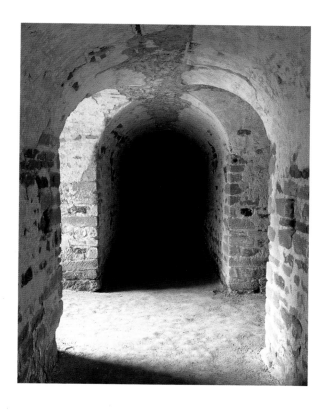

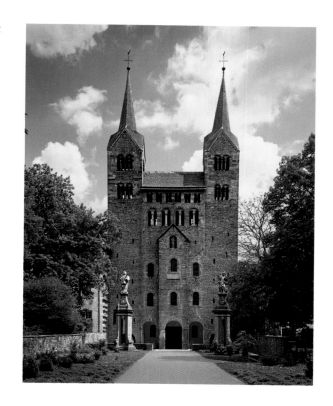

Two elements of Carolingian origin are the crypt and the westwork. Both are closely tied to the veneration of saints and the cult of the emperor. The crypt probably traces back to saints' tombs in late-antique cemeteries, over which chapels had been erected. Later, monasteries were often founded above these tombs, which lay hidden under the new churches. At St Peter's Basilica, in order to make the apostle Peter's tomb accessible to the faithful Pope Gregory (590–604) had a passageway built along the wall of the apse that led through a gallery and directly into the sepulcher. The floor of the apse was raised for that purpose. But only with the wave of construction sparked by imperial sponsorship from the late eighth century were crypts shaped as vaulted chambers or galleries. Two examples are the circular crypt of Fulda (illus. center left), which contains the tomb of St Boniface, and the crypt with galleries in Steinbach (illus. left). As early as around 820, the Sankt Gall monastery plan shows a fully developed elbow-shaped crypt with a sepulcher under the main altar. The crypts of Saint-Pierre in Flavigny-sur-Ozerain and Saint-Germain in Auxerre, from the second half of the ninth century, already have complex arrangements with multiple chambers and passageways, little groin-vaulted halls, and centrally planned side chapels. In most cases the crypt was only partially subterranean, resulting in a choir area that was elevated several steps above the main floor.

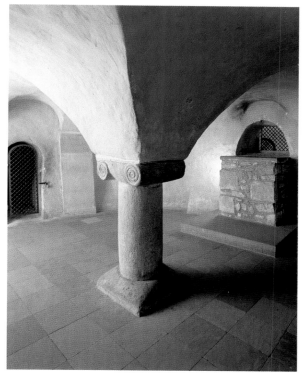

The westwork, also of Carolingian origin, is an isolated building section at the basilica's western end, a multi-story block flanked by towers that serves as a visual counterpoint to the eastern sections. On the ground floor it housed an entrance hall and an atrium; above these was typically a two-story chapel, encircled by galleries, which opened into the nave. The first verifiable westwork was at the abbey church of Centula in Saint-Riquier (dedicated 799); the earliest preserved example is in Corvey (illus. top and center right). The function of the westwork is not yet clear; various theories propose that it played a defensive role or served as a martyr's church, a chapel to St Michael, or an imperial chapel. The fact that all churches with westworks were, in fact, associated with the imperial household, and had a galleried central area like those in palace chapels, seems to support the imperial chapel theory. At the same time, the pictorial quality of the gate flanked by towers suggests an architectural symbol of a city, i.e. the heavenly Jerusalem, as symbolized by the church. The evolution of the westwork into a complete west end that formed part of the overall structure and was often symmetrical with the eastern sections seems to reinforce the conceptual sub-division of the Church into imperial and ecclesiastic power, or into *ecclesia militans* and *ecclesia triumphans*.

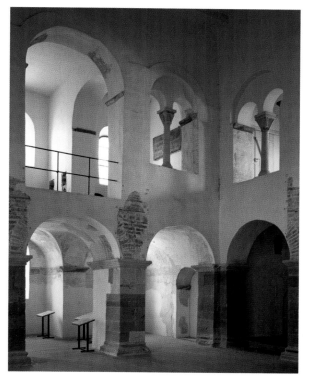

TOP LEFT:
Steinbach bei Michelstadt, Einhards Basilica, gallery crypt, completed 827

CENTER LEFT:
Fulda, chapel of St Michael, circular crypt, 820–822

LEFT:
Grenoble, Saint-Laurent, eastern crypt

TOP AND CENTER RIGHT:
Corvey, abbey church, west facade (1146) and westwork interior with imperial gallery (873–885)

RIGHT:
Oviedo, Monte Naranco, San Miguel de Liño, mid-9th c.

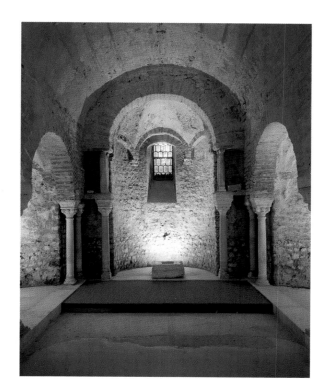

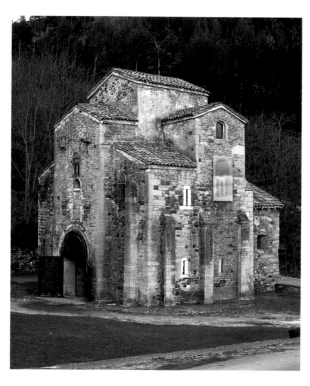

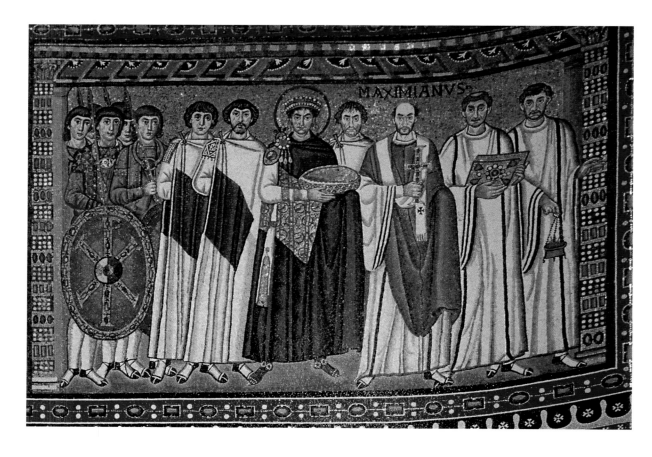

Ravenna, San Vitale, completed ca. 545, exterior and interior views; detail of mosaic

Judging from its uniformity and well-balanced proportions, the floor plan of this octagonal, centrally planned church was probably designed in Constantinople. The capitals used here were also brought from Constantinople. The sumptuous mosaics and the floor, worked in the *opus sectile* technique, date from the time of Bishop Maximian, who dedicated the building in 547.

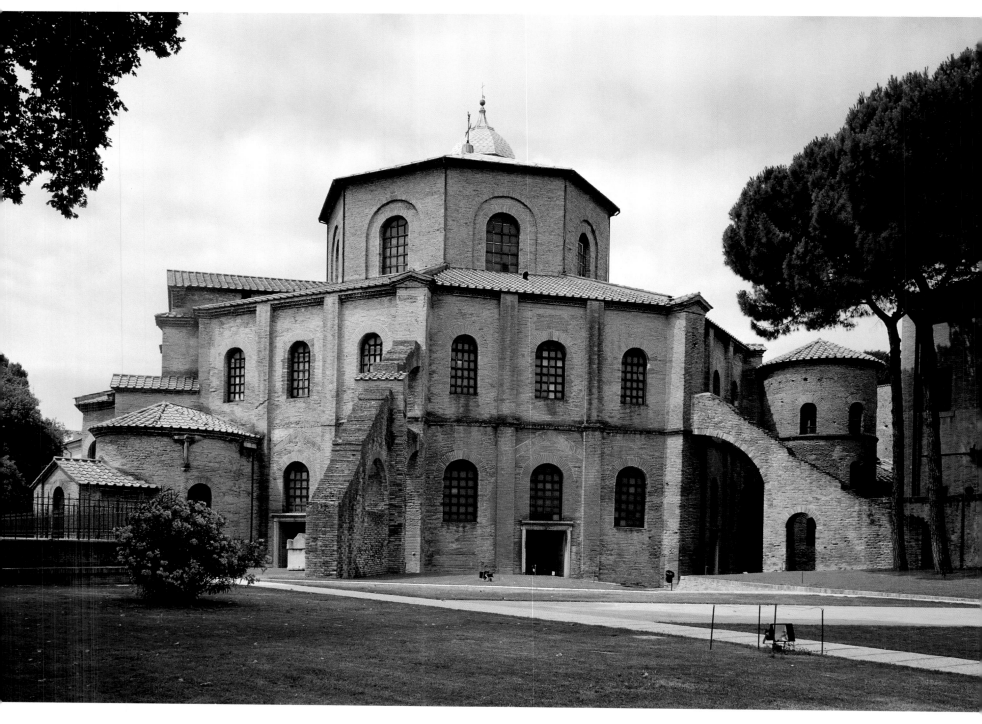

OPPOSITE: **Aachen, Palatine Chapel, ca. 800**

Master Odo of Metz built the chapel around 800 at the extensive Aachen palace of Charlemagne. The building is a principal work of the Carolingian Renaissance, with its extensive use of Byzantine and Roman prototypes and spolia.

Lorsch, gatehouse, ca. 774

The gatehouse, resembling a triumphal arch, was freestanding within an atrium that preceded the westwork and parvis of the abbey church of St Nazarius.

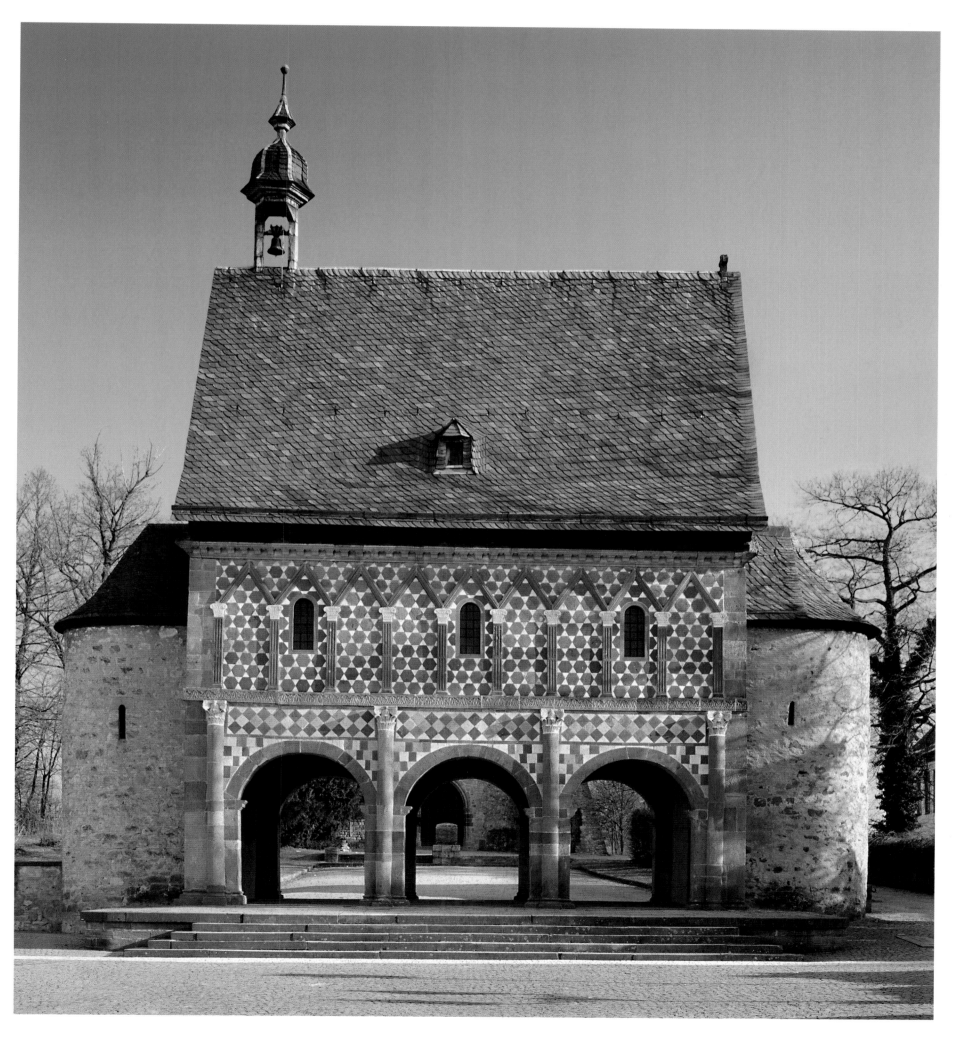

Oviedo, Monte Naranco, palace hall from the time of King Ramiro I, 842–850, exterior and interior views

The palace hall, where late Roman, Byzantine, and Parthic-Sasanid elements come together, was part of a palace of the Asturian kings. Soon after its construction, it was turned into a chapel dedicated to St Mary.

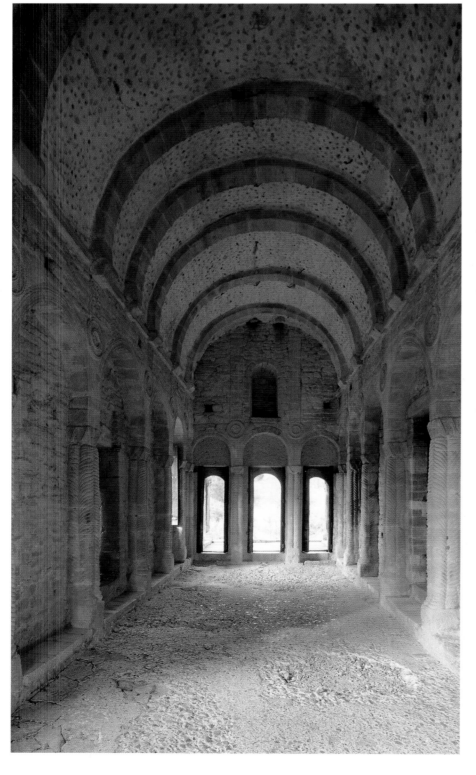

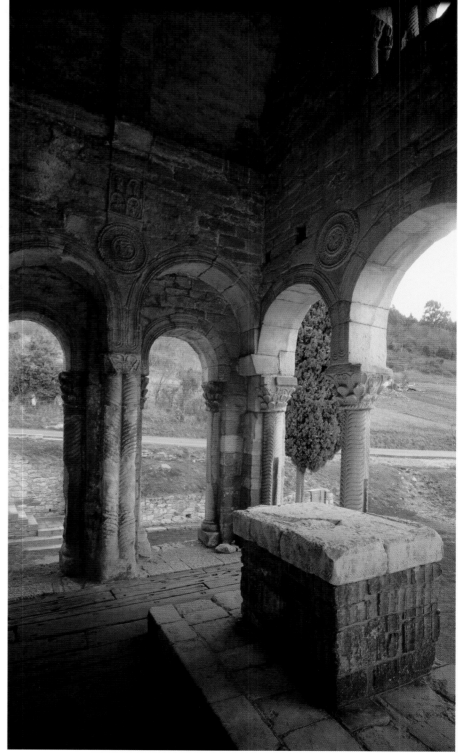

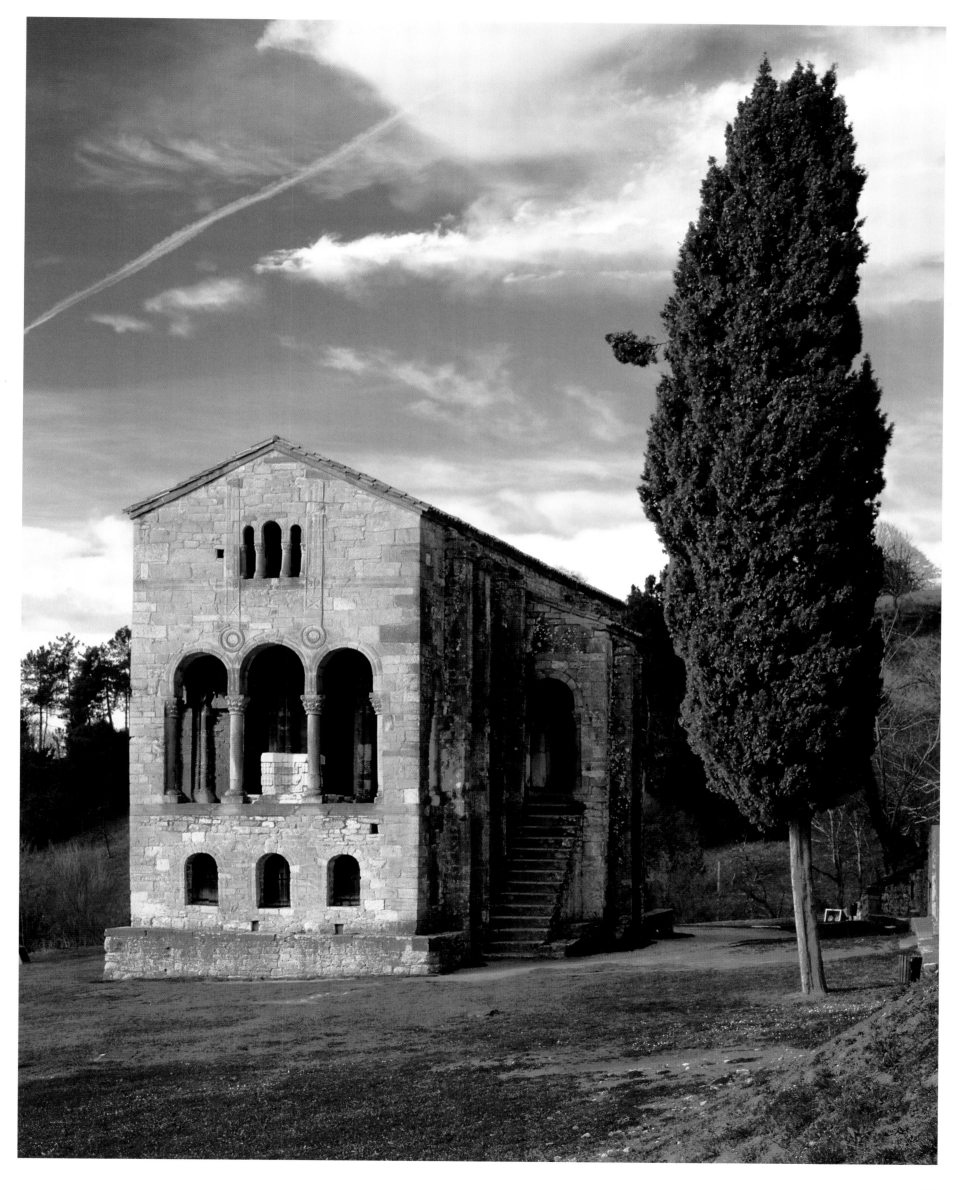

Pablo de la Riestra
Architectural Forms in Medieval Religious Buildings

The majority of medieval—and, for that matter, all Occidental—sacred buildings are designed with an axial plan: the nave, with one or more aisles, forms a central axis that leads to the sacred center, the altar area in the choir. As a rule the altar lies to the east, anticipating the source of salvation. Churches with this axial or longitudinal plan are referred to here as belonging to the first major group. A second main group consists of buildings with a central plan (see p. 17 bottom).

We distinguish three building types within the first major group of church. These differ mainly according to the layout and design of the nave. Depending on the composition of its nave, a church may be classified as a basilica, a hall church, or an aisleless church.

A *basilica* has a multi-aisle nave in which the ceiling above the center aisle is higher than those above the side aisles. The uppermost walls of the center aisle are known as the clerestory, and contain windows that provide direct illumination for the nave. If the center aisle is higher than the side aisles but has no clerestory windows, the church is called a pseudobasilica.

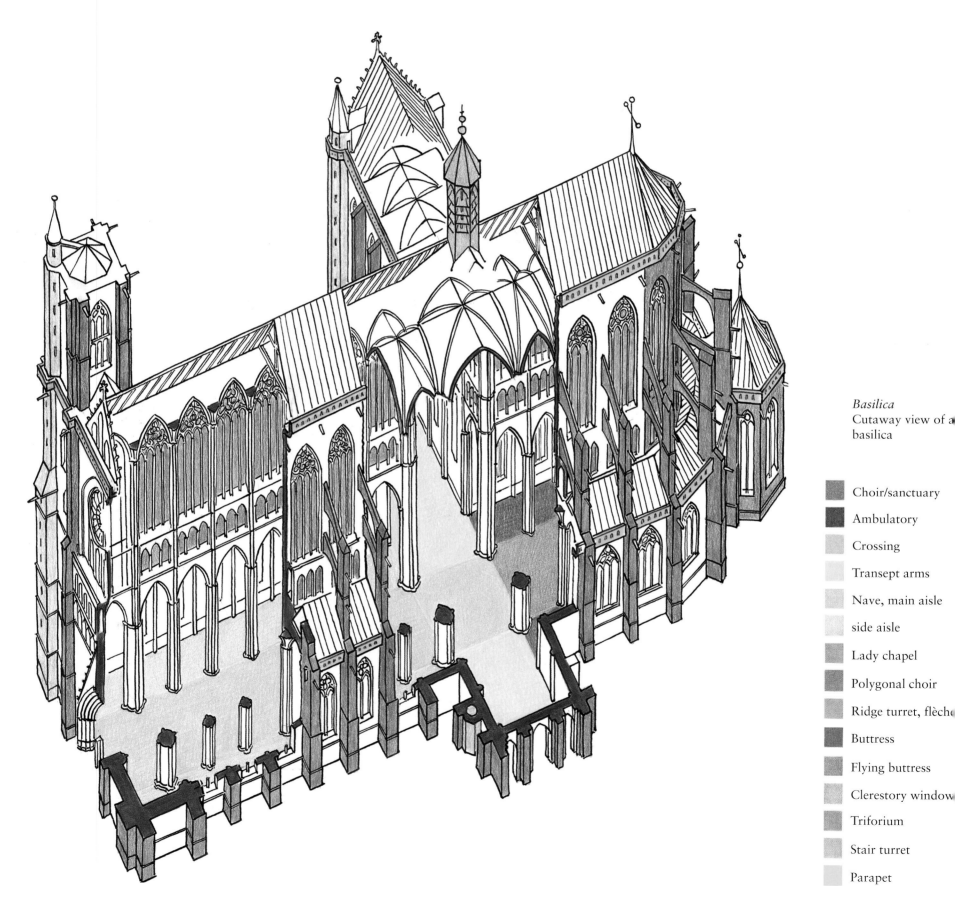

Basilica
Cutaway view of a basilica

- Choir/sanctuary
- Ambulatory
- Crossing
- Transept arms
- Nave, main aisle
- side aisle
- Lady chapel
- Polygonal choir
- Ridge turret, flèche
- Buttress
- Flying buttress
- Clerestory window
- Triforium
- Stair turret
- Parapet

Hall church

The typical hall church has three aisles, but they are found with anywhere from two to five aisles. Unlike a basilica, the hall church has side aisles of the same or nearly the same height as the center aisle. Light for the nave comes through the side-aisle windows. If the center aisle ceiling is higher, the structure may be referred to as a stepped or staggered hall church.

Aisleless church

An aisleless church has an undivided nave with no structural articulation. When supports and other structural moldings are present, as in subdivided vaulting bays, it is called a single-aisle church.

Cross section of a stepped or staggered hall church

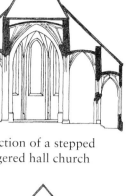

Cross section of a hall church

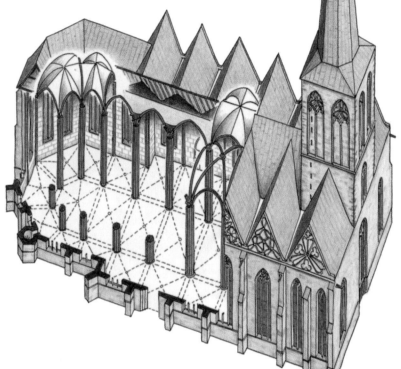

Choir

Single aisle

Sacristy

Central plan

Unlike basilicas and hall churches, which have an axial plan, the different sections of a centrally planned church are arranged symmetrically around a central focal point. The floor plan can be circular, polygonal, or square. Centrally planned churches are often domed.

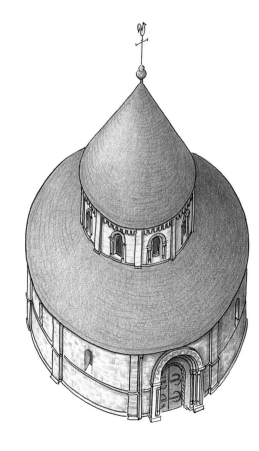

Romanesque
Cambridge, Holy Sepulchre, ca. 1120

Gothic
Heiligenstadt, St Anna Chapel, 2nd half 14th c.

Romanesque

Hildesheim
St Godehard
(from 1130–1172,
early 13th c.)

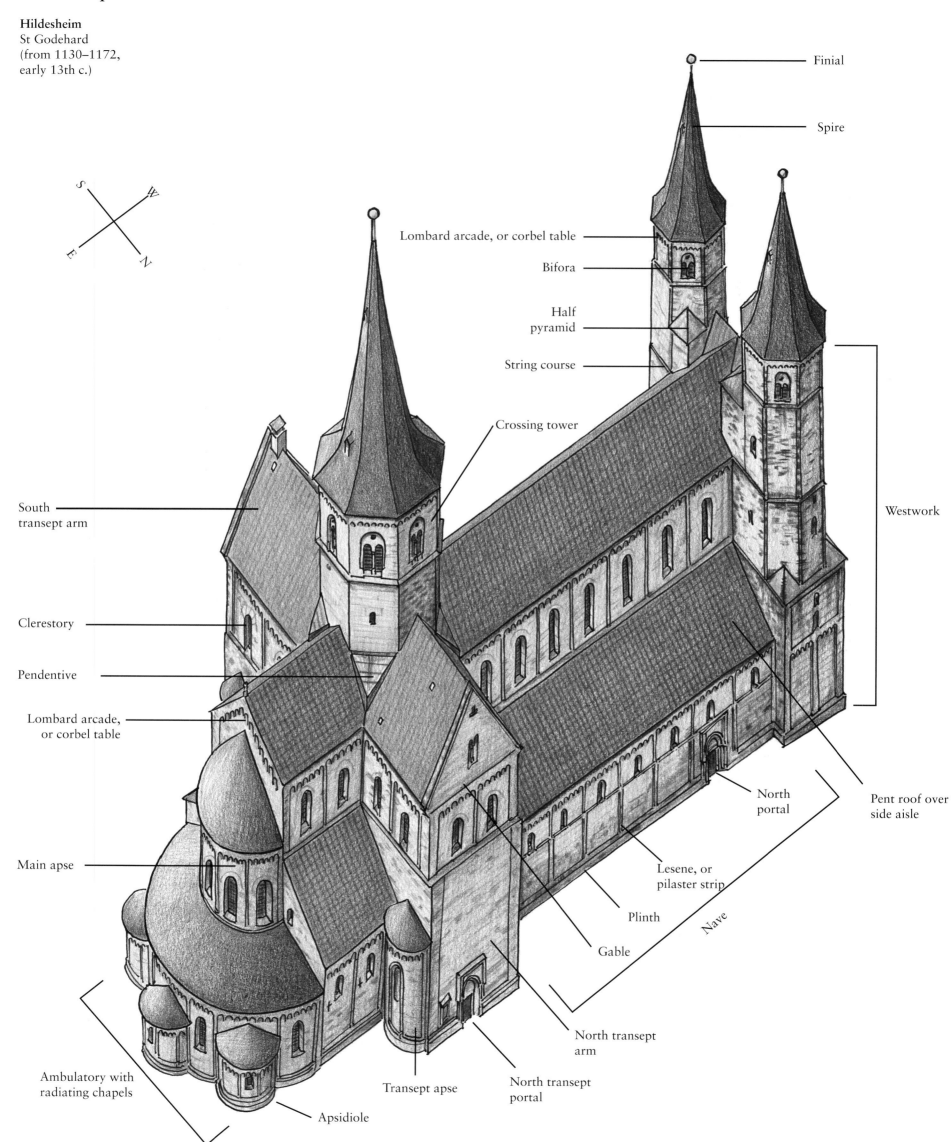

Finial

Spire

Lombard arcade, or corbel table

Bifora

Half
pyramid

String course

Crossing tower

South
transept arm

Westwork

Clerestory

Pendentive

Lombard arcade,
or corbel table

Pent roof over
side aisle

North
portal

Main apse

Lesene, or
pilaster strip

Plinth

Nave

Gable

North transept
arm

Ambulatory with
radiating chapels

Transept apse

North transept
portal

Apsidiole

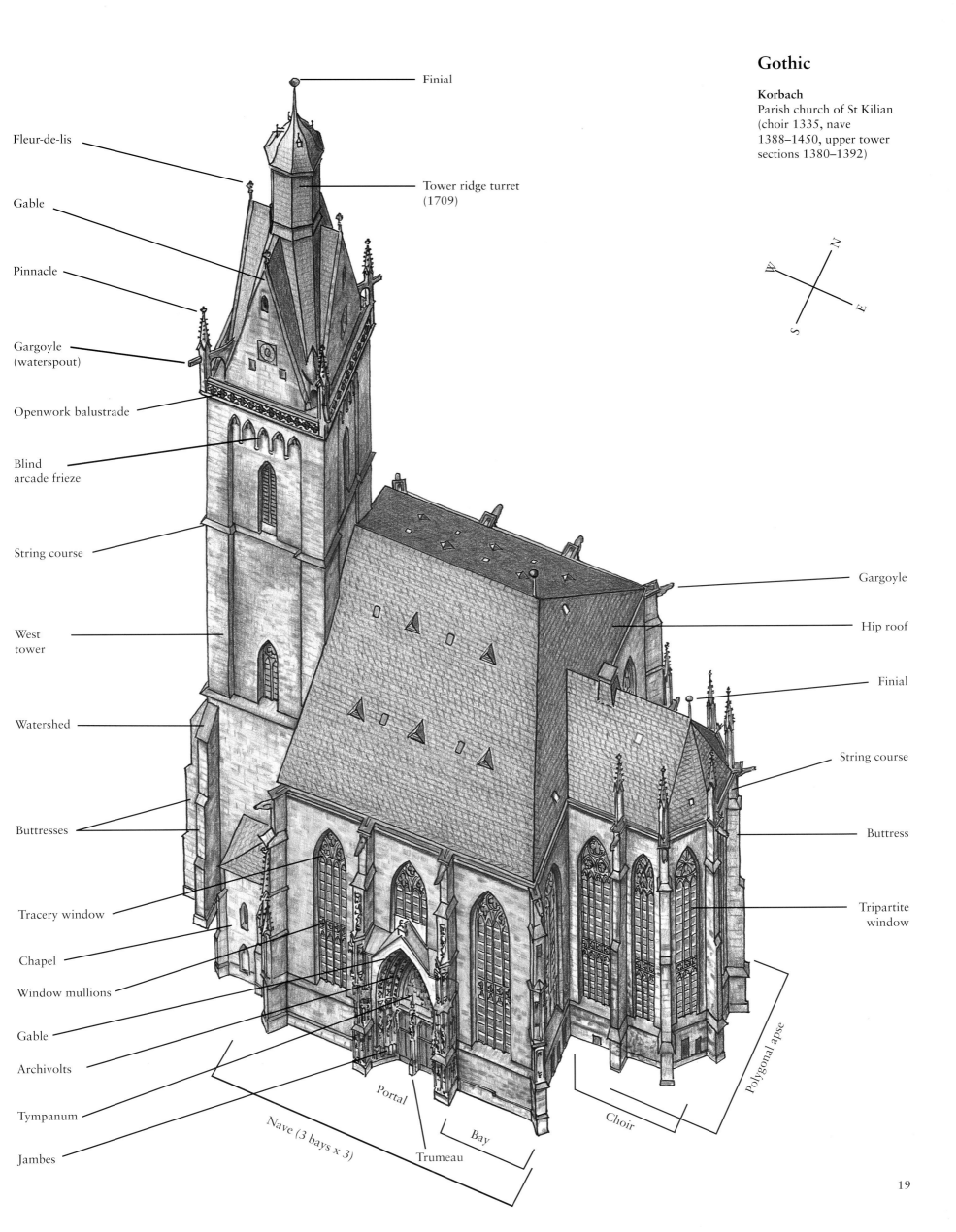

Gothic

Korbach
Parish church of St Kilian (choir 1335, nave 1388–1450, upper tower sections 1380–1392)

Finial

Tower ridge turret (1709)

Fleur-de-lis

Gable

Pinnacle

Gargoyle (waterspout)

Openwork balustrade

Blind arcade frieze

String course

West tower

Watershed

Buttresses

Tracery window

Chapel

Window mullions

Gable

Archivolts

Tympanum

Jambes

Gargoyle

Hip roof

Finial

String course

Buttress

Tripartite window

Polygonal apse

Choir

Bay

Portal

Trumeau

Nave (3 bays x 3)

Basilica Types

1 Basic with
 semicircular apse
1a Basic with
 polygonal apse

2 Basic with transept
2a Basic with transept

3 Double-ender with
 two choirs and
 single transept
3a Double-ender with
 two choirs and
 single transept

4 With Benedictine or
 staggered choir (main
 choir flanked by smaller
 apsidioles; also de-
 scribed as choir with
 apses in échelon)
4a With staggered choir

5 With continuous
 ambulatory
5a With continuous
 ambulatory

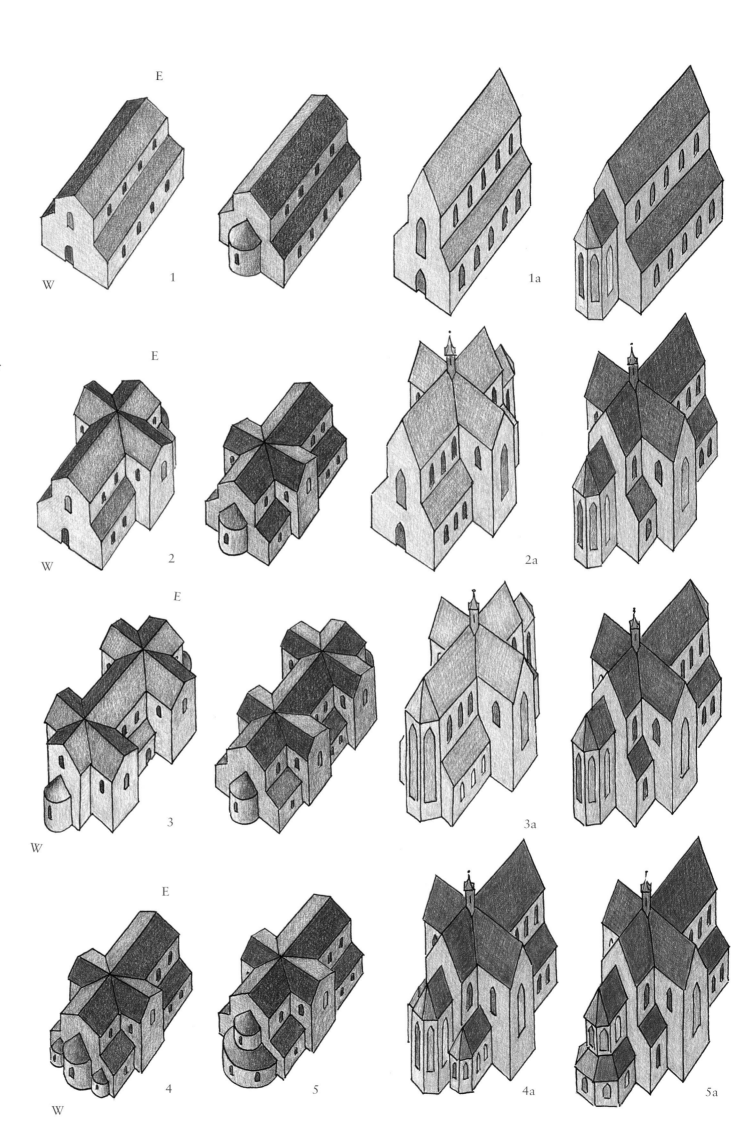

Romanesque **Gothic**

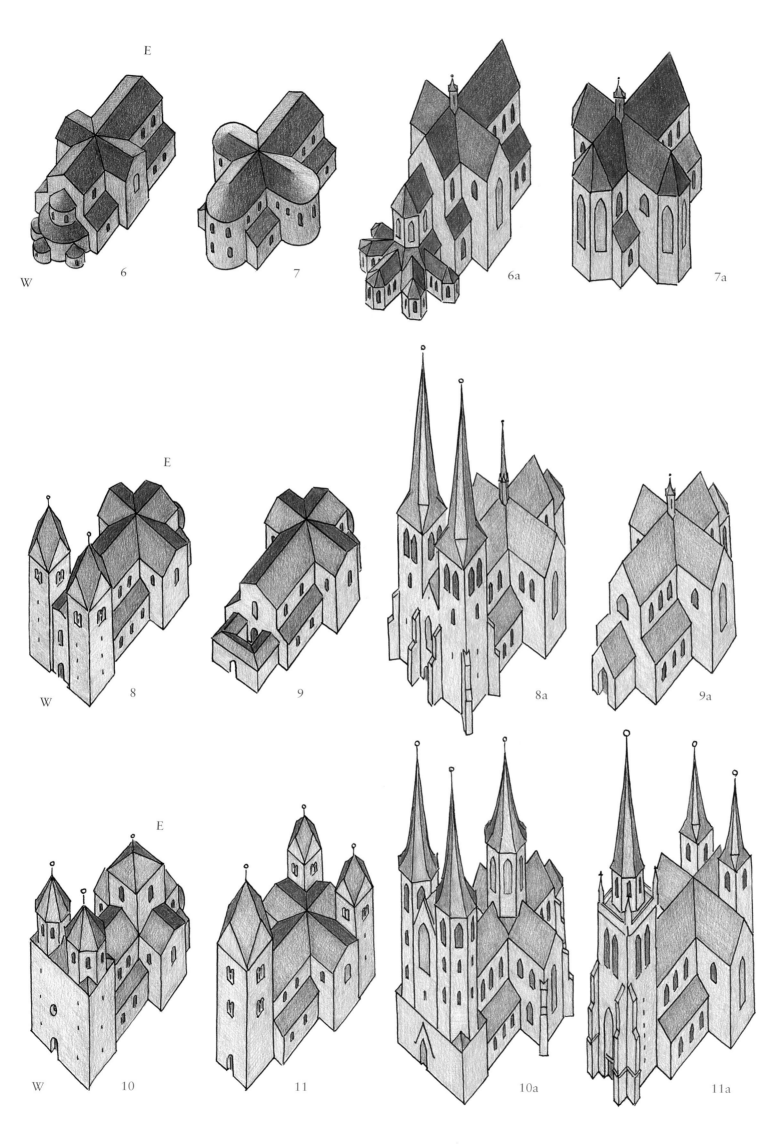

6 With chevet
 (ambulatory and
 radiating chapels)
6a With chevet
 (ambulatory and
 radiating chapels)

7 With trefoil choir
7a With trefoil choir

8 With twin-tower facade
8a With twin-tower facade

9 With atrium
9a With porch or vestibule

10 With westwork and
 crossing tower
10a With west end and
 crossing tower

11 With single-tower
 facade and choir with
 flanking towers
11a With single-tower
 facade and choir with
 flanking towers

21

Comparison of Basilica Interiors

Romanesque

Gothic

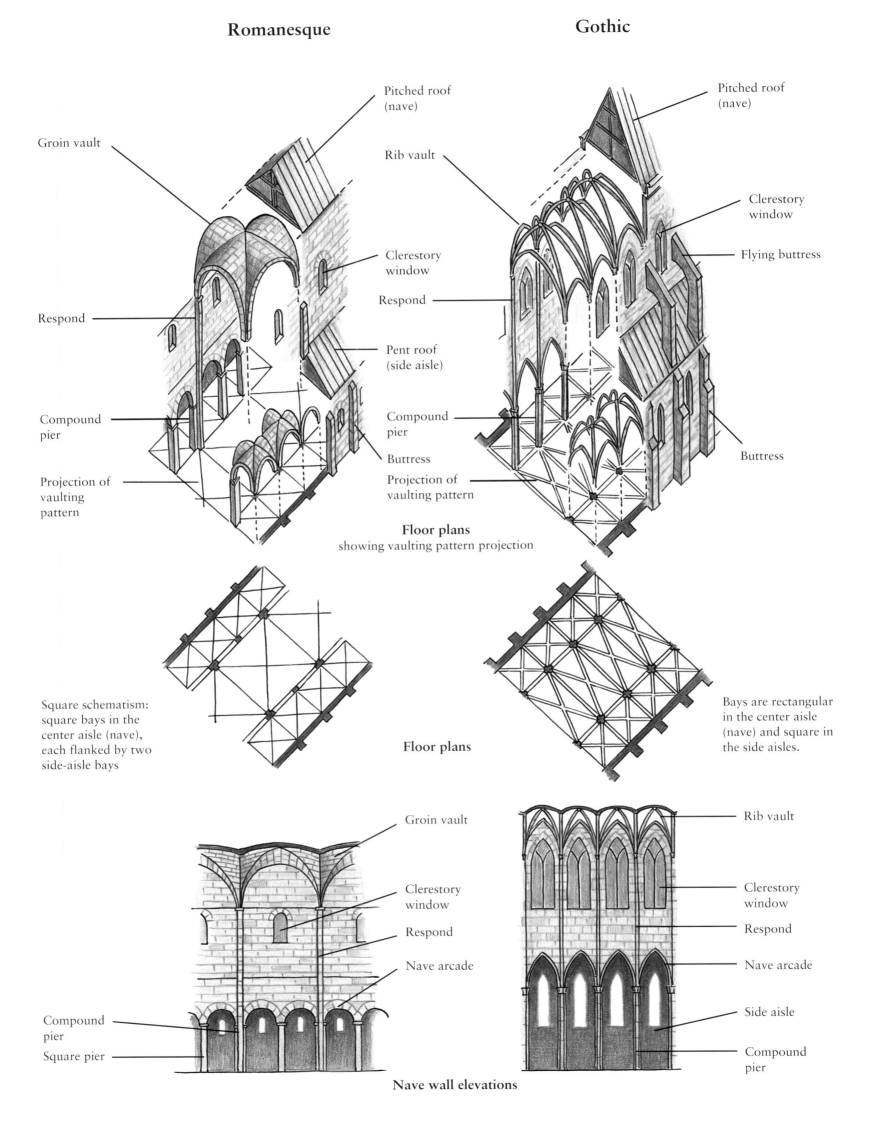

Pitched roof (nave)

Groin vault

Rib vault

Clerestory window

Respond

Clerestory window

Respond

Pent roof (side aisle)

Compound pier

Compound pier

Buttress

Projection of vaulting pattern

Projection of vaulting pattern

Pitched roof (nave)

Clerestory window

Flying buttress

Buttress

Floor plans
showing vaulting pattern projection

Square schematism: square bays in the center aisle (nave), each flanked by two side-aisle bays

Bays are rectangular in the center aisle (nave) and square in the side aisles.

Floor plans

Groin vault

Clerestory window

Respond

Nave arcade

Compound pier

Square pier

Rib vault

Clerestory window

Respond

Nave arcade

Side aisle

Compound pier

Nave wall elevations

Vaulting Types

Romanesque

Gothic

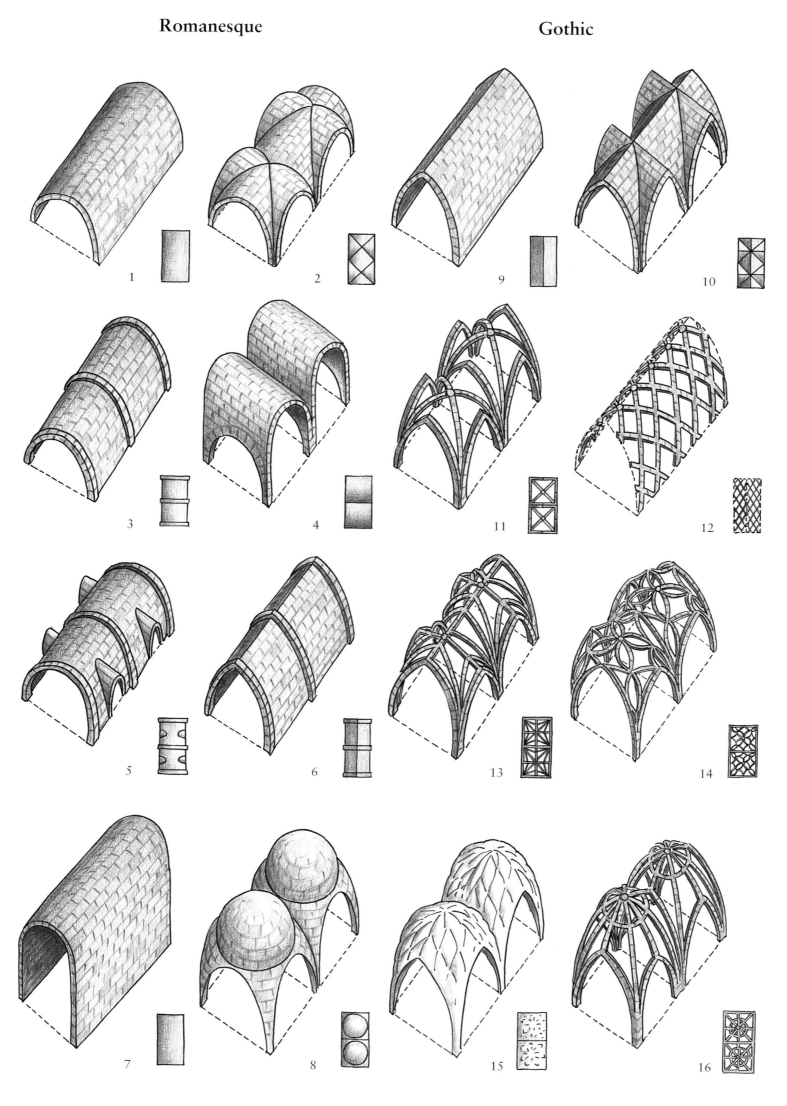

1 Barrel vault
2 Groin vault
3 Barrel vault with transverse arches
4 Transverse barrel vault
5 Barrel vault with transverse arches and projecting windows
6 Pointed barrel vault with transverse arches
7 Barrel vault on walls
8 Dome vaults with pendentives

9 Pointed barrel vault (also Romanesque)
10 Pointed groin vault
11 Rib vault
12 Net vault
13 Tierceron vault
14 Curving or curvilinear vault
15 Cellular vault
16 Domical vault

Arch and Window Forms

Romanesque	Gothic

1 Semicircular arch
2 Pointed arch

3 Trefoil arch
4 Ogee arch

5 Lily-shaped window
6 Tudor arch

7 Quatrefoil window
8 Segmental arch

9 Oculus
10 Depressed arch or basket arch

11 Half-wheel window
12 Shouldered arch

13 Wheel window
14 Curtain arch

15 Bifora (twin-arch) window
16 Cross window

Pier Shapes

Romanesque	Gothic

1 Square pier
2 Octagonal pier

3 Compound
 (cruciform) pier
4 Compound pier
 (pilier cantonné)

5 Columnar pier with
 block capital
6 Compound
 (clustered) pier

7 Twisted column
8 Twisted column (helical)

24

Wooden Spires

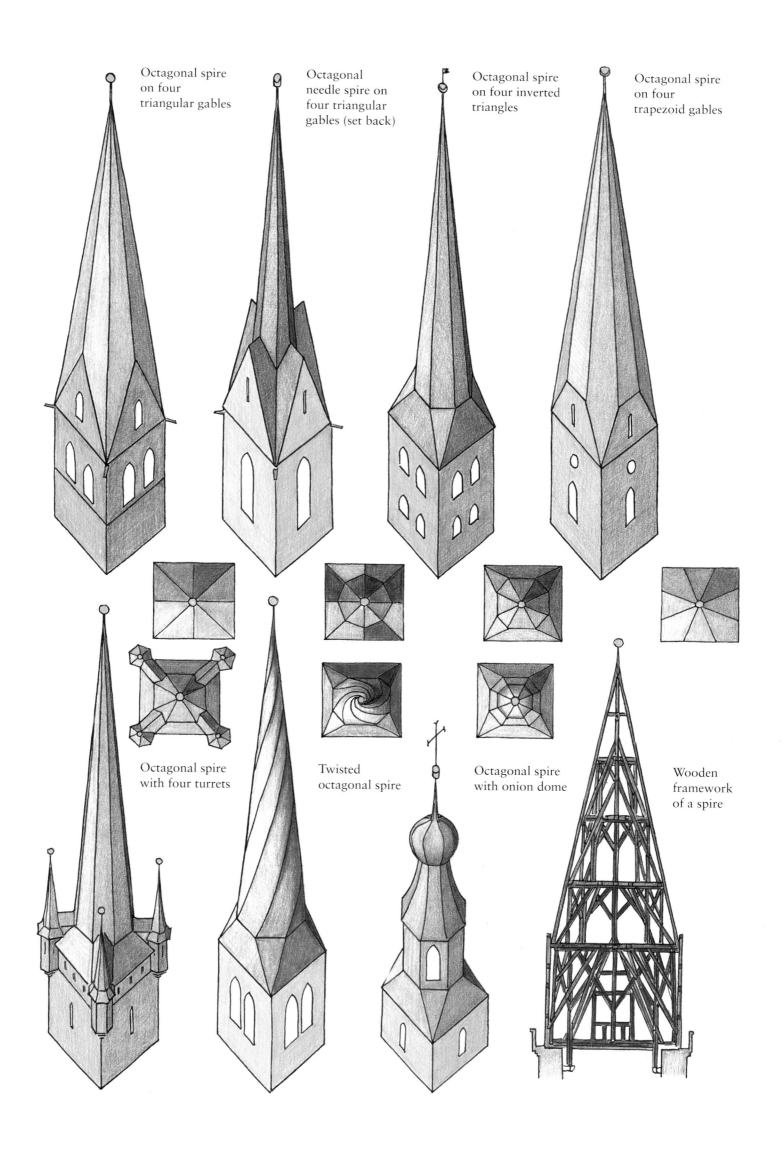

Octagonal spire on four triangular gables

Octagonal needle spire on four triangular gables (set back)

Octagonal spire on four inverted triangles

Octagonal spire on four trapezoid gables

Octagonal spire with four turrets

Twisted octagonal spire

Octagonal spire with onion dome

Wooden framework of a spire

Stone Church Spires

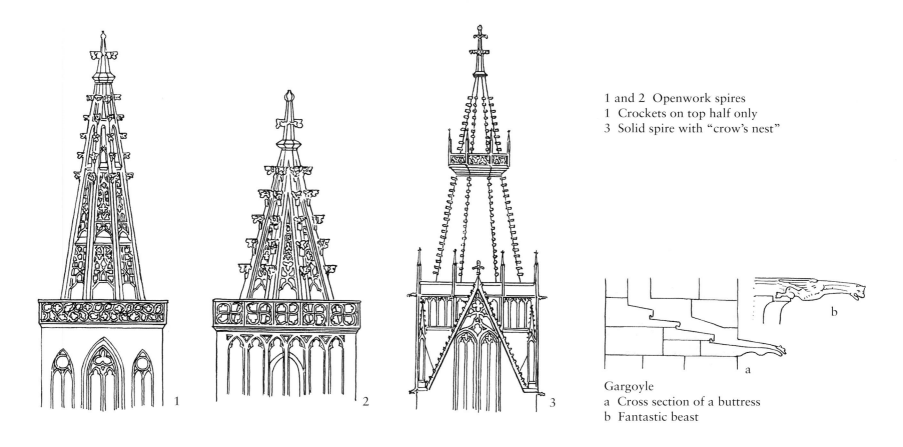

1 and 2 Openwork spires
1 Crockets on top half only
3 Solid spire with "crow's nest"

Gargoyle
a Cross section of a buttress
b Fantastic beast

Gothic Ornamentation

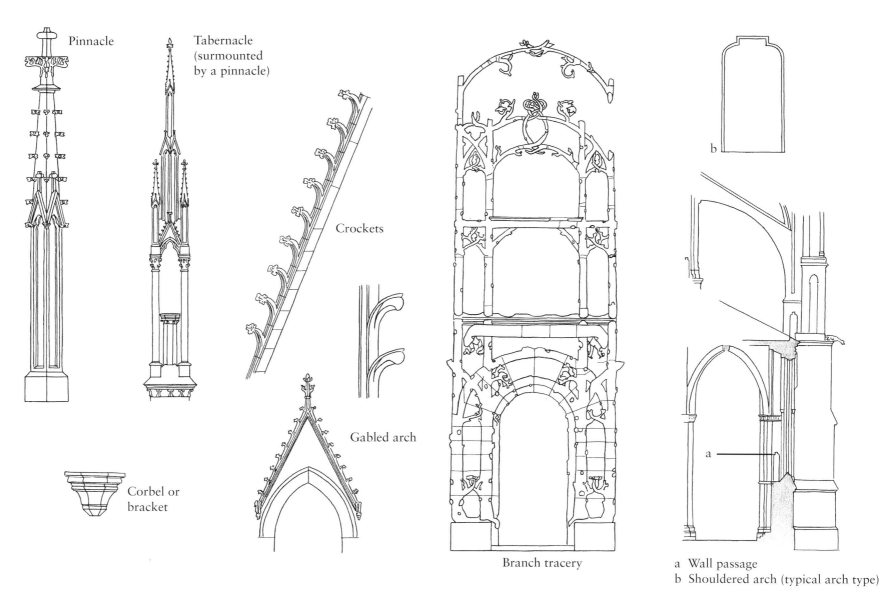

Pinnacle

Tabernacle
(surmounted
by a pinnacle)

Crockets

Gabled arch

Corbel or
bracket

Branch tracery

a Wall passage
b Shouldered arch (typical arch type)

Tracery

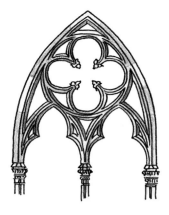

Bar tracery from a
13th-century window:
a quatrefoil crowning
two trefoil lancets

Flamboyant tracery from
the 15th century with four
swirling flame forms

Wetzlar Cathedral

Continuous Gothic reconstruction moving from east to
west as the original Romanesque church is successively
dismantled. By the time the Gothic reconstruction ran out
of funding, all that remained of the old Romanesque
structure was a section of the westwork, including the
north tower.

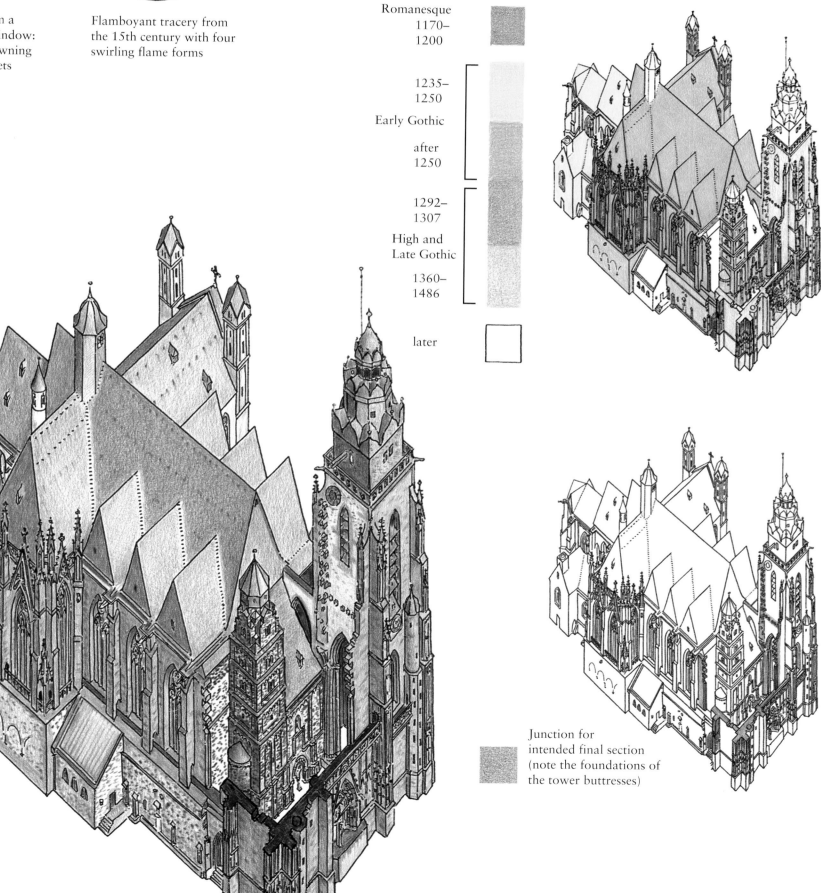

Romanesque
1170–
1200

1235–
1250

Early Gothic

after
1250

1292–
1307

High and
Late Gothic

1360–
1486

later

Junction for
intended final section
(note the foundations of
the tower buttresses)

Romanesque Sacred Architecture

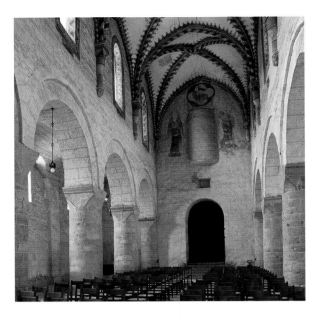

Romainmôtier (Switzerland), former abbey church of St Peter und Paul, ca. 1030/1040, nave looking west

In 843 the Treaty of Verdun divided the vast Carolingian Empire among the three grandchildren of Charlemagne. During the second half of the ninth century and the first half of the tenth, incursions by Huns from the east and Normans from the north and west brought war and destruction, putting an end to building activity for nearly a century. Only under Henry I, the first Saxon on the imperial throne, did the empire begin to restabilize. Under his successors Otto I the Great († 973) and Conrad II († 1039) the empire expanded toward the east and south. In the east Boleslaw Chrobry († 1025) had substantially enlarged the duchy of Poland, and to the north Knut the Great († 1035) ruled over Norway, Denmark, England, and Scotland. In the west the Capetian kings, who had ruled since 987, struggled to defend their small crown domains against strong territorial princes.

The court school of Charlemagne produced architecture with strong regional characteristics. In the German-speaking countries, the Ottonian emperors in particular incorporated and carried forward Carolingian policies in a very programmatic manner. Therefore, architecture developed in the maintained or re-established centers of the imperial household. In France, where the throne was less powerful and the nobles were constantly annihilating each other in political struggles, the development of sacred architecture emanated from the monasteries. Each monastery selected a church design based on its own needs and regional conditions. Even the powerful Cluny community never prescribed architectural regulations for its members. Thus, beginning in the late tenth and throughout the eleventh centuries, France became an extensive proving ground, where a wealth of floor plans and elevations were tried out and then discarded or further developed.

France

In 948 the monks of Cluny built their second abbey church (Cluny II), a basilica with three aisles that probably originally had a flat roof with accentuated crossing, a transept, and a five-part staggered choir in which a rectangular chamber was inserted between the main apse and each of the outer apses. The elevation seems to have consisted of arcades on columns and a clerestory. Around the year 1000 it seems that the center aisle was successfully topped with a barrel vault with windows cut into its foot. From its imitator churches in Romainmôtier (illus. right) and Payerne, we can surmise with some accuracy what Cluny II looked like. It was the realization of one of the chief goals of that era's church architects: the vaulting of an ever-widening nave with windows. Until the construction of the former abbey church Saint-Étienne in Nevers (dedicated 1097)—which must be seen as a "pilot project" for the third abbey church of Cluny—this was the problem that puzzled the master builders of eleventh-century France. Beginning in 1020/1030, long and varied experiments at Saint-Philibert in Tournus (illus. pp. 40/41) culminated in the construction of Cluny III. Its architect managed in a second attempt (1131/1132) to create a more stable pointed barrel vault over the 42-foot (14 m) wide center aisle. Cluny III, by the way, had an extensive progeny: Autun (illus. pp. 44/45), Paray-le-Monial (illus. pp. 42/43), Semur-en-Brionnais, and Saulieu are among the most famous.

To support the barrel vault, builders tested several elevation systems over the course of the eleventh century. In Tournus and Chapaize a two-zone elevation is supported by massive piers as in Cluny II; in Nevers the galleries have segmental vaults to support the upper nave wall; and in La-Charité-sur-Loire (illus. right) and Saint-Benoît-sur-Loire there are

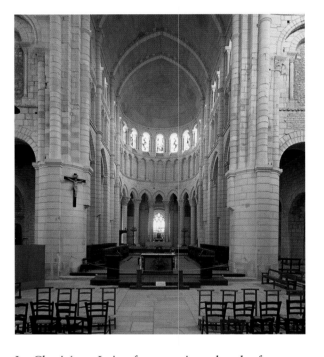

La-Charité-sur-Loire, former priory church of Sainte-Croix-Notre-Dame, 1056–1107, choir

blind triforia between arcades and windows. The latter was then the solution used in Cluny III.

The pilgrimage churches also have barrel vaults. Sainte-Foy in Conques, built between 1050 and 1130, is the oldest preserved example; the most recent and largest in France is Saint-Sernin in Toulouse (illus. p. 29). All their barrels have transverse arches across their 18–24-foot (6–8 m) wide naves, but they had no clerestories. Their elevations consist of columned arcades and high, vaulted galleries.

A small group of churches centered around the important abbey church Sainte-Madeleine in Vézelay (illus. pp. 46/47) began to favor groin vaults around 1120. East of the Rhine River, in contrast, the groin vault was remarkably successful and widespread.

Beginning around 1040, the transverse arches were supported from beneath by responds. The nave, which had been rather box-like and uncompartmentalized in appearance, now took on a progressive rhythm; it was subdivided into bays that might repeat several times, in a way binding together the elevation program and drawing the eye no longer only forward through the space, but upward as well.

In Saint-Bénigne in Dijon—where a High Gothic structure has since replaced what was likely a three-story galleried nave from 1001/1018—and in Saint-

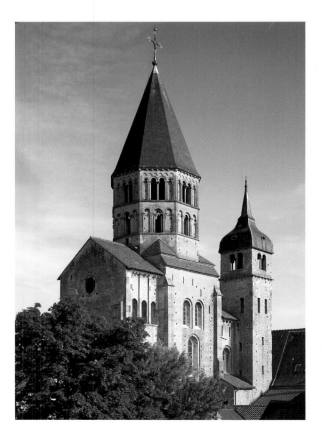

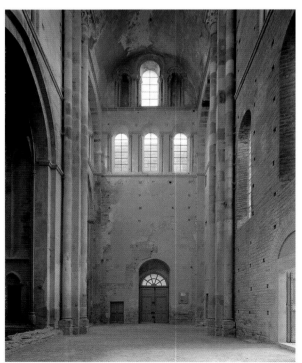

Cluny, former abbey church of Saint-Pierre-et-Paul (Cluny III), 1089–1131/1132, south transept ext./int.

Remi in Reims, the builders had to forego vaulting due to the naves' width. In Reims a gigantic thirteen-bay nave was built between 1020 and 1040 (illus. right). Clustered piers support a staggered arcade, above which follow a bifora gallery and clerestory. Subsequent rib-vaulting has added responds to the walls and piers to carry the ribs, and a blind arcade of framing arches over the gallery openings, interrupting the once purely horizontal structure with these vertical elements.

By 1040/1067 this wall conception was transposed into a more disciplined architectural expression at the abbey church of Jumièges (illus. pp. 56/57). Here, for the first time, the nave had vaulted and probably windowed galleries between the groin-vaulted side aisles and the clerestory, as well as a support system of alternating piers and columns. Responds were added to the piers to carry the transverse arches, giving the nave a new structure. The barrel vault intended for the center aisle was probably never completed for technical reasons, nor was it completed in the transept, but there a broad ledge in front of the upper windows is still present—an open walkway whose original purpose was probably to diminish the width of the transept in order to enable vaulting, but instead became the genesis of a new development.

William the Conqueror and his wife Mathilda endowed two abbey churches in Caen, Saint-Étienne and Sainte-Trinité (illus. pp. 52–54). Both begun in 1060/1065, they illustrate the evolution of the ledge in the wall: a broad passageway in front of the clerestory, set off from the nave by an arcade. This elevation program left only a short wall above it and appeared unusually light and compartmentalized; plasticity and rhythm dominate the space. The plan had obviously been to construct barrel vaults above the nave with gallery of Saint-Étienne and nave with triforia of Sainte-Trinité; they may even have been started, but failed. Not until the invention of the rib vault around 1120 was it possible to create a vault over such a broad space with these elevations. The motif of twin towers on the west facade was also exceptionally successful. It may have been developed at Bernay around 1020/1030, and impressive examples can still be seen in Jumièges and Caen.

Floor plan developments progressed along with those in elevation design (see top right). From the

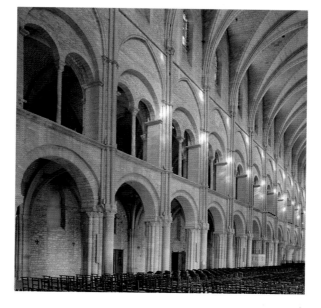

Reims, Saint-Remi, 1005–mid-11th c., Romanesque nave wall

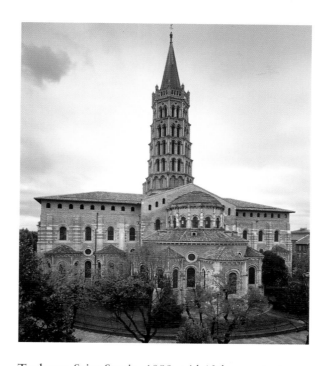

Toulouse, Saint-Sernin, 1080–mid-12th c., east view

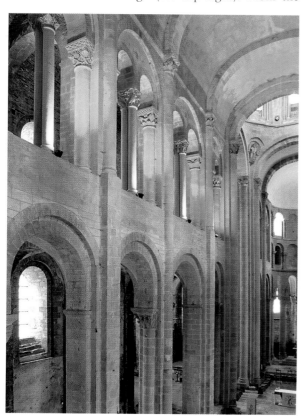

tenth century onward, a nave with three aisles was the norm, and the five-aisled nave tended to be the exception (Saint-Bénigne in Dijon, the Old Cathedral of Orléans, La-Charité-sur-Loire, and Cluny III), while the transept and choir ran the gamut of all possibilities. The typical transept had one aisle and consisted of three parts, including a separate crossing with tower. Saint-Remi in Reims and the pilgrimage churches have three-aisle transepts where the gallery is taken around the ends of the transept so that two zones of the elevation program follow the entire perimeter of the church. Cluny III finally boasted a double transept in the east. The east end had a choir ambulatory with radiating chapels that ran alongside the staggered choir, which itself incorporated as many as seven open apses that faced each other (illus. right). It obviously was meant to serve for station mass and the veneration of saints, because quite often a staggered choir was later be replaced by a choir ambulatory (compare Saint-Remi and La-Charité-sur-Loire). There is no doubt that the choir ambulatory with radiating chapels developed from the crypt. One of its oldest precursors is conserved in the crypt of Saint-Philbert-de-Grandlieu, which dates from about 847. Along an orthogonal passageway—as already seen on the St Gall monastery plan—five

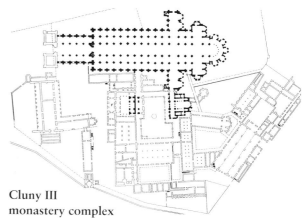

Cluny III monastery complex

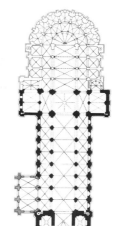

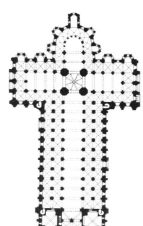

Caen, Saint-Étienne **Toulouse, Saint-Sernin**

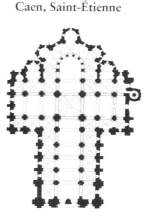

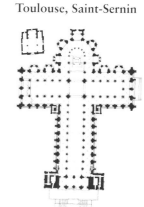

Conques, Sainte-Foy **Santiago de Compostela**

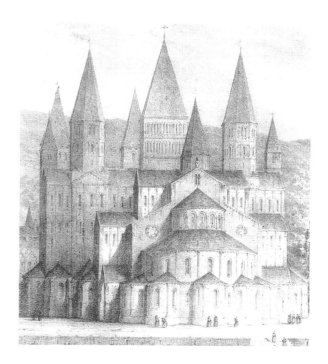

Cluny III, lithograph (after 1789): east view in the 16th c., Paris, Bibliothèque Nationale

LEFT: **Conques, Sainte-Foy**, ca. 1050–1130

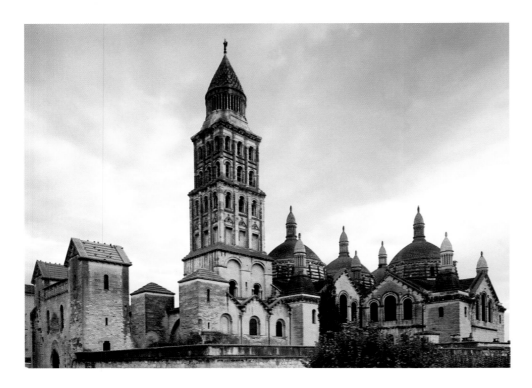

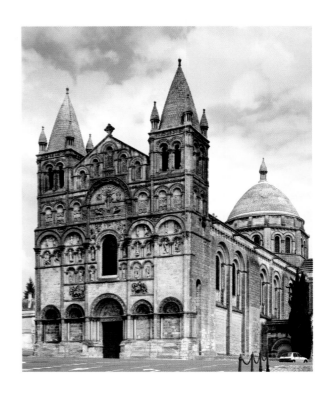

LEFT:
Périgueux, Saint-Front, after 1120

RIGHT:
Angoulême, Cathedral of Saint-Pierre, begun 1120/1130

BOTTOM
LEFT AND RIGHT:
Sénanque, former Cistercian monastery, abbey church interior and exterior, after 1150

parallel chapels open on the east side. The greatest achievement in crypt construction is the cavernous, circular all-saints crypt of Saint-Bénigne in Dijon (after 1001), which has remained a unique phenomenon (illus. pp. 38/39). Over the course of time, the orthogonal passageway appears to have been adapted to the curve of the apses, and the chapels were laid out in a radial pattern. An early choir ambulatory remains in Tournus, where the monks from Saint-Philbert-de-Grandlieu found refuge.

In western France, two small groups of churches emerged: the hall churches with barrel or rib vaults—Saint-Savin-sur-Gartempe (illus. p. 65) and the repeatedly redesigned nave of Notre-Dame in Cunault (1100/1110–1180) are two examples—and the domed churches, in which the crossing dome vault was repeated over square nave bays. The former abbey church of Fontevraud (illus. p. 64) was given a single-aisle nave with four domed bays. This design was presumably substituted for an originally planned hall nave, since its choir was the basis for

Cunault. The cathedral in Angoulême, begun in 1120/1130 (illus. above right), is a replica of Fontevraud. Saint-Front in Périgueux (illus. above left), with its cruciform plan and five domes, follows more the example of San Marco in Venice.

In the region east of the Rhône River, stylistic impulses were taken not only from the region's numerous preserved buildings from antiquity, but also from Catalonia, Burgundy, and the pilgrimage churches. When the cathedral in Aix-en-Provence was renovated (it was rededicated in 1103), a barrel-vaulted aisleless nave design with high, wide transom niches was constructed that remained relevant for more than a century.

During the twelfth century, the churches of the Cistercian order formed their own little group. The order, founded by Robert de Molesme at the end of the eleventh century, strictly opposed pomp and extravagance, as well as the relaxed interpretation of the Benedictine Rule that had become the norm in the Cluny monasteries. The Cistercian order pre-

scribed rigorous adherence to the Rule of Benedict and a life of absolute poverty and strenuous manual labor. The most famous and influential representative of this order was Bernard of Clairvaux. The oldest Cistercian church is the abbey church of Fontenay (illus. pp. 48–51), which together with Clairvaux, La Ferté, and Pontigny, were among the first of many daughter monasteries of Cîteaux. Bernard himself probably chose the design for Fontenay. Construction of the pseudobasilica with a barrel-vaulted nave and transverse barrel vaults in the side aisles was begun in 1133. On the east side of the single-aisle transept are small square chapels and a square choir behind a choir bay. This layout was later widely used with numerous variations. In Sénanque (illus. below), Silvacane, and Le Thoronet, all Cistercian monasteries in southern France whose churches were begun around 1150/1160, the builders experimented with longitudinally barrel-vaulted side aisles, with the addition of a clerestory in the nave at Sénanque.

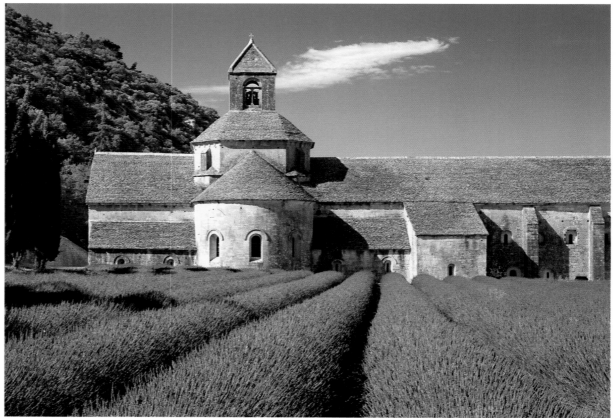

Germany

In the course of the Carolingian Empire's political and artistic renewal of the Germanic countries, new Ottonian cultural centers came into existence that generated architectural trends. During Salian and Staufen times as well, architecture remained connected to the imperial house. Cologne, founded by the Romans, had since the fifth century maintained twelve collegiate churches (representing the twelve apostles) erected over the sepulchers of martyrs in its Roman graveyards, all of which were renovated into large Romanesque structures. Other diocesan cities in the south and east imitated them. Thus a multitude of cathedrals and collegiate churches were being built in German-speaking regions under the influence of emperors and bishops at the same time as the great monastic architectural projects in France.

The oldest preserved major religious structure is Sankt Cyriak, a former women's collegiate church in Gernrode, founded by Margrave Gero in 961 (illus. pp. 76/77). It is a gallery basilica with three aisles and a flat ceiling, whose transept with eastern apses barely protrudes from the nave. The crossing was

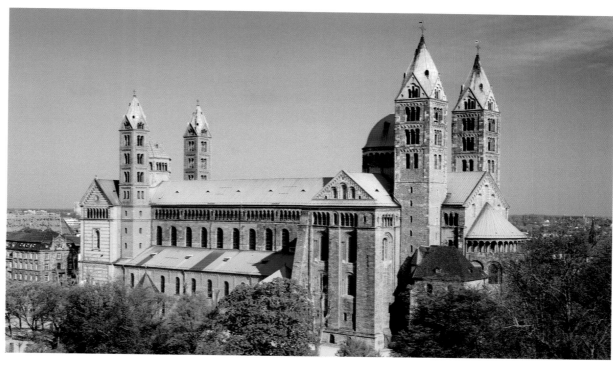

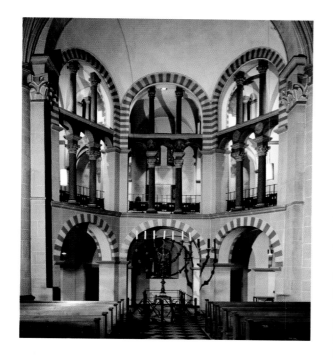

originally cordoned off and its main apse was built behind a square choir bay. The choir is elevated above the crypt. In floor plan and elevation, axial proportions are not strictly respected. Not until decades later, at the abbey church of Sankt Michael (illus. pp. 78/79) founded by Bishop Bernward of Hildesheim, were the long-desired goals of uniformity and symmetry and a structured, accentuated space achieved. At Sankt Michael we encounter for the first time east and west transepts that frame the three-aisle, a flat-ceiling nave with perfect symmetry, as well as an integrated system that builds on the floor plan of identical squares, the accentuated crossing, and the Saxon alternating pier system that gives the nave bays a pier-column-column-pier rhythm. Also new is the alternating red and white masonry block pattern of the arches, which highlights the boundaries between spaces. In the east there was a choir with three apses; in the west a broad stilted apse. Sankt Michael's in Hildesheim was highly influential in the German Romanesque.

The ongoing impact of Carolingian traditions in the imperial centers, in contrast, is apparent in the former women's collegiate church in Essen, built around 1040/1060 and now the city's cathedral (illus. above). In charge of construction was Abbess Theophanu, a granddaughter of Emperor Otto II.

LEFT: **Essen, cathedral, former collegiate church St Cosmas und Damian**, mid-11th c., western apse modeled after the cathedral in Aachen

TOP AND BOTTOM: **Speyer, Cathedral of St Maria und St Stephan**, after 1027/1030, southeast view (top); nave (bottom)

The walls of the exterior crypt still stand, as does the western section, whose form is strongly reminiscent of the westwork. Three sides of an octagon open into the west crossing. Its elevation replicated that of the Aachen cathedral except that here, too, alternating masonry bands accentuate the arches.

Just as innovative as Hildesheim was the cathedral in Speyer (illus. above, below, and pages 82/83). Conrad II, the first Frankish emperor, began with the construction of the eastern crypt in 1027; the cathedral was dedicated in 1061. In spite of extensive destruction and reconstruction in 1689, large portions of the elevation, and most importantly, the conceptual design of the overall complex are still preserved. More than eight stages of the building process and almost as many plan changes can be traced, all of which were aimed at enlarging and enhancing its architectonic form. Since the destruction of Cluny III, the cathedral of Speyer has been the largest Romanesque building in Europe. It is characterized by its two groups of three towers each in the east and the west, originally identical, which framed the elongated three-aisle nave. Evidence indicates that Conrad had seen the barrel vault in Cluny II during his tenure as rector of Burgundy in 1032 and that he wished to have a barrel-vaulted nave at Speyer to "create a form of sacred sovereign representation not known in Ottonian times. In direct reference to his predecessor's sepulchral church in Aachen, vaulted throughout, Conrad II tried to outdo the sepulchral churches of Henry I in Quedlinburg, Otto the Great in Magdeburg, Otto II in Memleben, and of Henry II in Bamberg, as well as, naturally, the large diocesan structures from the turn of the millennium, in previously unparalleled monumentality ... Conrad II's cathedral is an expression of the idea of Christian world supremacy, which also became the goal of the Clunians and of the papacy in the late eleventh century." (Wischermann)

Due to its nave width of 42 feet (14 m), the barrel vault project failed and Speyer initially had a flat ceiling. Its elevation, however, is quite innovative: Atop the square piers of the tall arcade, continuous semicircular responds alternate with pilasters with one engaged semi-column atop another more mas-

sive one. The pilasters and responds support the framing arches of the clerestory windows; the semi-columns support the transverse arches. These arches, originally meant for the barrel vault, today separate the bays of the groin vaults that Henry IV had installed between around 1080 and 1106. With that, Germany had its first stone vault, and until the first rib vaults were constructed in Alsace in the second half of the twelfth century and around 1200—for example in Sankt Aposteln in Cologne—the groin vault existed on an equal footing with the flat ceiling. Square schematism, once viewed as a necessity, had found its ideal form of vaulting. The cathedrals of Mainz (illus. p. 84) and Worms (illus. p. 85) are unmistakable descendants of Speyer. Their exteriors—richly decorated with pilasters, blind arcades,

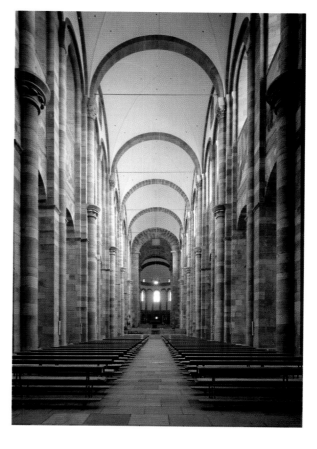

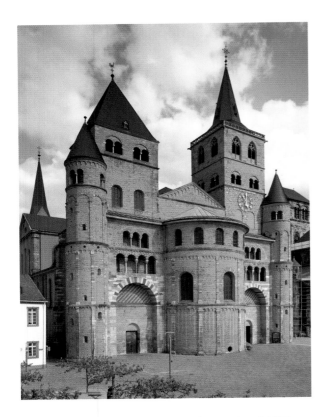

Trier, St Peter Cathedral, west end, completed 1074

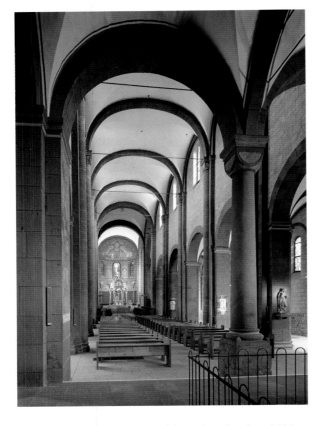

Maria Laach, Benedictine abbey church, after 1093, interior looking east

cornice arcades, and dwarf galleries—are typical of the late German Romanesque, in which friezes and bands are used to tie together individual architectural elements and thus create a three-dimensionally organized overall ensemble.

The development of Romanesque sacred architecture thus began with a two-story, box-like nave (the galleries in Gernrode are an exception), which in the east and often in the west as well were expanded by a transept or at least a west end. These were occasionally still in the Carolingian westwork tradition, and displayed continuous galleries, as seen at Sankt Pantaleon in Cologne (illus. pp. 80/81). Early on, in addition to the crossing tower, slender towers were added alongside the east choir (Limburg an der Haardt, 1025–1045, cathedral in Speyer) as a counterweight to the twin west towers that had already characterized the westwork. Thus a group of east towers paralleled the triple-tower structure on the west end. In 1074, the west end of Trier's cathedral was expanded by a central apse and massive square towers above the transept arms, accompanied by slender round towers in the corners (illus. left).

Naves, which at first had exclusively flat ceilings, began to receive groin vaults during the last quarter of the eleventh century (Maria Laach, illus. center left and pp. 90/91, Knechtsteden, 1138–ca. 1160). The two-zone elevation of arcades and clerestory was enriched—possibly influenced by the cathedrals of Mainz and Worms, where the tall blind arcades of Speyer were transformed step by step into blind niches between the arcades and the clerestory—with a blind triforium over small columns. The naves of Sankt Aposteln (in the course of modifications to the nave after 1193), Sankt Andreas, and Sankt Kunibert (until 1227) in Cologne are examples of this. At the same time, galleries, which had been common in France since 1000, were introduced into Romanesque works east of the Rhine River, for example in the cathedrals of Freiburg and Basel (illus. above), both built around 1200, or in Sankt Ursula in Cologne (second half of the twelfth century).

The floor plan and architectural program remained constant for almost two centuries, with some minor variations. However, renovations to Sankt Maria im Kapitol, newly consecrated in 1049 or 1065, introduced a triconch choir design (illus. pp. 86/87). Extending from the three-aisle pier basilica are the cloverleaf-form east sections. Their vaulted side aisles lead around the center aisles, which have flat roofs. Underneath the eastern "leaf" is a hall crypt with radial chapels. This unusual floor plan, which continues the ambulatory into the transept arms, makes it possible to walk around the entire church perimeter and calls to mind the pilgrimage churches with their three-aisle transepts. In Cologne it was imitated several times, becoming a common

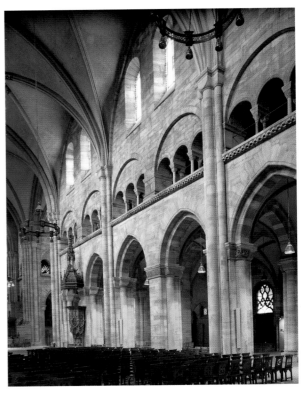

Basel, former St Maria Cathedral, now a protestant parish church, after 1185, nave wall

motif, though always with niche structures instead of the ambulatory. Examples are Sankt Georg (1059–1067), where the triconch was obviously combined with the concept of a choir with three apses, Groß Sankt Martin (around 1150/70), and Sankt Aposteln (nave circa 1030, trefoil choir after 1193).

In a remarkable number of the preserved examples are hall crypts, always groin-vaulted and located under the east or west sections of the church. The explanation for the popularity of the hall crypt traces back to Emperor Otto the Great, who combined the idea of the cult of the saints with the cult of the emperor by having himself interred in the crypt of the Magdeburg cathedral. From then on crypts housed many tombs of patrons and rulers.

Another important group of churches in Germany is those that conformed to the Hirsau reforms that stemmed from those at Cluny. The churches are two-story columned basilicas with flat ceilings, projecting transepts, and a three-part choir. A feature typical of them is a pier in the first nave bay west of the crossing, which set the *chorus minor* apart from the main choir. The movement's first church, in Hirsau (1082–1091), remains an impressive ruin (illus. p. 89). Another very beautiful church from the Hirsau movement is the Benedictine abbey church of Sankt Benedikt in Alpirsbach (illus. p. 88), which dates to the first third of the twelfth century.

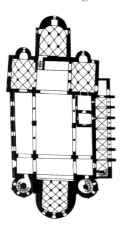

Gernrode, St Cyriakus

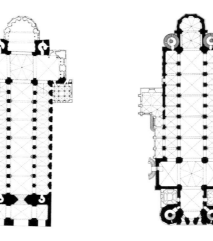

Hildesheim, St Michael

Speyer, cathedral

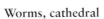

Worms, cathedral

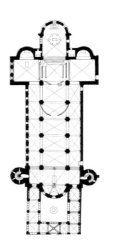

Maria Laach, abbey church

Cologne, Groß St Martin

Italy

The architecture of the eleventh and twelfth centuries in Italy varies as widely as the political situation in that country. Throughout the Middle Ages the history of northern and central Italy was tied to that of the Frankish and later the German Empire due to Charlemagne's conquest of the Lombards and his promise to protect the Papal State. The cities of northern Italy gained increasing political independence in the course of the Investiture Controversy between emperor and pope, and the early and powerful presence of merchants on the Adriatic Sea opened the country to architectural and social innovations as well as political and religious influences. The outstanding and most striking example of these influences is San Marco in Venice. Begun in 1063, it is based on the floor plan of the Church of the Apostles in Constantinople, with fascinating interior mosaics and a facade that opens itself toward the city (illus. pp. 106/107). But San Marco, like Venice itself, remained an exception.

Led by Lombard builders, a school of church construction developed in northern Italy that drew from many sources. These included the Ravenna-type transeptless basilica of the fifth and sixth centuries, the galleried basilica with alternating piers of northern France, and the early Christian basilica of Saint

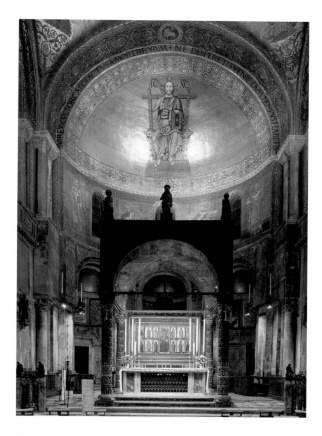

Venice, San Marco, begun 1063, choir mosaics (detail)

RIGHT:
Bari, San Nicola, begun 1089, northwest view

Peter's in Rome. The Lombard School used its creative abilities to enrich ornamentation and develop exterior walls. Their motifs—galleries, blind arcades, arch and corbel tables, and pilasters—were in turn inspired by Byzantine forms and found extensive use, especially in the advanced German Romanesque era. Examples in Italy are the cathedrals of Modena (illus. p. 101), Murano (dedicated around 1140), Parma (twelfth century), San Zeno Maggiore in Verona (illus. p. 102), and Sant' Abbondio in Como (1027–1095), where the increasing openness of exterior walls and the development of double facades

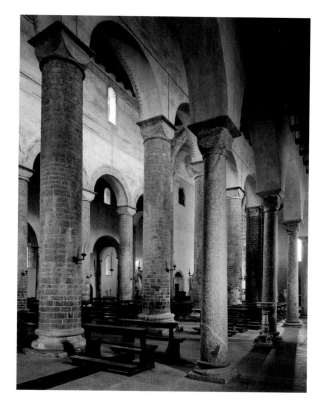

Como, Sant'Abbondio, 1027–1095, interior view of the column basilica

can be noted. In the interiors, exposed-timber or flat ceilings and groin vaults were all commonly used. The abbey churches Santa Maria in Pomposa (illus. p. 103) and Sant'Abbondio in Como (illus. above)—the latter with five aisles—are beautiful examples of transeptless column basilicas with exposed-timber ceilings inspired by Ravenna. Sant'Ambrogio in Milan (illus. pp. 98/99), a building with an unusually long and complex construction history, was also once part of this group. The choir with three apses, the crypt, and the campanile were built in the ninth century. The nave probably looked like the one in Pomposa. In the late twelfth century an interconnected system was created when galleries and ribbed vaults were added; a clerestory was abandoned. The cathedrals of Modena (after 1099) and Piacenza (after 1122), on the other hand, were from the outset planned as three-story gallery churches with pier alternation modeled after Jumièges. The rib vault resulted from changes in the design during the long construction period.

In Tuscany, the ancient Tuscia, the building type of the transeptless column basilica was also continued, but here the relatively plain and uncomplicated interior and exterior architecture was embellished with marble applied in geometrical patterns. The most famous example is San Miniato al Monte in Florence (second half of the eleventh century), whose

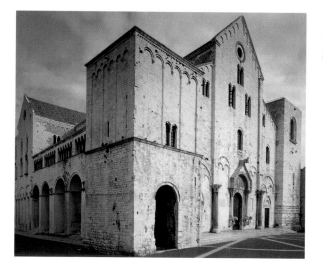

facade bears the motif of five blind arches (illus. p. 107) that became characteristic of Tuscan churches. Even richer is the marble sheathing of the baptistery of San Giovanni in Florence, which resembles a monumental shrine.

Construction of the cathedral in Pisa, one of Italy's leading maritime powers, commenced in 1063—not coincidentally, the same year as the cathedral in Venice was begun. Pisa's cathedral was also a unique building in its time, and in combination with the famous leaning tower and baptistery, forms an awesome ensemble. Above a five-aisle floor plan rises an unusually high, flat-ceilinged column basilica with a tall three-aisle transept and a domed crossing, an antechoir, and an apse. The eminently representative, narrow, and graceful center aisle is lined by pseudo-galleries—galleries without a floor—and a small clerestory. Equally grand is the facade (illus. p. 110/111), with five superimposed rows of arches that relieve the massiveness of the exterior; it was emulated many times.

An exception in Italy is the church of the Benedictine monastery Sant'Antimo (illus. p. 112), founded in 1118, where an ambulatory with groin vaulting and chapels connects to the three-aisle nave. The plain, barely structured exterior parallels an interior that is based on French models.

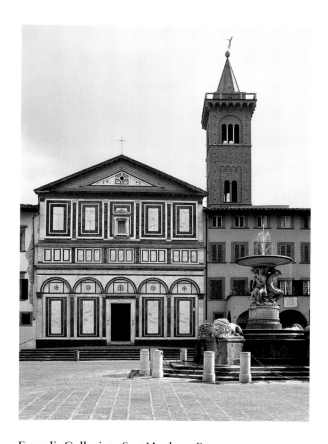

Empoli, Collegiata Sant'Andrea, Romanesque renovation, after 1093, west facade

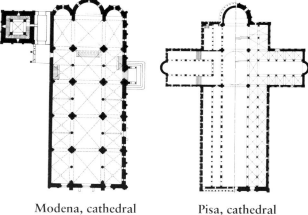

Modena, cathedral Pisa, cathedral

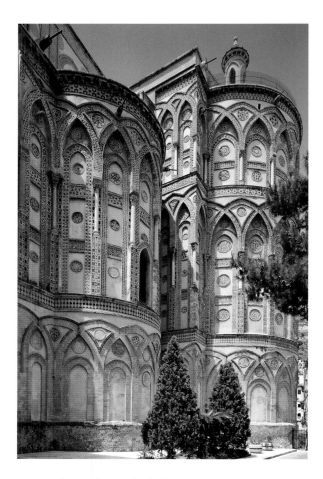

Monreale (Sicily), cathedral, 1174–1189, view of choir section from the southeast

Between 1041 and 1063 the Normans conquered Apulia and Calabria, expelled the Byzantine regents, and founded a duchy. The first of a group of Norman churches in Apulia is San Nicola in Bari (illus. p. 33 bottom), which was erected within the ruins of the Byzantine governor's palace and made use of large parts of it. The result was a flat-ceiling gallery basilica similar to those in Normandy, which had also been adopted in northern Italy. Probably due to the incorporation of existing material, its rhythm stems not from the alternation of buttresses, but from double columns in the arcades. The exterior ornamental elements are reminiscent of Lombard models.

By 1091 Sicily was also under Norman rule. The Arabs who had controlled the island from 827–878 were ousted, and the Normans now controlled a second territory in Italy that became part of the kingdom of Naples and Sicily founded by Roger II in 1130. The Normans, newly Christianized, continued to tolerate the culture of their predecessors here, as elsewhere, and created religious architecture that bears clear traces of Byzantine and Arab influences. One of the main monuments of this architecture is the Capella Palatina of Roger II (1130–1143) in Palermo, a three-aisle basilica with transept and triple apses. The arches and stalactite ceiling are of Islamic origin, while the ornate mosaics are Byzantine style. The palace chapel became the model for churches in Palermo throughout the twelfth century, especially for the cathedral in Monreale (illus. above and on p. 117), even though the latter has a flat ceiling. Roger decided his tomb should be located in Cefalù and started building a cathedral there in 1131 (illus. p. 116). The massive three-bay choir, the high transept, and the west towers also show clear Norman traits in their elevations (clerestory passageway, intended vaulting). Work on the ornate mosaics continued until 1148. The planned high nave was never completed; instead King William I commissioned a simple column basilica.

England

In 1066 the Norman duke William the Conqueror landed in Hastings on the southern shore of England. The Bayeux Tapestry, an embroidery more than 230 feet (70 m) long and approximately 20 inches (50 cm) wide, was created in Canterbury, England, an important center of book illumination, probably for William's half brother, Bishop Odo of Bayeux. In words and pictures it depicts the battle that preceded the Norman conquest and reorganization of England. All important places in the country were reapportioned, and hardly any buildings dating from Anglo-Saxon times evaded the Normans' reconstruction: Goscelin de Saint-Bertin recommended that those who wanted to build something better should first tear down what was standing.

A major early Norman construction was Westminster Abbey, commissioned by Edward the Confessor around 1045/1050. He had grown up in Norman exile on the continent and was familiar with the abbey churches and cathedrals there. Apparently the church had a twin-tower facade, a three-aisle, twelve-bay nave with alternating supports, a large transept with crossing tower, and a staggered choir. Robert Champart, bishop of London since 1044, had conceived and begun Notre-Dame in Jumièges in 1040, while he was the abbot there. This may have served as precedent for Westminster, also a gallery basilica, and certainly intended to have a barrel-vaulted nave. Westminster was consecrated in 1065. This model from Normandy remained the standard for all major buildings in the British Isles from the first large post-conquest stone structure, the church of Battle Abbey (dedicated 1094), up to the early Gothic reconstruction of Canterbury cathedral. They differed in their use of ambulatories with radiating chapels or staggered choirs, but the elevations always consisted of arcades, illuminated galleries, and clerestories with walkways. This was not surprising insofar as William awarded abbots' and bishops' posts exclusively to his Norman liegemen.

The Italian Lanfranco, who had presided over the monastery of Saint-Étienne in Caen since 1063, and had probably designed the church there, was appointed archbishop of Canterbury in 1070. He immediately initiated plans for the cathedral of Canterbury, which he modeled after the one in Caen.

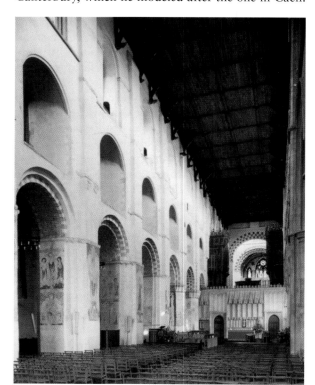

St Albans (Hertfordshire), cathedral, begun ca. 1078, Romanesque nave wall

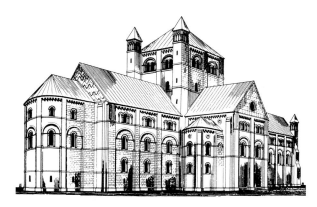

York, cathedral, begun ca. 1079(?), built by Thomas of Bayeux, reconstruction (northeast view)

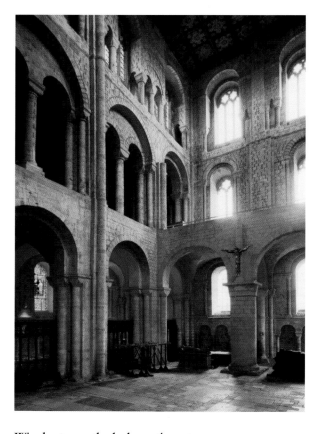

Winchester, cathedral, northern transept arm

Stone vaulting was probably not planned, since it had failed at Saint-Étienne; a wooden substitute may have been used instead. Meanwhile, Abbot Scotland of Mont-Saint-Michel had been appointed abbot of the monastery of Sts Peter and Paul (formerly St Augustine's Abbey) in Canterbury. He also began a significant new church—in competition with the cathedral—around 1073, a three-aisle pier basilica with a transept, an ambulatory (like Mont-Saint-Michel) and a twin-tower facade. The Romanesque cathedral of Lincoln was built by Bishop Remigius, who had been almoner of the Fécamp monastery from 1073/1074. Like many cathedrals of the time, it did not survive the Gothic era. St Alban's, a cathedral since 1877, is the work of the monk Paul, who became abbot in 1077 and also came from Saint-Étienne in Caen. St Alban's is the oldest at least partially preserved building (illus. left), a massive basilica more than 410 feet (125 m) long with a projecting transept and—at one time—a seven-part staggered choir. The series of continental abbots and bishops and their Norman church buildings continued with Bishop Walkelin of Rouen, who had Winchester Cathedral rebuilt *a fundamentis* (from its foundations) from 1079 until 1120. For the first time in the British Isles, Winchester displays a three-aisle transept (illus. above). It has the same elevation

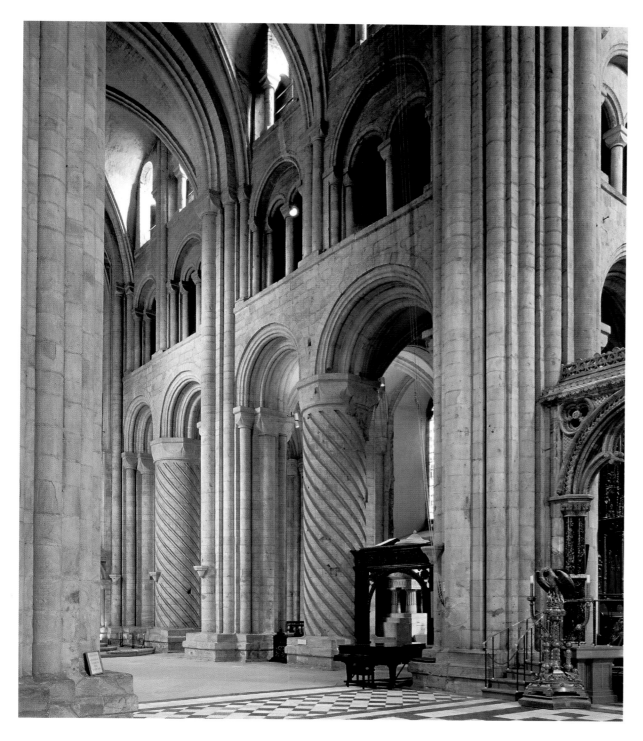

LEFT:
Durham, cathedral, begun 1093, nave wall

BELOW:
Iffley (Oxfordshire), parish church,
west facade, last third of the 12th c.

BOTTOM:
Patrixbourne (Kent), parish church,
last third of the 12th c.

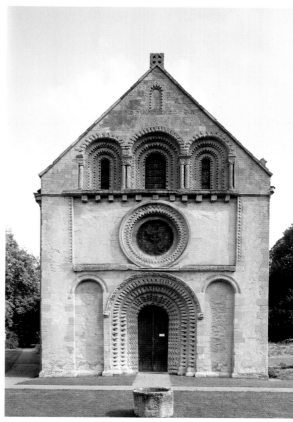

program as the nave (compare to the pilgrimage churches). The thickness of the choir walls, as well as the respond-support alternation, indicate that a barrel vault was planned for the choir. The preserved transept of Hereford cathedral (eastern parts around 1080–1110) deviates from the contemporary pattern, since its elevation consists of blind arcades, a triforium passageway, and a clerestory with passageway. The barrel vault was not successful here, either. The next step in this progression can be seen in the cathedrals of Worcester (begun 1084) and Gloucester (begun 1089), and in the completely preserved churches of the two dependent priories of Tewkesbury and Pershore. Above the arcades and the barrel-vaulted galleries, Worcester cathedral's choir had a triforium passageway with tiny windows under stone vaulting. There are no galleries in the nave, and with the Gothic period came a clerestory and rib vaulting. This elevation became quite significant during the early Gothic period.

A stone vault above arcades and galleries was also achieved above the narrow center aisle of St John's Chapel, begun around 1078 in the White Tower. All other vaulting projects failed until the rib vault was invented around 1120. Blind arcades in several registers, literally covering facades, enriched the building exteriors in the meantime. This is true, for example,

for the western sections of Ely cathedral (illus. p. 120/121), the west facade of Castle Acre (illus. p. 119) and the west end of Durham cathedral.

In the wake of the construction fever that had dotted the island with large churches, there was no demand for them after the second quarter of the twelfth century. The only large complexes built after that time were initiated by the Cistercians, who had begun to cross the English Channel around 1120. By 1160 there were already 51 Cistercian monasteries in England; most of their churches are preserved only as ruins. They largely followed the floor plans and elevations of the Burgundian monasteries, though they only rarely had stone vaulting. Two examples are Fountains Abbey (founded 1135) and Rievaulx Abbey (illus. pp. 124/125)—the latter had a gallery elevation and clerestory passageway inspired more by the cathedrals.

The late Romanesque period in England produced, apart from the Cistercian churches, a few remarkable smaller churches. Among them are the parish church of Kilpeck, the former priory church of the Augustines in Oxford, and the nave of the Worksop Priory (Nottinghamshire). Examples of the late Romanesque delight in ornamentations are the portals of the churches in Iffley (illus. center right) and Patrixbourne (illus. right).

Spain and Portugal

The Iberian peninsula was conquered by the Moors during the first millennium. In the early eleventh century, the Count of Barcelona gradually managed to expel the Moors from Catalonia. With neighboring Roussillon, this region was characterized by a common architecture. One of the most important sponsors of building projects at that time was Oliva Cabreta de Bedalú y Cerdagna. He first served as abbot of Saint-Michel-de-Cuxa in Roussillon, then of Santa Maria in Ripoll. In 1018 he became bishop of Vic. At Saint-Michel (illus. pp. 72/73), sometime before 1040, he expanded the existing tenth-century building with a twin-tower facade in the west and a vaulted choir. The floor plan of the choir is similar to those of Saint-Philbert-de-Grandlieu and Tournus I; thus it may be counted among the forerunners of the ambulatory choir. Its three-aisle nave, however, was not vaulted. In Ripoll, Cabreta expanded the existing five-aisle church from the late ninth century with a projecting transept, and increased the number of east apses from five to seven (compare to St Peter). By this time, vaulted buildings had appeared in the region as well, such as the church of Saint-Martin-du-Canigou (illus. pp. 74/75), the two-story mausoleum of the counts of Cerdagna, which was founded around 1000. The lower and upper stories each had three barrel-vaulted aisles and groin-vaulted eastern sections; there was no clerestory. Obviously Cluny II influenced architecture far to the south. In 1022 the small abbey church of Sant Pere de Rodes was consecrated (illus. pp. 130/131); it too was a barrel-vaulted pseudobasilica founded by Oliva Cabreta. The abbey church of San Miguel de Fluviá (begun 1046) is a sister building of Sant Pere.

The castle church of Sant Vicenç in Cardona (illus. below and pages 132/133) was built between 1029 and 1040. The floor plan and elevation have an unusually strict structure. Following a short narthex is a three-aisle nave with extremely narrow side aisles, a projecting transept, an antechoir and apses. However, Sant Vicenç is now a true basilica, with a barrel vault above a clerestory and groin vaults in the side aisles. This corresponds chronologically as well as architecturally to the phase of the Tournus nave project, which was ultimately transformed into a narthex. A late Romanesque building from Catalonia is the cathedral of La Seu d'Urgell (illus. p. 132), begun in 1175. The building type remained the same, but the decoration and structure were more ornate.

During the second half of the eighth century the relics of St Jacob, apostle of the poor, came to Santiago de Compostela in Galicia. Not until around 1000, however, did the region become accessible to Christians. Over the decades that followed, four pilgrimage routes were established through France, all converging in Puente la Reina. From there all the pilgrims traveled together from stopover to stopover on the long route west. The Romanesque cathedral of Burgos was replaced by a newer Gothic structure, but San Martín in Frómista is preserved and provides a wonderful example of the architecture that developed along the pilgrims' route (illus. pp. 134/135) and followed the Catalonian model. This pseudobasilica with three aisles has a barrel vault in the center aisle above square piers, with compound piers and segmental vaults in the side aisles. The tall transept only projects slightly and opens eastward into three apses. Further along the route are San Lorenzo de Sahagún and San Isidoro in León, the latter another three-aisle basilica with barrel vault whose nave is illuminated—thanks to its late date of origin (dedicated 1149)—by a tall clerestory. Today, the oldest part of the San Isidoro building complex is the Panteón de los Reyes (illus. p. 139). It lies to the

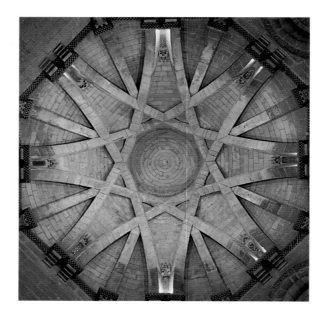

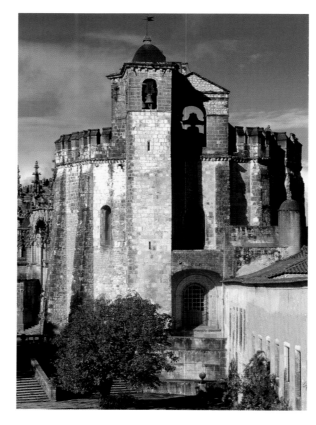

west of the church and served as a royal sepulcher. This building is captivating because of its wall and ceiling paintings and very skillfully sculpted capitals.

Christians and Moors had for three centuries fought fiercely over the region between Duero and Tajo. Only after the Spanish crown conquered Toledo in 1085 did it become repopulated. Another several decades passed before three large sacred buildings were started between 1145/50 and 1160. These marked the beginning of what in a European context would become the late Castilian Romanesque: the Old Cathedral of Salamanca (1145/1150–1289), the cathedral of Zamora (illus. p. 140), and the collegiate church of Santa María la Mayor in Toro (illus. p. 141). In layout and dimensions they followed the example of Cardona. However, the vaulting of Salamanca and Zamora did not take place until the Gothic era; both have rib vaults. Above the crossing in all three is a massive tambour dome with a 16-part vault, rising above a double clerestory (single in Zamora) carried by pendentives.

Beginning in the early twelfth century, knightly orders were founded with the aim of reconquering the Holy Land and Moorish Spain. Though French in origin, their organization, like their architecture, was international. One of the largest churches of these orders was built by the Knights Templar beginning around 1165/1170 in Tomar (illus. center left). It was a central plan church consisting of a 16-sided ring crowned with battlements and a two-level octagonal chapel, connected by an annular vault. The interior opens through arcades onto the ambulatory; above is a tall window story. The Church of Vera Cruz (which means "true cross") in Segovia (consecrated 1208) was probably built by the Order of Canons of the Holy Sepulcher. It also has a circular design, with lesenes on the exterior and a staggered choir in the east. In contrast, the Church of the Holy Sepulcher in Torres del Río is an octagon with two opposing apses. Noteworthy here are the dome vaults with ribs that intersect in a stellar pattern (illus. top left).

Cistercians began arriving on the Iberian peninsula around 1170/1180. Their oldest complex is the monastery of Moreruela, the church of which (begun 1168) is now a beautiful ruin (illus. opposite). It is clearly similar to the early Gothic ambulatory choir of Pontigny, which may in fact have been inspired by Moreruela. Though Pontigny has rib vaulting throughout, the choir, nave and transept here still used barrel vaults.

The Romanesque sacred architecture of Portugal can be viewed mainly in the Spanish context, and it will suffice to provide just a few examples here. The cathedrals of Coimbra, Evora, and Lisbon as well as the churches in Braga and Porto are preserved but have been substantially altered and overly restored. They were mainly variants of gallery basilicas and pilgrimage churches.

TOP LEFT:

Torres del Río, Church of the Holy Sepulcher, end 12th/early 13th c., dome of the round building

CENTER LEFT:

Tomar (Portugal), Church of the Knights Templar, view of the circular church, late 12th c.

BOTTOM LEFT:

Cardona, San Vicenç, 1029–ca. 1040, view down the very narrow side aisle

OPPOSITE:

Moreruela, ruin of the Cistertian church, after 1168, interior view of the choir

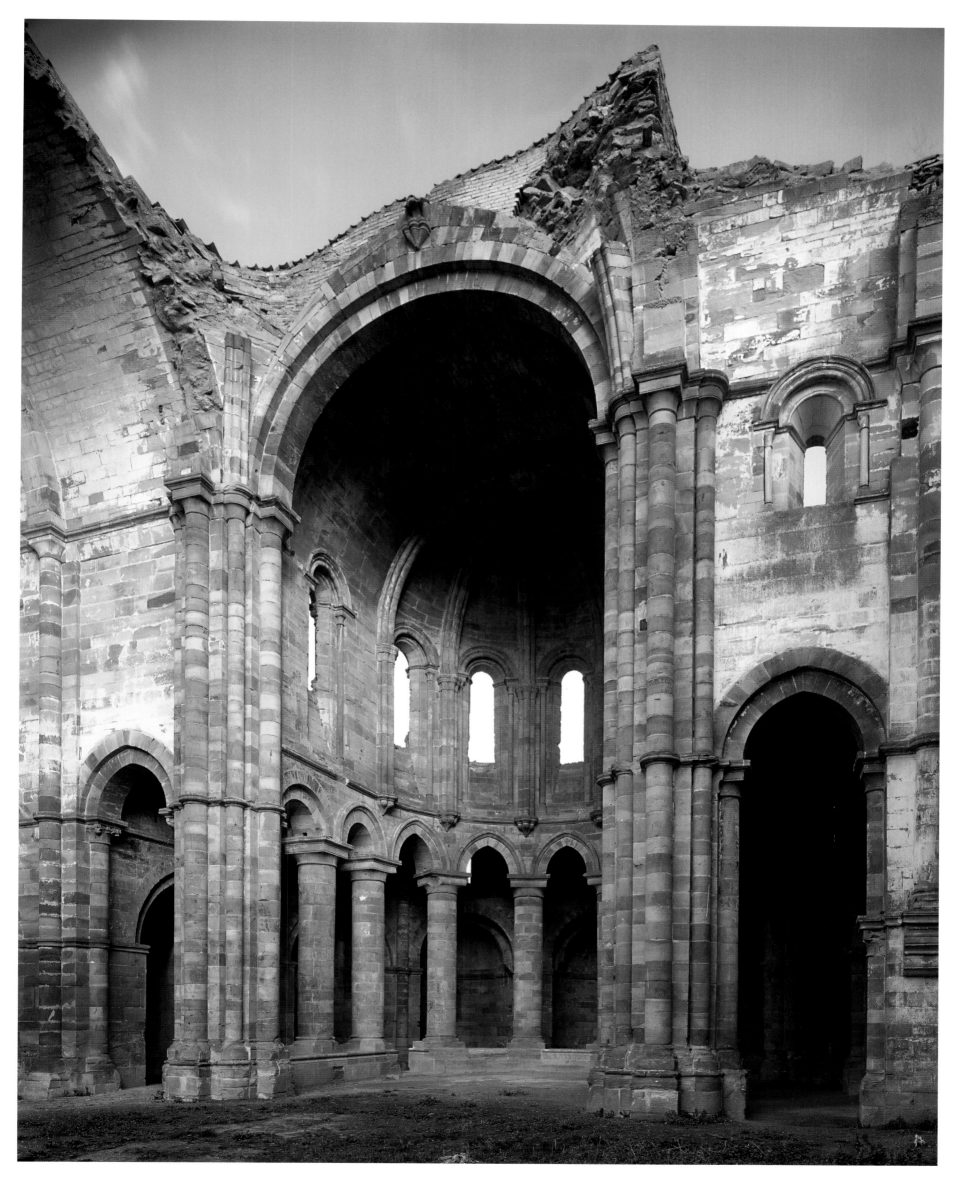

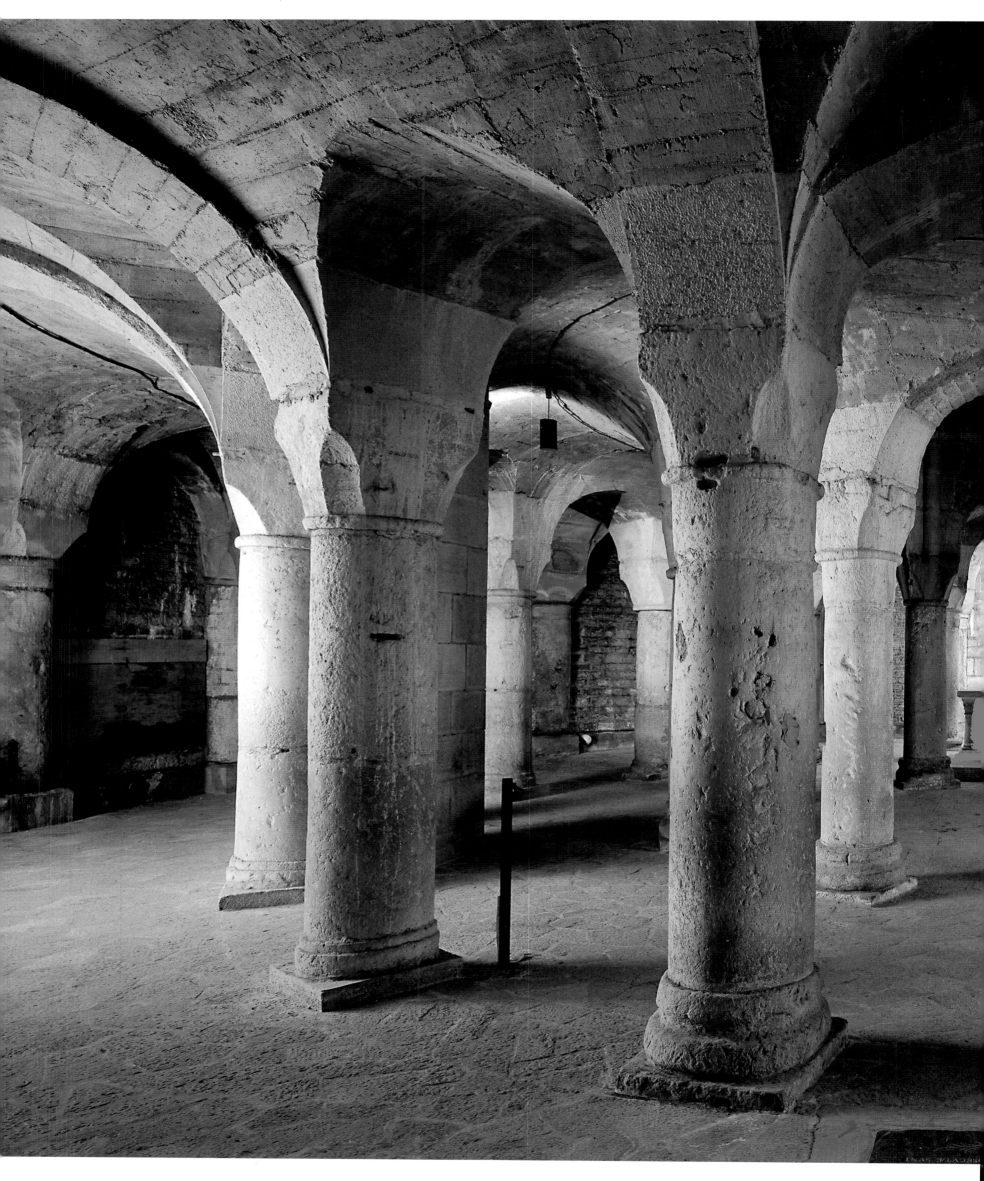

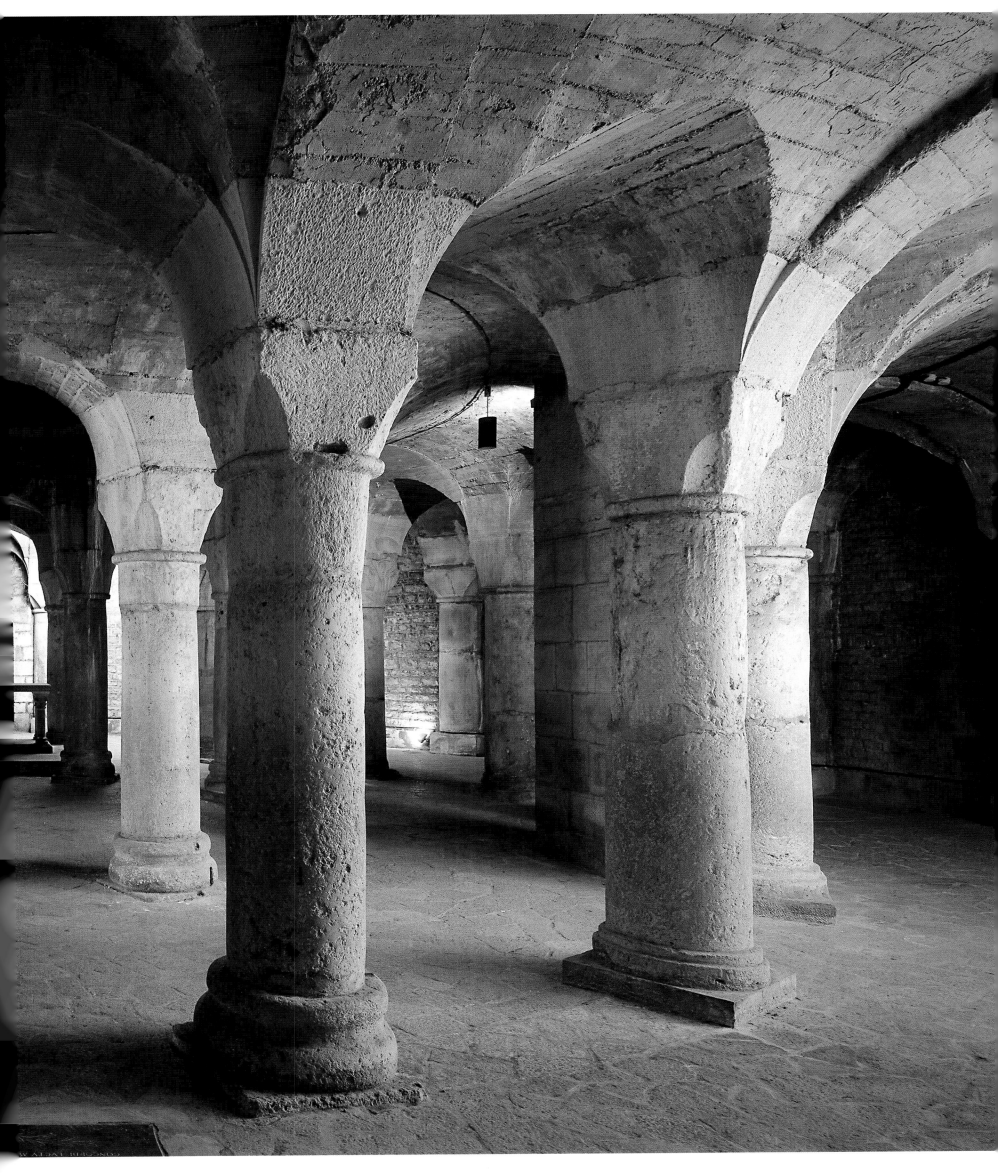

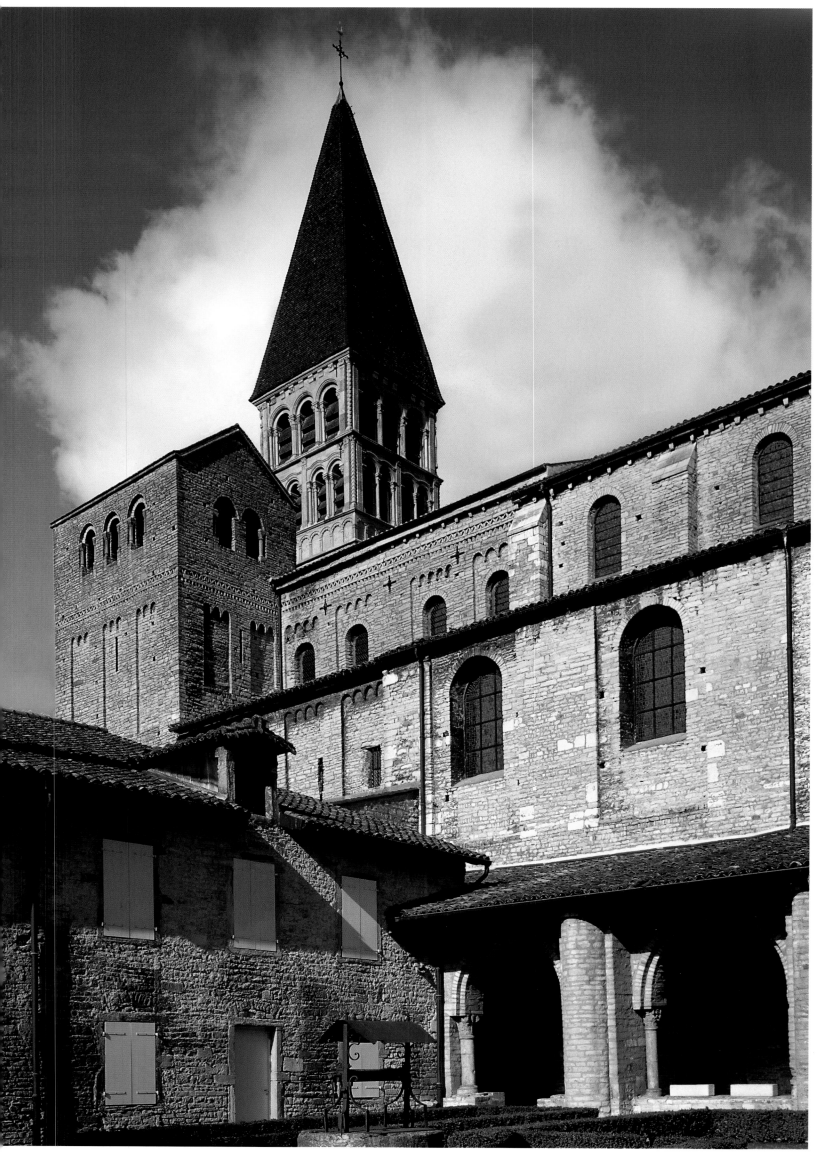

PAGES 38/39:
Dijon, Saint-Bénigne,
rotunda, 1001–1018

This rotunda, unique
in art history, was
situated at the apex of
the choir of the church
of William of Volpiano.
It was part of the
expansive crypt
underneath the
church's eastern section
and extends over three
(reconstructed) stories.
The central well opens
in an *opaion*, or
occulus.

LEFT AND OPPOSITE:
**Tournus, former
abbey church of
Saint-Philibert,**
10th c.–1120,
exterior view from the
southeast and interior

One of the first vaulted
buildings in Burgundy,
in the tradition of
Cluny II, Saint-Philibert
came about through a
long and complicated
building process. It
incorporates exterior
walls of an older nave
and choir. The curious
cross barrels were an
emergency solution
after the original barrel
vault over the center
aisle collapsed.

PAGES 42 AND 43:
**Paray-le-Monial,
former abbey church of
Notre-Dame,** 1st half
of the 11th c. and
1090, exterior view
from the northwest
and interior

Notre-Dame, founded
by Abbot Hugo of
Cluny, is considered the
"pocket version" of the
third abbey church of
Cluny, which was
dismantled during the
French Revolution. Its
three-aisle nave repeats
its elevation with all
its refinements.

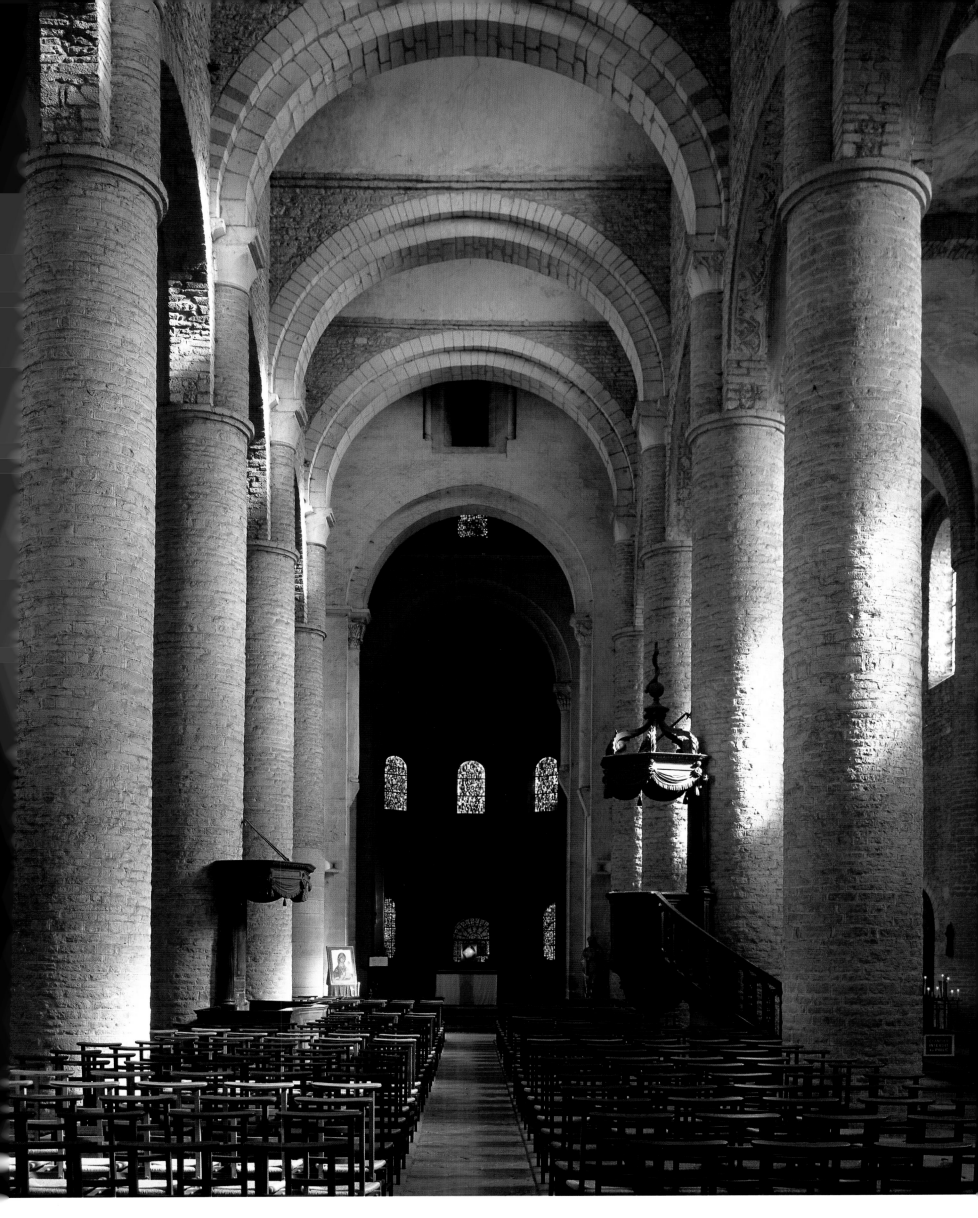

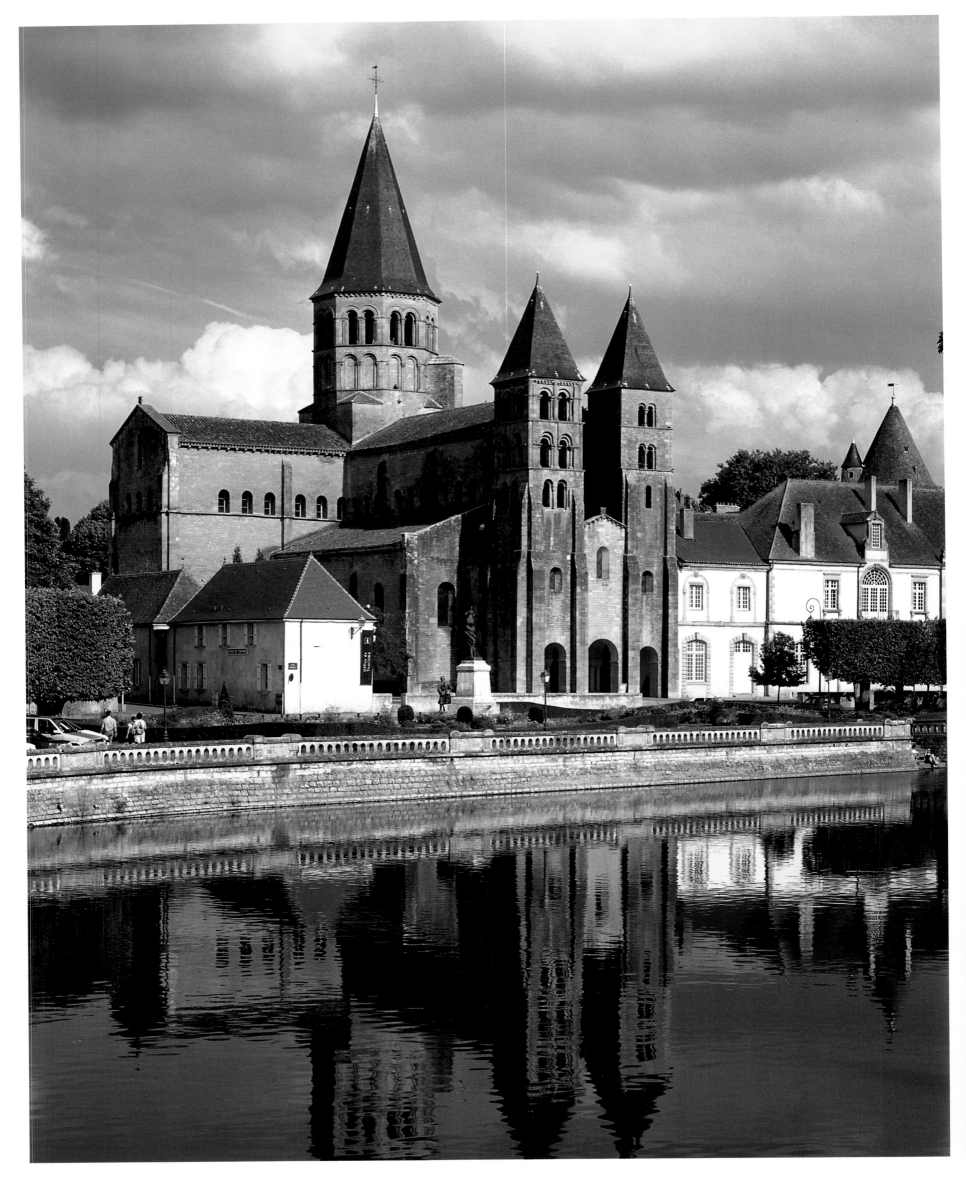

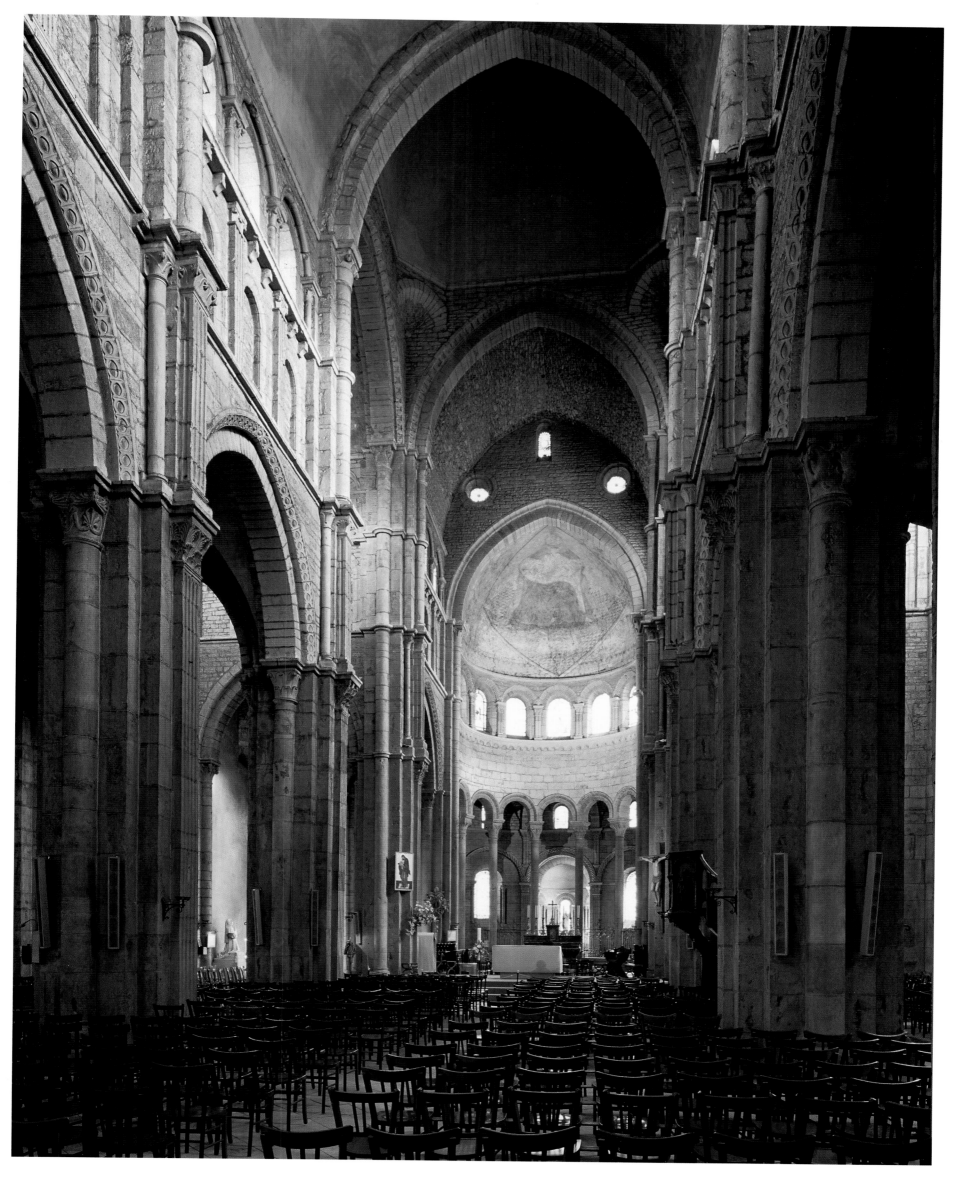

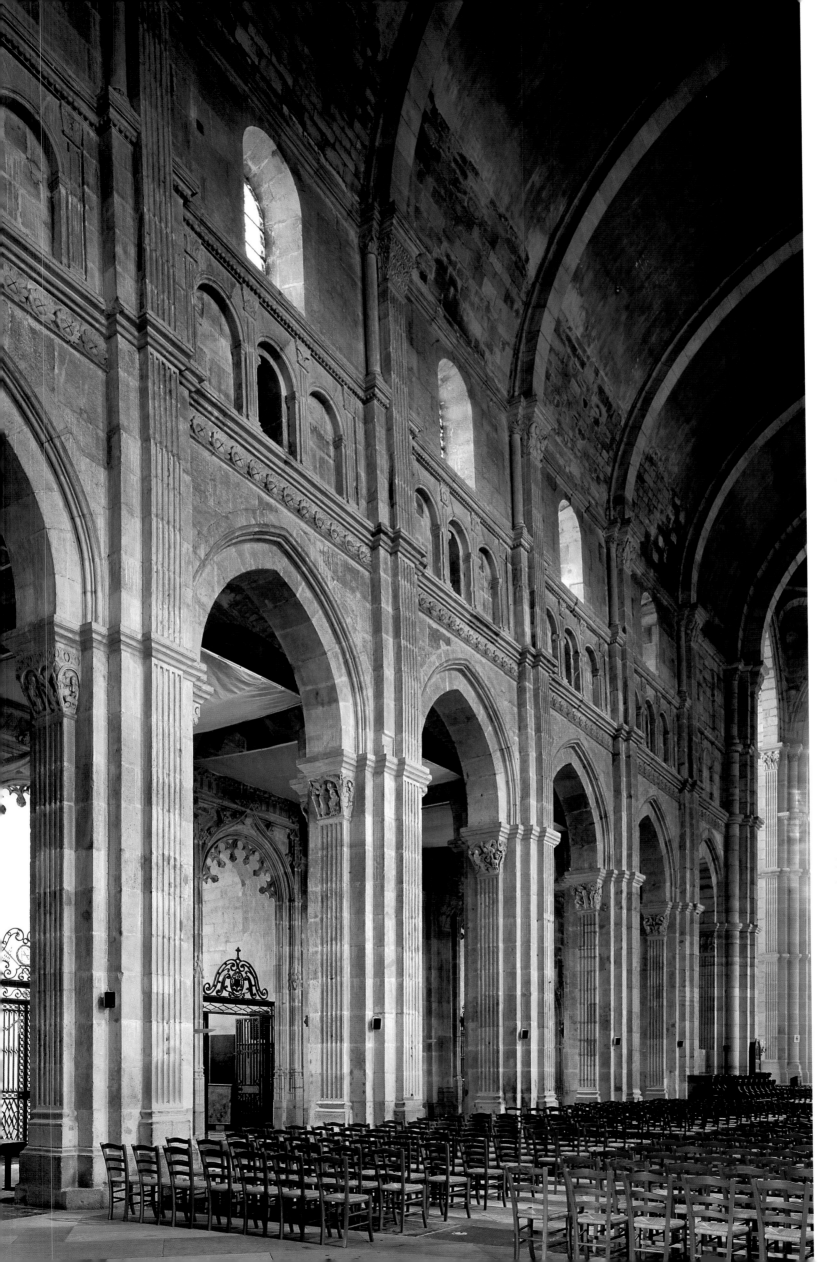

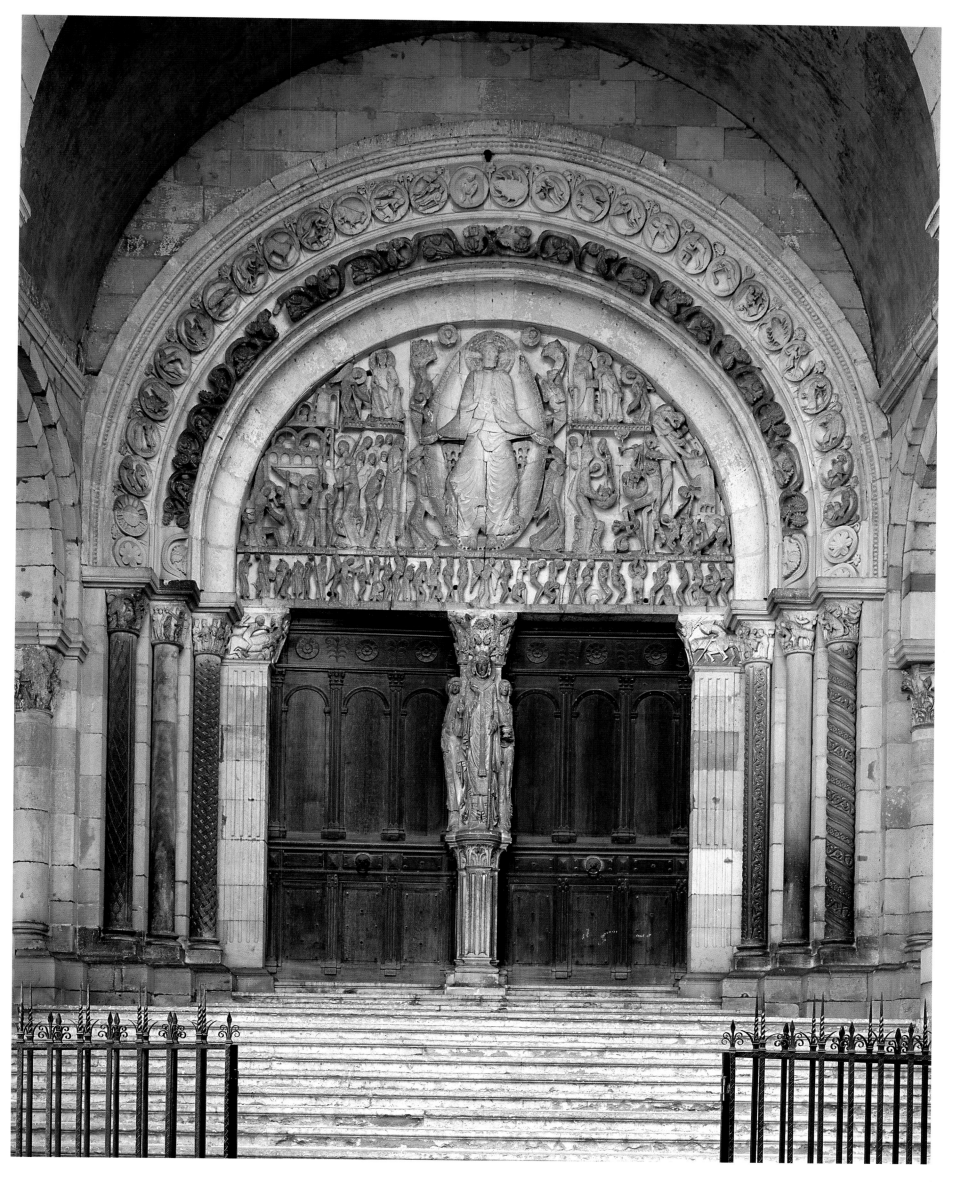

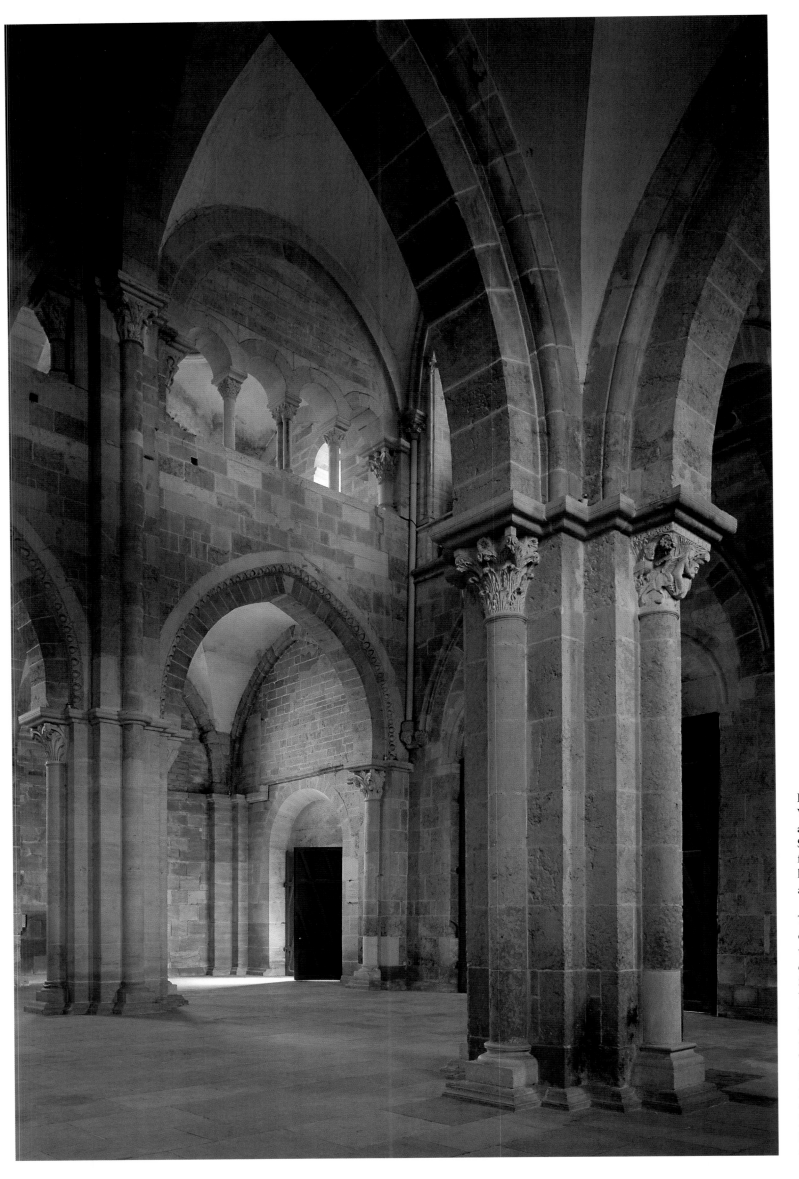

LEFT AND OPPOSITE:
Vézelay, former abbey church of Sainte-Madeleine, from 1120, high choir late 12th c.; vestibule and nave

The main representative of the group of churches with groin vaults in the center and side aisles is Sainte-Madeleine in Vézelay. Its sculpture, both figural and ornamental, is among the best in Burgundy. The enormous tympanum (illus. p. 2) presents a combination of the themes of Receiving the Holy Spirit and the Mission of the Apostles.

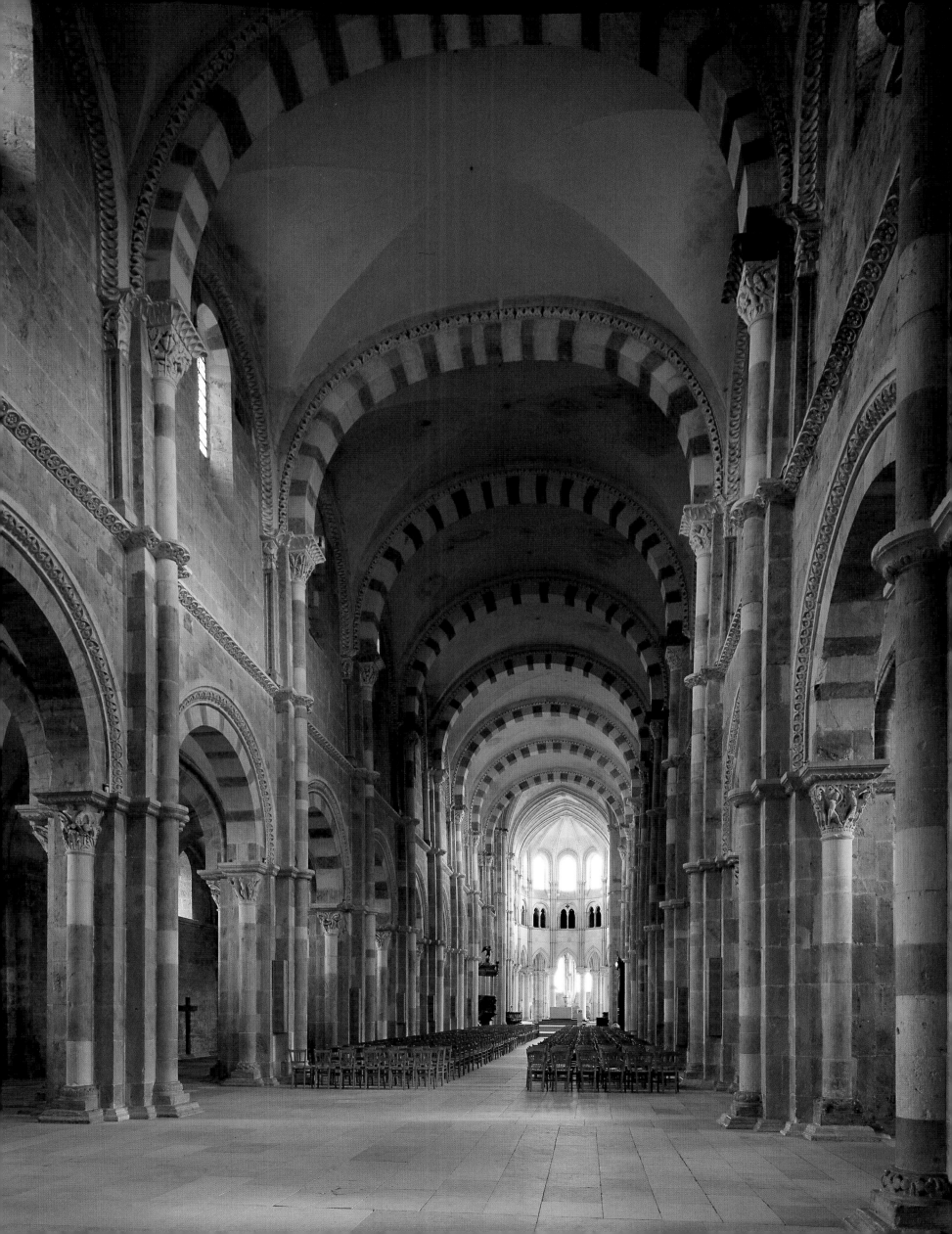

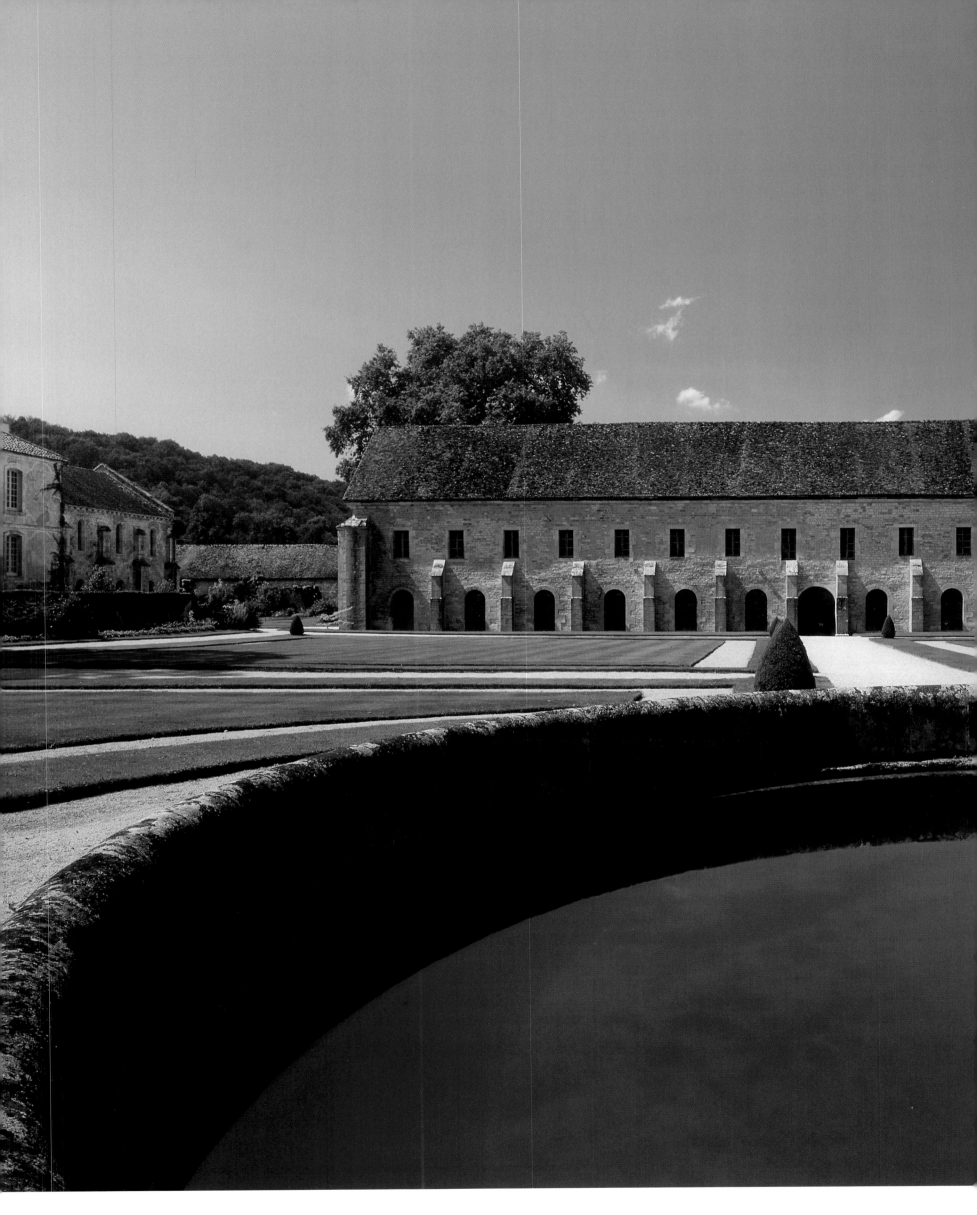

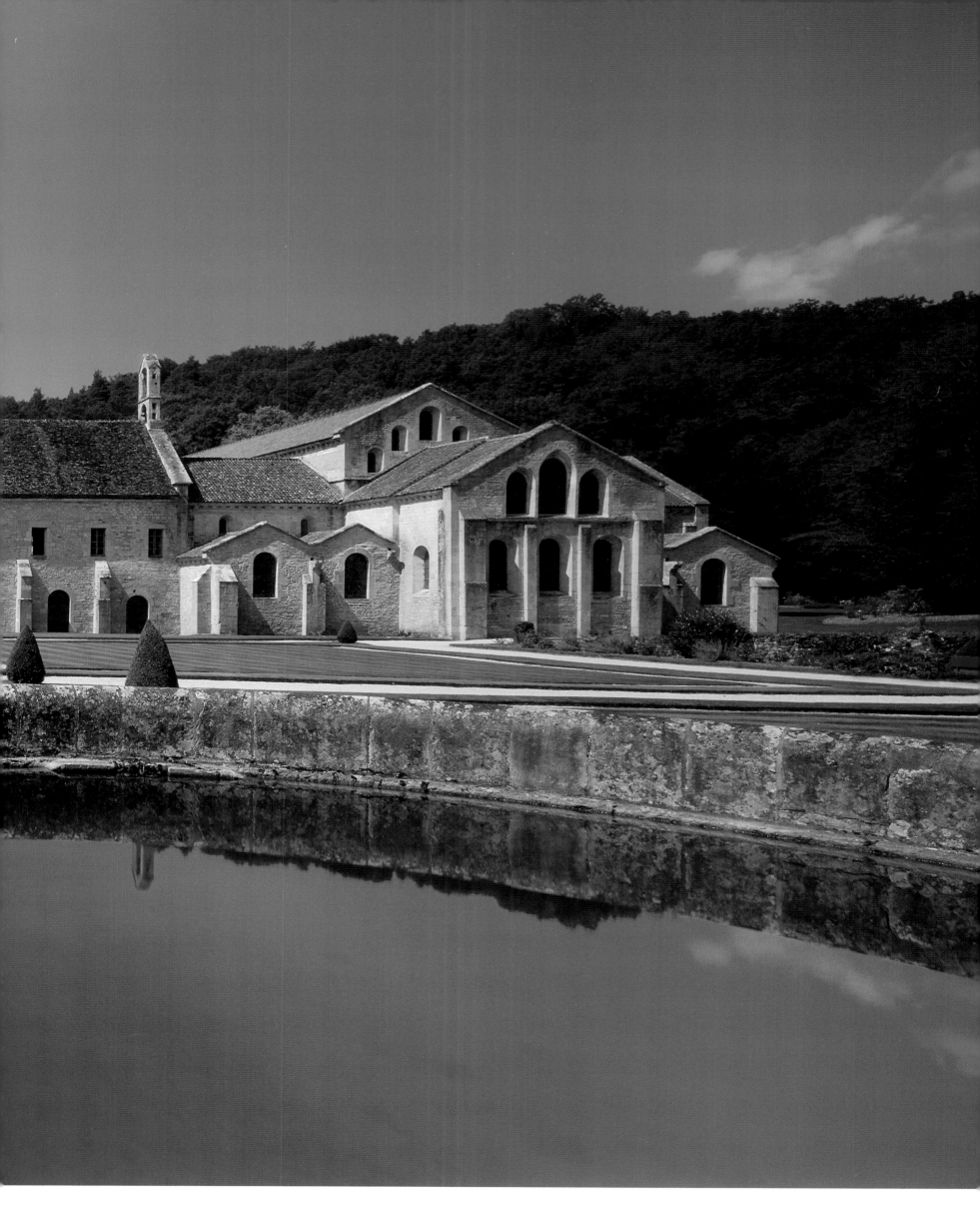

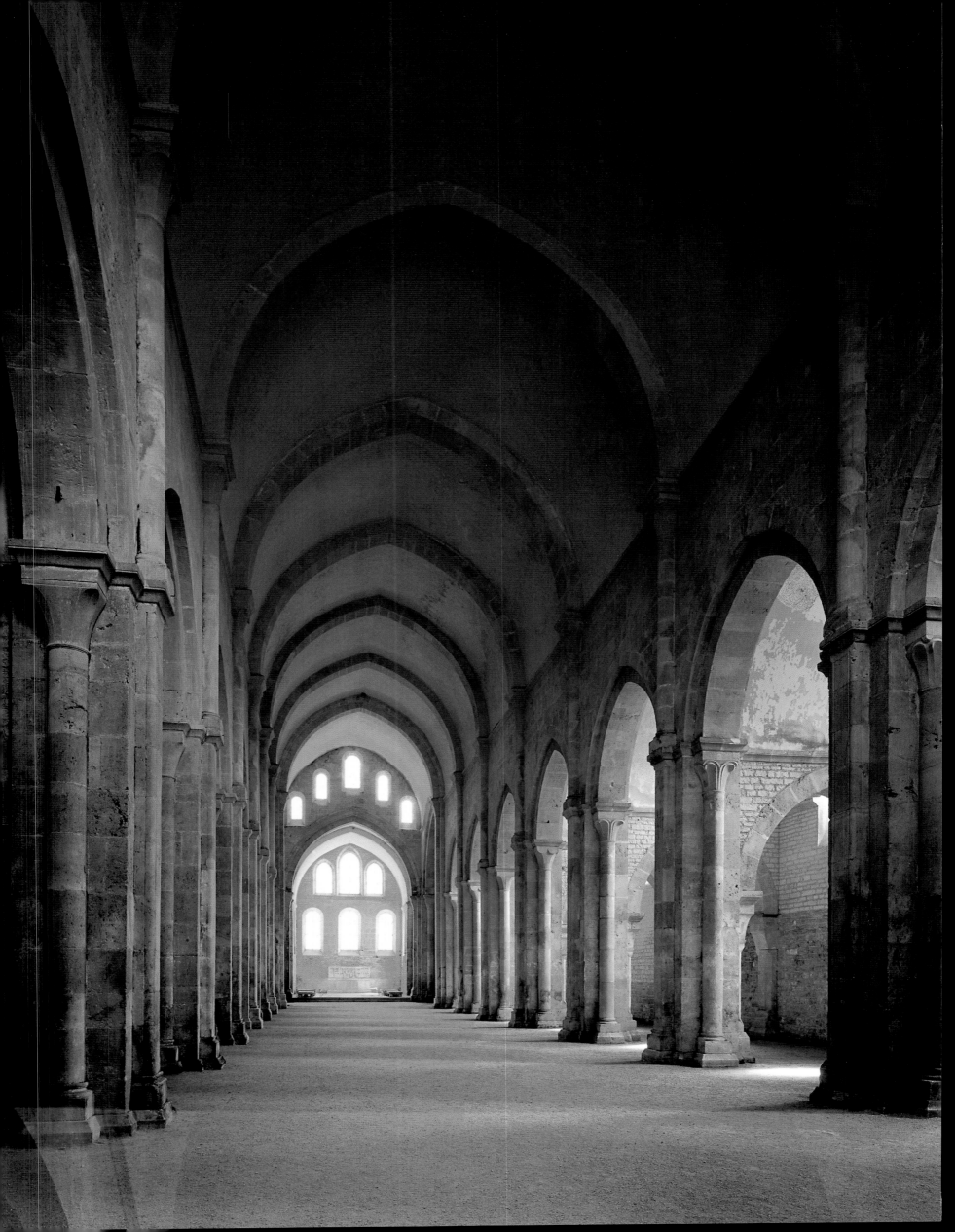

Fontenay, former Cistercian abbey, 1139–1147, exterior view of the monastery complex; interior view of the church (opposite); and chapter hall

Together with Clairvaux, La Ferté, and Pontigny, Fontenay was one of the first daughter cells of Cîteaux. The church and the monastic buildings were probably erected under the guidance of Bernard of Clairvaux himself, and became the prototype for Cistercian construction. Following Gothic renovations and the dismantling of the other three monasteries, Fontenay is today the oldest preserved testament to the architecture of the order. The barrel-vaulted pseudobasilica with cross vaults in the side aisles combines perfect workmanship with an almost complete absence of ornamentation. The chapter hall, on the other hand, was built at the end of the 12th century, and emanates the grace and delicacy of early Gothic architecture.

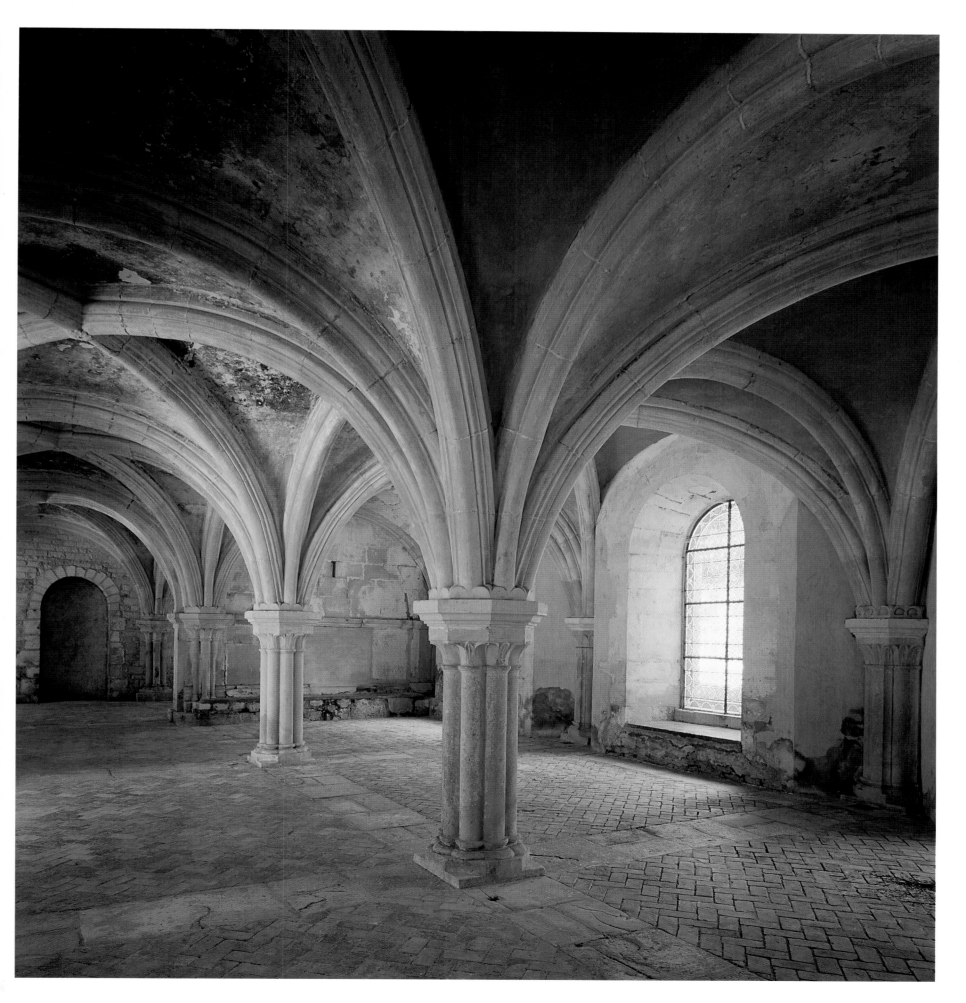

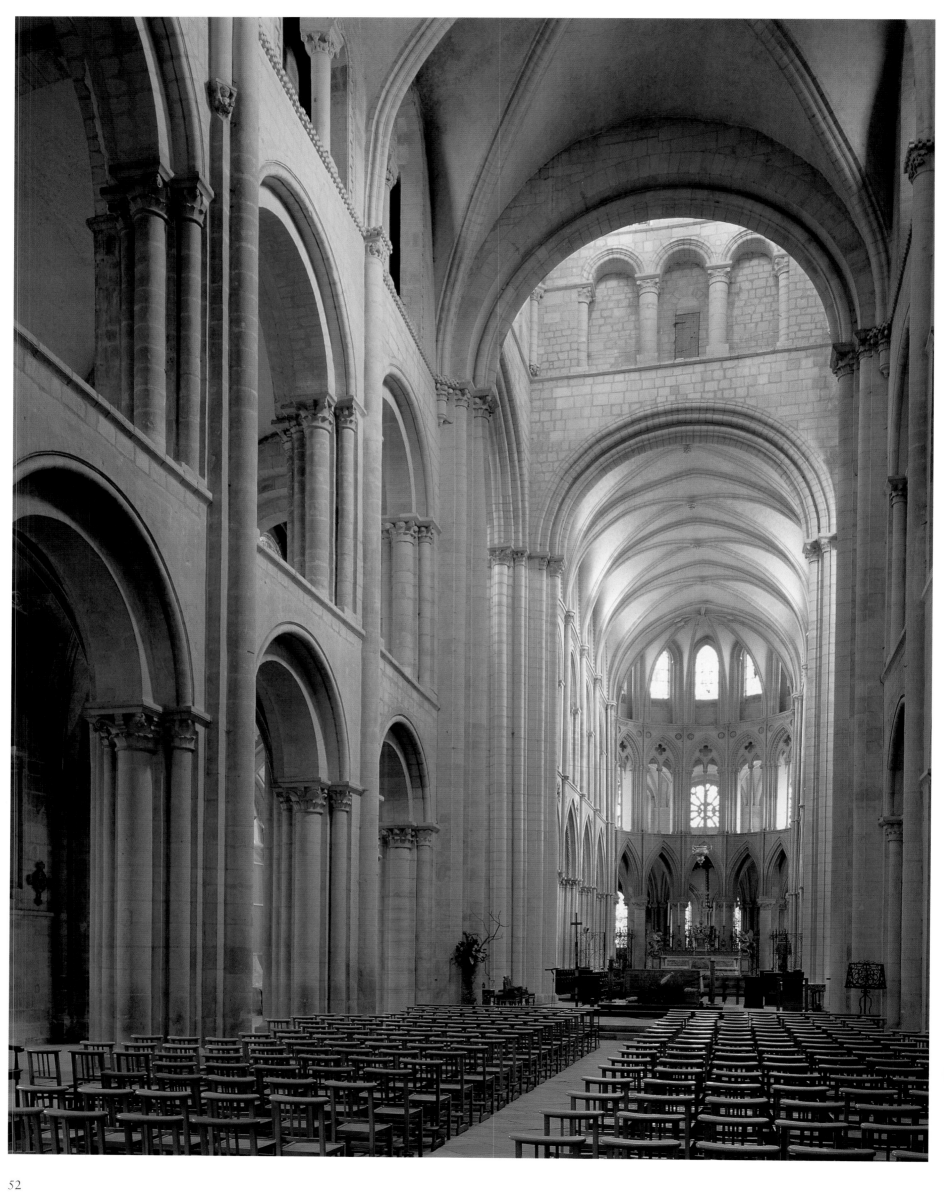

Caen, former abbey church of Saint-Étienne,
ca. 1060/65–1181, vaulting ca. 1120, choir late 12th c.,
interior view facing east; exterior from the southeast

Saint-Étienne is the sepulchral church of the Norman duke
William, a structured building with three aisles, galleries,
and a clerestory with walkway. It was the model for
almost all English Romanesque architecture. It was
probably here that the first successful ribbed vault was
built over a center aisle, in 1120.

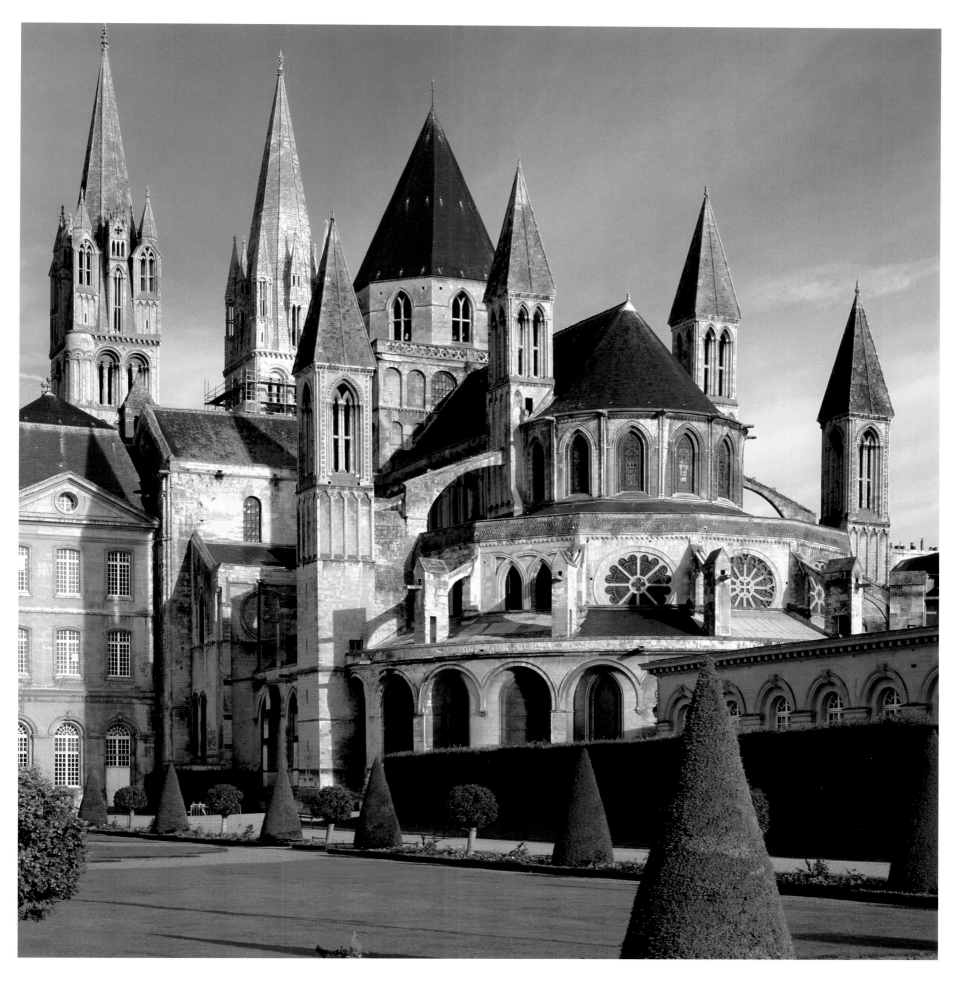

Caen, former abbey church of Sainte-Trinité,
ca. 1060/65–ca. 1120, west view

Sainte-Trinité is the endowment of Duchess
Mathilda of Flanders, a basilica with trifora in
place of galleries. The west side is characterized
by a powerful twin-tower facade.

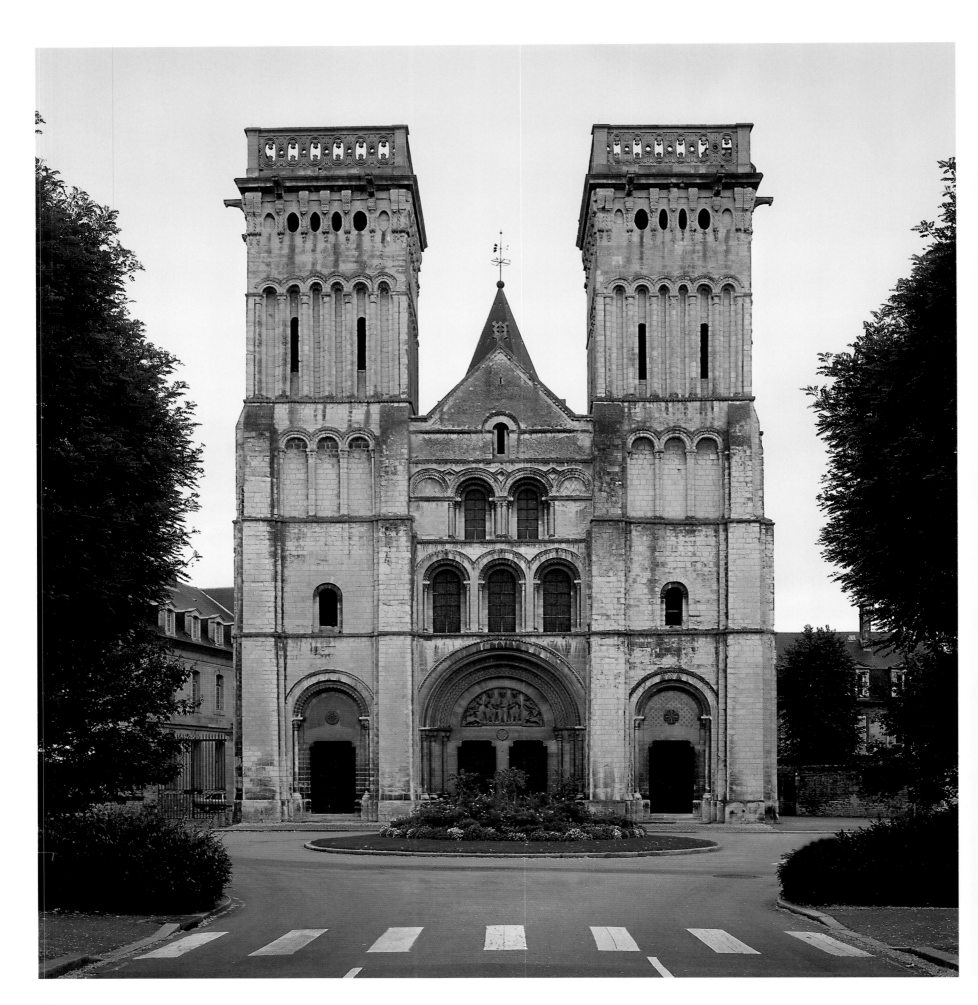

Cerisy-la-Forêt, former priory church of Saint-Vigor, ca. 1080/85

Saint-Vigor is a successor of Saint-Étienne and gives us an idea of what its original choir might have looked like. Only two bays of the nave were completed.

PAGES 56/57:

Jumièges, former abbey church of Notre-Dame, 1040–1067, view from the south

The abbey church of Jumièges is the earliest Norman Romanesque construction with an expansive gallery elevation and a clearly structured center aisle. The twin-tower facade anticipated those in Caen, but does not display the same structure.

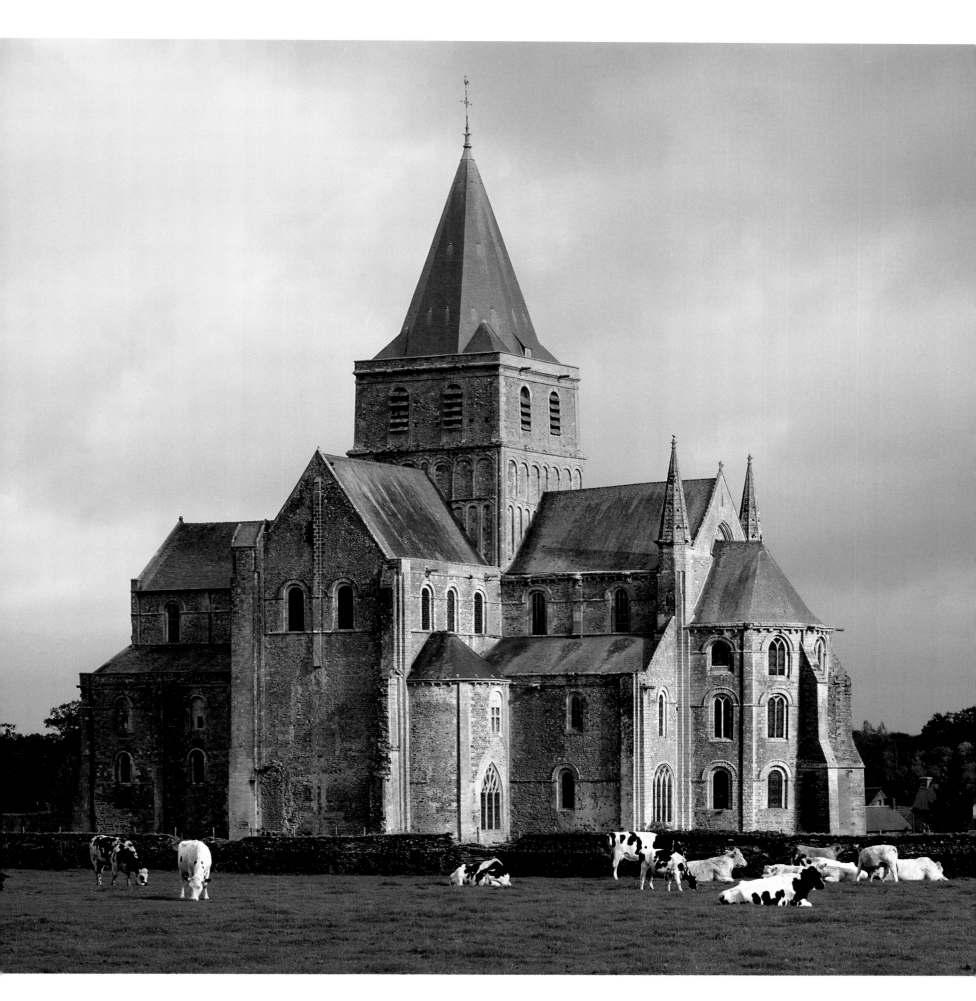

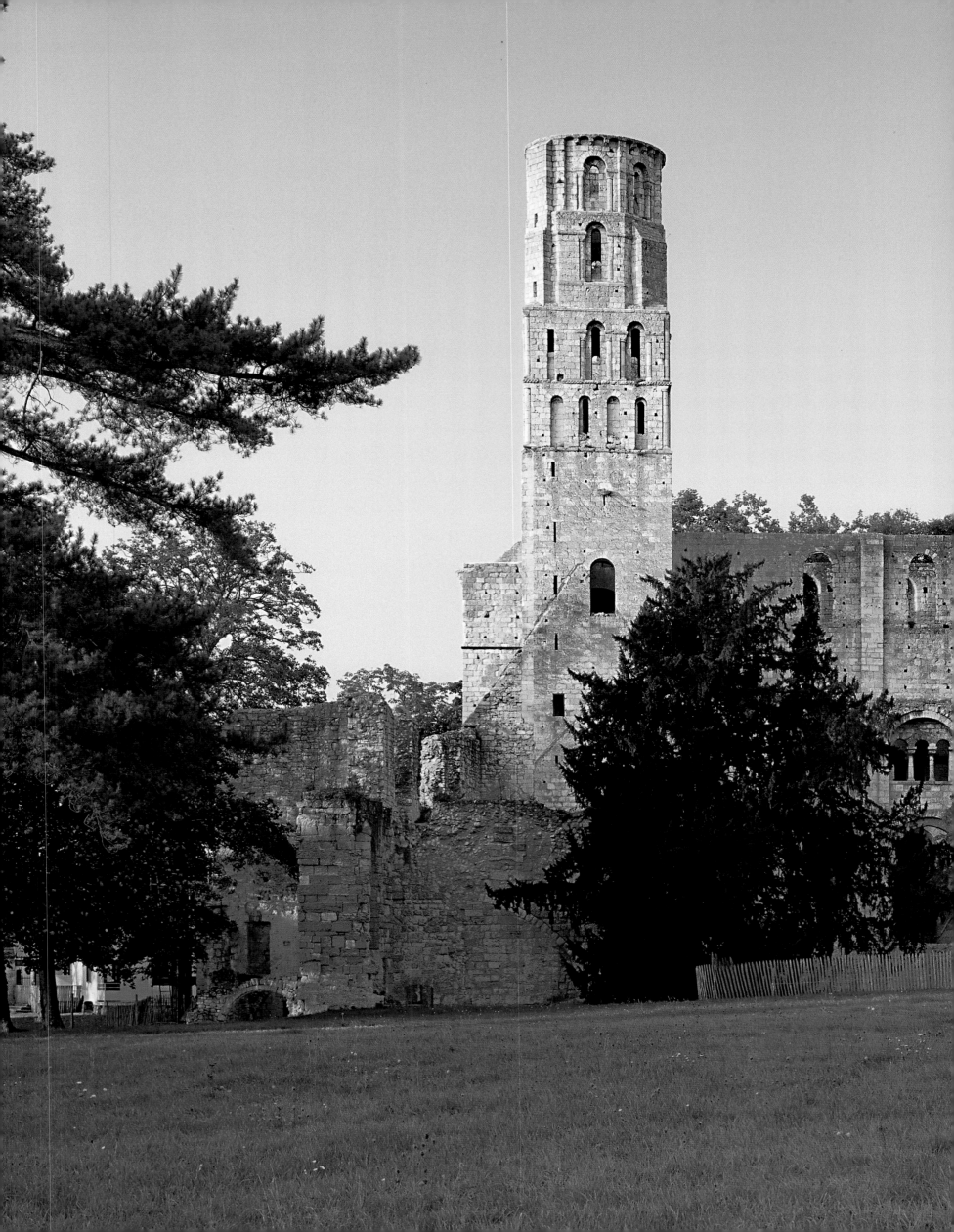

Saint-Nectaire, former abbey church,
begun ca. 1080, view from the southeast

Saint-Nectaire is one of a group of pilgrimage
churches that forgo a clerestory in order to have
barrel vaulting. That explains the compact exterior
construction. Typical of them are also the stepped
transept that is higher at the crossing, as well as the
low ambulatory.

OPPOSITE:

Issoire, Saint-Paul, begun ca. 1130, view from
the east

Saint-Paul, another pilgrimage church, hardly
distinguishes itself from Saint-Nectaire as far as
its structure is concerned. However, the mosaic-like
decoration of the surfaces in the chapels, main choir,
and crossing tower is more ornate than that in
Saint-Nectaire.

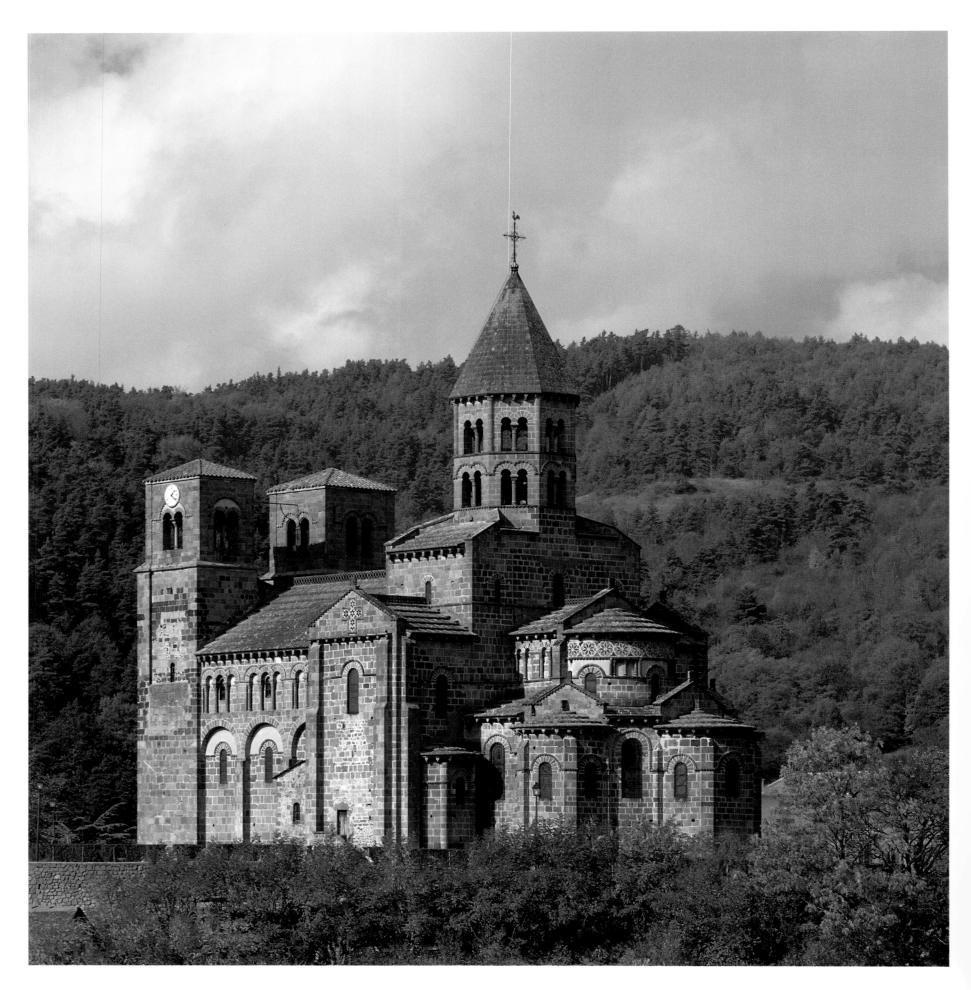

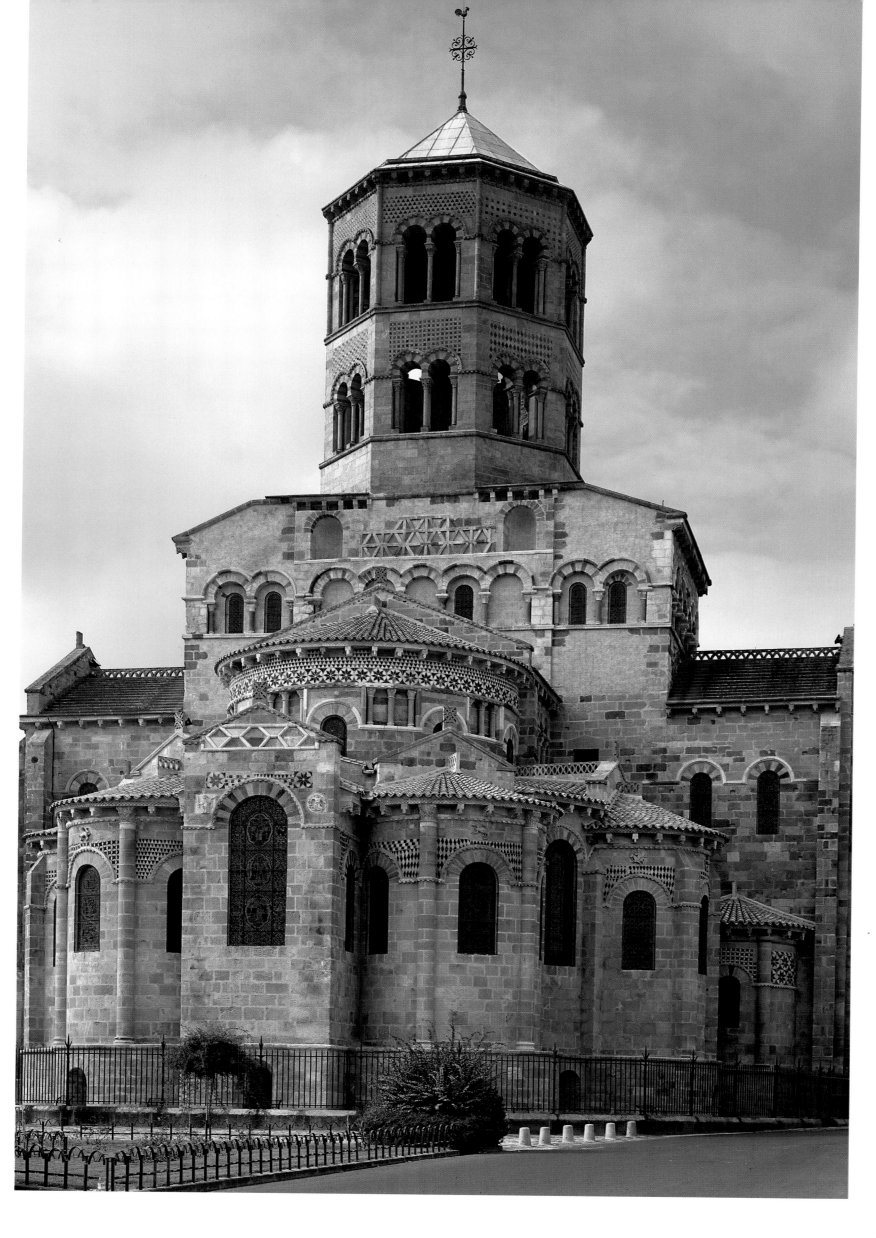

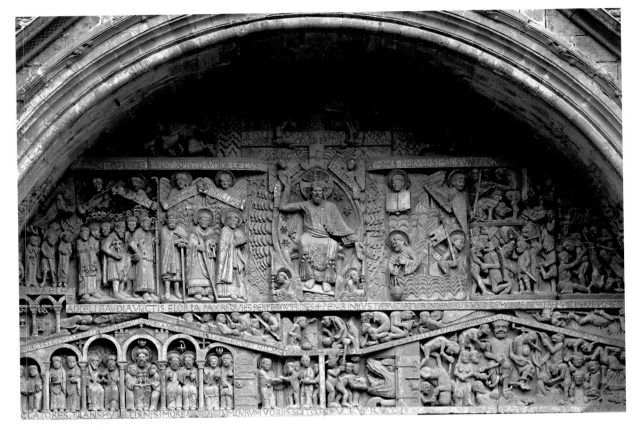

Conques, former abbey church of Sainte-Foy, after ca. 1050, tympanum of the west portal, 3rd quarter of the 12th c.; view of the village and the church from the southwest

Le Puy, view of the city with the chapel Saint-Michel-d'Aiguilhe and the Romanesque cathedral

In the course of the 10th century, four main routes through France established themselves as the primary pilgrimage routes to Santiago de Compostela, one of the most significant places in Christianity. The so-called pilgrimage churches functioned as stations along the way. The four paths merge in Roncesvalles and in Puente la Reina. In addition to their special architecture, typical of these churches is a wealth of sculpture that was intended to convey sacred truths to the pilgrims in pictures. The tympanum of Conques, for example, depicts themes from the Last Judgment in a way that directly addressed the fears of the faithful.

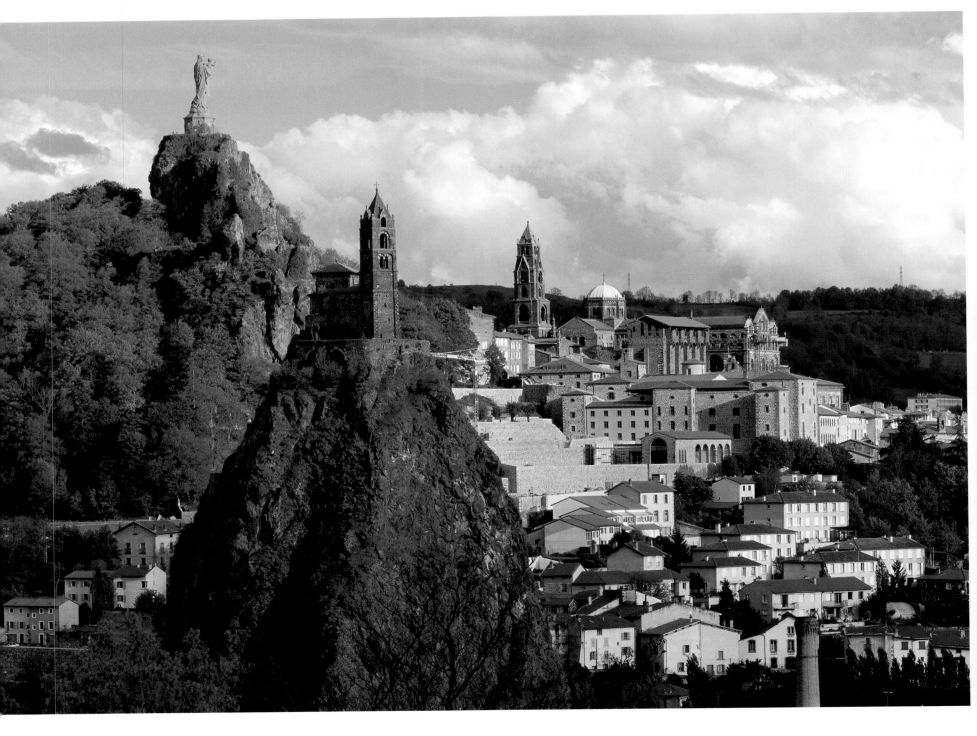

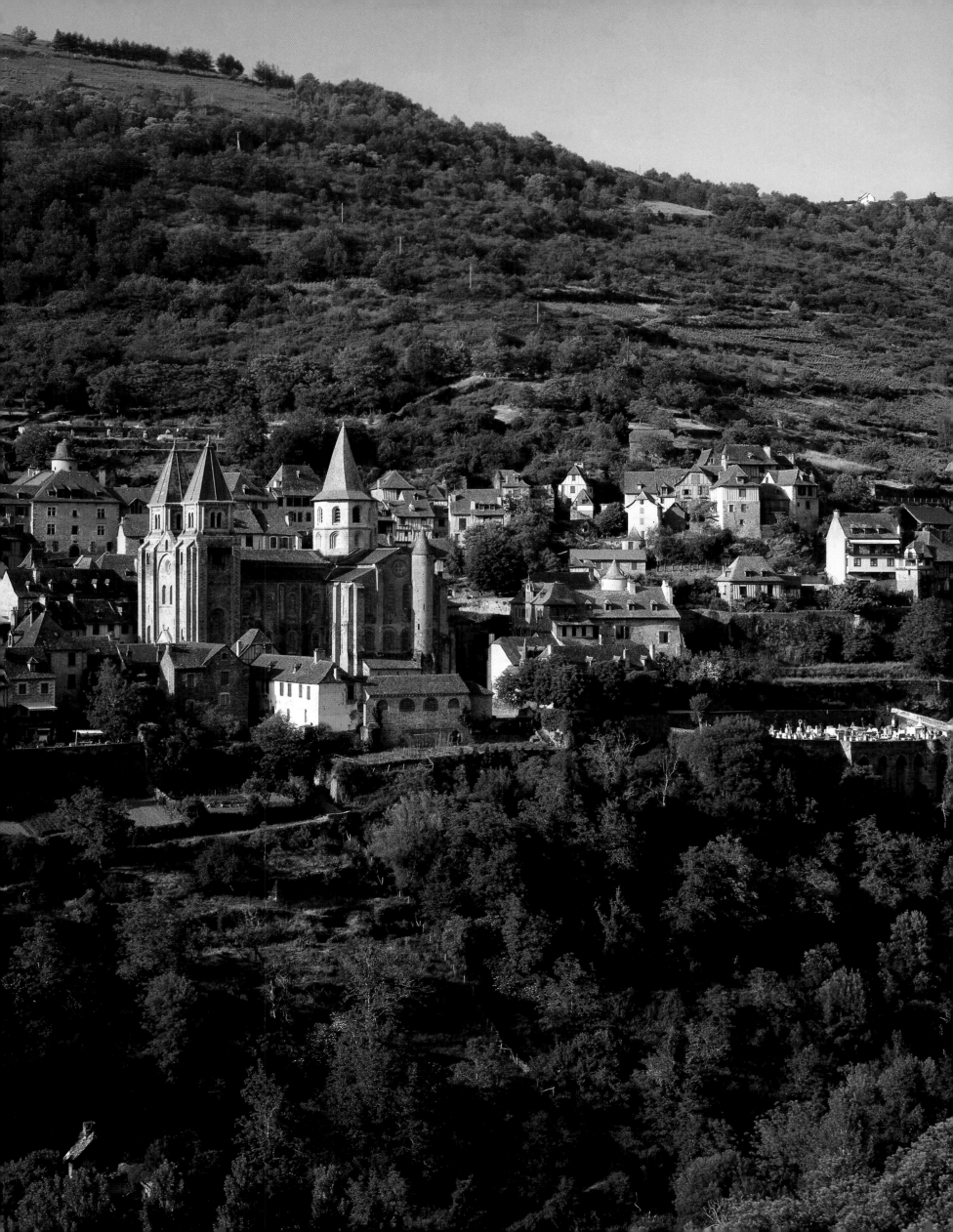

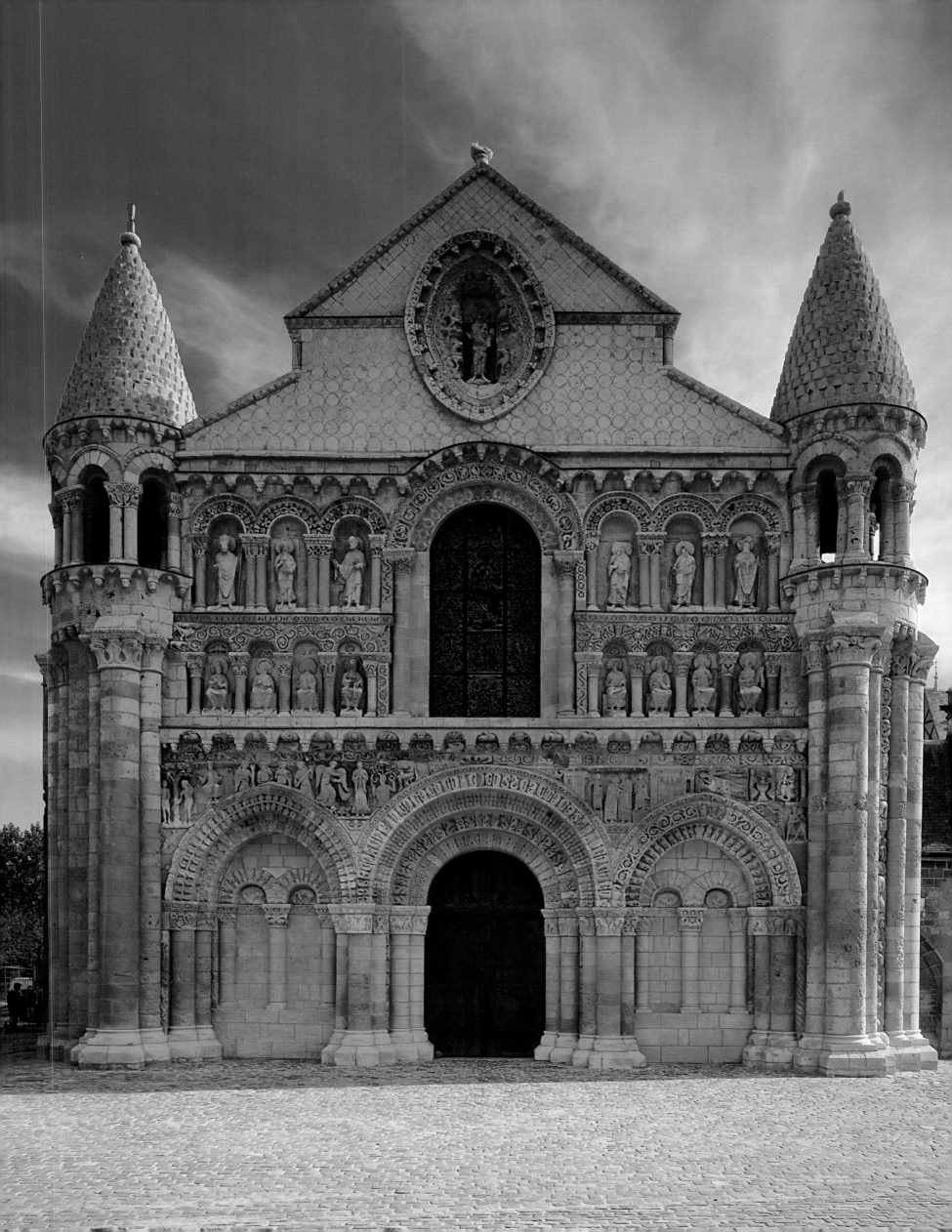

OPPOSITE:
Poitiers, Notre-Dame-la-Grande,
west facade, ca. 1150

BELOW:
Aulnay, Saint-Pierre,
south transept portal, ca. 1130

These portal and facade decorations are characteristic for Poitou, Saintonge, and Angoumois. This so-called "Western School" did without tympana, and instead decorated each individual stone of the portal frame with a small figure. In Poitiers this decoration system was extended over the entire facade, and blind arcades offer the framework for the rich sculptural decoration that is distributed over the whole surface.

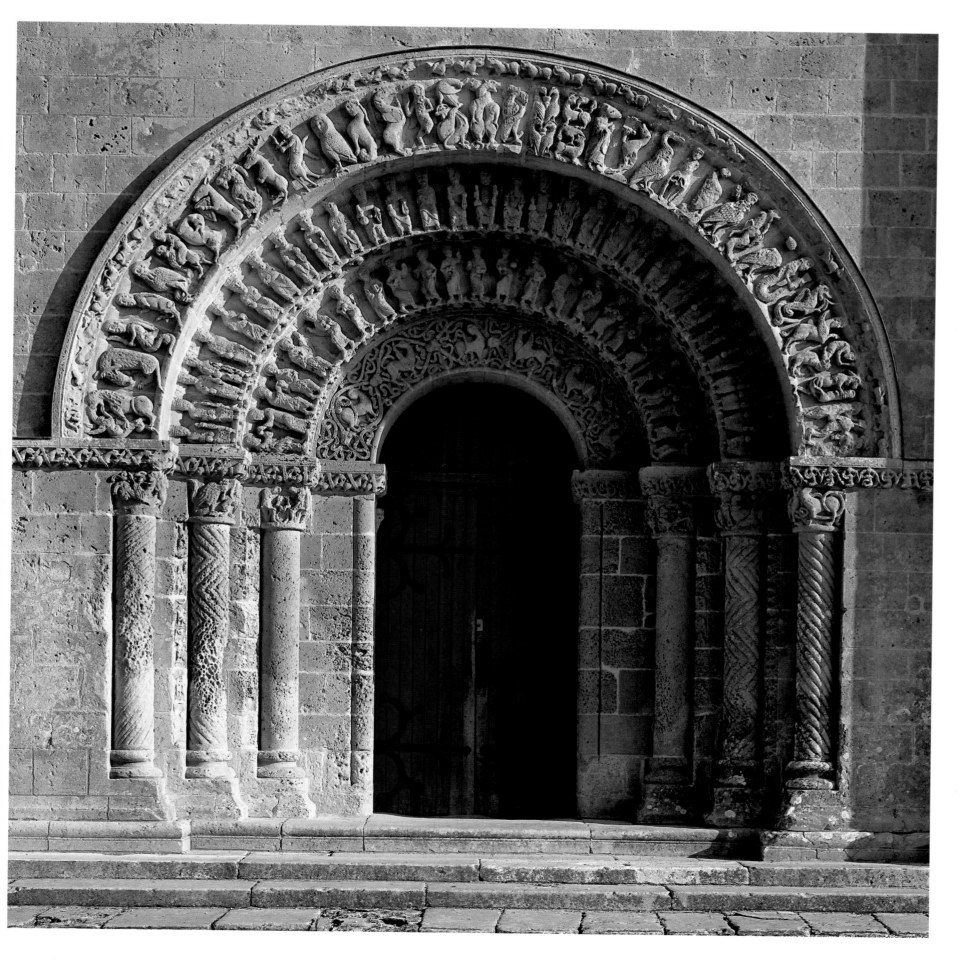

Fontevraud, former abbey church, founded 1110

This is an aisleless church with four consecutive domes; the transept and ambulatory have barrel vaulting. From 1190 until 1204 Fontevraud was the sepulchral church of the English Plantagenet kings.

OPPOSITE:
Saint-Savin-sur-Gartempe, former priory church, 1065–1080 and 1095–1115, column nave

This is a typical example of the hall churches in western France, which were all vaulted. The supports and vaulting bear extensive remainders of Romanesque painting.

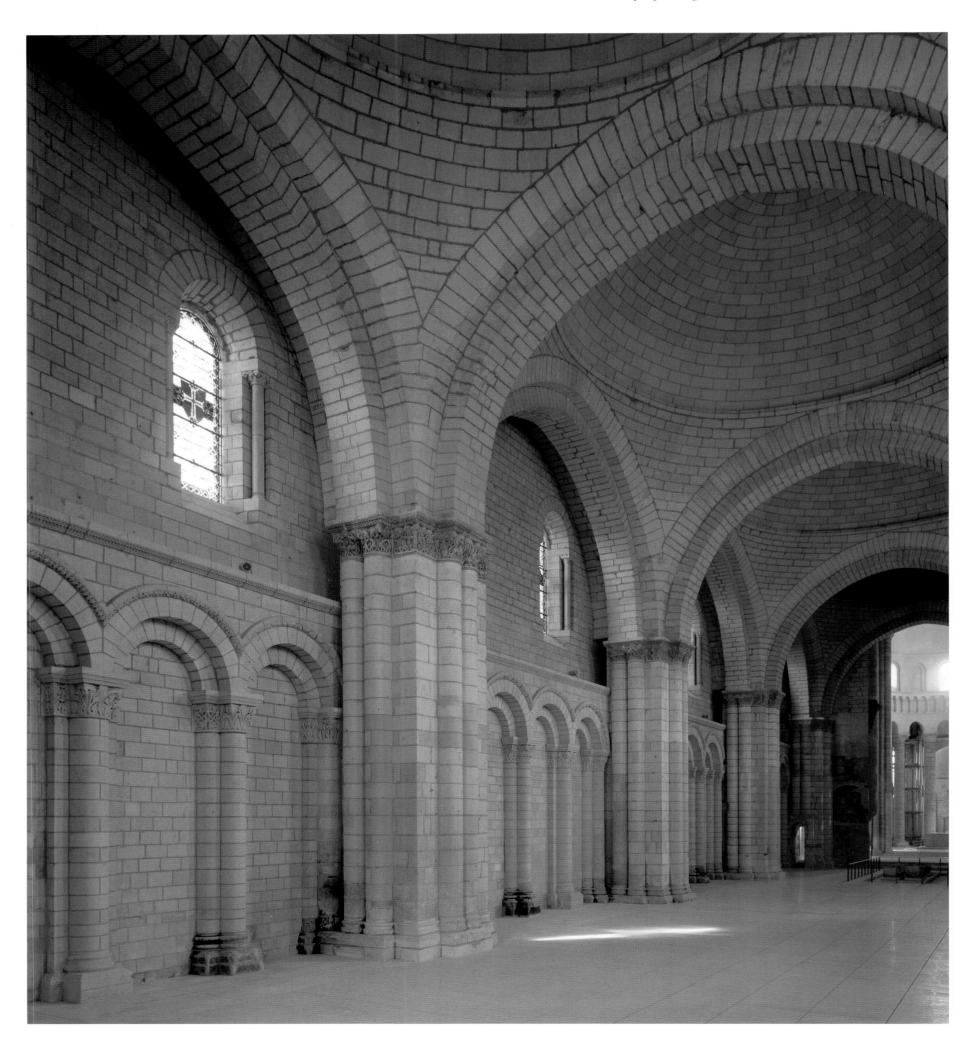

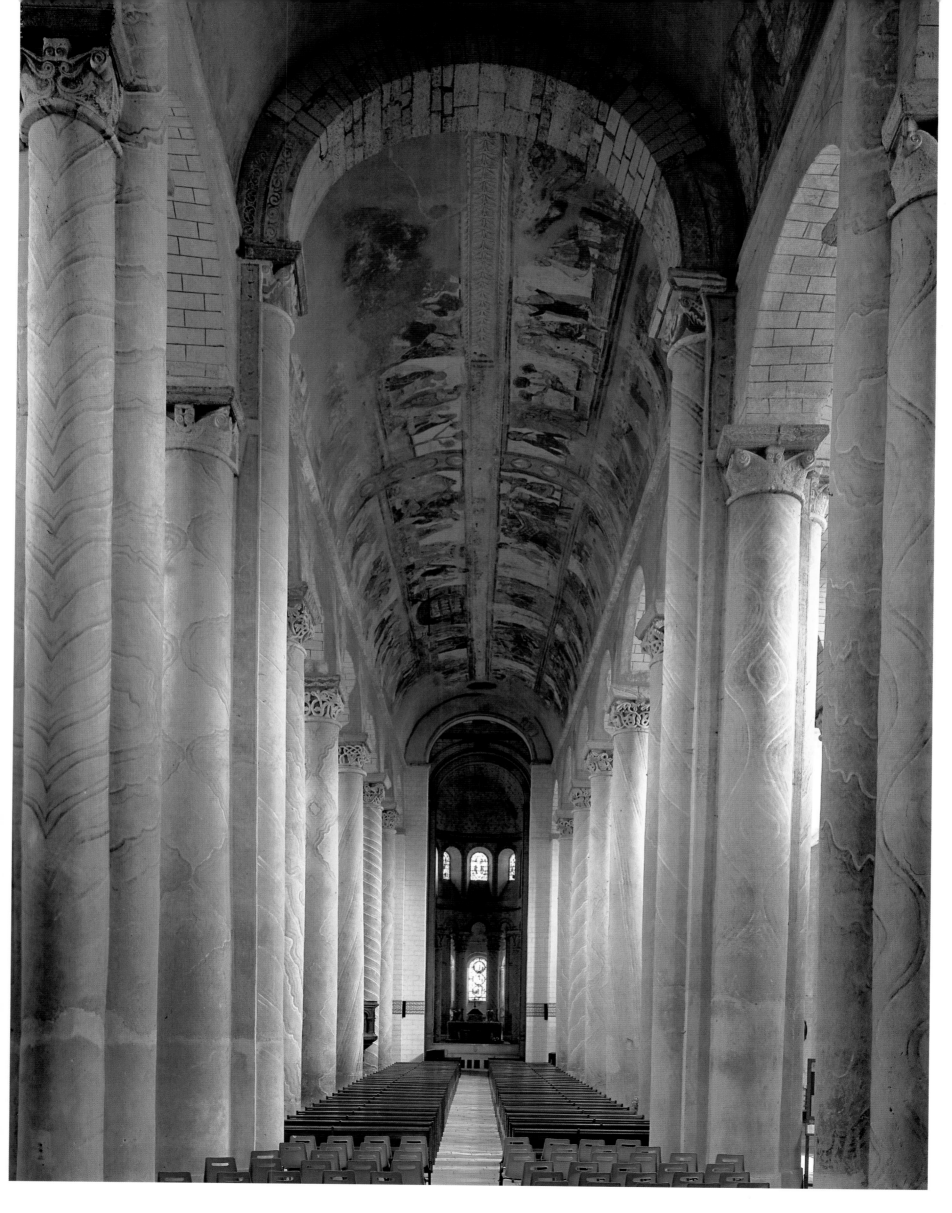

Apart from Saint-Gilles, the portal in Arles is the only large-figure portal in the Provence region. Its design is reminiscent of Roman triumphal arches. The sculpture shows a strong tendancy toward highly detailed and decorative work. In spite of the sculptor's obvious familiarity with antiquity, it remains flat and without body. The statuary solidity of the figures contrasts with the tension and movement apparent in contemporary sculpture in regions further north. Only the northern and eastern wings of the cloister actually date from the Romanesque era.

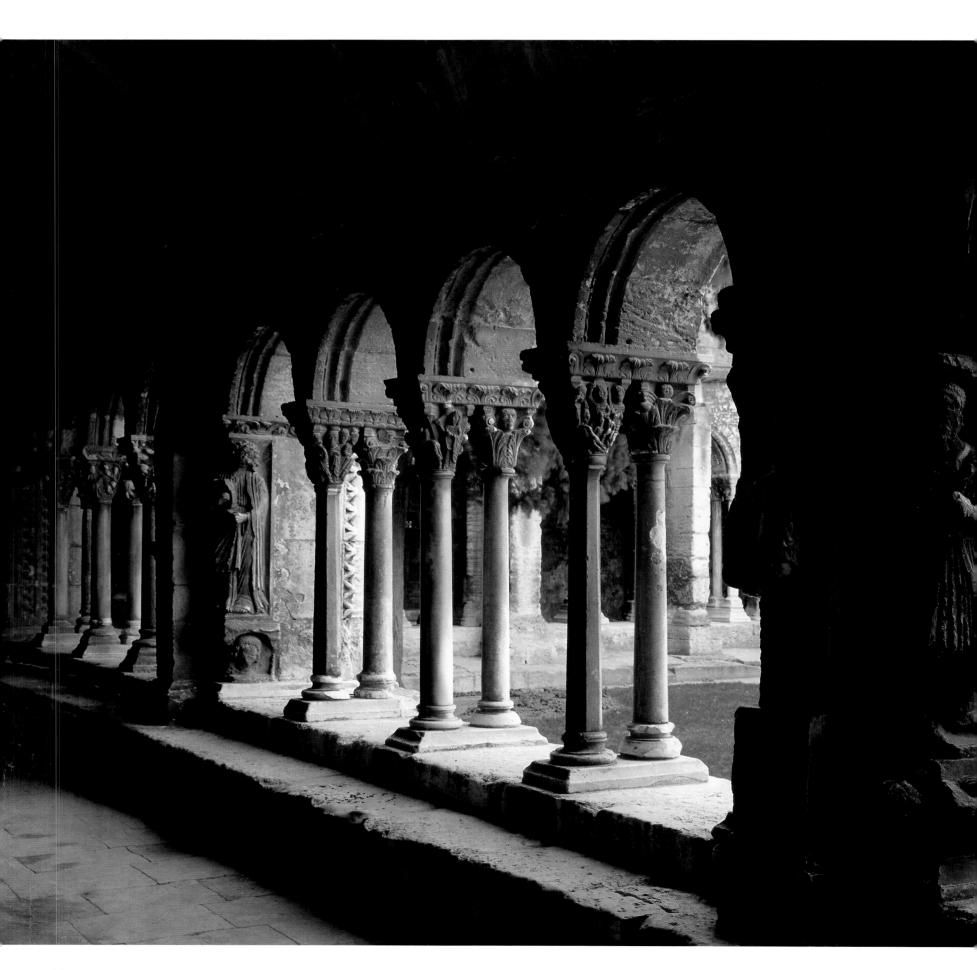

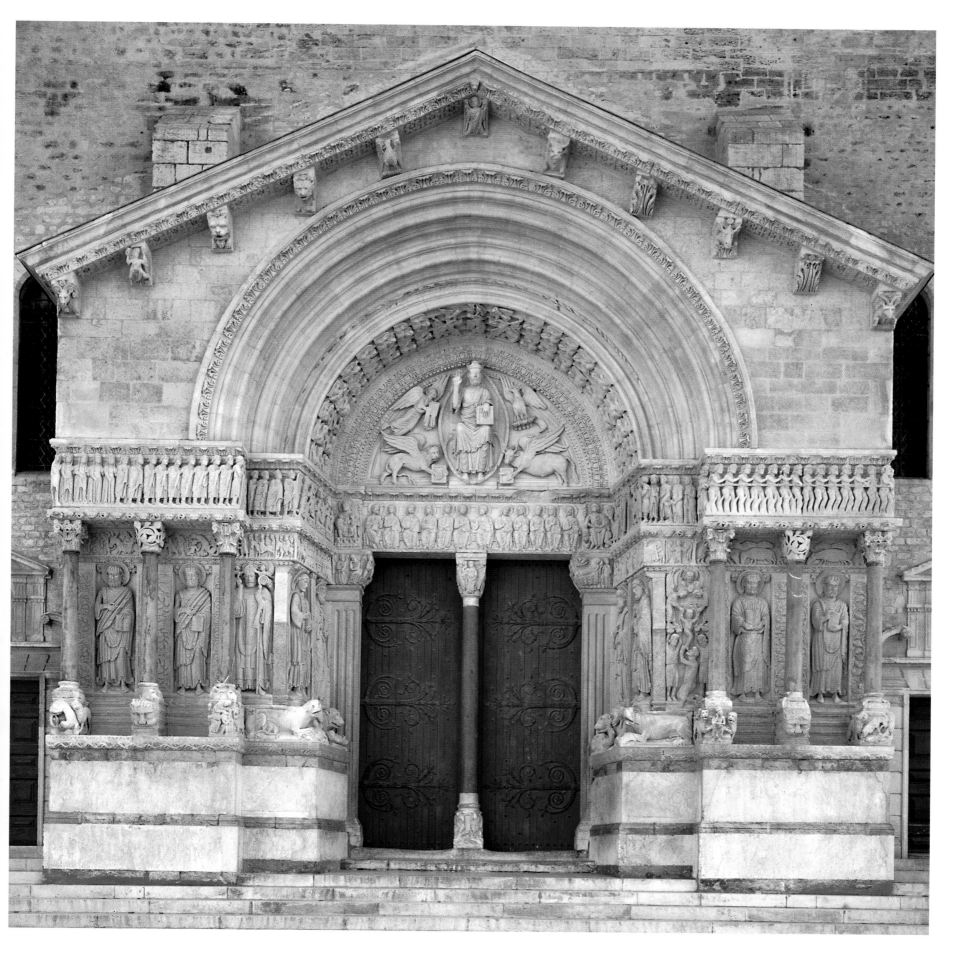

Saint-Gilles-du-Gard, former abbey church of Saint-Gilles, west facade; main portal, detail of the right (southern) wall, ca. 1170/80

The three-portal complex of Saint-Gilles is a monumental wall display in front of an older facade. Figures of different ages and styles (the work of at least four identifiable masters, including the Archaizing Master, the Michael Master, and the Thomas Master) are combined to form an entirely unusual work, in terms of both iconography and composition, that is reminiscent of Roman triumphal arches and theater architecture.

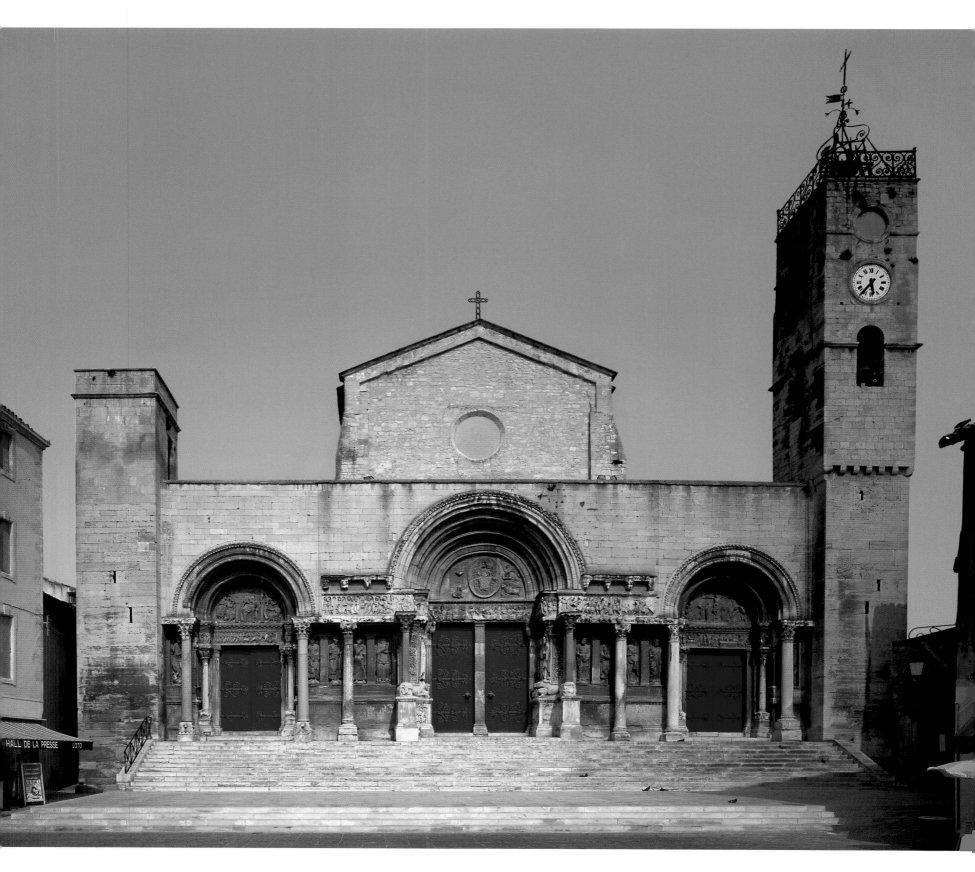

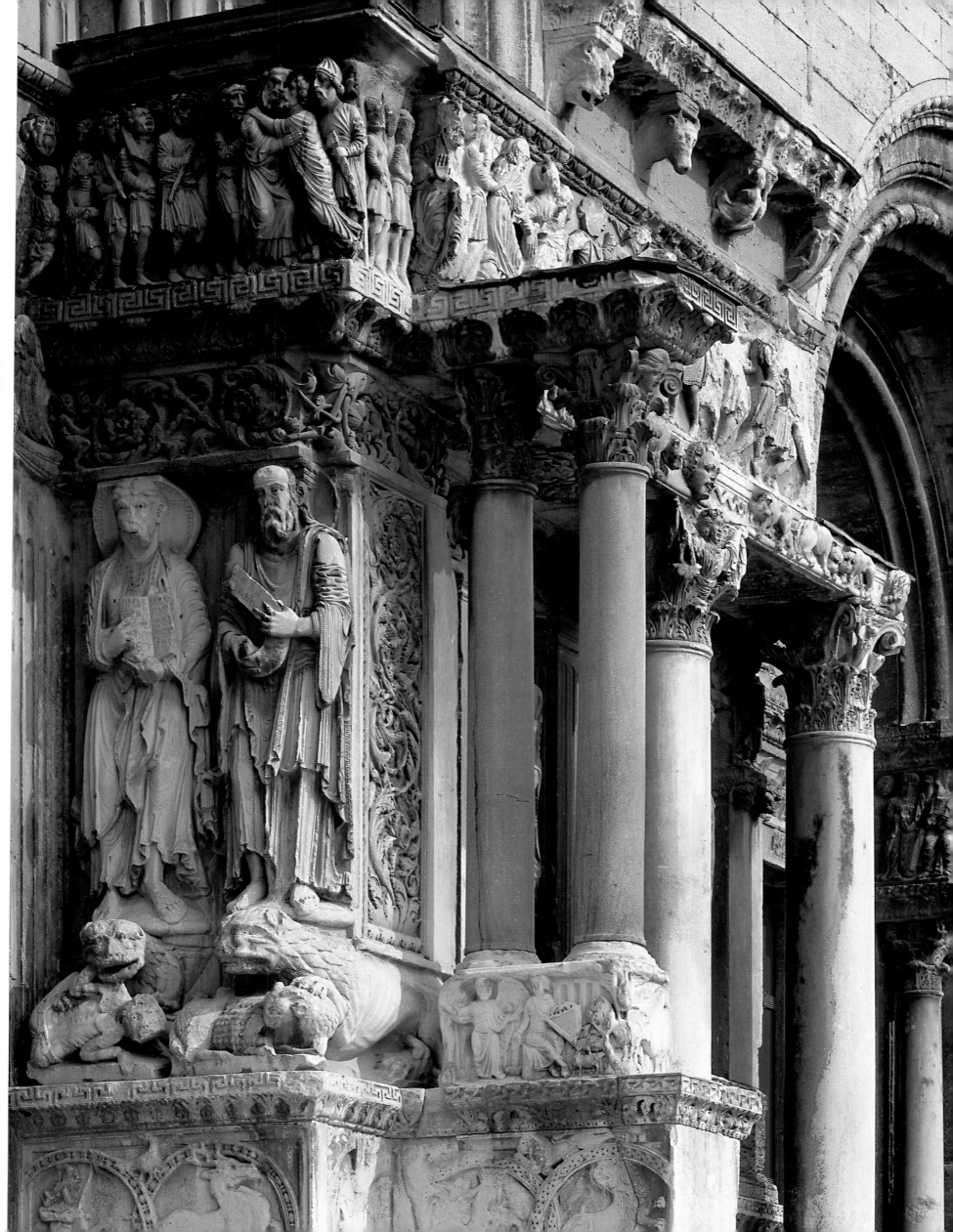

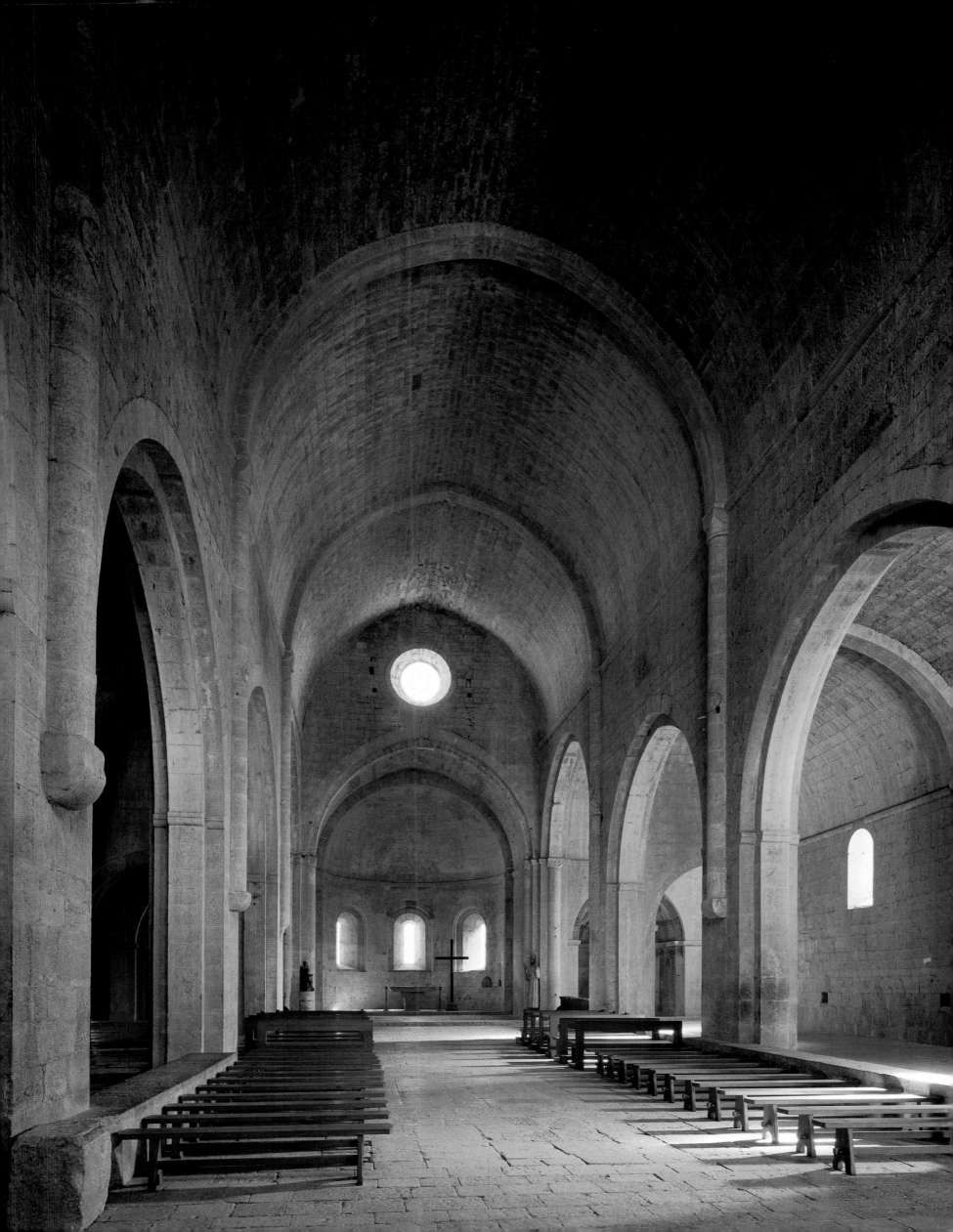

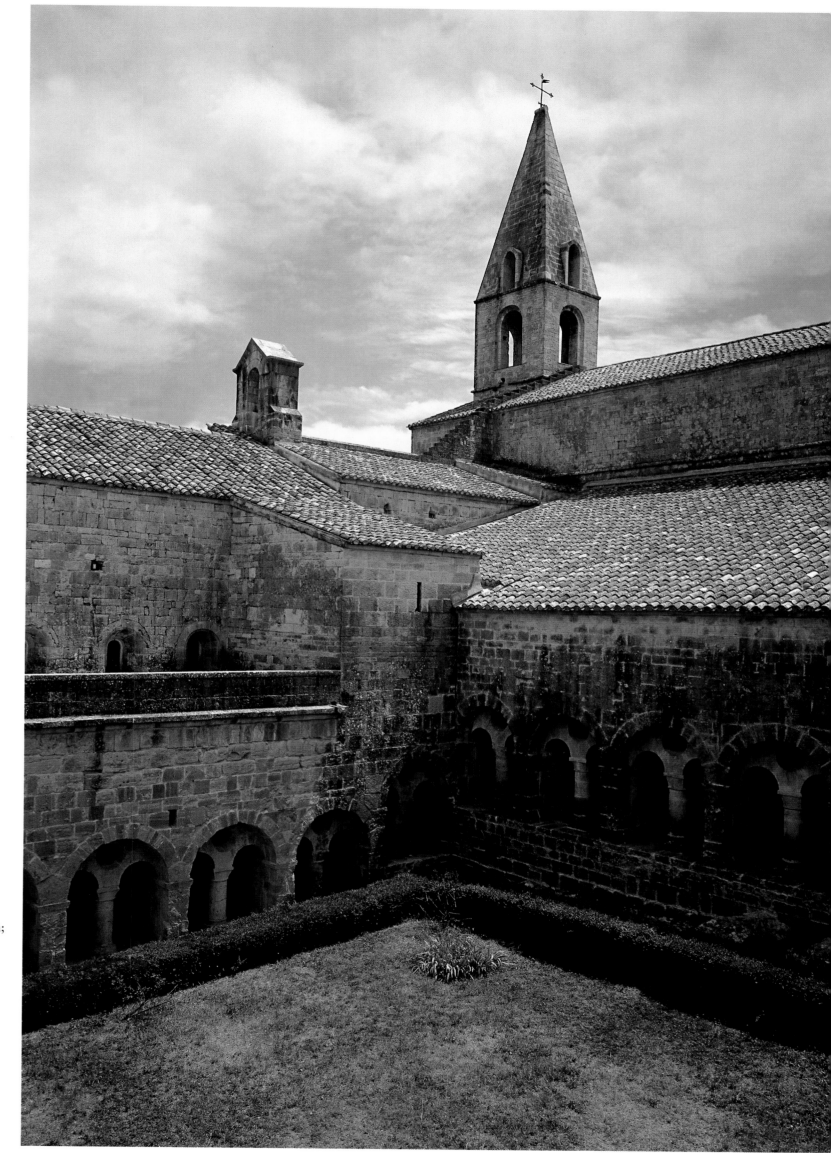

OPPOSITE AND RIGHT:
**Le Thoronet, former
Cistercian abbey,**
ca. 1150–1200, interior
view of the abbey church;
inner courtyard of the
cloister

Together with Sénanque
and Silvacane, Le
Thoronet represents
Cistercian monastic
building in the Provence
region. The abbey
churches are closely
linked to Fontenay and
emanate the same severe
dignity and rigorous
asceticism.

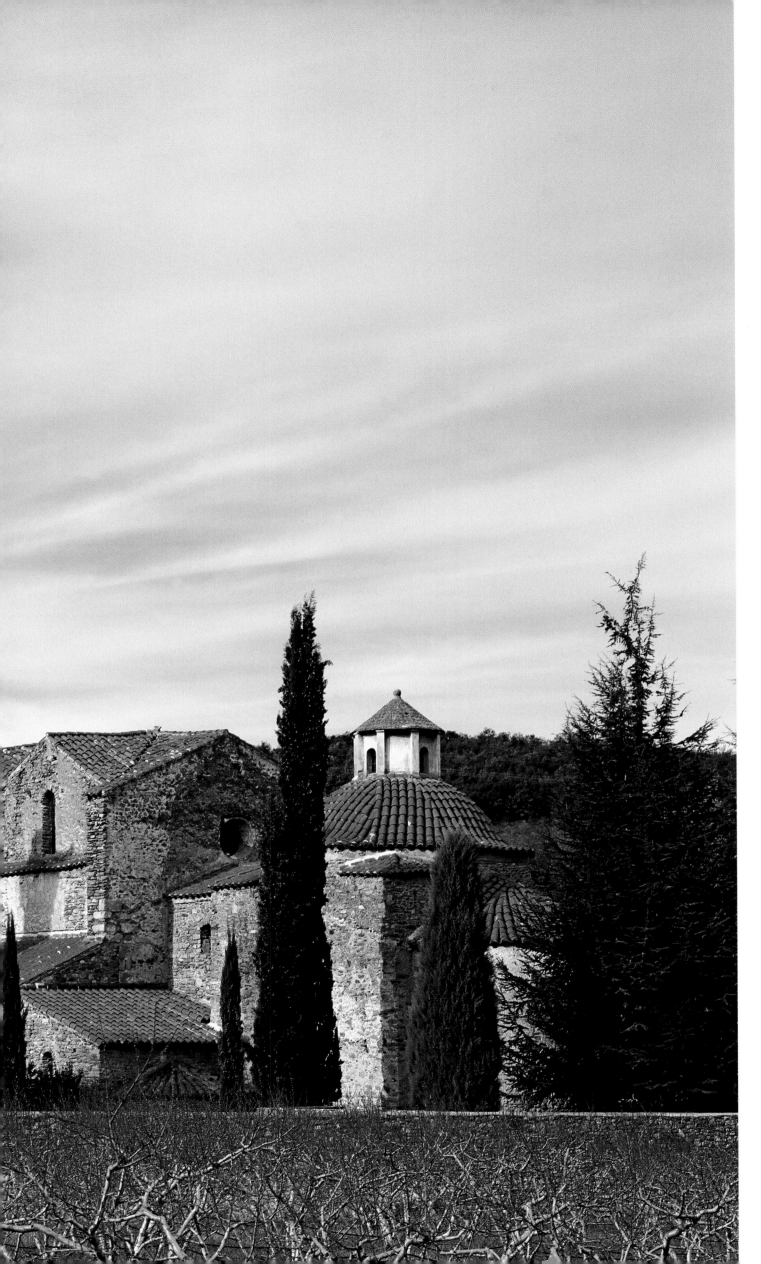

**Saint-Michel-de-Cuxa,
former Benedictine monastery,**
church dedicated 975,
completed ca. 1040

The church was extended in
the early 11th c. by Abbot
Oliva, and in the latter half of
the 12th c. received a stone
vault over all the aisles as well
as a cloister and a richly
decorated tower.

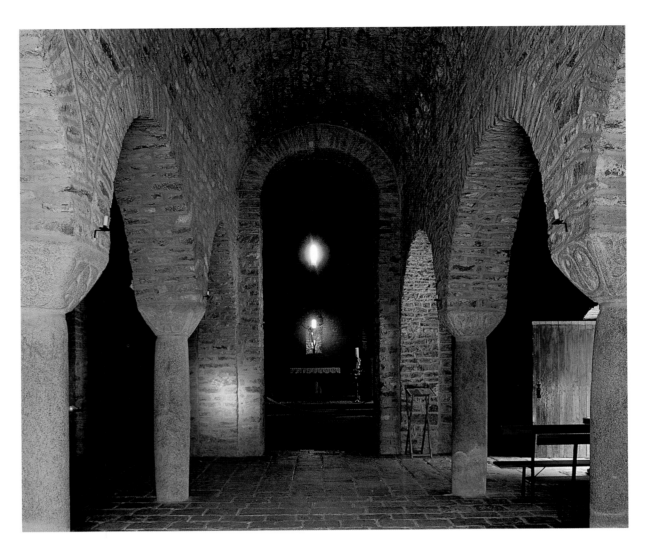

Saint-Martin-du-Canigou, former Benedictine monastery, founded in 1001, interior of the church facing east; monastery complex

A first dedication in the year 1009 was probably in celebration of the completion of the lower church, while the upper church was only finished in 1026. Both are halls covered with barrel vaults. Their execution seems archaic due to the heavy, baseless columns and the inelegant block capitals.

BELOW:
Serrabone, former priory of Sainte-Marie, ca. 1070/80 and 1151

The triple-arched and rib-vaulted singers' tribune, which originally stood in the west part of the church, was later moved to the center of the nave. Its front side is covered in exquisite bas relief.

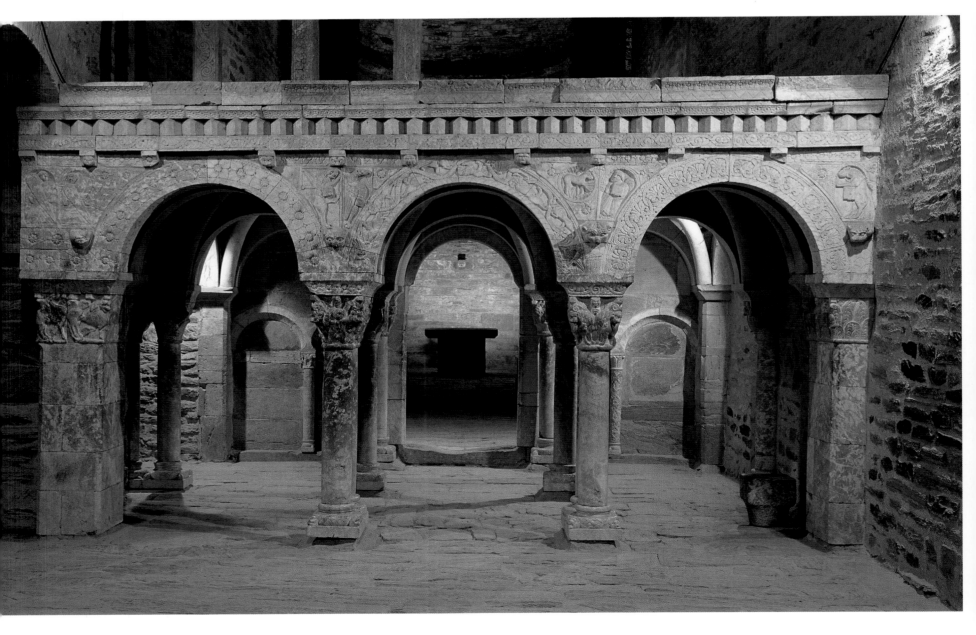

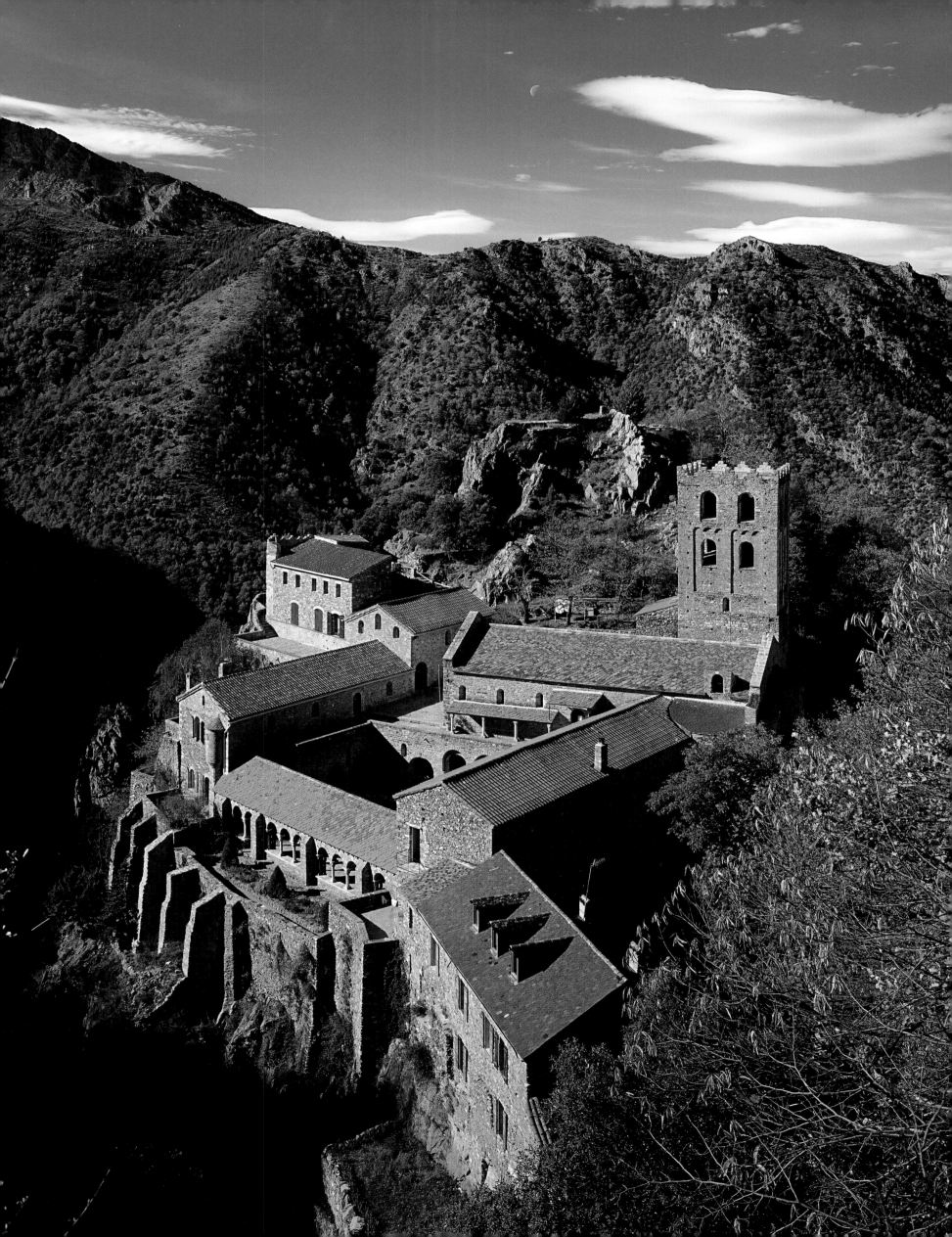

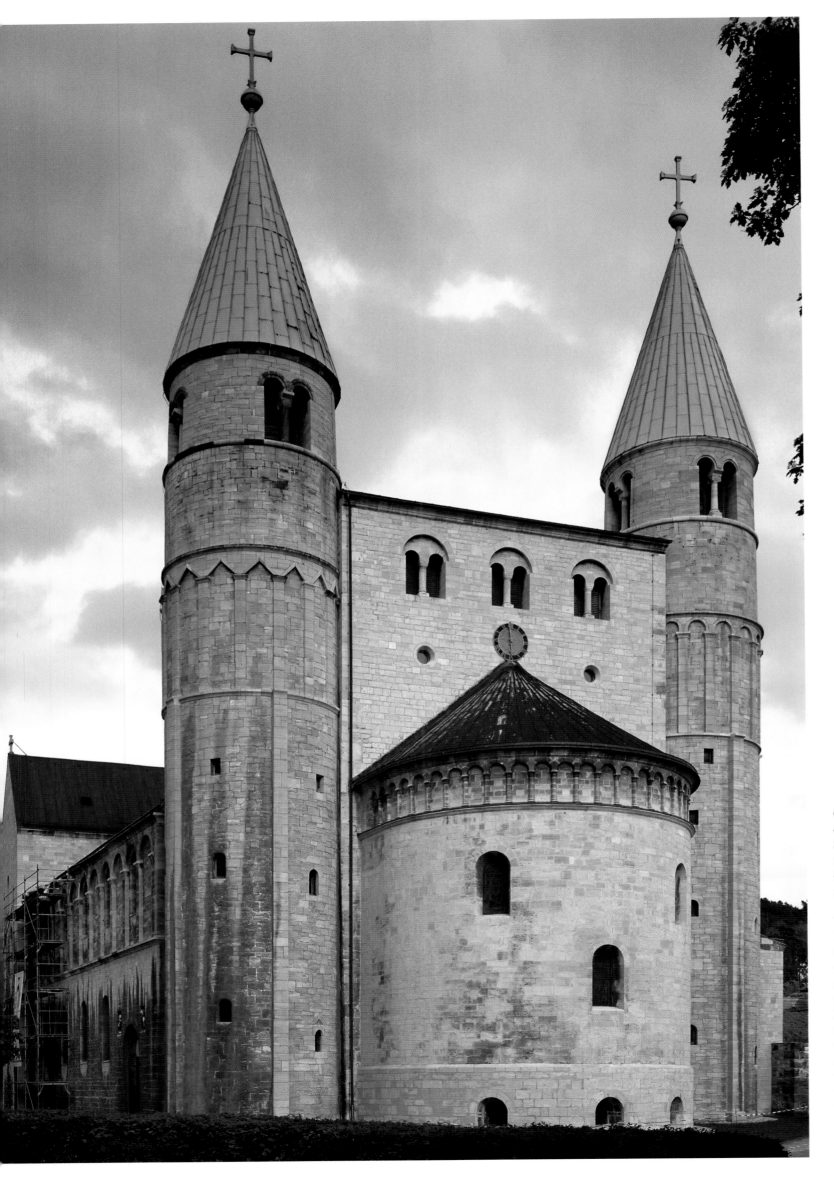

Gernrode, former convent church of Sankt Cyriak, founded 961, exterior from the west; nave facing east

The oldest preserved large building from Ottonian times, this church is still in the tradition of Carolingian architecture. New, however, are the shorter transept arms, the distinct crossing (i. e., all four arches are of the same height), wider side aisles, and the Rhenish alternation of supports (pillar-column-pillar) used in the nave.

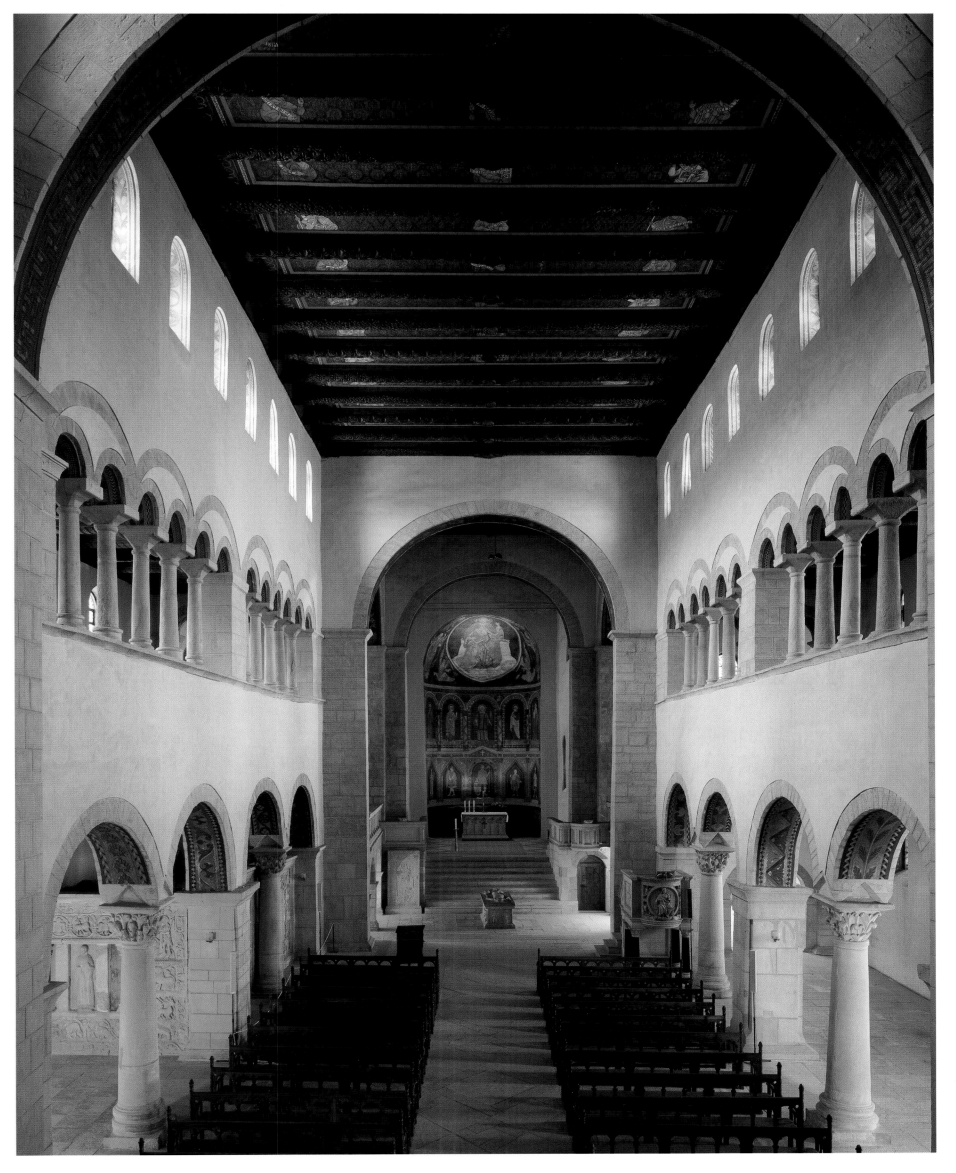

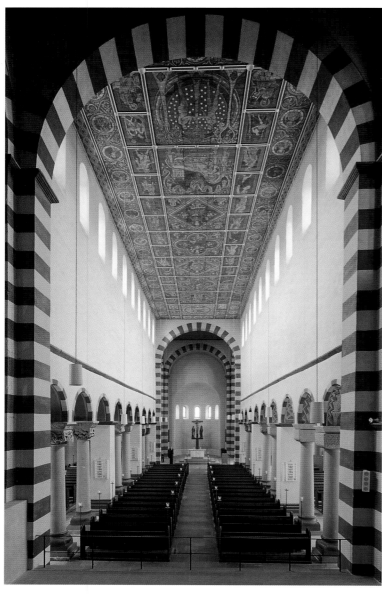

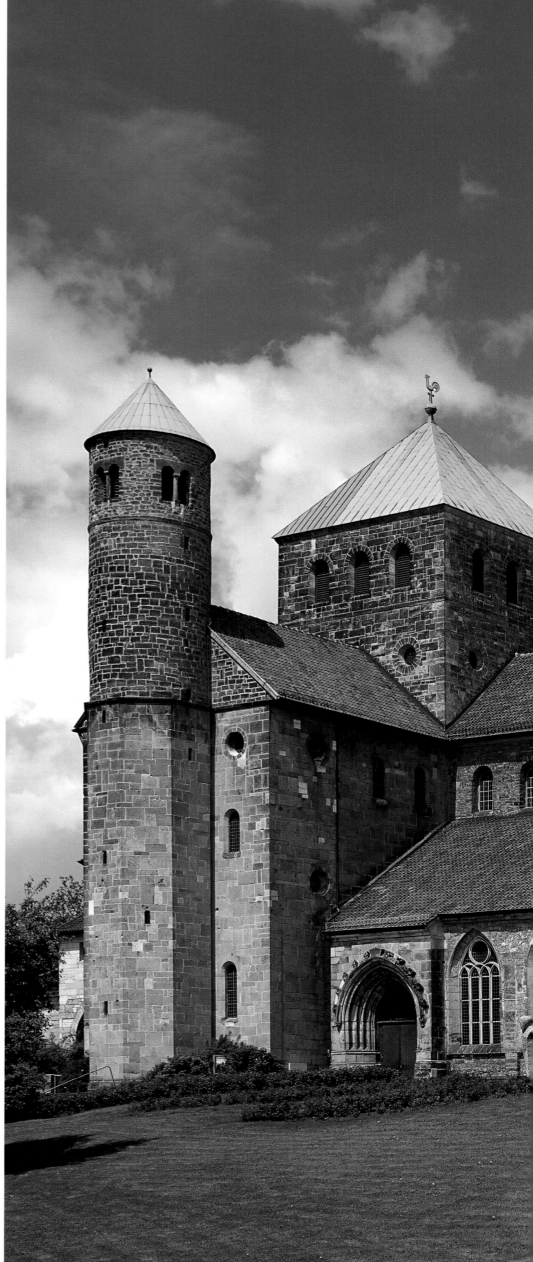

Hildesheim, former Benedictine monastery of Sankt Michael, founded 996, church 1010–1033, detail of the arcades; interior; exterior view from the southeast

Sankt Michael is the initial building of Ottonian architecture, which aimed for symmetry and balance. The bound system and the two symmetrical transepts with distinct crossings are innovative.

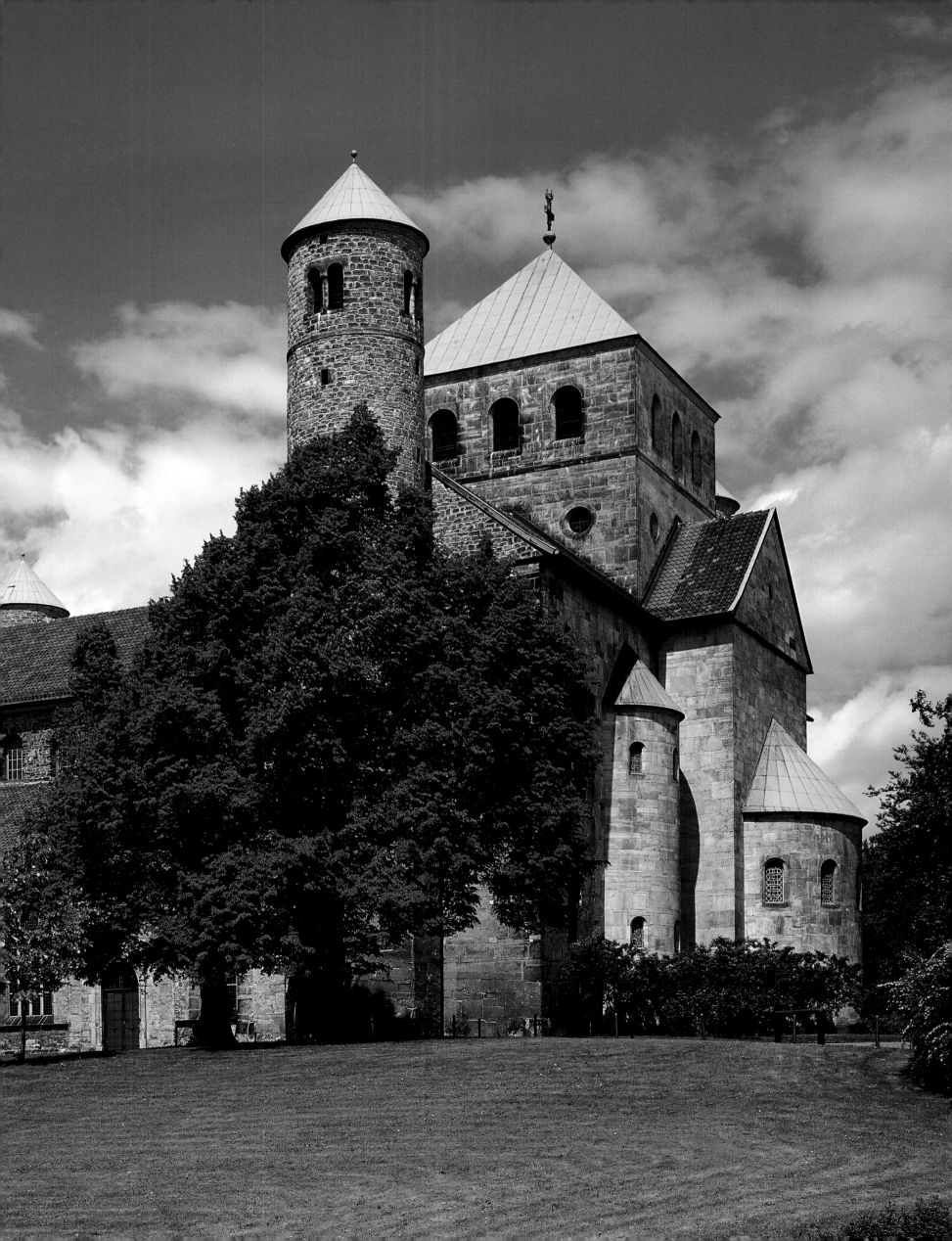

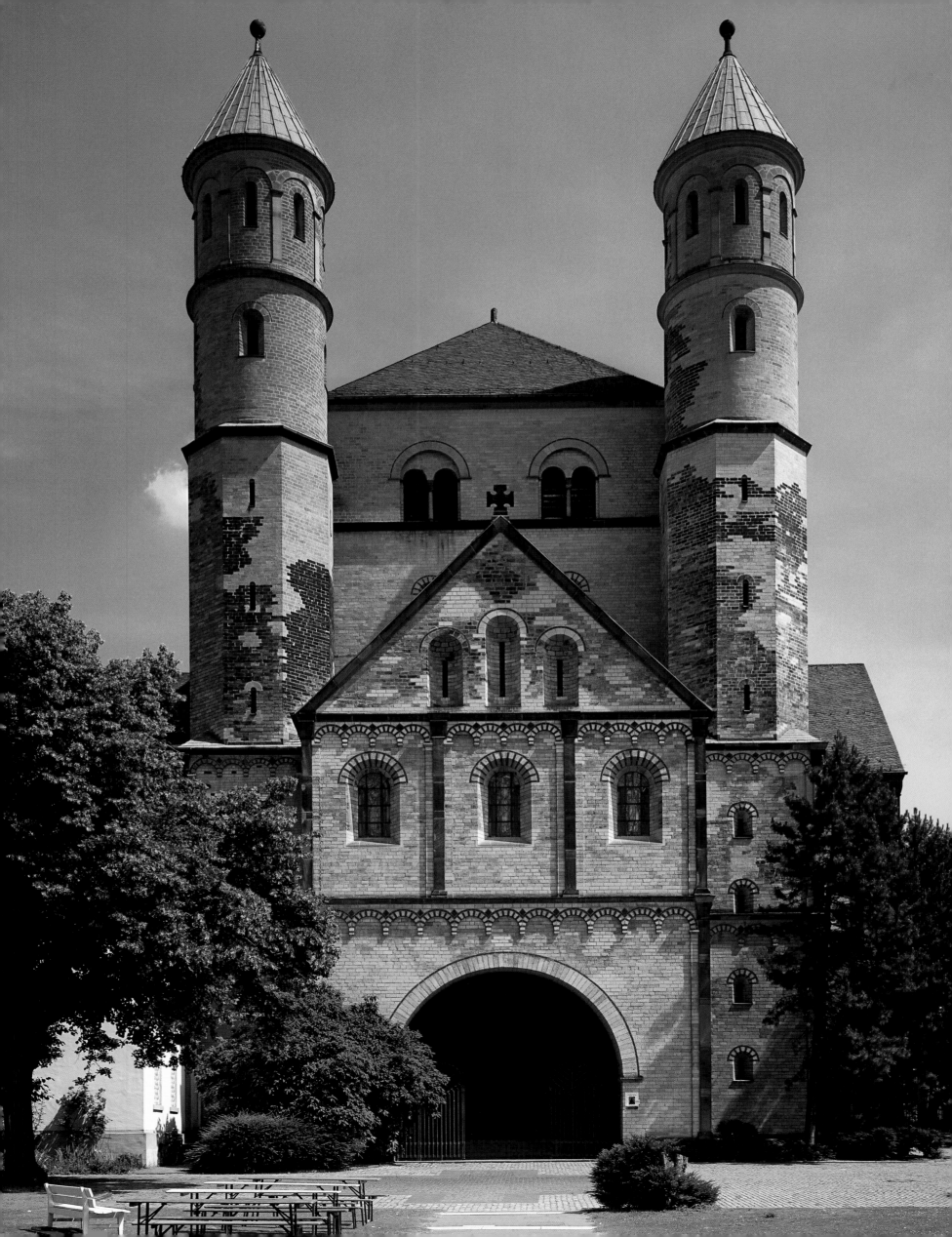

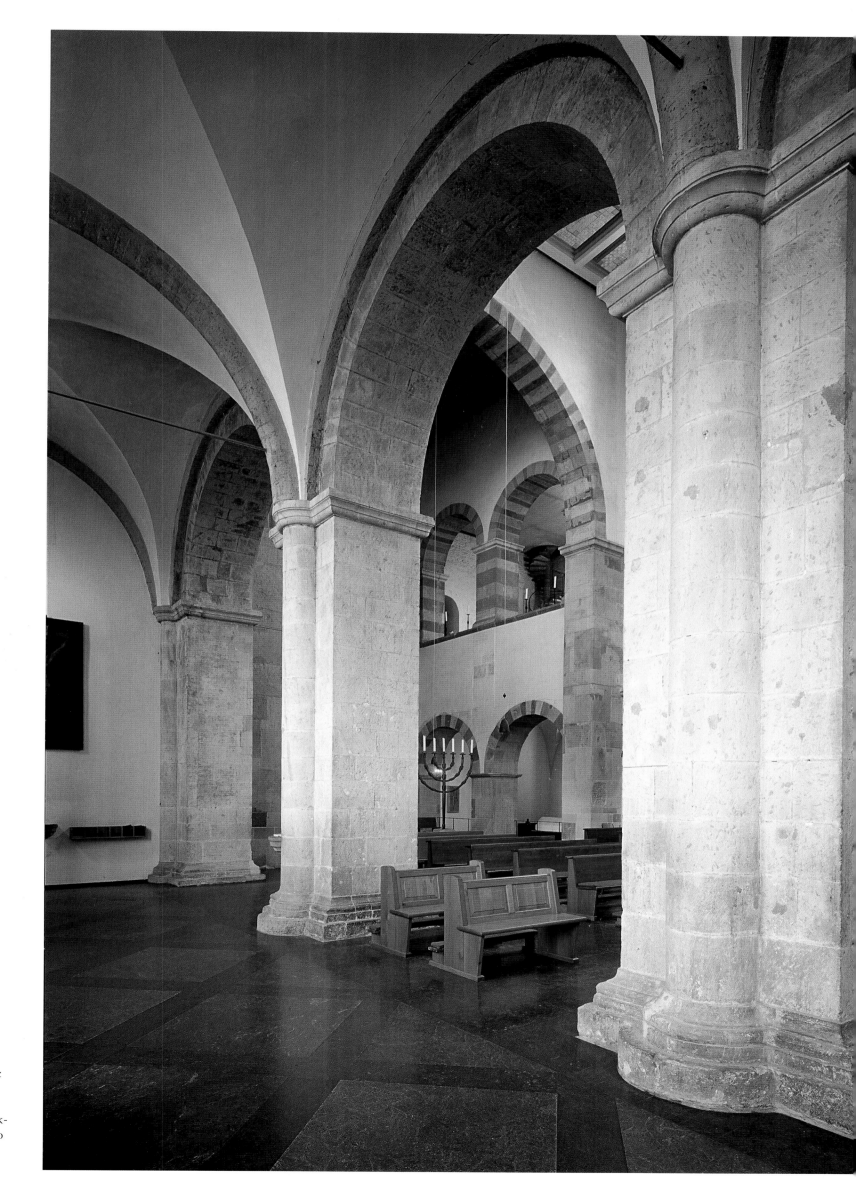

Cologne, former collegiate church of Sankt Pantaleon, begun 991, west end and interior

All that has been preserved of the aisleless church begun in 991 is the west end, which is in the tradition of Carolingian west-works. Characteristic are the central-plan atmosphere of the interior and the block-like exterior with two towers that flank a low vestibule.

Speyer, cathedral, begun ca. 1030,
northern side aisle; exterior from the east

The original plan for the Speyer cathedral was
the earliest monumental barrel vault building.

Conrad II chose it as his sepulcher and made it
representative of his extensive ambitions and
claims. After the planned vaulting failed, the
center aisle was covered with a flat ceiling and
in ca. 1080 with a groin vault.

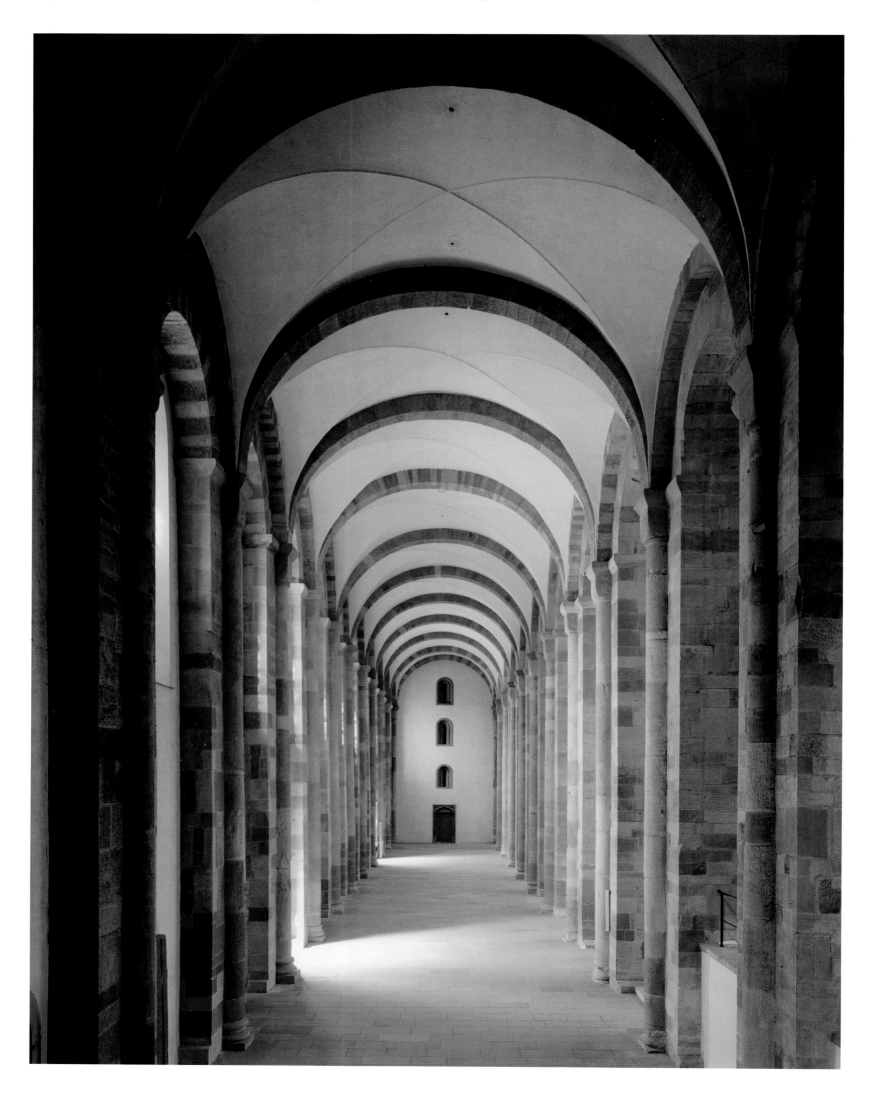

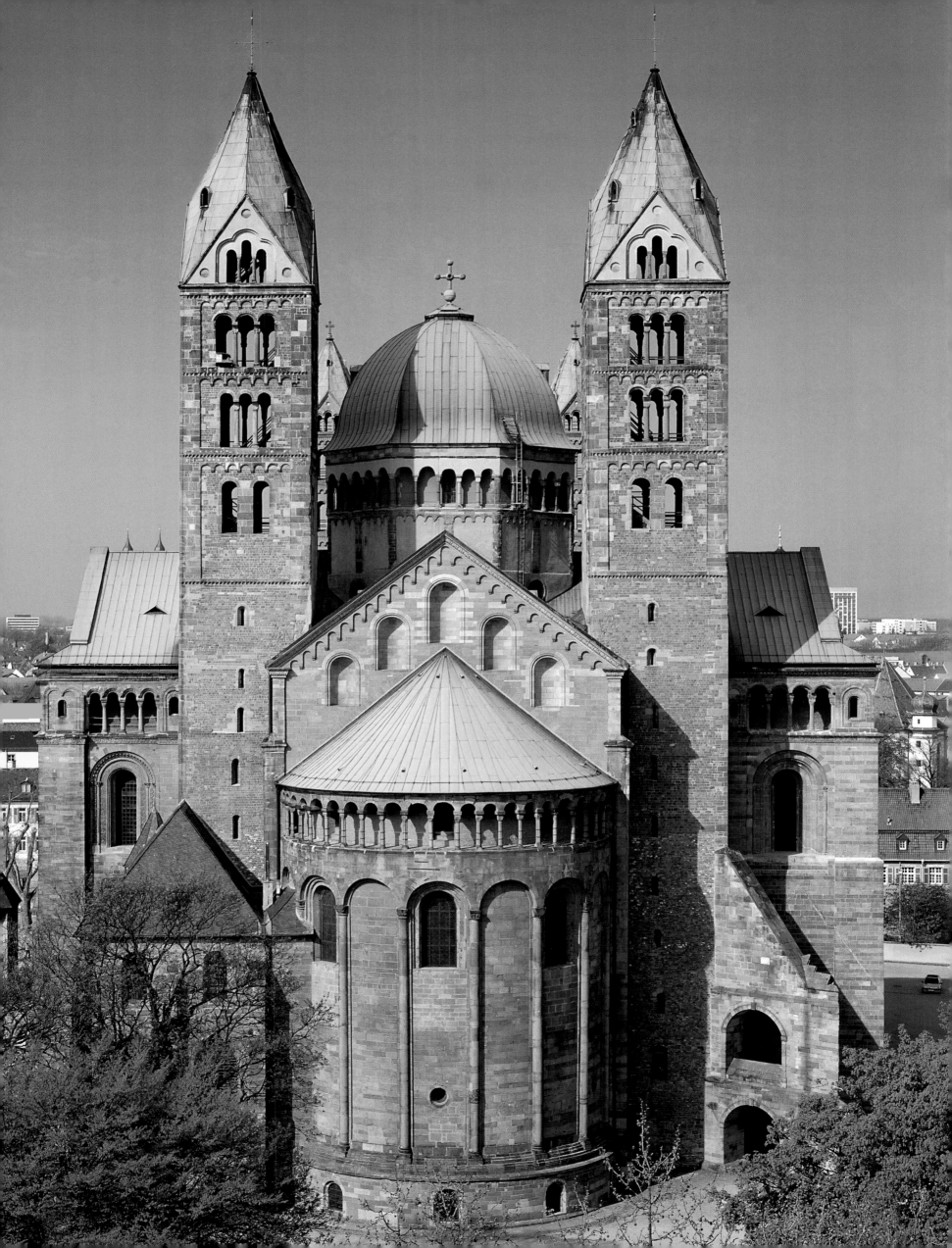

Mainz, Sankt Martin und Sankt Stephan Cathedral,
begun 1081, exterior view from the east (right);
miniature gallery on the eastern apse (below right);
nave facing east (bottom left)

OPPOSITE:
Worms, Sankt Peter Cathedral,
late 12th/early 13th c., west choir

The cathedrals of Mainz and Worms are unmistakably successors of the Speyer cathedral. New, however, is the sculptural structuring of the facades through deep, blind niches and dwarf galleries, which adds three-dimensionality and depth to the walls and gives the body of the building greater unity.

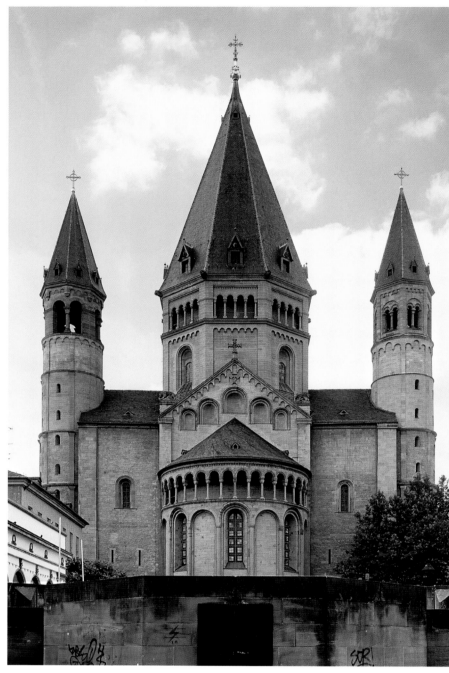

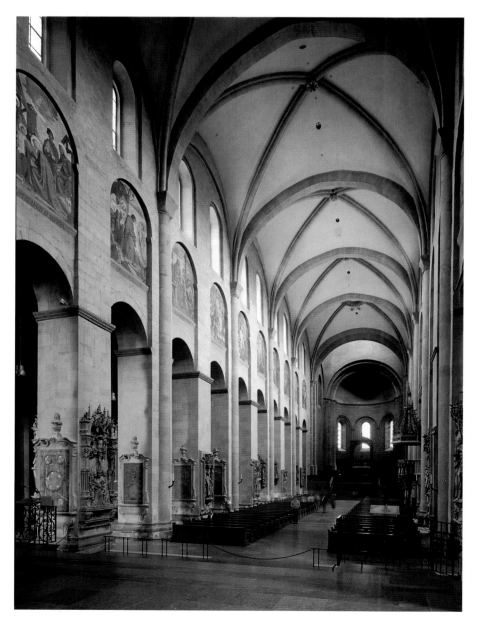

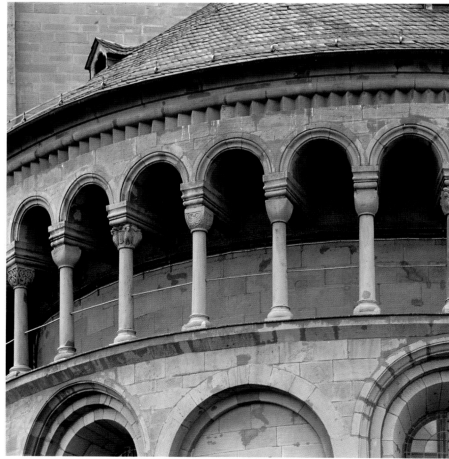

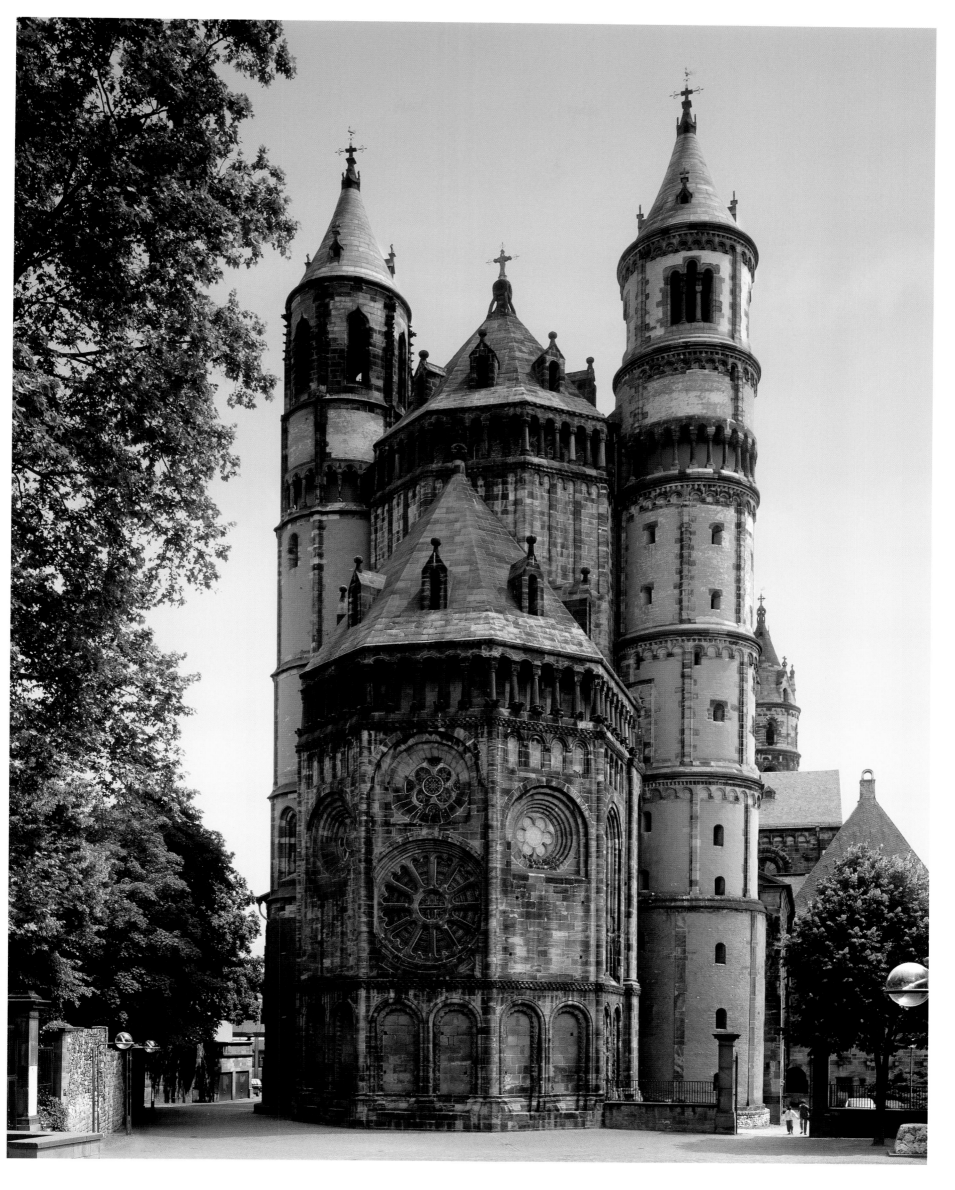

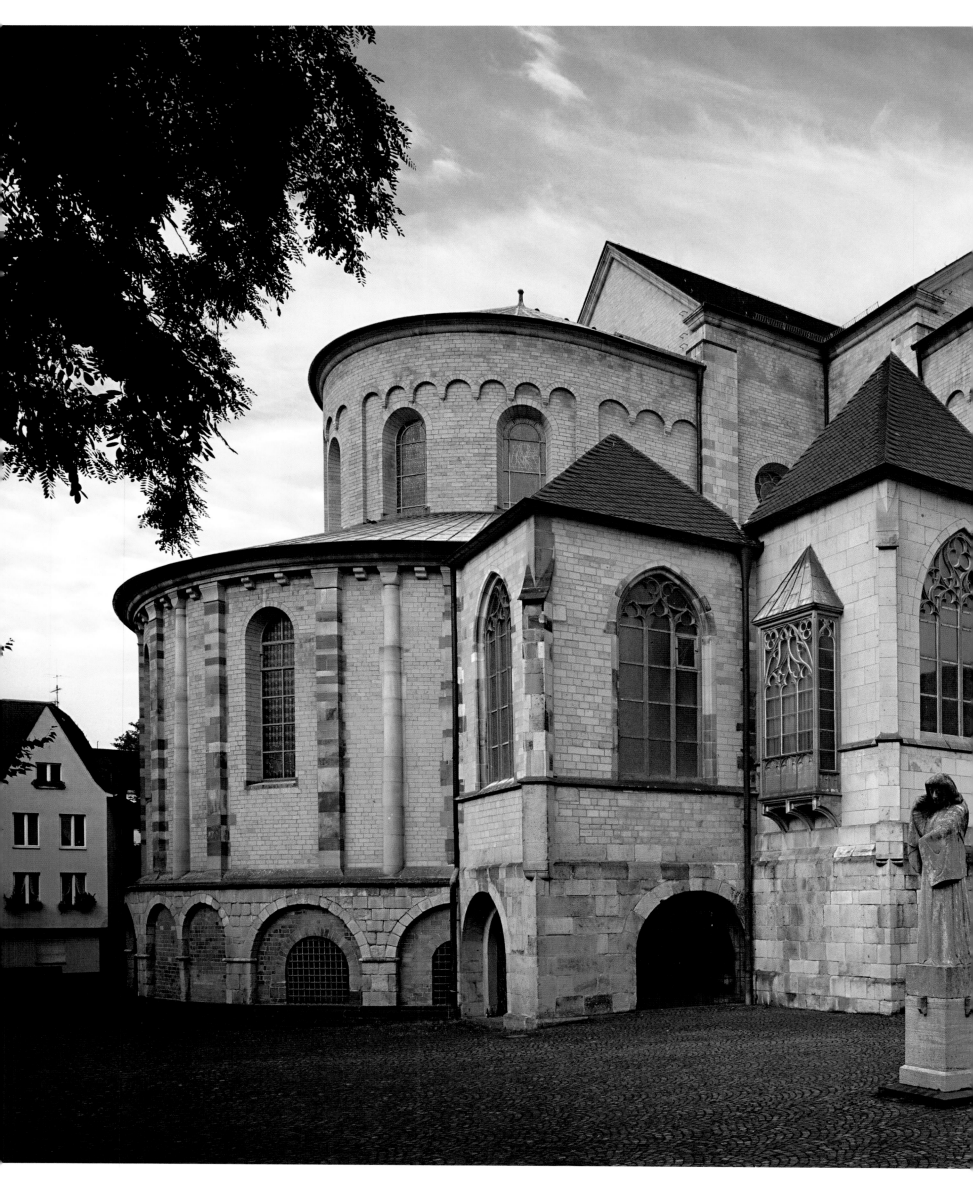

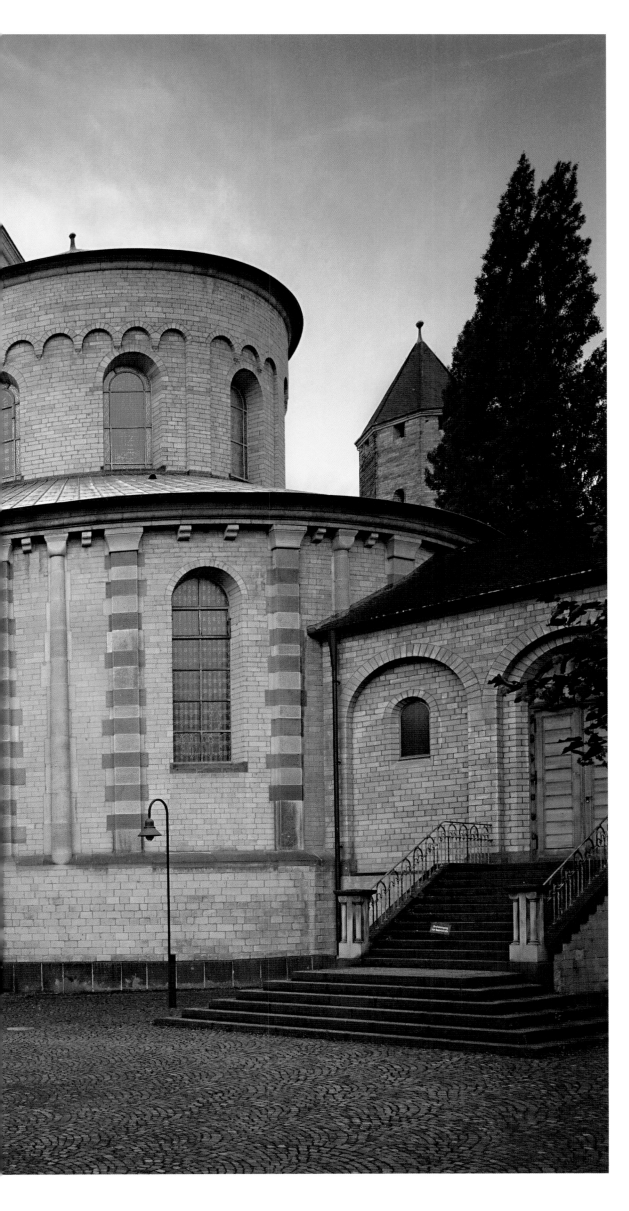

Cologne, former collegiate church of Sankt Maria im Kapitol, crypt by 1049, church by 1065, exterior view of the trefoil choir

The starting point of the 11th-century "Rheinish School" of building was Sankt Maria im Kapitol. The most noticeable motif is the trefoil; the side aisles of the nave are guided around it. Underneath the eastern section is an expansive hall crypt.

BELOW LEFT AND RIGHT: **Alpirsbach, former Benedictine abbey church of Sankt Benediktus,** 1099–1125, nave facing west; exterior view from the east

OPPOSITE: **Calw-Hirsau, former Benedictine abbey church of Sankt Peter und Paul,** 1082–1091, view through the monastery ruins onto the so-called Owl Tower, the north tower of the former twin-tower facade.

Under Abbot William, who introduced Clunian reforms in Hirsau, the monastery became a spiritual and religio-political center of Germany as well as the starting point of the Hirsau building school, which nonetheless remained closer to the building ideals of the Cistercians than those of Cluny. One of the purest preserved examples of their work is the abbey church in Alpirsbach.

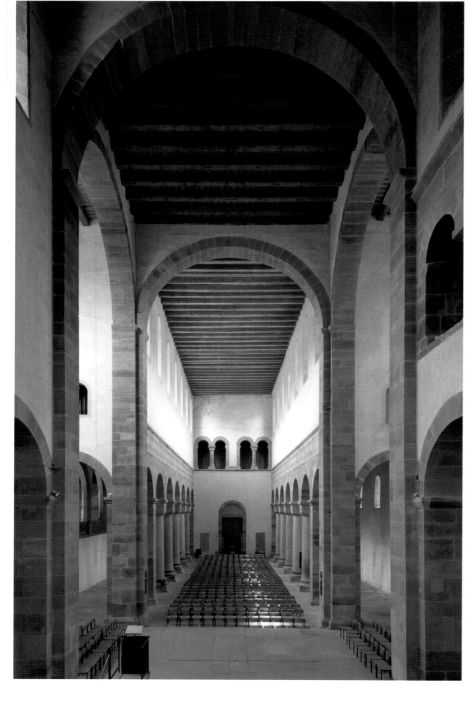

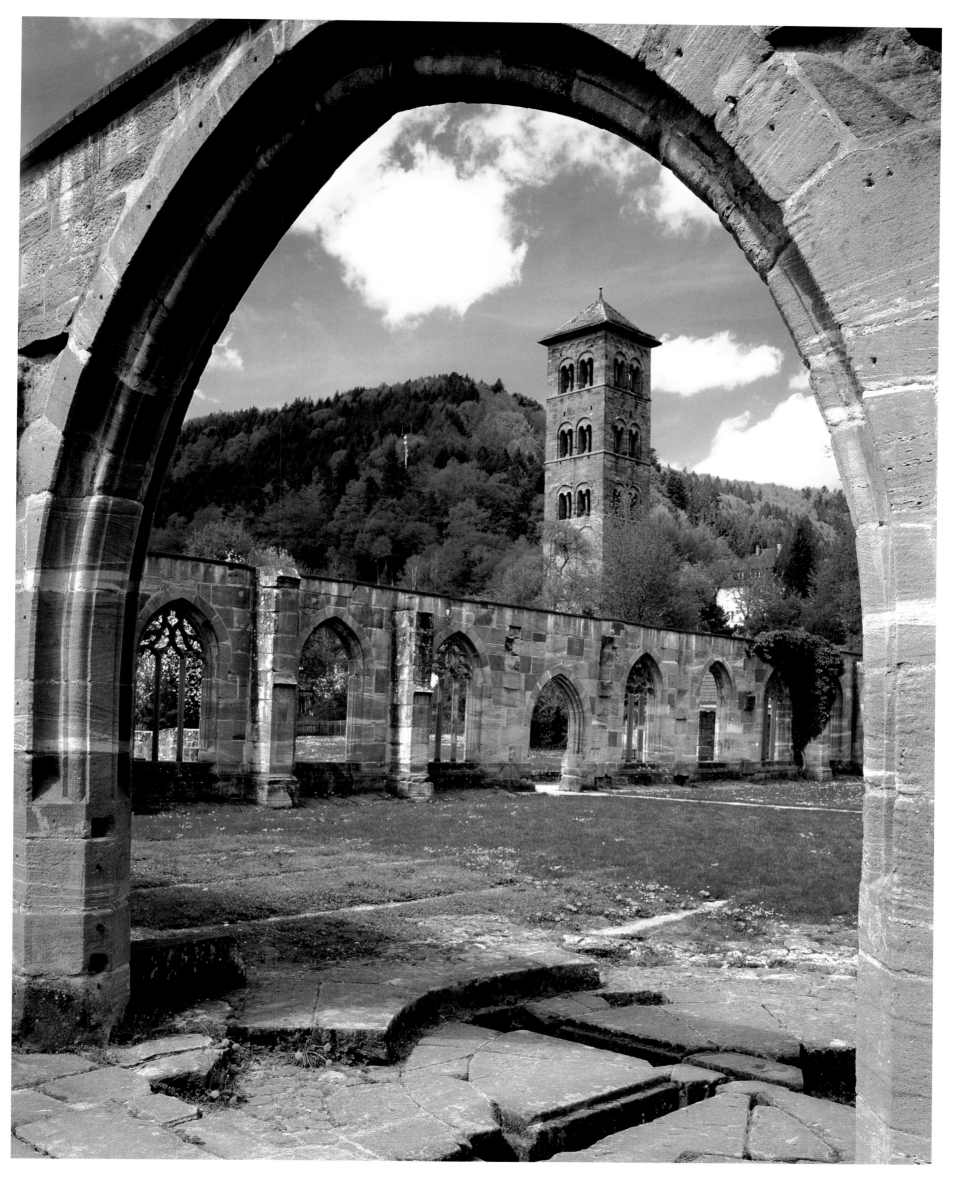

Maria Laach, Benedictine abbey church,
founded 1093, dedication of the crypt 1156,
completion of the choir 1170, of the atrium 1230/40;
interior courtyard with lion fountain (below);
west view with atrium

In spite of the slow progress of the construction,
which hindered completion of the groin-vaulted
basilica until the Gothic era, its forms are entirely
Romanesque. The only exception is the uniform
continuous bays, which are atypical for Romanesque
architecture.

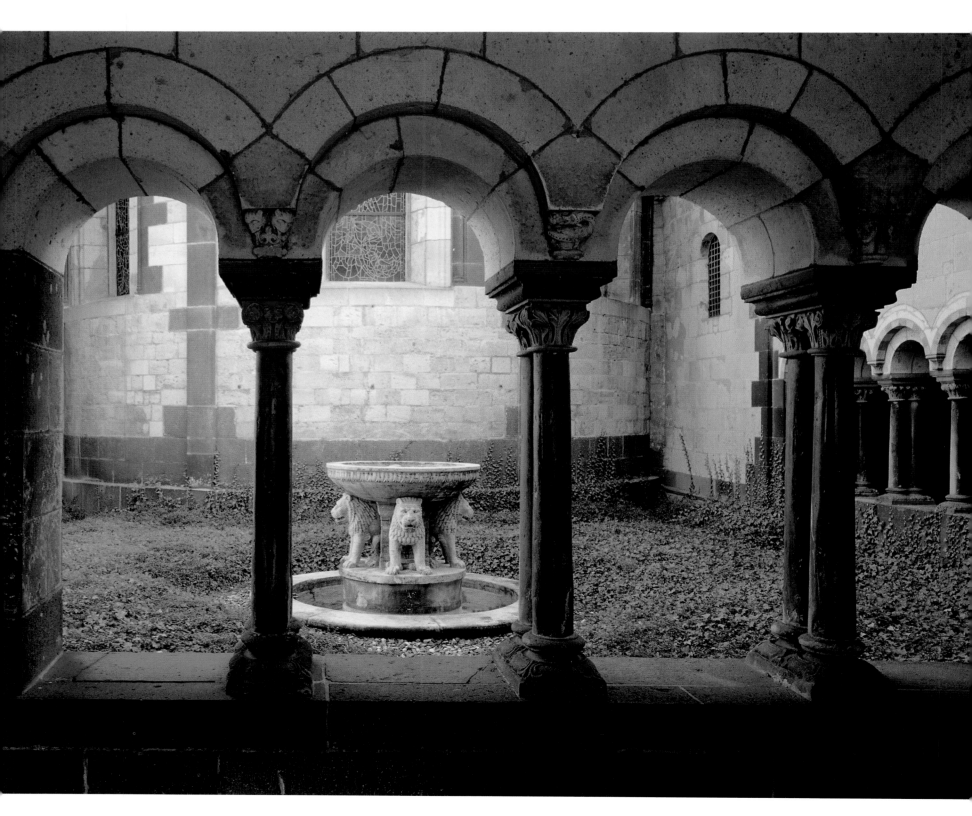

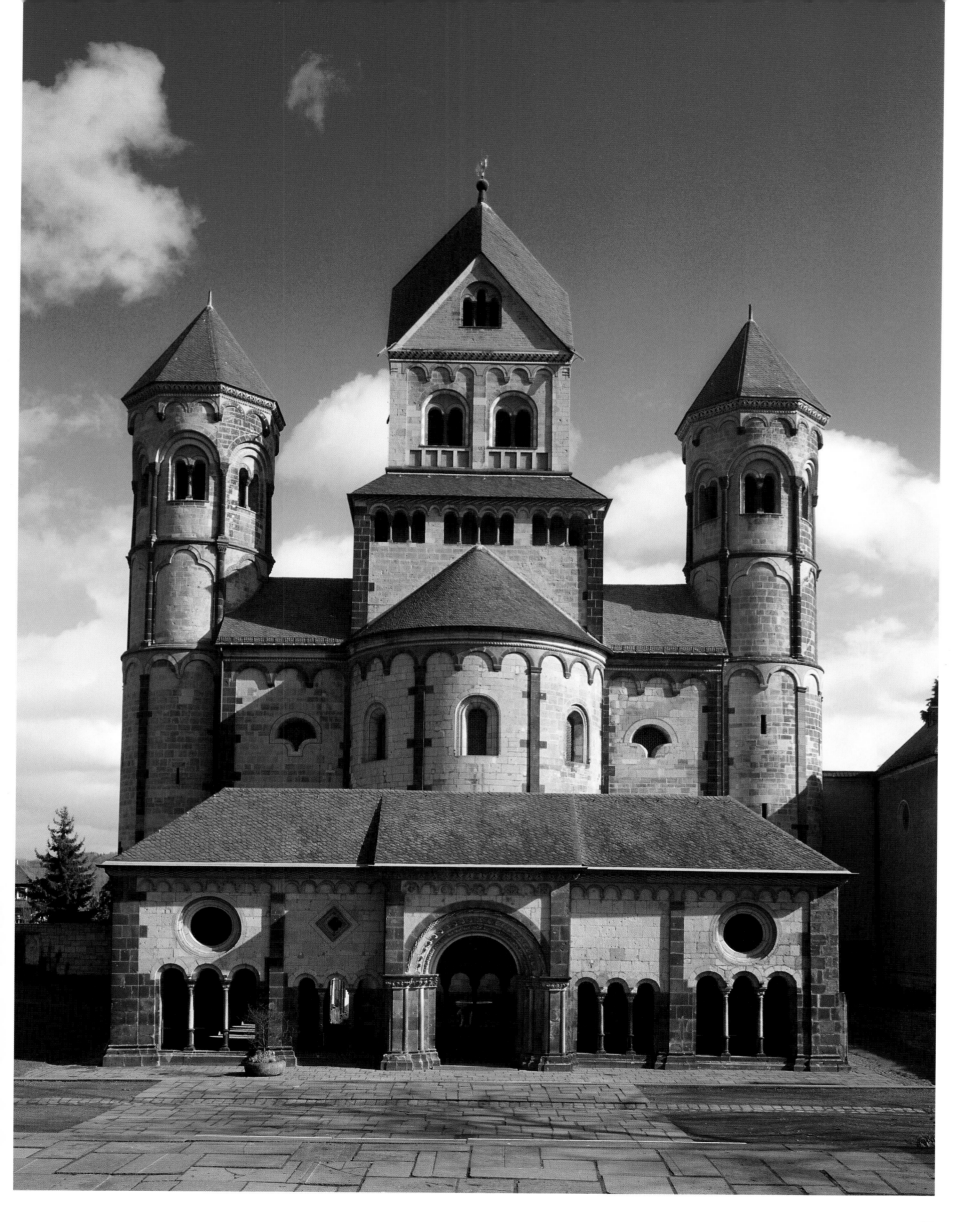

BELOW: **Mauersmünster (Marmoutier), former abbey church,** mid-12th c.

Characteristic for the Romanesque in Alsace are the impressive groups of towers that set accents to the suspenseful monumentality. Two floors of varying heights carry the compact tower group.

OPPOSITE: **Murbach, former abbey church,** ca. 1130

In Murbach it is the twin towers of the east section that literally tower over the side aisles. The walls are made of the typical gold-red sandstone that, together with the low relief of the wall, creates a lively color play.

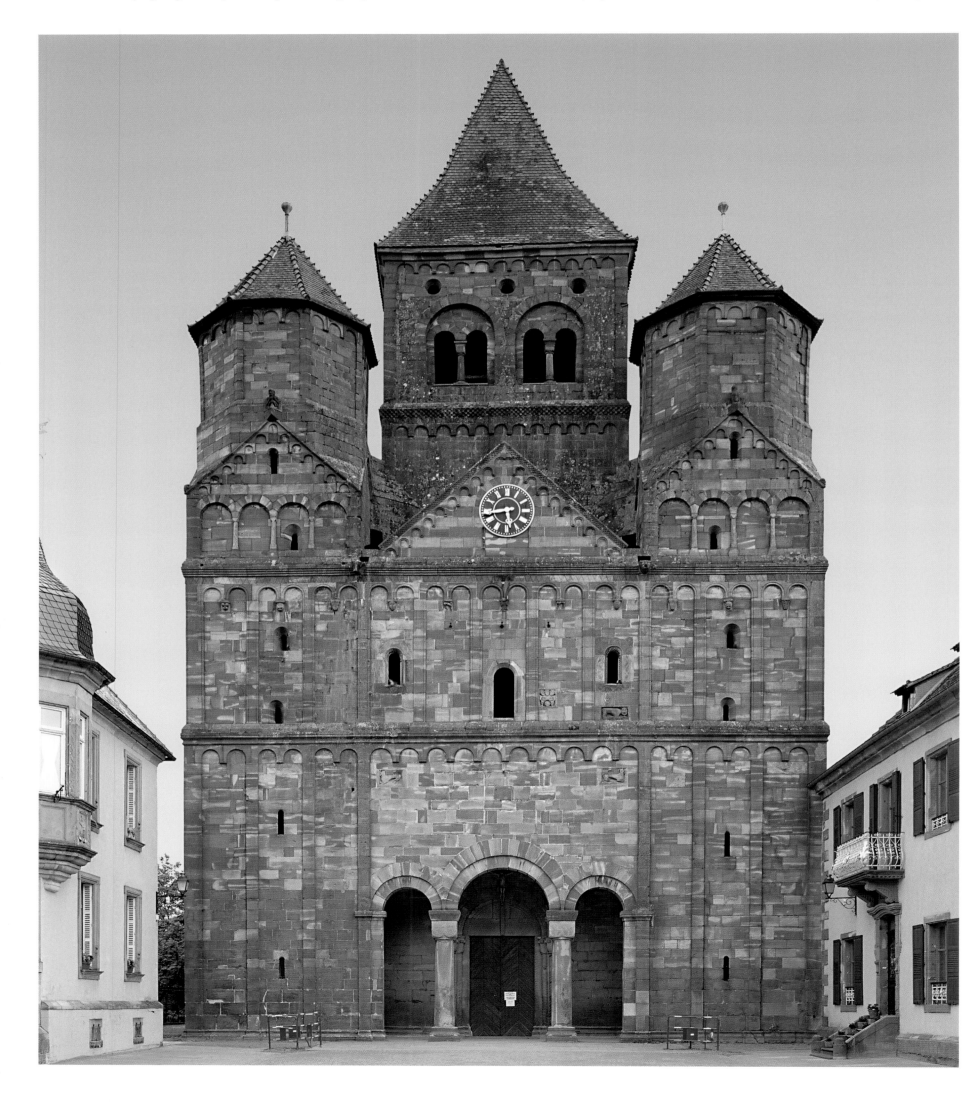

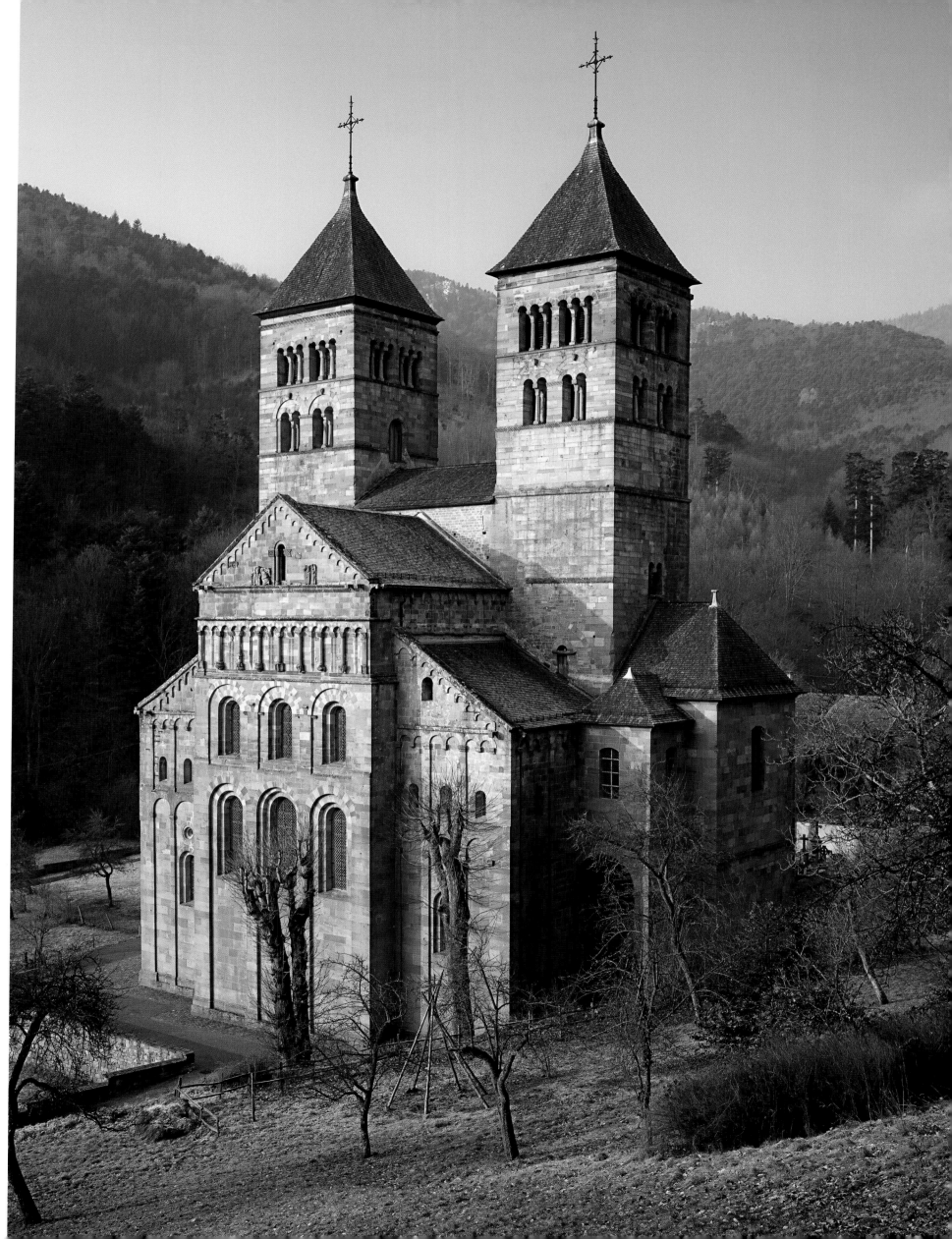

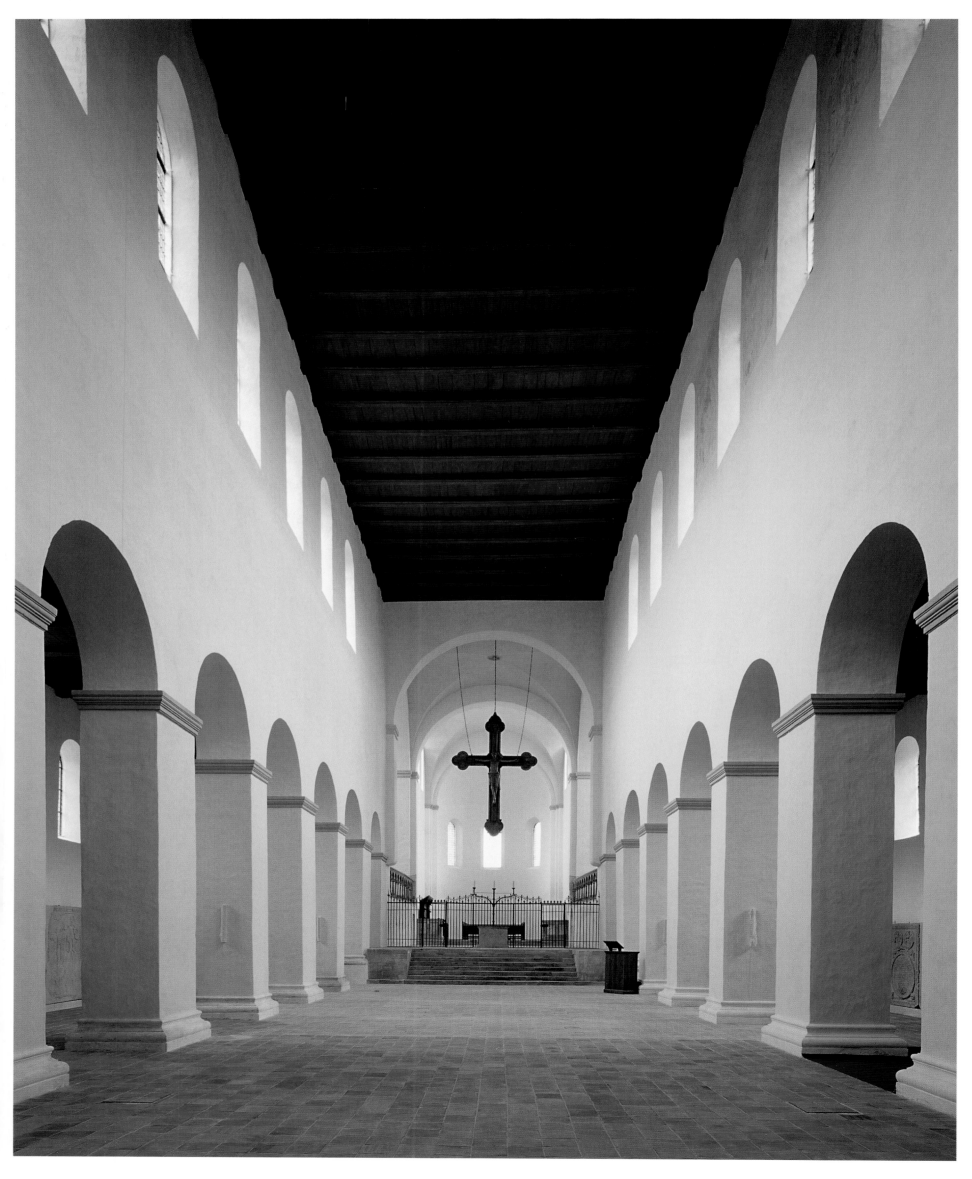

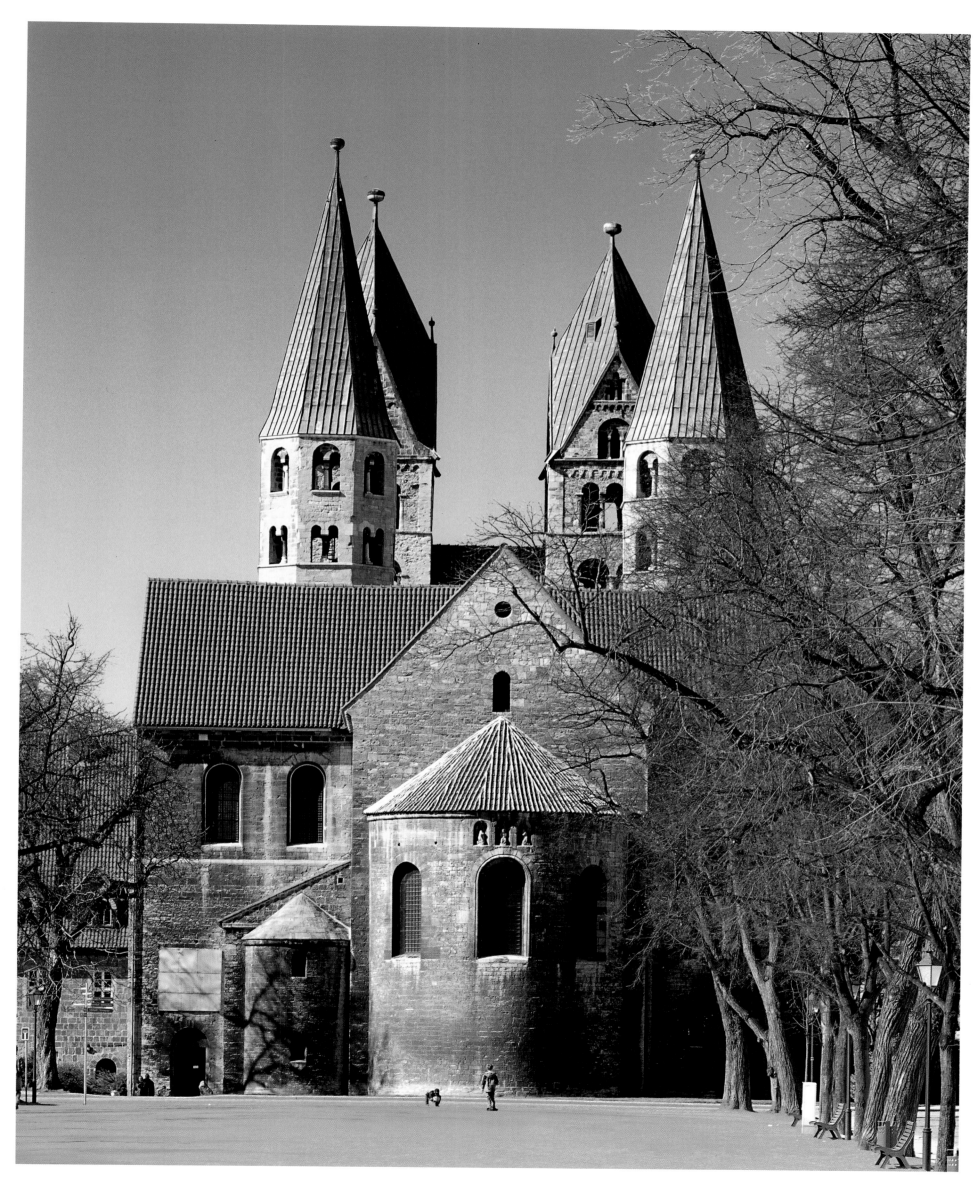

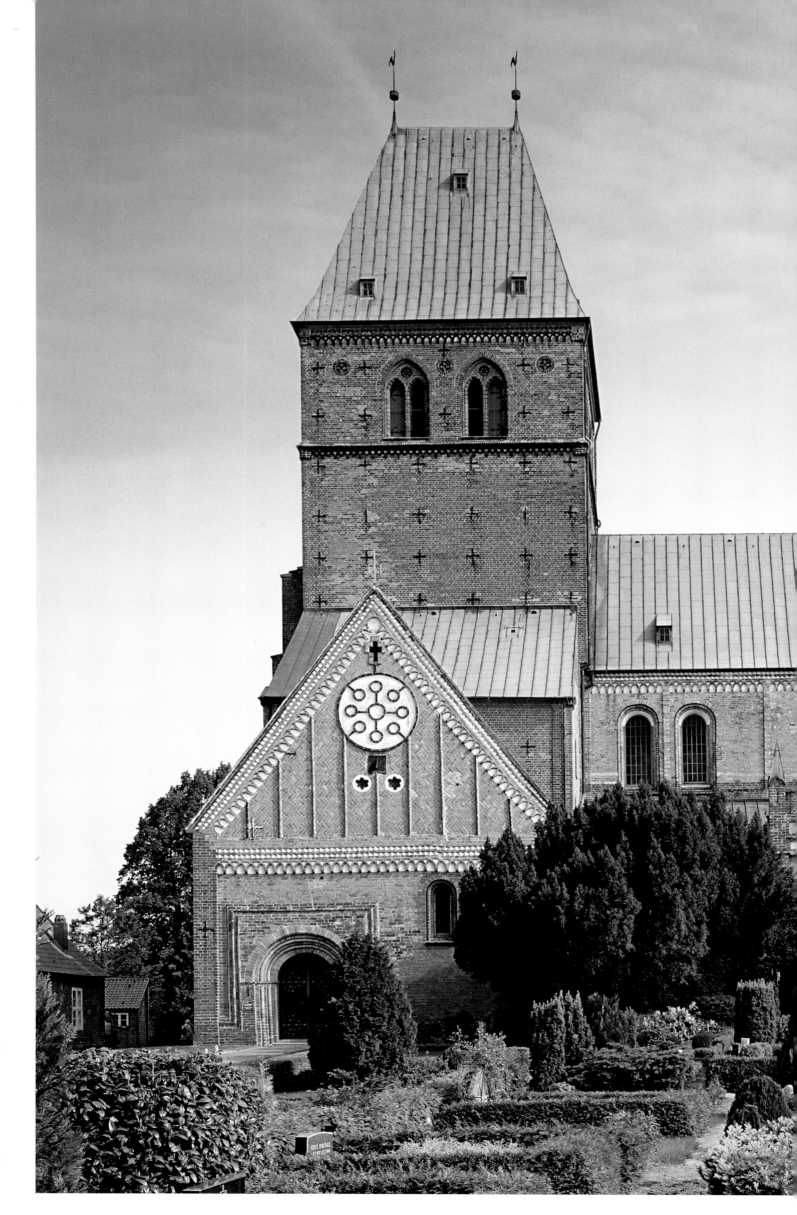

PAGES 94 AND 95:
**Halberstadt,
Liebfrauenkirche,**
ca. 1140, nave facing
east; eastern view of
exterior

The three-aisle pillar
basilica with a flat
ceiling, a high transept,
and a Benedictine choir
completely forgoes
ornamentation and
articulation, both inside
and out, thus placing
itself in the tradition of
early Romanesque
models like Hersfeld or
Limburg an der Haardt.

RIGHT: **Ratzeburg,
Sankt Maria und
Sankt Johannes
Evangelist,**
today cathedral,
1160/70–1215/20

The cruciform basilica
with a Benedictine choir
has a single, massive
tower in the west
accompanied by high
extensions that look
like a transept. This
arrangement, as well as
the gracefully structured
gables, is found more
often in brick Gothic.

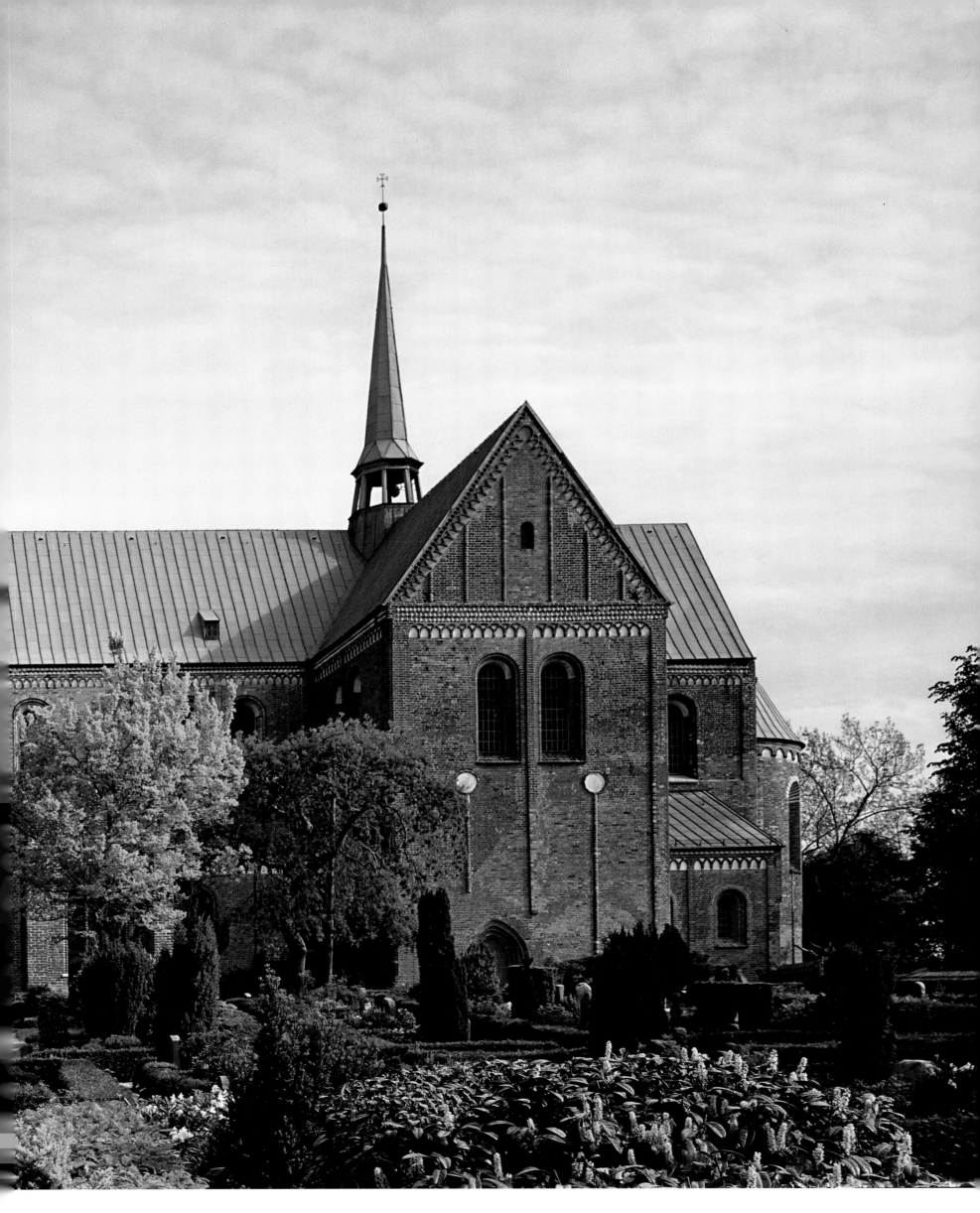

Milan, Sant'Ambrogio, 9th–12th c., interior view facing east (below left); pulpit (below right); atrium and west view (opposite)

Sant'Ambrogio evolved from a 4th-century basilica that had been dedicated to the martyrs Protasius and Gervasius, which became the burial place of Saint Ambrosius. Constant remodeling and enlarging turned it into one of the largest and most important churches from the 9th and 12th centuries. It combined the forms of the Lombard School with motifs of Saint Peter.

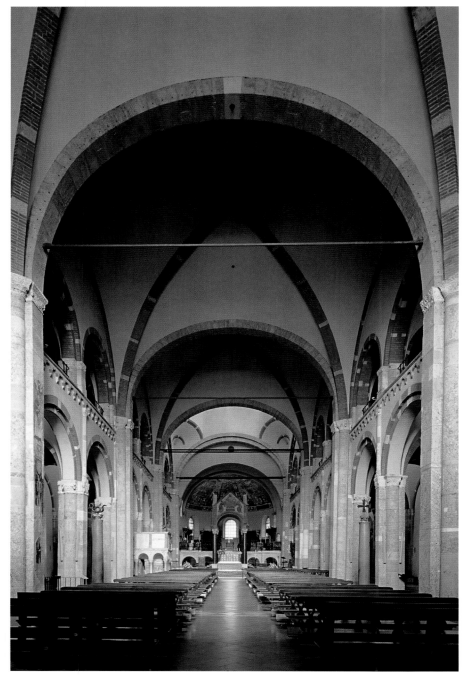

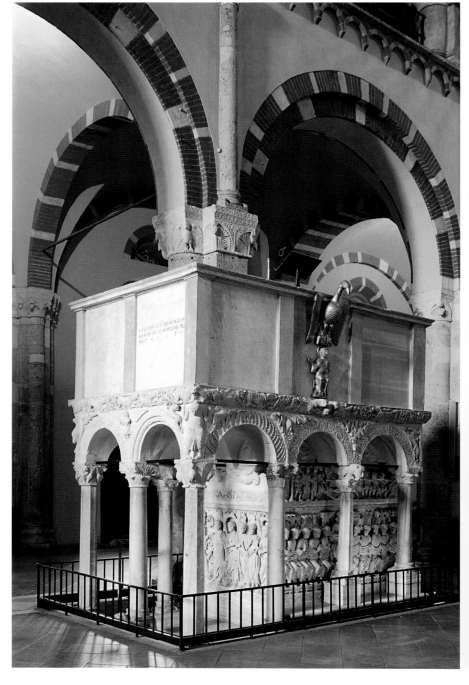

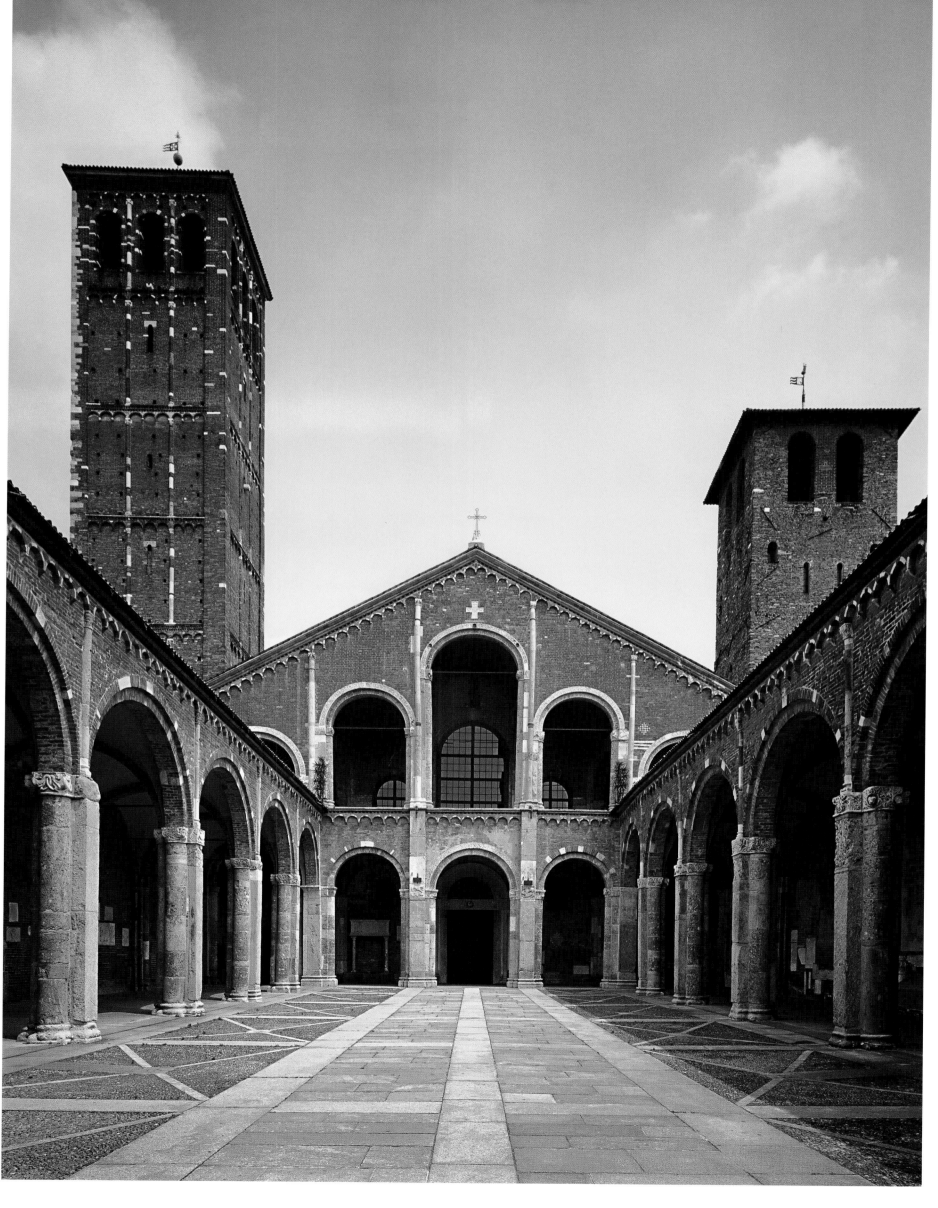

Fidenza, cathedral, west facade, detail of the portal area, end 12th c., portal sculpture by Benedetto Antelami and his workshop (?)

The portal complexes of Fidenza and Modena are impressive displays of both the potential and the development of portal sculpture. The sculptor Wiligelmus drew richly from ancient tradition and from the monumental sculptures of Apulia and the Languedoc. Even Ottonian ivory works were influential. The Master of St Donninus in Fidenza (possibly Antelami) created lively, highly physical figures incorporated into the evenly structured portal wall.

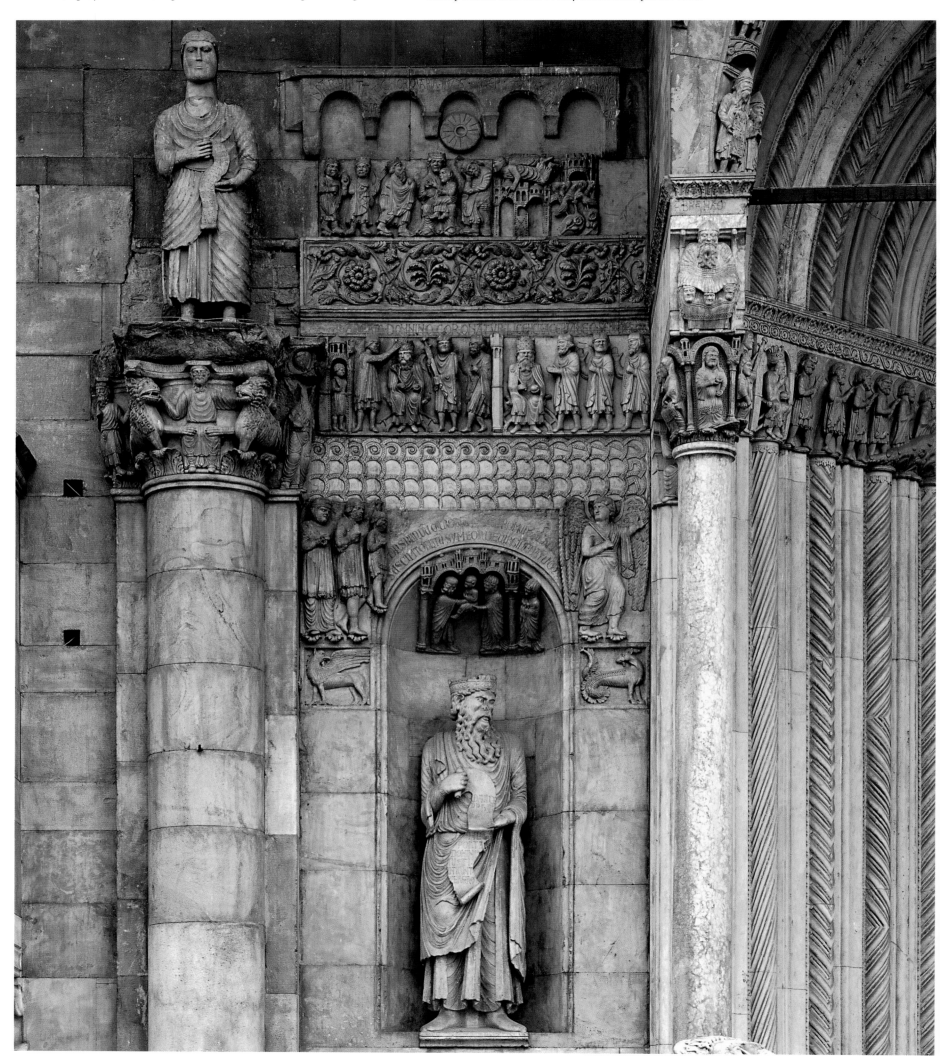

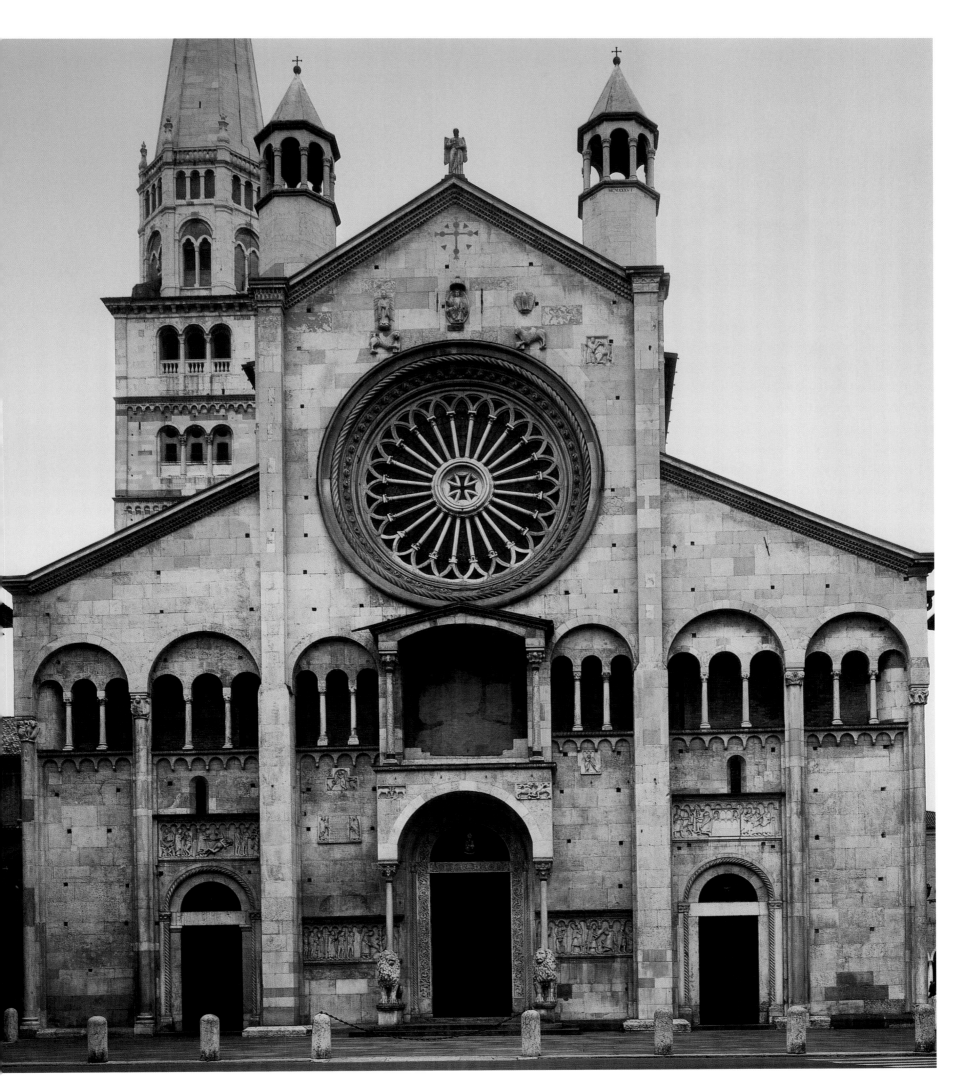

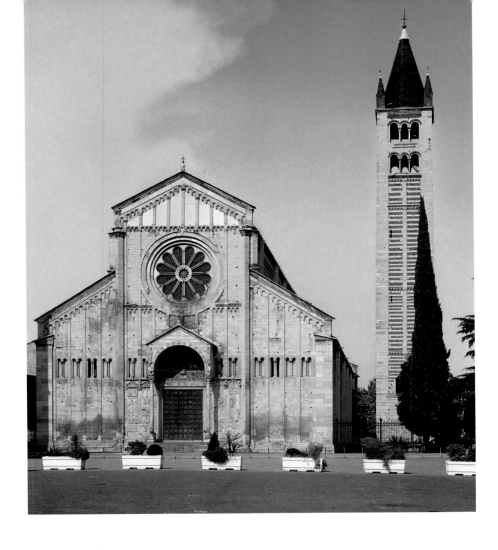

LEFT AND BELOW:
Verona, San Zeno Maggiore,
12th c., west facade and interior view facing east

The eastern end of this basilica with three aisles but no transept concludes with three apses. Strong pillars with spandrels (for a vault?) alternate with columns; the clerestory starts remarkably high. The partially sunken crypt has been dated to 1225; it is a later addition.

OPPOSITE AND PAGES 104/105:
Pomposa, former abbey church of Santa Maria,
dedicated 1036, interior facing east; detail of facade

The column basilica Santa Maria, with its richly ornamented marble floor and open trussed ceiling, as well as the slender campanile, are graceful examples of the building style of the Lombard School.

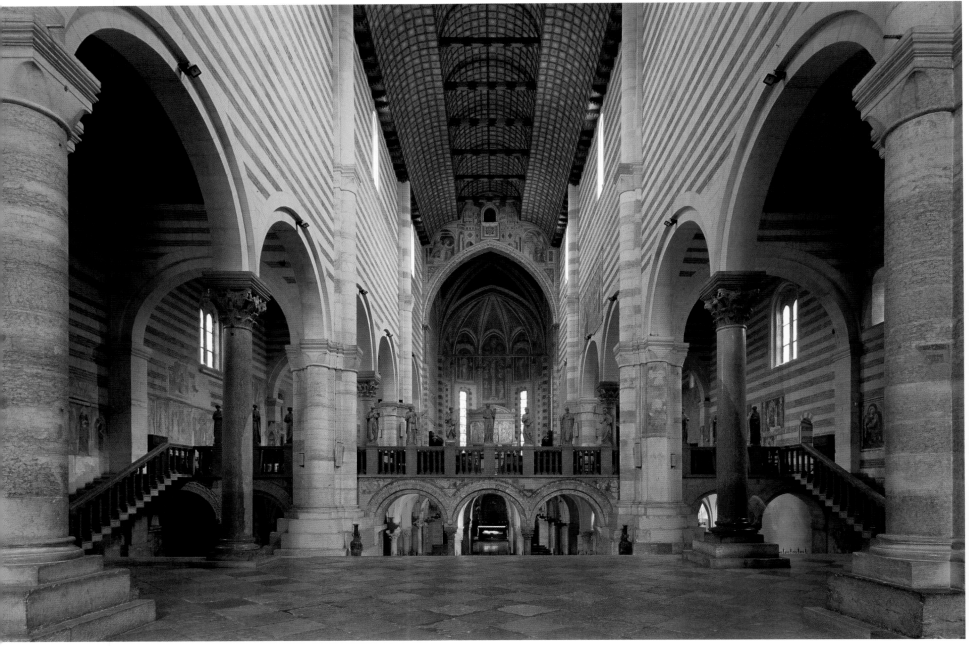

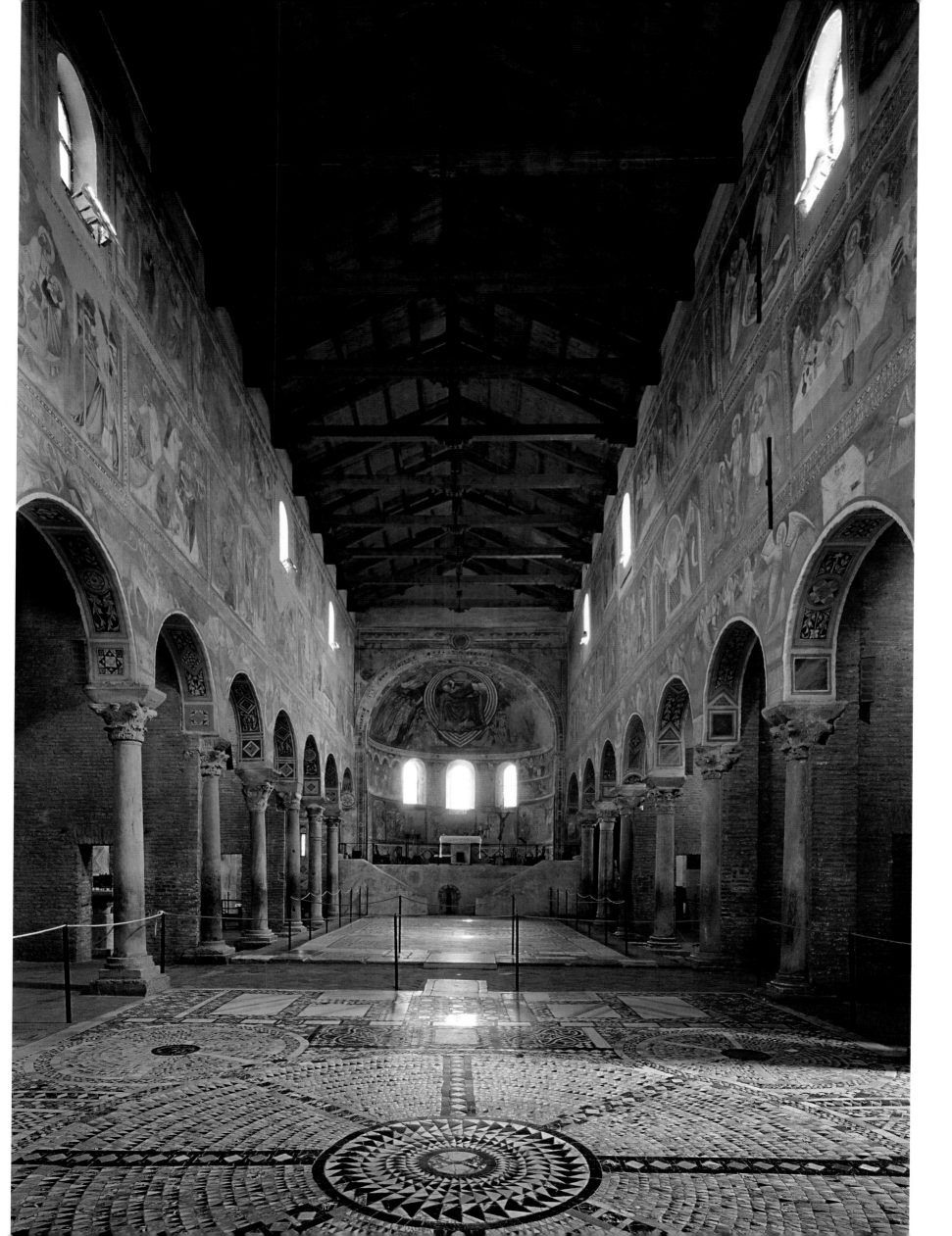

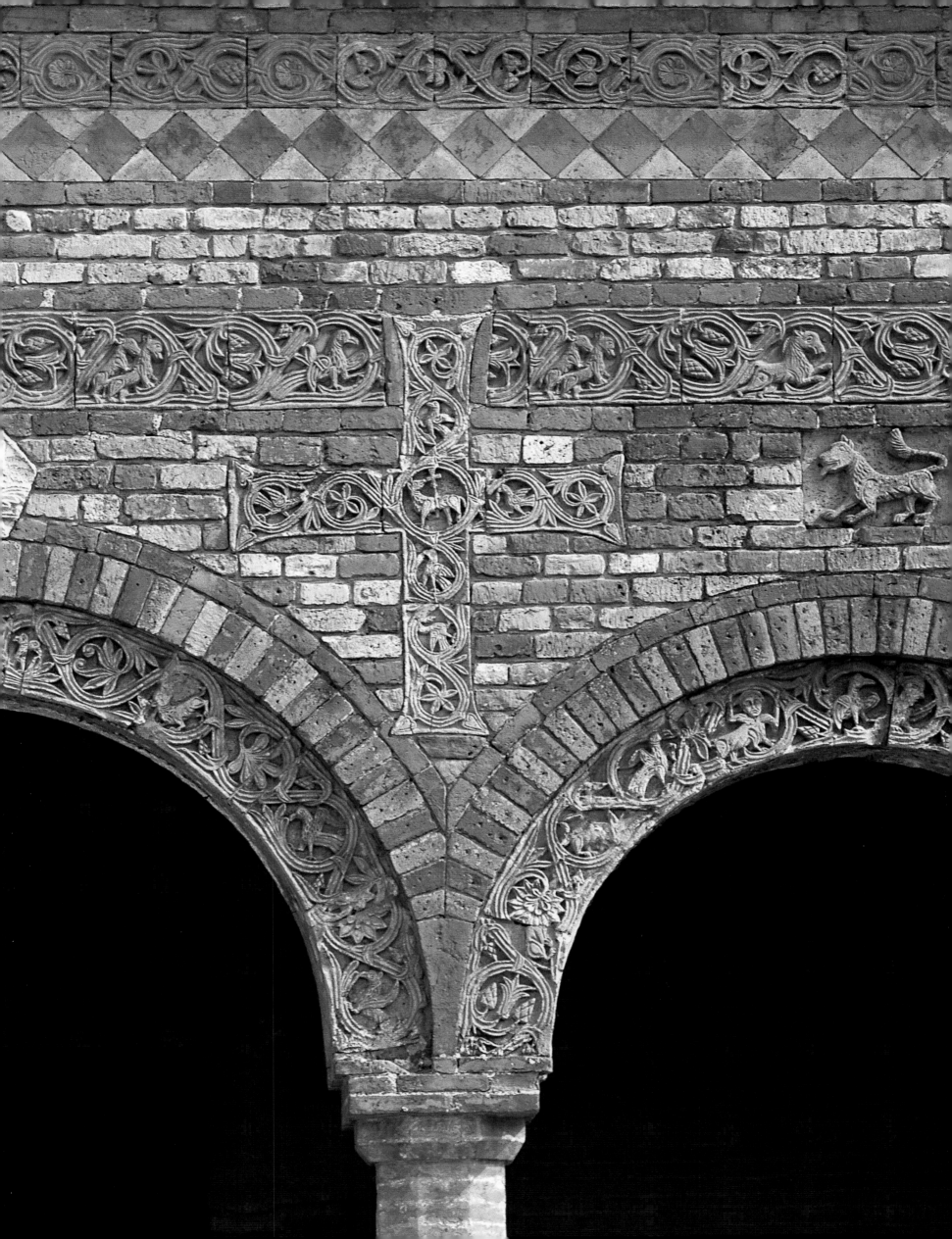

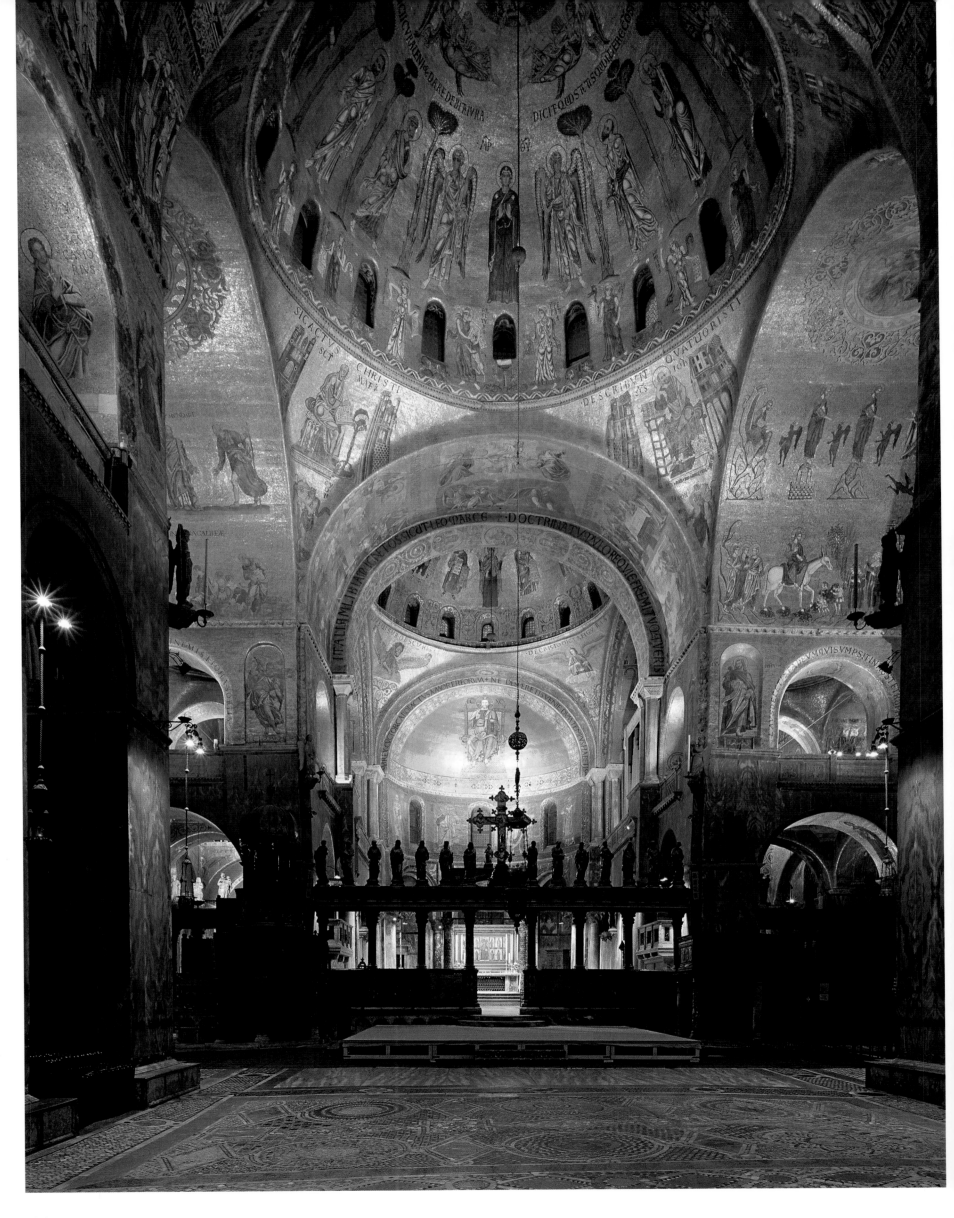

OPPOSITE AND BELOW:
Venice, San Marco, begun 1063, interior of the choir and exterior facing St Mark's Square

The church of the Apostle Mark in Venice owes its floor plan and elevation to the church of the Holy Apostles in Constantinople—certainly a statement of the Venetians concerning both their spiritual openness and their political and economic influence. That also explains the uniqueness of this church, which was rarely imitated.

RIGHT AND PAGES 108/109:
Florence, San Miniato al Monte,
2nd half of the 11th c., detail of the west facade and interior facing east

Like Santa Maria in Pomposa, San Miniato exemplifies Italy's lack of engagement with the problematic of structure and interior vaulting in the 11th century; instead, simple, even bland spaces were decorated in an elaborate manner. San Miniato is entirely covered, inside and out, with a veneer of grey and white marble in geometric patterns. It became the starting point of a long local tradition.

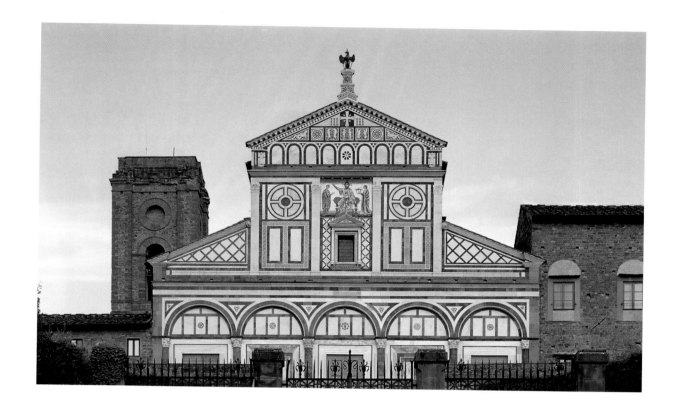

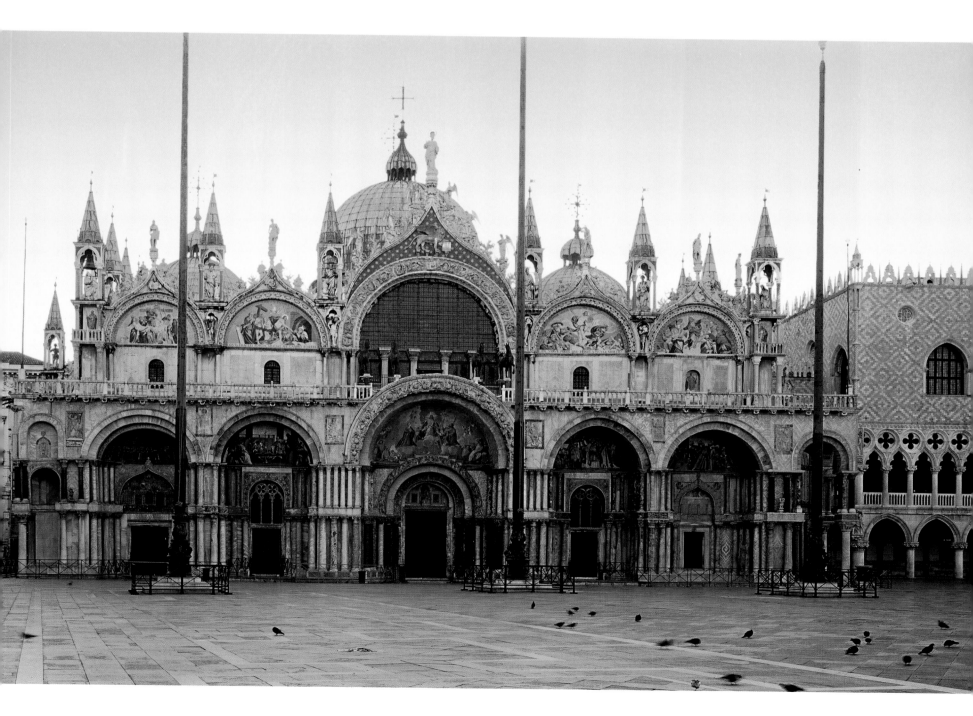

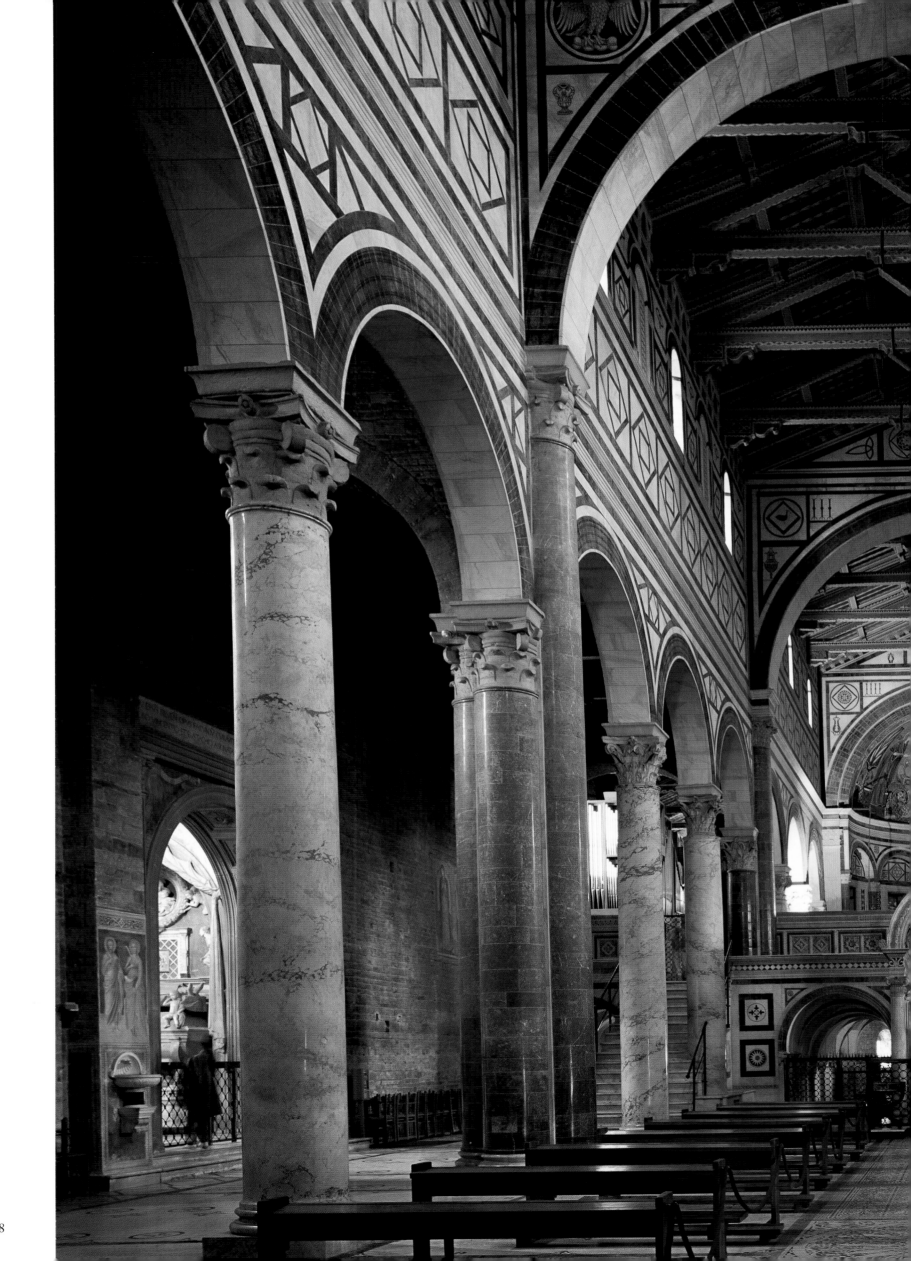

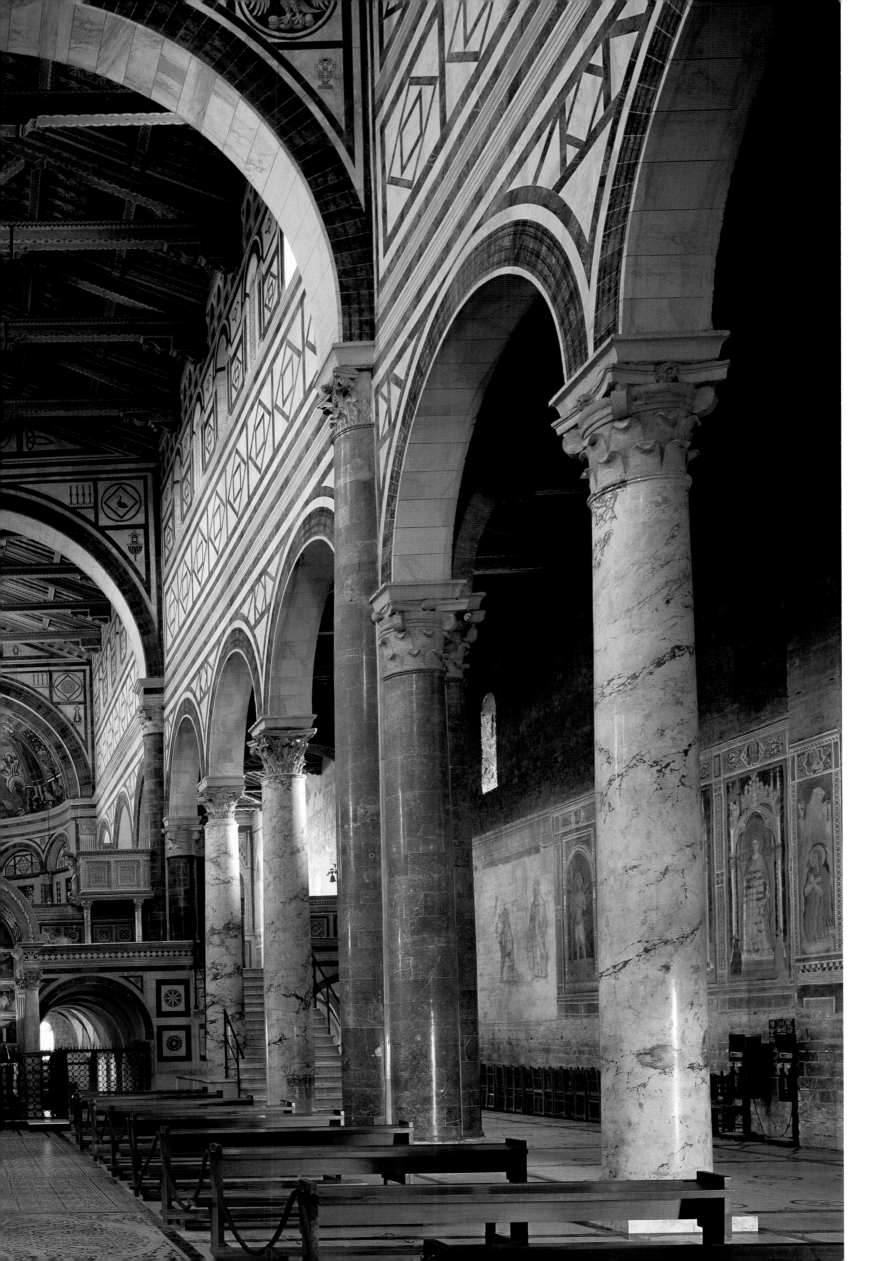

Pisa, cathedral, 1063–1350, baptistery (left) and leaning tower

It is no coincidence that Pisa, one of Italy's major naval powers (others were Venice and Genova), began construction of its cathedral in the year 1063, as did Venice. In Pisa, it took the form of a five-aisle basilica with a gallery and flat ceiling. At the beginning of the 12th century the basilica was extended toward the west, and a new baptistery was erected in its axis.

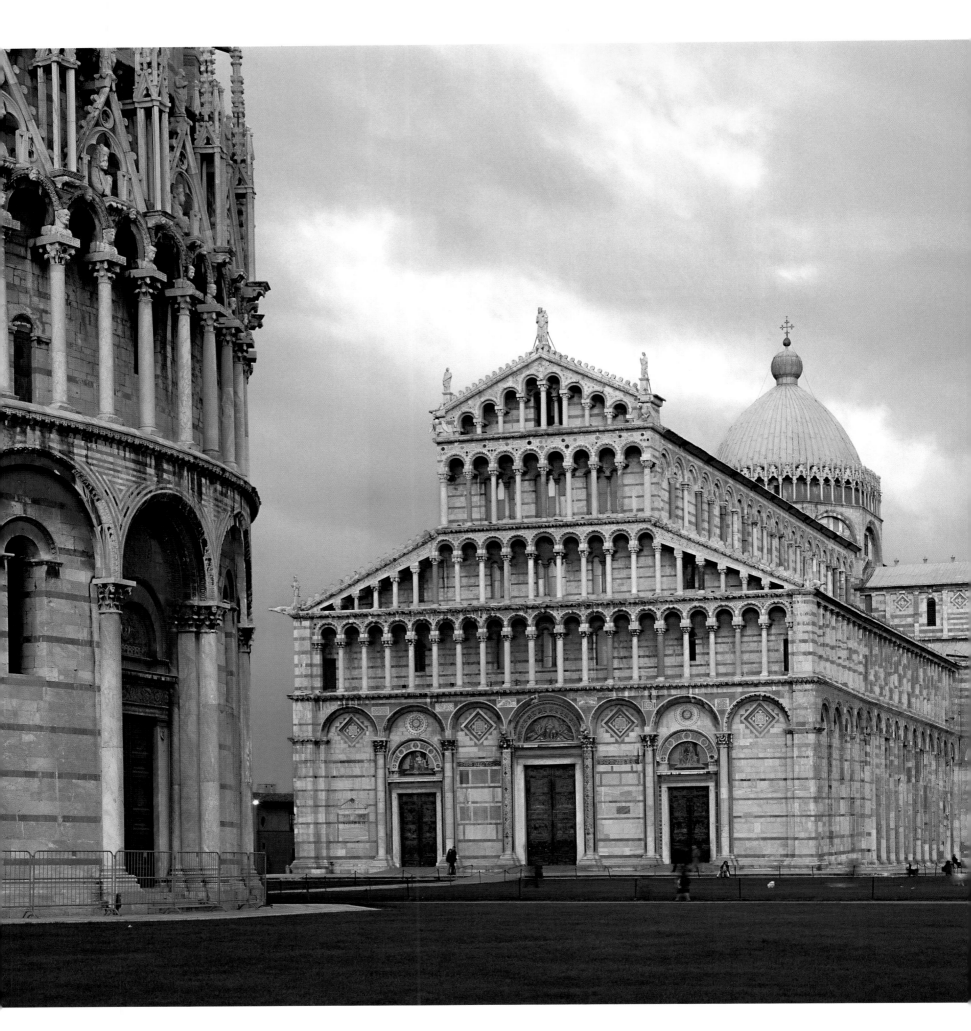

Tuscania, San Pietro, begun end of the 11th c., detail of the facade

This is another example of the many possibilities for lavish decoration of the facade in the 12th century. The wheel window with its minute ornamentation anticipates Gothic rose windows, but places it in an entirely different context.

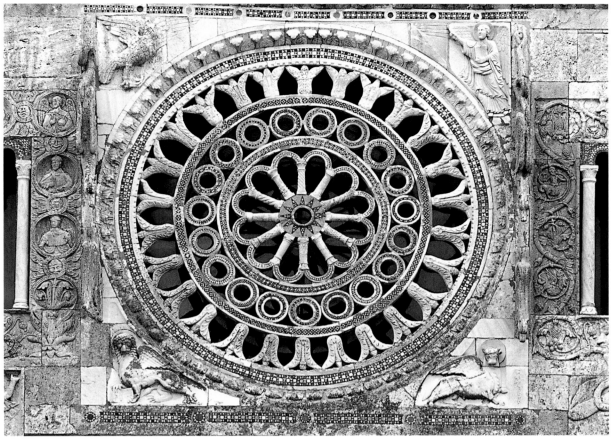

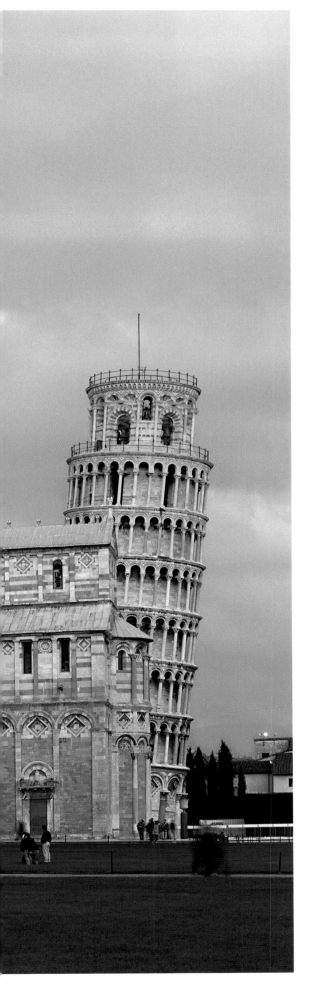

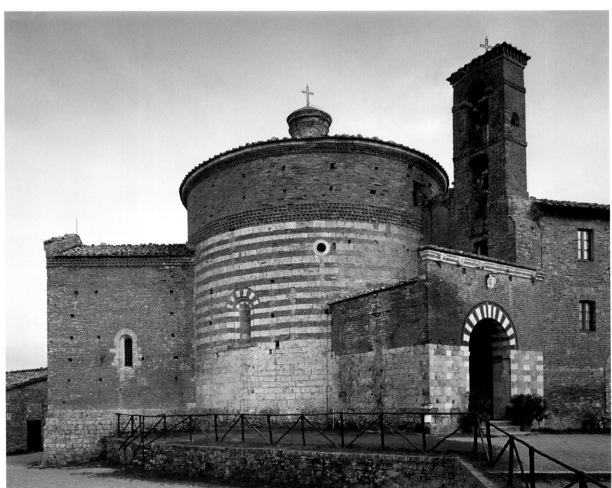

Monte Siepi, chapel of San Galgano, ca. 1185

This small, round building with minute windows and topped by a dome is built in layers of limestone alternating with brick in order to create the striped pattern that was immensely popular in Tuscany.

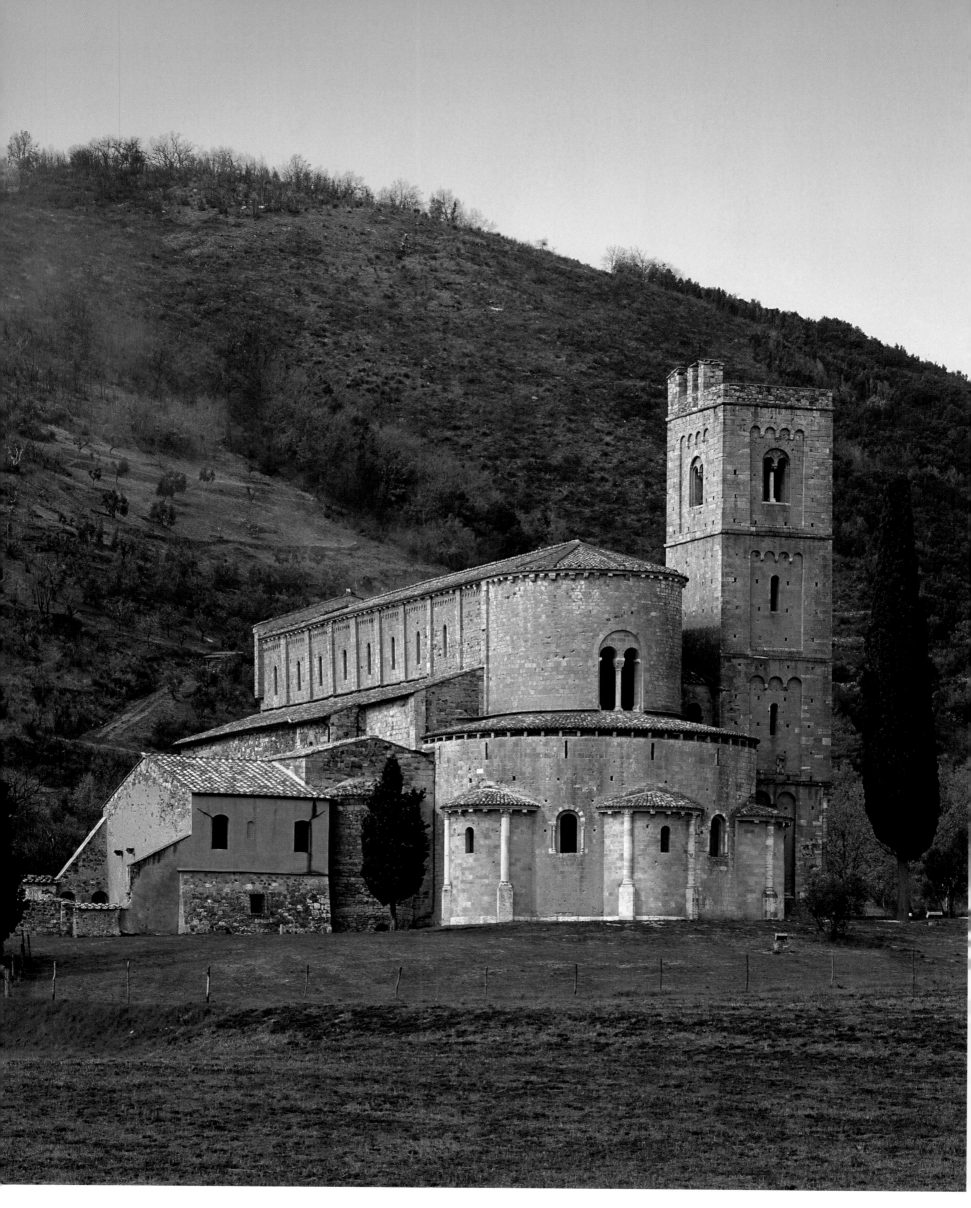

PAGES 114 AND 115:
Trani, cathedral, begun 1098,
interior and exterior views

Sant'Antimo was the last large Benedictine abbey founded in Italy before the Cistercians gained influence and started to build important monasteries. The form of the building and the interior structure of the ambulatory recall the Burgundian churches of the Cluny movement, but the simplicity of the exterior is clearly Italian-Lombard.

In the mountainous hinterland of Marken county the monastery still exudes the hermitic spirit of its founder, St Romualdo. St Peter Damian expanded the monastery in the 11th century and thus laid the foundation for his fame. The nucleus of the complex are the Romanesque-Gothic church and the chapter hall.

Trani is a successor of San Nicola in Bari, a three-aisle basilica with a gallery and flat ceiling. The relative height of the side aisles proportional to the height of the entire building is typical for this group. This leaves very little space for a clerestory and the enormous, box-like transept, from which the apses protrude with no bays preceding them.

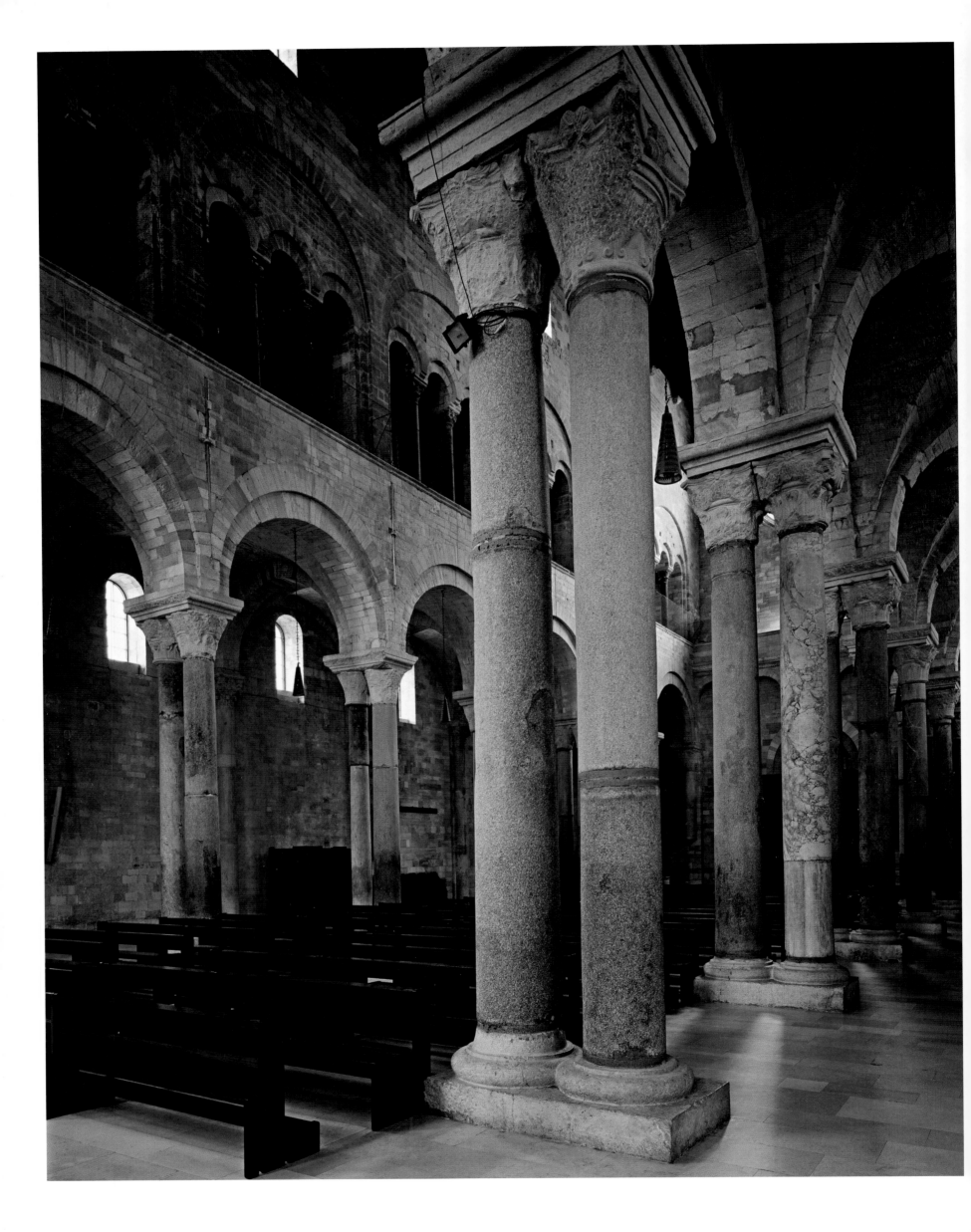

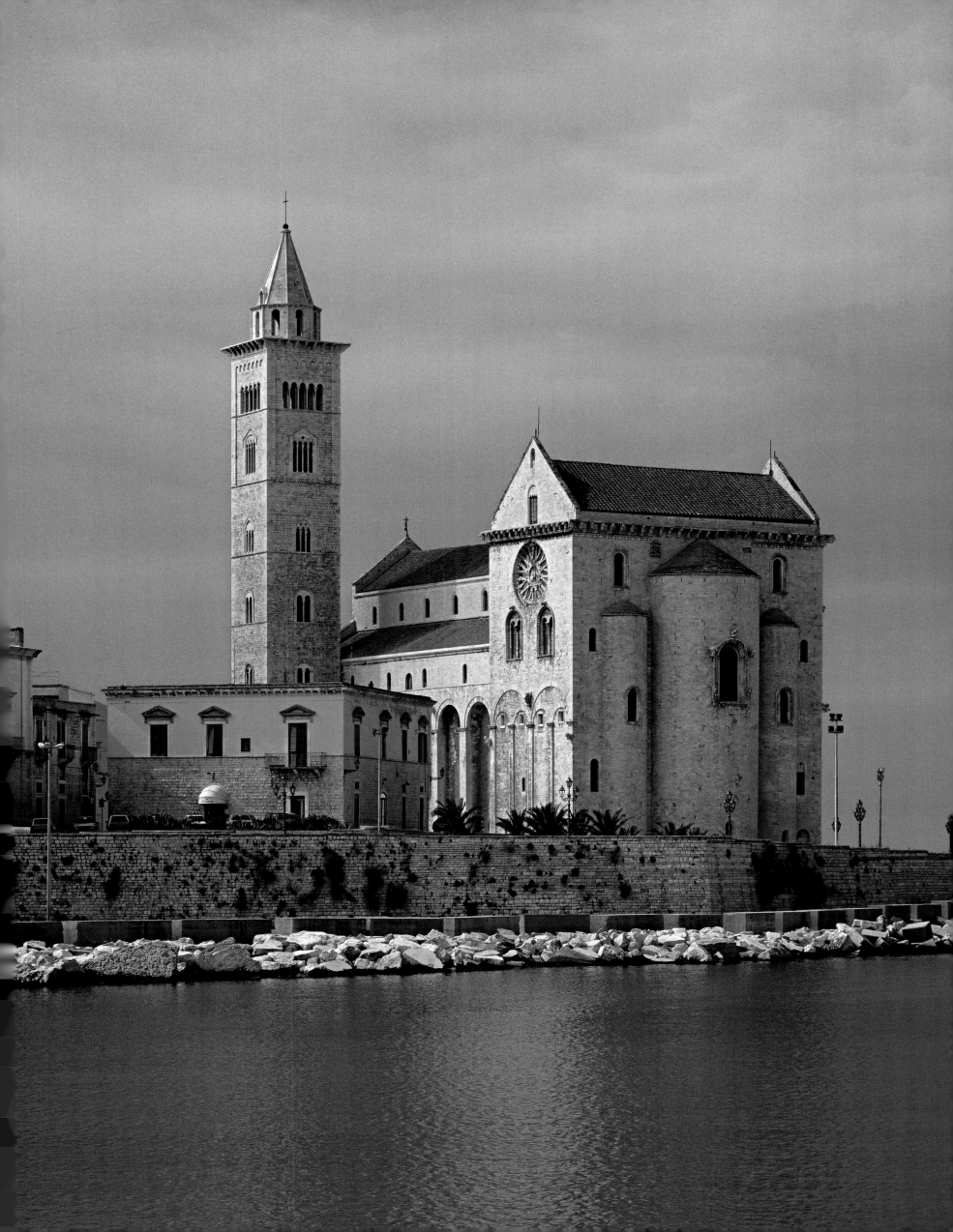

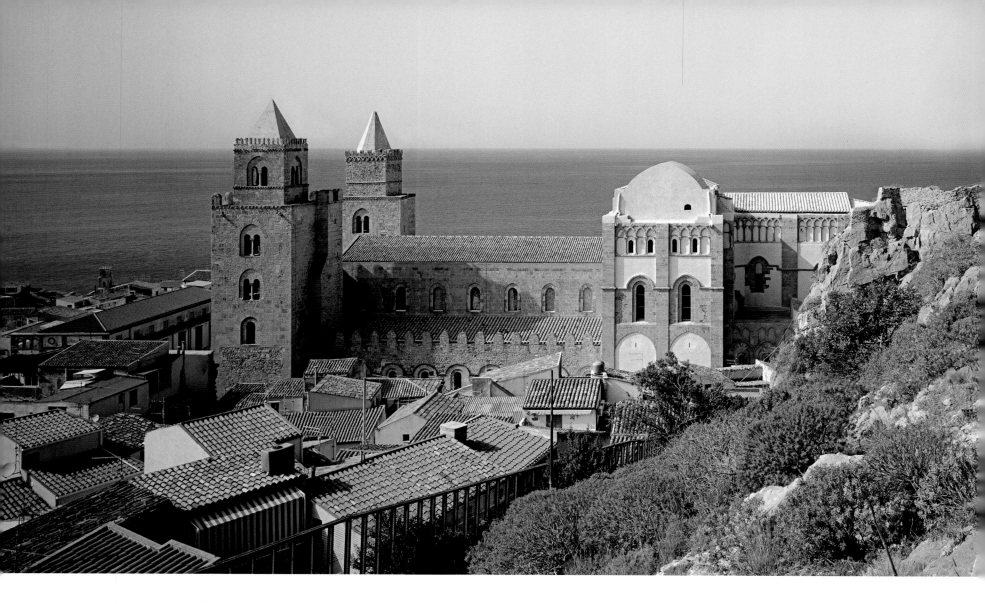

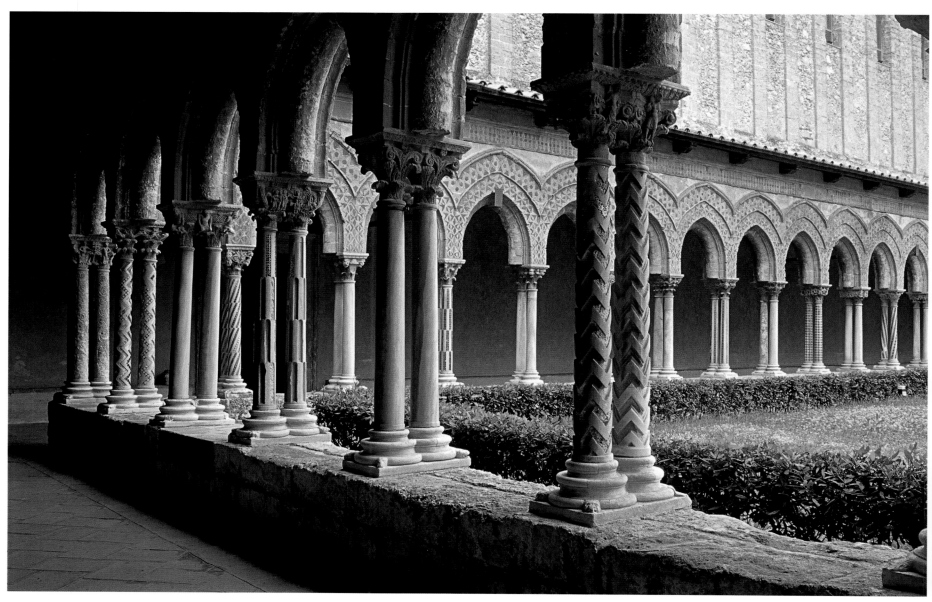

Cefalù, cathedral, begun 1131

The Norman Roger II, who founded the kingdom of Naples and Sicily in 1130, began building the cathedral of Cefalù as his sepulcher. The stately Benedictine choir and the transept bear clear traces of Norman traits (arcade walkway along the clerestory, intended vaulting). The interior of the eastern section is lavishly decorated with mosaics that bequeath the date when the eastern part was completed: 1148. The planned nave was never built; instead William I finished the cathedral with a low basilica nave.

Monreale, former abbey church,
today cathedral, 1174–1189

Monreale was also endowed by royalty. With the exception of the ceiling, the church follows the Capella Palatina in Palermo in which Byzantine, Muslim, and Occidental traditions merge.

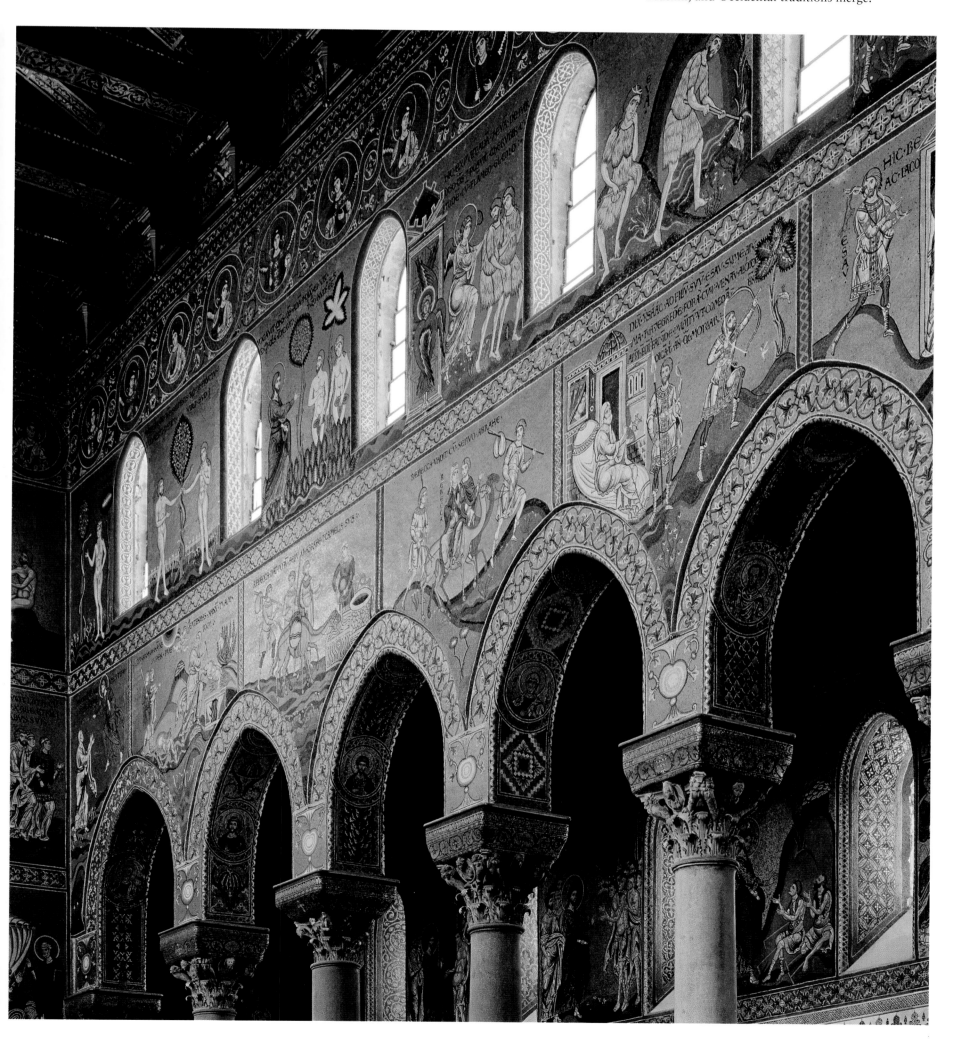

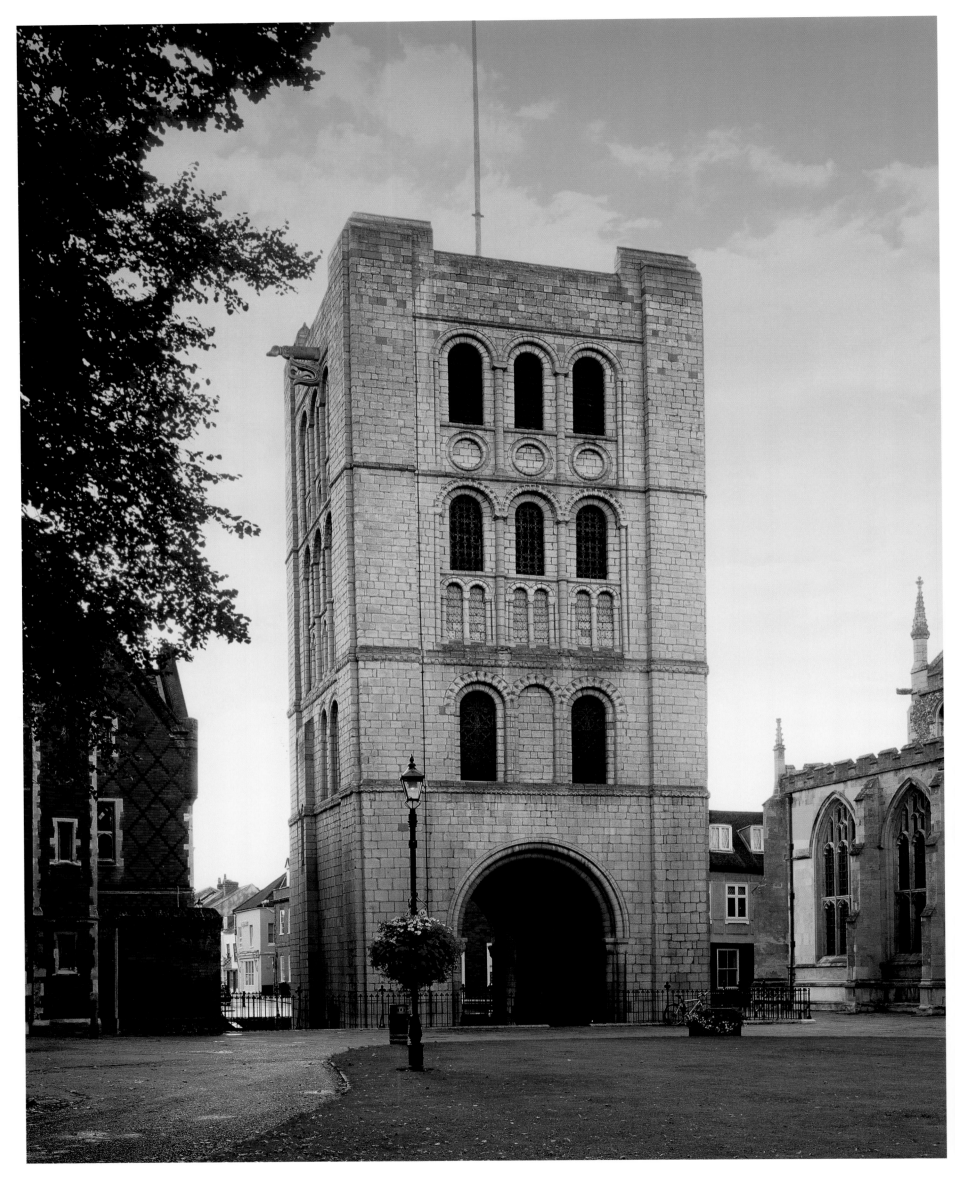

Bury-St-Edmunds, former abbey, begun 1081

Abbot Baldwin from Saint-Denis erected this
505-foot (154-m) long church over the grave of
St Edmund († 870); all that remains today is a ruin.
Only the tower over the entrance hall remains
standing; it has several zones with groups of three
windows and bifora.

BELOW:
Castle Acre, former Cluniac priory,
begun 1089

Here, too, only a ruin is preserved. Rows of
intersecting round arches alternating with low
blind arcades cover the facades in many registers.
Ornamental figures were completely omitted.

PAGES 120 AND 121:
Ely, cathedral, begun after 1081,
interior view facing east; west facade

After William had conquered England, new abbey
churches and cathedrals were built everywhere.
Most followed the example of Saint-Étienne in Caen,
which is also true of Ely. The west facade with its
towers, however, shows how the model of Bury-St-
Edmunds was developed and the extent to which
windows and niches penetrated the massive walls.

PAGES 122 AND 123
Norwich, cathedral, begun 1096,
exterior view with crossing tower; interior

This building is a further example of the uniformity
of Norman building style in England. The nave of
Norwich, which probably had a flat ceiling when
first built, was equipped with a fanned vault in the
14th century that constitutes a blatant contrast to
the calm forms of the nave walls.

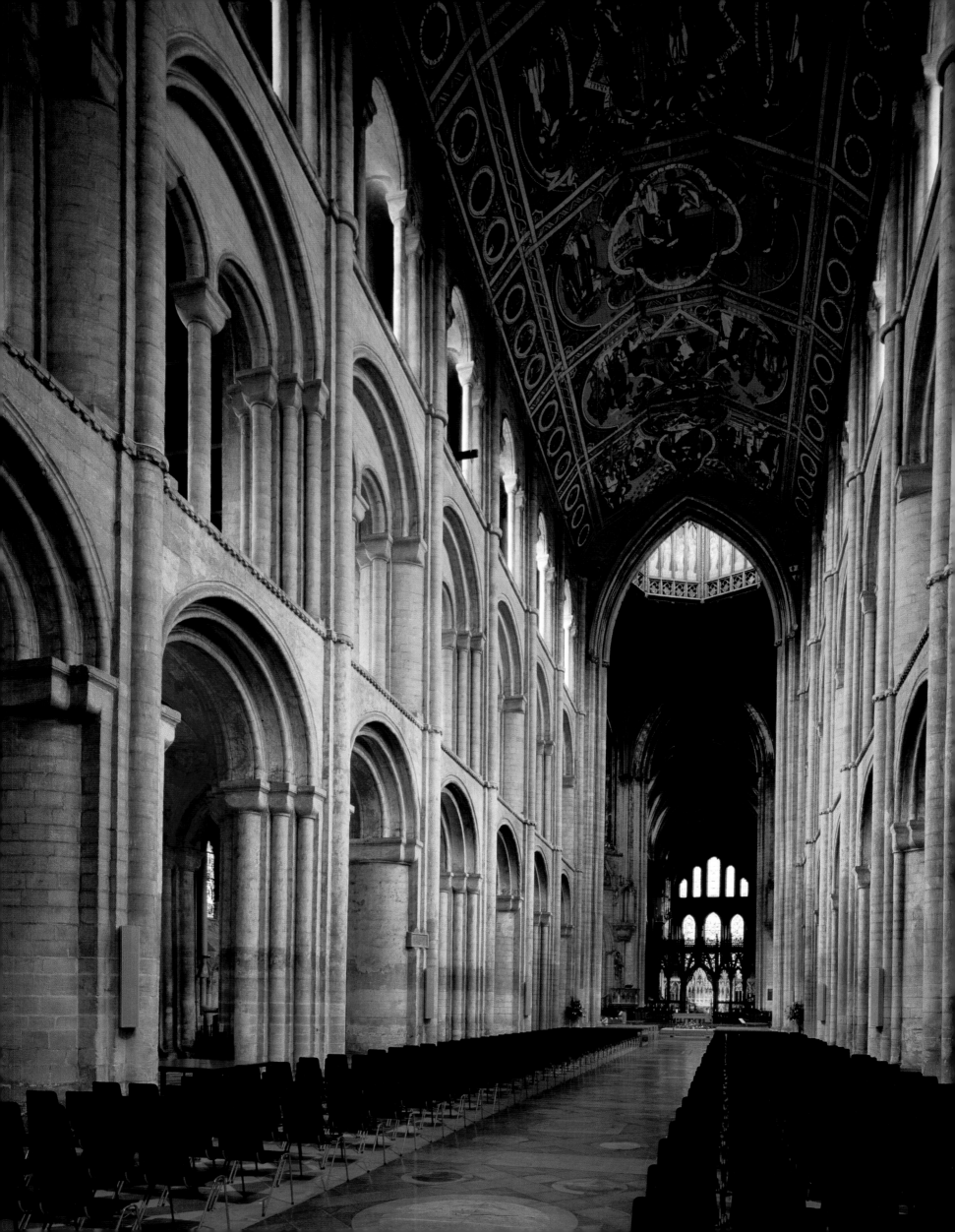

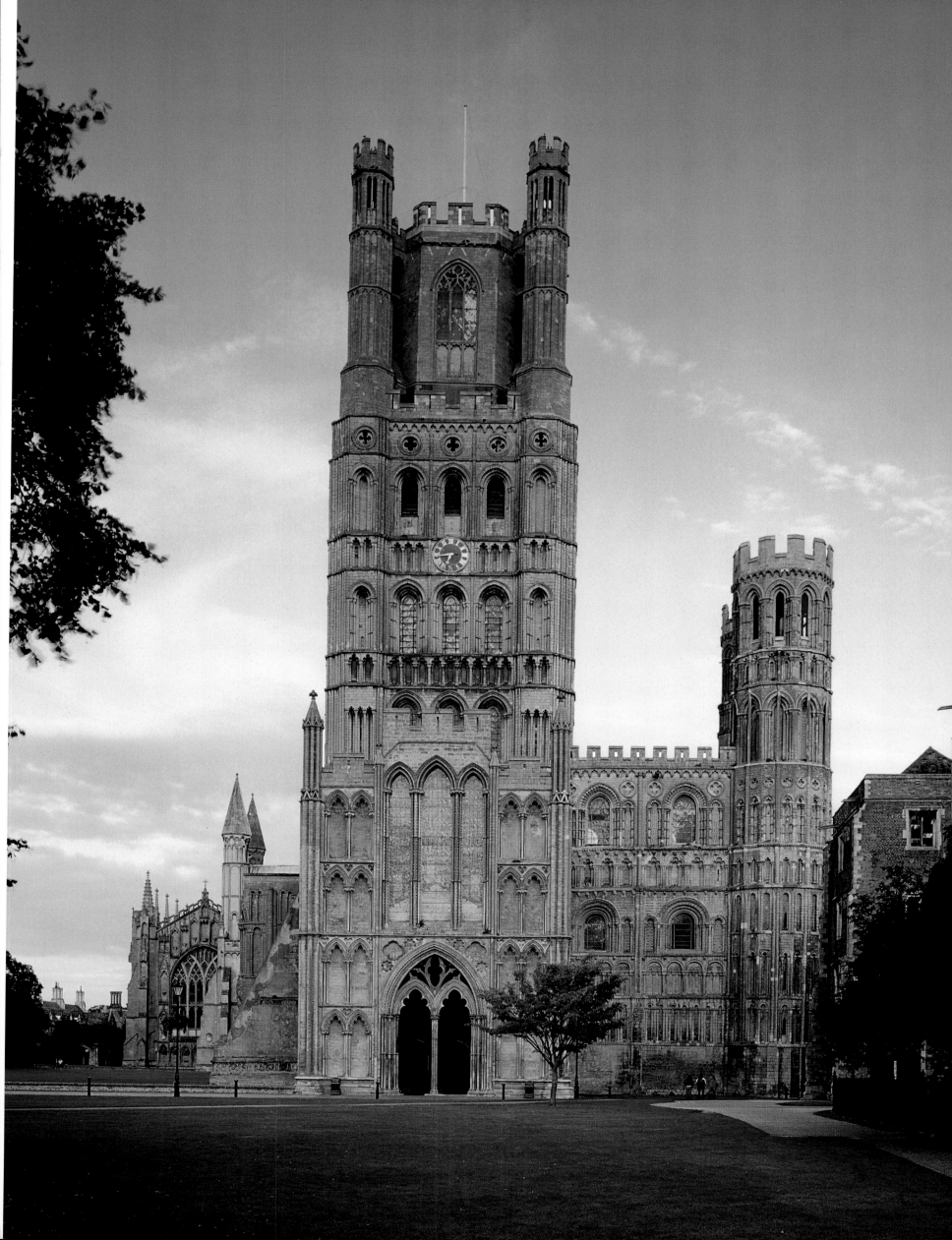

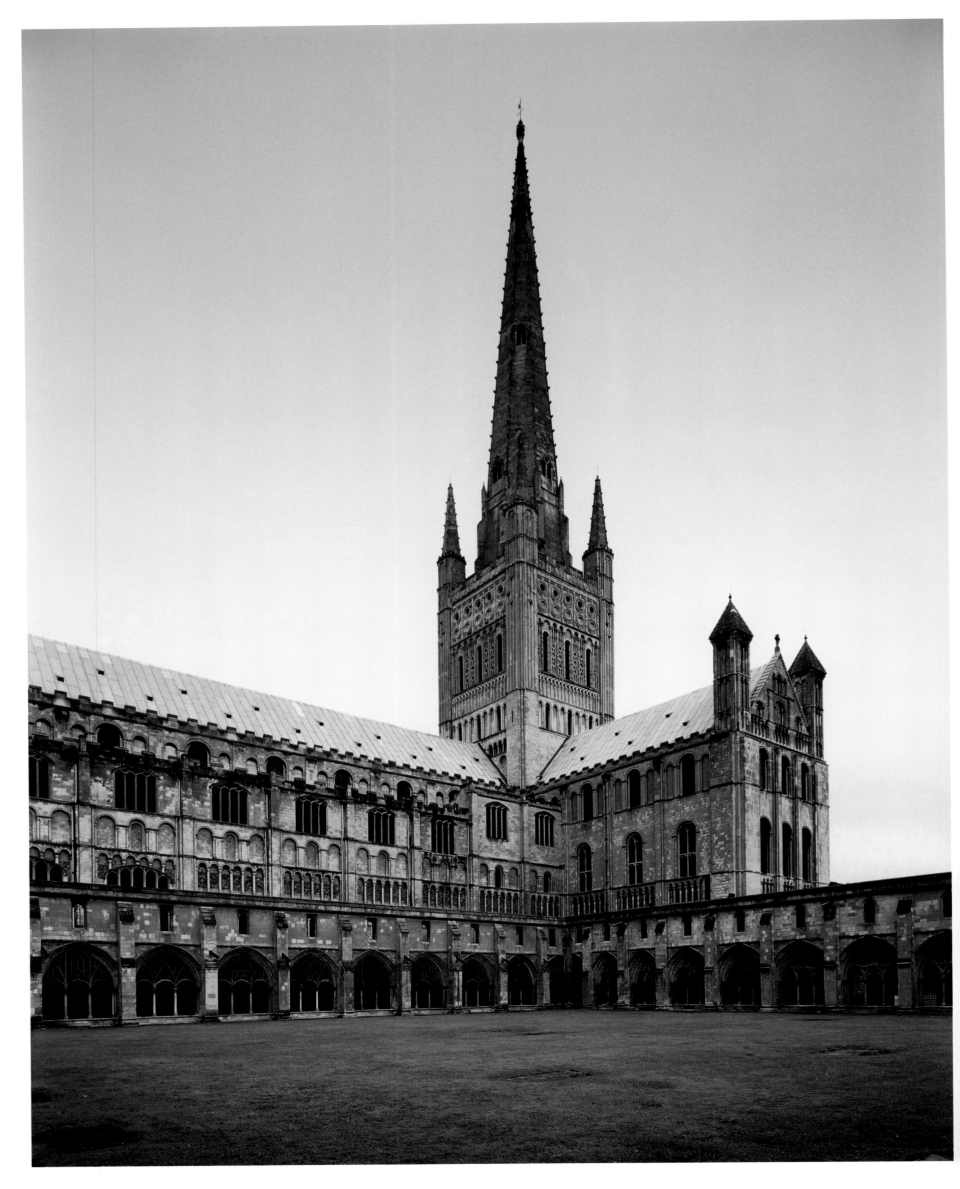

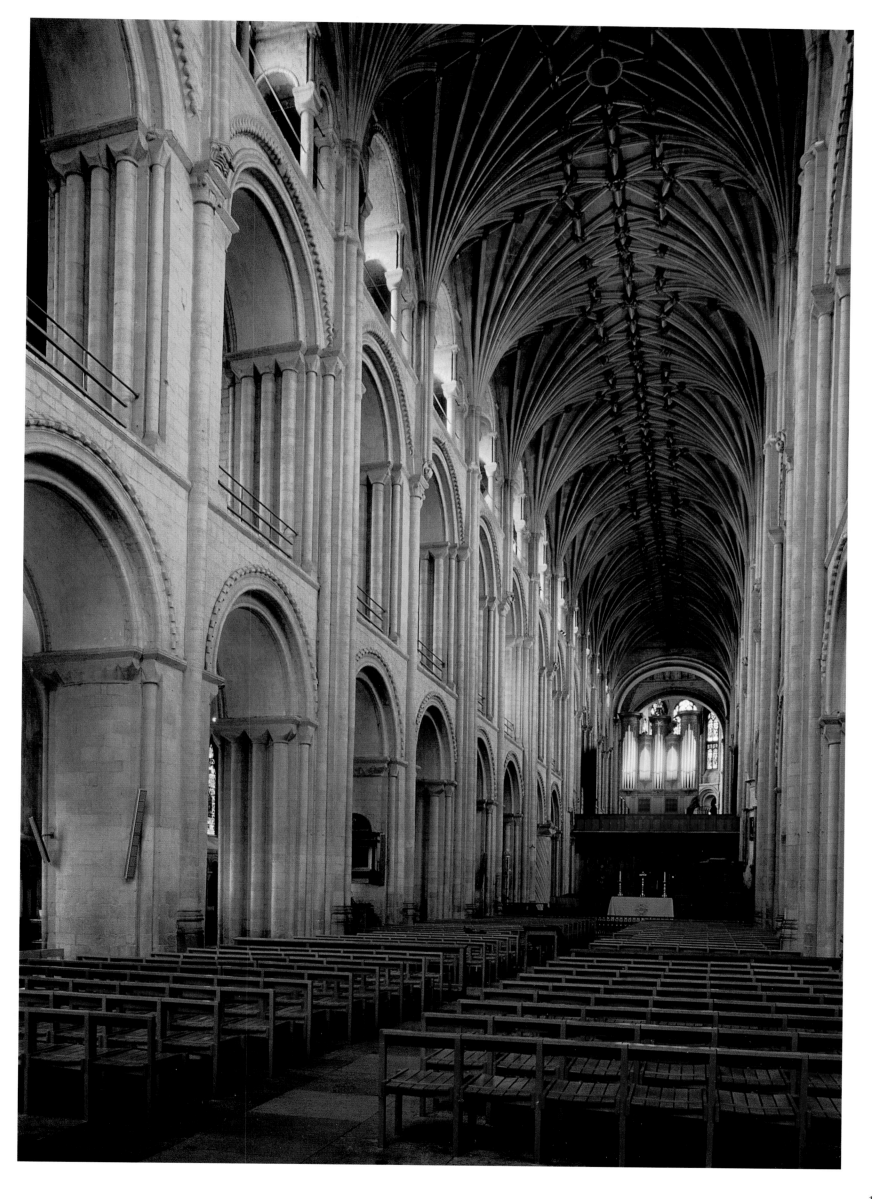

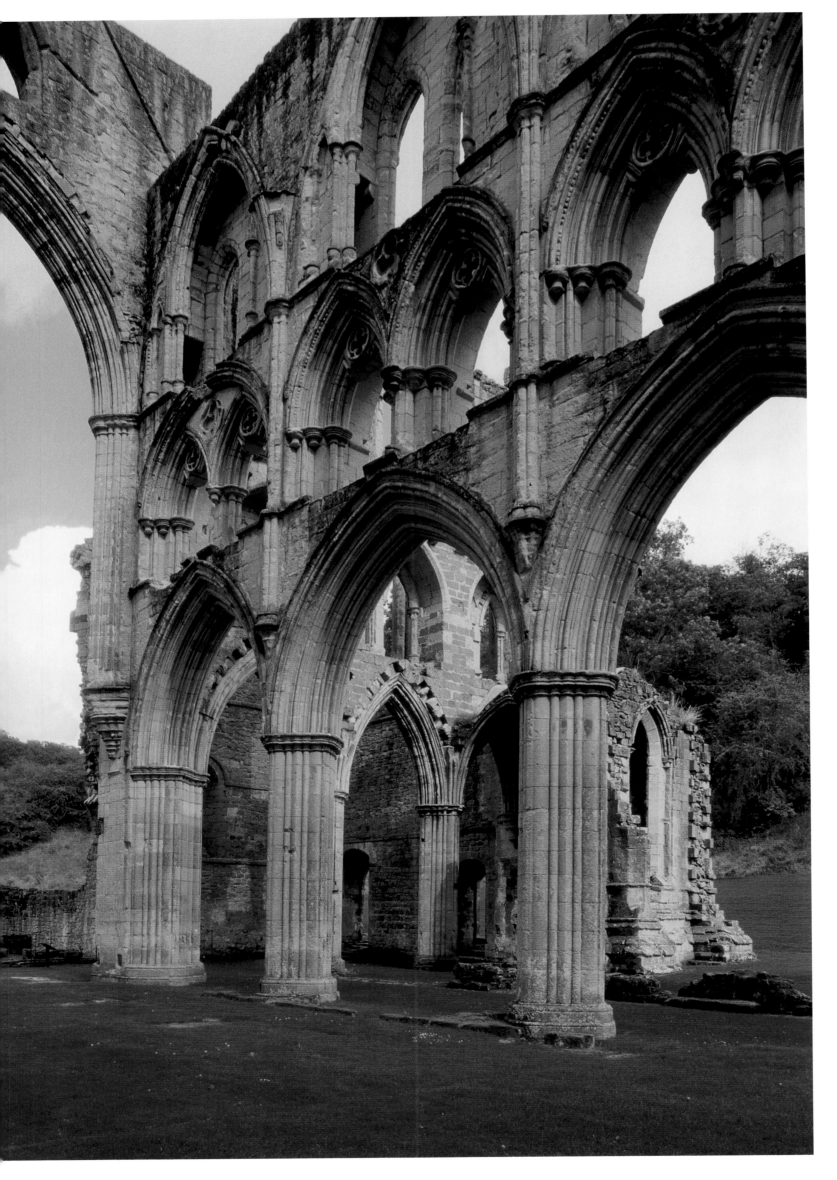

Rievaulx monastery, former Cistercian abbey church, founded 1132

From the 1130s the Cistercians were also a presence on the British Isles and built impressive abbey churches, almost all of which are available to us only as ruins. Rievaulx Abbey had a three-part elevation, taking after the cathedrals, and a monumental transept.

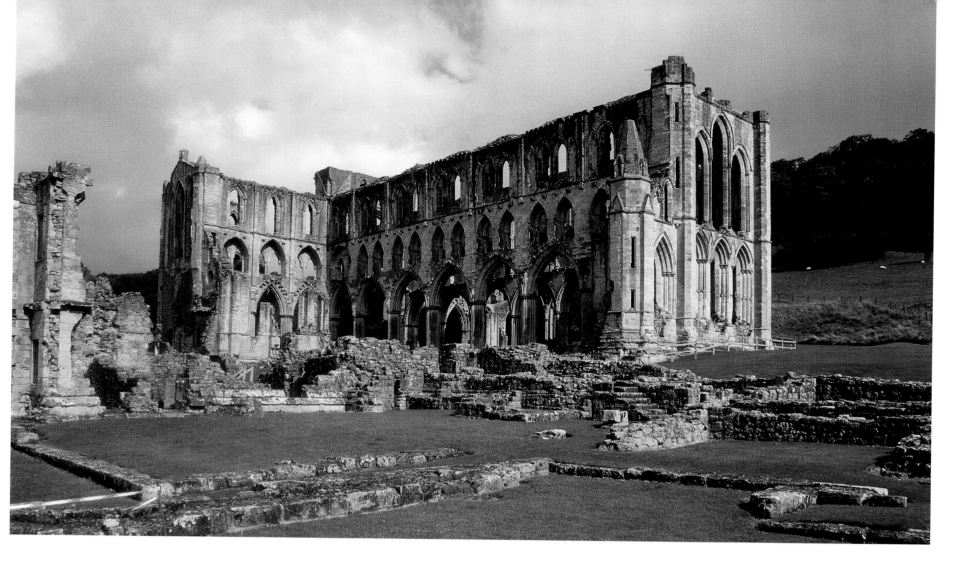

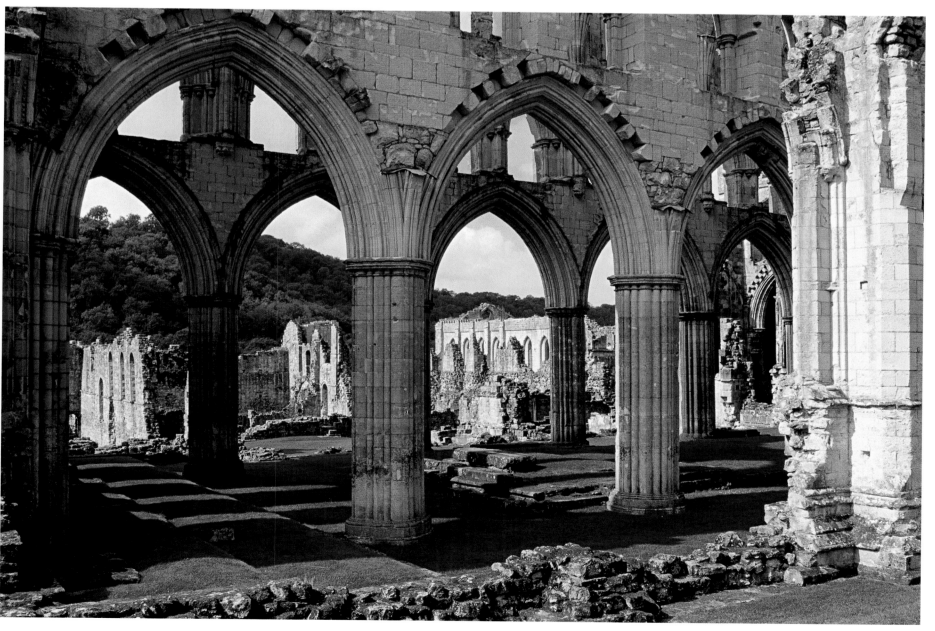

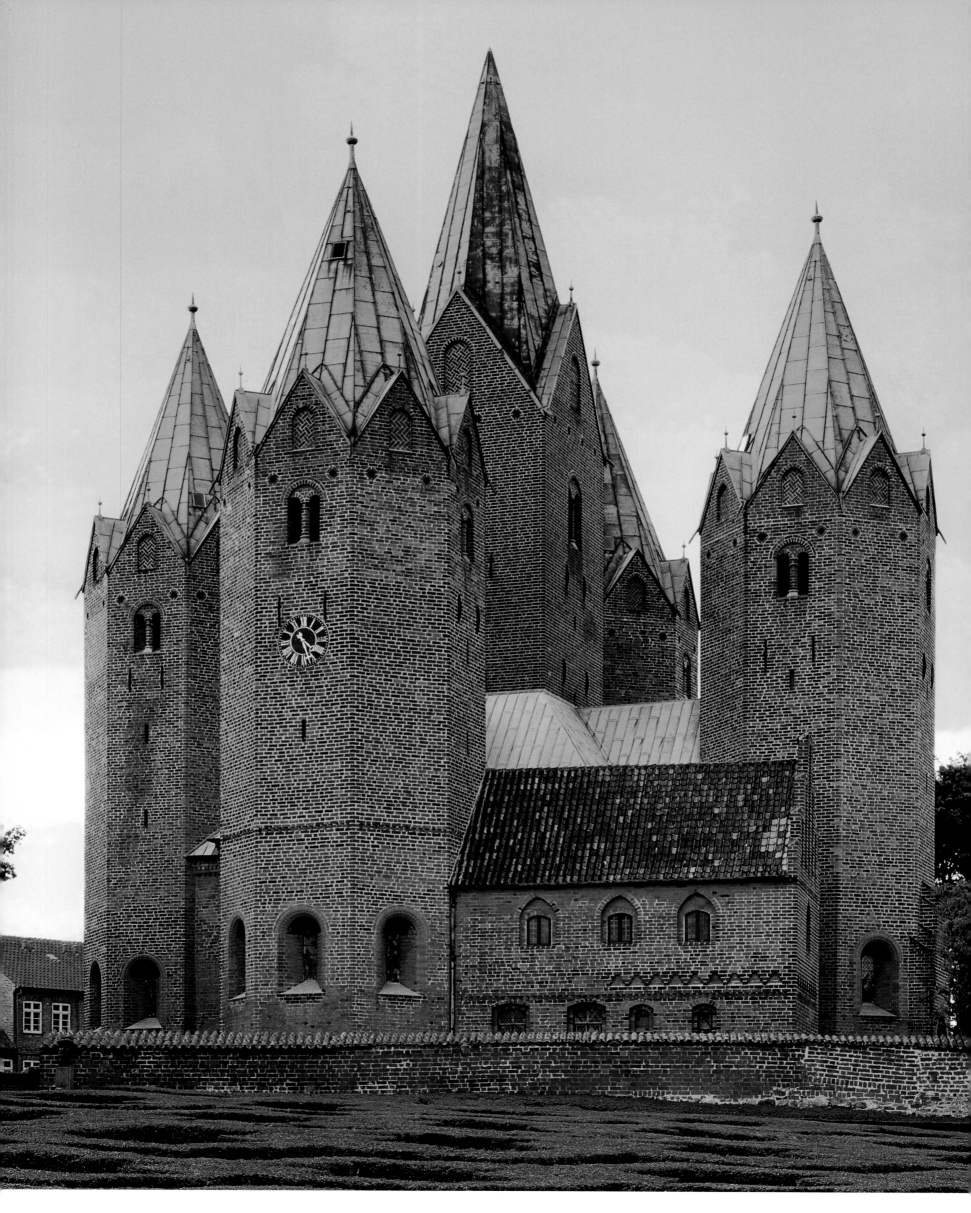

OPPOSITE:
Kalundborg, Vor Frue Kirke, 1170/90

BELOW LEFT AND RIGHT:
Lund, cathedral, ca. 1130/40,
west view (left); east view

Scandinavia was Christianized only very late:
Denmark after the 9th century, Norway by around
1000, and southwest Finland as late as after 1150.
The cathedrals along the northern Rhine River and
the Norman sacred buildings in England became the
standards for the large Scandinavian buildings that
came into existence no earlier than 1100. The
cathedral of Lund is a successor of Speyer, while the
Vor Frue Kirke is a castle church, a cross-shaped
central plan with five towers.

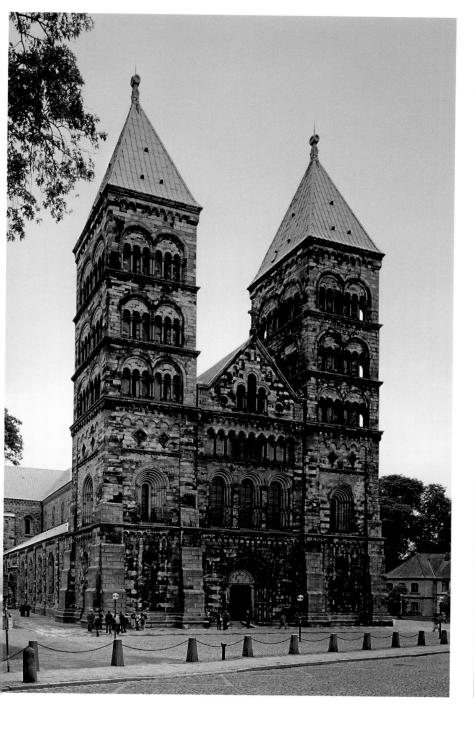

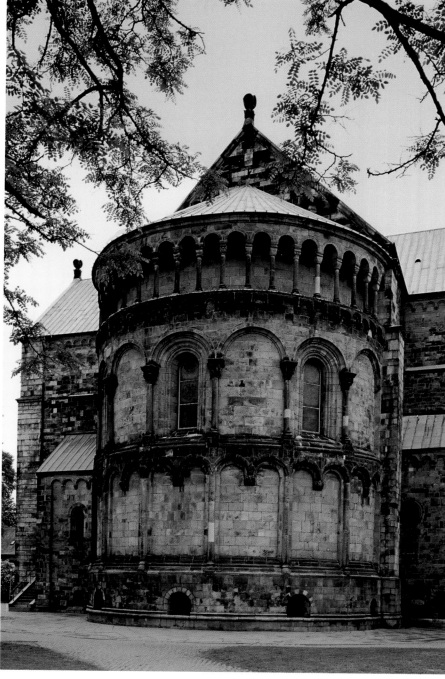

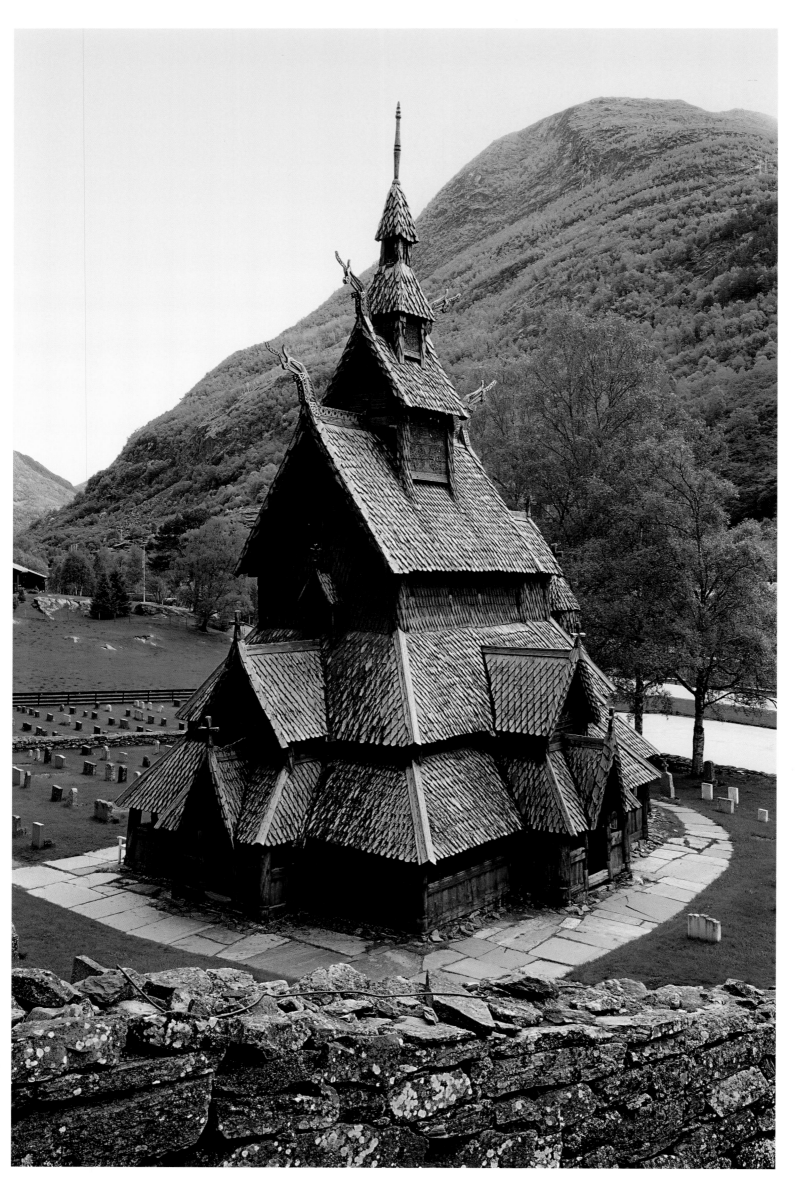

LEFT AND OPPOSITE:
Borgund, stave church,
ca. 1150

Of the several hundred wooden stave churches built in the 11th and 12th centuries, only 25 are still preserved. One of the most beautiful is the stave church of Borgund, a late example that shows that here, as well, development moved from simple to more complex forms, that proportions were refined, and that decorations became richer over time. The interior elevation of the post construction draws from the nave walls of stone sacred buildings. The portals and gables are adorned with carvings and rune inscriptions.

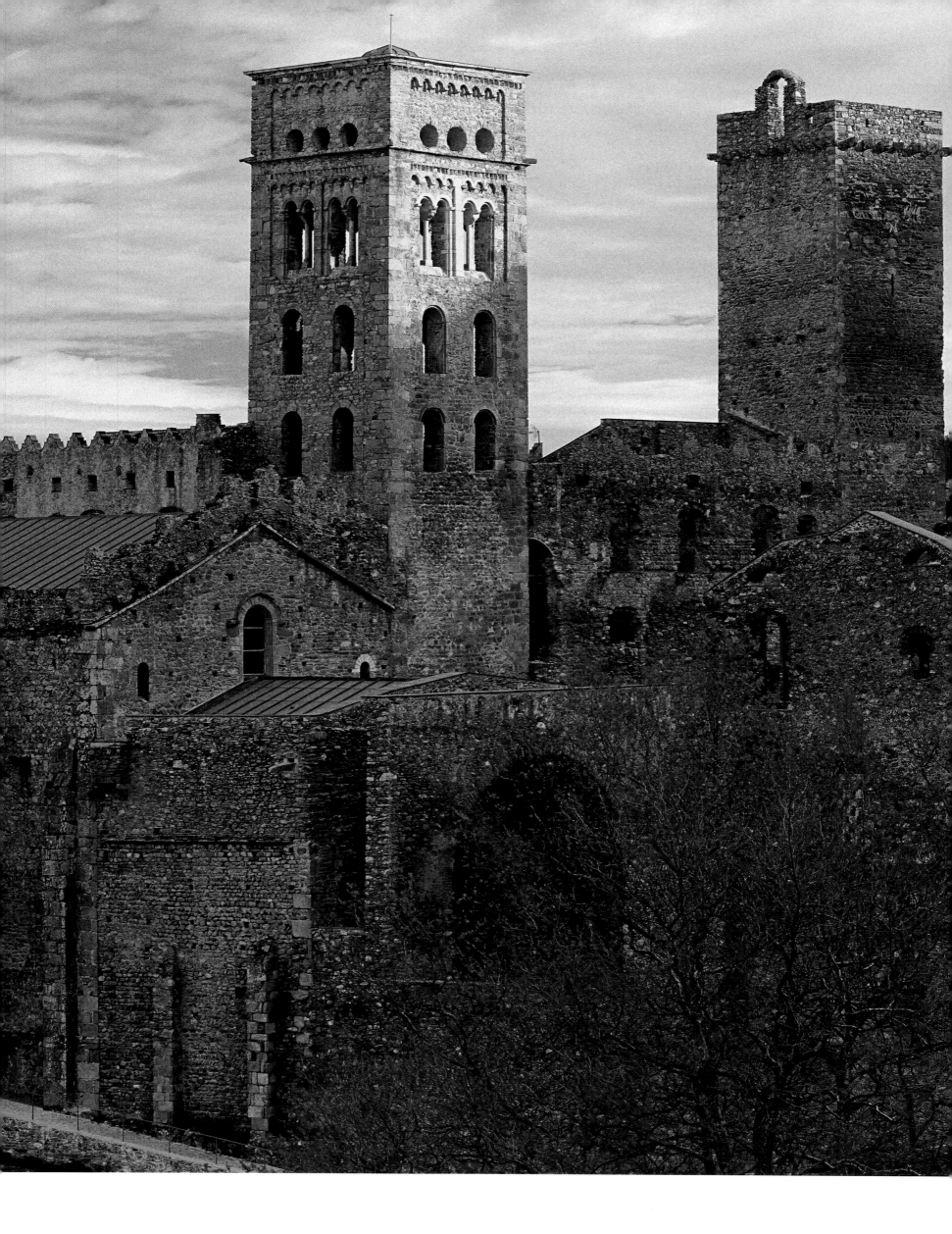

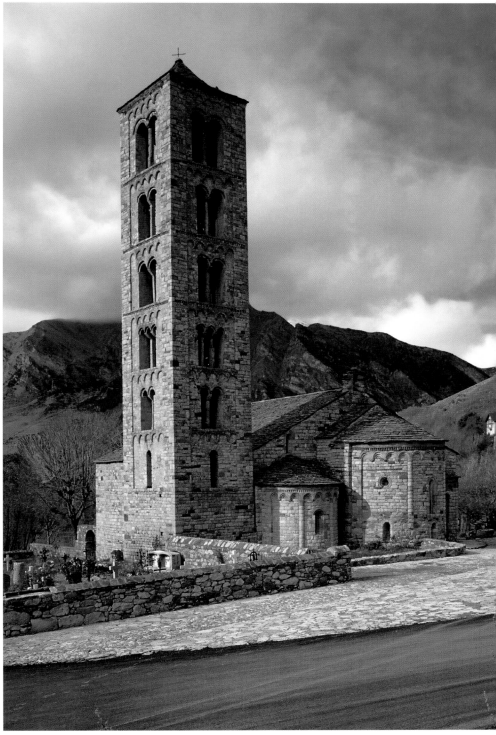

ABOVE:

Tahull, San Clemente, dedicated 1123

The church of San Clemente, which is a century younger than Sant Pere de Rodes, is not vaulted. A three-part choir is a direct extension of the nave, which has simple round pillars. The bell tower on the south side of the building is both massive and ornate.

LEFT:

Sant Pere de Rodes, former Benedictine abbey, dedicated 1022

By 1022, this extensive monastery high above the sea in the Catalonian mountains included a small church that built upon an older atrium. It was endowed by Count Oliba Cabreta, the well-traveled and very erudite abbot of Saint-Michel-de-Cuxa and later of Santa Maria in Ripoll who became bishop of Vic in 1018. It is an example of an early vaulted building, a pseudobasilica with a transept and simple ambulatory choir.

Cardona, castle church of San Vicenç,
1029–ca. 1040, view from the northeast;
wall of the nave

San Vicenç is a very advanced vaulted structure
for its time, a basilica with a barrel vault over the
clerestory, admittedly of small scale. Underneath
the choir, which has three apses, is a partially
subterranean crypt.

BELOW:
La Seu d'Urgell, cathedral,
from 1175, view from the east

This late Romanesque cathedral demonstrates that
building forms of the early period were indeed
maintained, and only the ornamentation became
more elaborate. In this case it takes the form of
deeply recessed window embrasures with small
columns and archivolts, as well as an arcaded
ambulatory under the eaves of the apse.

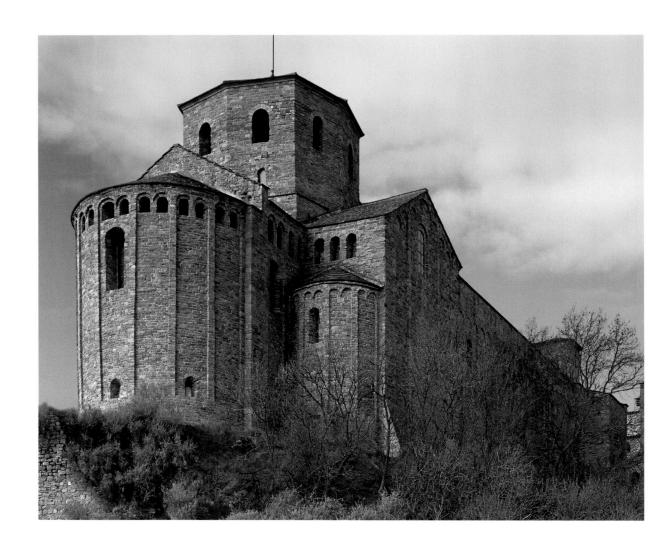

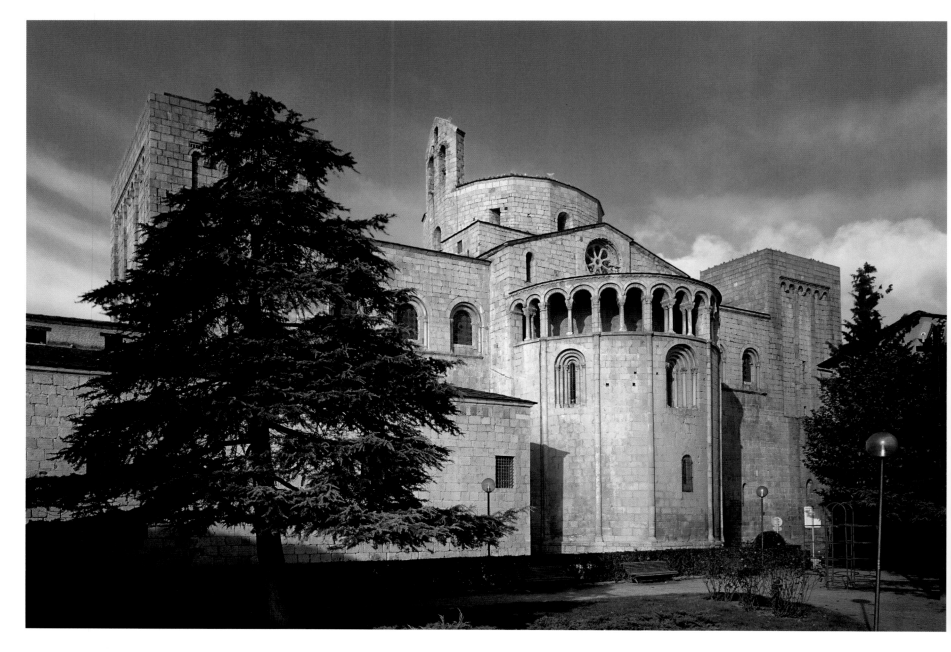

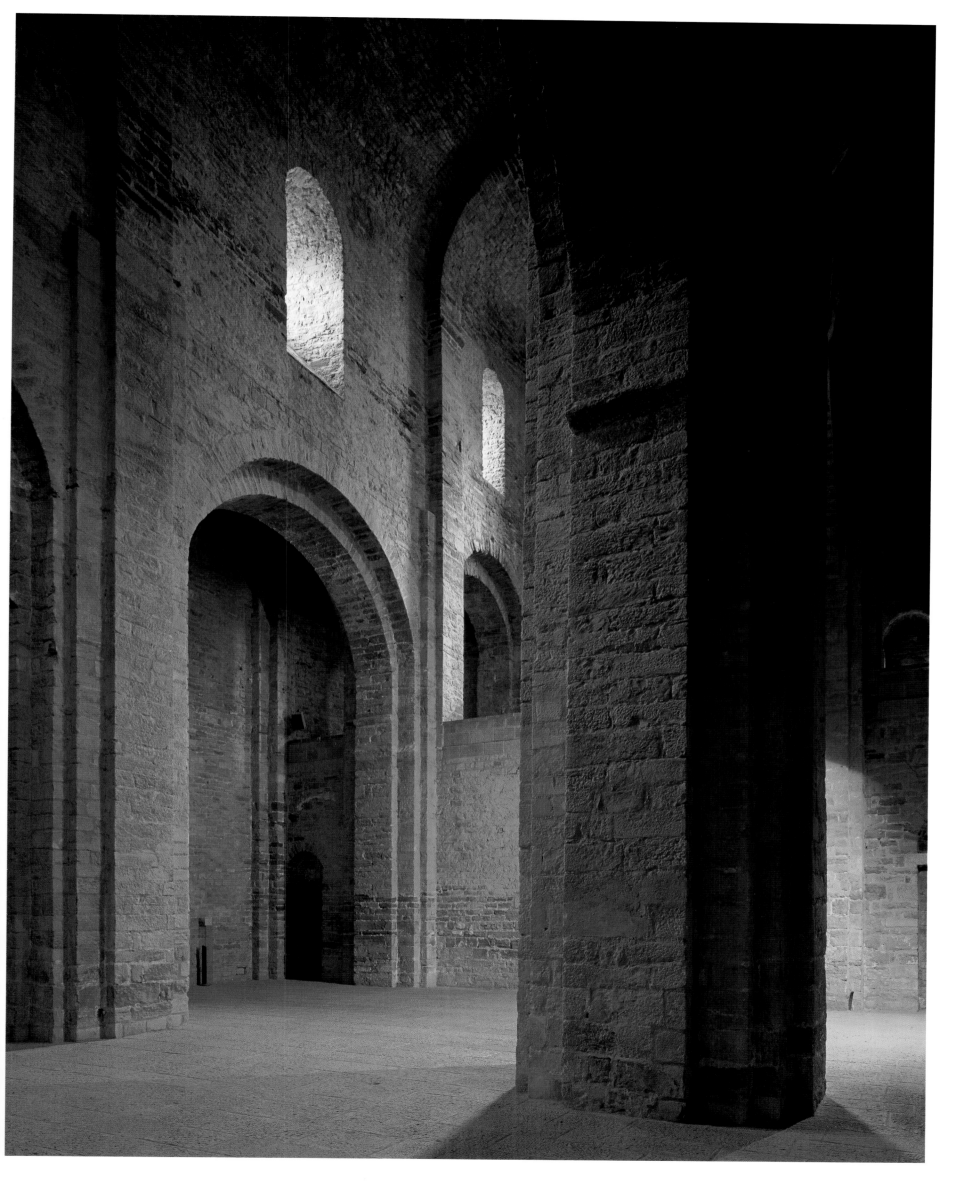

BELOW AND OPPOSITE:
Frómista, San Martín,
before 1066(?)–after 1100, view from the southwest (below); interior view facing east

Like Sant Pere de Rodes, San Martín is a pseudo-basilica with a barrel vault, but here it is combined with a tripartite choir. Noteworthy are the sculpted capitals and friezes, as well as the meticulous attention to proportionality and the execution of every detail.

PAGES 136/137:
Santo Domingo de Silos, cloister,
end of 11th/beginning of 12th c.

The Benedictine prior Dominicus (around 1000–1173), who was later canonized, came to Silos in 1041 and led the monastery to a period of great prosperity. After his death a reconstruction of the church commenced that was completed with the transferal of his relics in 1088. The cloister was probably built around the same time as the church.

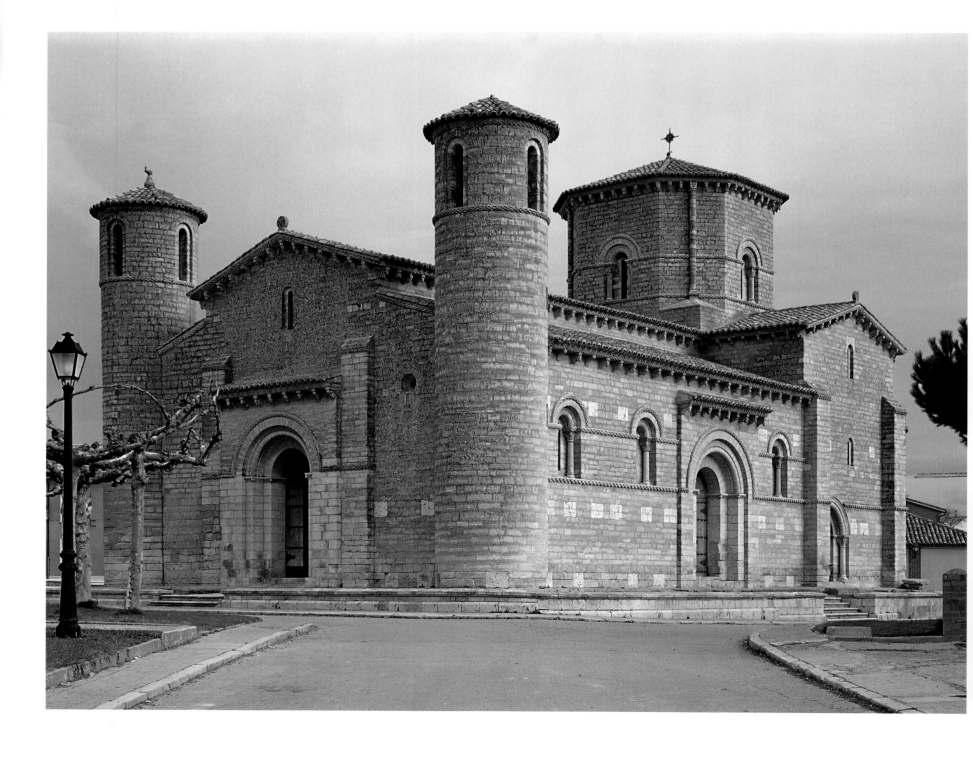

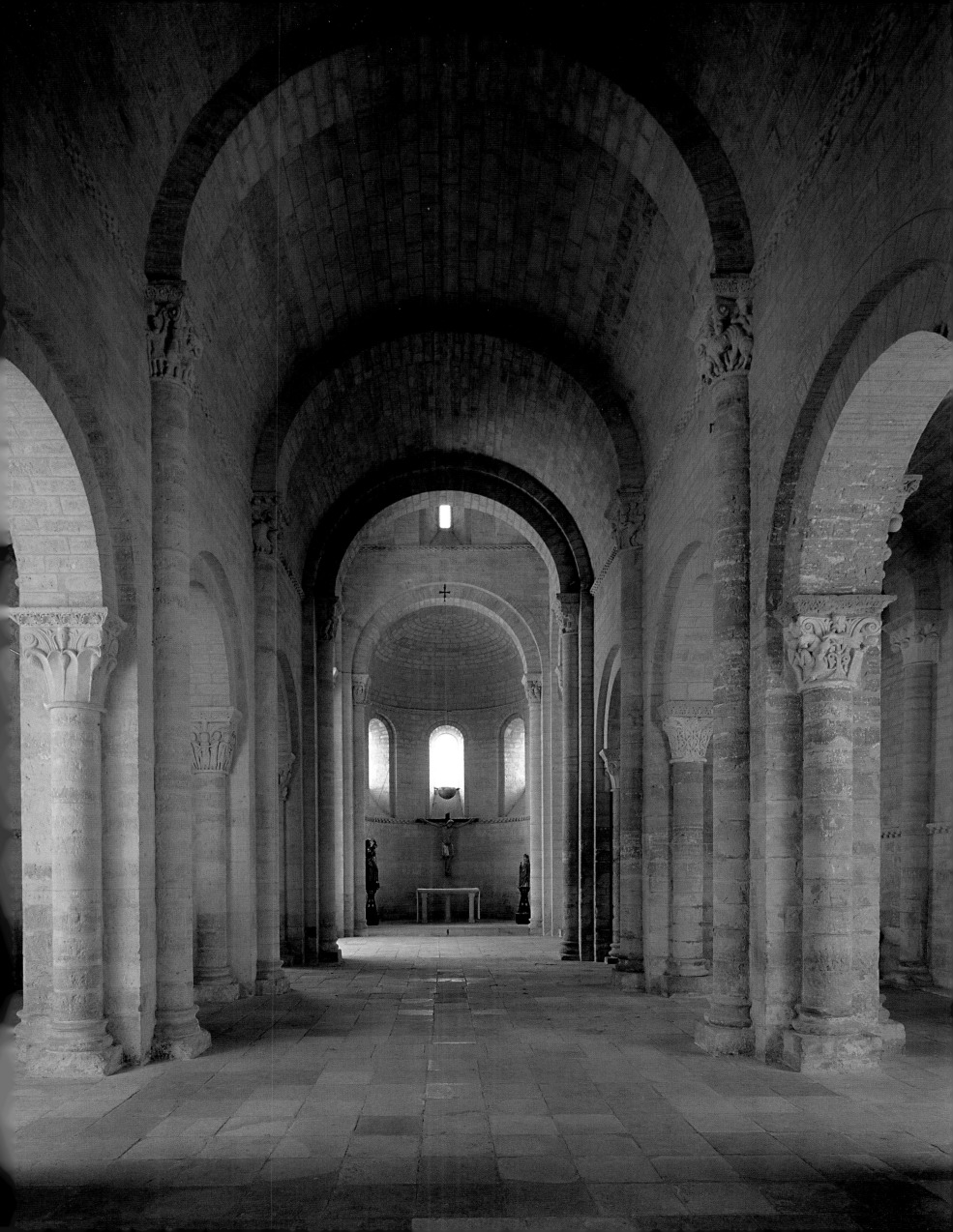

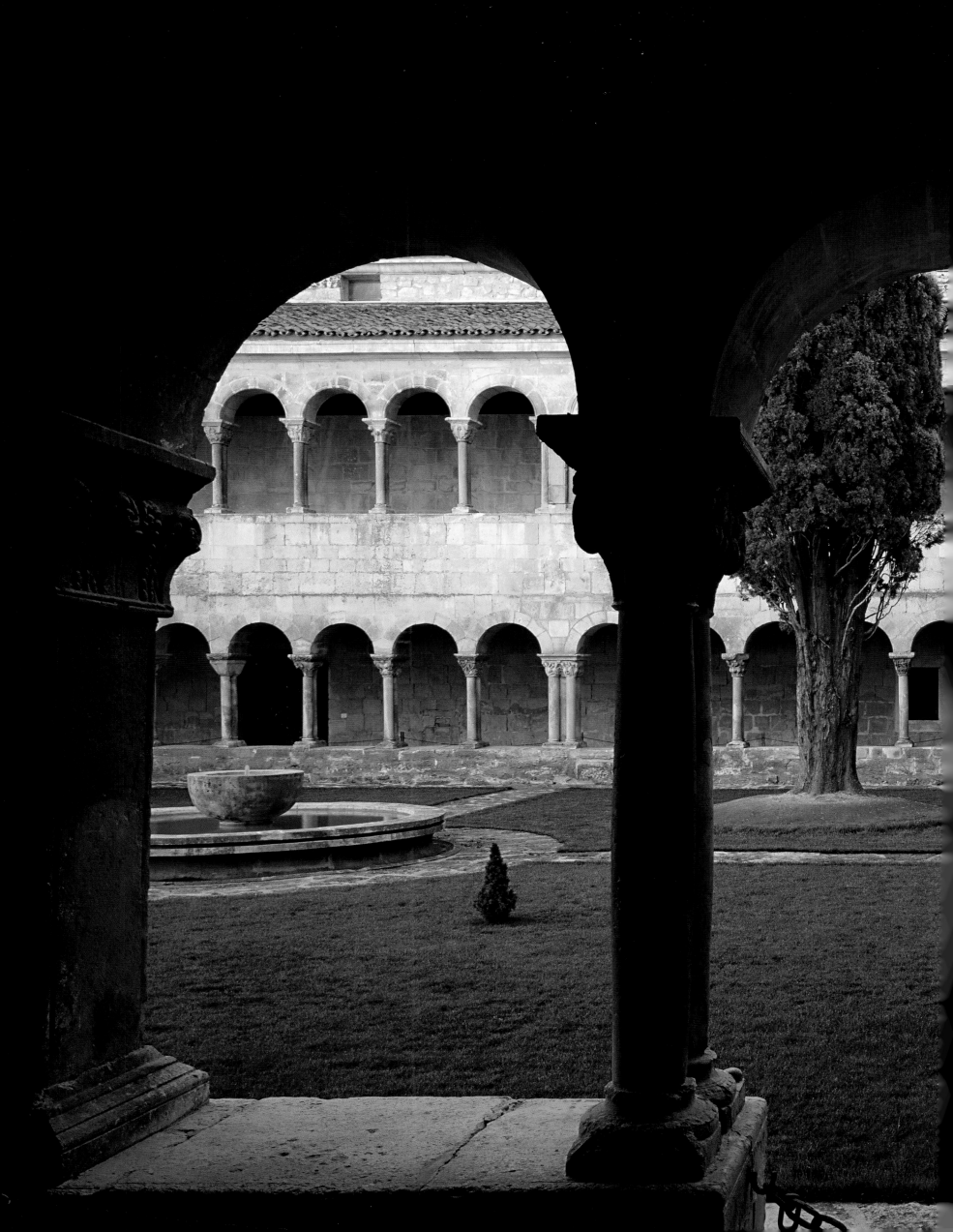

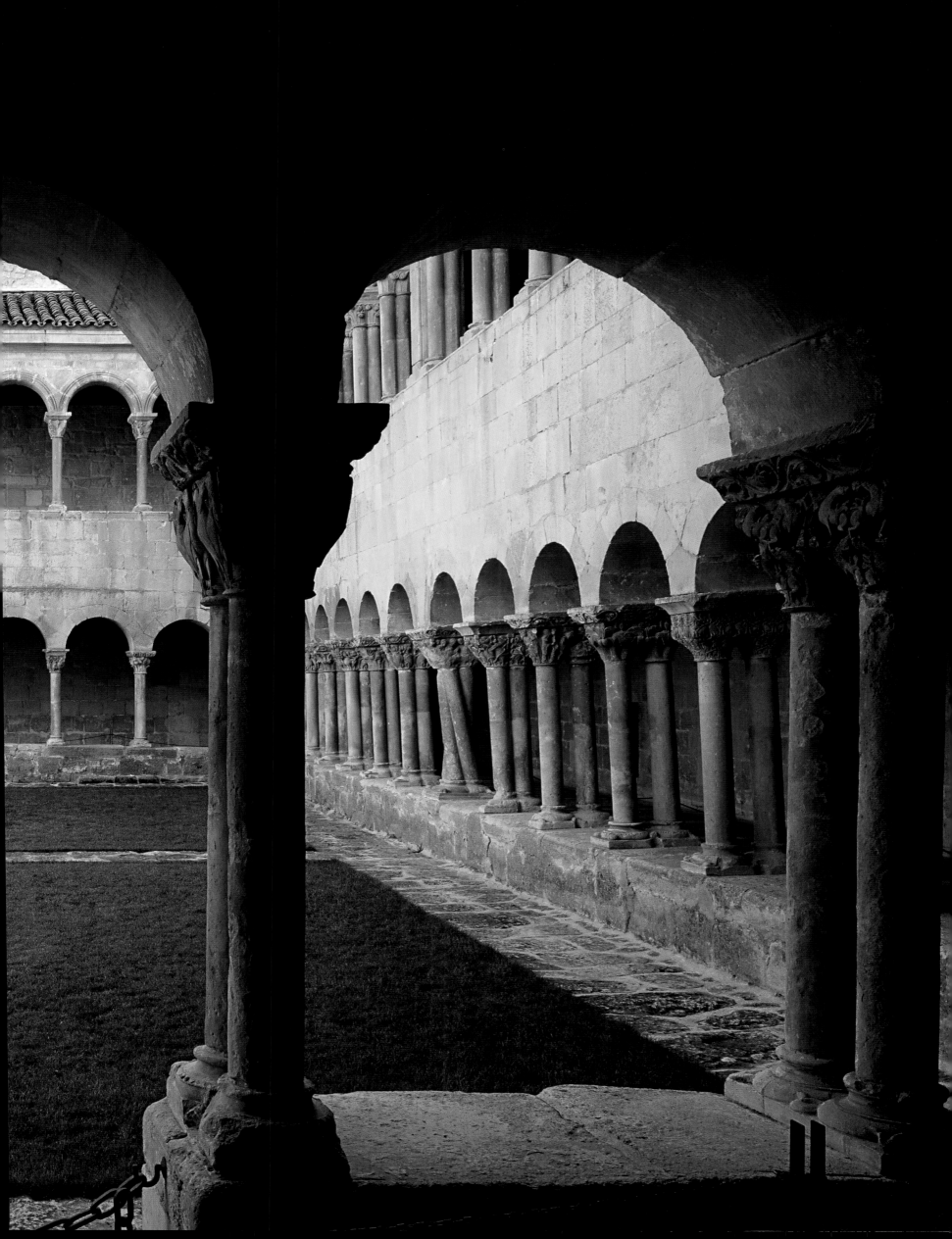

BELOW AND CENTER:

Santiago de Compostela, cathedral, begun ca. 1075, Pórtico della Gloria or Gate of Glory (below), a work of Master Mateo, 1168–1188; interior view looking east

The highlight and goal of all pilgrimages to Spain was the church dedicated to St Jacob, whose grave was discovered in 813 under miraculous circumstances in a region occupied by the Arabs. The patron saint of Spain and the poor, his church—its construction was supported by King Alfonso VI—

belongs to the type of the pilgrimage church. The nave and transept have three aisles, and the choir ambulatory has five radiating chapels. The Gate of Glory, the center portal in the west facade, is framed by a tympanum with many figures created by Master Mateo in the Burgundian tradition.

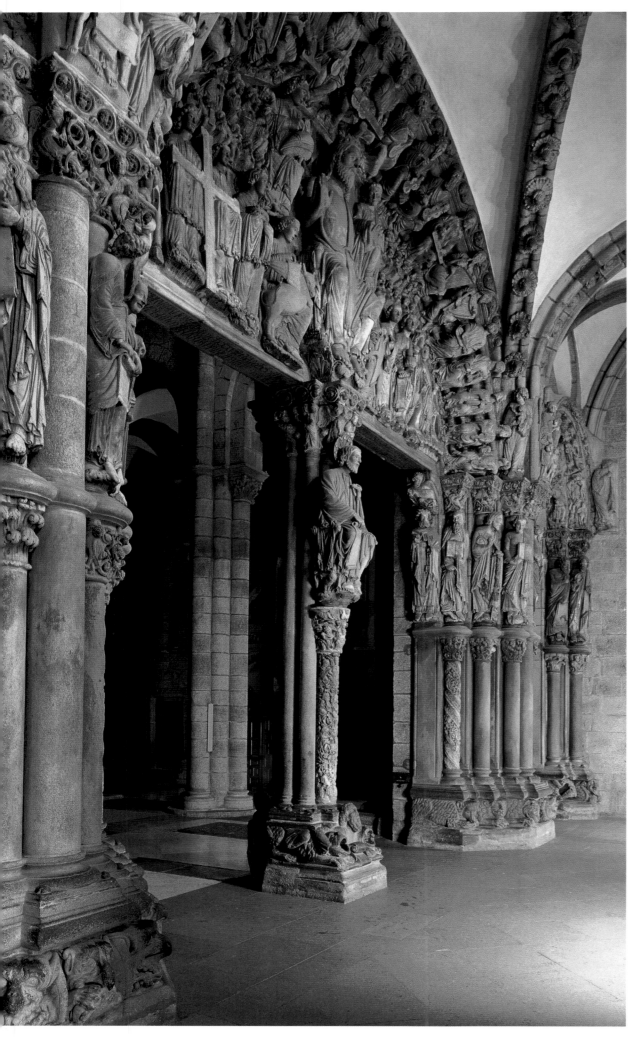

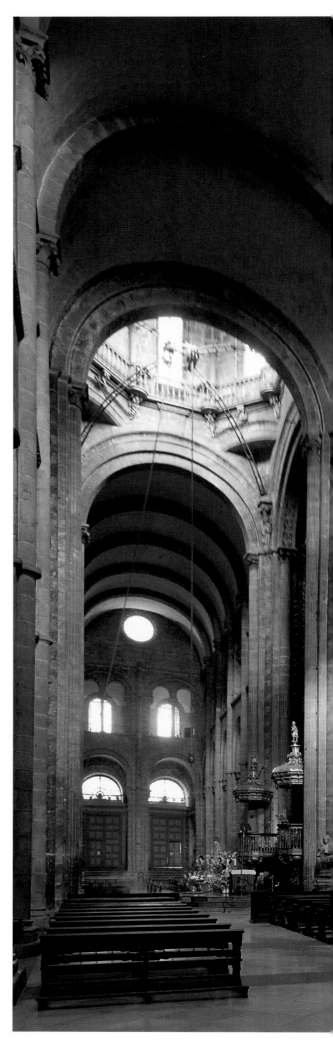

León, San Isidoro, Royal Pantheon,
ca. 1063–1100, detail of vault painting

West of San Isidoro, Doña Sancha had the
Panteón de los Reyes, or the Royal Pantheon,

built as a sepulchral monument for the kings.
It is a groin-vaulted hall church with three
times three bays, elaborately structured and
containing excellent sculpted work. All the
vaults and lunettes are covered with frescoes.

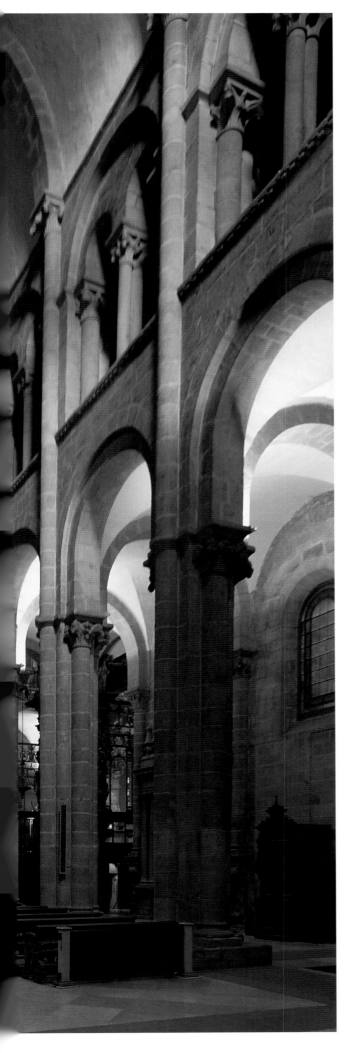

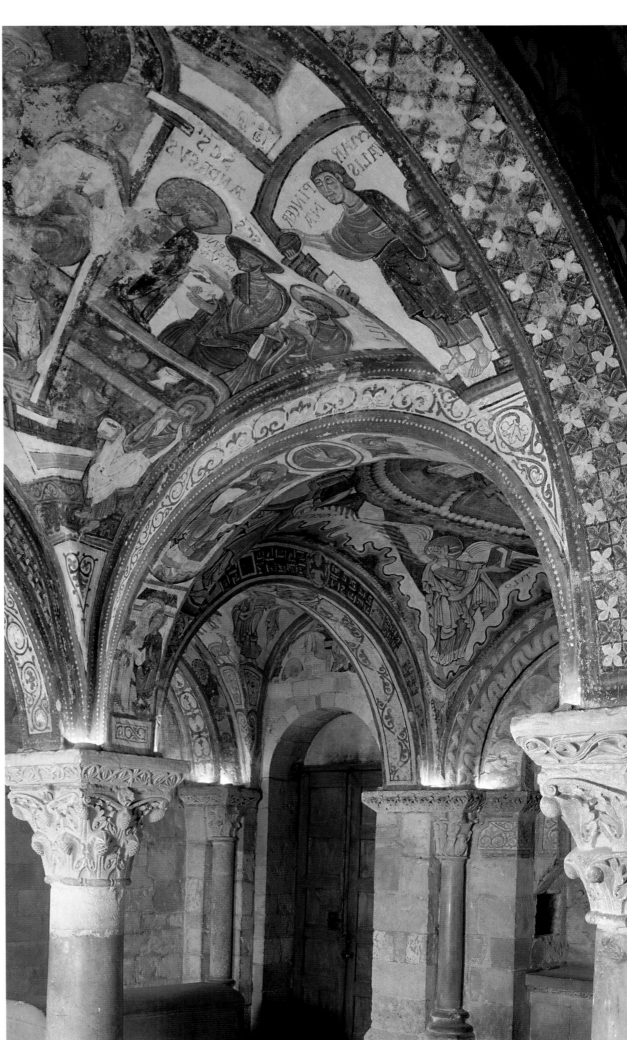

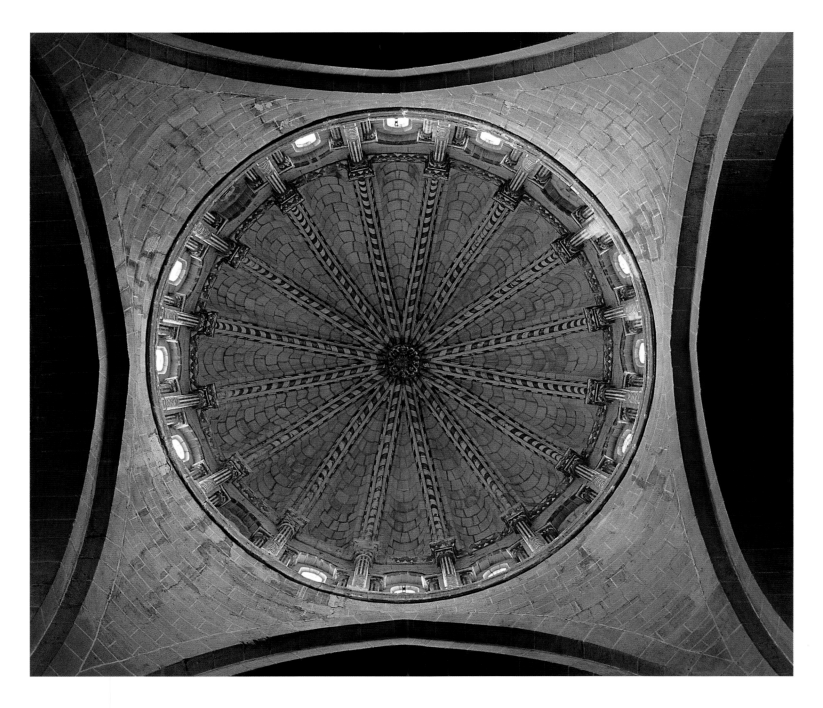

ABOVE AND RIGHT:
Zamora, cathedral, 1151–1171,
interior of the crossing dome;
view from the southwest

OPPOSITE:
Toro, collegiate church of Santa María la Mayor,
begun 1160, view from the south

Built around the mid-12th century, Zamora and
Toro share a series of traits: short naves with three
aisles, wide side aisles, relatively short transepts, a
choir with three apses, and especially the unusual
ribbed domes above their crossings.

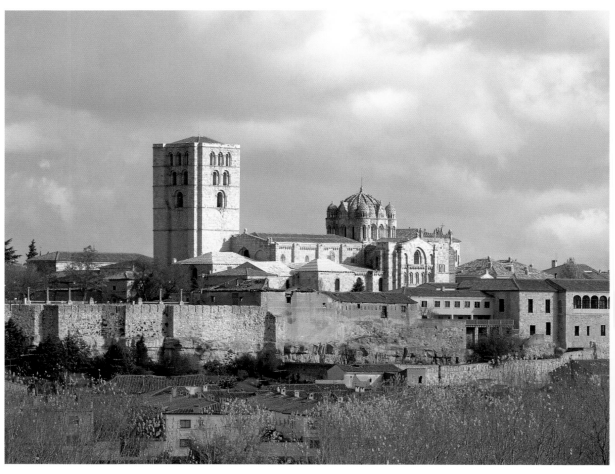

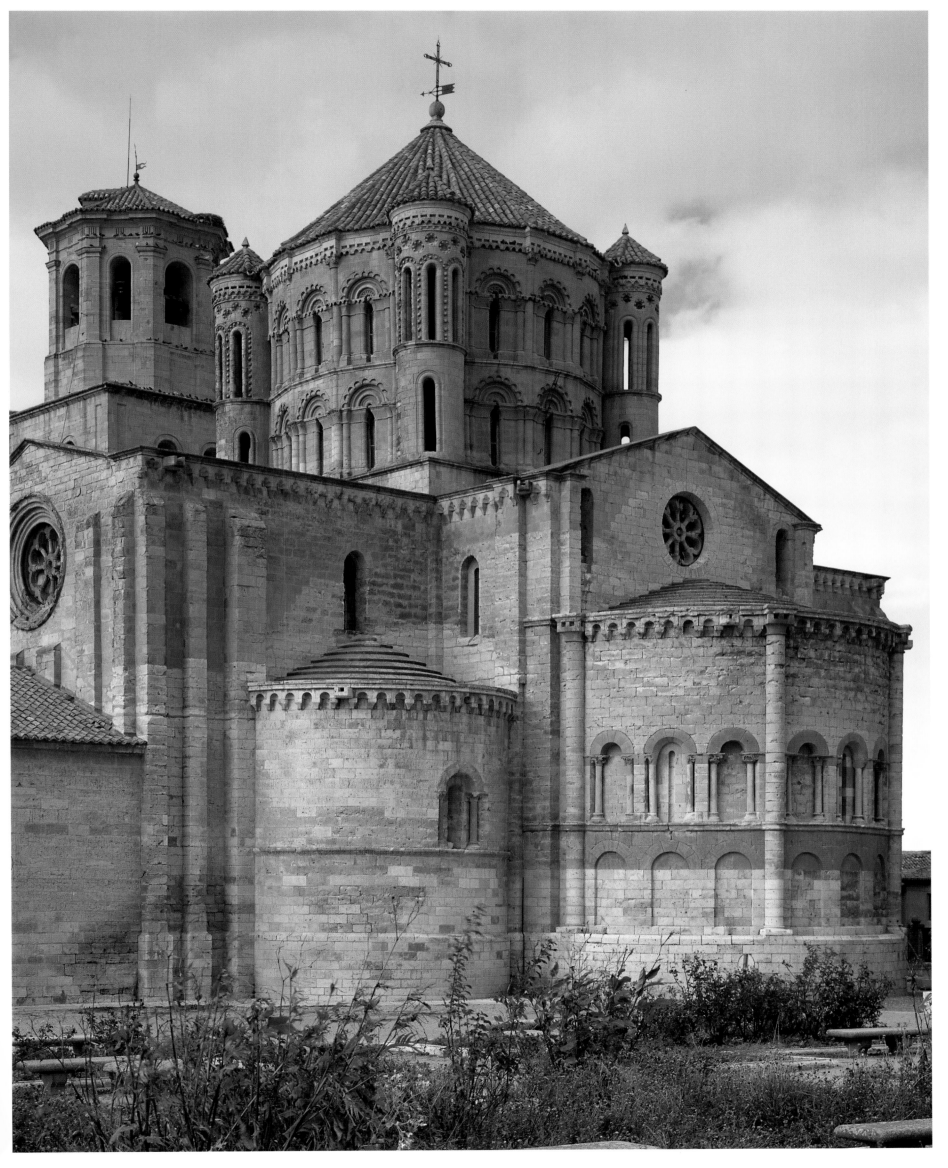

Gothic Sacred Architecture

The term Gothic refers to European art created between around 1140 and 1500. One must bear in mind, however, that the new architectural ideas being developed in Île-de-France and northern France spread to other regions at very different time spans. And in Italy, for example, the Gothic was overtaken by the Italian Renaissance soon after 1400. The overwhelming popularity of humanist thought and classical building structures were accompanied for many by a deep disdain of the period, which would not be redeemed until the Romantic Movement in the nineteenth century. Gothic evolved to its zenith in France over the course of half a century, becoming the building style *par excellence* for cathedrals. It lived on even into the sixteenth and seventeenth centuries, as can be seen for instance in the cathedral of Orléans.

France

Many of the architectural motifs and forms considered typical for the Gothic era were developed as early as the eleventh century, mainly in religious buildings in Normandy and Burgundy. By the mid-twelfth century they were commonly known: bays that are always equal in size, pointed arches, the triforium, the twin-tower facade, the choir ambulatory, the double-shelled wall, and even the rib vault. But what distinguishes Romanesque from Gothic sacred architecture? What is specifically Gothic? Who or what initiated a transformation in sacred architecture and why? In the pages that follow, we will attempt to answer these questions.

Let us start with the characteristics: technically speaking, the development of an exterior support system was a precondition for all the architectural developments of the twelfth and thirteenth cen-

turies. Over the course of the eleventh century, builders had attempted to perfect the stone barrel vault, the weight of which was distributed over the entire length of the nave walls, calling for extremely thick walls and limiting the nave's width. The invention of the rib vault made it possible to distribute the weight among the four or six vertical supports that define a bay. Then, thanks to external buttresses, the wall became merely a shell, its thickness no longer relevant to the structure's stability. Norman architects had already pursued the idea of adding spaces on the various levels, abandoning their attempts at vaulting in the process. Buttresses allowed this idea to be developed freely, and nave walls became lighter and lighter. Stained glass techniques and glass painting flourished parallel to buttressing, and colorful windows of previously unknown dimensions came into existence that bathed the spaces in mystical light, at the same time presenting extensive cycles of images with pedagogical content. The new structural system also made larger spaces possible. Ever taller and wider naves were built. The choir of the Beauvais cathedral, begun in 1225, was more than 154 feet (47 meters) high and the center aisle measured 52.5 feet (16 meters) in width. Only the spectacular collapse of the cathedral put an end to these attempts, and then only temporarily.

The treatment of the walls also underwent fundamental changes in the twelfth century. Almost universally, in churches built in the eleventh century the arcades rested on cross-shaped piers with responds that continued up the clerestory walls to support the transverse arches or ceiling rafters. The stepped arcades looked as if they had been carved out of the walls. The Gothic, however, aimed at sculpting all elements to achieve a certain physical-

Chartres, Notre-Dame cathedral, after 1194, detail of the south wall with buttresses

ity. It switched to cylindrical columns for support, out of which rose three or five responds that picked up the lines of the vaulting. Thus, in the triforium and gallery zones, three-dimensional bundles of columnar responds replaced sections of the wall. These respond bundles were "bound" at regular intervals by shaft rings. In the nave of the Laon cathedral (illus. pp. 160/161), these coincide with the lines of the cornices that separate the elevation zones, highlighting the proportional relationship of the different stories (5:3:1:3—arcades:gallery:triforium:clerestory). Finally, the invention of the

Saint-Denis, former Benedictine abbey church, built between 1140 and 1144, exterior of choir

Noyon, Notre-Dame cathedral, exterior of choir, probably begun mid-12th c.

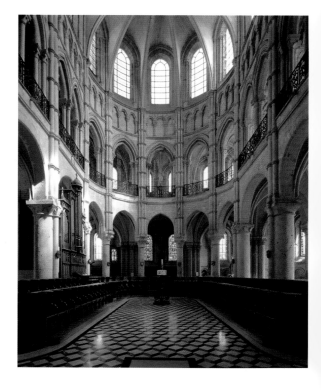

Noyon, Notre-Dame cathedral, interior of choir

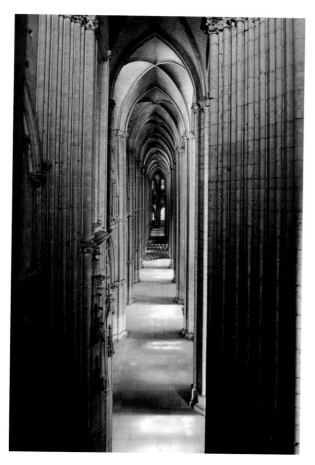

Bourges, Saint-Étienne Cathedral, begun 1194, inner side aisle

For the floor plan the Gothic era adapted the choir ambulatory with slightly protruding chapels (see below). In contrast to the eleventh century, they are no longer treated as separate rooms, but as glassed-in extensions of the ambulatory and often of the three-aisle transept. The reason the three-aisle transept was favored probably lies in the Gothic aspiration to attain uniformity and visual unity throughout the building. The same effect was sometimes achieved by omitting the transept altogether, as for example at Bourges (begun 1194). The choir ambulatory was the logical consequence of this effort: its elevation could be continued around the entire complex—by the way, another reason for the almost exclusive use of round pillars. Apart from that, the ambulatory with its chapels formed a complex spatial enclosure around the choir. Saint-Denis in Paris (begun 1163) and the cathedral of Bourges have ambulatories with two aisles. The naves of the latter two have five aisles—exceptional even for the Gothic period. In Paris, the side aisles are of equal height, so that they form a wide hall ambulatory that originally contained no chapels. The cathedral of Bourges, however, is unique, and still one of the most beautiful churches of the Gothic era (illus. left and pp. 170–173). Possibly following the example of Cluny III—an attempt that was replicated in the choirs of Le Mans and Coutances—it consists of a double basilica. This

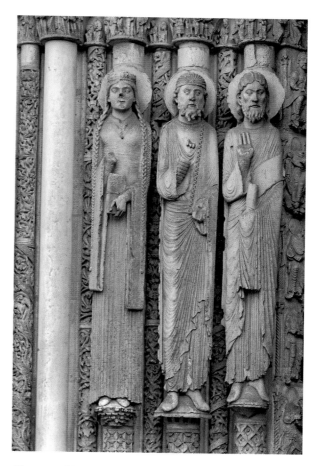

Chartres, Notre-Dame cathedral, main entrance of the King's Portal, figures on left facing, ca. 1145/55

compound pillar in the cathedral of Chartres (illus. p. 169) fulfilled the Gothic's desire to attain visual uniformity and unity of all building elements.

The freedom in designing nave walls led at first to a four-zone elevation, with which the cathedral builders in Worcester and Gloucester had already experimented. Above the gallery and below the clerestory was a row of blind arches that visually opened up what in earlier designs had been a solid wall covering the gallery vaulting. The earliest four-story elevation in France could be seen in the Suger choir of the abbey church of Saint-Denis, near Paris (1140–1144). It was adopted in the cathedrals of Senlis and Noyon (both begun around 1150/1155; illus. p. 142 bottom). In the nave of Noyon (at Senlis the windows have been changed at the expense of the original triforium) the arcades of the triforium zone disengage from the floor and form a walkway underneath the clerestory. Colored light enters through the almost completely glassed-in chapels, the tall gallery windows, and the clerestory, creating a vivid play of light and shadow on the sculpturally decorated walls.

The cathedral of Chartres was innovative in more than just the shape of its pillars; it was also the first that did away with a gallery. Thus, an elevation with three zones came about that had clerestory windows comparable in size to the arcades, as well as an uninterrupted triforium that held the entire elevation together like a belt (illus. p. 169). The springline of the vault, which had previously always started at the bottom of the clerestory, was now moved partway up it. This elevation program was very successful, and became the standard for French cathedrals of the thirteenth century. Reims (begun 1211) regularized the compound pillars—which in Chartres still alternated between octagonal with round responds and round with octagonal responds—and created the continuous band of capitals on those pillars. In Amiens we encounter the earliest windowed triforium (illus. pp. 176–177).

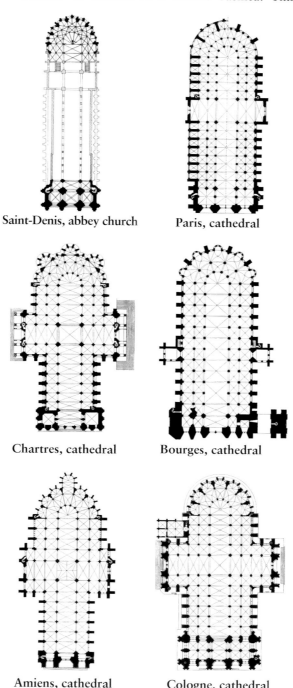

Saint-Denis, abbey church **Paris,** cathedral

Chartres, cathedral **Bourges,** cathedral

Amiens, cathedral **Cologne,** cathedral

means the nave arcades, above which are a triforium passageway in the form of a gallery and triple clerestory windows, frame the elevation of the inner side aisle, which is almost identical to that of the nave. The enormous height of the inner piers visually unites the center aisle and the interior side aisles into one enormous hall flanked by the darker corridors of the outer side aisles. Very slender semicircular responds surround the massive pillars, whose inward-facing segments continue up the clerestory wall. This architectural trick gives the observer the impression that the pillars continue along the interior of the walls and support the vaulting all by themselves. On the other hand, the wall gains a special quality by the alternation of flat and rounded elements, the same tension that is achieved, for example, by the alternation of extremely tall and extremely squat supports.

It is logical that thirteenth-century architecture, with its inclination toward sculptural composition and delineation, became the impetus for the rapid and complex development of architectural sculpture. Portal and capital had existed throughout the twelfth century. Taking those overly slender figures that seem hardly to have a body at all (illus. above) as a starting point, a new style emerged during the late twelfth and thirteenth centuries, informed by sculpture from antiquity as well. The figures on capitals were replaced by bud and vegetal motifs.

One building element, more than any other, rose to great prominence during the Gothic and opened up a whole new area of design: the window. The invention and development of tracery for the structuring of the windows entailed as much change in High and late Gothic wall composition as the exterior system of buttresses during the early Gothic period. In the oldest churches of early Gothic—Noyon, Laon, Paris, and Saint-Denis—the windows were in the form of undivided lancets. An iron grid held the colored panes in place and braced them against wind. In the choir of Saint-Remi in Reims—

143

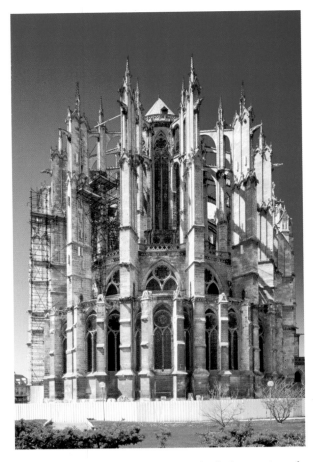

ABOVE: **Beauvais, Saint-Pierre Cathedral**, exterior of the choir, begun 1225, rebuilt after collapse in 1284

RIGHT: **Saint-Denis, former Benedictine abbey church**, nave facing east, after 1231

BELOW: **Laon, Notre-Dame cathedral**, begun before 1200, detail of facade: gargoyle

which replaced its Romanesque predecessor around 1170/1180, and has a four-zone elevation—each clerestory bay has three lancet windows. The central one is taller, accommodated by the peak of the vault. It seems as if slender colonnettes and profiled round frames have been carved out of the wall, and continue downward into the triforium structure. In the nave at Bourges, the triple lancets are of equal height and barely extend into the shield arch, which contains an oculus. The three-zone wall program at

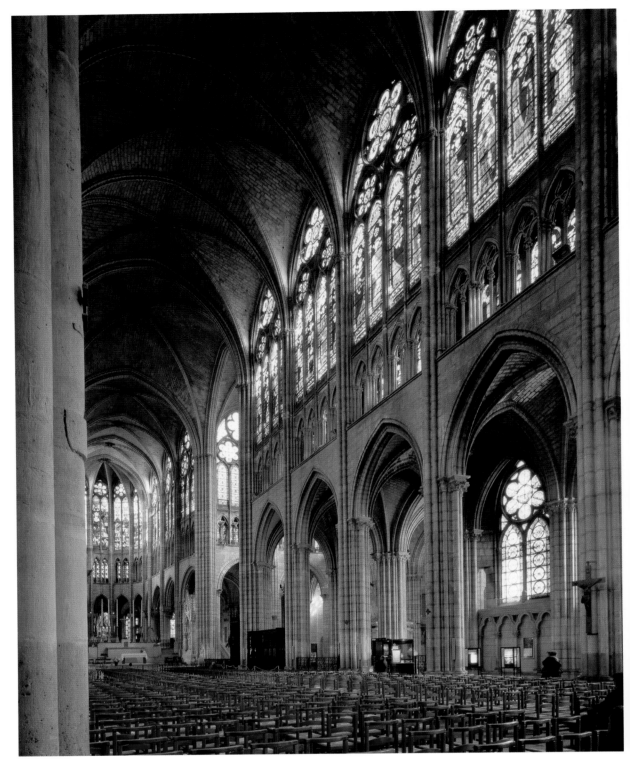

Chartres made the clerestory windows even taller. Their interior structuring is clearly designed with the aim of bringing in more light. Since the oculus is located in the spandrel between two lancets, the remaining solid wall area has been markedly reduced.

The first real tracery appeared shortly after 1211 in the choir chapels of the cathedral in Reims. The remaining wall area between the openings is reduced to narrow bridges. The improvement over "panel tracery" lies in the ability to create even taller windows and make them even more prominent in the architecture, as well as the ability to unify the shape of the windows throughout the building. As early as in the early Gothic choir of Saint-Remi, the bridges between the lancets extend upward into the triforium, giving it a three-part structure as well. Next, in the main choir of Reims cathedral, this feature is developed to its fullest extent: the round staves that were laid on top of the tracery staves continue downward in order to create an inter-dependent articulation between the triforium and the clerestory windows. Later on, this allowed the tracery, with its manifold forms, to be transformed into a web that took over the entire wall, even

replacing it. Examples are the nave, transept, and upper parts of the choir at Saint-Denis (illus. above), the choir of Beauvais cathedral (from 1250 on-ward), Saint-Ouen in Rouen (first half of the four-teenth century), and others.

The facades at first still exhibited the three-portal motif that went back to the triumphal arch: three groups of windows and an arched gallery for figures (Saint-Denis, Laon, Paris). With the use of tracery and blind tracery, facades became constructions consisting of smaller and smaller forms filling up every free space. Baldachins, pinnacles, crockets, gabled arches, fleurs de lis, and gargoyles were added as well (illus. left). Thus the choir exteriors, already quite busy with their buttresses and flying buttresses, create a confusing and at the same time fascinating spectacle in which lines meet, cross each other, move apart, and create new structures at every turn (illus. above left).

Amiens marked a temporary pause in the evolu-tion of Gothic church architecture. The architecture of the period that followed is classified under the term Rayonnant, from the French word for radi-ating light. During this period, the structure and

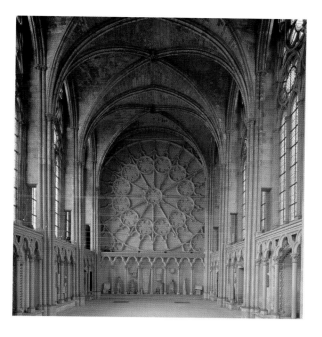

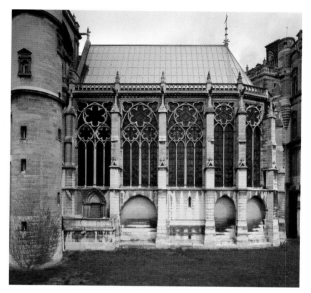

ABOVE: **Saint-Germain-en-Laye, former royal palace chapel of Notre-Dame,** begun 1238, exterior and interior

ABOVE RIGHT: **Évreux, Notre-Dame cathedral,** choir, begun just before 1300, interior

CENTER RIGHT: **Rouen, Saint-Ouen,** begun 1318, interior looking east

BELOW: **Saint-Germer-de-Fly, former Benedictine abbey church,** ca. 1260/65, exterior and interior of the choir apse chapel.

tracery forms developed into ever more delicate and filigreed patterns. Again we come to Saint-Denis; this time to its nave (illus. p. 144 top), which replaced the old Carolingian one beginning in the 1230s (a Suger nave had certainly been planned here, but was never built). The compound piers of the five-aisle building are fully encased in tightly spaced, slender columnar responds, three of which rise up to the springing of the nave vault. Here the springline coincides with the curved part of the windows. Enormous tracery rosettes, which give the impression of being as thin as parchment, fill the entire upper wall of the transept fronts. The royal chapels of Saint-Germain-en-Laye (illus. above) and the Sainte-Chapelle in Paris (illus. p. 183), with their slender, fine structuring, belong in this context, as do the choir chapel of Saint-Germer-de-Fly (illus. right), the cathedral of Carcassonne (illus. p. 180) and many more.

After 1300, this development eventually transformed the triforium zone into a balustrade for the clerestory windows. The cathedral of Évreux (begun around 1300) and Saint-Ouen in Rouen (begun 1318) are early examples (illus. right). The upper walls lose even more of their substance; once the triforium passageway has been dispensed with they become thin, richly perforated foil. Marking the conclusion of this development is the cathedral of Nantes, begun in 1434 and not finished until the eighteenth century, with its immensely high arcades between strand-like, finely detailed piers.

The impetus behind the quest for new forms can almost always be linked to changes in power structures and society. King Louis VI (1081–1137), the first Capetian on the French throne, with counsel from Abbot Suger of Saint-Denis, began to reinforce the position of the French king. He subdued the vassals of the crown domain, who had been making too many demands, and sought unity with the Church and the cities. His claim was comprehensive: He not only invoked the authority of Charlemagne, who had been crowned king of the Franks in Saint-Denis, and Charles the Bald, who was buried there alongside the other Frankish and French kings, but also the role of the king—especially the French king—in God's plan for salvation. His son Louis VII (1120–1180) took part in a crusade together with Conrad III. Abbot Suger served as regent of France during that time, and remained Louis' most important advisor until Suger's death in 1151. After that point Louis divorced Eleanor of Aquitaine, whose subsequent marriage to Henry II of England provided the foundation for the latter's far-reaching claims of sovereignty.

The major beneficiaries of the new distribution of power were the cities and especially the bishops, under whose influence popular religious beliefs changed. Until then the desire of the faithful had focused on touching saints' relics that were kept in the crypts and multiple altars at monasteries. In the eleventh century, this brought about an economic and political blossoming of the monasteries (Cluny, for example). Now it was in the interest of the bishops and church chapters to shift the focus of the faithful toward the cathedrals, so a liturgy evolved that had the bishop at its center. Instead of worshipping the saints by touching their relics, the people worshipped the Holy Host, visually participating in the mystery of the Eucharist, the changing of bread and wine into the flesh and blood

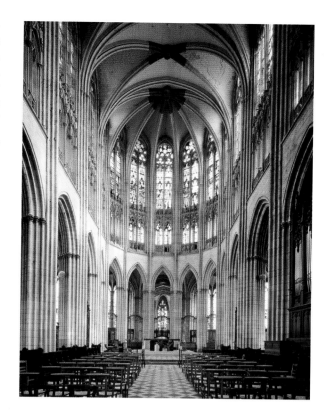

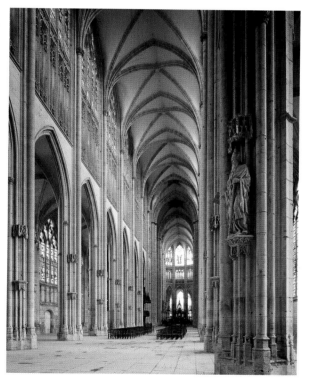

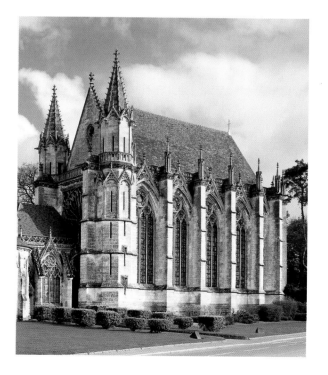

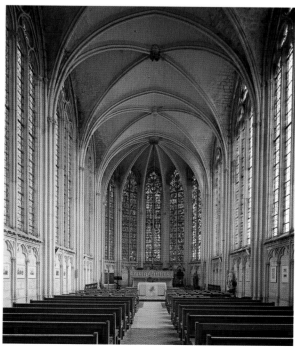

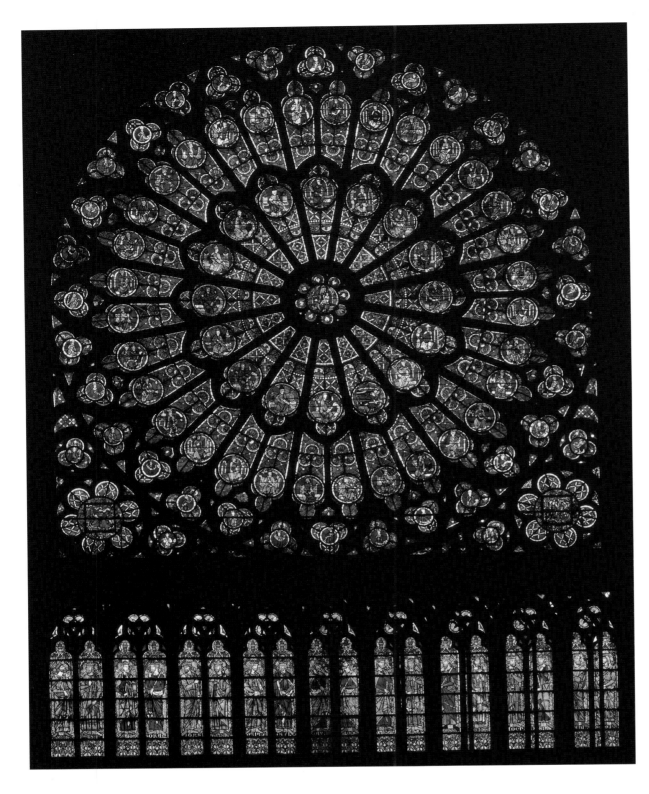

On the ground floor are three large portals that are strongly reminiscent of Roman triumphal arches. In the upper story are several chapels. A crown of pinnacles embraces the massive building, whose tower-like buttresses lend it a sculptural effect and give it the look of a city wall—undoubtedly a reminder of the abbot's worldly power as well as a reference to the Heavenly Jerusalem. But this west end also imitates in form and function the westworks found in Carolingian buildings that were closely associated with imperial power.

Even more manifest is Suger's solution for the choir, begun in 1140, of which unfortunately only the lower zone still remains. Clearly influenced by the pilgrimage churches, Suger built an ambulatory with chapels. What is completely new, however, is the fact that the chapels are directly adjacent to one another and are accompanied by a double ambulatory with extremely slender supports that do not partition the space, but rather seem to integrate it (Saint-Germer-de-Fly and Saint-Martin-des-Champs, occasionally pointed out as forerunners, were actually changed to follow the example of Saint-Denis). Thus arose the four-part floor plan—choir, inner ambulatory, outer ambulatory, and chapels—that was repeated in the elevation. There a gallery, triforium, and clerestory stood above the arcade level, a structure that can be seen in churches subsequent to Saint-Denis, for example, Senlis and Noyon. The extraordinary proportion of stained glass wall surface in the chapels created a shell of colorfully shimmering light that shone directly into the choir, thanks to the slender support structure. From there the light continued through the gallery and the clerestory. Suger himself spoke of the *lux continua*, or continuous light, referring to the uniformly colorful light throughout the entire choir section. Saint-Denis set the standards for sacred architecture. In regions that were not part of the crown domain, special Gothic forms emerged.

In Burgundy, the Cluny III model had an especially long-lasting influence, and the first Gothic buildings were not erected until shortly after 1200. The earliest example is the choir of the Cistercian church of Pontigny, begun around 1185 to replace

of Christ as performed at the altar by the priests and deacons. The liturgy became a manifold, complex, and cozening spectacle. Its precious robes and church implements used during mass, the colorful light from the windows, the polyphony of church music (which also has its origins in this time), and the rites themselves wove a dense web of symbolic and allegorical allusions to the mingling of the heavenly and earthly spheres during mass. The hierarchy among clerics took on new significance. It was no longer immaterial who celebrated the mass; the person of the bishop could now make his presence known while at the same time maintaining his distance from the congregation.

The new liturgy required spaces that eleventh-century churches did not offer. There needed to be a way to walk all the way around the main altar so that the rites taking place there, as well as the church treasures (relic shrines, grails, lusters, etc.) located on the main altar, could be seen clearly from all sides. The church interior needed to be well-lit, spacious, and apparently required a certain uniformity of architectural design to create a visual connection between the public areas and the space

reserved for the clergy, which was still elevated and sectioned off by the choir rood.

Two large buildings mark the beginning of the Gothic era: the cathedral of Sens, a gallery basilica with a six-part vault and originally only a narrow transept (clerestory windows and transept were later enlarged) in the tradition of the Norman churches (illus. right), and the west end and choir of the abbey church of Saint-Denis near Paris (illus. pp. 158/159). In charge of the construction there was Abbot Suger, the regent of France. Saint-Denis is a programmatic edifice. Suger began his building enterprise, which he documented meticulously, with the restoration of the imperial memorial to Charles the Bald, thus invoking the Carolingian tradition of the French kings. The alliance between king and church, which he advised King Louis to revive, went back to Charlemagne. Charlemagne had built his Palatine Chapel in Aachen using models and motifs that reflected carefully chosen parallels in sense and meaning and thus created a new style. Suger chose the same path in Saint-Denis. The west end, begun in 1137 (altered in the eighteenth and nineteenth centuries), has three aisles and a depth of two bays.

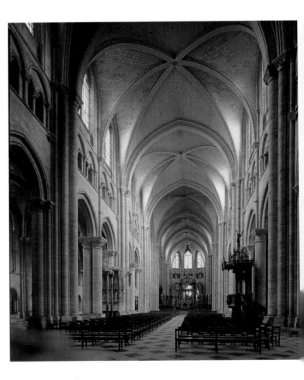

Sens, Saint-Étienne Cathedral, begun 1140, nave

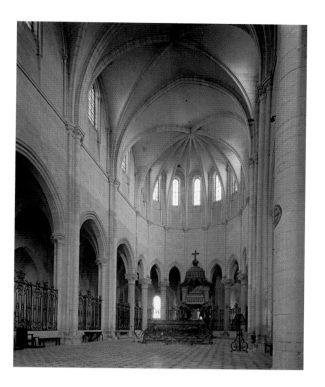

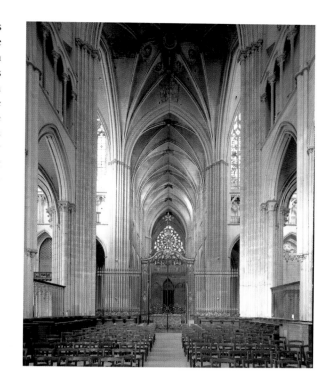

the older, straight choir (illus. left and p. 7). Its motif of chapels arrayed in a broad semi-circle would play a role in the German late Gothic. From the outside, only the open buttress system reveals that the upper choir has a rib vault. The chapels, in a radiating arrangement, are still set off from the ambulatory in Romanesque fashion. Similarly, in the two-zone upper choir it is only the individual forms of the arches, capitals, and rib vaults that identify the choir as Gothic. Among Burgundy's important Gothic churches are the choir of Sainte-Madeleine in Vézelay (late twelfth century), Saint-Père-sous-Vézelay (from 1225/1230), the cathedral of Auxerre (illus. right, erected from 1215 on the site of several consecutive predecessors and still showing early Gothic characteristics in the choir), the city church of Notre-Dame in Dijon (a simple yet elegant building from around 1220/1230, with a unique facade), the nave of Saint-Bénigne in Dijon (replaced an older one from 1001–1018), Notre-Dame in Semur-en-Auxois (1220/1225 and after), Notre-Dame in Auxonne (1235/1237 and after), and Notre-Dame in Cluny. In addition, a whole series of simple, beautiful country churches were built, some of which were originally castle churches, including Talant (1240/1245 and after), Rouvres-en-Plaine (1233 and after), Saint-Thibault-en-Auxois (1240/1250 and after), and others.

In Normandy, the early Gothic style from Île-de-France was adopted quickly, even though this region was under British rule and only returned to France in 1204 under King Philippe II Auguste. There, mostly cathedrals were built: Lisieux (from ca. 1160/1170), Coutances (illus. pp. 178/179), Bayeux (illus. right), Rouen (from 1200), the choir of Le Mans, (1217–1234), as well as abbey churches such as Fécamp, Mont-Saint-Michel, Jumièges, and the choir of Saint-Étienne in Caen (illus. left). In many places, however, the forms of the supports, the reduction or abandonment of a triforium, the retention of galleries or similar openings, and the clerestory passageway still clearly recall Norman traditions. The decorations in the spandrels link Normandy with England.

King Henry II of England claimed the west of France when he married Eleanor of Aquitaine after her divorce from Louis VII. Therefore, only very few Gothic projects were built there. The cathedral of Angers, begun around the mid-12th century, is an aisleless church with a transept, a semi-circular apse, and a two-zone elevation. Characteristic are its dome vaults with slender, affixed ribs, the so-called Angevin vaults. Other examples of those vaults are Saint-Serge in Angers (early thirteenth century) and the cathedral of Saint-Pierre in Poitiers, a three-aisle hall church that displays more Romanesque than Gothic characteristics.

The Duchy of Toulouse and the Languedoc were ruled until 1271 by the Count of Toulouse, whose power was broken during the Albigensian Wars. Not until then were cathedrals built: Narbonne (illus. right), Carcassonne (illus. left), Perpignan (from 1324), and Montpellier (from 1364). Perpignan testifies to the strength of local traditions in the south, as well: it is a single-aisle wall pillar church with simple oculi in place of a clerestory. Narbonne and Carcassonne are beautiful, richly structured buildings of the late Gothic era.

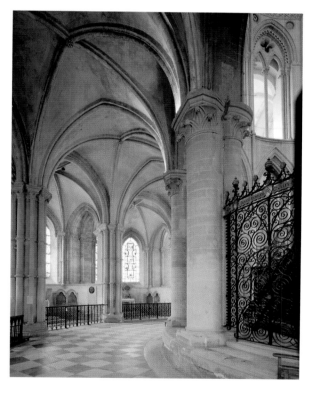

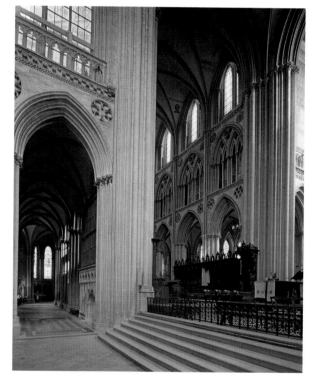

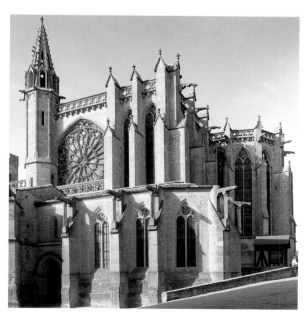

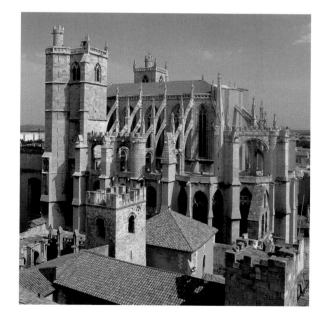

TOP: **Pontigny, former Cistercian abbey church,** interior of choir, last third 12th c.

CENTER: **Caen, Saint-Étienne,** choir ambulatory, ca. 1200

LEFT BOTTOM: **Carcassonne, Saint-Nazaire Cathedral,** begun 1283, choir and transept

RIGHT BOTTOM: **Narbonne, cathedral,** from 1272

ABOVE: **Auxerre, Saint-Étienne Cathedral,** 1100/20– mid-13th c., interior facing west

CENTER: **Bayeux, cathedral,** choir, ca. 1230–1245

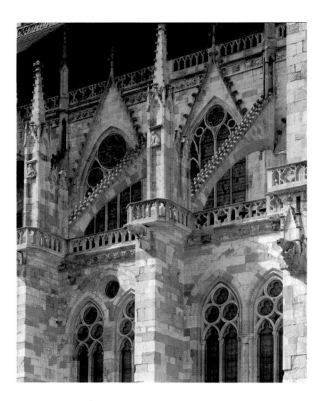

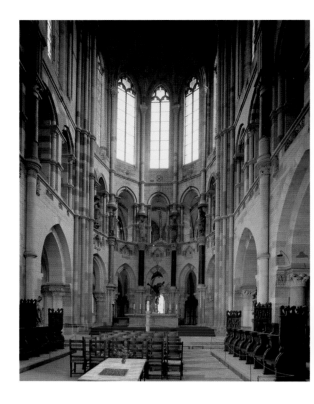

LEFT: **Regensburg, cathedral**, begun 1273, detail of exterior wall with buttresses

RIGHT: **Magdeburg, cathedral**, early Gothic choir (from 1209) incorporating columns dating to antiquity from the preceding Ottonian construction

CENTER: **Cologne, St Peter und Maria**, begun 1248, choir dedicated 1322, exterior view from east

BOTTOM: **Strasbourg, cathedral**, west facade, begun 1277

terns. Thus in the Münster cathedral, the builders experimented with so-called Angevin vaults from western France; in the cathedral of Limburg an der Lahn (1215–1235), an early Gothic four-part elevation following the example of Noyon was combined with the alternating supports typical for the Rhine region, six-part rib vaults, and a richly decorated late Romanesque exterior. Magdeburg cathedral (illus. right)—whose Ottonian predecessor had

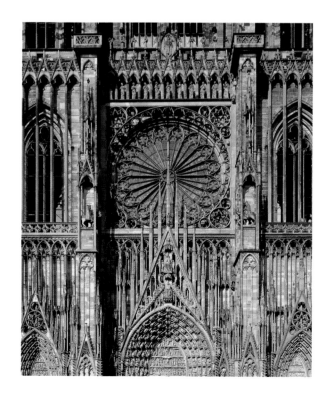

Germany

The Gothic style reached the German-speaking regions only after a long delay. While one can find rib vaulting in structures from as early as the second half of the twelfth century in Alsace, the new ideas from France did not find their way across the Rhine River until after 1200.

The political situation in the German countries during the thirteenth and fourteenth centuries was different from that in France, where the Gothic style had come into existence and was developed as an instrument of the royal house and the bishops, its political allies. In the power vacuum during the competition for the throne between the Staufens and Guelfs, German bishops did gain influence as well, but their relationship with their kings was quite the opposite of that in France. The cathedrals in Bamberg, Naumburg, Halberstadt, Regensburg, Cologne and Strasbourg are witnesses to the bishops' power, but they met stiff competition from the bourgeoisie as it gained wealth and self-confidence. The prospering cities organized themselves and acquired the parish rights that hitherto had belonged to monasteries. The Gothic style thus became an expression of the urban population's pride and claims in some places. The third significant source of construction projects was the abbey churches, mainly those of the Cistercians and the mendicant orders.

It is probably the numerous project commissioners and their alternating independence or competition over the course of almost 200 years that create a confusingly varied picture of sacred architecture that is not easy to evaluate with respect to quality. A distinctively German Gothic style was not achieved until the second half of the fourteenth century. Adding to the challenges are regional singularities such as Westphalian hall churches, the Brick Gothic in the north, and other outstanding individual achievements.

In many places it was the bishops, in particular, who refused to part with older traditions—as the choirs of the Bamberg cathedral (from ca. 1220), Strasbourg cathedral (from ca. 1190/1200), or the west choir of the Mainz cathedral (dedicated 1239) can attest. The fact that west choirs continued to be built, as for example in Naumburg (mid-thirteenth century), in itself indicates the stability of the older traditions. A large number of experiments, influences, and archetypes can be recognized and document the search for effective forms and pat-

burned down in 1207 and was reconstructed beginning in 1209—is clearly a "hybrid" with its massive piers, arcades, and upper walls; its archaic gallery elevation; its lack of open buttress systems in spite of some Gothic elements; and the heightened windows of its subsequently redesigned clerestory.

In Cologne, the powerful and self-confident Bishop Konrad von Hochstaden laid the foundation stone for the new cathedral in 1248 (illus. left and pp. 190/ 191). The choir and the eastern wall of the transept were completed by 1304. It takes its floor plan and elevation from the cathedral of Amiens, begun in 1220, but surpasses Amiens in transept length and by having a five-aisle nave (see floor plans p. 143). The construction continued until 1560 and was then halted. It was finally completed in the nineteenth century thanks to an awakening of national pride. The west facade and towers were finished according to a parchment plan dating from around 1300 that is more than 13 feet (4 meters) high (illus. p. 185). In spite of its long construction history, Cologne's cathedral is an example of pure French Gothic cathedral style in Germany. The same is true of the choir of the Aachen cathedral (illus. p. 149 center left), created between 1355 and 1414 to replace the rectangular Carolingian choir and modelled on Sainte-Chapelle in Paris, and for the nave of the Strasbourg cathedral, begun circa 1240. After four fires during the twelfth century, reconstruction began circa 1180 on the foundations of the Wernher edifice. The eastern sections, however, are pure late Romanesque. The episcopal churches followed almost exclusively the basilican plan.

In the thirteenth century, the hall church in its many variations emerged alongside the basilica. St Elisabeth in Marburg, founded in 1235 by the German Knightly Order, is equipped with a triple conch in the east for the completion of its various functions. Its nave is a hall whose supports and vaulting system as well as its tracery windows clearly demonstrate a perfect knowledge of the Gothic style of the Champagne region (illus. p. 149 bottom left). The same is true for St Maria in Trier (begun before 1242), one of the rare central plan churches (illus. pp. 186/187). Here, too, the structure and individual elements refer to Champagne. St Maria zur Höhe in Soest (second quarter of the thirteenth century) is a stout complex with dome vaults above heavy square piers. Paderborn cathedral

(1225–1276), with its traditional pillar and vaulting forms, does not give a very modern impression, while the Minden (1276–1290) and Verden (begun before 1297) cathedrals indicate a knowledge of French support and vaulting systems. All the afore-mentioned examples still maintain the traditional relationship between wide center and narrow side aisles that would change in the fourteenth century in favor of wider side aisles. We can only speculate about the reasons for the extensive adoption of the hall type. Possible arguments for the hall church are the demonstrative simplicity of its exterior and its spacious, bright, and uniform interior. No open buttress system was needed, and the side aisles could be enlarged to the width of the center aisle. Hall churches often have no transept, leaving an impressive, uninterrupted series of immensely tall pillar arcades; or instead of a transept there may be small chapels. In eliminating the traditional eleva-tion program, the hall churches have taller, unin-terrupted pillars that are the only elements giving structure to the space. Light can pass unobstructed from the tall side-aisle windows to flood the entire space. The overall breadth of the space grew, as did

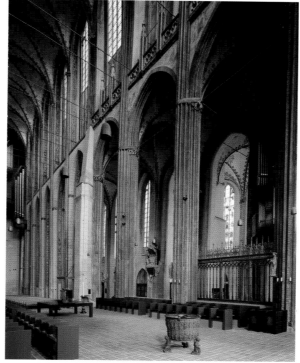

the overall volume, which due to the side aisles was approximately double that of a basilica.

The use of bricks, typical for the north, continued during the Gothic era. The Marienkirche in Lübeck (illus. above and pp. 194/195) became the archetype for many churches in the Baltic Sea region. In 1160 Henry the Lion had made this previously heathen Wendish settlement a bishopric and granted it sub-stantial privileges. Besides the cathedral, a first small city church was erected here. After 1220, this was replaced by a brick basilica that was larger than the cathedral, with choir ambulatory and three chapels. After several design changes, by about 1290 the basilica had a two-zone interior with a walkway in front of tall clerestory windows. Instead of a tran-sept, two two-bay chapels were added on either side of the seventh and eighth nave bays. A twin-tower facade frames the relatively simple exterior. St Nikolai in Stralsund, begun in 1276, is undoubtedly modeled after the Marienkirche, even though its proportions are less steep. The angular pillars of Lübeck, with their many, overly slender responds, are stout octagons in Stralsund; the closed balus-trade in front of the walkway forms a strong hori-zontal accent between the two zones of the elevation (illus. right). In Schwerin, Wismar, Rostock, Wolgast, Stargard, Greifswald, and even in Malmö and Riga, hall churches already under construction were redesigned as basilicas under the influence of Lübeck. The church of St Maria in Stralsund, not begun until 1380, also shows this influence. It seems as if the Hanseatic League had adapted the cathe-dral or basilica as its main church type.

For churches of lesser importance, the hall type remained the rule. Often they are simple rectangular spaces with no transept, and choir roods that indicate status sections. Examples are St Maria in Greifswald, St Maria in Stendal, and St Johannis in Lüneburg, all sober and relatively modest construc-tions, while St Maria in Gdansk (1343–1502), with its rich cellular vaults and massive west tower, is a very impressive representative of its type.

The decision not to use cut stone gave northern churches an unmistakable character, but it also confined them. Architectural sculpture, which was a distinctive feature elsewhere, has limited possibilites in brick. For this reason, the exteriors in particular often seem very sparing. Beginning in the fourteenth century, the brick Gothic found a way around this. The result was rich, elaborate, perforated facades, preserved for example on St Maria in Prenzlau (illus. below and p. 197), in the Cistercian monas-tery of Chorin, on St Maria in Neubrandenburg, as well as on many secular buildings.

At the beginning of the thirteenth century, Saints Francis and Dominic had founded the first mendi-cant orders. As wandering preachers following in

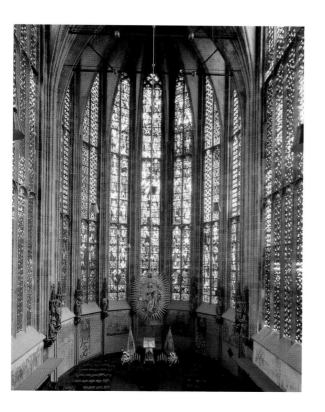

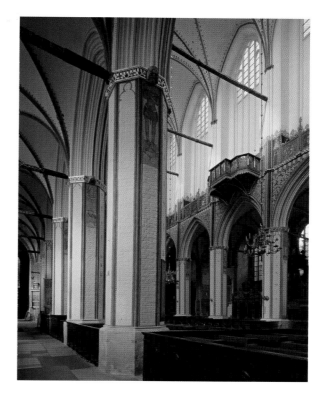

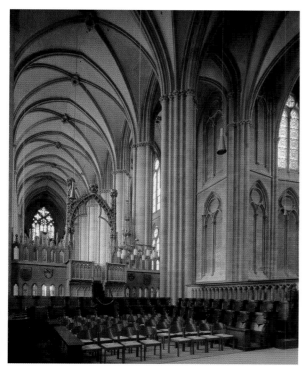

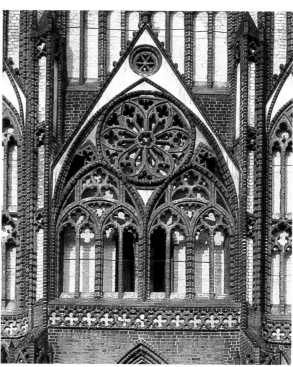

ABOVE: **Lübeck, Marienkirche**, completed ca. 1280, nave wall

CENTER LEFT: **Aachen, cathedral**, interior of the choir, ca. 1355–1415

CENTER RIGHT: **Stralsund, St Nikolai**, side aisle and nave wall, from 1276

LEFT: **Marburg, former hospice and pilgrimage church St Elisabeth**, begun 1235, interior facing west

RIGHT: **Prenzlau, Marienkirche**, under construction in 1325, detail of the east view

the footsteps of Jesus, they sought their audiences in the burgeoning cities, and for the first time eloquently explained the doctrine of salvation to the poorest people. When these orders found more and more followers a new challenge emerged—the construction of the churches of the mendicant orders. Since they had to be suitable for preaching and at the same time comply with the orders' ideal of humility, unvaulted nave halls and unremarkable east ends sufficed at first. Later, with these orders' increasing prosperity, the churches changed into vaulted spaces with two or three aisles; their elevation, however, remained two-level. Around 1300, the choirs grew longer—probably to accommodate the growing convent. In Strasbourg, the 26-foot (8-meter) choir was extended in 1307 to more than 95 feet (29 meters). Prominent examples for churches of the mendicant orders are several Dominican churches including that in Colmar (1283/1306–ca. 1339), St Paul in Esslingen (ca. 1230/1240–1268), St Blasius in Regensburg (begun 1229/1230), in Erfurt (illus. pp. 192/193), and others. In Imbach, a Dominican convent church was erected between 1269 and 1285; it has two aisles and a vault, but shows no original buttresses. The western section of the generously proportioned church has a gallery for the nuns above the low entrance.

An important contribution to the spread of the Gothic style came from the Cistercians. After about 1230 they relaxed their strict laws governing construction and finally accepted "cathedral motifs" and hall designs. Among the oldest Cistercian settlements in the German-speaking regions is probably the Heiligenkreuz monastery in Lower Austria, whose church has a Romanesque nave that was dedicated in 1187. Its hall choir, completed around 1295, is rectangular according to Cistercian traditions. The proportions and structure of the supports, the vaults, and the fine tracery in the windows, which are almost as tall as the room itself, make it one of the most elegant works of its time (illus. below). The nave in Zwettl adopts the model of Heiligenkreuz, but combines it with an ambulatory choir like its second source of inspiration, Pontigny. In the Cistercian monastery of Lilienfeld, founded in 1202 in Lower Austria, another hall choir was dedicated in 1230. The Cistercian church in Doberan, a

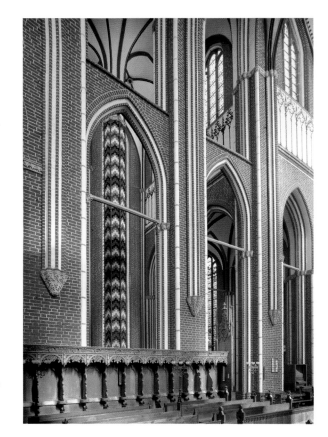

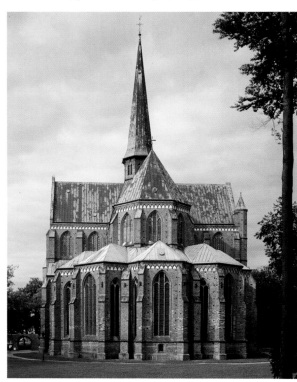

Doberan, former Cistercian church, 1294–1368, pseudo-transept (left); east view

brick building (1294–1368), received a triforium and leaf capitals—at least in painted form—while the exterior was still indebted to the early Cistercian model (illus. above). In the transept, which is separated by a two-story arcade, the vaulting sits on a central support that also lends a hall-like character to the space. The same configuration can be found in Pelplin (from 1276). The abbey church in Altenberg (around 1380) finally converges in elevation and proportions with the cathedral (illus. bottom right). Starting in the late thirteenth century, tracery, colored windows, and figurative paintings were probably also allowed, as seen in the abbey churches of Salem (first half fourteenth century), Altenberg, and Heina. The facades of the abbey church of Chorin (1273–1377), preserved as a ruin, which also served as the home monastery of the Askanian margraves, shows what concessions the Cistercians were finally willing to make. The richly structured tripartite front has niches and tracery windows, and is crowned by a vivid, almost playful silhouette of gables and turrets (illus. p. 196).

The second half of the fourteenth century marks the beginning of the late Gothic period, which is more uniform and easier to sum up architecturally than the preceding one. It is the accomplishment of a few innovative and excellent architects, first and foremost among them the members of the Parler family, especially Peter, builder of Emperor Charles IV's cathedral in Prague.

In 1344 Prague became an archbishopric. Charles IV immediately commissioned Matthias of Arras to build a cathedral church there. He began with the east sections and erected the five radiating chapels, an ambulatory, and the arcades of the choir head in the Gothic style of southern France. In 1352 Matthias died and was replaced by Peter Parler. Parler stayed true to the type of the basilica, but molded it into a dynamic, vivid space (illus. pp. 204/205). Above the tall and closely spaced arcades runs a triforium, the back wall of which forms a single glass surface with the clerestory windows. The triforium is topped by a sloping wall that is drawn forward toward each pillar, causing it to protrude like a casing. This creates the impression of a wave-like motion in the middle of the elevation.

Parler did without transverse ribs to separate the bays, choosing instead to double up the diagonal ribs—this, too, along with the uniformly advancing rhythm of the bays, gives rise to a pendulum-like effect. This no longer has any connection to the French High or late Gothic. Here we encounter an entirely new understanding of architecture; it is more blithe, playful, experimental, and ingenious. It is the same spirit that typified the early Gothic era in France, but with different results.

Apparently Peter Parler or his father Heinrich had already tested the characteristic motifs of the spatial conception used in Prague on a smaller scale, namely in the choir of the Heilig-Kreuz-Kirche (Church of the Holy Cross) in Schwäbisch-Gmünd (after 1351; illus. pp. 200/201). Here we find a hall choir (the nave is basilical) whose chapels are arrayed in a wide polygon (inspired by Pontigny and

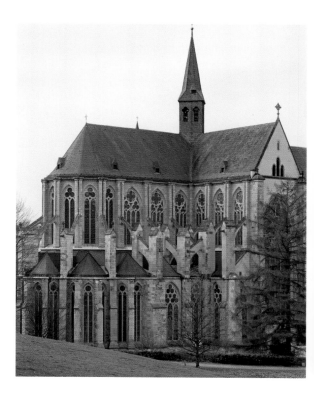

Altenberg, former Cistercian church, begun 1259, exterior view from northeast

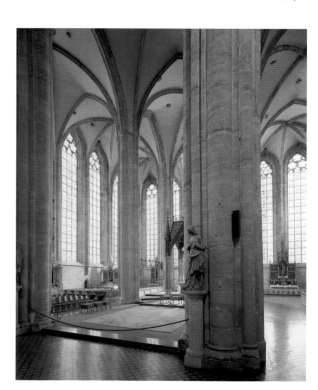

Heiligenkreuz (Austria), Cistercian church, under construction in 1288, hall choir

later Cistercian choirs?), but the motifs and their effects are indeed comparable. One element they have in common is the continuous cornice that runs between the arcade of the chapel entrances and the clerestory above, jutting out to accommodate the responds that rise out of the arcade piers. A second trait is the absence of transverse ribs separating the bays, which abolishes not only the rhythm, but also the connection with the piers and any other supporting element. Later on this vaulting style evolved into the net vaulting that characterizes the German late Gothic.

The hall church became the dominant type (an example of a basilica built during this period is the Ulm Cathedral, 1392–1471, the citizens' urban church). The pillars most often had a circular or octagonal form; the side aisles became wider. But while one group avowed a strict renunciation of any decoration or delineation, the other profited for decades from the Parlers' ideas. Examples from the first group are the Frauenkirche in Munich (1468–1488), St Martin in Landshut (1385–ca. 1460), the former main parish church in Salzburg (from 1408), and St Georg in Nördlingen (illus. of all three pp. 202/203). The ribs of the net vaulting, accentuated by their coloring, and the tracery windows constitute the lone, restrained decoration

of the interior spaces. The exterior as well, which often appeared as enormous box-like constructions in the cityscape due to their elevation program and aisle width, are decidedly simple, having a unified silhouette, and only the towers—two in Munich, in Landshut one that is visible from afar—are an expression and symbol of the citizens' pride here, as in Ulm (illus. below right) or in Freiburg.

The second group consists mainly of the Saxon hall churches: St Anna in Annaberg (illus. below); the collegiate church in Freiberg (after 1484); the churches of St Maria in Zwickau, Pirna, and Marienberg; St Wolfgang in Schneeberg; and the Marktkirche (market church) in Halle. All of these to some degree follow the example of St Lorenz in Nuremberg, whose hall choir was begun in 1445 and completed by 1466 (illus. right). Here the motif of the protruding cornice is found again in an enhanced form. Crowned by a tracery balustrade, it forms a honeycomb-like pulpit between the two rows of windows in the choir. In Saxony the decorative elements are enriched, and unique forms of vaulting abound. They no longer have much in common with the late Gothic churches of France. Instead, they represent a different feeling for space, a greater freedom in the use of decorative motifs, and an enhanced plasticity in wall treatments.

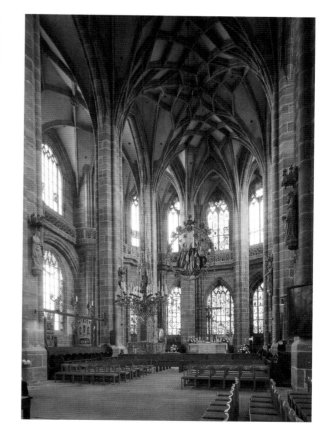

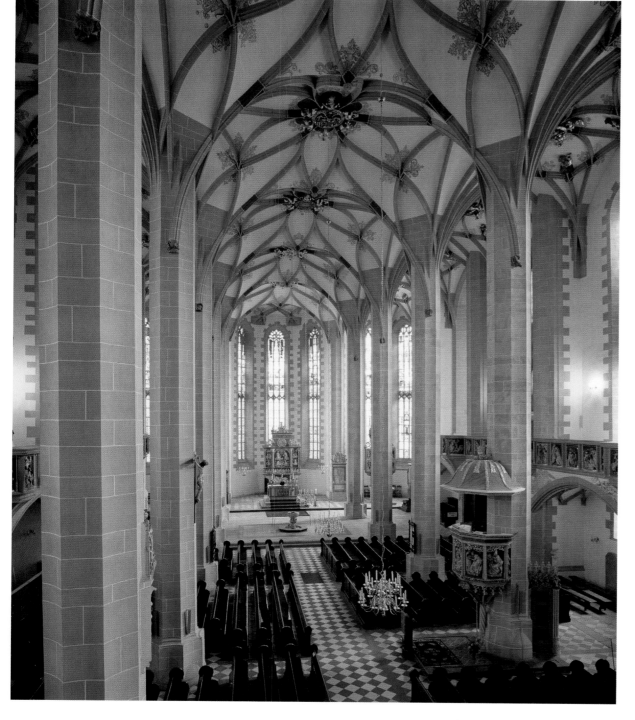

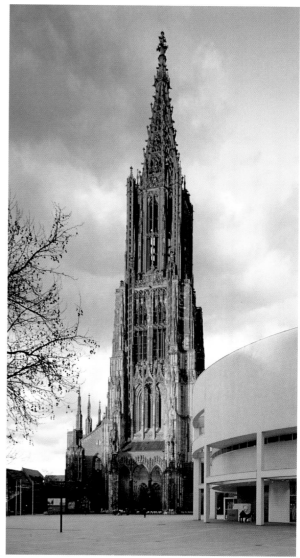

ABOVE: **Nuremberg, St Lorenz**, interior of the choir, begun 1445

LEFT: **Annaberg, St Anna**, interior facing east, 1499–1525

BELOW: **Ulm, cathedral**, tower, begun 1392

Italy

It has been debated whether the sacred architecture of the thirteenth century in Italy can even be classified as Gothic. While secular buildings, under the influence of the newly constituted city organizations, adapted their forms from the outset to their new functions, sacred construction continued to follow older traditions or came about as continuation or completion of projects already underway. Out of this arose processes of adaptation and change. Thus, the exteriors of Sant'Andrea in Vercelli (1219–1224) or the cathedral of Trient (begun around 1212) differ only in details from the buildings of the twelfth century. In its interior, however, Vercelli follows the form of a modest Gothic country church (illus. pp. 208/209).

Other reasons for the complexity of Italian sacred architecture in the thirteenth century are the political and cultural discord in Italy at the time, as well as a remarkable inclination toward individualism that likely had its origins in the fierce competition among religious orders, bishops, communities, and private patrons over the shape cities would take, as well as in fierce inter-city rivalries.

Examples of possible variations are the cathedral of Orvieto (illus. above right), a completely traditional building with a two-zone elevation and open-truss roof framing; the cathedral of Siena (illus. right), whose Romanesque interior received only a tracery clerestory and rib vault after substantial enlargement projects; and the cathedral of Florence (illus. pp. 212/213), where an enormous nave modeled after Santa Croce (see bottom right) was completed in 1378 after a long and complicated design period. The dome is the work of Filippo Brunelleschi, who was commissioned to finish the complex in 1420.

The two early mendicant orders, the Franciscans and the Dominicans, were responsible for the construction of the first Gothic churches in Italy. Their architecture is based on various models and is not uniform, even if they have some basic characteristics in common. In 1228, the year of St Francis' canonization, construction of a double church over his tomb began. Consecrated in 1253, San Francesco is known less for its architecture than for its frescoes, in which Giotto depicted the life of the saint. Five square bays form a hall that ends in a low, polygonal

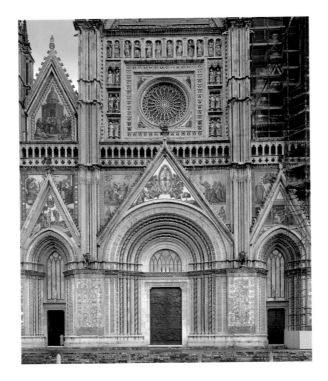

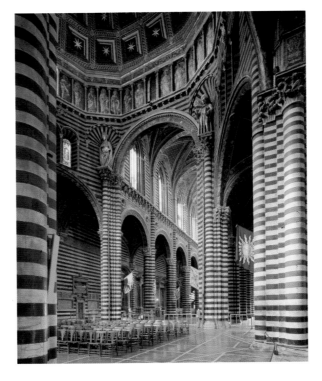

apse. Two elongated rectangular bays serve as transept arms (illus. left). Respond bundles on the walls carry the vaulting ribs. A narrow walkway runs below the simple, paired lancet windows with an oculus in the spandrels. Its French models (Angers, Fontevraud) and their progeny (each of which is domed) are all located in western France. San Francesco became the model for Santa Chiara in Assisi and for many churches in central Italy.

The Franciscan church in Bologna (illus. p. 210) incorporated other influences. It is a transeptless basilica with a six-part vault over octagonal pillars

ABOVE: **Orvieto, cathedral**, begun 1290, facade detail

CENTER: **Siena, cathedral**, reconstruction of the Romanesque complex from the first half of the 13th c., nave

LEFT: **Assisi, San Francesco**, 1228–1253, interior of the upper church

RIGHT: **Florence, Santa Croce**, begun 1294, interior looking east

that also has a choir ambulatory and polygonal radiating chapels. The floor plan seems to be a simplified version of the abbey church at Pontigny, especially of its early Gothic choir. The six-part vaulting of the nave, carried by supports without responds, is a stark simplification of the vaulting system at Notre-Dame in Paris. The Dominican church Santa Maria Novella in Florence (illus. pp. 210/211) also has a two-zone basilican nave with a four-part rib vault, a transept with square chapels, and a low, enclosed choir. This is the older Cistercian concept, but here the arcades are broader and rest on semi-columns engaged in slender piers. As one moves eastward the arches become progressively narrower, enhancing the effect of perspective. Probably in competition with Santa Maria Novella, the Franciscan church of Santa Croce, begun in 1294 in Florence, is even larger than the Dominican church (illus. below). A basilica as well, it has octagonal columns and a walkway on consoles running at the foot of the clerestory, but is not vaulted (due to a design change?). The floor plan of the eastern section is again Cistercian. A kind of choir portal, along which the walkway passes, separates the nave from the vaulted eastern section. The high arch in its center precisely frames the main apse and its tall, colored glass tracery windows. Low arches flanking the center one frame the choir chapel windows. Each has a second window above it. This subtle layering and arrangment of a room by means of space and light is indeed Gothic in character.

The two principal works of Venetian Gothic art, the Dominican church of San Giovanni e Paolo and the Franciscan church of Santa Maria Gloriosa dei Frari (both begun around 1330 and not finished until the fifteenth century), continue the main idea of the floor plan in Florence, though with a reduced number of chapels. Two or three square chapels, each with its own apse, flank the head of the choir, which has an antechoir and apse on each side. A five-part transept leads into the three-aisle vaulted nave. The head of the choir is now dissolved into several tracery zones and fully glassed in. The naves of these two churches are identical, with tall, broad arcades that account for approximately two-thirds of the entire height, as in Santa Croce. Because the architects did not use an exterior buttress system, it was necessary to set collar ties across the nave at the

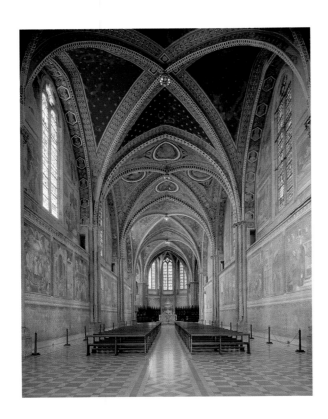

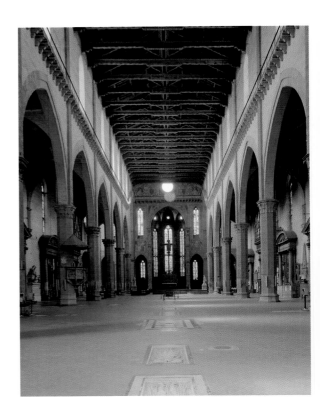

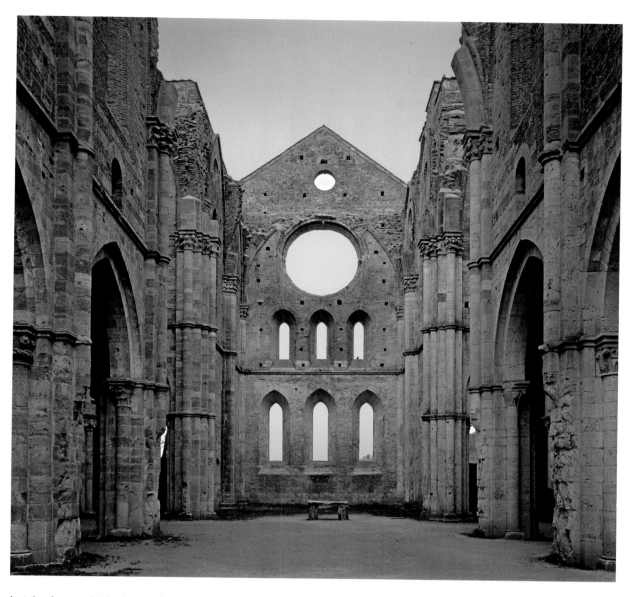

for example from Saint-Serge in Angers or the cathedral of Poitiers.

Beginning in 1224, the Cistercians erected an abbey church in San Galgano (illus. left), which has a stylistic relationship to its mother church in Fossanova (consecrated 1217). In its floor plan, pier cross-section, profiled arcades, and nave responds it recalls Fontenay, although San Galgano was substantially taller, had a clerestory above small openings in the knee wall above the side aisles, and at one time had a rib vault.

The cathedral in Milan (illus. p. 215) marks the end of Gothic architecture in Italy. Begun in 1387, it combines a polygonal ambulatory choir without chapels, a three-aisle transept, and a five-aisle nave. It is the result of careful planning and calculations undertaken by a commission of international master builders. The exterior is mainly Gothic Revival.

England

In 1174 the choir of Canterbury cathedral (consecrated in 1130) burned. The monk Gervasius, an eyewitness, described the catastrophe and gave an account of its reconstruction. In 1175, after careful deliberation, a certain William was chosen as the building master. He had built the early Gothic cathedral of Sens beginning in 1140. With the reconstruction of Canterbury emerged a true early Gothic English structure (illus. pp. 216/217). The floor plan and elevation are recognizable as copies of Sens, though with certain distortions arising from the reuse of walls from the previous five-part staggered choir. That also reduced the height of the small transept. Like Saint-Étienne in Sens, the long choir has three aisles and ends in an ambulatory with a crown chapel. The fourth bay of the choir protrudes on either side to form a small transept with a semicircular apse in each arm (in Sens, this small transept was lost when the newer, larger one was erected). In elevation, too, they are almost identical. Canterbury, however, in spite of having a six-part vault, does not possess a distinctive alternation of supports. Instead, round and octagonal supports are alternated, but the arcade and triforium forms are still similar. In Sens the windows were enlarged at a later point. They, too, may have had a walkway in front of the clerestory in keeping with Norman tradition. Particularly English, however, is the use of Purbeck marble in combination with light sandstone, which would become characteristic for many structures in that country. A large transept marked the west end of this choir. As seen earlier at Cluny III, Canterbury had two transepts, a feature repeated several times in the English Gothic, for example in Salisbury (1220–1266) and Lincoln (1220–1240).

In spite of this early and exact adoption of a French prototype, English Gothic architecture does not demonstrate the linear development seen in France. Here, as in Germany, the reasons were political. At the famous battle of Hastings in 1066, Duke William of Normandy had defeated young King Harold of England and quickly established a Norman occupation that in the space of a few years had placed its own men in all bishoprics, monasteries, and significant political positions. In addition, the—for France unfortunate—divorce of

height from which the vaulting would have sprung. Unlike the umbrella facades of the Tuscan churches, which hide their basilican elevation, the two Venetian churches of the mendicant orders received cross-section facades.

In 1310 the church of St Antonius was completed in Padua (it is commonly known simply as Santo). It consists of a cross-shaped complex with square nave and transept bays that carry tambour domes (illus. below). The floor plan of the choir duplicates that of Bologna. Geographical proximity would suggest a Venetian influence, but the support alternation and

the square schema of the side aisles suggest other, older models located north of the Alps. The Santo also bears a certain resemblance to Saint-Hilaire in Poitiers.

The mendicant architecture of Italy also included hall designs, as for example at the Franciscan church in Todi (illus. p. 211). The stilted rib vault rests on two rows of not entirely identical clustered piers with slender, partially engaged columnar responds. This produced a broad space, bathed in light, with low chapels extending from its long sides. Here, too, influences from western France have been indicated,

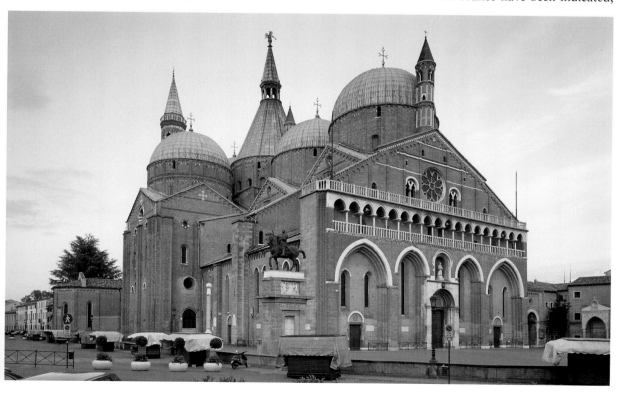

Louis VII and Eleanor of Aquitaine and her subsequent marriage to Henry Plantagenet placed all of western France and the counties of Toulouse and Languedoc under the control of the English crown. Kings Philippe Auguste and (Saint) Louis IX, a major patron of sacred architecture, managed to regain large areas. The ties between England and France were severed and the former "internal" exchange ended. In 1339, under Edward III, the Hundred Years' War began, bringing major losses to both sides and shutting down many construction sites for extended periods.

The English Gothic is divided into three periods—Early English, Decorated Style, and Perpendicular Style—that do not always correspond with the continental terms of the early, high, and late Gothic. The first two epochs did indeed begin with the adoption of a French prototype; but they were soon adapted to the local traditions that understandably remained operative here. The term Early English comprises the time from circa 1170 until 1240, beginning with the choir of Canterbury cathedral. Decorated Style refers to the time between circa 1240 and 1330; it begins with the reconstruction of Westminster Abbey that harkened back mainly to the cathedral of Reims. The Perpendicular Style covers the period from circa 1330 until 1530.

It is no coincidence that the cathedral of Sens was especially well-liked in England. Its conception demonstrates the continuation of Norman building ideas that had been further developed in England for over a century, and that belonged to the basics of the French Gothic as well (wall structuring, clerestory passageways, pointed arches, experiments with rib vaulting). In France, however, the choir of Saint-Denis, like Sens begun in 1140, marked the beginning of the "cathedral Gothic" under royal patronage. Sens would not be an influential model.

Experiments with French Gothic motifs appeared even before Canterbury cathedral. The choir of Ripon (1160–1175), originally without stone vaulting and a smaller successor of the lost choir of York, and the nave of Worcester (from 1175) adopted the number and pattern of responds above piers and the lower gallery zone from Saint-Denis, Noyon, and Laon. Because of the arcades' width, however, they were accompanied by narrow blind arches and crowned with a traditional clerestory

with a trellised walkway. Striking are the rich profiles of the arcades, which are unusually high and broad in comparison to their French forerunners. These became characteristic of the English Gothic.

Beginning in 1192, the cathedral of Lincoln was rebuilt following an earthquake (illus. pp. 220/221). It had two transepts and a square choir—this, too, later became a frequent motif in English sacred buildings. Both choir and nave imitated the elevation of Canterbury, but enriched with moldings in the tympana of the gallery (compare to Gothic architecture of Normandy) and by numerous ornamental motifs. The syncopated blind arcades of the choir are especially unique, as are the "crazy vaults," whose ribs playfully run off kilter and set the canopies slightly out of alignment with one another (illus. right). The broad, high arcades of the nave, built after 1220, rest on clustered piers that are surrounded by many variations of slender engaged columns with capitals of the highest quality. The canopies of the vault are foreshortened and are connected by a small longitudinal rib along the central axis. Additional ribs are located between the diagonal ribs and the ribs separating the bays. As a result, a fan is created over each support. Seen from below, the vaulting appears as a pointed barrel vault with intersecting minor vaults studded with ribs. The forms of the rib vault became immensely varied over the course of the English Gothic; hardly any two are alike. Often, however, they were not executed in stone, but in wood. This, too, is an eleventh-century tradition.

At the same time, in 1220, construction began on Salisbury cathedral (illus. p. 222), which is closely related to the one in Lincoln in terms of floor plan and elevation. It was possibly a conscious act, however, to use less of the irregular ornamentation. The cathedral of Worcester (from 1224) drew on both of them as models.

In 1239 the cathedral of Wells was consecrated, a pier basilica with blind triforia and simple lancet windows in the clerestory. A walkway cuts through the vault caps. The arcade and clerestory zones are approximately the same height; the responds of the vaulting sprout from the spandrels of the triforium, while the numerous responds of the piers simply articulate the archivolts of the arcade. The proportion and elevation recall Chartres, but it seems that because of the arcade profiles, a dif-

Lincoln, cathedral, nave vaulting with "crazy vaults," 1192–ca. 1210

ferent pier style was chosen. Noteworthy here is the use of ornamental heads between the arches of the arcade and triforium. The scissor arch at the western edge of the crossing, inserted in 1338 between the nave and transept in order to support the crossing tower, is world-renowned (illus. p. 223).

English Gothic found its own unique solution for its facades: they are rectangular presentational walls crowned with towers or gables. The portals, which on many continental churches constitute the highly decorated center of the facade, are kept small here, like a side entrance. The entire canon of decorations consists of rows of blind arcades or gabled niches one atop the other. The facades of the cathedrals of Wells and Exeter boast a rich display of ornamental sculptures, while in Peterborough there are only a few figures, and they are so high up in the air that they are hardly discernable to the observer on the ground (illus. pp. 224/225).

The rebuilt Westminster Abbey (illus. below), like Saint-Denis, is a programatic project and owes its

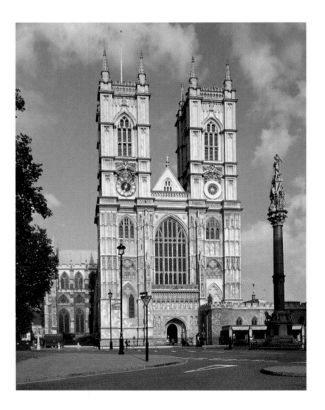

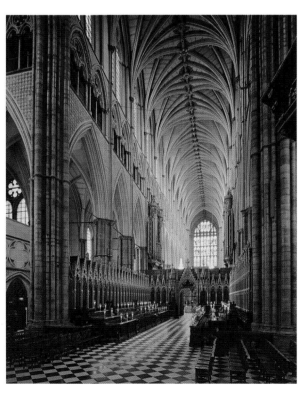

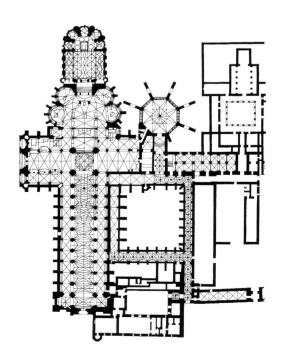

LEFT: Westminster, abbey church, west facade; nave facing southwest; floor plan, 1245–1269

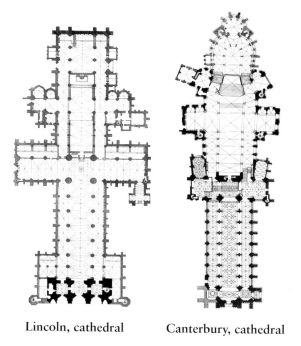

Lincoln, cathedral

Canterbury, cathedral

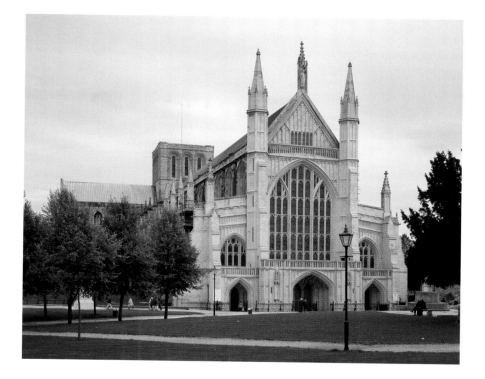

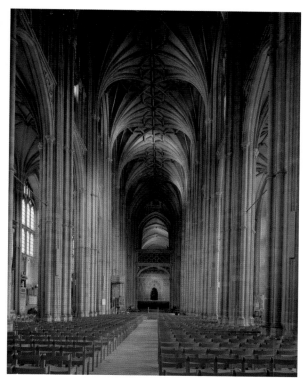

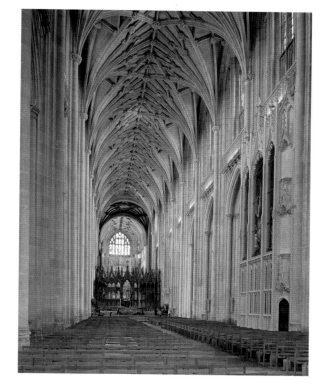

appearance directly to the intentions of Henry III. Westminster was the burial place of his predecessor, Edward the Confessor, who had been canonized in 1161. At the time the French royal family did not yet boast a saint, even though the French kings cultivated a close alliance with the Church. Henry himself provided the funds, since a valorization of the English kings was at stake. These intentions left no doubt about the choice of a model for the church: Reims cathedral, where the French kings had been crowned since the time of the Franks and where the oriflamme, the sacred banner, was kept. Beginning in 1245, Master Henry of Reyns (Reims) built an ambulatory choir with five partially engaged circular chapels, a three-aisle transept, and a nave of ten bays. The similarity to Reims is unmistakable, and if Westminster's fan vaulting actually surpasses Reims, it was fully intentional on the part of its patron. The very pointed arcade arches, the gallery in place of a triforium, and the use of Purbeck marble, however, are all English.

In the wake of Westminster, elevations did not change, but decoration programs were diversified with the introduction of tracery from Reims (the

first genuine tracery appeared in the choir chapels there) and covered the walls as well in the form of blind tracery. In the Angel Choir at Lincoln (1256–1280), the arches of the arcades and galleries as well as the coving between colonnettes are filled with foliage and ornamentation. Figures and busts decorate the arch spandrels and springings.

The nave of York cathedral (illus. pp. 218/219), begun in 1291, finally introduces the triforium to the English Gothic. Its lancets are crowned with wimpergs and connected to the clerestory window tracery by means of vertical staves. It is thus England's first truly filigreed building, with a thin skin of glass above the arcades and a structural arrangement throughout the entire building. The elevation program at Exeter (illus. pp. 228/229) is similar to York's, but the approach to the structure is entirely different. The massiveness of the wall has returned, as can be seen clearly in the richly profiled archivolts of the arcades, on the triforium, and the walkway above it. The clustered piers and the fan vaults, whose ribs now number eleven, thus correspond to the arcade archivolts. The effect is grandiose and at the same time curious.

The Perpendicular Style originated as a makeshift solution. Around 1330 it was decided to give the choir of Gloucester Cathedral (illus. p. 230) a new shape, but without knocking down its Romanesque walls. The royal master builder Thomas of Canterbury encased the old nave walls with a curtain of supports and inserted tracery zones, above which a new tracery clerestory and an intricate net vault was added. The repeating parallel vertical and horizontal lines dominate the structural system and create a uniform pattern of trellises that now displaced the swaying lines and shapes. The raster can best be seen in the east window, which occupies the entire wall. In the nave of Canterbury cathedral (illus. center left), the pattern is reduced again to the familiar three-part elevation with especially high arcades. Characteristically, however, the responds rise from the floor without any interruption to the springing of the vault, and the cornice of the triforium forms the dividing horizontal line. In this respect the Perpendicular and the late Gothic period in France, for example at the cathedrals of Orléans and Évreux, or at Saint-Ouen in Rouen, are reunited. In the nave of Winchester cathedral (illus. above and right), begun around 1360, the only horizontal element is a low bal-

ustrade above bust consoles, behind which the clerestory recedes over blind tracery zones. The ribs of the fan vault cross and shade the vertical profiles. They are so deep that the onlooker standing in the nave looking east can hardly see the windows. One of the latest examples of the Perpendicular Style is the chapel of King's College in Cambridge (illus. p. 231), which appears to consist exclusively of vertical staves and a long, glorious fan vault that was installed in 1515.

Spain and Portugal

As a result of stronger political and cultural ties to France, Gothic construction ideas were adopted faster and with more variety on the Iberian Peninsula than elsewhere. It seems that here, too, the Cistercians, with their international organization, served as carriers of the new style. The abbey church of Moreruela (illus. p. 37), erected after 1168, resembles the choir of Pontigny (the nave was still given a barrel vault), as does the especially high and slender choir of the Cistercian church of Alcobaça in Portugal, begun in 1178. The nave of the latter, however, a tall, three-aisle hall, remains puzzling.

The Romanesque naves of San Vincente in Ávila and of the old cathedrals in Salamanca and Lérida were apparently completed in the early thirteenth century with modern rib vaults.

The French canon of forms was adopted in the choir ambulatory of the cathedral of Ávila, built during the 1170s (illus. center right), which unequivocally evokes Saint-Denis; in the church of the Cistercian nuns in Las Huelgas, a royal residence; and in the cathedral of Cuenca, which adopted both motifs from the cathedral of Laon.

The first Spanish complexes that actually used the model of the French episcopal churches are the cathedrals of Burgos (illus. below left) and Toledo (illus. below), both of which were begun shortly after 1220 and are scaled-down variations of the cathedral at Bourges. Begun in 1255, the cathedral of León (illus. pp. 238/239) ultimately adapted the purest forms of French High Gothic architecture—specifically from those cathedrals that were sponsored by the king. The floor plan of the choir

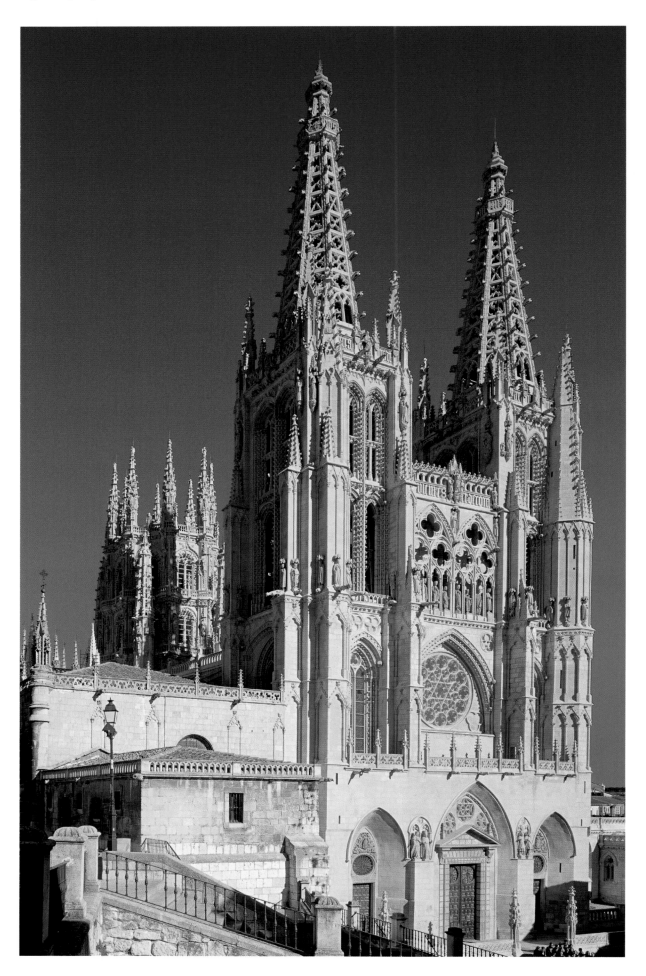

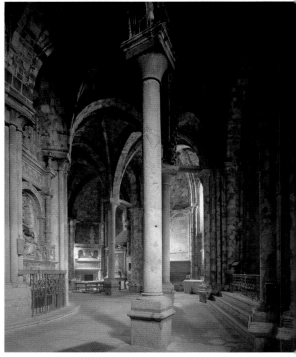

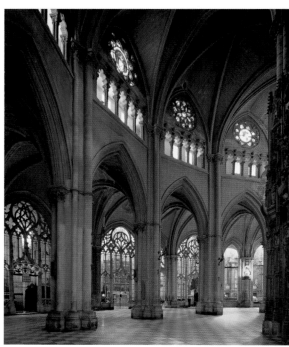

ABOVE: **Ávila, San Salvador Cathedral,** choir ambulatory, last third 12th c.

CENTER: **Toledo, cathedral,** begun ca. 1222/23, choir ambulatory

LEFT: **Burgos, cathedral,** begun 1221, west facade

follows the Reims model; the west and transept facades are clearly influenced by the abbey church of Saint-Denis with its royal tombs. The elaborate structure of the interior also brings to mind Saint-Denis or Sainte-Chapelle in Paris. The same prototypes formed the basis of the plans drawn for the construction exterior of the choir at Santiago de Compostela (which were never carried out), and the enlargement of the cathedral of Burgos, undertaken between approximately 1260 and 1280. All these buildings are closely associated with King Alfonso X, who attempted to follow the French

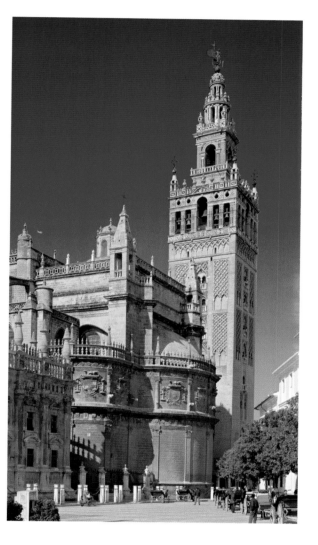

Seville, Santa Maria Cathedral. The minaret, completed in 1198 and called the Giralda, was modified and integrated into a Christian context.

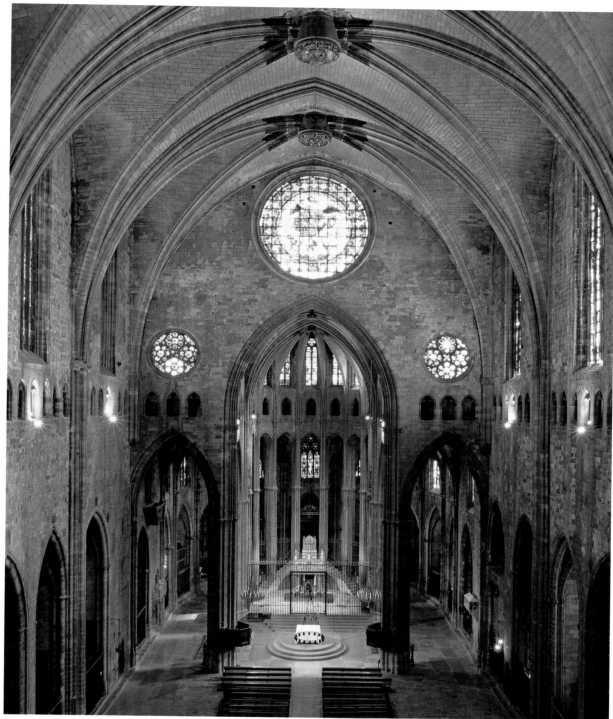

Girona, Santa Maria Cathedral, 1312–1604, view into the nave, begun in 1417, and the mid-14th c. choir

example by creating a centralist state that was centered around the king. The failure of his ambitions halted the progress of Gothic architecture in Castilia for quite some time.

Barcelona was the capital of the Empire of Catalonia and Aragon, which thanks to maritime trade rose to political and economic power starting in the late thirteenth century. Here an extensive ensemble of representative secular and sacred buildings from the late Middle Ages is preserved. In 1298 the cornerstone for the cathedral was laid. Its three-aisle nave is a large hall with square nave bays between massive compound piers. A five-part transept leads into the choir with ambulatory and radiating chapels and an extremely high main apse (illus. p. 240). Above the side-aisle chapels open tribunes. The church of Santa Maria del Mar was erected between 1329 and 1384. It harmonized and perfected the floor plan and elevation of the cathedral, and greatly enhanced its ambience by means of balanced proportions and subtle lighting

(illus. p. 241). The cathedral of Santa Maria in Girona, whose eastern sections were begun in 1312, took up this design as well. The nave, however, not started until a century later, is without any subdivision, producing a gigantic, aisleless church with side chapels, a low triforium, and high lancet windows. The rib vault over this space ended up being the broadest vault of the Gothic era (illus. above).

Between 1276 and 1349 the kingdom of Mallorca was independent, and during this time, from around 1300, a cathedral was built there in Palma (illus. pp. 242/243). This three-aisle basilica's high side aisles and octagonal columns, as well as its side chapels, indicate the influence of Barcelona.

Seville had been taken back from the Muslims in 1248; in 1401 it was decided to build a cathedral of demonstrative character (illus. pp. 244/245). Already demonstrative was the decision to build it above the former mosque, using its footprint. Seville's cathedral was the largest construction site of its time, an

enormous rectangular block with five aisles and side-chapels, divided by a non-protruding transept. The lancet windows of its clerestory follow immediately above the high arcades. The side aisles are not much lower than the center aisle, but more than twice as wide, giving the flying buttresses on the outside an almost horizontal silhouette.

By the beginning of the fifteenth century, the Castilian kingdom's economy had recovered. Trade relationships with Burgundy introduced the Dutch-Burgundian, intensely courtly late Gothic style to Spain, where it was mingled with Moorish traditions. The result was the so-called Hispano-Flemish style, to which German late Gothic motifs were added due to the commissioning of German building masters. Examples are the tomb chapel of Don Alvaro de Luna (from ca. 1430), the Puerta de los Leones at the choir of Toledo's cathedral, and the Capilla del Condestable (1482) at the choir of the cathedral in Burgos. In the late fifteenth and early sixteenth centuries, this decorative style became the official art form of the court under Catholic Queen Isabella and King Ferdinand. The Cartuja de Miraflores near Burgos (after 1454) and the monastery of San Juan de los Reyes (begun 1476) are its most prominent examples.

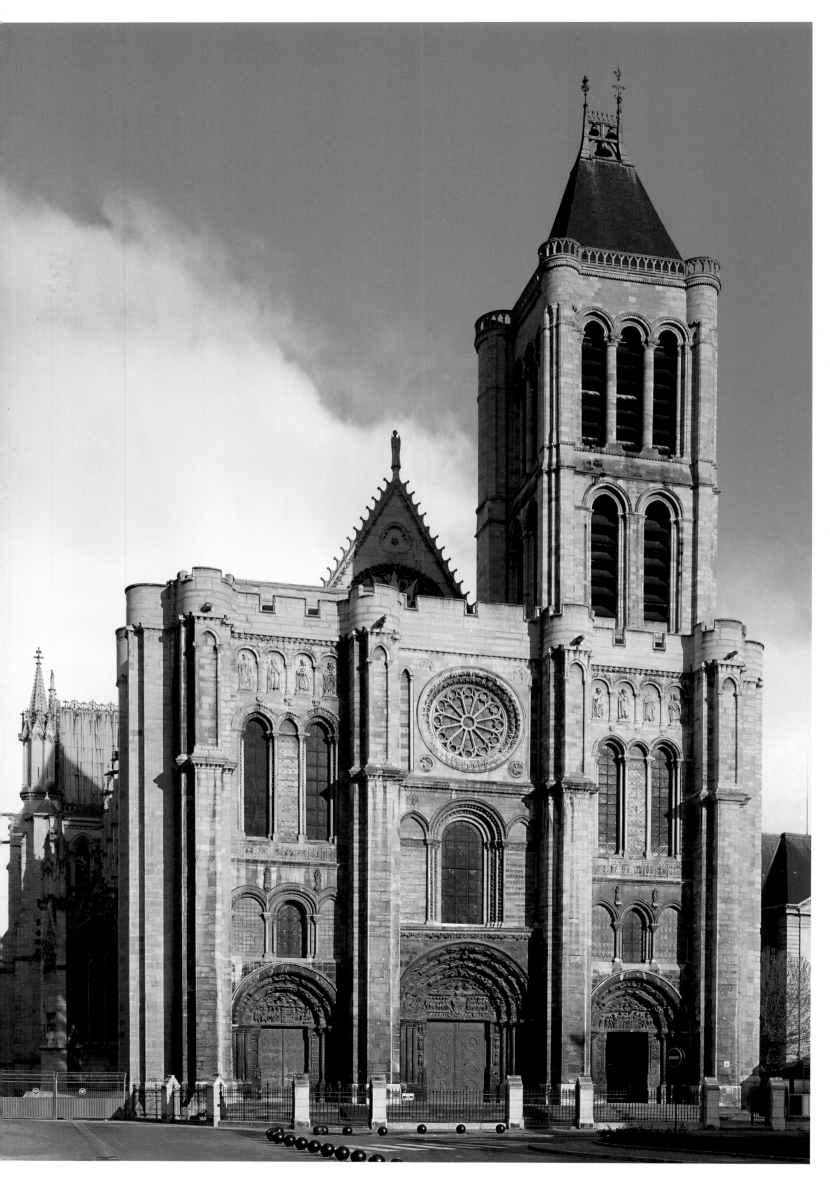

LEFT AND OPPOSITE:
**Saint-Denis,
former abbey church,**
west section (left),
1137–1140; choir
ambulatory (opposite),
1140–1144

When Abbot Suger
began his renewal of
the royal abbey with al
its rich tradition, he
began with the west
section. Today,
unfortunately, it has
been heavily restored.
This west facade is the
point of origin for the
developments that led
to the classic cathedral
facades of the High
Gothic.

Of the ambulatory
choir, which was
certainly intended to be
followed by a nave,
only the lower sections
are preserved. The
transparency of the
ambulatories and
chapel niches that form
constantly changing
patterns of space still
fascinate visitors.

PAGES 160 AND 161:
Laon, cathedral,
begun ca. 1170/80,
nave; begun before
1200, facade

Construction of the
nave started around
1200 after a small
change of design.
The alternation of
supports in the eastern
bays is evidence of
experimentation with
different forms, which
as purely round pillars
have no real connection
to the responds starting
above them.

The facade of Laon is
the first time that the
twin-tower type facade
fully correlates to the
church's interior, whose
measurements and
forms are transposed to
the exterior. The
exterior also displays
the same trend toward
three-dimensionality
and shaping of the
space as the interior.

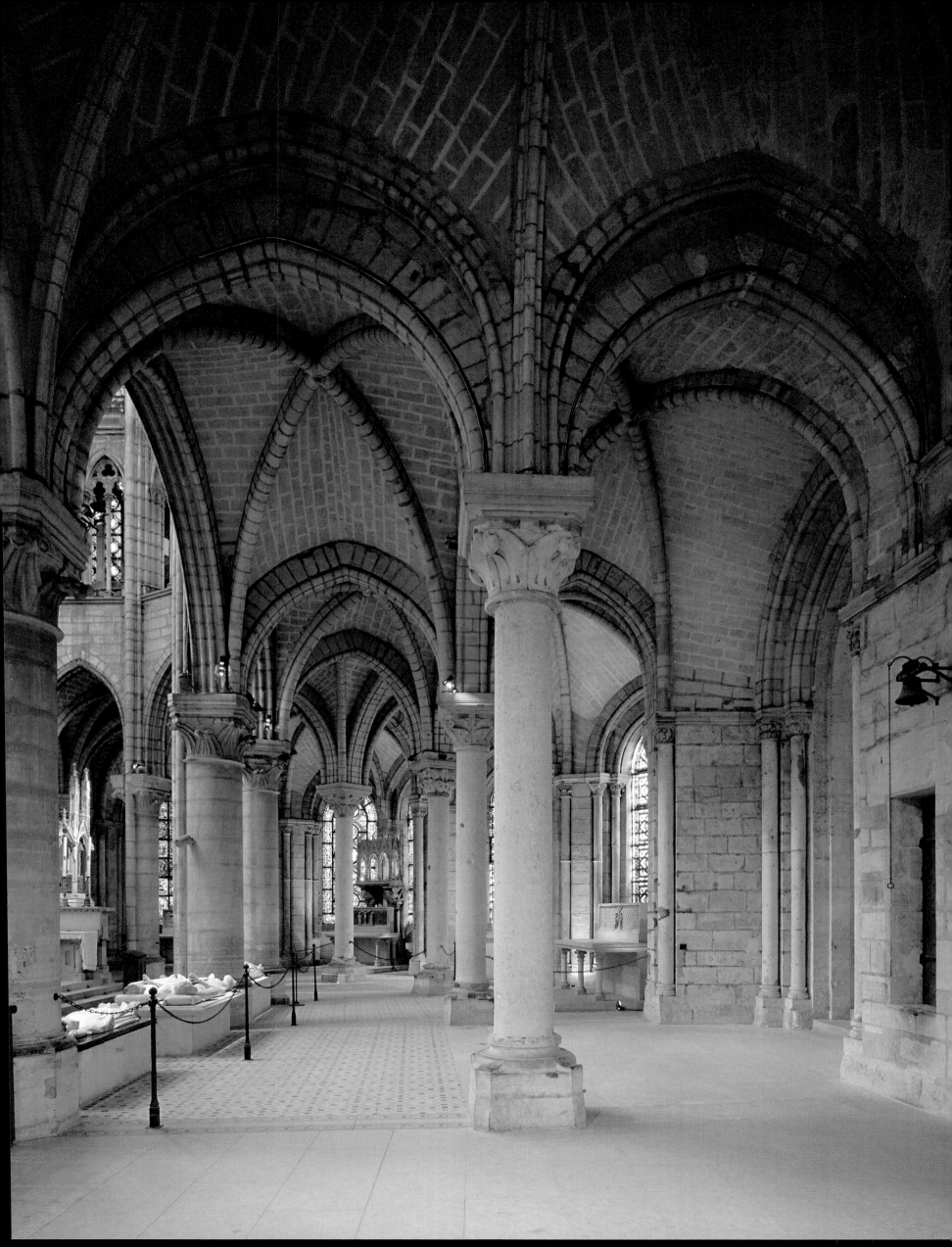

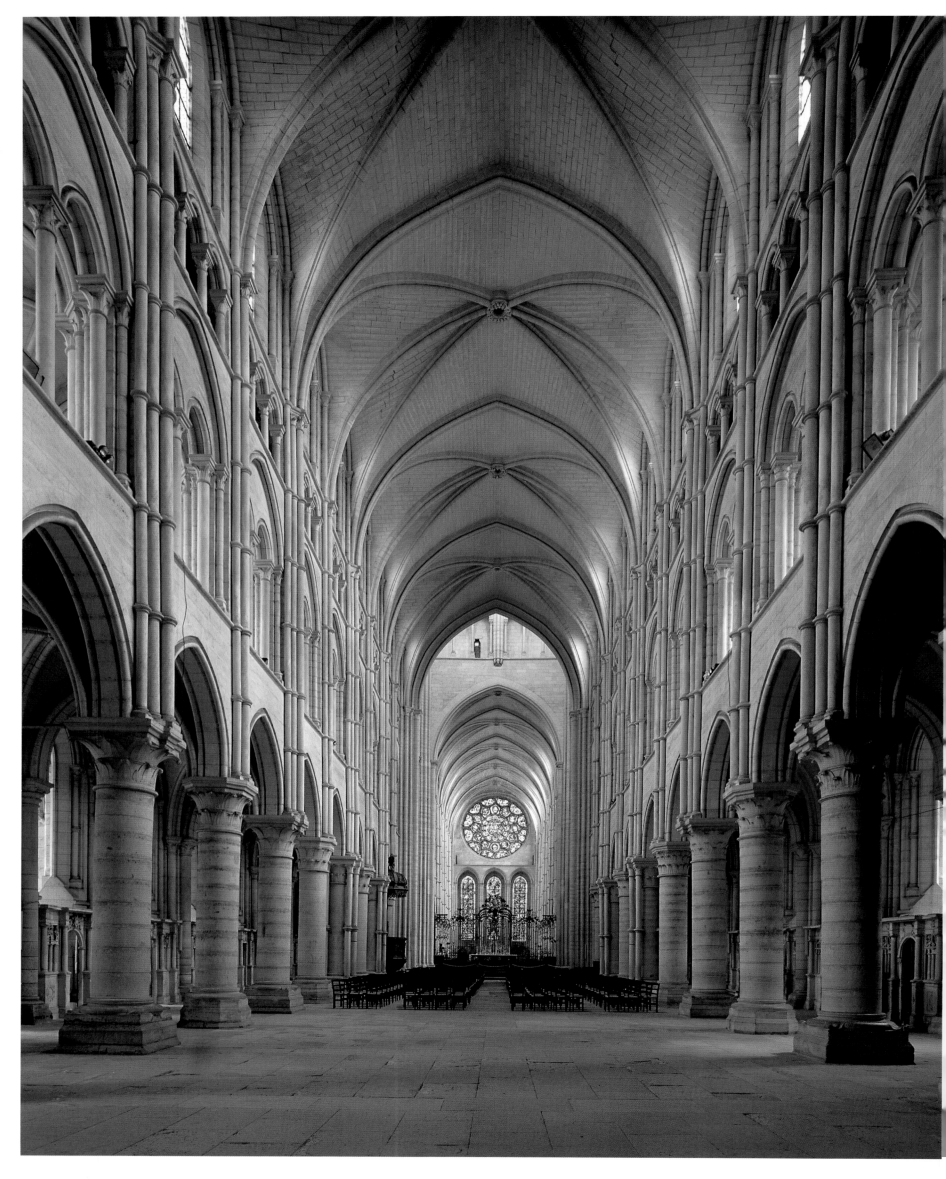

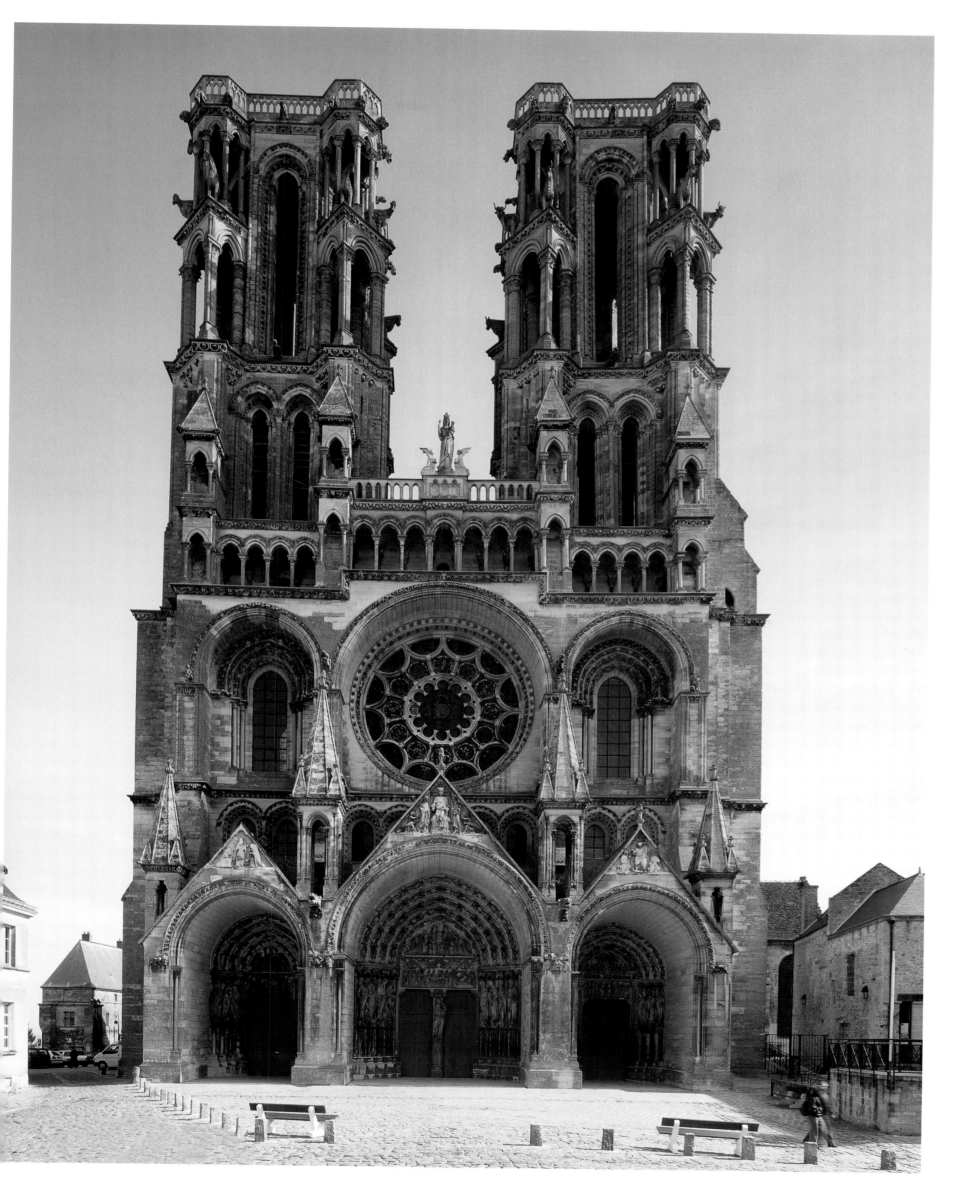

Paris, Notre-Dame Cathedral, begun 1163, nave wall (below); vault (center); and choir (right)

The center aisle of Notre-Dame today has three zones because of an enlargement of the windows in the clerestory. Only the bays nearest to the crossing are reconstructed and show the oculi that were originally between the gallery and the high windows (see below). The six-part vaults are articulated throughout by three responds, leaving no responds at the periphery of each bay to carry the clerestory wall ribs. Instead, those ribs end next to the diagonal ribs on the same respond.

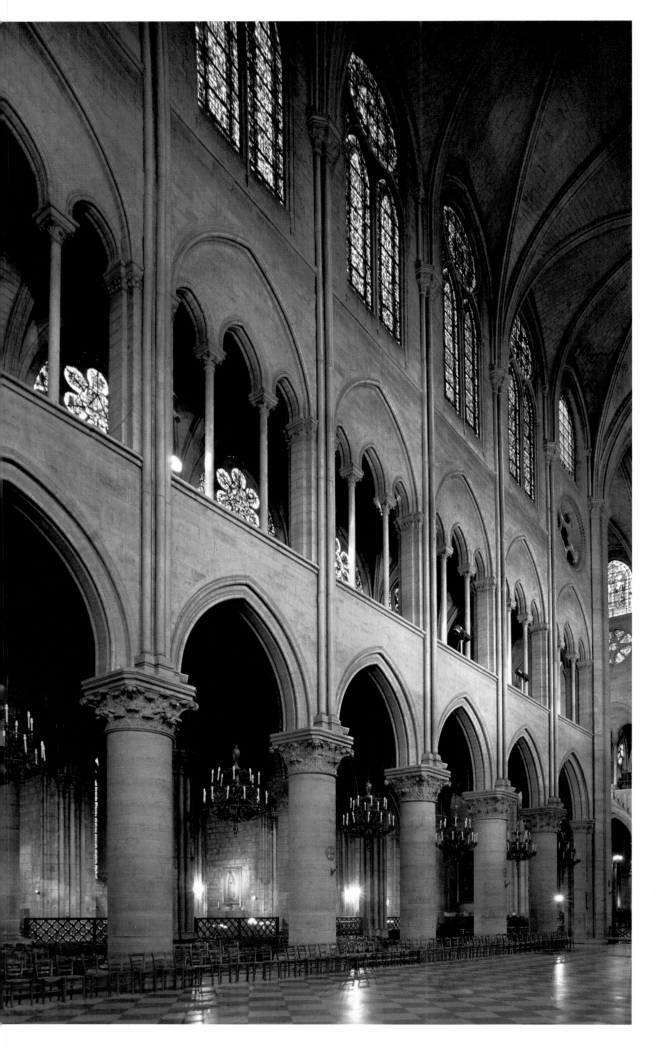

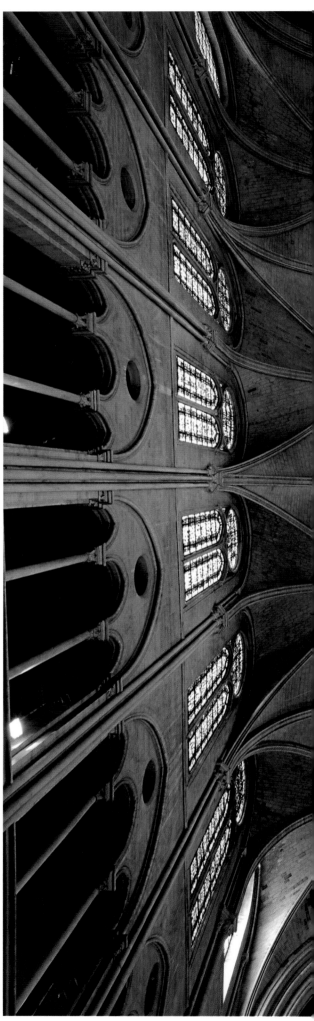

The elevation of the choir was exactly replicated in the nave, the only difference being the width of the arcades. The narrower arches of the choir only allow space for a double arch above them (instead of the triple arches found in the nave).

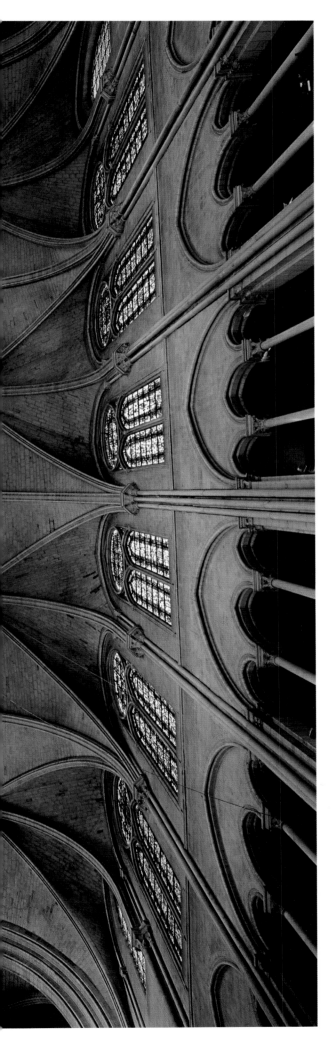

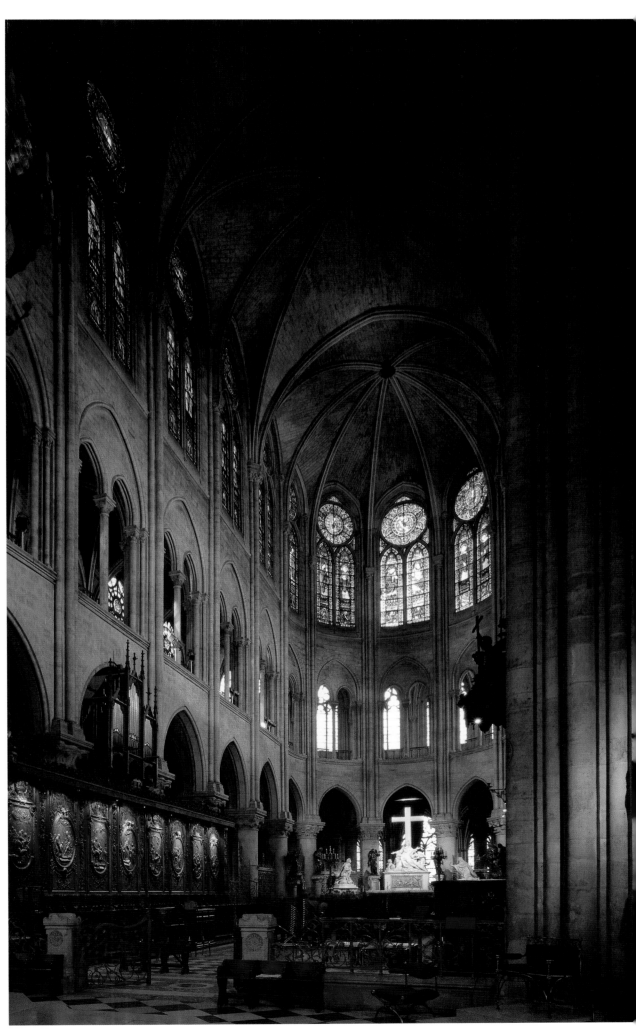

Soissons, cathedral, after ca. 1180,
exterior from the east; interior facing east

The original design of a triconch with ambulatories in
the east was abandoned around 1200 in response to the
cathedral of Chartres. The choir, the three-aisle north
transept, and the nave may well be considered as
successors of Chartres.
Looking at the choir from the east, one can discern the
chapels, whose three polygonal sides stand out slightly
and are only separated from one another by a buttress,
as well as the slender, evenly rising choir head and its
story-high windows.

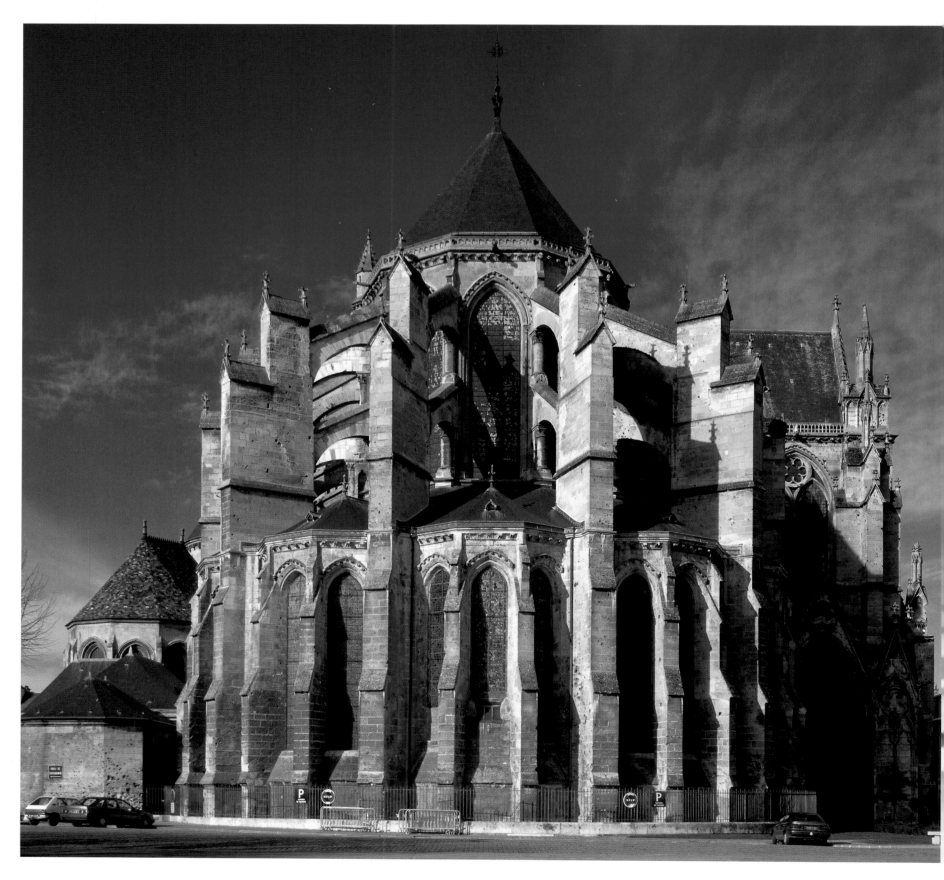

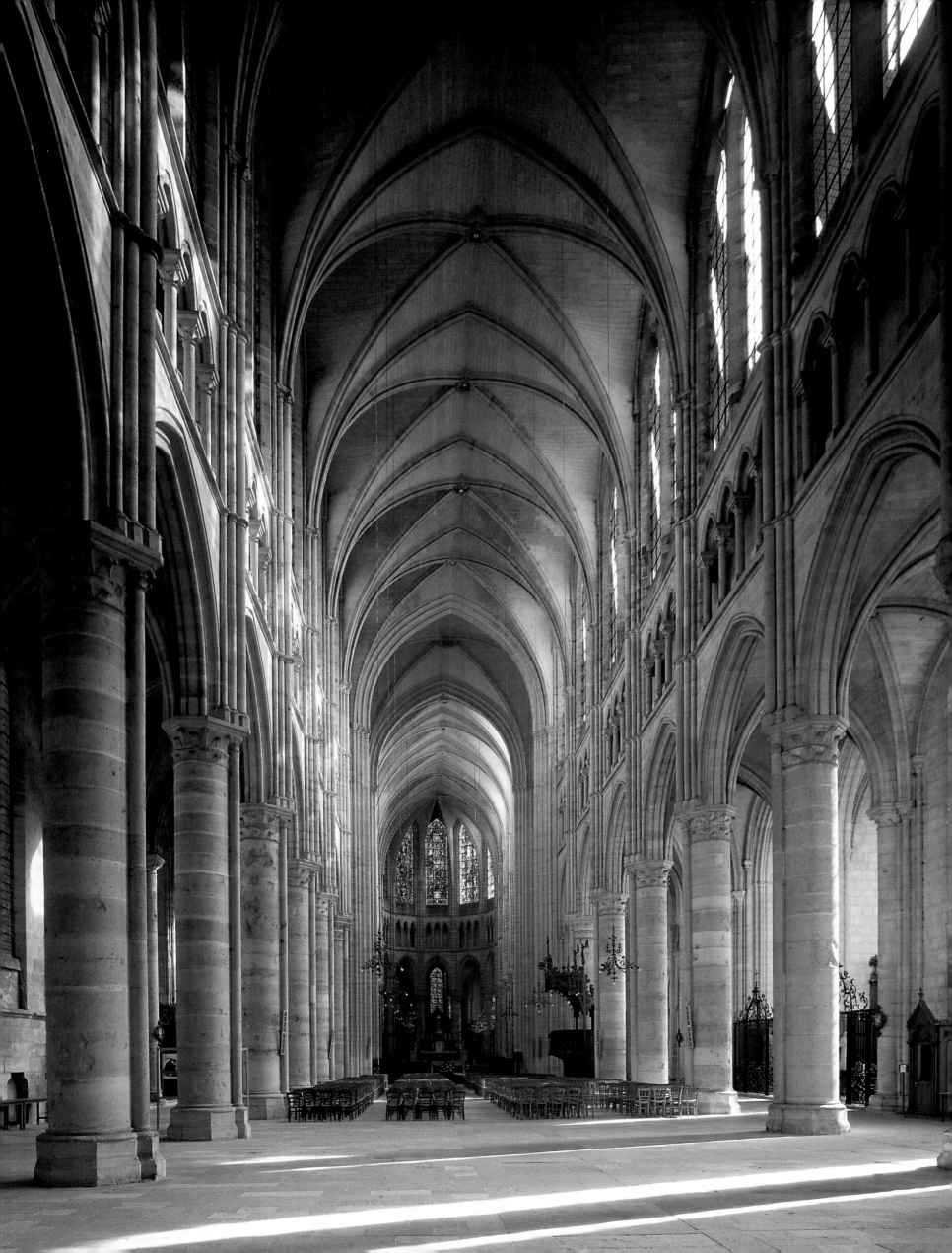

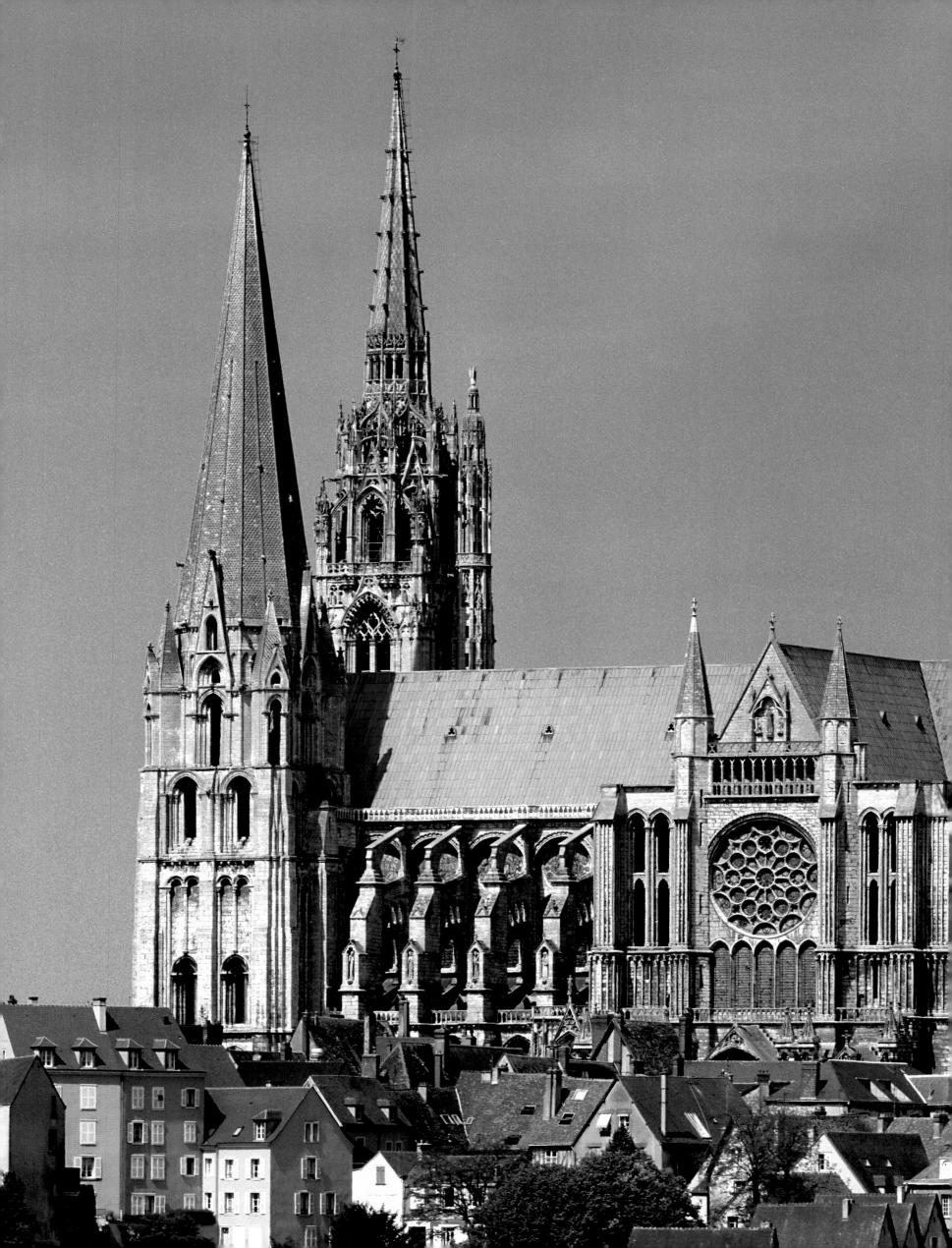

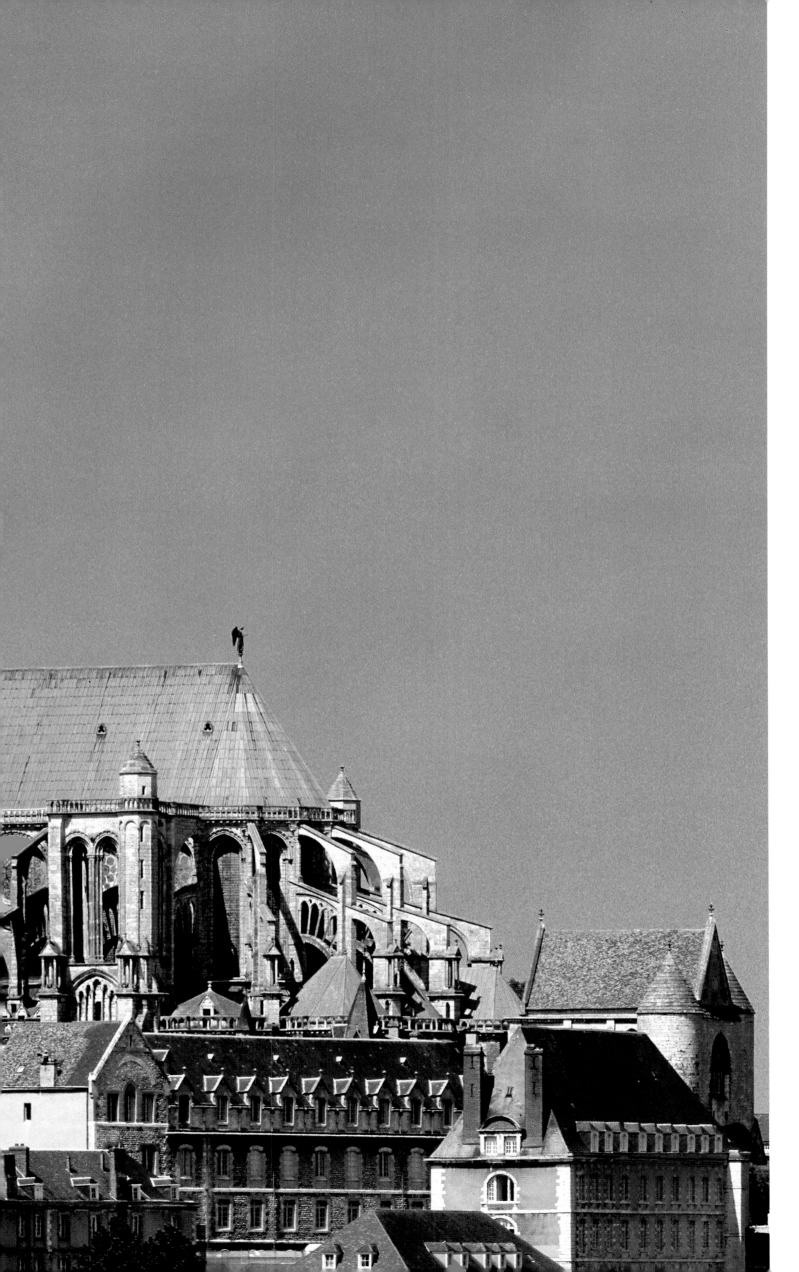

Chartres, cathedral,
begun 1194, view
of the city and the
church; main portal
(p. 168), 1145/55;
interior (p. 169)

The cathedral is
almost always the
highly visible center
of a French city. As
the largest church of
the city, it constituted
a sign of royal and
episcopal power
with its towers and
complex structures
enveloped by buttres-
ses as if draped by a
loose cape.

The west portal of
Chartres, tradition-
ally called the Royal
Portal, is considered
one of the master-
works of early Gothic
sculpture. The jamb
figures in particular
have always attracted
attention, notable for
their combination of
hermetic stylization
and expressive, life-
like quality. The latter
refers to the figures'
faces, to which
Viollet-le-Duc
attributed "the
character of portraits,
portraits made by a
master's hand."

Chartres introduced
two motifs into the
development of
architecture that later
became canonic: the
three-zone elevation
with a continuous
triforium, and the
compound pier,
which represents a
synthesis between
the round support
and continuous
articulation from the
ground upward.

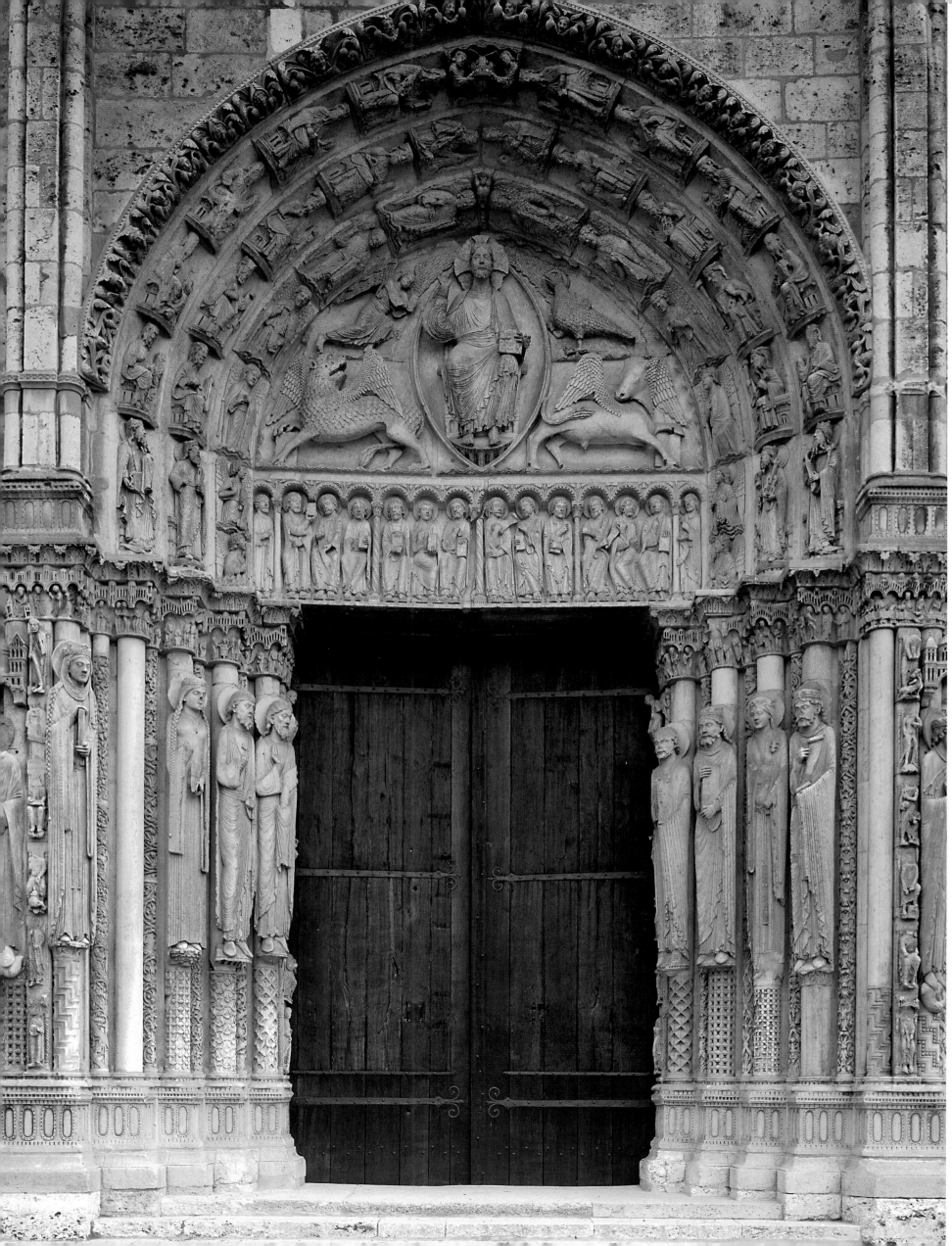

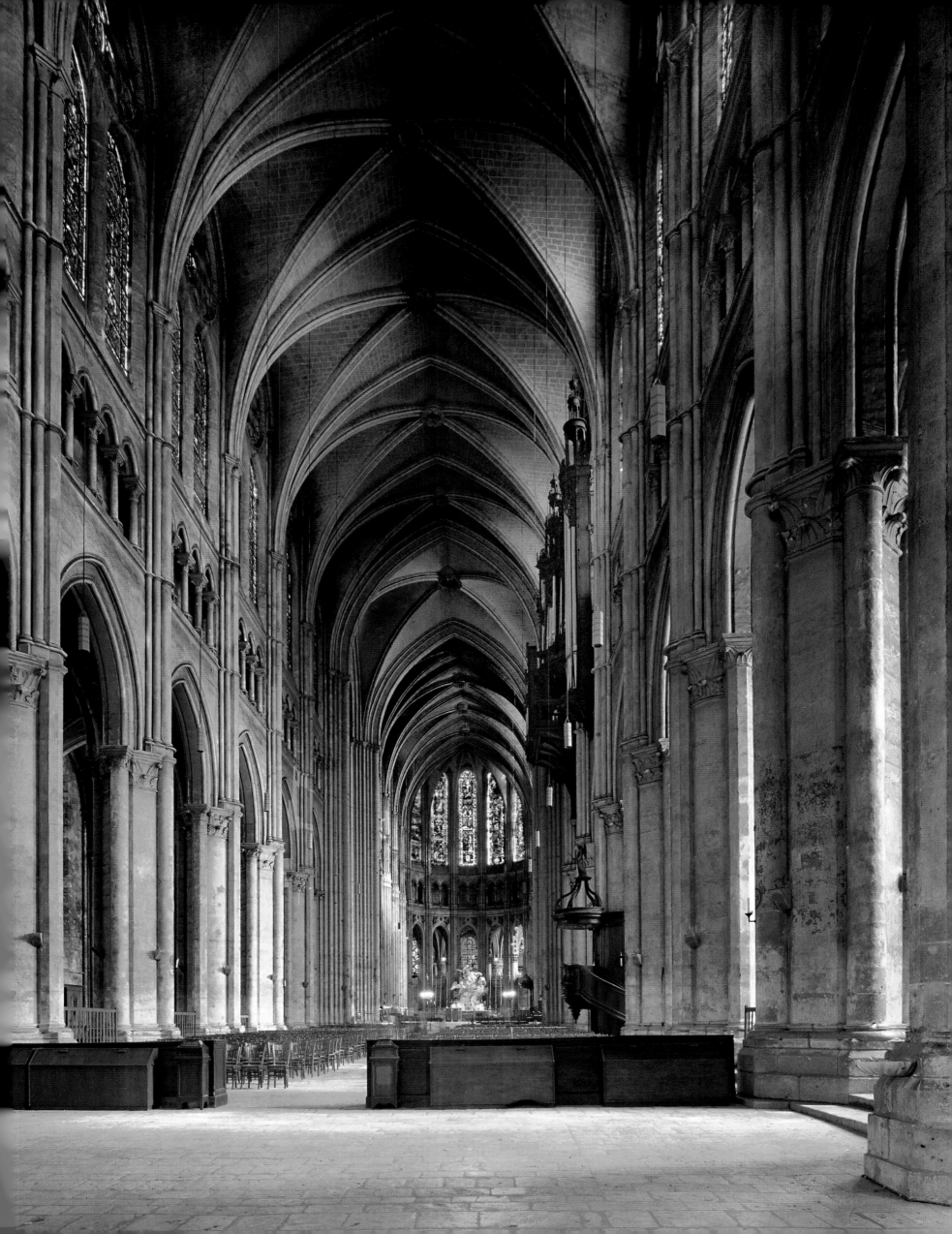

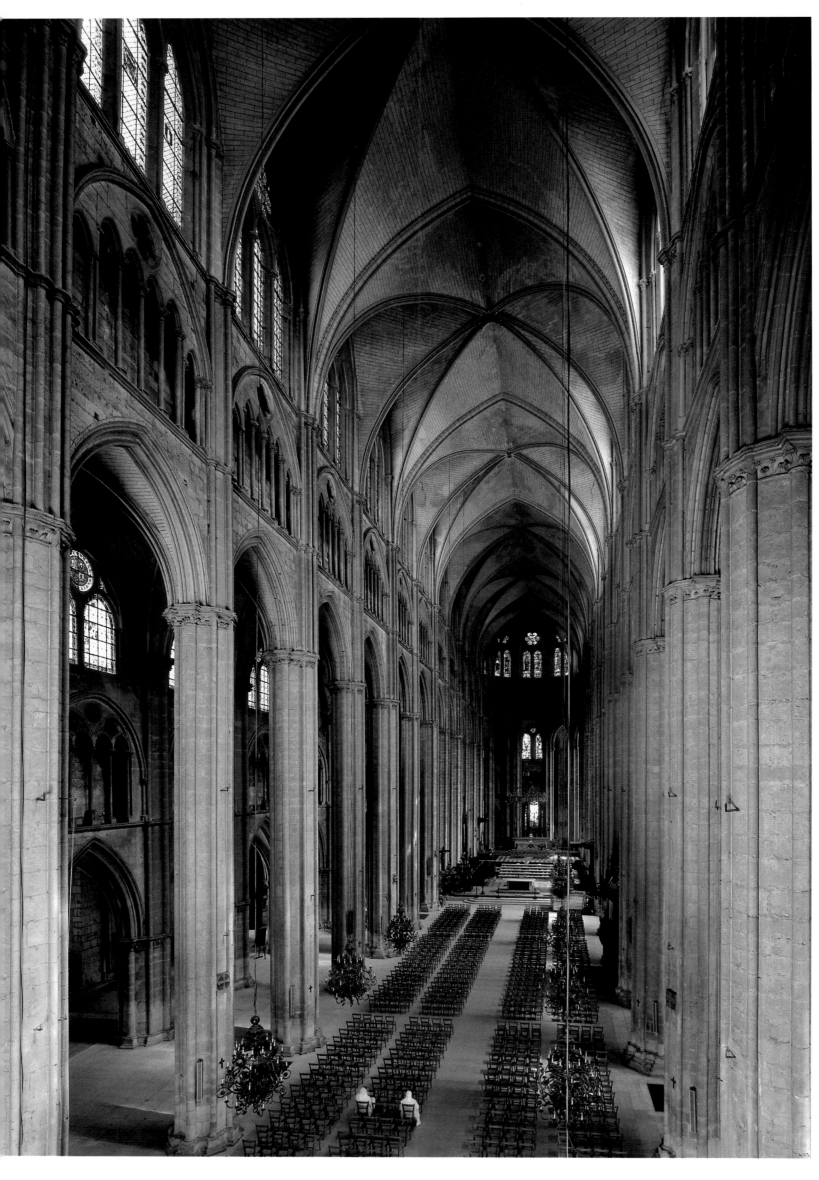

LEFT, OPPOSITE, AND
PAGES 172/173:
Bourges, cathedral,
begun 1194,
nave facing east (left);
choir ambulatory
(opposite); exterior
view from the south-
east (pp. 172/173)

The cathedral of
Bourges is unique
and was seldom
imitated. It has five
aisles, the floor plan of
a double basilica, and
foregoes a transept.
The piers, which are
exceptionally high in
the inner ambulatory
and extremely stout in
the outer ambulatory,
create an impression
of space that was
unequalled in any
other Gothic church
in France.

As a result of the
consequent continu-
ation of the five aisles,
the choir was built
with a double ambula-
tory, to which tiny
chapels are attached
like beehives without
disrupting the
ambience of the space.
Here, too, the hall
character of the choir
head and the first
ambulatory is notable,
while in comparison
the outer ambulatory
comes across as a dark
shell of space.

The peculiarity of the
interior elevation
results in a noticeably
horizontal external
appearance, which is
only interrupted by
the west towers. The
buildup is achieved
in three stages, sur-
rounded by buttresses
and the extremely
steep ribs of the flying
buttresses.

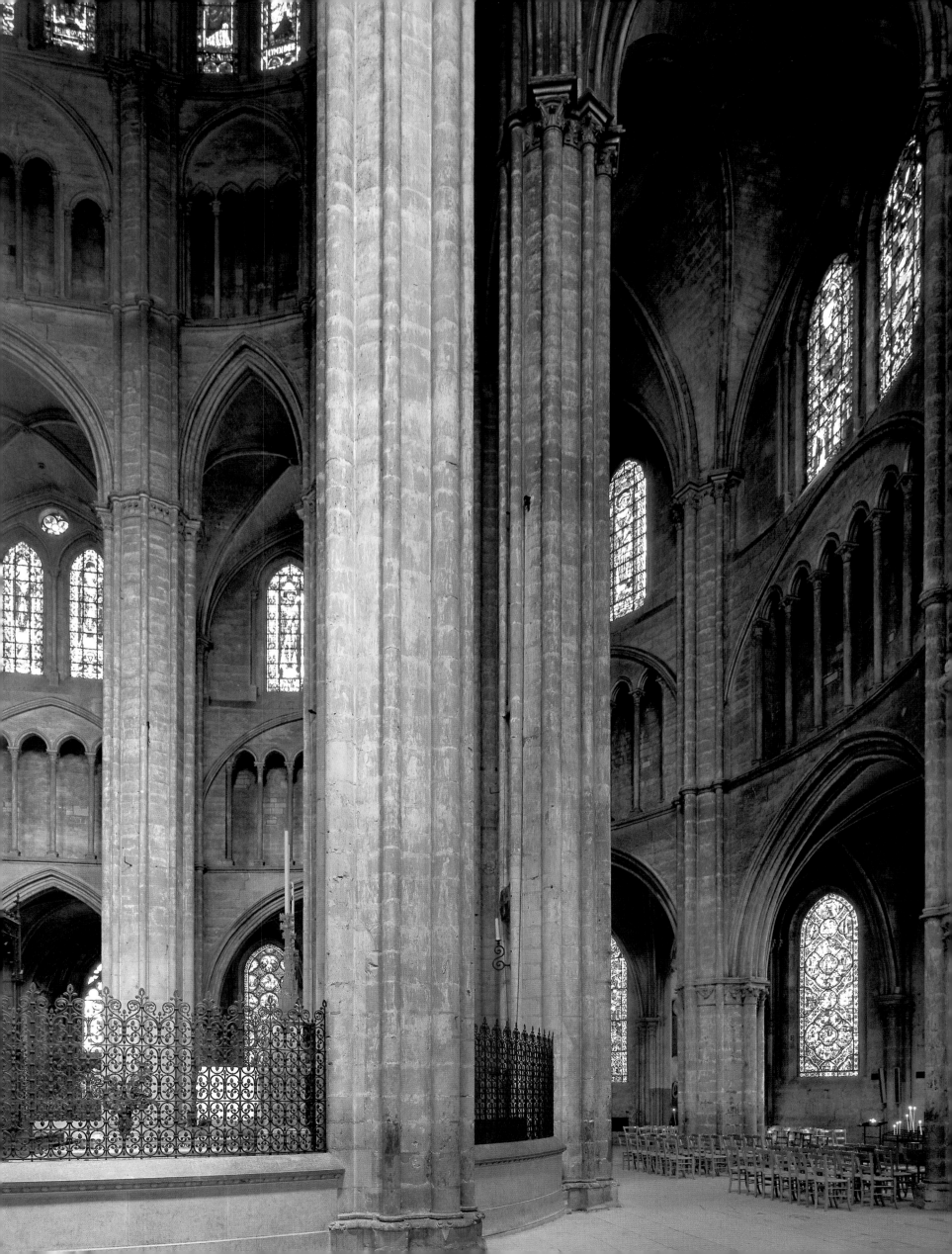

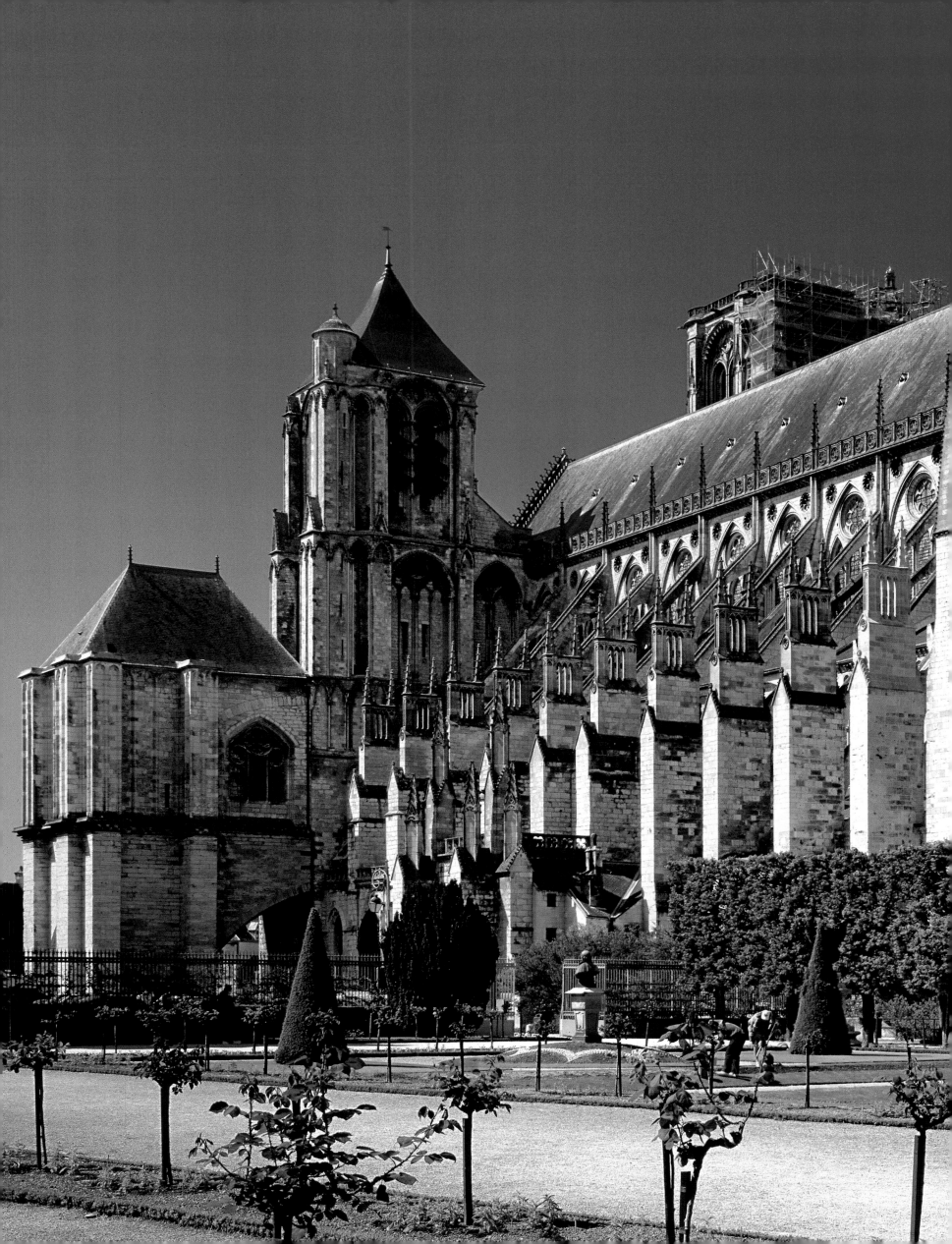

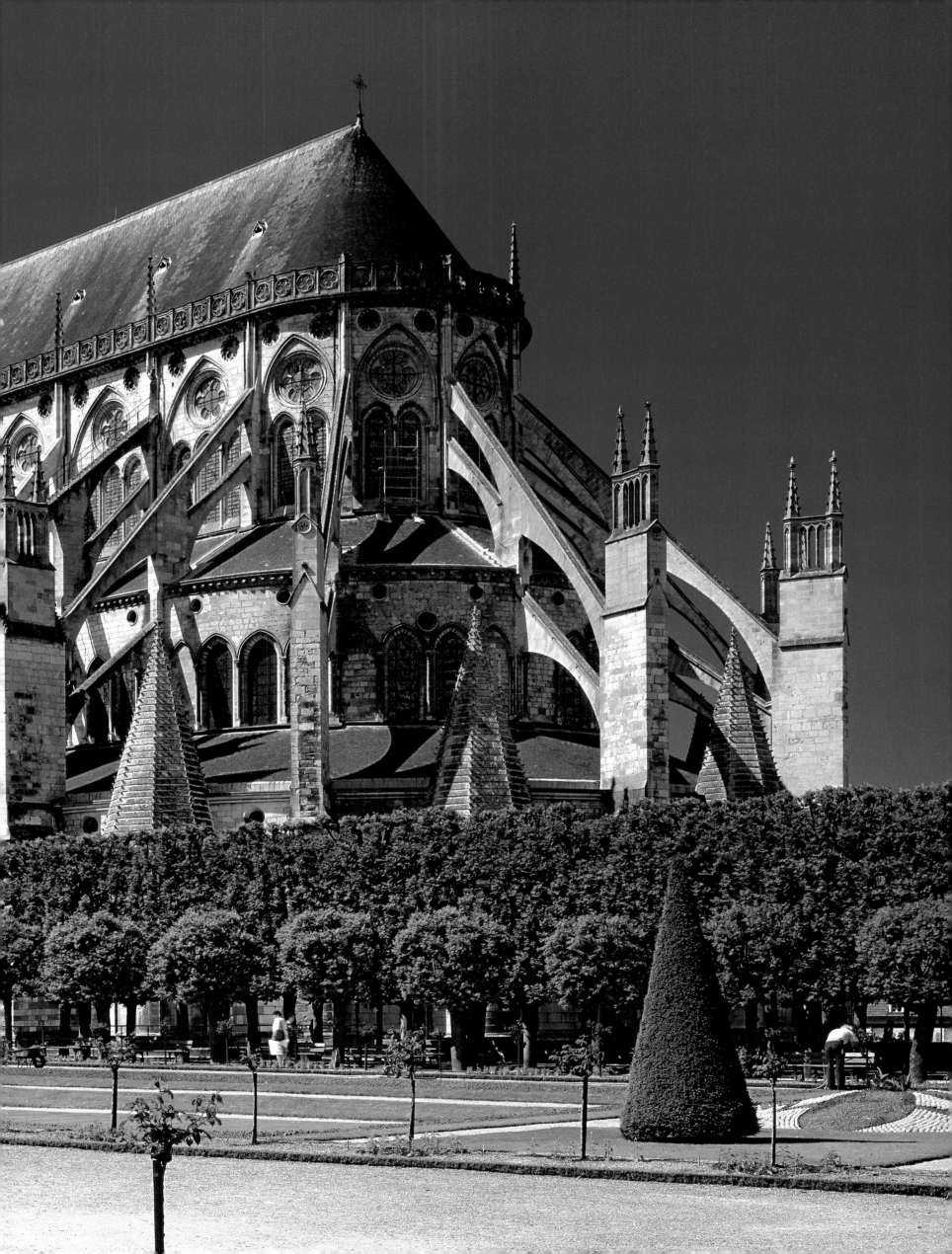

BELOW, CENTER, AND RIGHT:
Reims, cathedral, begun 1211, west facade (below), after 1254; view of the choir from the east (center); interior view toward the west (right)
The cathedral of Reims marks the beginning of the High Gothic era. Unified in all its parts and structured across all stories, it completely fulfilled all aesthetic requirements by normalizing even the compound piers (in Chartres, round piers with octagonal responds alternated with octagonal piers with round responds). Capital bands were also added, which further enhanced the ensemble.

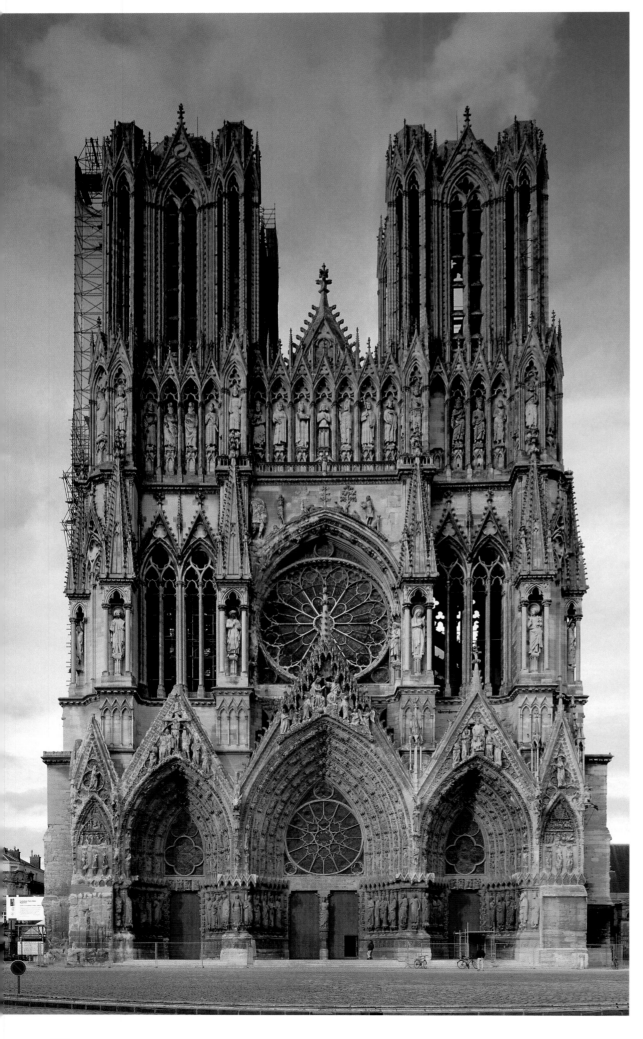

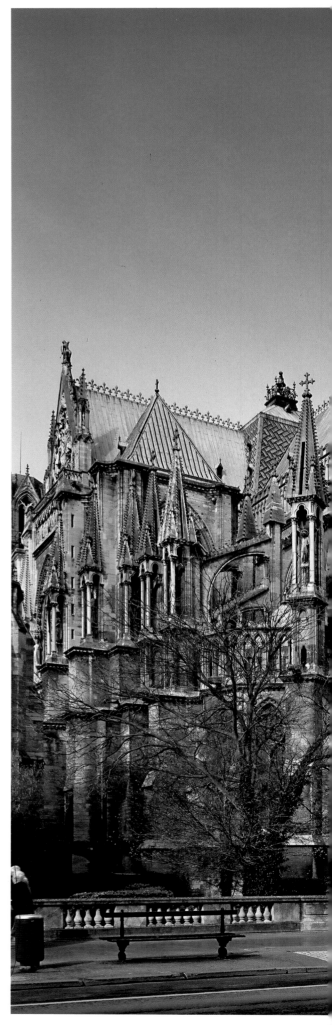

In the choir chapels one finds the first examples of pronounced tracery, which consists of nothing more than thin ridges and applied profiles. Unlike in older buildings, the buttresses have now been replaced by figure niches, and are crowned by pinnacles and cross flowers.

Like the choir, the west facade was also enriched with numerous forms of ornamentation. The tympanum at the portals was abandoned and replaced by windows—quatrefoil windows in the sides and a rose at the central portal that is repeated in monumental size in the upper story.

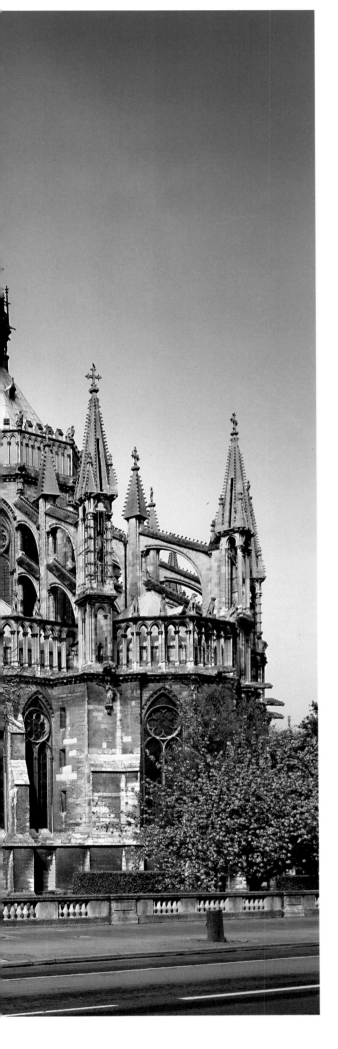

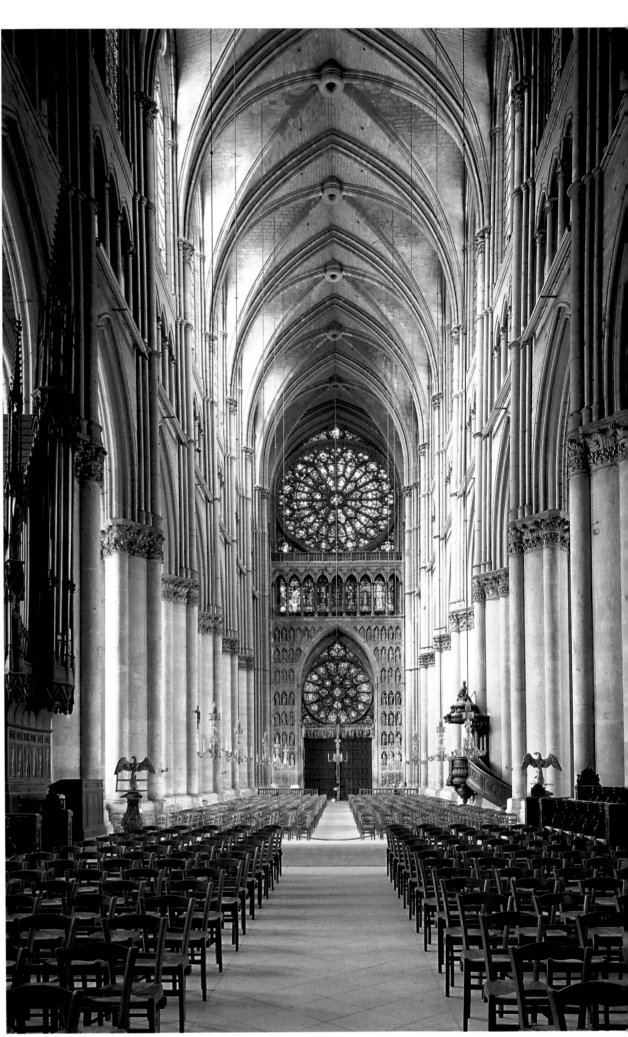

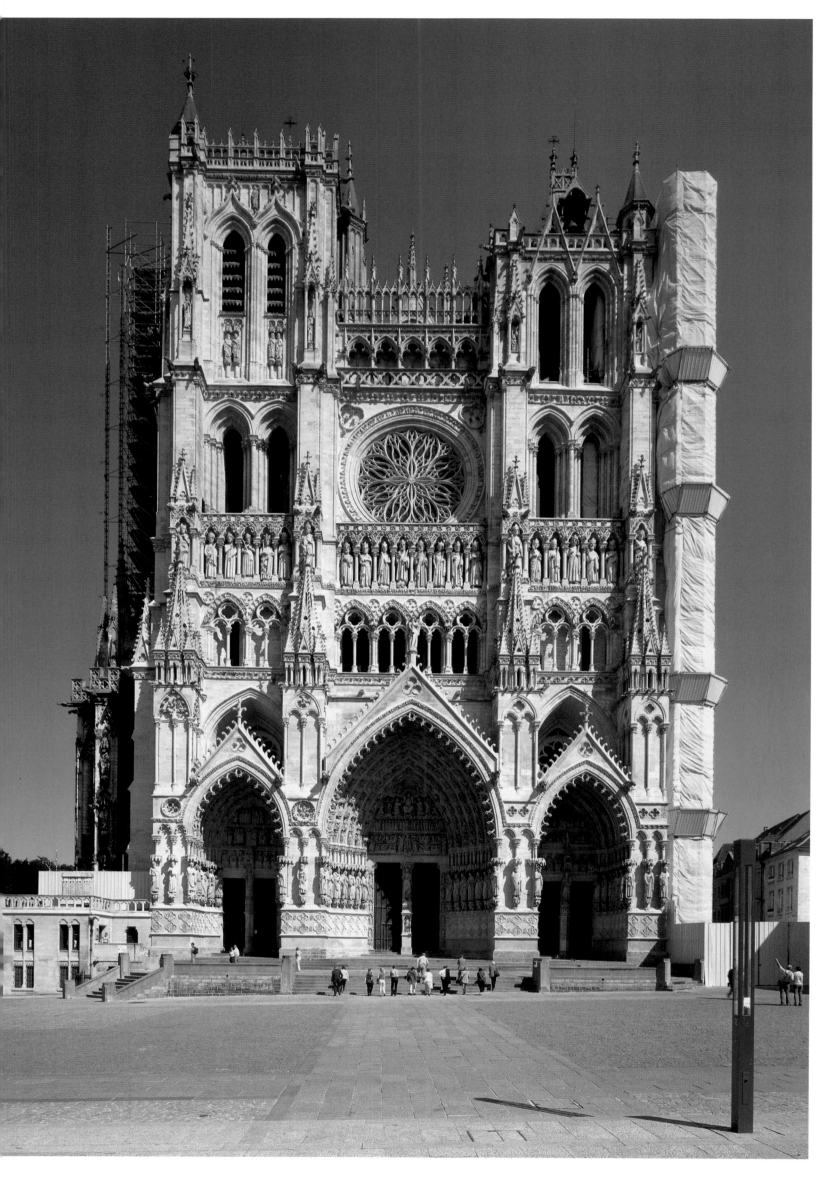

Amiens, cathedral,
begun 1220, west facade
and interior looking east

The decorative ex-
pression of the High
Gothic era starts in
Amiens. The tracery
of the clerestory incor-
porates the triforium
into the whole; a decor-
ative band runs along
the foot of the triforium;
and in the choir, gabled
arches—until then
found exclusively on the
exterior of structures—
decorate the arches of
the triforium, which
for the first time is
illuminated.

Compared to the west
facade of Reims, here
the stories have been
changed. A walkway
with tracery and the
figure gallery have been
inserted between the
portal zone and the rose
window level, resulting
in a cohesive lower
structure from which
the towers rise higher
and more filigree.

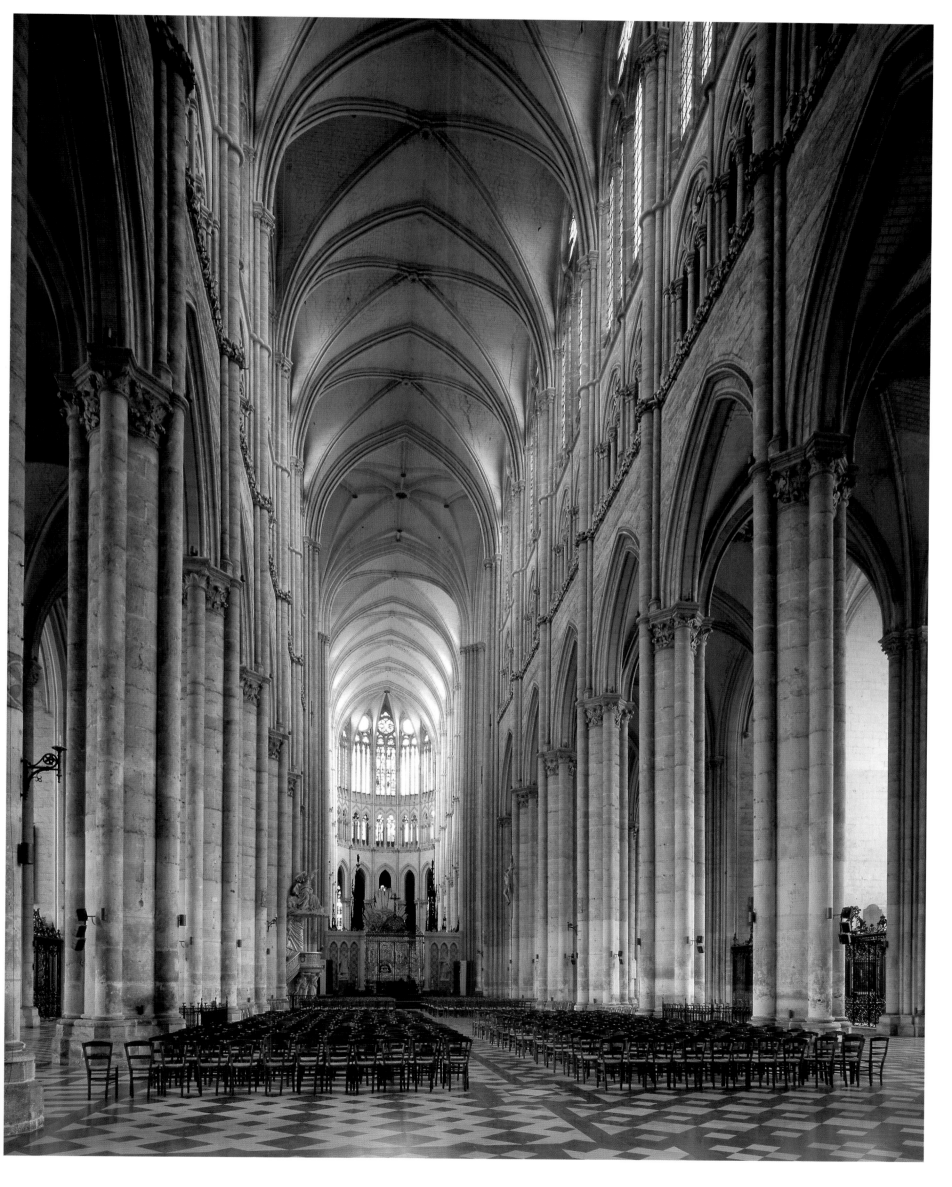

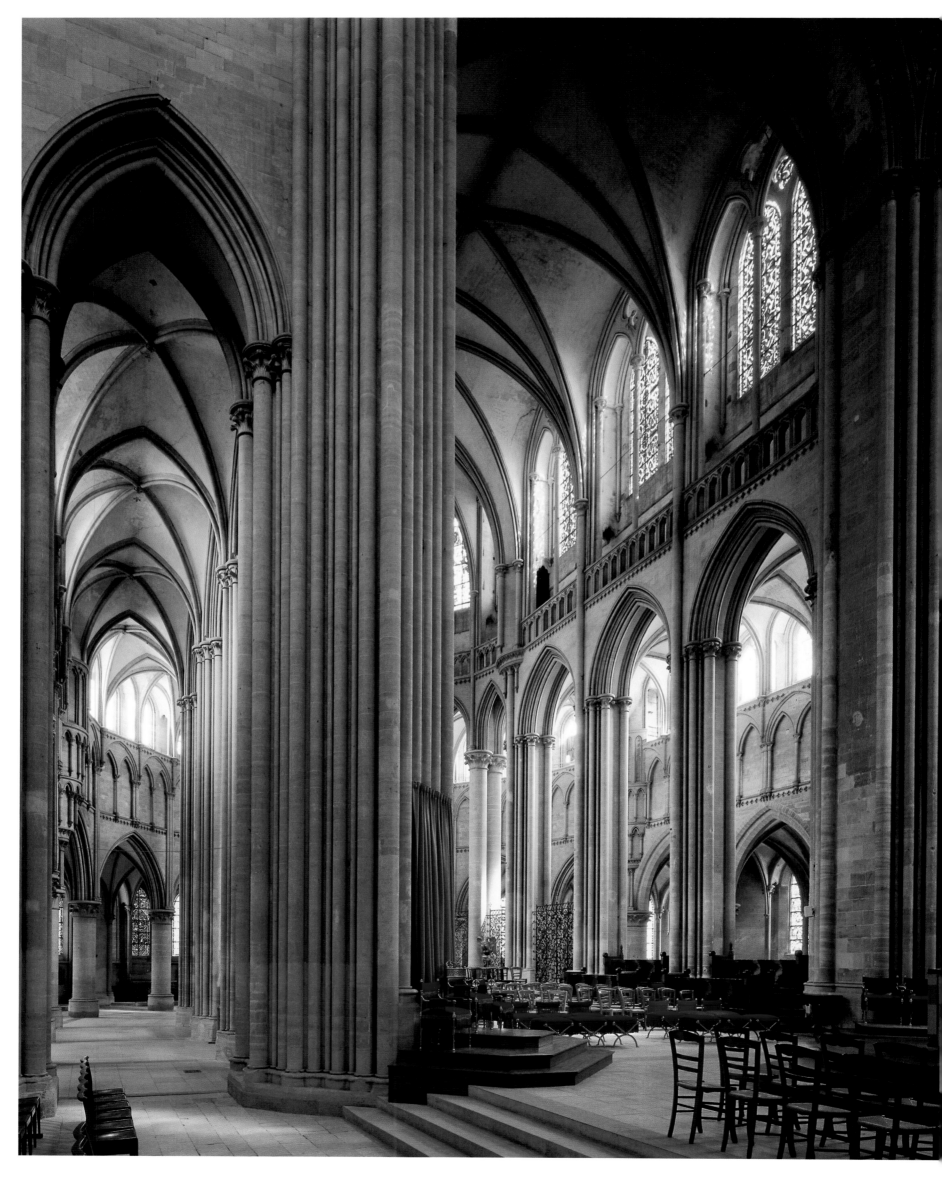

Coutances, cathedral, after 1180,
choir; view from the east
The five-aisle choir of Coutances is built as a double basilica like those of Bourges and Le Mans so that here, too, the arcades of the center aisle are very high, but the elevation of the choir head and interior choir ambulatory do not correspond. The walkway in front of the clerestory is traditional Norman.

PAGE 180: **Carcassonne, cathedral,** begun 1280, interior of the choir and transept

The choir of the cathedral of Carcassonne incorporates Cistercian influences in its floor plan and elements from Sainte-Chapelle in Paris (dedicated in 1248) in its elevation. Above a plinth with blind tracery rise steep lancet windows, before which a cycle of figures appear under baldachins.

PAGE 181: **Albi, cathedral,** 1287–ca. 1400, interior view of the wall pier church

The cathedral of Albi is a special case of French Gothic architecture, a wall pier church with chapels surmounted by tribunes on the exterior sides. A single, massive, brick tower rises above the east section of the church.

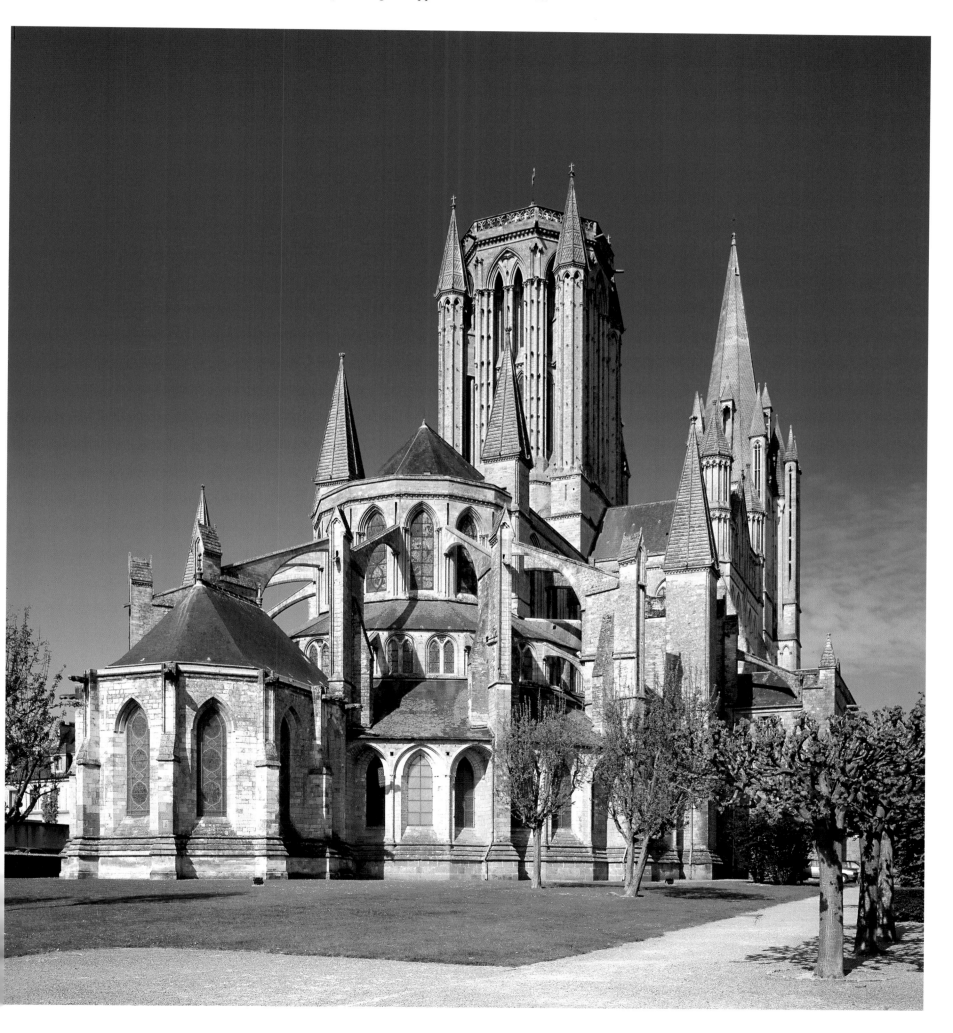

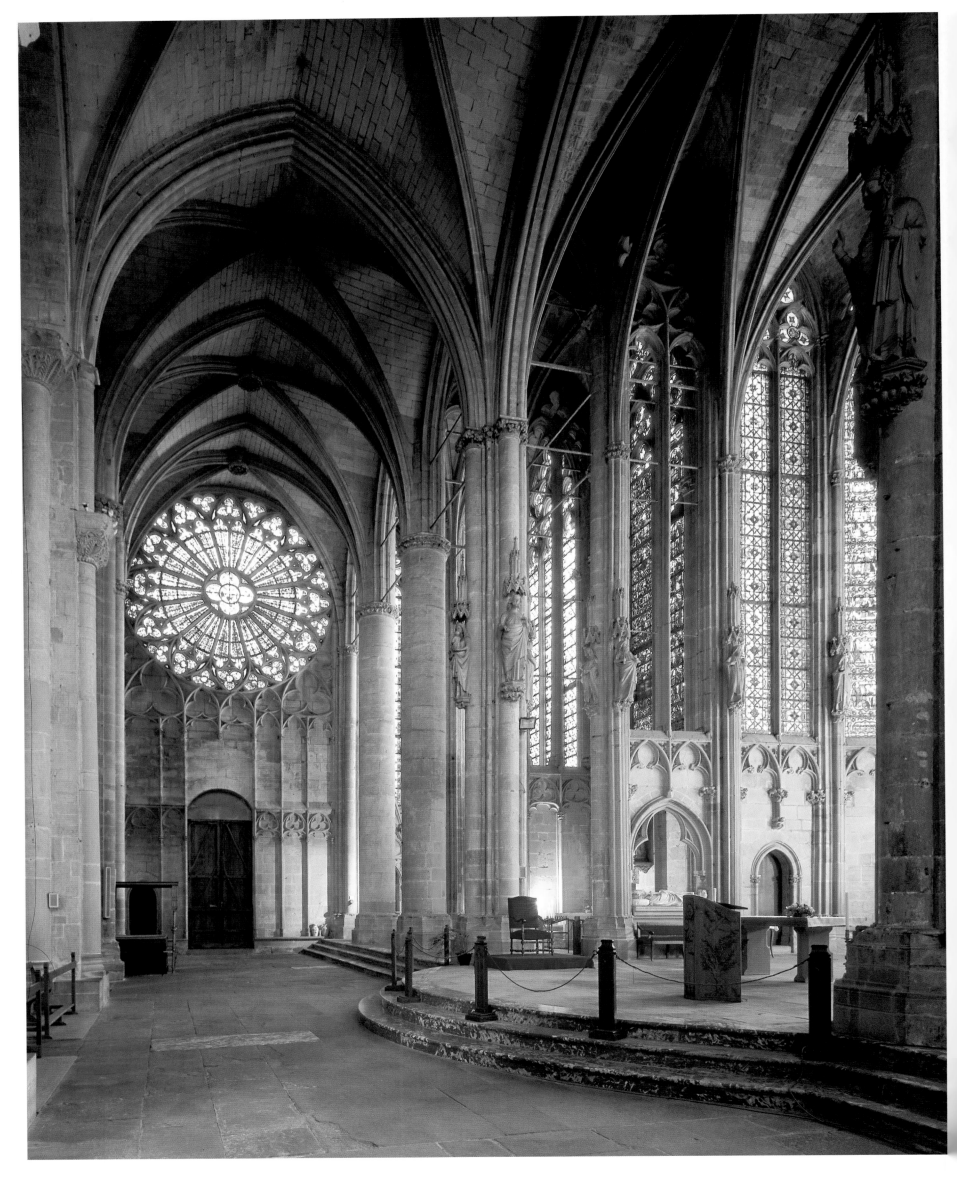

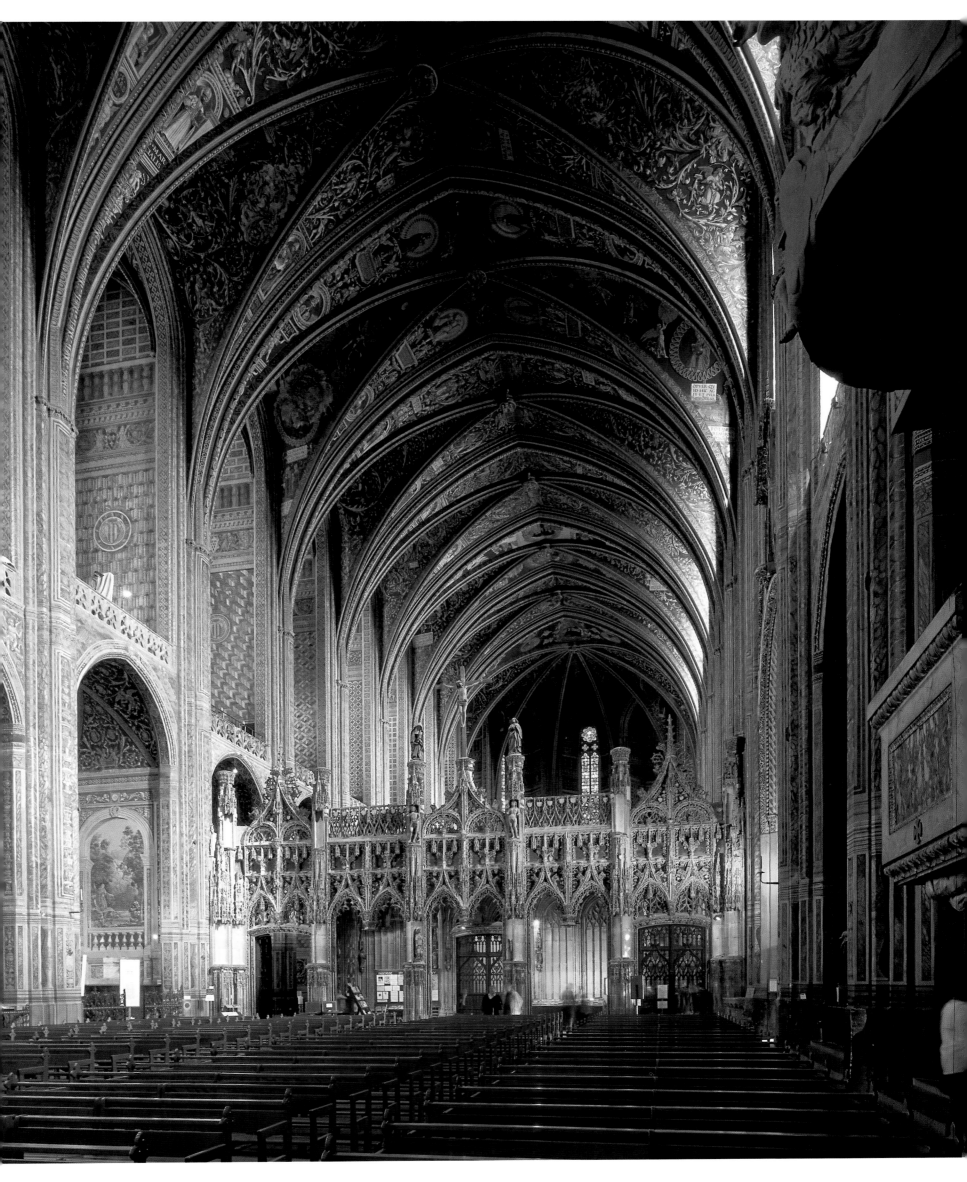

Paris, Sainte-Chapelle, dedicated 1248, interior of the lower church (below) and upper church (opposite)

King Louis IX had the two-story Sainte-Chapelle built in order to house the crown of thorns that Emperor Baldwin II had acquired and which were brought to Paris in 1239. Saint-Chapelle serves as a precious shrine whose architecture and accoutrement displayed and further enhanced the sacred character of the kings of France.

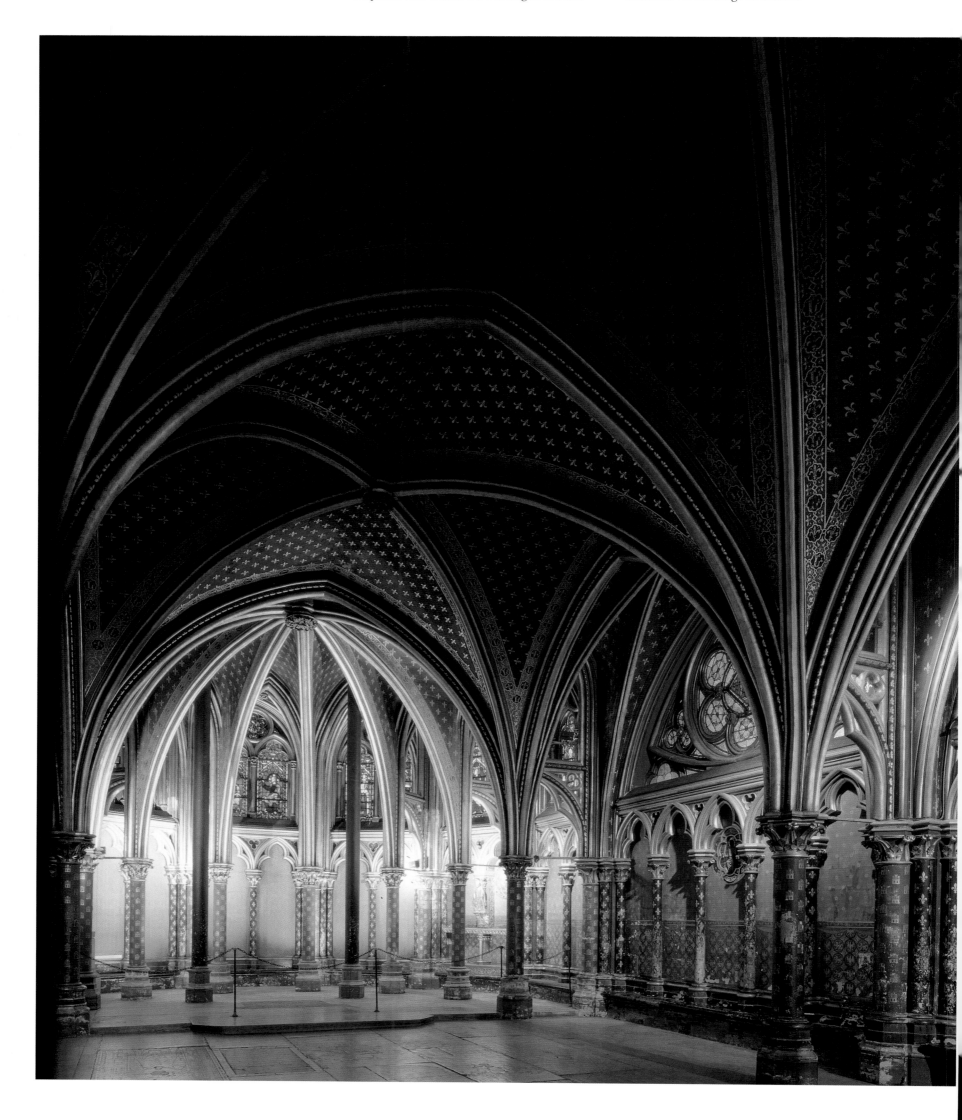

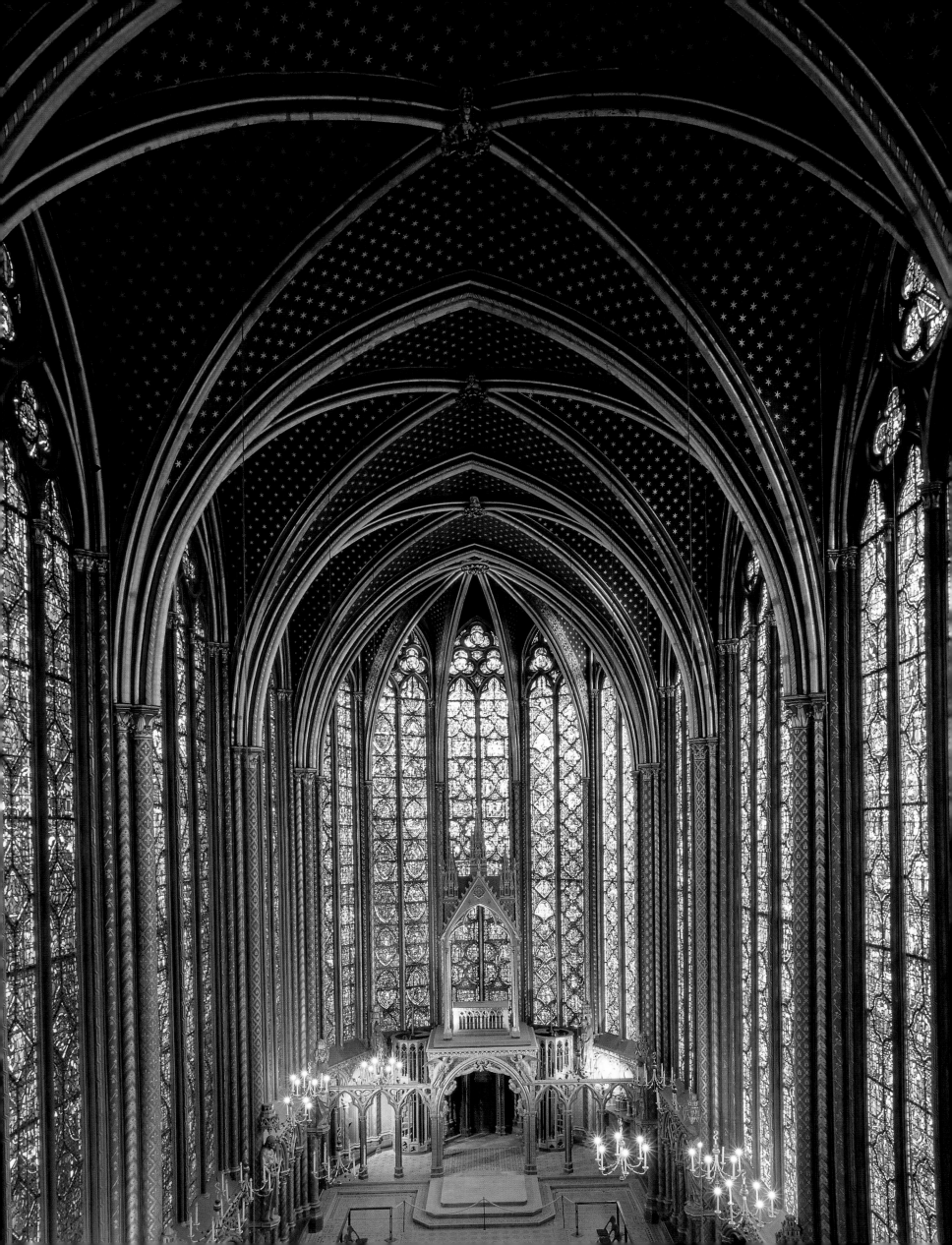

Medieval Building Sites

The oldest preserved tract on architecture is *De architectura*, a ten-volume text by the Roman architect Marcus Vitruvius Pollio that appeared in 28 B.C. It provides detailed information about the training of a building master, about creating and designing all kinds of structures, proportions, technique, tools and machines, and construction materials. It also gives an overview of the knowledge of that era—which was extensive. It does not address the organization of construction projects, nor their financing. These ten books on architecture were copied in Carolingian times and served as basic reference material for the building masters commissioned by Charlemagne. Notker Balbulus, a monk at St Gall, described the role of Charlemagne as a patron or commissioner of works in his *Gesta Karoli* (written ca. 885). He reports that Charlemagne wanted to build a church of his own design in Aachen that was more glorious than the buildings of the ancient Romans. To achieve this he called together artisans and masters from all lands this side of the ocean and put in charge of the project an abbot who was the most knowledgeable of them all. The emperor ordered all magnates of the region to provide for the artisans as his emissaries and to contribute whatever was necessary for the construction. Those who came from afar were to be fed and clothed from public funds by the majordomo Liutfried. The *Vita Caroli Magni* by Eginhard (833) and a letter to the emperor from Alcuin, president of the royal court chapel, confirm that Charlemagne made sure that the church received resplendent accoutrements and that he arranged for columns and marble slabs to be brought from Rome and Ravenna. Thus the patron himself made decisions concerning finances and the procurement of materials and manpower, and he most certainly decided which designs were to be followed. For this very prominent project, we even know the name of the master workman: Master Odo of Metz. He was not, by the way, called an architect.

Until the thirteenth century, the term *architectus* referred not only to the master workman, who was in charge of all the craftsmen, but also to the patron and commissioner. Early examples can be found in the catalog of the abbots of Fulda, where Abbot Ratgar (802–817) is referred to as *sapiens architectus*. The same is true for Bishop Evraclus of Liège, Abbot William of Hirsau (1069–1091), the bishops Gérard I († 1049) and Gérard II (1076–1092) of Cambrai, and others. In those cases, the terms *architectus* and *auctor* (creator) are used interchangeably.

Church construction was generally financed by patrons and donations, but also from episcopal and monastic wealth that took the form of cash, chattel, land, and buildings. On top of that came the enforcement of annual contributions to the construction, as for example in the case of Cluny III, which was generously supported by the king of Spain. Responsibility for the administration of these church treasures fell to the episcopal president of the church or to the abbot, sometimes superposed by government entities. However, since the medieval practice of law was extraordinarily complex and differed greatly from region to region, the financing of each building project was handled very individually.

The management of the actual construction was the duty of the building administration—called the *opus*, *opera*, or *fabrica*—that was affiliated with the chapter; legally, however, it was an independent entity. In some cities it still exists to this day. This institution administered finances and manpower, established contracts with the master craftsmen, and was accountable to the bishop and the chapter.

Medieval building records contain information on work hours and salaries at the construction sites. Most work was done on the basis of daily wages, paid weekly; in some cases, payment by piece was possible. Wages were lower in winter than summer due to the shorter working hours. In summer work began at 5 a.m. and ended at 7 p.m., with three meal breaks, with actual working time amounting to about 11 hours. On Saturdays work ended at 5 p.m., but every other Saturday the workers were released at 3 p.m. to give them time to use the public baths. The change between summertime and wintertime took place on a specific date that could vary by several days from region to region. In winter, a workday lasted approximately 10 hours. Due to the many holidays, feast days, and commemorations, people in fact worked only about half of the year.

For the design of a new building or the alteration of an existing one, one of the first steps was to hire a qualified *magister operis*, or building master. In his often quoted *Tractatus de combustione et reparatione Cantuariensis ecclesiae* (*Tract on the burning and restoration of the Church of Canterbury*; 1185), the monk Gervase of Canterbury describes the catastrophic fire of 1174, the parts of the church that were lost, and the commissioning of the building

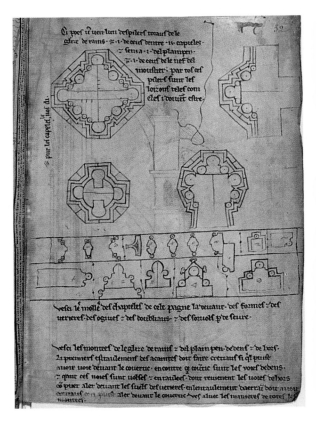

Villard de Honnecourt, *Portfolio*, shaped stones for piers and windows, Paris, Bibliothèque Nationale, Ms. fr. 19093

master William of Sens, who at the time was working on one of the first early Gothic cathedrals in France. Gervase also recorded William's counsel and measurements from the construction site of Canterbury cathedral. He talks about the difficulties in obtaining stones from the continent, the invention of rope winches, and the creation of templates for hewn stones. Next follows a report on progress at the construction site and an account of how William fell 50 feet from the scaffolding and was hurt so badly that he had to return to his home in France, making it necessary to find a replacement in Canterbury.

The chronicle of the Bloemhof monastery tells of the laborious work on the foundation of its brick church, begun in 1238, and offers a detailed description of materials and the way they were used, of the hiring and feeding of the workers (who worked for

LEFT: **Archbishop Anno II of Cologne with his five church patrons**, *Vita Annonis Minor*, created in Siegburg ca. 1180/1181, Darmstadt, Hessische Landes- und Hochschulbibliothek, Hs. 945, fol. 1 verso

RIGHT: **Construction of the Tower of Babel**, *Hrabanus Maurus*, "De originibus," 1023, Monte Cassino, Abbey Library, Cod. 132

God's wages), and of the hardships suffered during a famine that resulted from a bad harvest. In some paragraphs the chronicle reads like a handbook for the technique of laying foundations. There was no sketched out plan, since the author talks about the sections that were left unfinished due to an interruption of the construction so that they could be completed later according to the original plan.

The practice of drawing construction plans on parchment came about as late as the thirteenth century. Around 1230 the draughtsman and painter Villard de Honnecourt, from the Picardie region of France, traveled throughout that country drawing floor plans and elevations in a portfolio. It is a kind of handbook or architectural diary in which he recorded his observations and reflections. The oldest preserved plans on parchment are only slightly more recent, from around 1260: two sketches for the facade of the transept in Reims and a drawing for the west facade in Strasbourg. From then on it became the norm to design facades and towers on parchment. Examples are the famous elevation of the Cologne cathedral (around 1300, illus. right), without which completion of the west facade would not have been possible, Madern Gerthener's well-known plan for Frankfurt, and many more.

Approximately half a century earlier, a process had begun that could be called the individualization of the master workman. Starting in the early Gothic period, what had been the exception—as in the case of the Palatine Chapel in Aachen, Cluny III, and a very few other instances—now became the rule: sources now mention not only the initiator of the project and its patrons, but also the name of the master workman. This may have to do with the increase in written documentation as well as with a change in style. The Gothic is more an epoch of artistic style than the previous eras had been; it aimed at achieving certain spatial effects via artistic means: dissolution of the walls, diaphanous structure, colored light, tall spaces with high vaults. In many cases, a Gothic church consists of more sections and is more complex than a Romanesque one. As a result design, execution, and building coordination became more complex and the master workman was less expendable, and more distinctive. On top of that, the budding self-assurance of the citizens who came into wealth in the growing cities left its mark. A builder like Charlemagne or Conrad II, whose churches in Aachen or Speyer served to illustrate their claims and intentions, is seldom encountered during the Gothic era; Abbot Suger, the builder of Saint-Denis, is one such exception. As a rule, the development of architecture, the increase of size and effect, lay in the hands of the masters; commissioners were the bishops and chapters, and in a certain way the citizens, and a cathedral was intended less to express a specific program than to extol greatness.

Technical methods, tools, and materials are mentioned in innumerable picture and text sources.

Among the earliest medieval illustrations are the *Psychomachia* by Prudentius, painted around 1000 in southern Germany, and *De origine rerum*, a tract by Hrabanus Maurus dating from 1022/1023. They show images of construction workers (and possibly monks) sawing, erecting walls, and transporting materials. Sources increased in the second half of the twelfth century. The *Hortus deliciarum* of the Abbess Herrad von Landsberg, dating from 1175/1191 but preserved only as a copy, depicts stonemasons and their assistants at work in the context of the construction of the Tower of Babel. Their tools are a hoe with a long handle used to mix mortar, striking irons and wooden hammers, a double-pointed pick-axe, a plumb line, straightedge, and trowel—most are items still in use today. In the *Vita of the Saints Albanus and Amphibalus* by Matthew Paris (from around 1250) transport systems are depicted: a wooden wheelbarrow, a carrying frame, and winches (no pulley). Angled walkways resembling ladders serve to reach higher ground. A carpenter works the beams with a wide axe. The master workman is recognizable by the tools of his trade, the compass and square.

Along with illustrations—for example, a mosaic from the second quarter of the thirteenth century in the west narthex of San Marco in Venice—remaining anchor holes for scaffolding and posts in walls and floors demonstrate that simple wooden scaffolding was used. Such cantilever scaffoldings were depicted from the second half of the twelfth century, while north of the Alps post scaffoldings were probably only known as late as the mid-fourteenth century. The *Chroniques et conquêtes de Charlemagne* by J. de Tavernier (1450/1460) show a scaffolding held together by ropes. The scaffolding that Benozzo Gozzoli depicted in his 1468/1485 mural in the Campo Santo in Pisa seems much sturdier, and the winches have several wheels instead of just one.

Cologne, cathedral, detail of the west facade elevation, ca. 1300, 159.5 in (405 cm) high, 26 pieces of parchment attached to each other, Cologne, Archiv der Dombauverwaltung

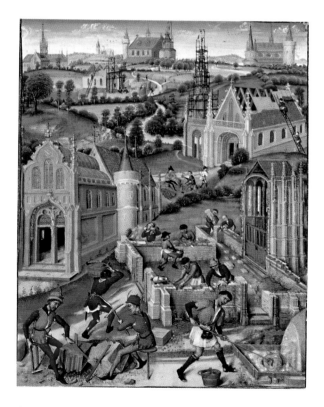

ABOVE: **Depiction of a construction site from *Roman de Girart de Roussillon*,** Vienna, Nationalbibliothek, Cod. 2554, fol. 164, 2nd half of the 15th c.

LEFT: **Drawing according to Herrad von Landsberg, *Hortus deliciarum*,** fol. 27, 1175/1191

Trier, Liebfrauenkirche, 1233/34–1260,
interior; exterior from the southeast

Dedicated to Mary, this cross-shaped central plan church
was erected on top of a late-antique complex from the 4th
century. The steep proportions, which are equally evident
in the interior and the external construction, as well as the
slim supports and articulations, demonstrate the builders'
familiarity with early Gothic of the Champagne region.

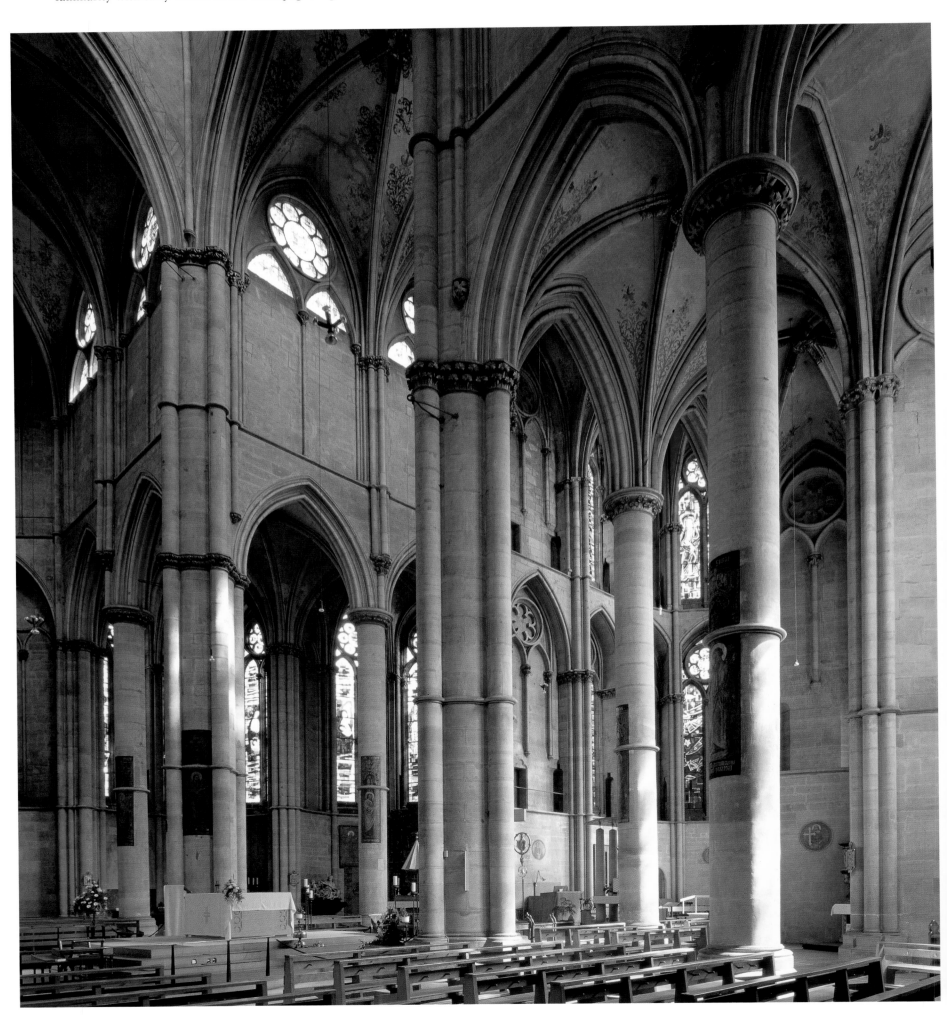

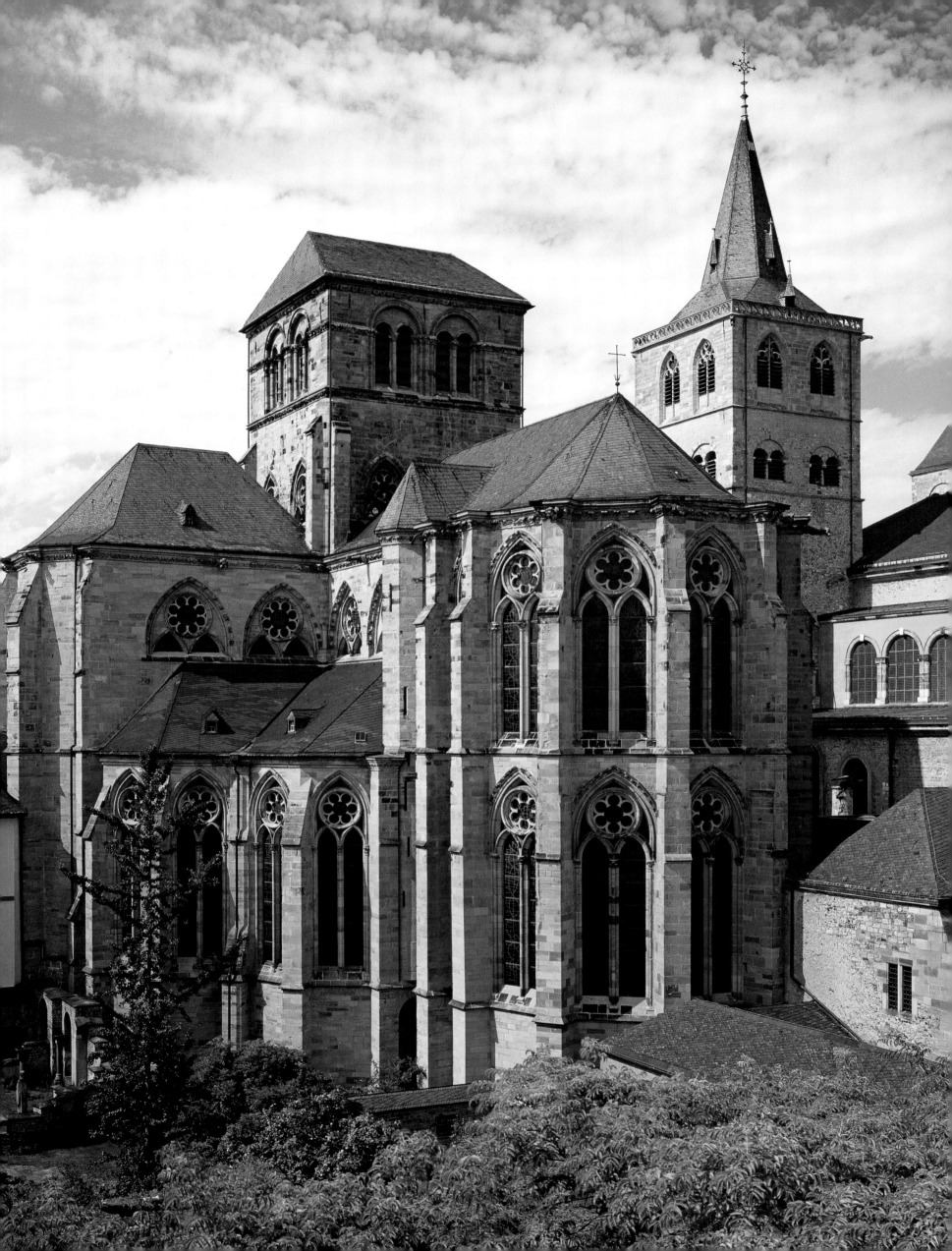

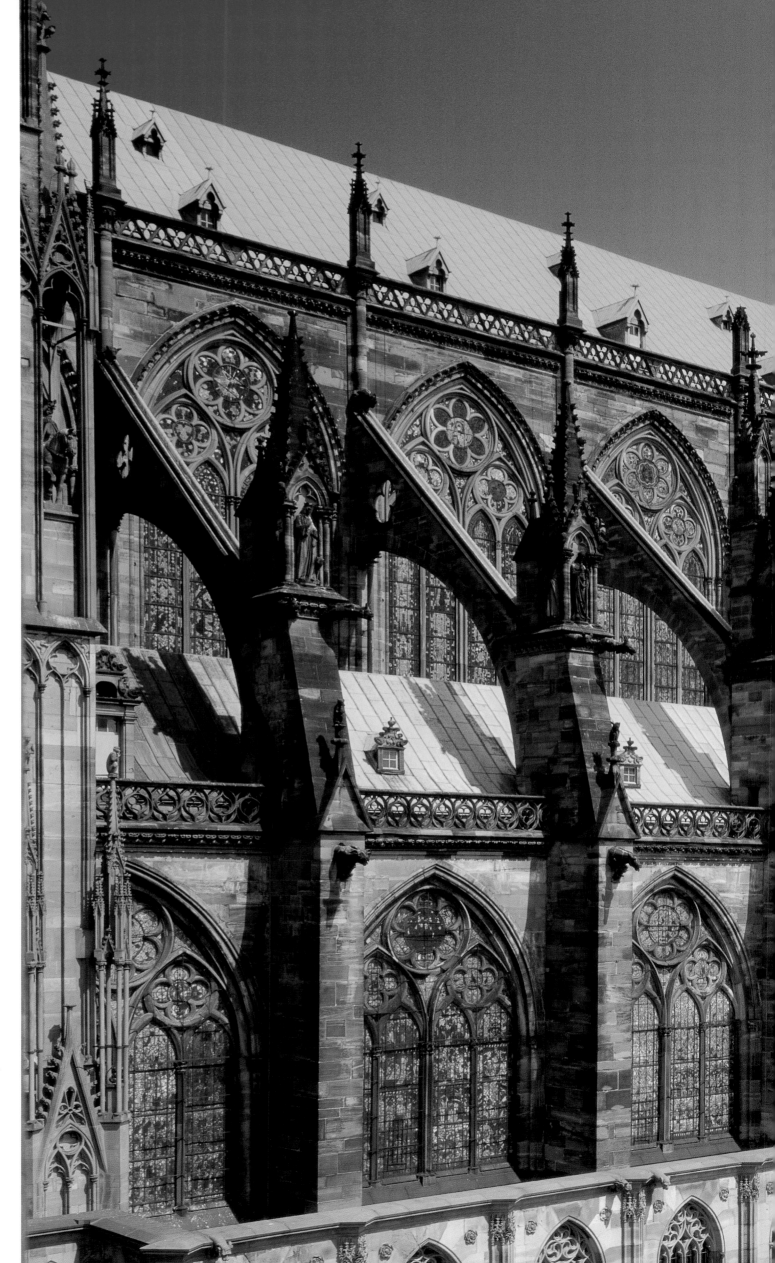

RIGHT:
Strasbourg, cathedral,
southwest view

From ca. 1240, a High
Gothic nave was added
to the late-Romanesque
eastern sections, which had
been built after ca. 1180
using the foundation of the
Wernher construction (ca.
1000). The dimensions of
the nave were determined
by the previous structures.

The west facade, begun in
1277 and ascribed to
Erwin of Steinbach, has
two shells; the back wall is
used for a dense web of the
finest tracery, resulting in
manifold shadows.

PAGES 190 AND 191:
Cologne, cathedral, begun
1248, choir (p. 190); wall
of the center aisle (p. 191)

Archbishop Konrad von
Hochstaden laid the cor-
nerstone for his ambitious
reconstruction of the cathe-
dral in 1248. An important
model was the cathedral
of Amiens, begun in 1220,
whose dimensions were
surpassed by those of
Cologne. The cathedral
was not fully completed
until the 19th century.

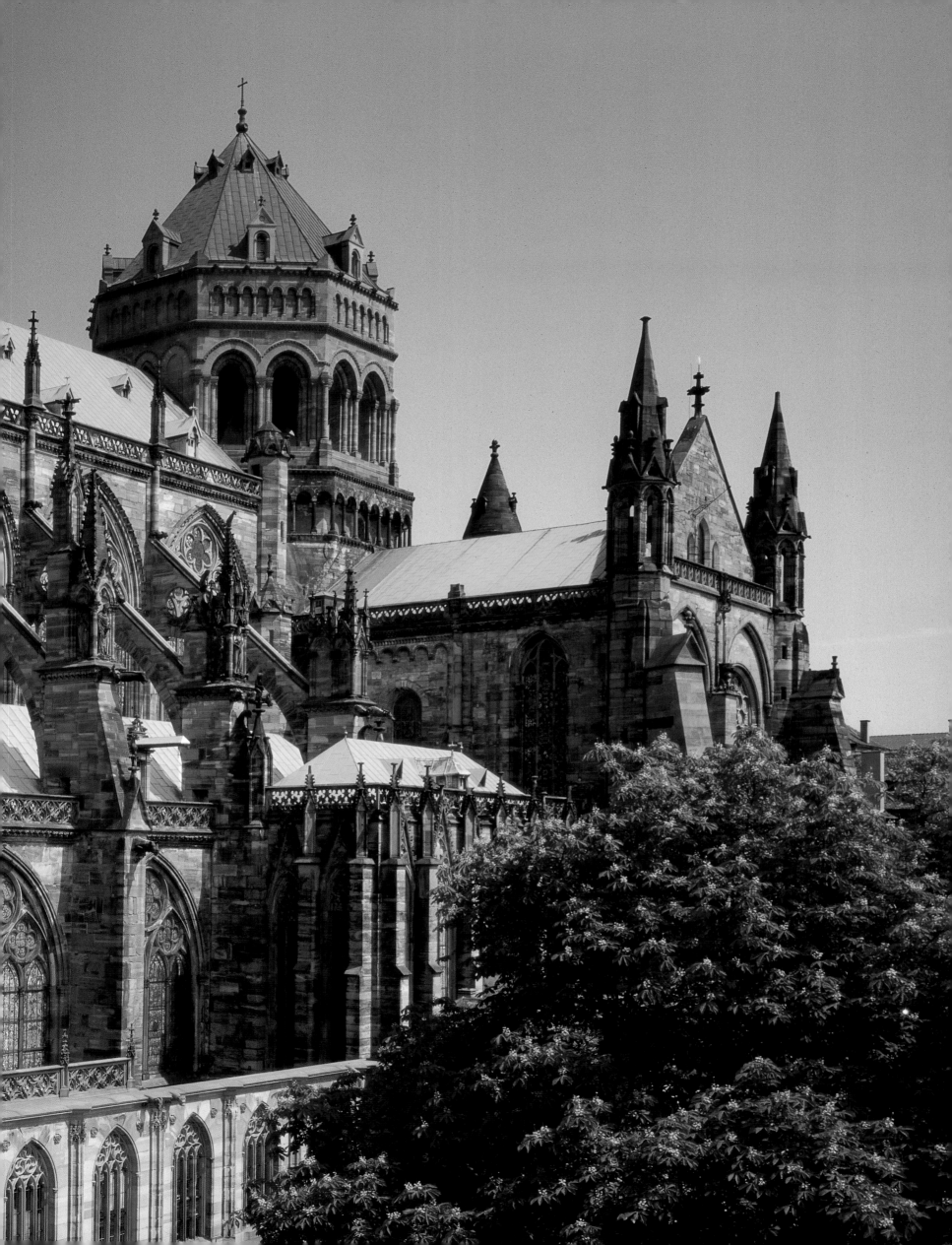

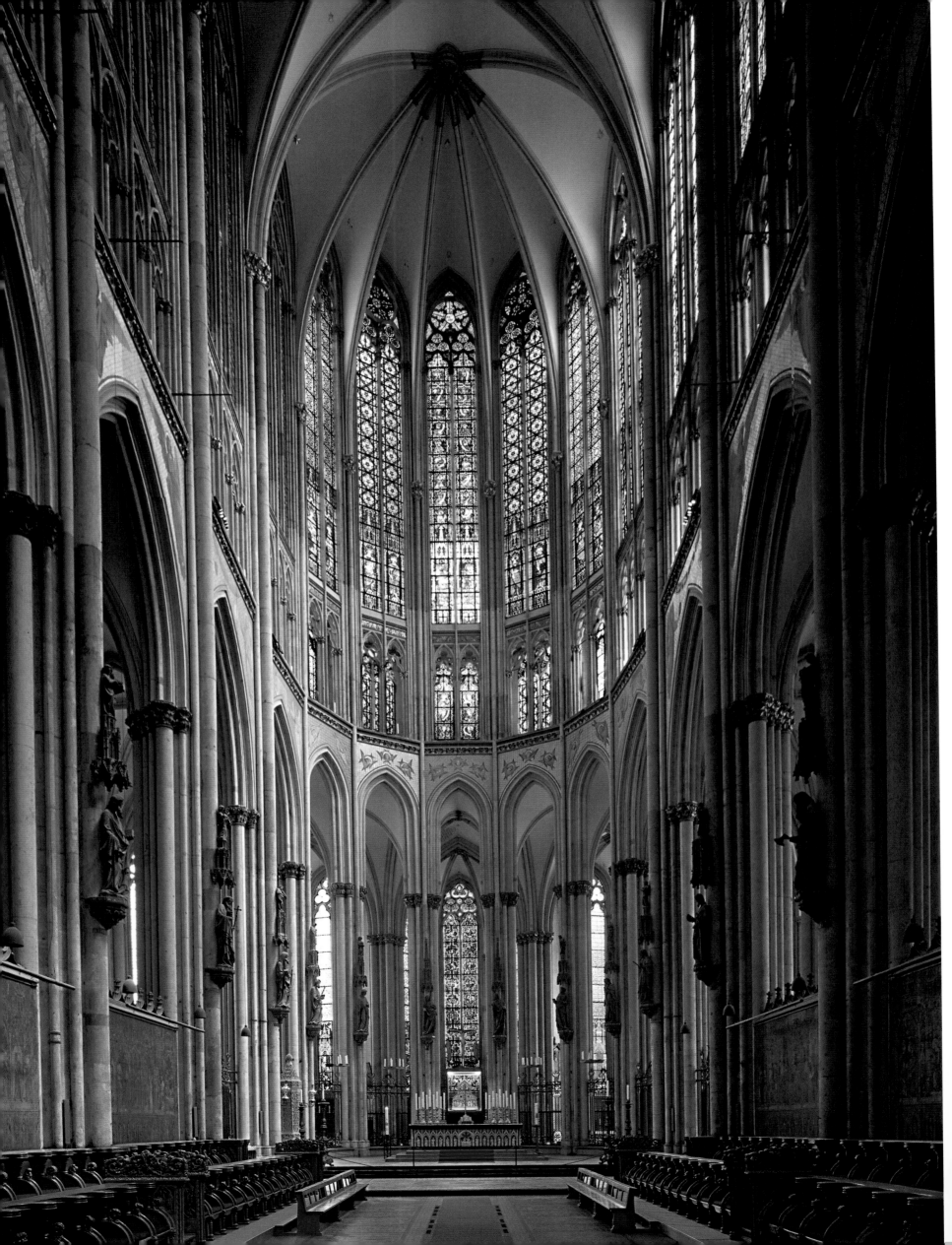

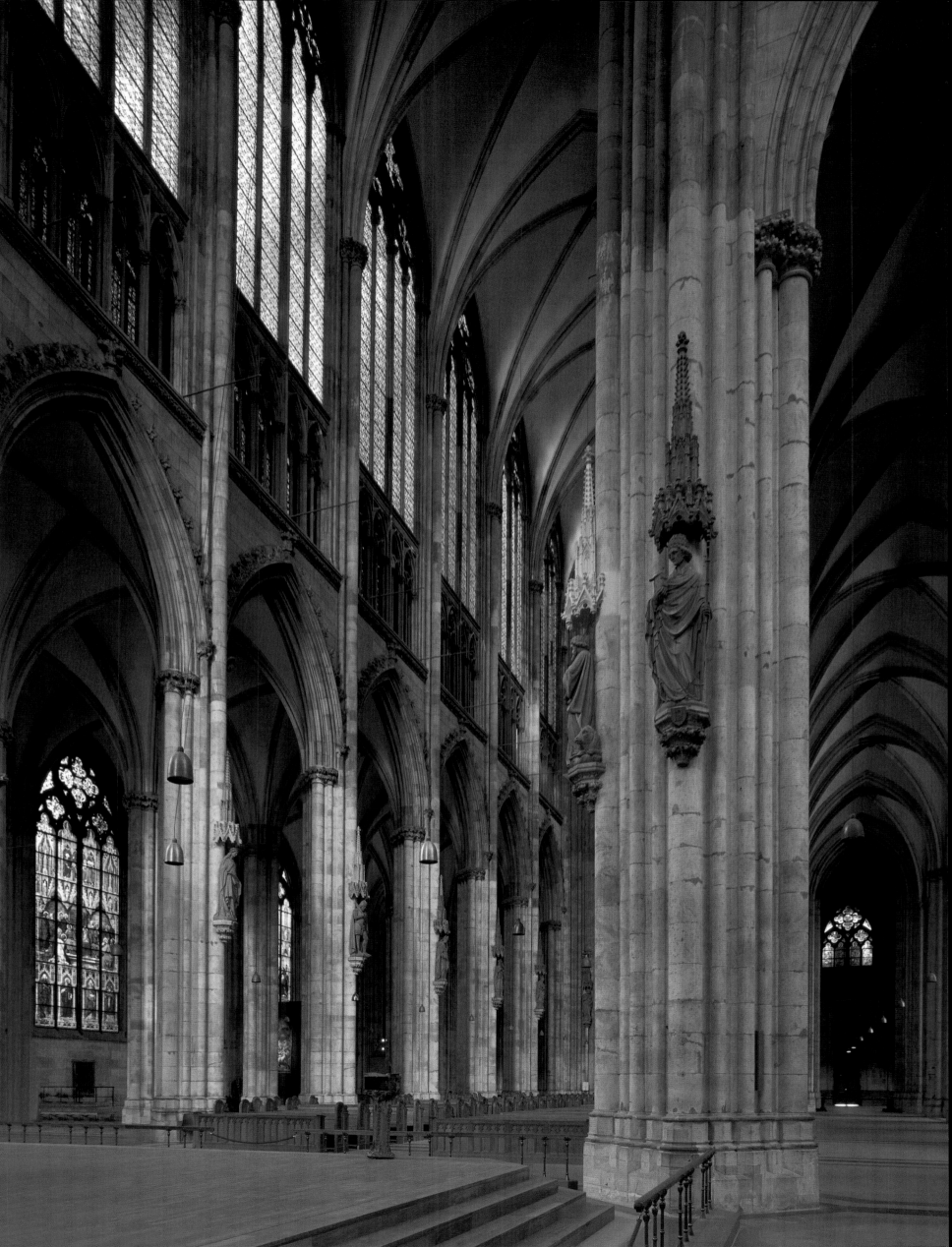

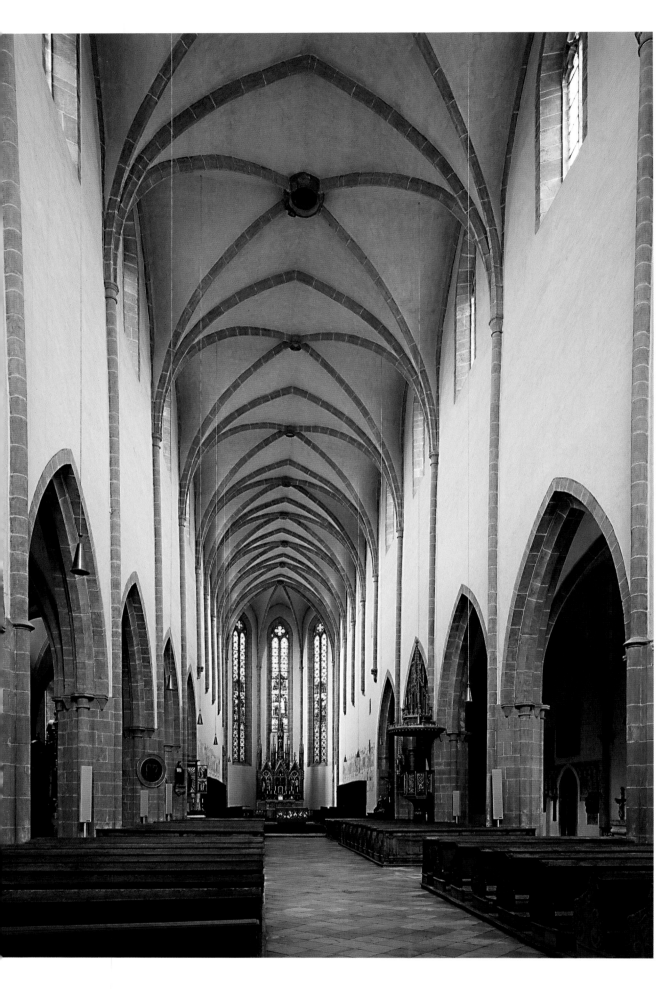

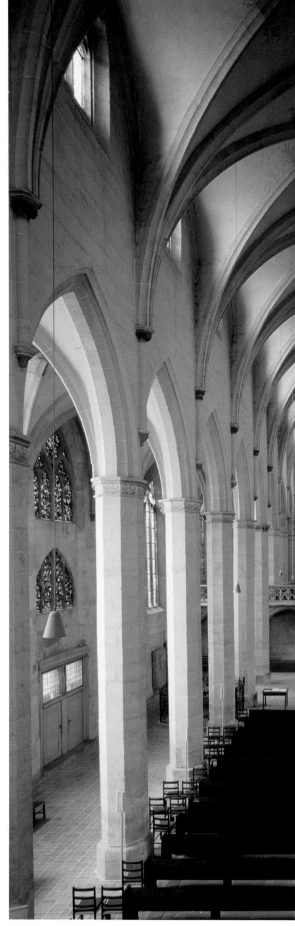

ABOVE:
Regensburg, St Blasius, 2nd half of the 13th c.

CENTER:
Erfurt, St Johannes Ev., begun 1278

RIGHT:
Cologne, Minoritenkirche, 2nd half of the 13th c.

All three of these examples of three-aisle vaulted basilicas demonstrate the extent to which the mendicant orders, which had only been founded at the beginning of the century, had established themselves by then. The churches in Regensburg and Cologne show striking similarities, an indication that there were ideal plans within the orders. Erfurt was begun around the same time, but construction took some time and was not completed until the 15th century. That explains the lofty proportions reminiscent of a hall church.

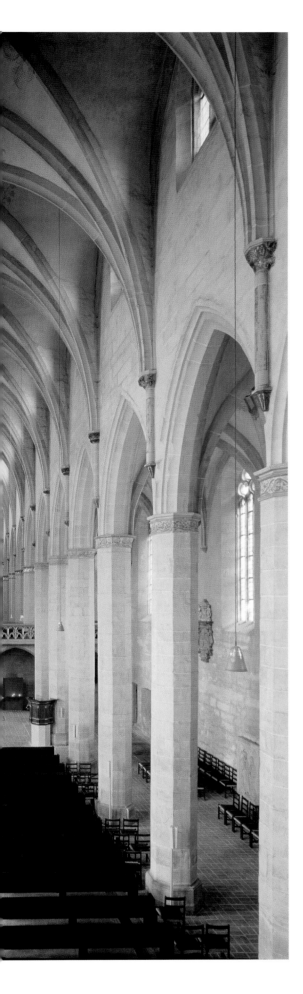
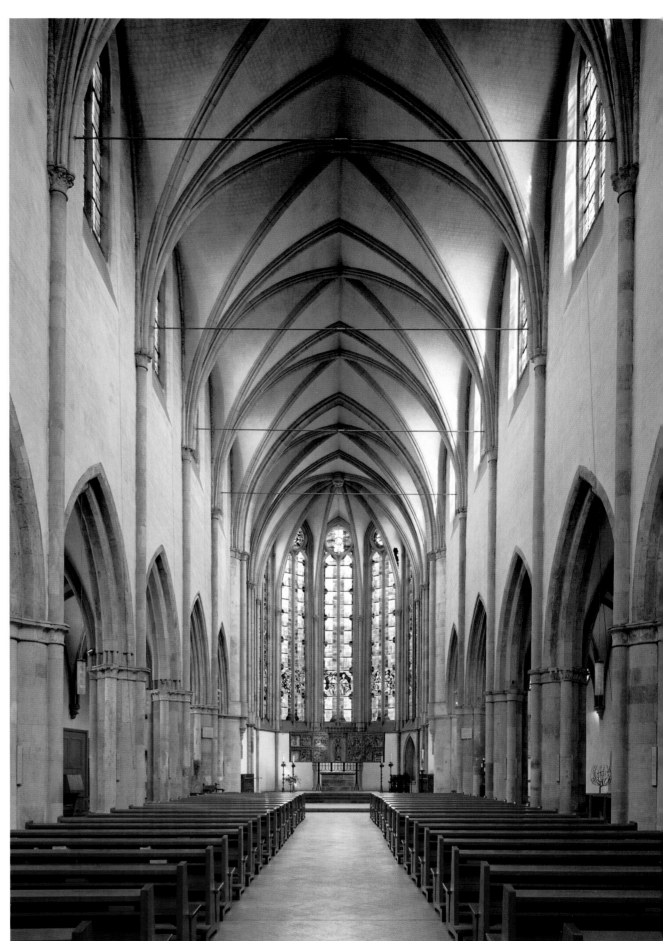

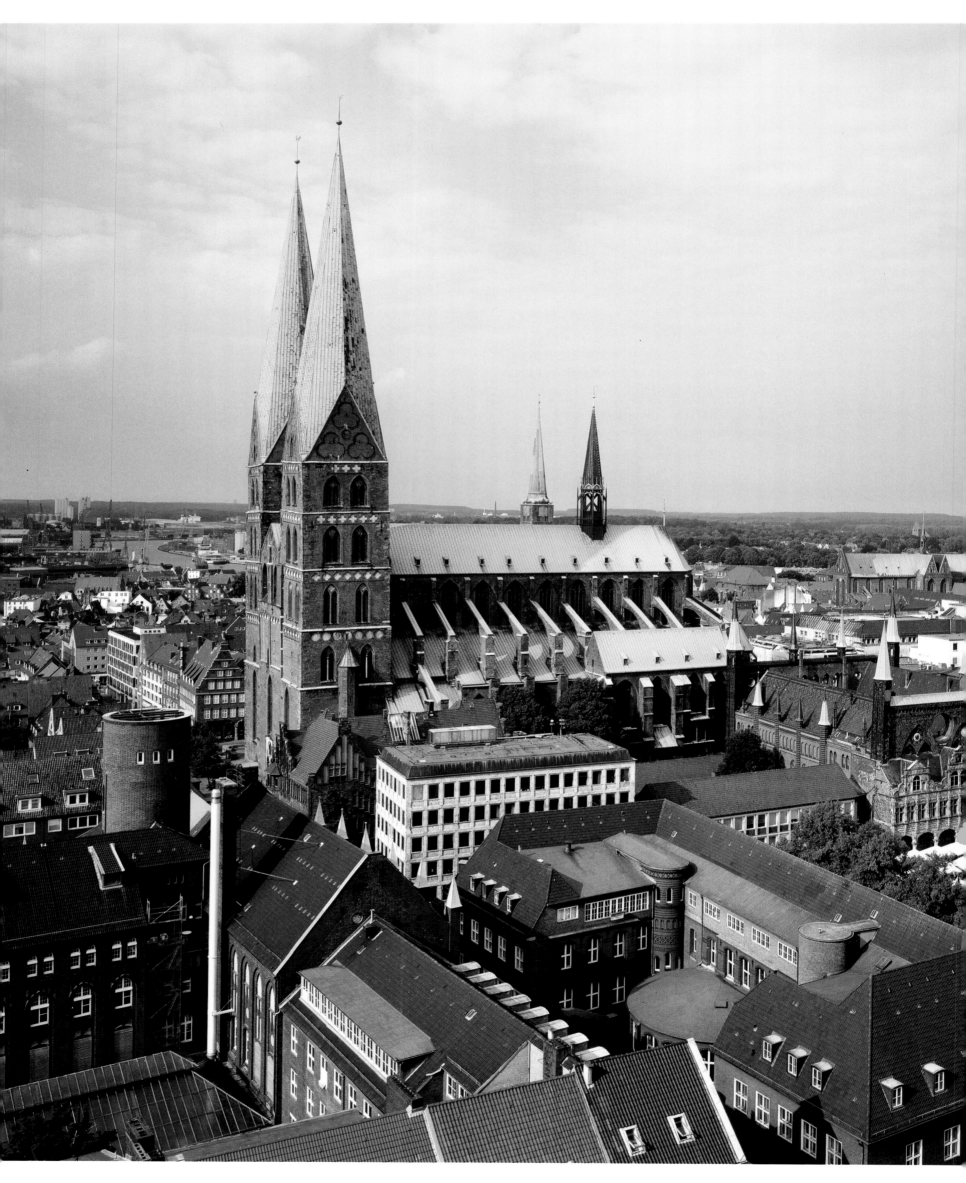

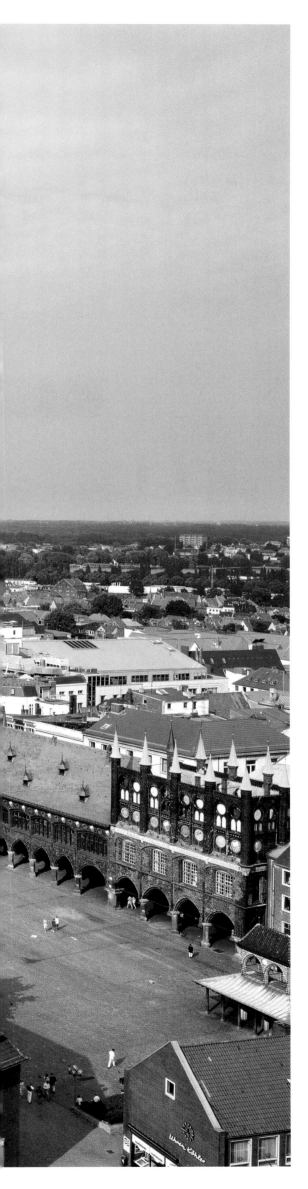

Marienkirche in Lübeck is the main representative of the brick Gothic style and became the prototype for large urban churches in the entire Baltic Sea area. Consciously rejecting the type of the hall church, the building type of the French Gothic cathedrals was chosen as a model, the basilica. The only vertical elements are the two high west towers that dominate the old part of the city of Lübeck. The nave proceeds behind them in the regular rhythm of its buttresses.

Being the family monastery of the Askanian margraves, the appointments at Chorin were richer and statelier. This is especially evident in its facade, which has a high central block crowned by gables and turrets.

The facade is an example of the rich design possibilities achieved by the brick Gothic in the course of the 14th century.

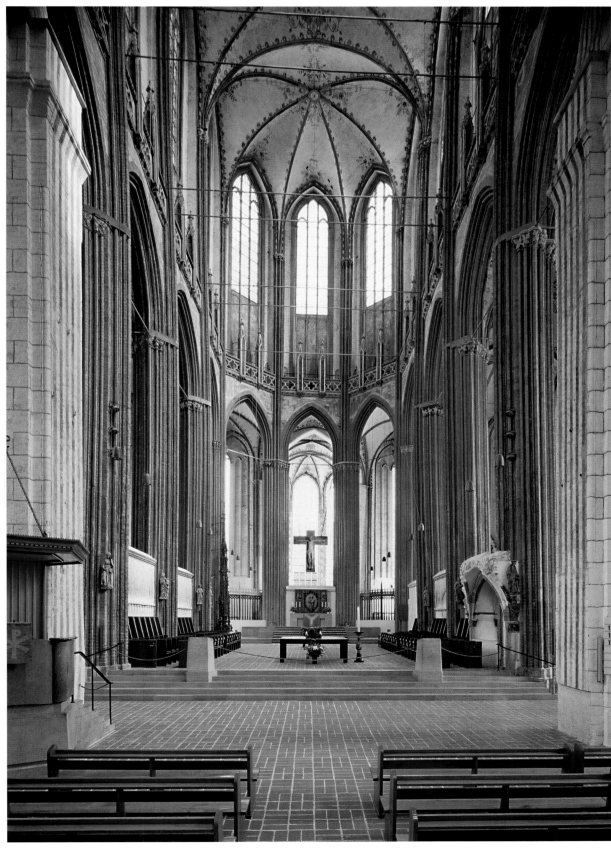

Lübeck, Marienkirche, from ca. 1260/65–1351

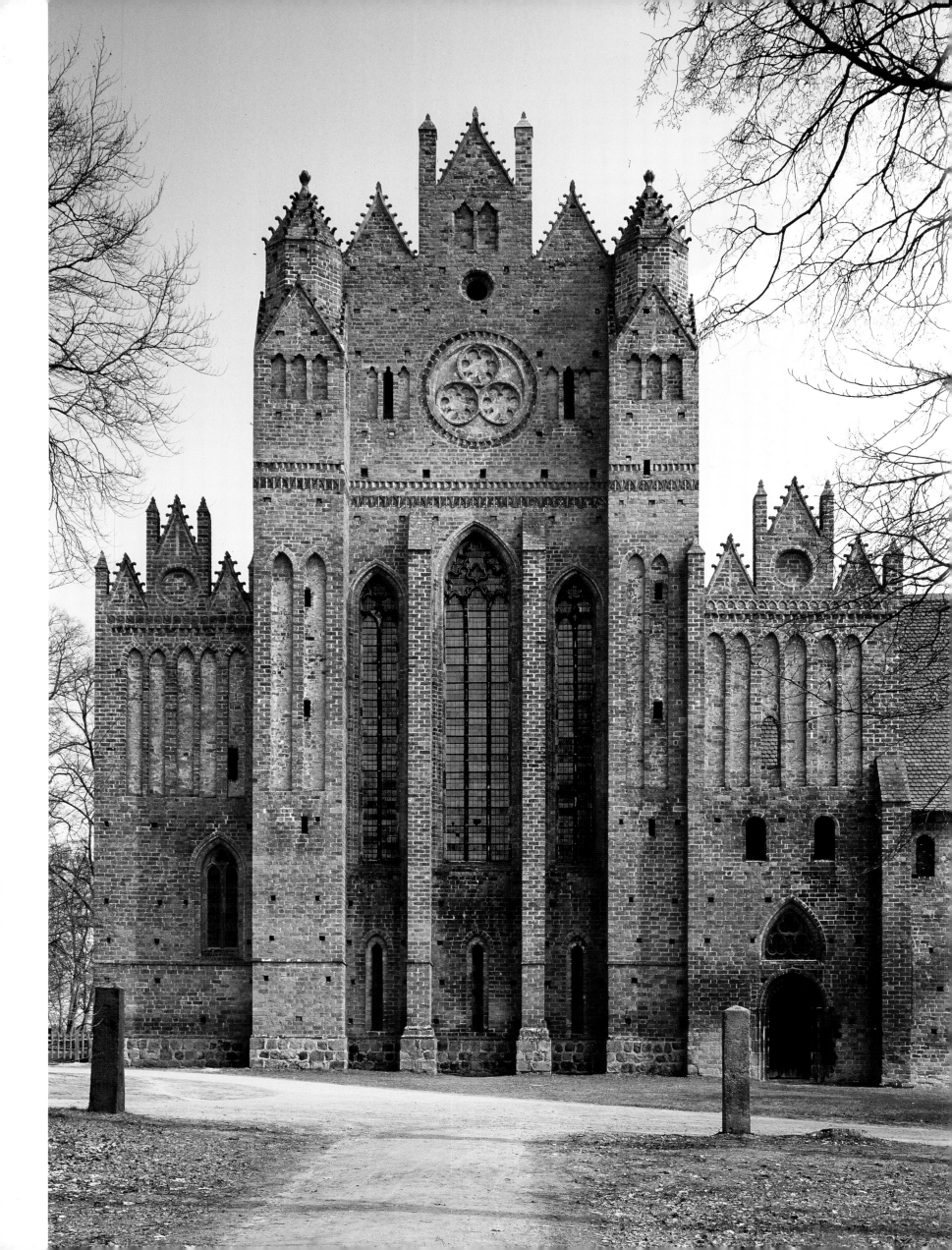

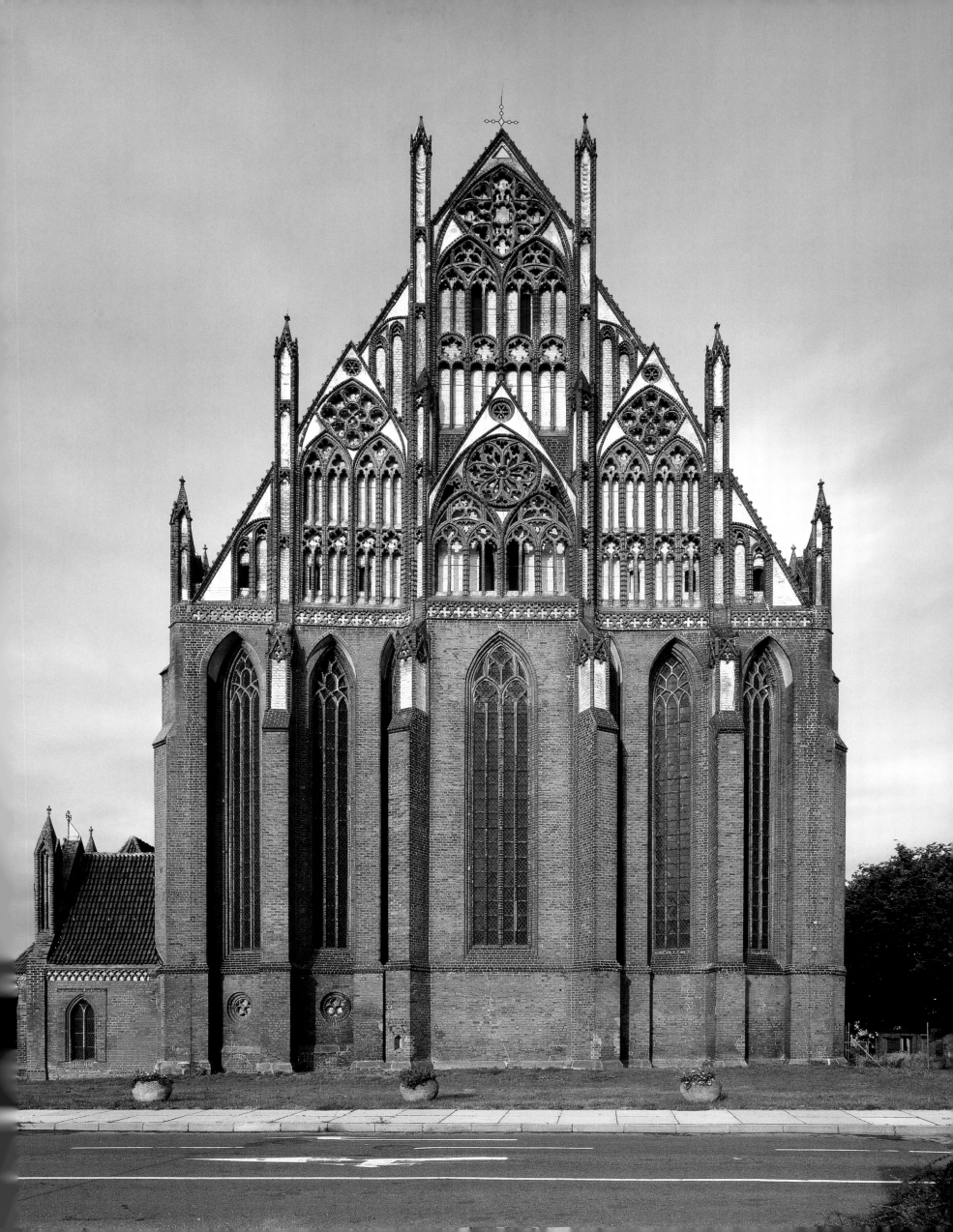

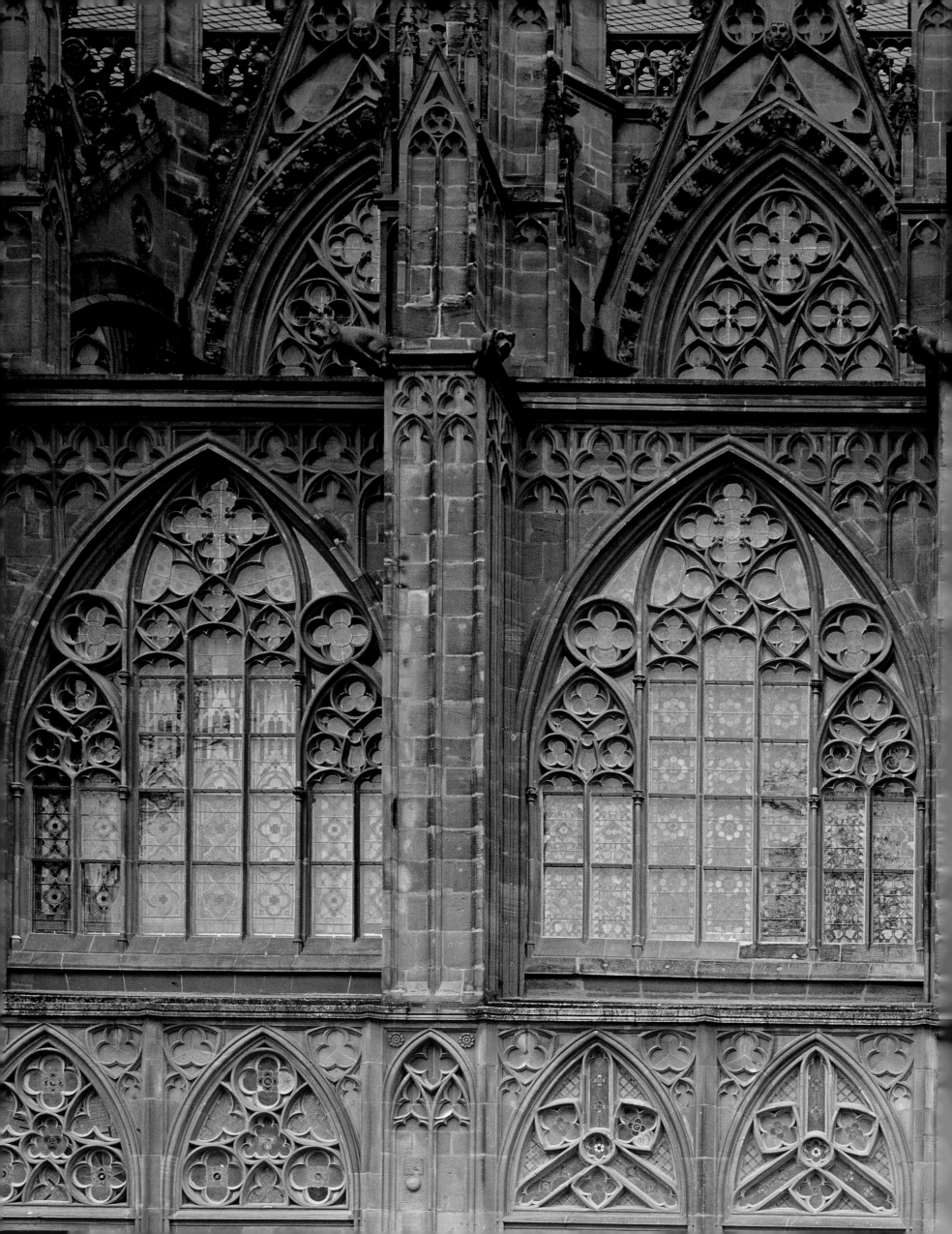

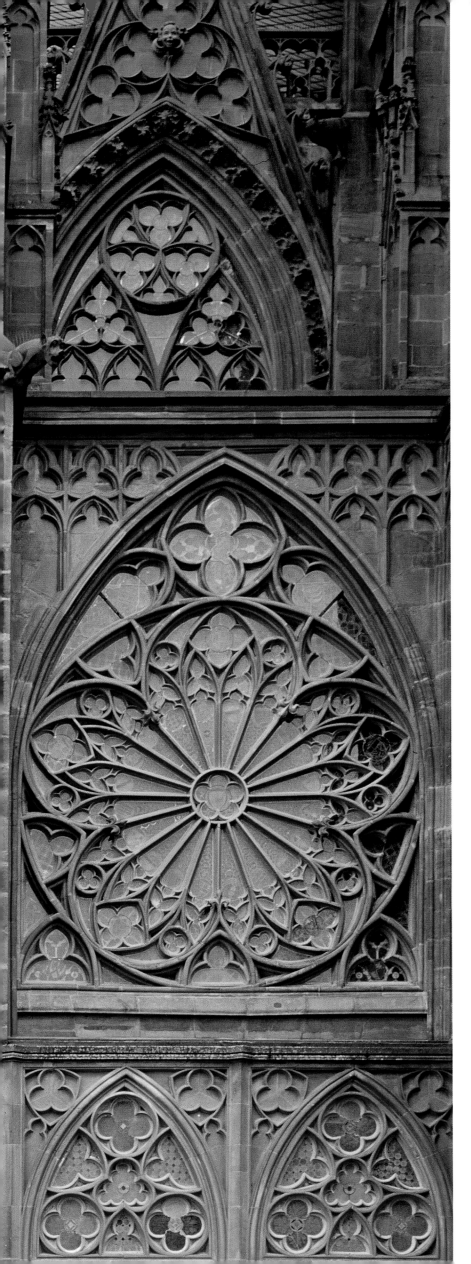

LEFT: **Oppenheim, St Katharina,** begun 1317

BELOW: **Salem, former Cistercian abbey church,** dedicated 1414

These examples of tracery windows suggest the variety of forms possible in the design of windows. The window from Salem proves that by that time the Cistercians had loosened their strict building regulations to the extent that tracery windows—as well as colored glass, by the way—were permissible.

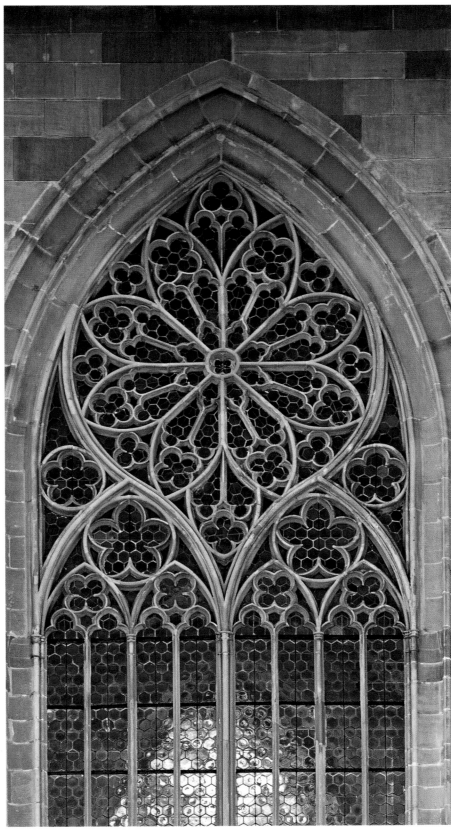

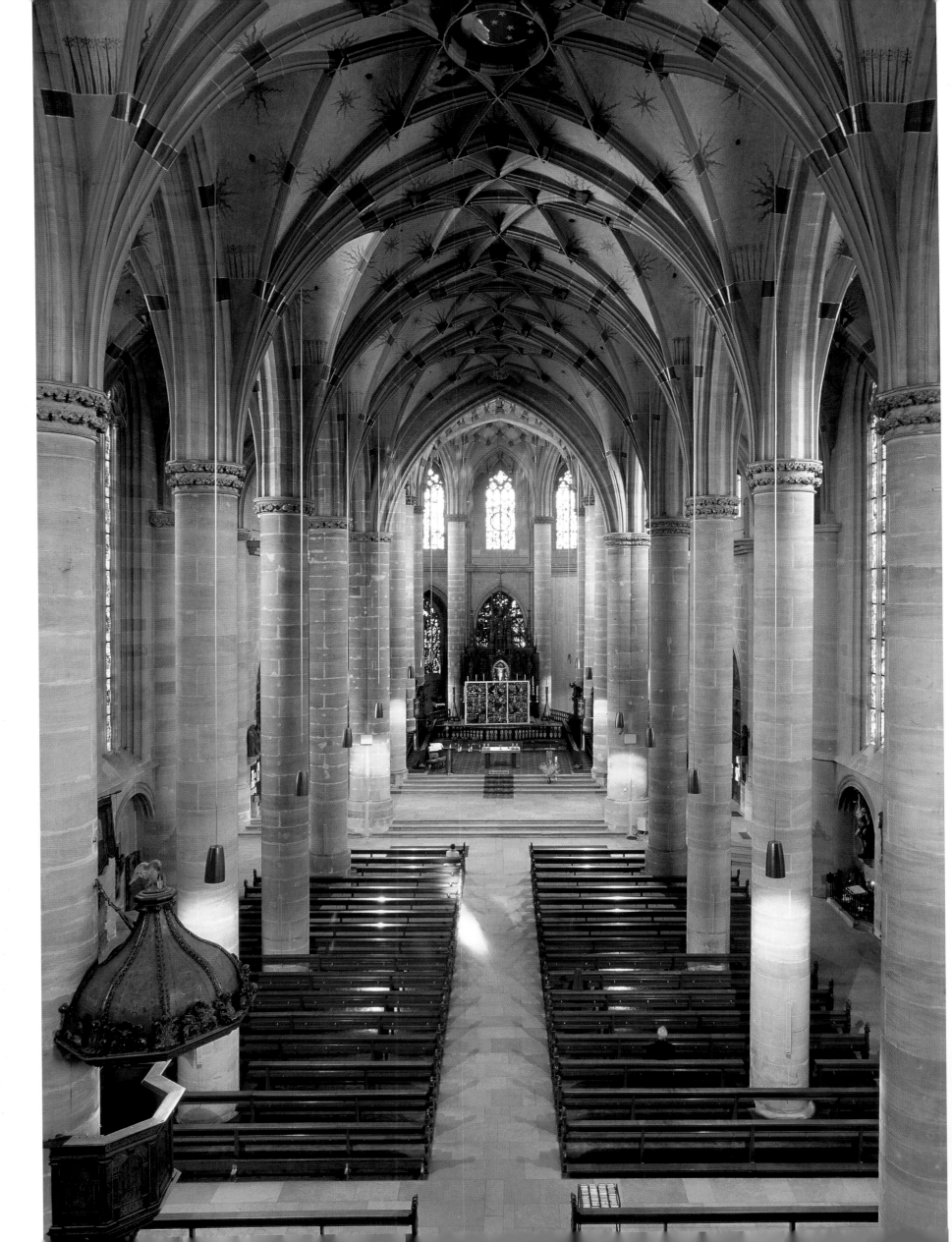

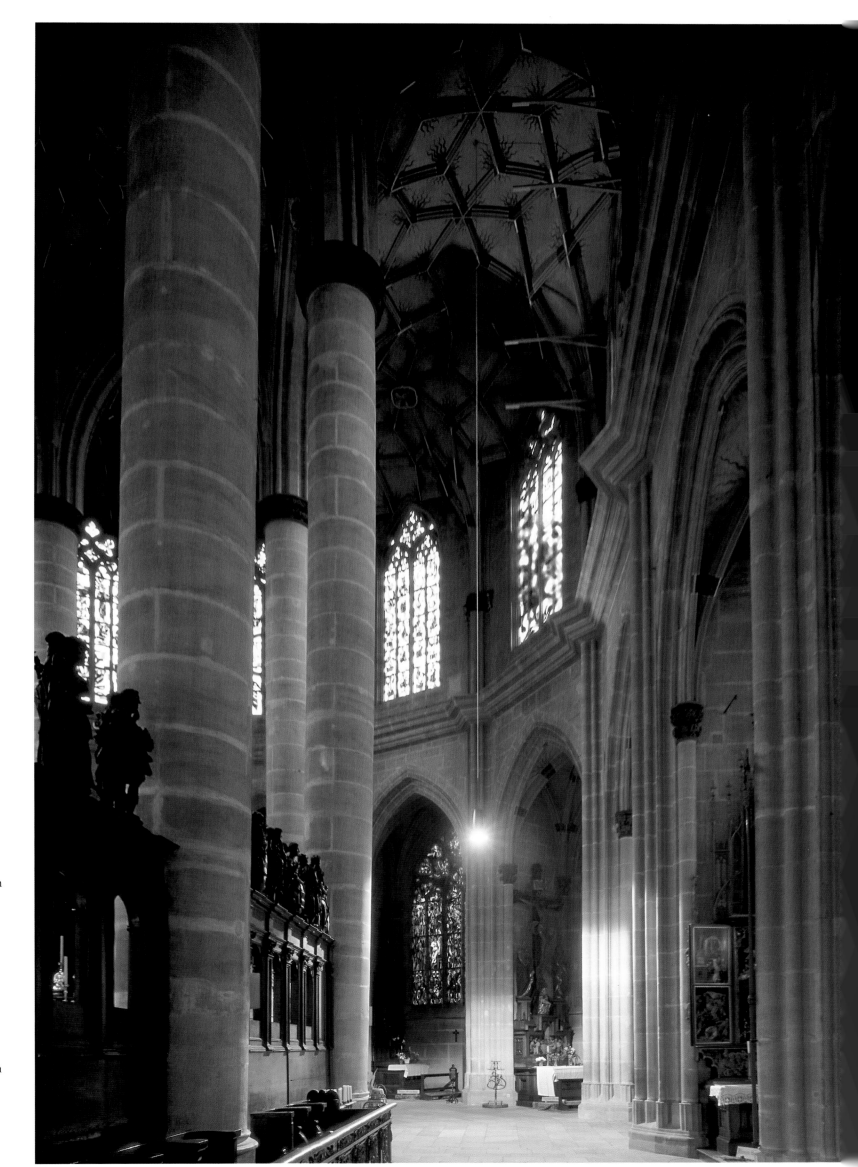

Schwäbisch-Gmünd,
Heilig-Kreuz-Kirche,
begun 1351, interior
view facing east; choir
ambulatory

In place of an older
complex, a hall church
was erected starting
in 1351. It marks the
beginning of a devel-
opment that led to
the creation of an
independant German
Late Gothic style.

Of special importance
are the motifs of net
vaulting and the con-
tinuous cornice, which
protrudes in a conspi-
cuous way across the
supports and creates
an elegant wave-like
movement above the
chapel entrances.

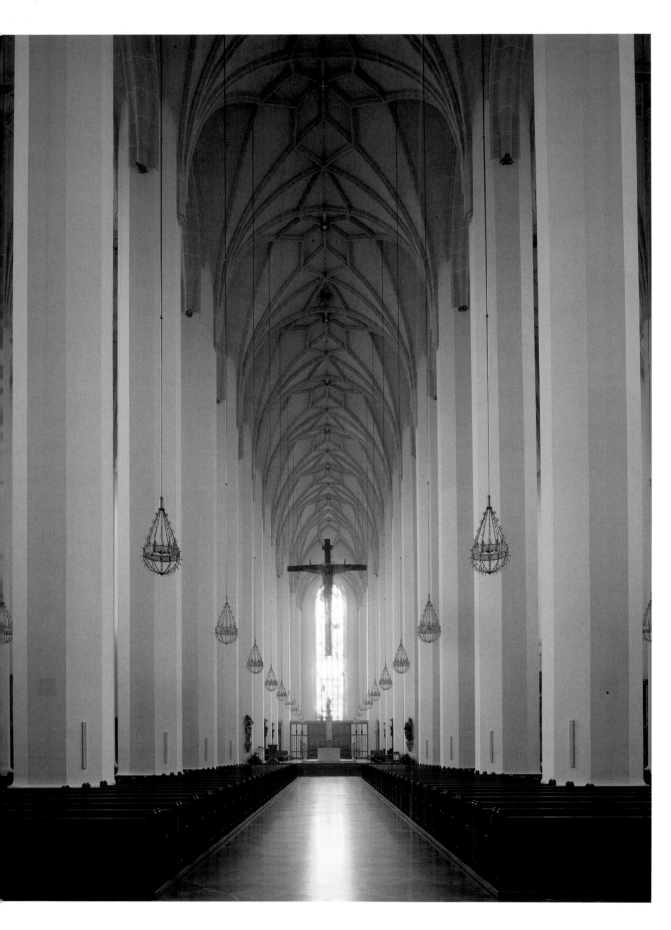

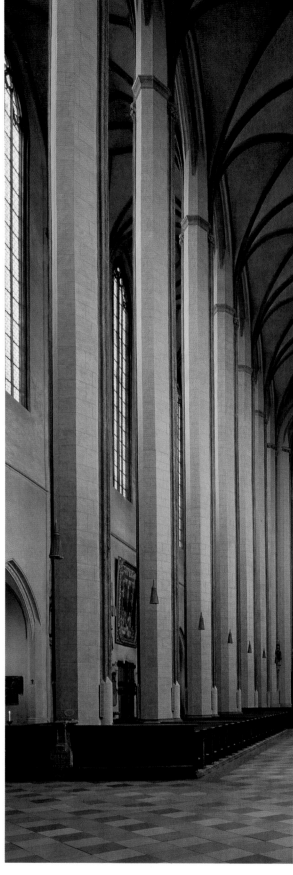

LEFT: **Munich, Frauenkirche, 1468–1488**

CENTER: **Landshut, St Martin, 1385–1460**

RIGHT: **Nördlingen, St Georg, 15th/16th c.**

The citizens' churches of the residence cities of the Wittelsbach dynasty, Munich and Landshut, as well as the St Georg church in Nördlingen, are representatives of a group of hall churches that dispensed entirely with ornamentation. Their beauty lies in their spaciousness and in the effect of the netted vaults.

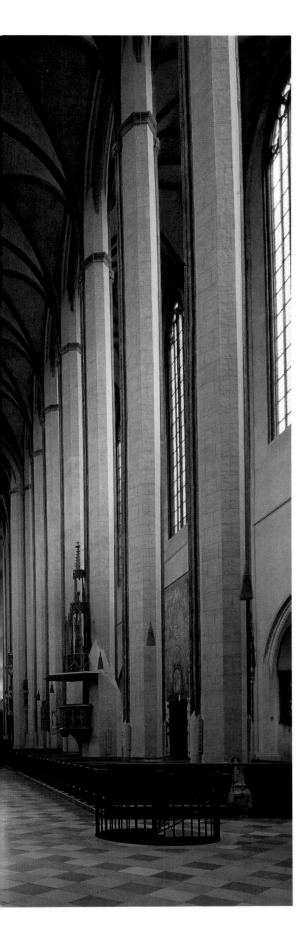

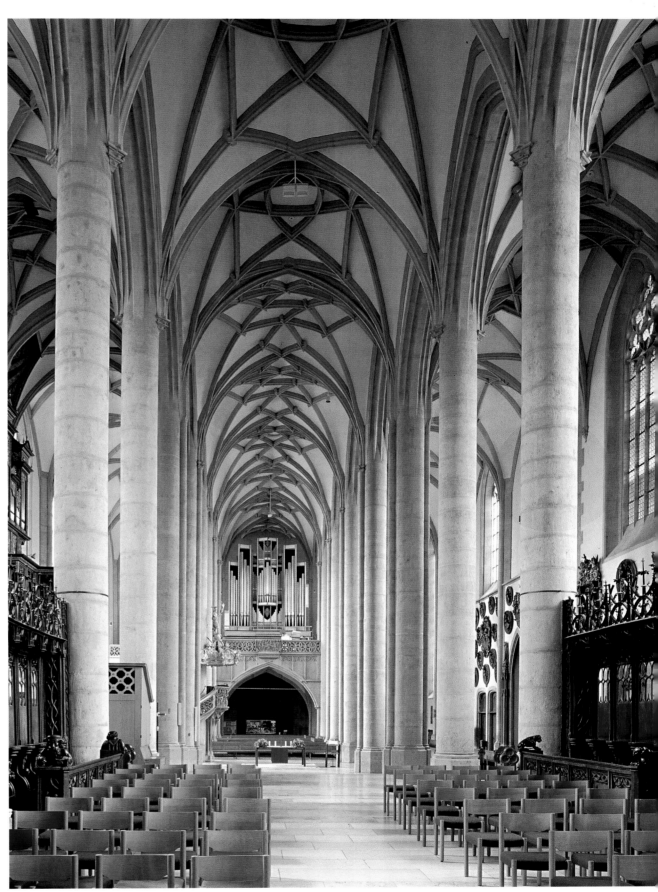

Prague, St Vitus Cathedral, begun after 1352, exterior and interior views of the choir

The view from the east shows the adjoining chapels of the ambulatory of southern French coinage designed by Matthias of Arras, which Peter Parler ingeniously crowned with the glass of his choir head. There one finds the motif of the continuous cornice, used by Parler to great effect in the triforium, which now precedes the clerestory windows as a dynamic tracery gallery.

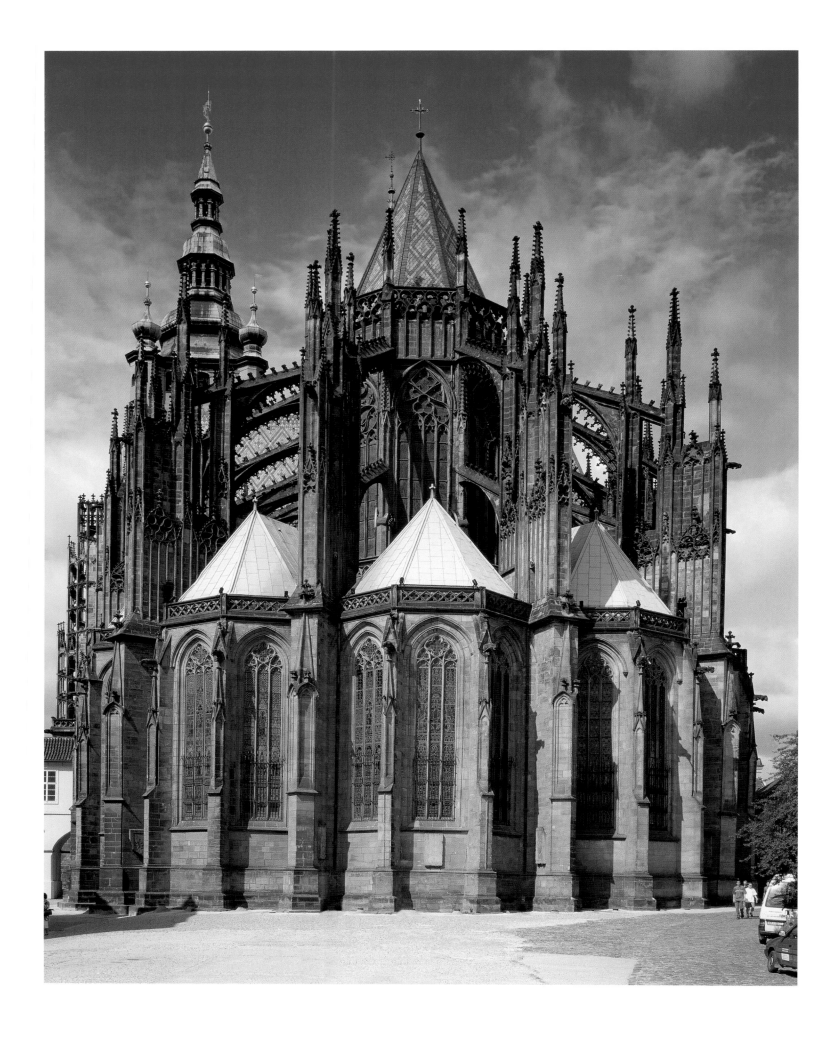

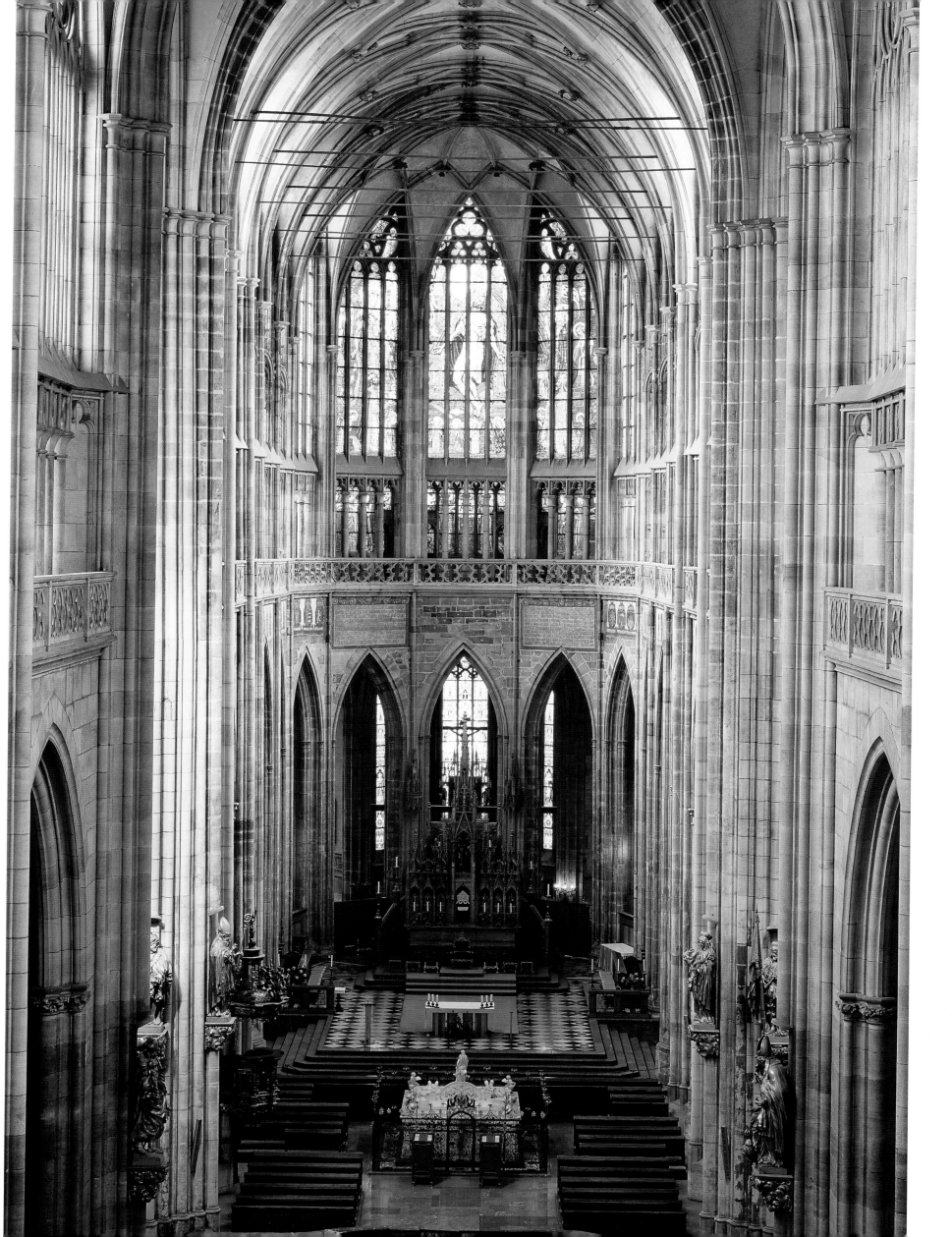

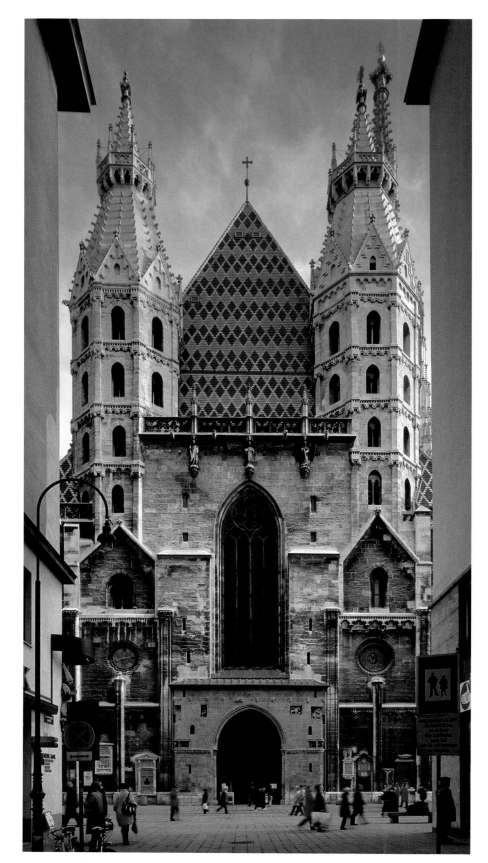

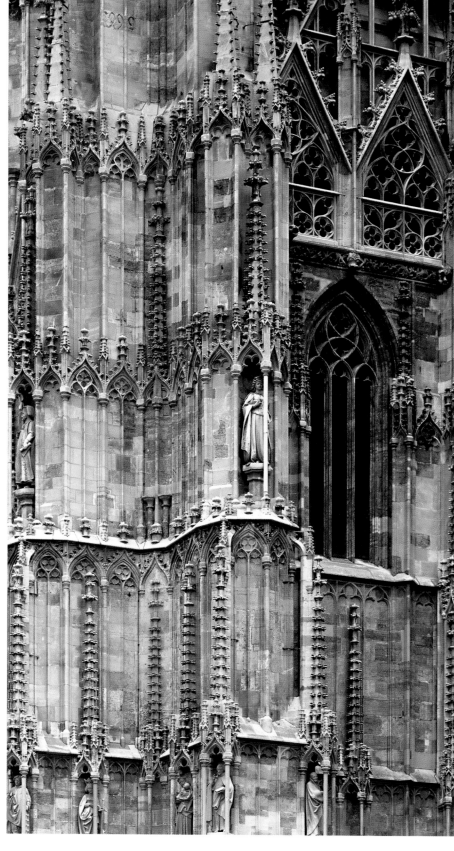

Vienna, St Stephan Cathedral, after 1304,
Romanesque west facade (above left);
detail of the northern or Adlerturm ("Eagle Tower");
pulpit by Anton Pilgram (opposite)

In 1304 planning was initiated for the renewal of
the choir of St Stephan in Vienna, which had been
completed in 1263. In 1340 the three-aisle hall choir
was dedicated. In 1359 renovation work and con-

struction of the remaining sections followed,
beginning with the exterior walls of the nave,
conceived as a stepped hall, as well as the south
tower. Only the west complex with galleries and
two towers was retained. In 1450 the cornerstone
was laid for the north tower. The building orna-
ments in the tracery gables of the south side and
the south tower as well as the sculptural fittings
represent the latest style of the Gothic era.

Vercelli, Sant'Andrea,
dedicated 1234,
west facade; interior

Here is one of the few
Gothic churches in
Italy that has a clear
relationship with the
French Gothic. The
structural principles
and individual forms
of Sant'Andrea are
combined with a
characteristically
French floor plan.

Bologna, San Francesco, 1236–1256

This early construction of the Franciscan order combines motifs of the Cistercians with early Gothic vaulting, and thus is also in the French tradition.

Florence, Santa Maria Novella, begun 1246

Santa Maria Novella is the church of the Dominicans of Florence. It, too, incorporates Cistercian influences. The alternating bands on all the arches is Florentine tradition.

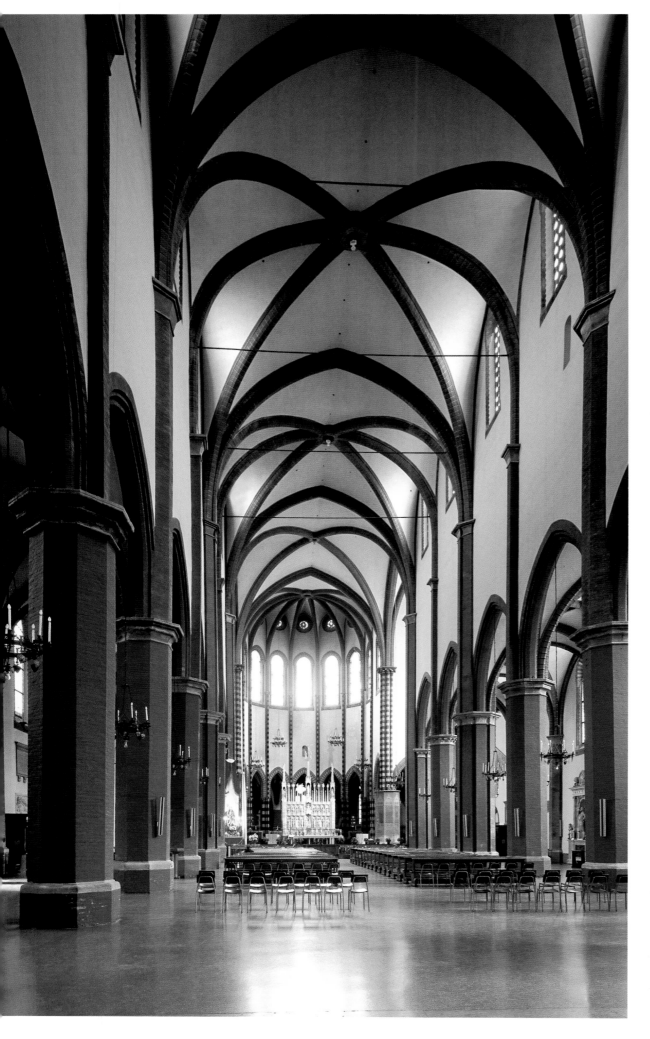

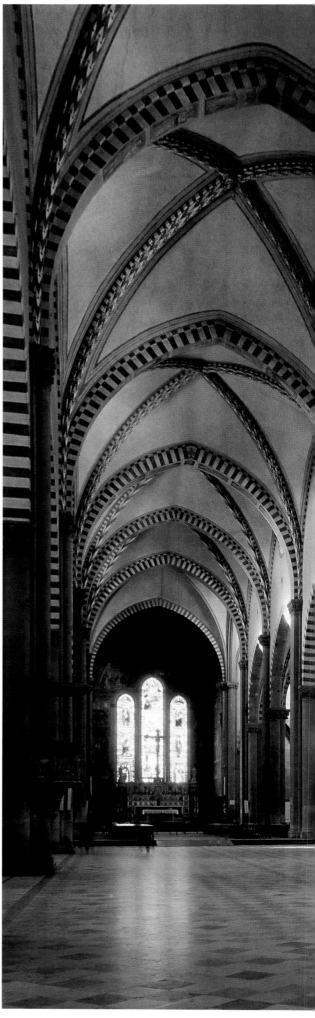

Todi, San Fortunato, 1292–1328

This church of the Franciscan order is a hall church
similar to those found in western France. The bridge-
like supports recall Saint-Hilaire in Poitiers.

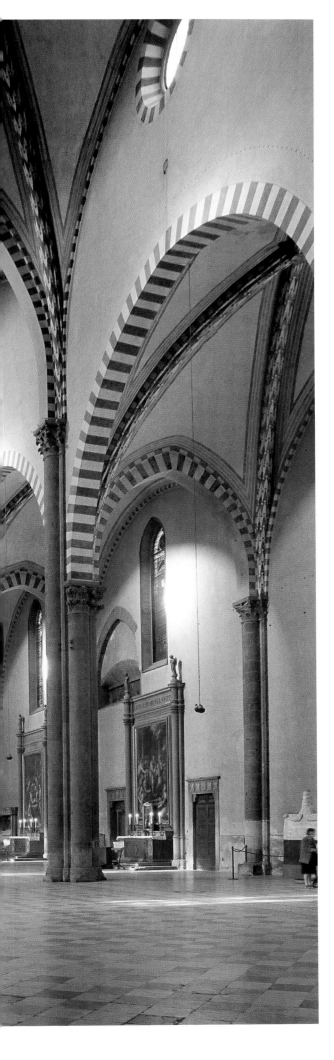

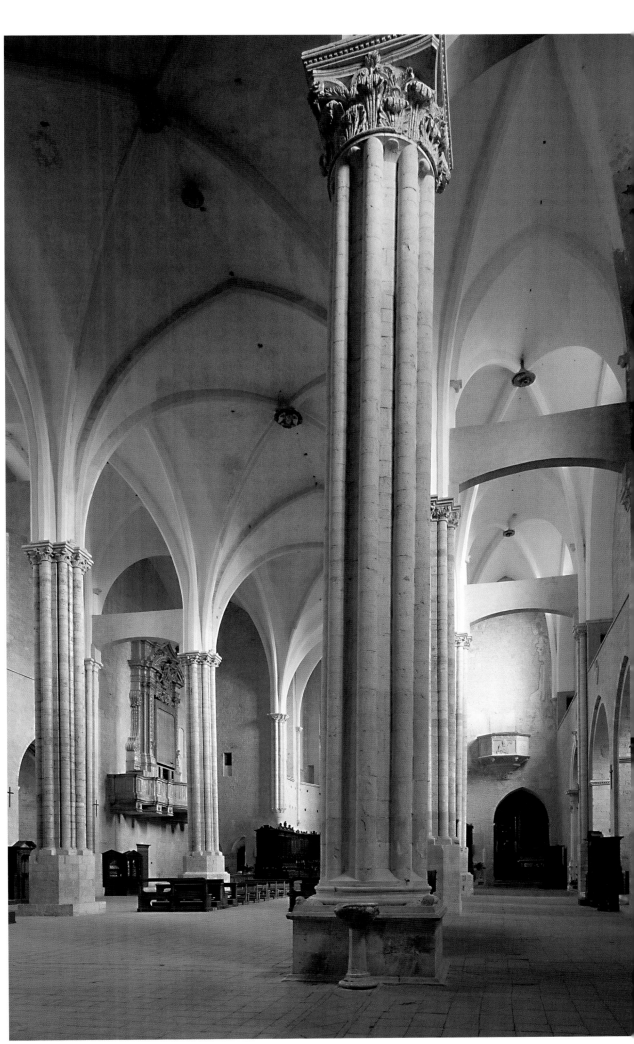

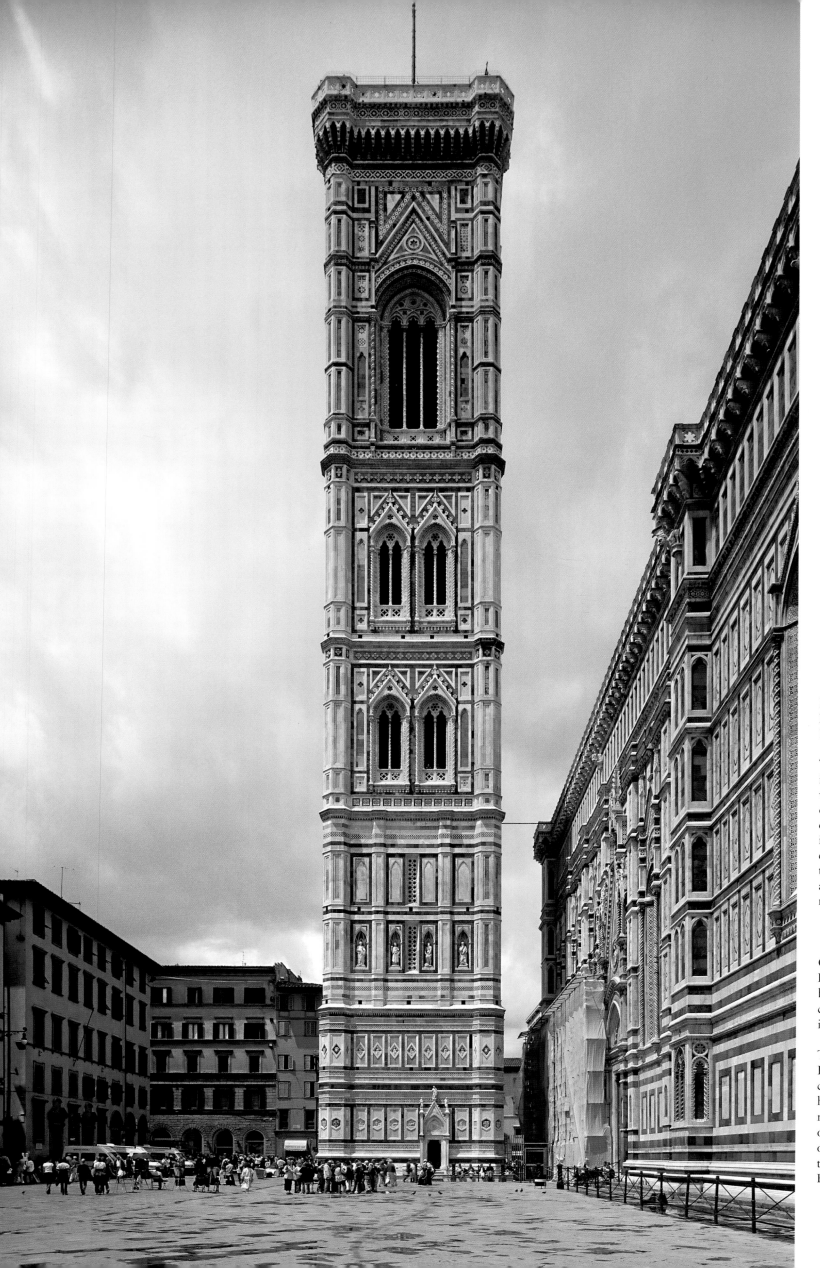

LEFT:
Florence, campanile,
begun 1334

The campanile with
its clear cubic form
was erected by Giotto
di Bondone. The multi-
colored marble veneer
is characteristic of 14th-
century Florence. The
tower is crowned with
a battlement above
machicolation.

OPPOSITE:
Florence, cathedral,
begun 1294/96,
completed 1420,
interior

The cathedral of
Florence has a rather
complicated building
history. The grand nave
recalls the two churches
of the mendicant orders
of the city. The dome is
the work of Filippo
Brunelleschi.

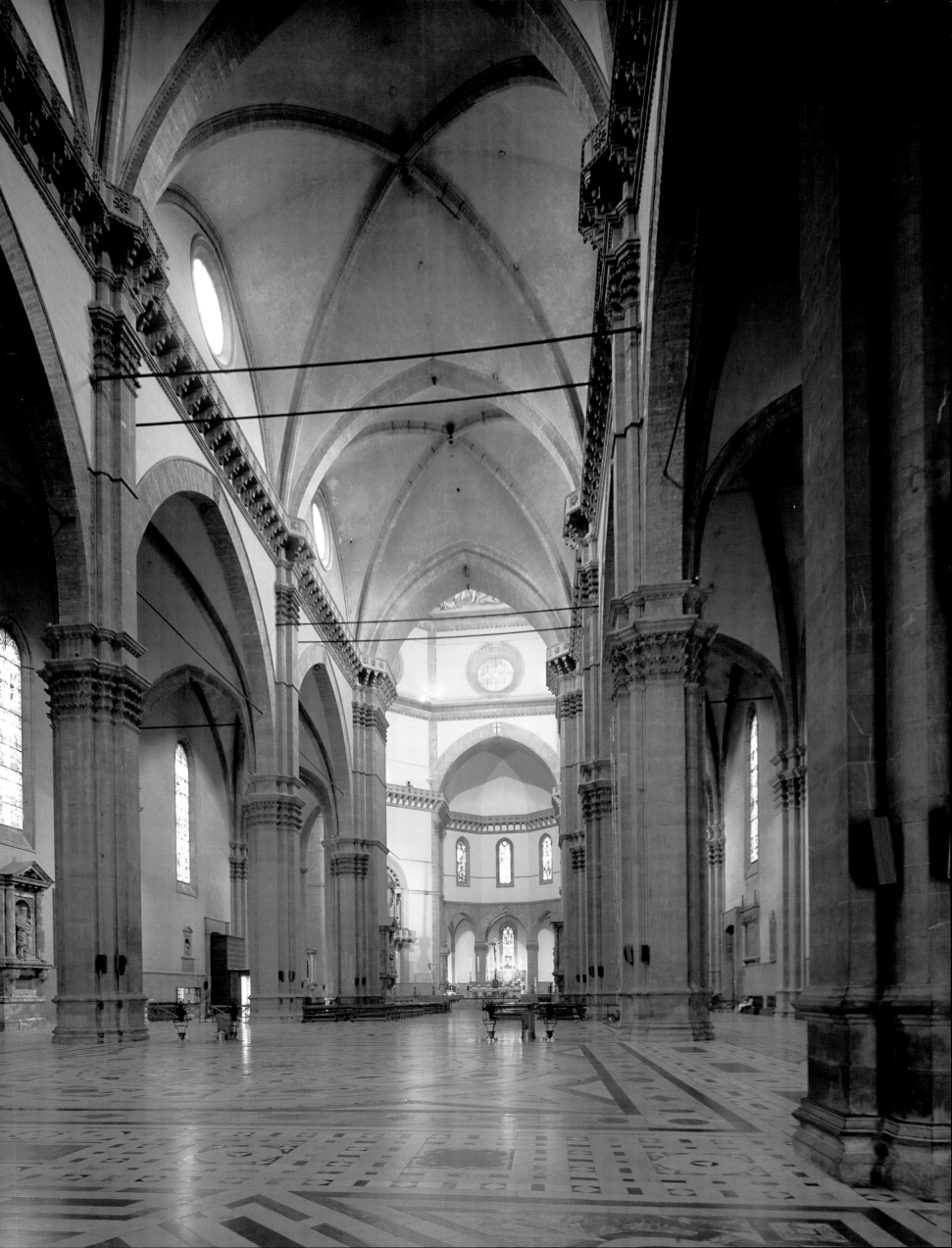

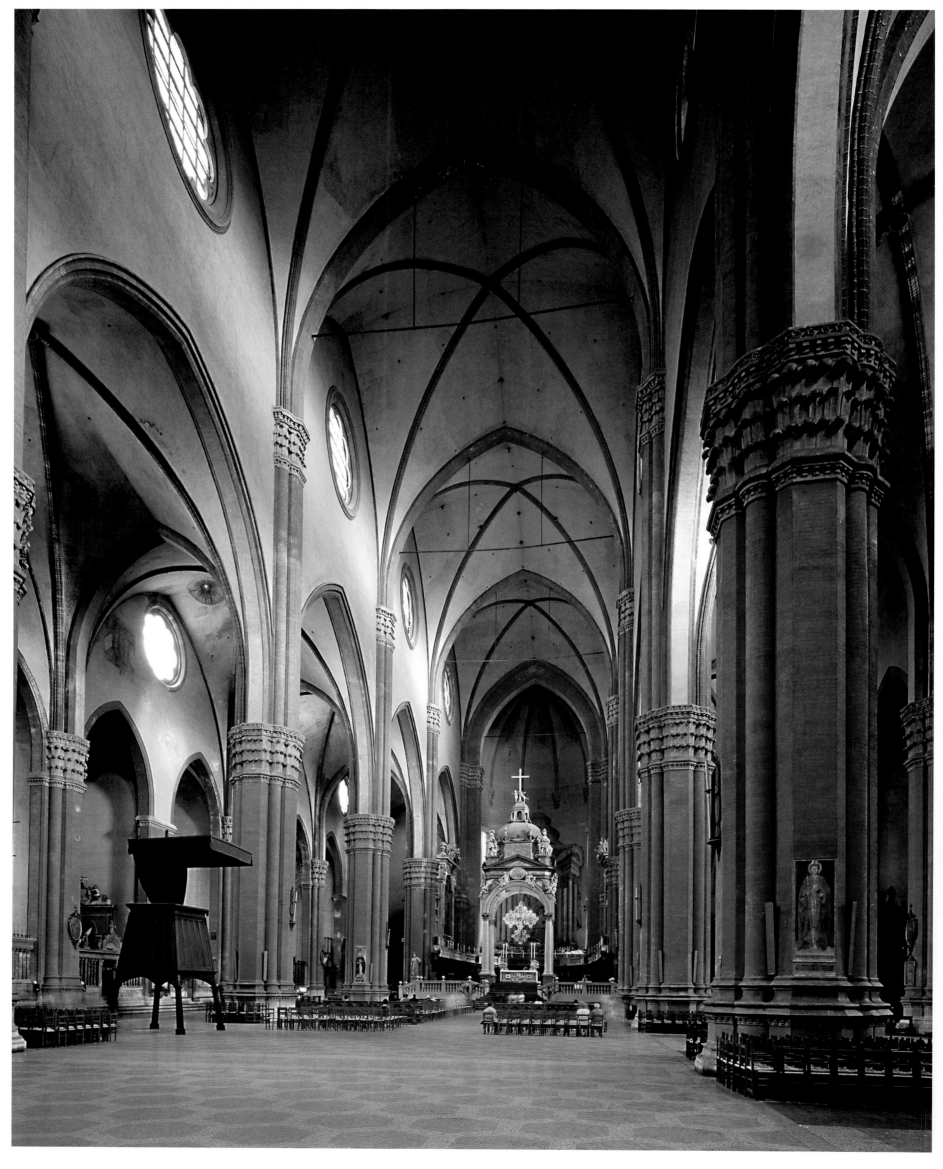

San Petronio is the incomplete, gigantic project
of the citizens of Bologna. The model for the
brick building was the cathedral of Florence.
Each bay measures 65.5 feet (20 meters) long.
The completion of the nave was only achieved
in the 16th century; the choir and transept were
never built.

Milan, cathedral, begun 1387

This project was also planned on such
an enormous scale that it could only be
completed with great hardship in the late
16th century. A large portion of the exterior
had to wait even longer, until the 18th
and 19th centuries, to be finished in neo-
Gothic style.

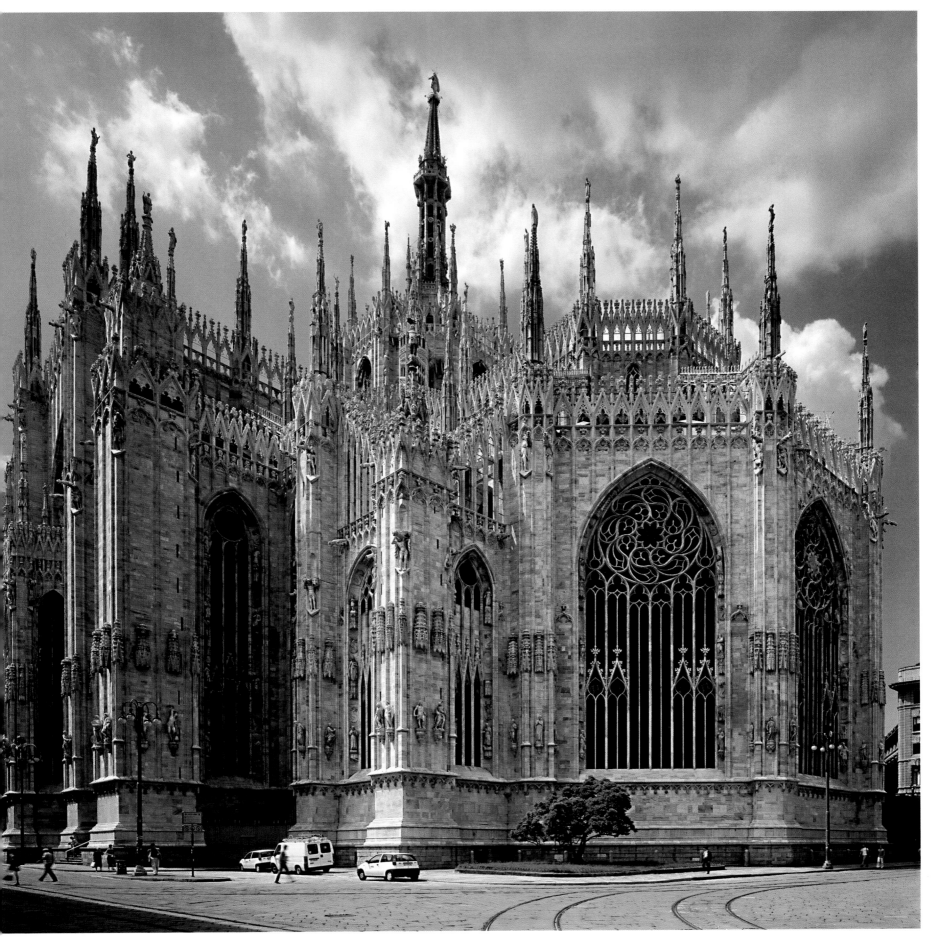

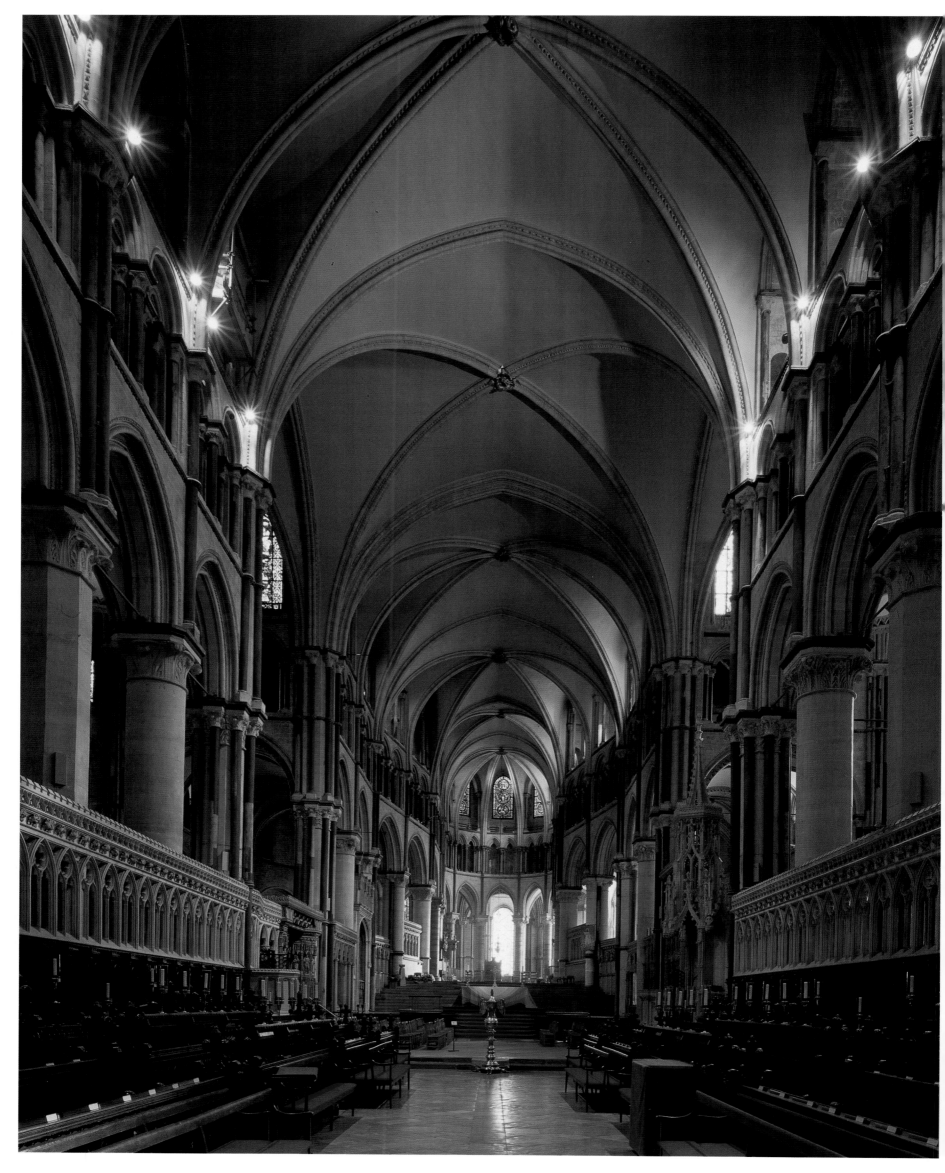

Canterbury, cathedral, interior view of the choir, 1175–1184; exterior from the southeast; glass windows in the chapel of the Holy Trinity

The choir of the Canterbury cathedral, the work of the French master builder William of Sens, marks the beginning of the Early English period within the Gothic era. Floor plan and elevation very closely adopted the forms of the cathedral of Sens—and possibly permit conclusions concerning the lost clerestory there.

In the window below, eight pictures of identical composition, each with three figures, tell the story of the archbishop of Canterbury, Thomas Becket, who was canonized in 1173 after he was clubbed to death by knights of King Henry II in the cathedral in 1170.

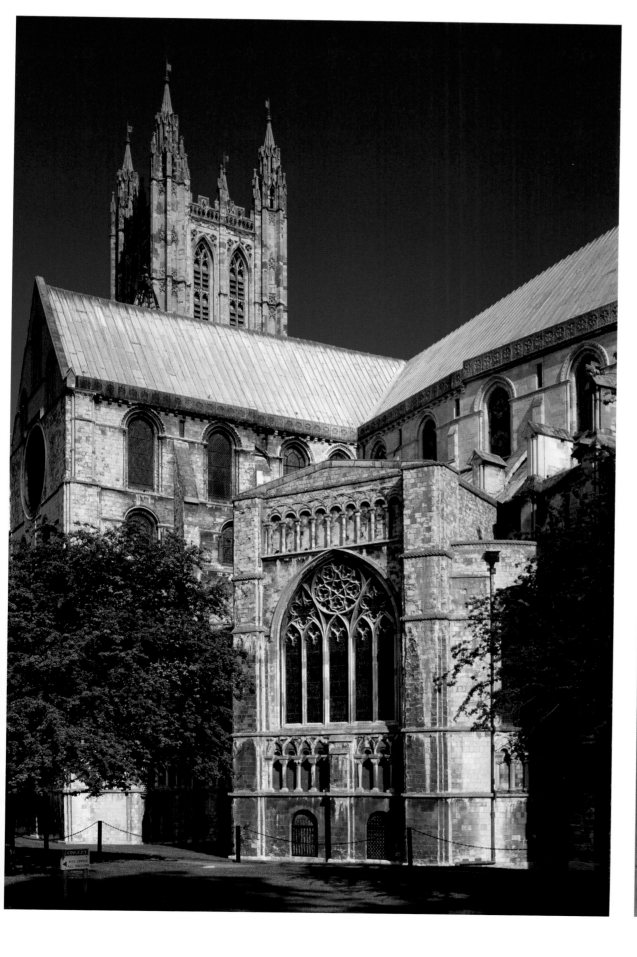

217

BELOW, CENTER, AND RIGHT:
York, cathedral, north arm of the
transept, ca. 1234–1251 (below);
nave facing west, 1291–1340 (center);
east window (right)

The flat horizontal boundary of the
clerestory in the transept at York remains
close to older elevation systems that were
covered with flat ceilings, open trusses, or
wooden barrel vaults. Otherise, this section
of the cathedral is modeled after Lincoln.

A unique example of the execution of
French High Gothic in England is the nave
of the cathedral of York, with the skeletal,
thin walls of the high aisle in which the
triforium and clerestory are contracted
into a single zone.

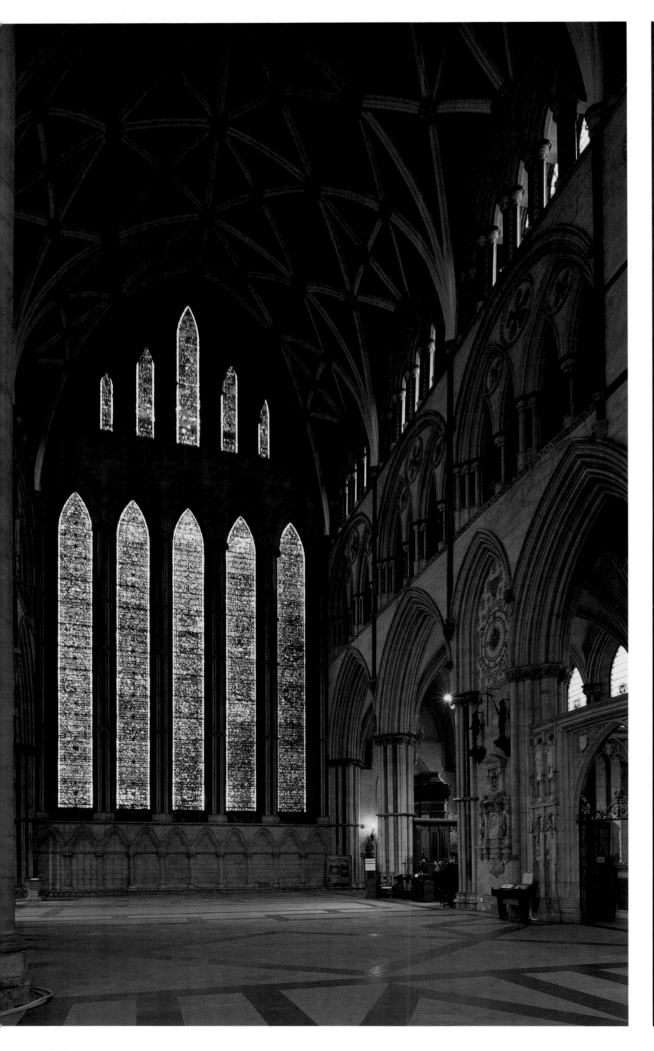

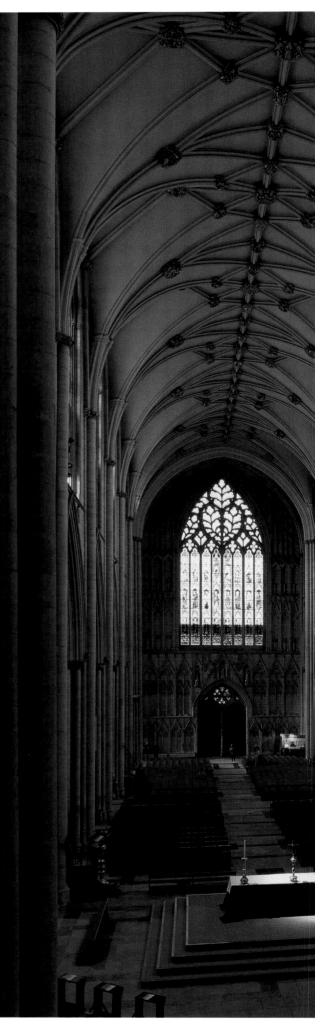

PAGES 220 AND 221: **Lincoln, cathedral,** nave facing east, ca. 1220–1240 (p. 220); so-called Angel Choir, 1256–1280 (p. 221)

The choir and nave are an especially artful work of English Early Gothic that displays a plethora of refined and playful individual forms. The retro-choir is one of the major works of the Decorated Style. Blind tracery, figural and ornamental reliefs, and moldings fill the spaces in the spandrels as well as on arches and responds.

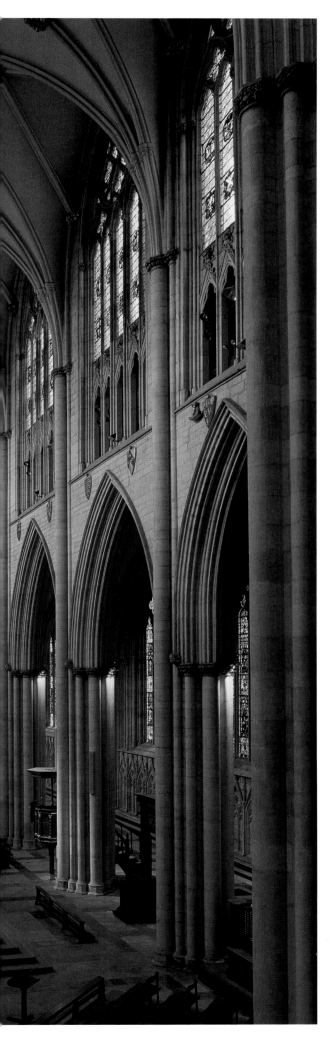

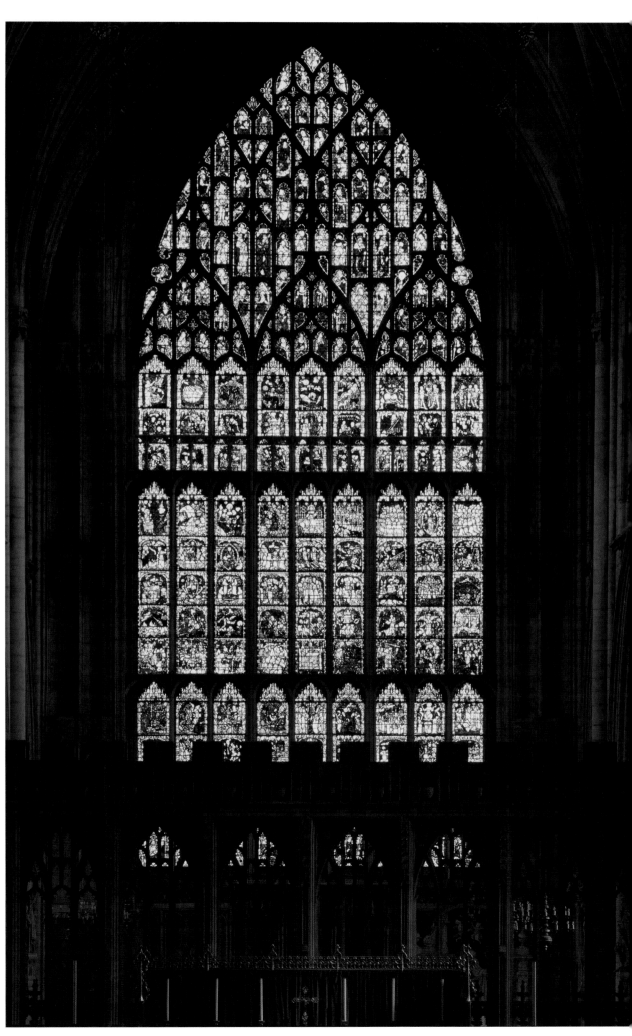

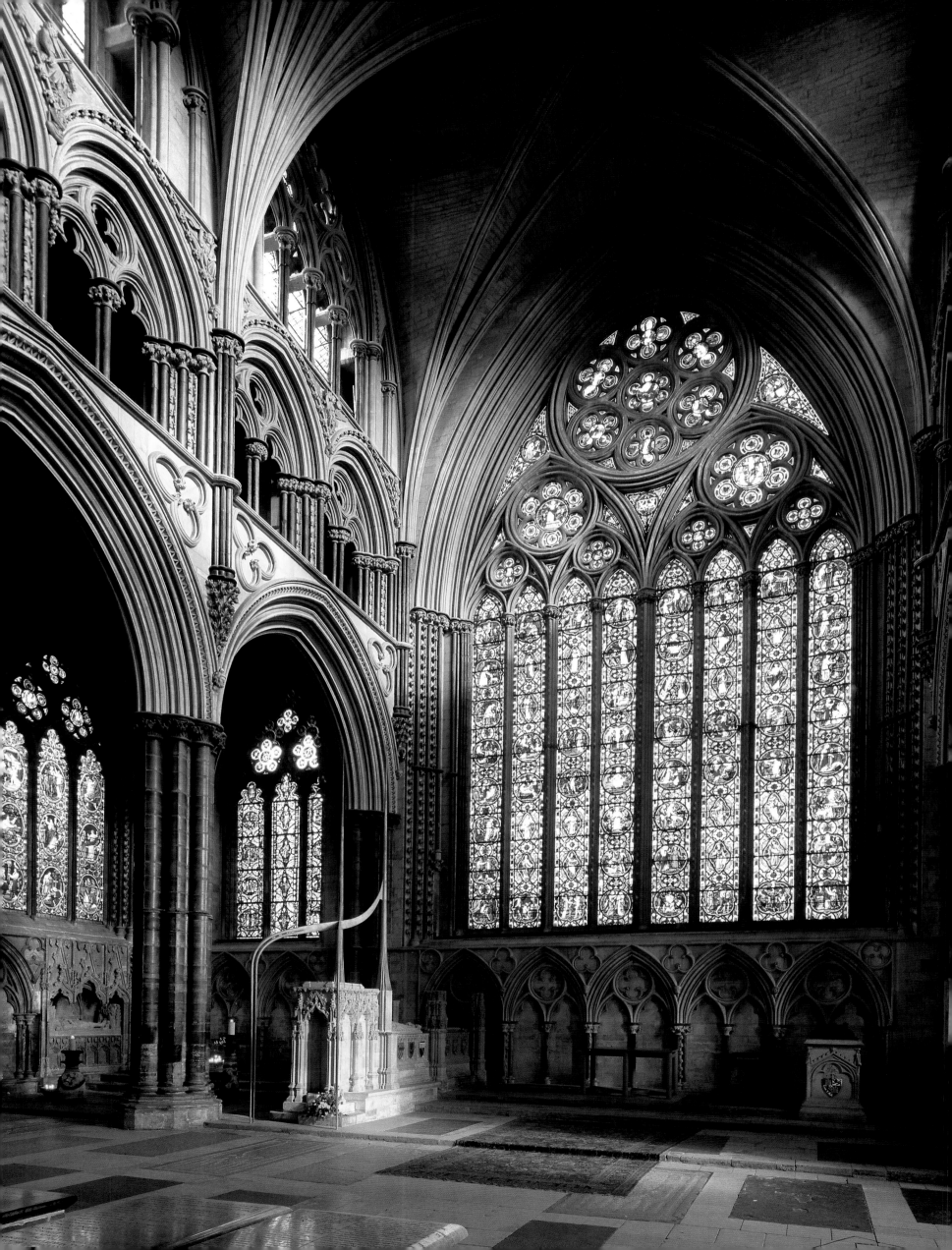

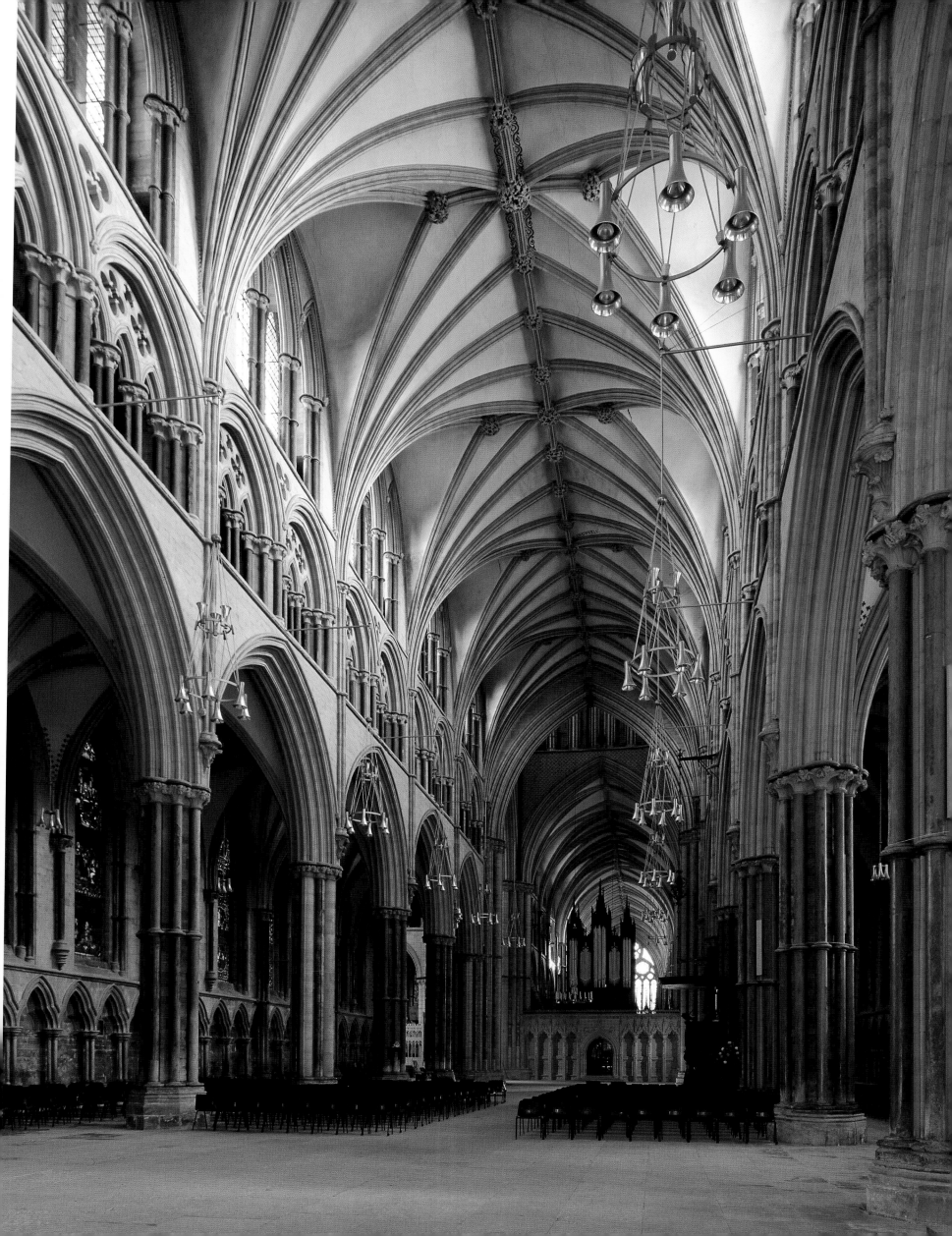

BELOW: **Salisbury, cathedral,**
Chapel of the Holy Trinity, 1220–1225

The Chapel of the Holy Trinity is a hall resting on extremely slim marble supports, which along with the choice to use only very few stylistic devices results in an exceptionally elegant space.

OPPOSITE: **Wells, cathedral,**
nave, ca. 1180–1240, interior view toward the east

The nave of Wells follows the model of Chartres by choosing the form of uninterrupted triforia for the galleries. Unusual is the absence of bases and capitals in the triforium and the springing of the vaults from the spandrels of the triforium.

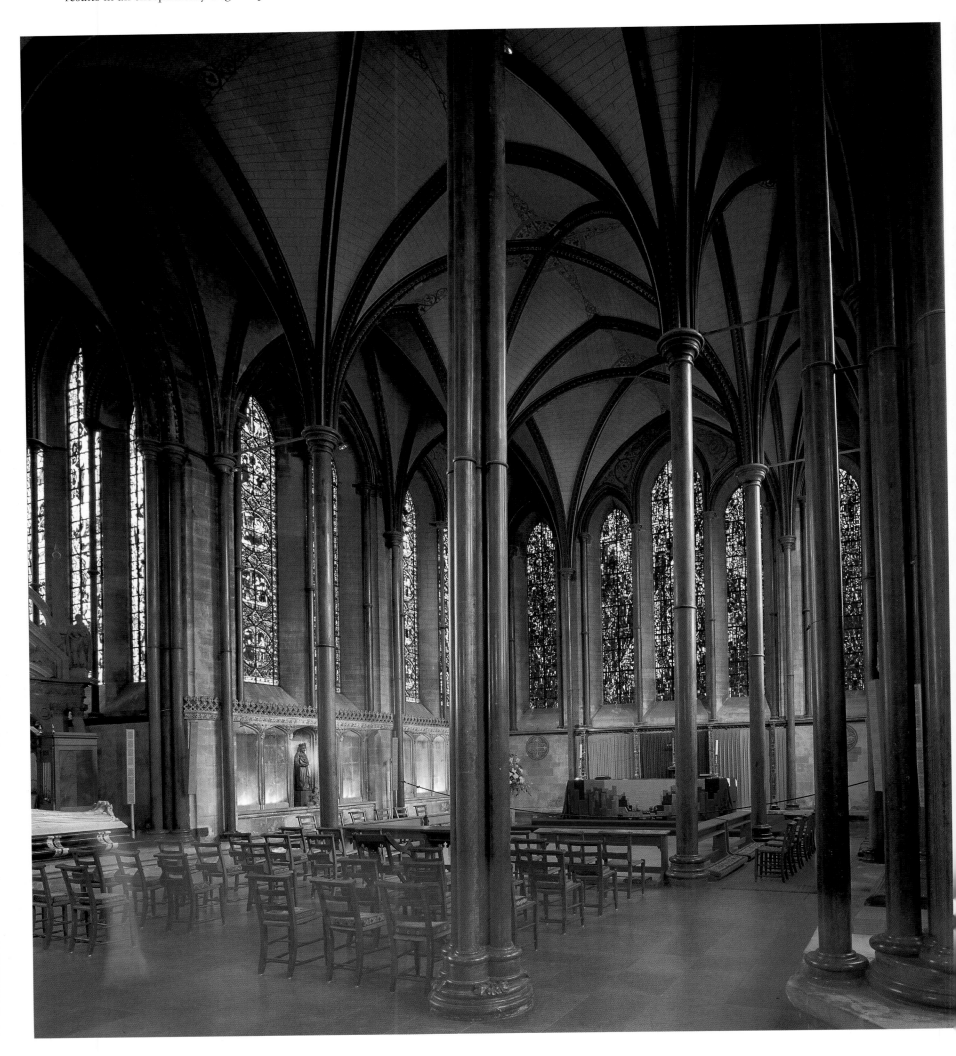

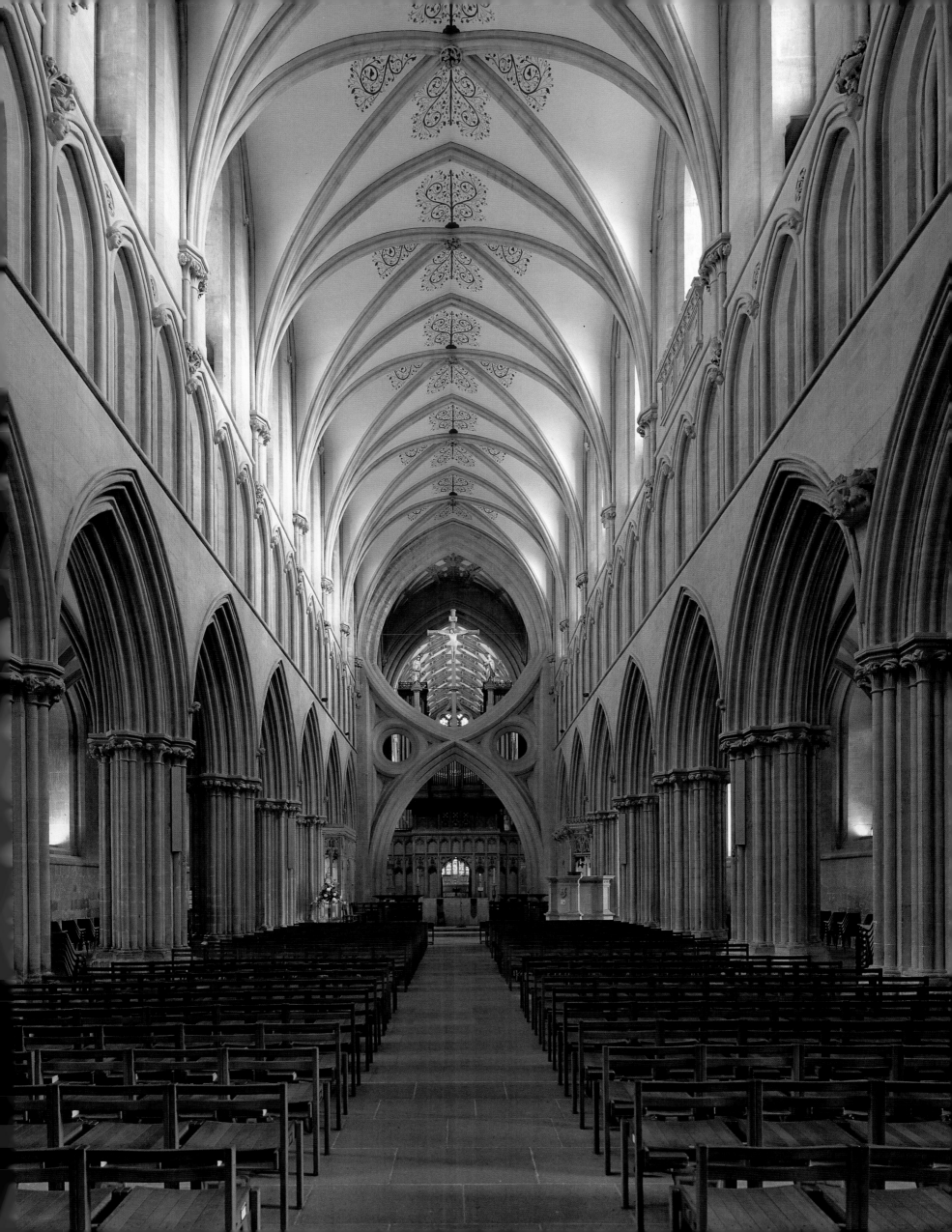

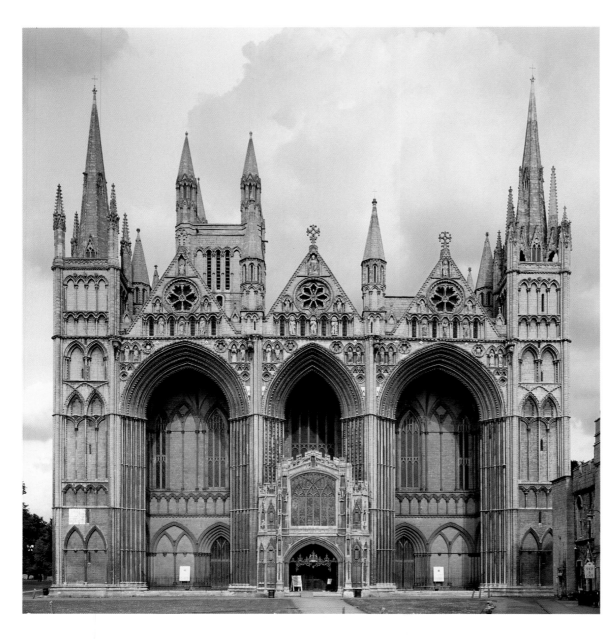

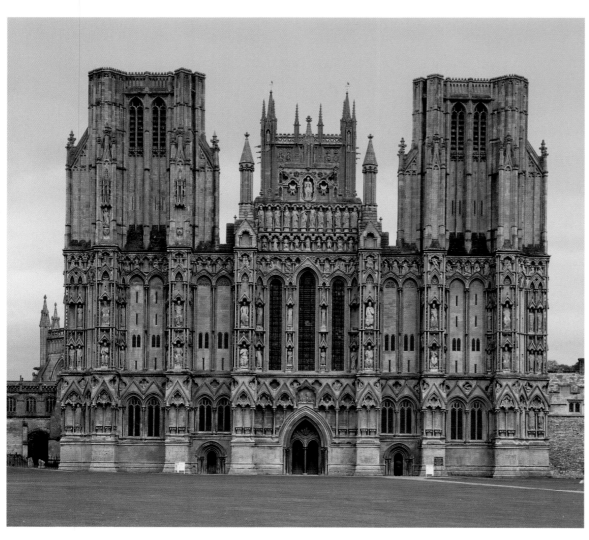

A special challenge of the Early English period was the screen facade, an element where the insulated Gothic of the British Isles went its own way. These screen facades relate only indirectly to the nave behind them. Noteworthy is also that the west portal does not serve as the representative entrance and to display sculpted figures. Since Anglo-Saxon times the main access typically lay in the north under a richly ornamented atrium.

PAGES 226/227: **Wells, cathedral**, staircase to the chapter house; chapter house, ca. 1290/1300

The octagonal chapter house is one of the most beautiful of its kind in England. Unlike in other chapter houses, the design here emphasizes not the windows, but the vaulting, which seems to flow out of the central support and the eight slim responds.

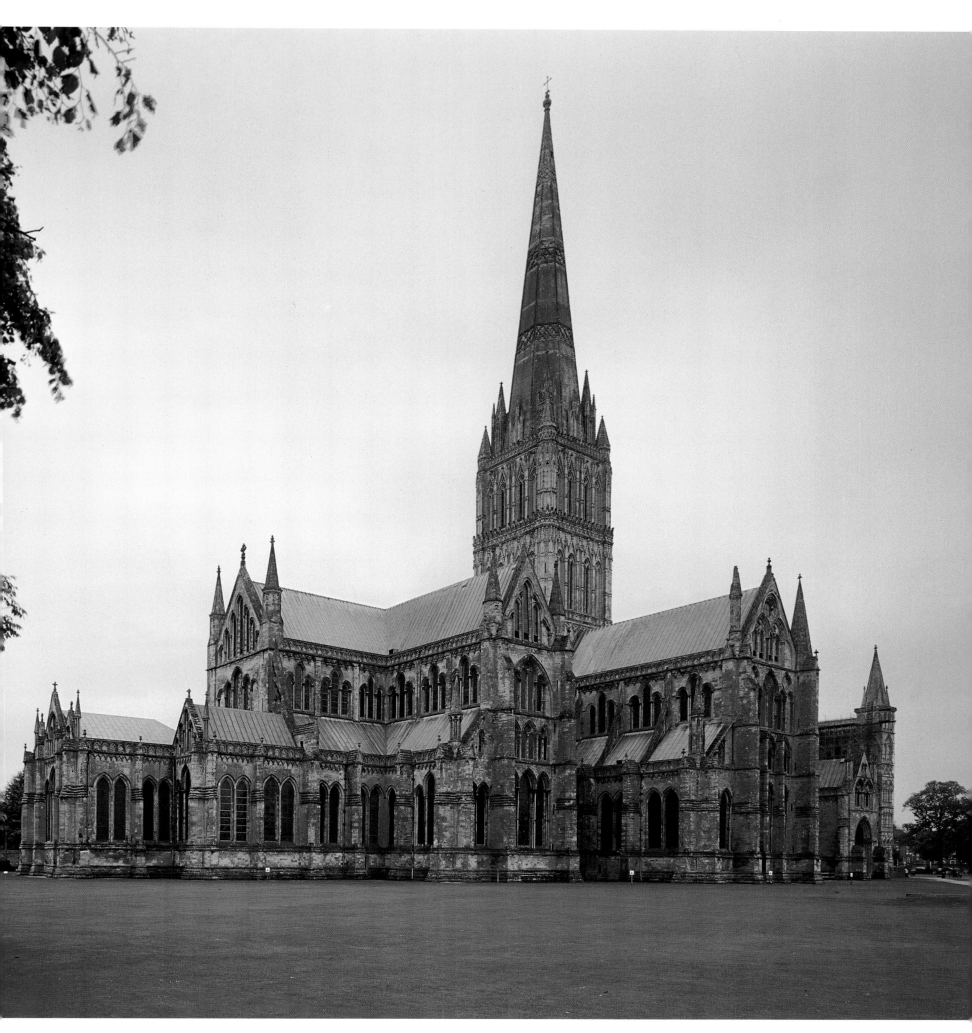

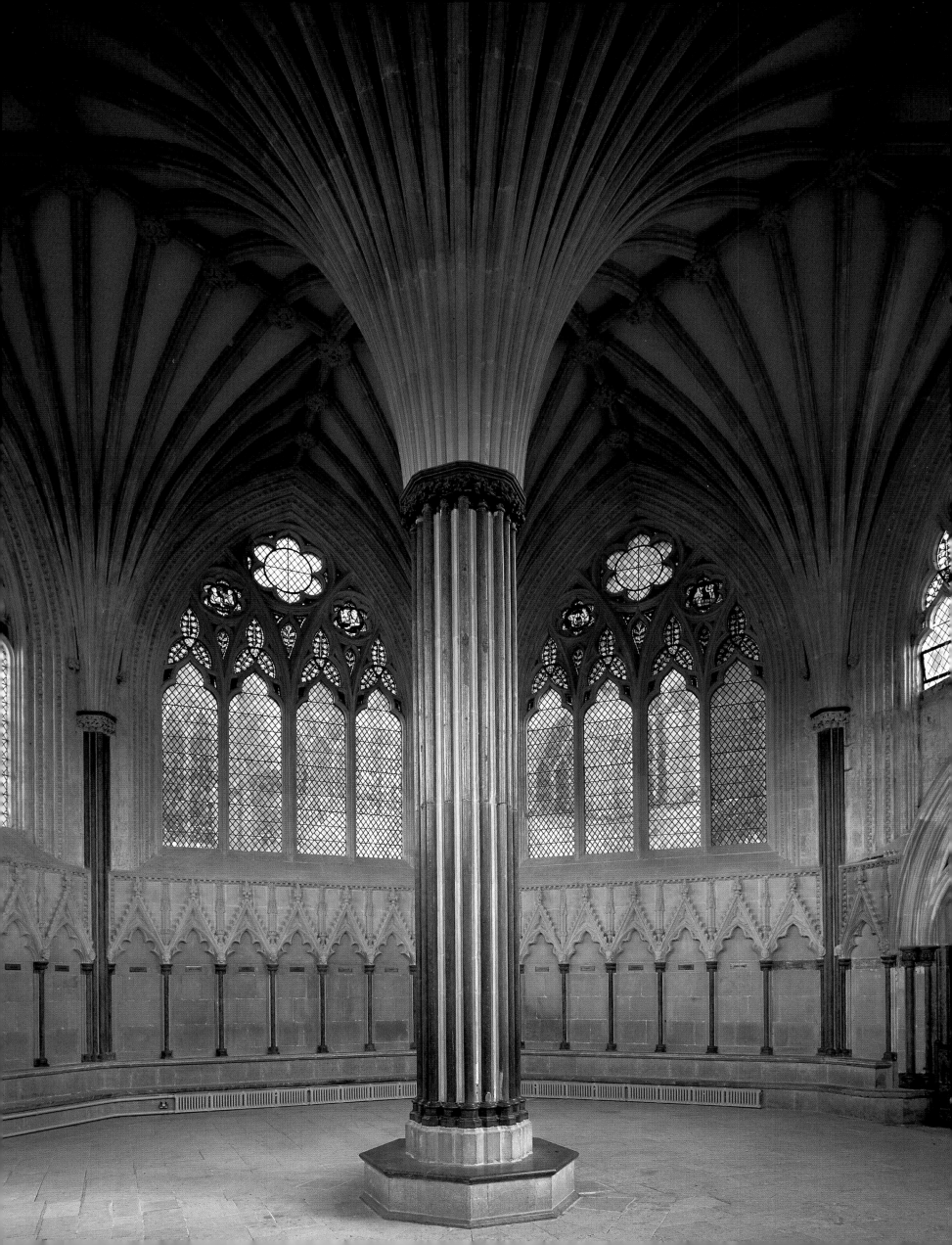

Exeter, cathedral, west facade, 1329–1342; interior view of the nave looking east (ca. 1310)

Exeter is an example of a different type of facade, the cross-section facade. The figure-studded blind wall in the lower zone is a more recent addition, however, derived from the concept of the screen facade.

One of the centers of the Decorated Style that emerged during the last quarter of the 13th century was in southwest England. The oldest example of this group is the cathedral of Exeter. The low-reaching fan vaults give the space a compact appearance, which is reinforced by the thick bundles of responds that support the profile of the arcades.

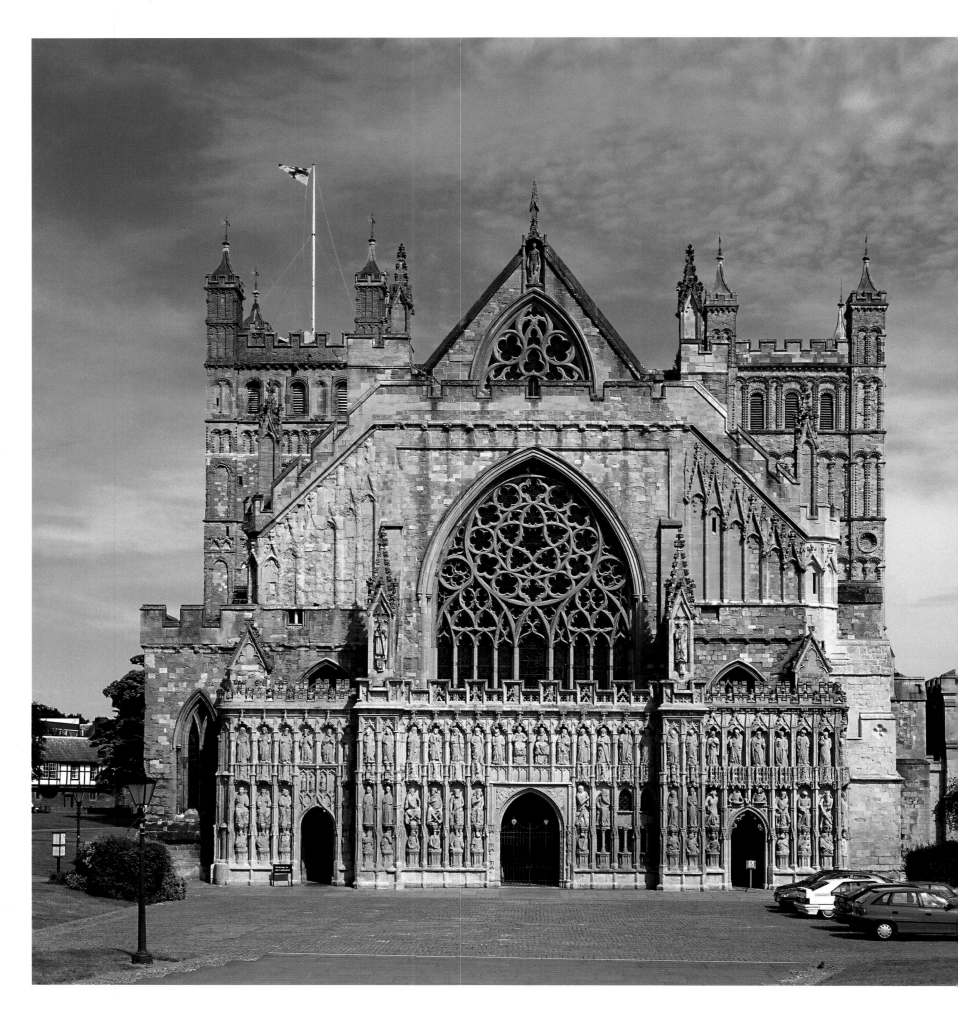

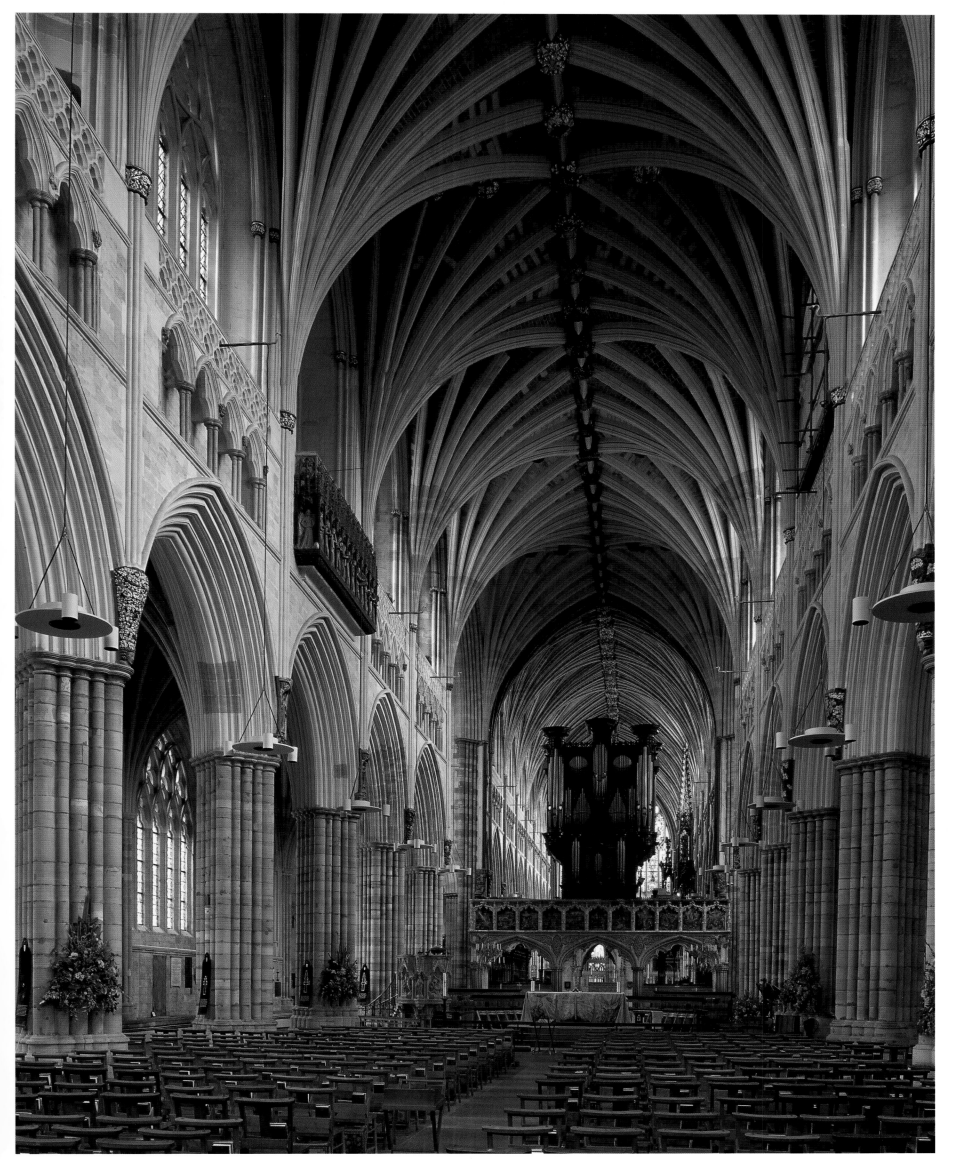

As a reaction to the ornamental exuberance of the Decorated Style on the one hand, and as a means to resolve a problematic situation on the other, the choir of the cathedral of Gloucester resulted in a solution that became the starting point of the Perpendicular Style with its strong horizontal and vertical lines.

The extraordinary forms with which the late Gothic period in England culminated can be admired, for example, in Cambridge. Here, too, the horizontal and vertical lines of the tracery dominate.

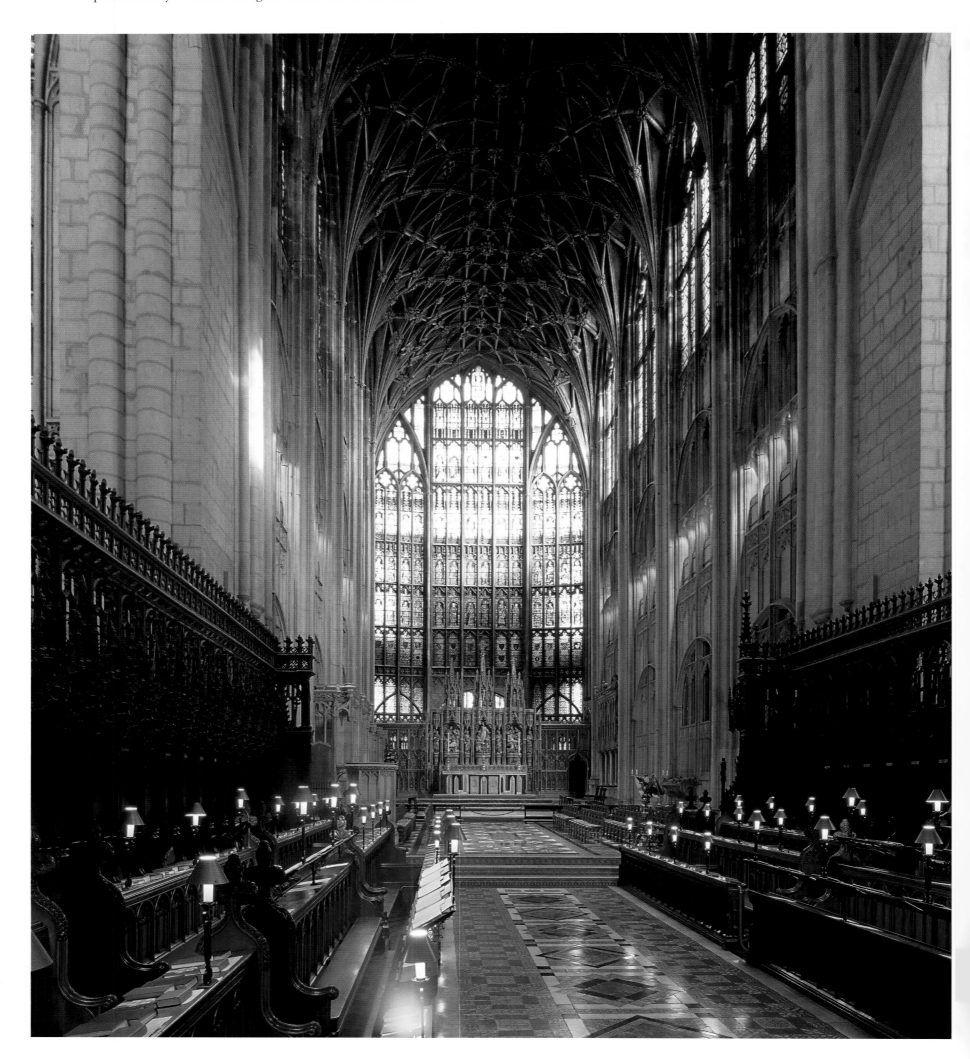

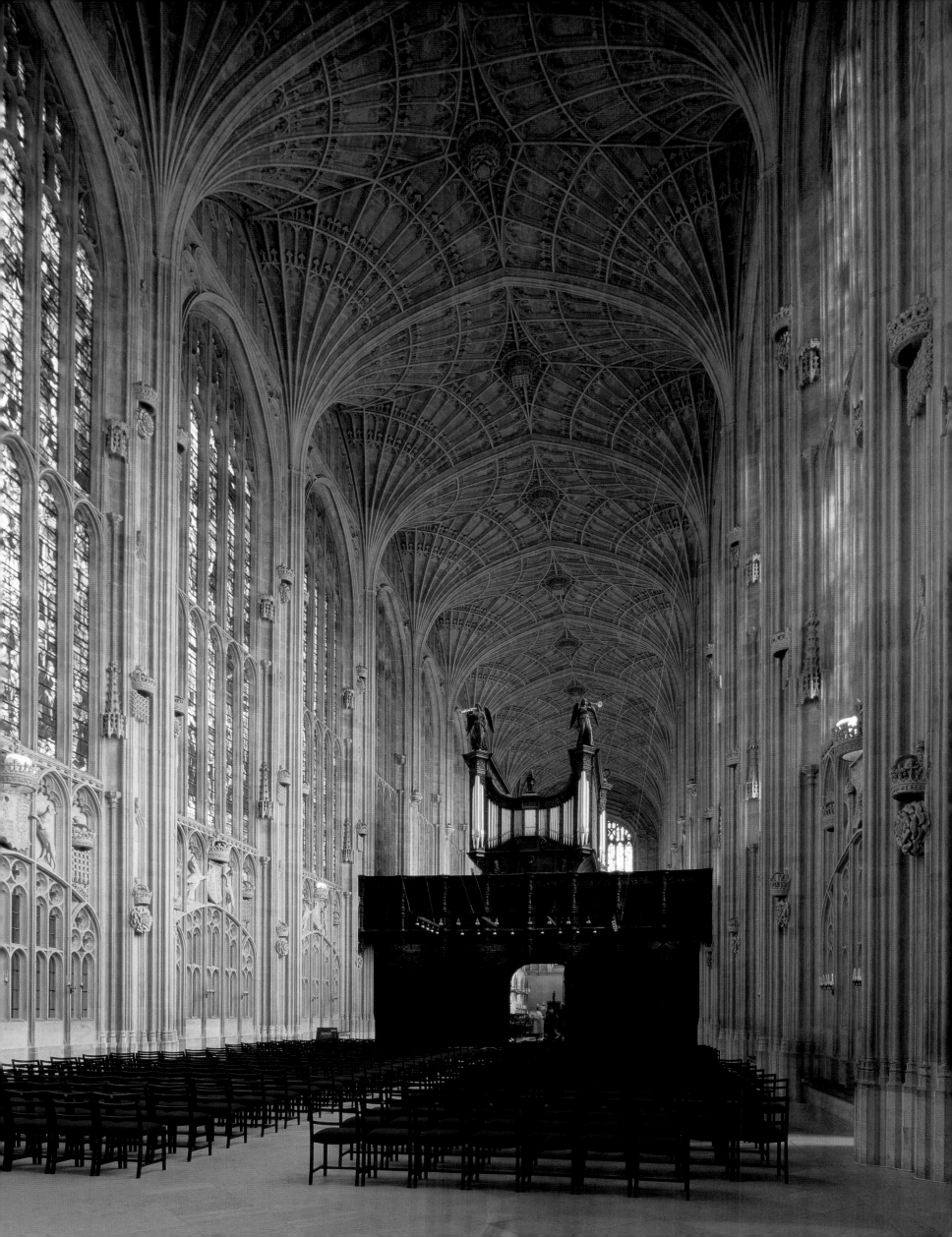

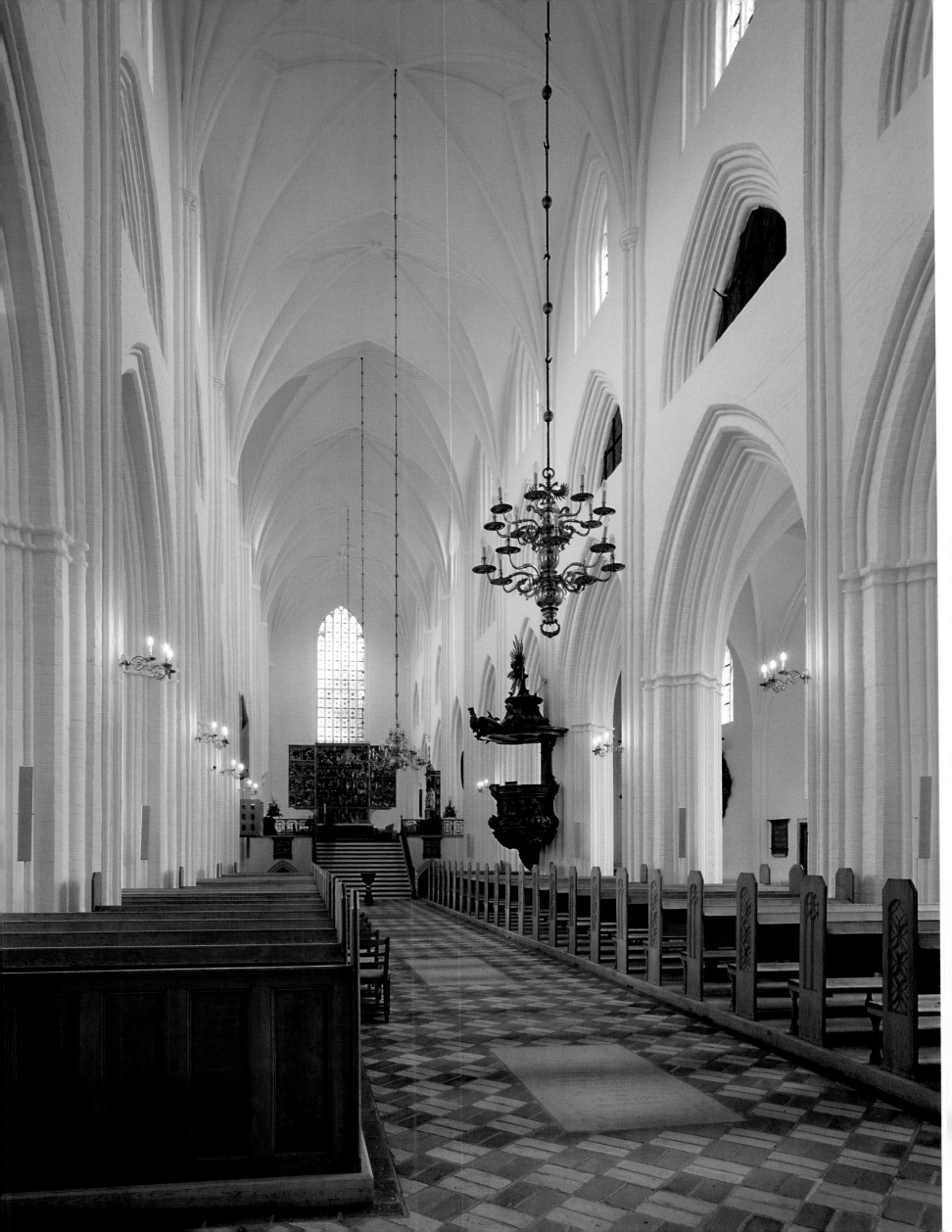

OPPOSITE:
Odense, Knud Cathedral,
14th and 15th c., nave looking east

The examples of Knud Cathedral, the cathedral of
Roskilde and others show that English cathedral archi-
tecture, as well as the brick Gothic of the Baltic Sea
region, remained influential for Danish sacred architec-
ture into the late Middle Ages.

BELOW LEFT AND RIGHT:
Uppsala, cathedral,
13th c., exterior view from the south; interior

The cathedral of Uppsala is the seat of the archbishop of
Sweden and one of the main works of Gothic architecture
in the country. Here, too, the Gothic tradition of the
Baltic Sea region seems to have had a strong influence.

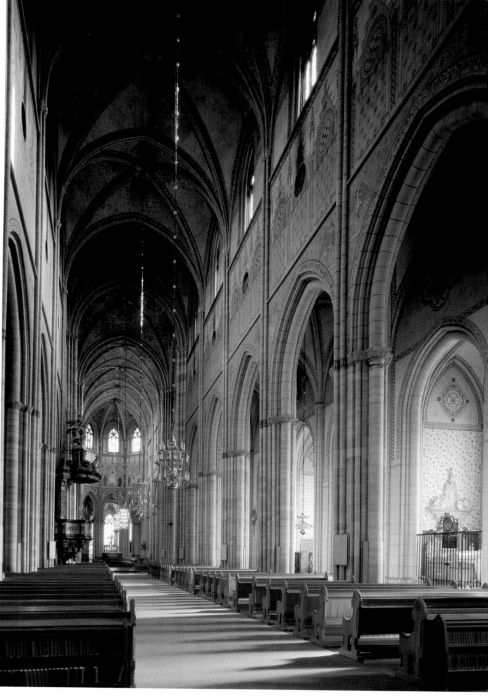

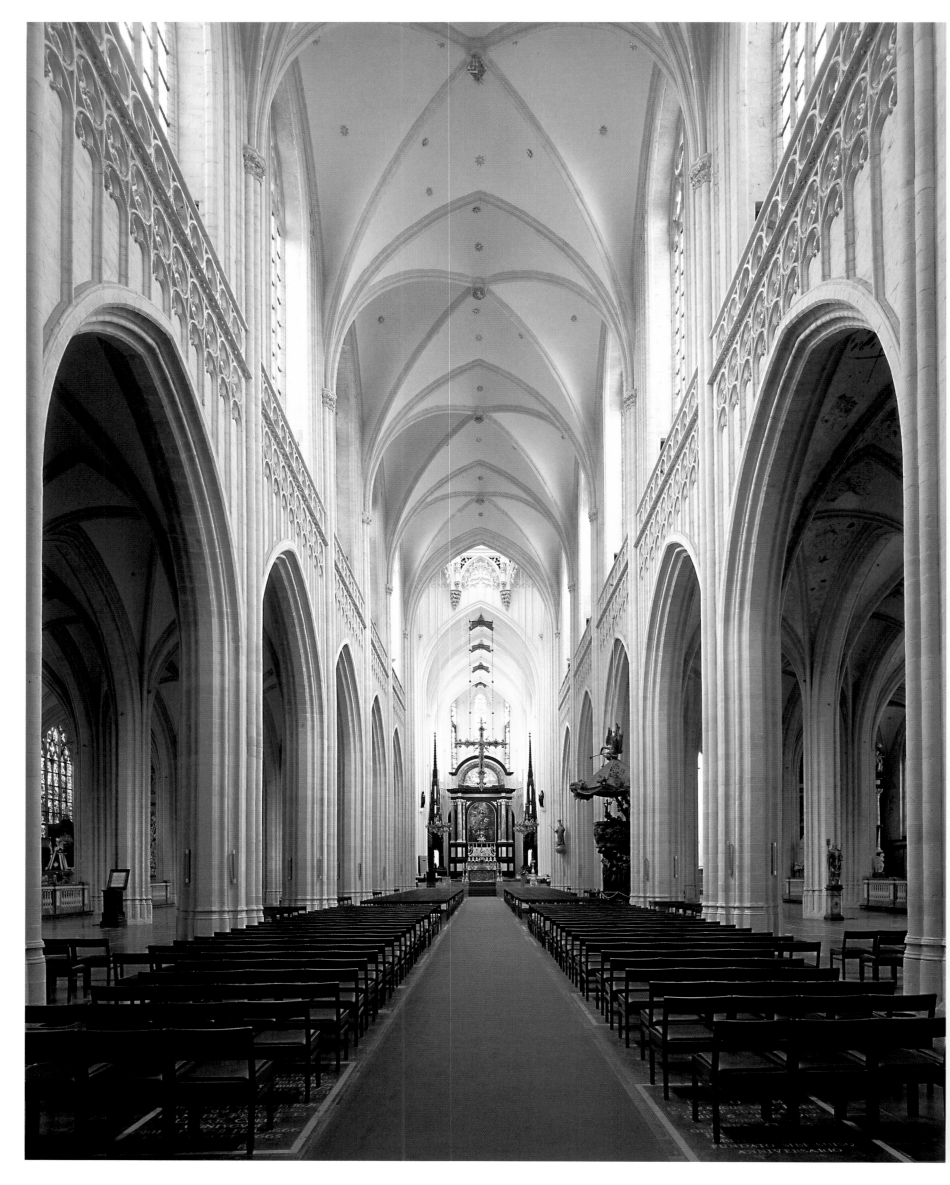

OPPOSITE AND BELOW:
Antwerp, Onze Lieve Vrouwekathedraal,
begun 1352, interior and exterior

The Cathedral of Our Lady is a five-aisle
basilica with a transept, a choir bay, and
an ambulatory with radiating chapels.
Characteristic is the unification of the entire
elevation of the nave through the blind
tracery, a motif that was already found in
St Rombout.

PAGE 236:
Mechelen, St Rombout, begun 1342

The floor plan and elevation of the former
collegiate church, now a cathedral, follow
the classic prototypes in France. An original
trait is the fine net of tracery that extends
over the triforium zone and the clerestory,
even including the gussets of the arcades in
the choir.

PAGE 237:
Delft, Nieuwe Kerk, 1453–1476

Not all elaborate buildings of Dutch Gothic
architecture followed the pattern of the
cathedral. The Nieuwe Kerk (New Church),
for example, is a brick church with a wooden
ceiling and extremely sparse forms. Between the
arcades and the clerestory, with their explicitly
humble tracery, lancet groups open like a
window onto the trusses of the side aisles.

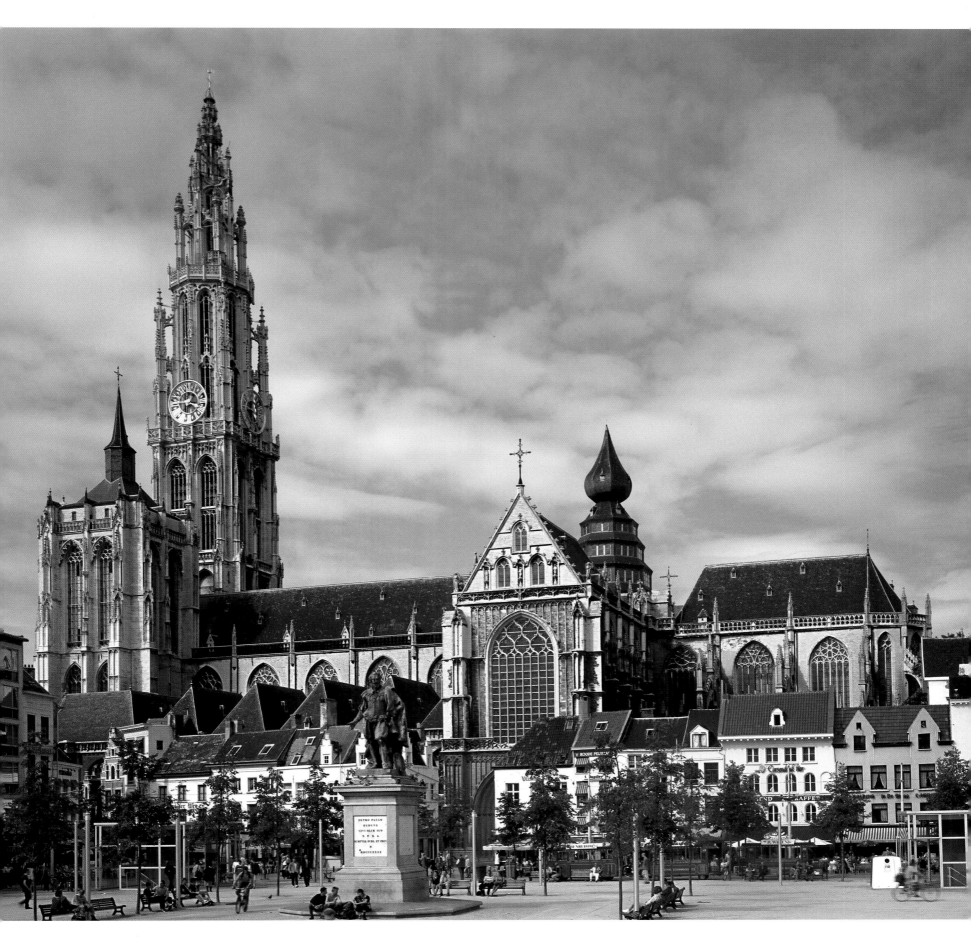

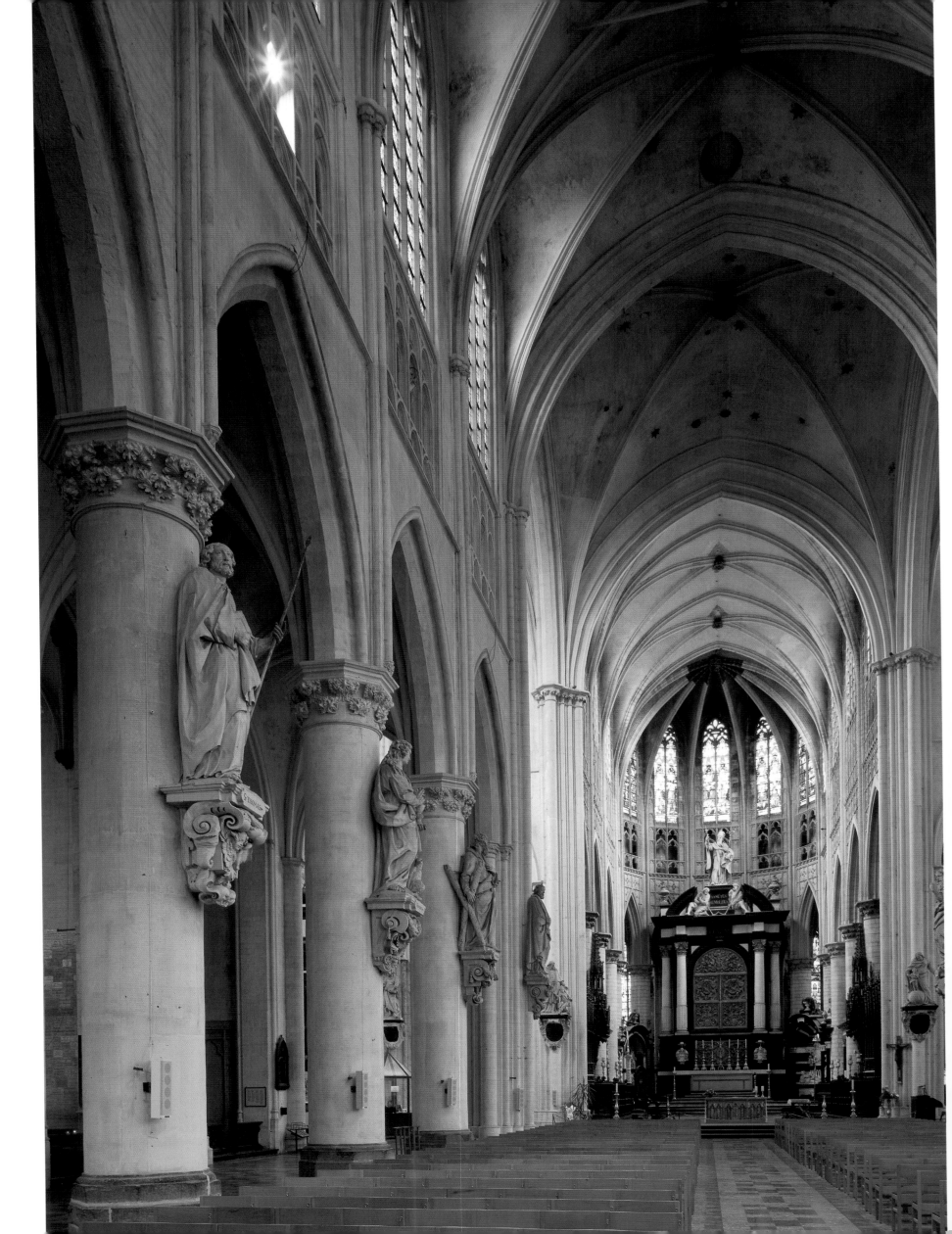

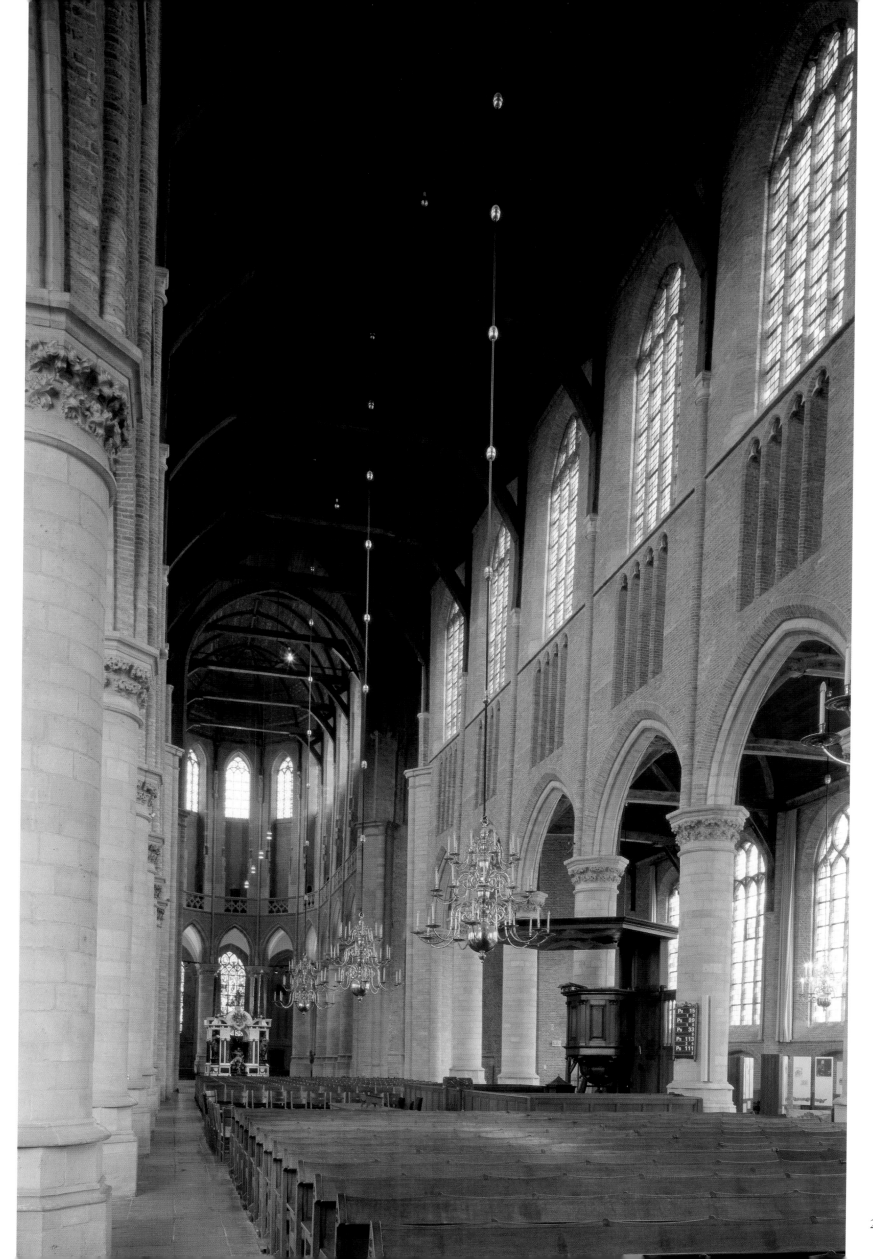

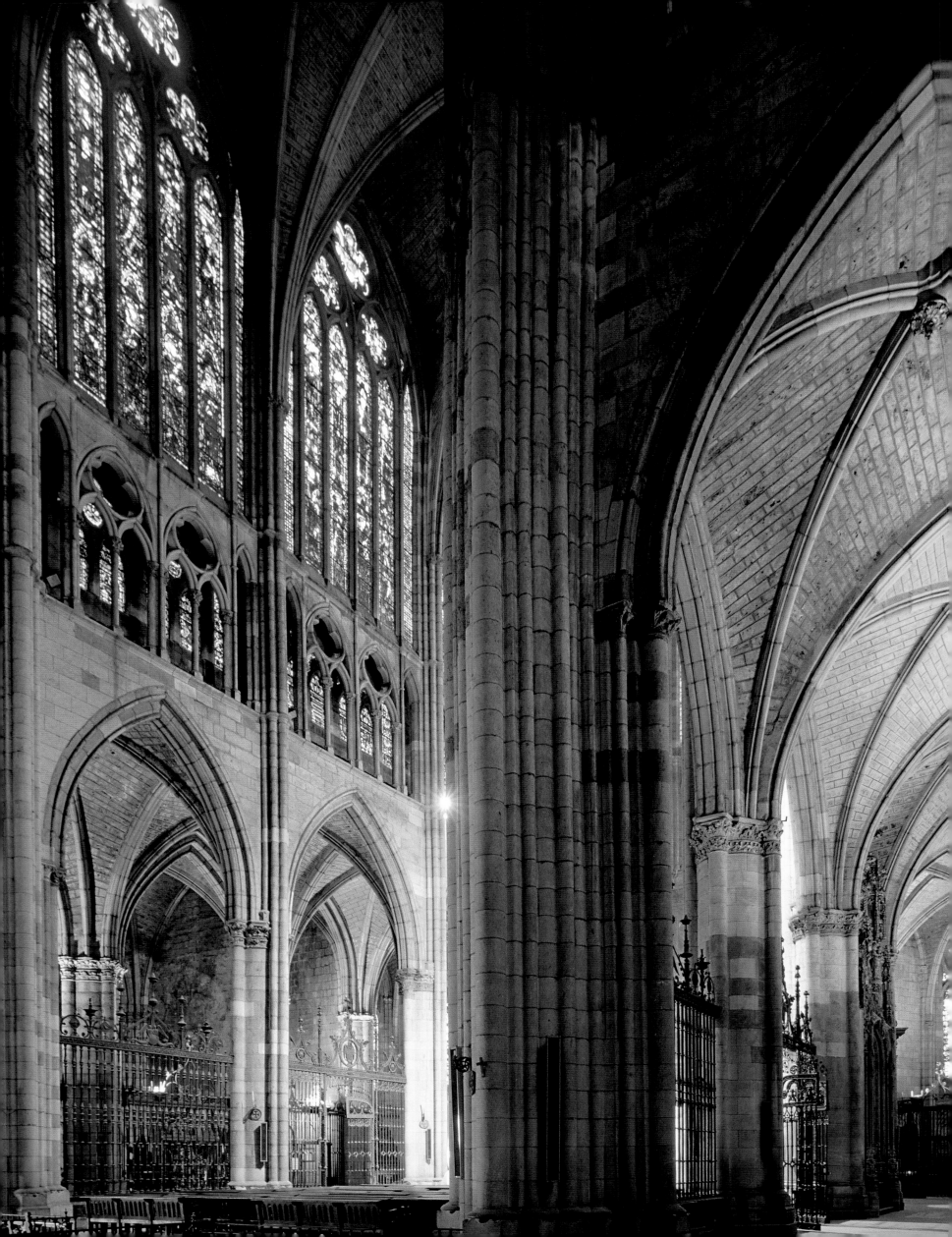

León, cathedral,
interior of the nave, begun 1255;
exterior view from the southwest

The floor plan follows the cathedral of Amiens, though on a smaller scale. The same is true of the elevation, with an illuminated triforium and the tracery of the clerestory extending beyond the triforium. The west facade is an independent solution. It consists of a deep complex of three portals inserted in between the side towers, with an isolated central block rising above it.

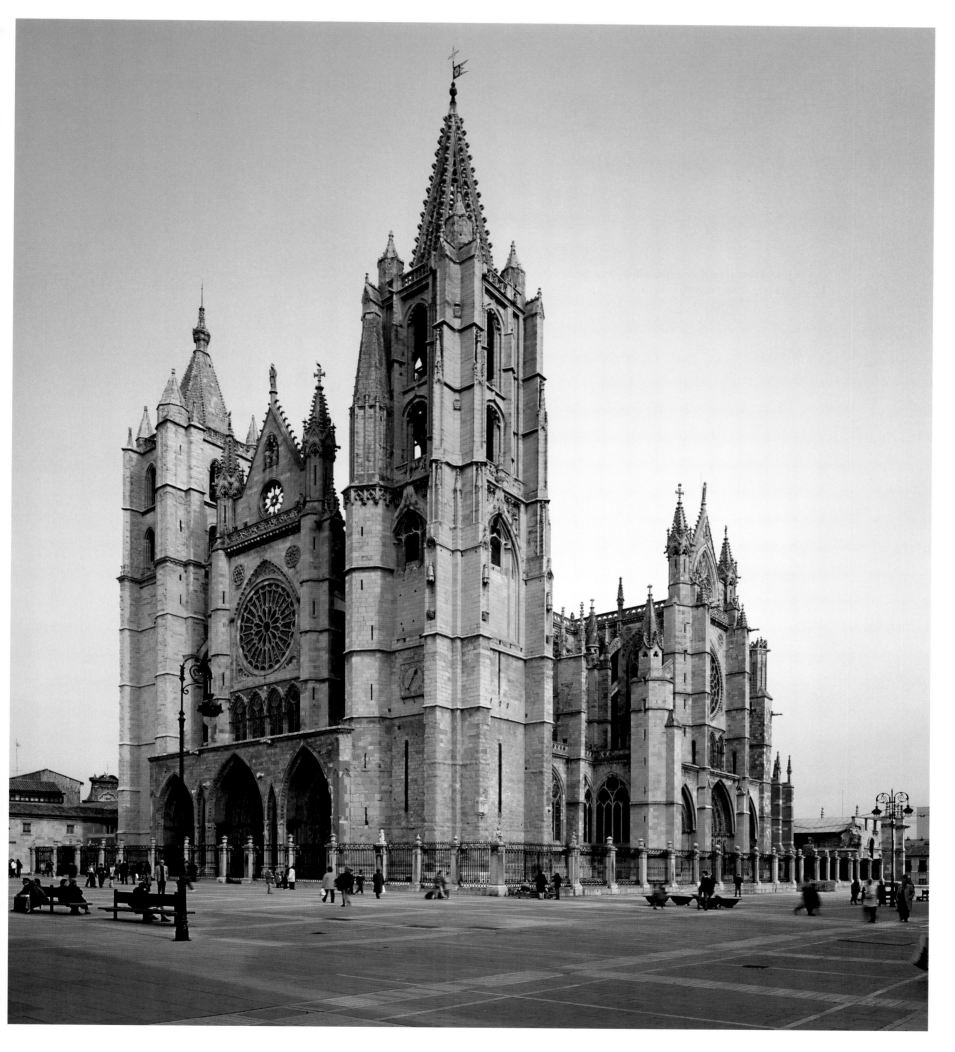

BELOW: **Barcelona, cathedral,** begun 1298, choir

With its length of 260 feet (79 meters), its width of 82 feet (25 meters), and its height of 82 feet (26 meters), this cathedral is one of the most impressive works of Catalan Gothic. Its construction was supervised by Master Jaume Fabre. The crypt under the cathedral was completed in 1337.

OPPOSITE: **Barcelona, Santa Maria del Mar,** 1328–1383

Santa Maria del Mar, the church of seafarers and traders, surpasses even the cathedral. The building masters were Berenguer de Montagut and later Ramon Despuig and Guillem Metge.

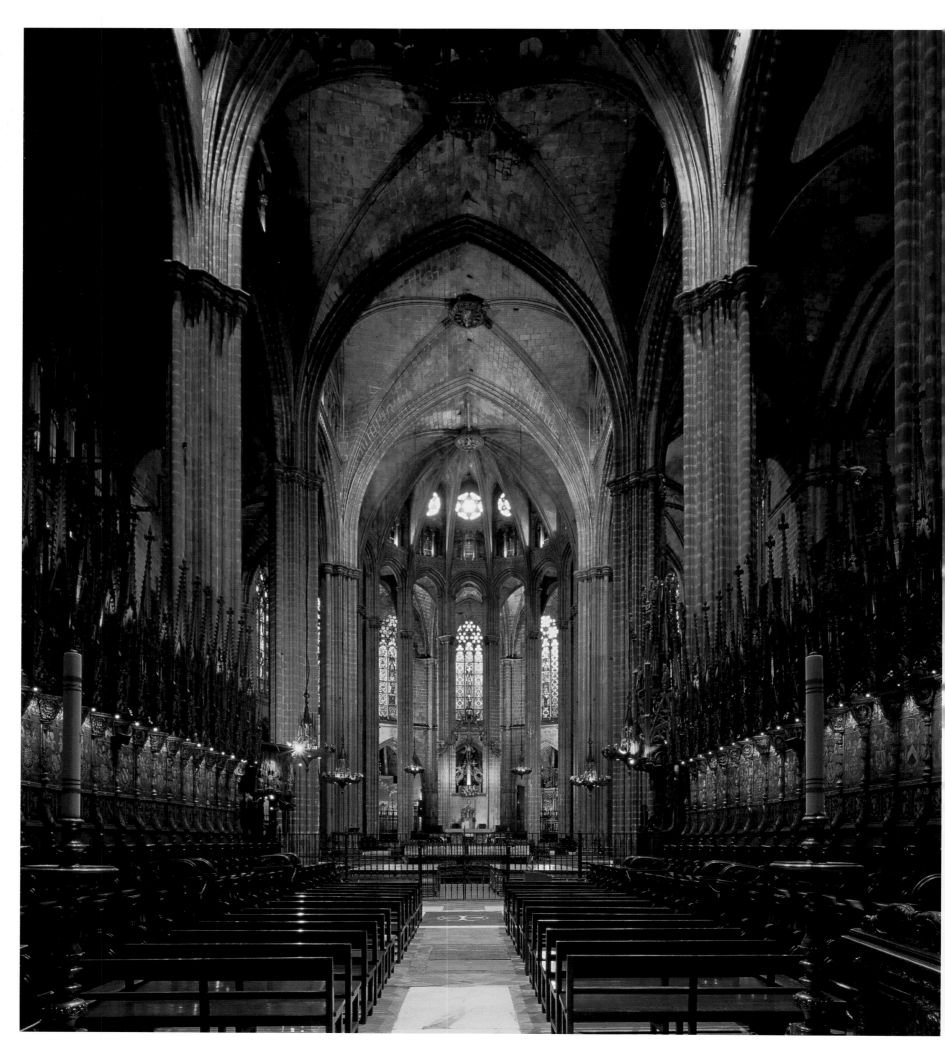

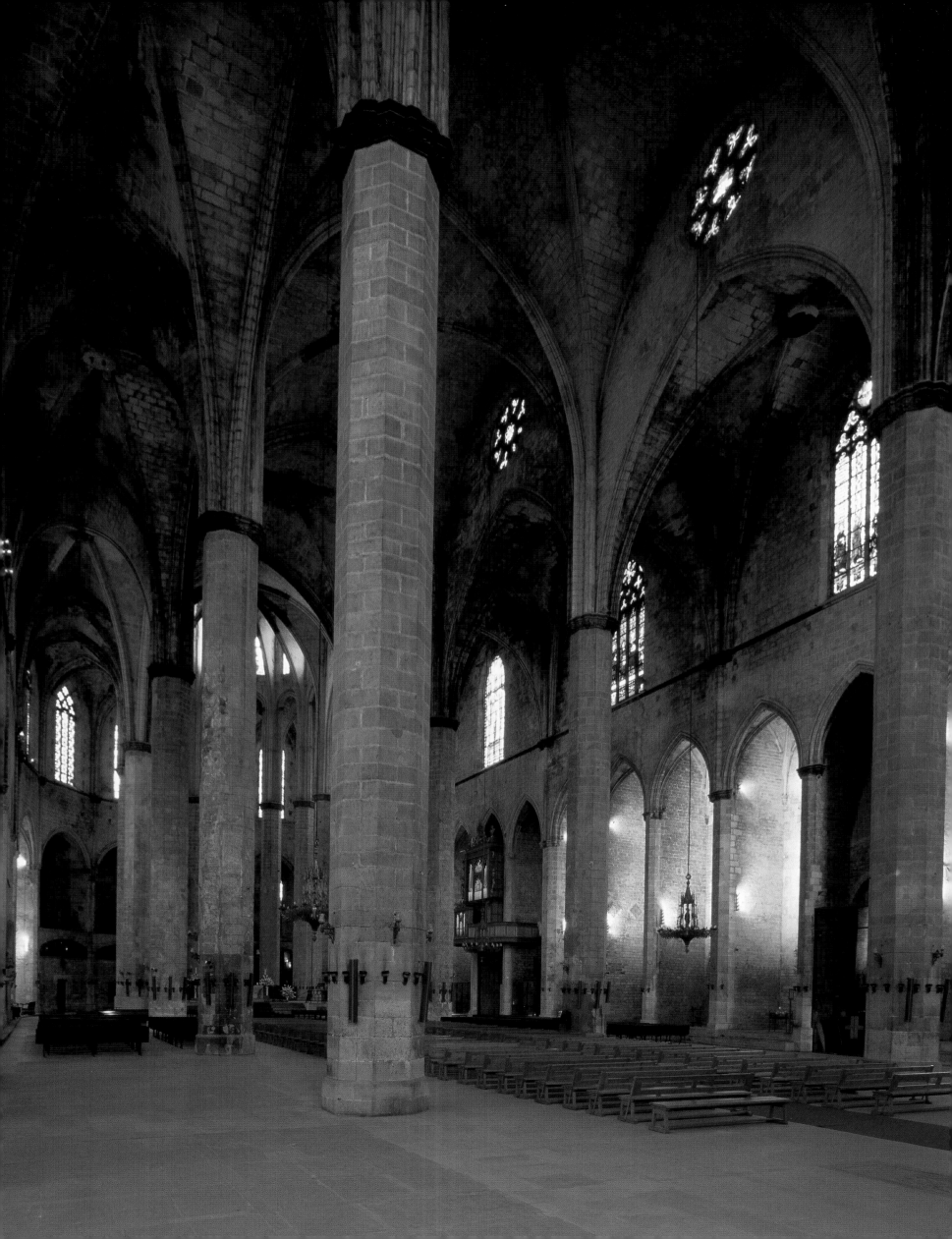

Palma de Mallorca, cathedral, begun ca. 1300

The construction of the cathedral of Palma is also attributed
to Berenguer de Montagut. It was built on the site of the Arab
mezquita whose foundation walls were preserved until 1412.
The exterior, which can be seen from afar from the sea, is
characterized by massive buttresses that stand very close to
each other and give the building an almost fortress-like
appearance.

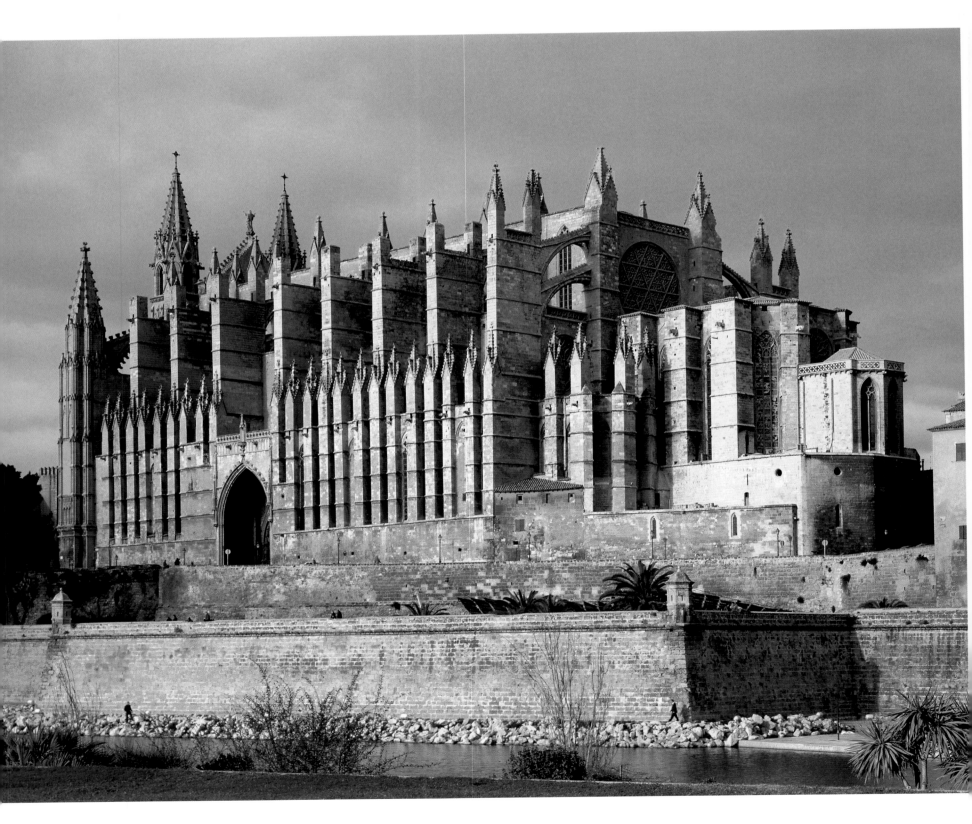

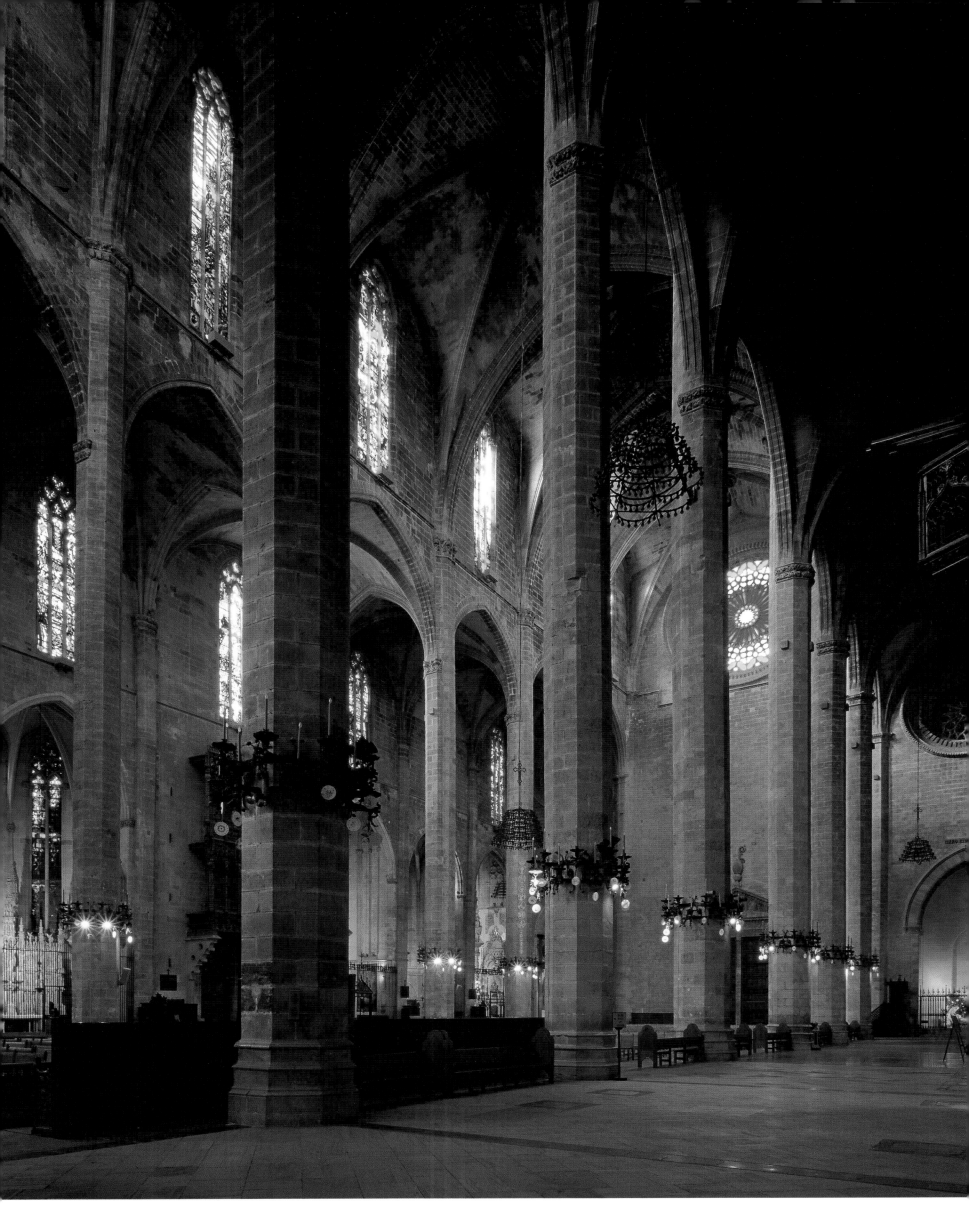

Granada, Capilla Real,
begun 1504, interior;
detail of the vault

In 1504 the Catholic royalty
commissioned Enrique Egas
to build the Capilla Real
as a sepulchral church im-
mediately adjacent to the
main mosque in Granada,
which had been conquered
in 1492.
In the richly decorated
chapel, Ferdinand and
Isabella are buried together
with their daughter, Joan
the Mad, and her husband,
Philip the Handsome. The
floor plan and elevation,
portal, and vault are all in
the late Gothic tradition.

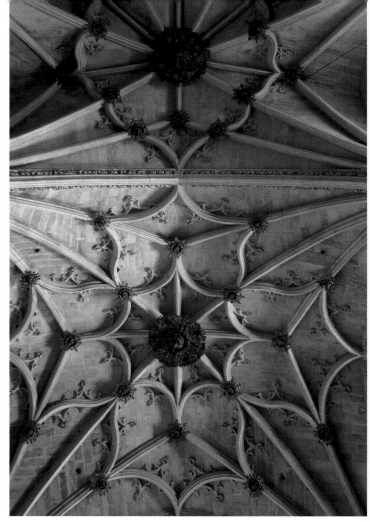

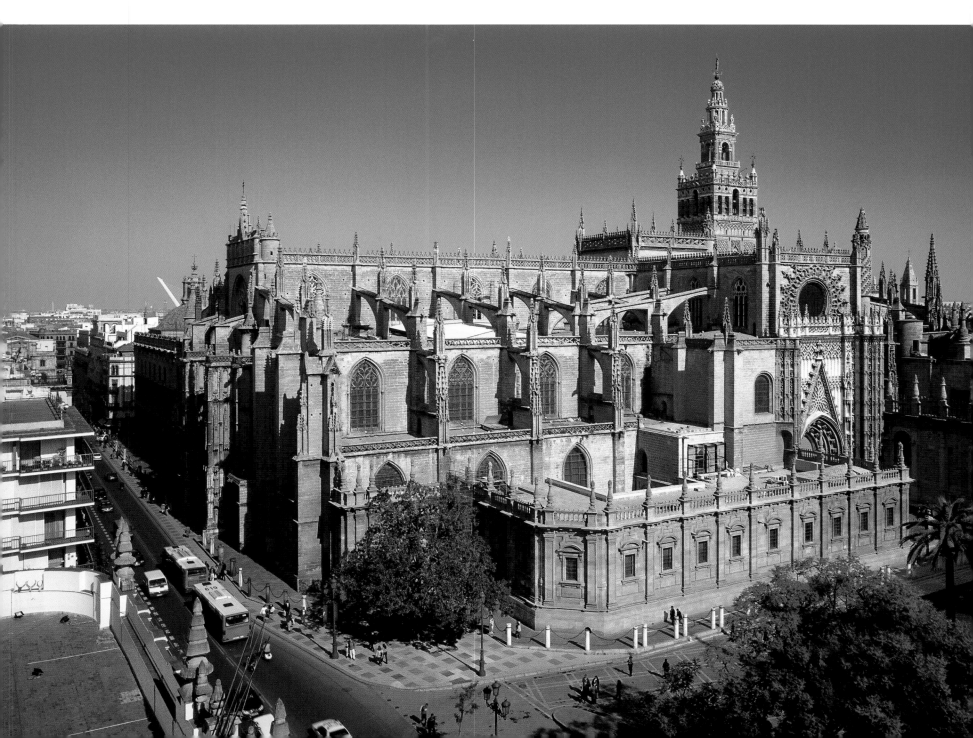

The building masters of this
church—the largest and
most unusual project of the
15th century—were mainly
foreignors, one after the
other: Pedro García
(1421–1434), the Flemish
Ysambert (1434), the
French Carlìn (1439–1449),
Juan Norman (1454–1472),
and finally Juan de Hoces.
In 1496 the sources mention
a Maestre Ximon, possibly
Simon of Cologne.

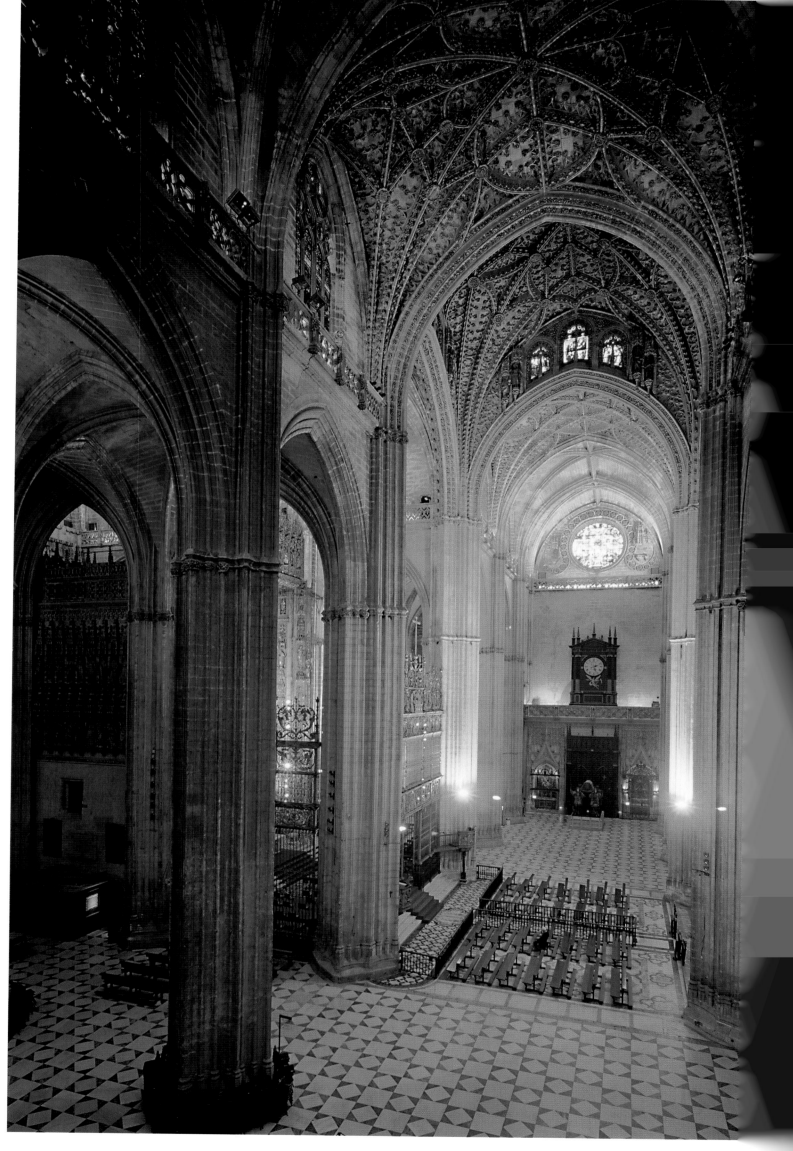

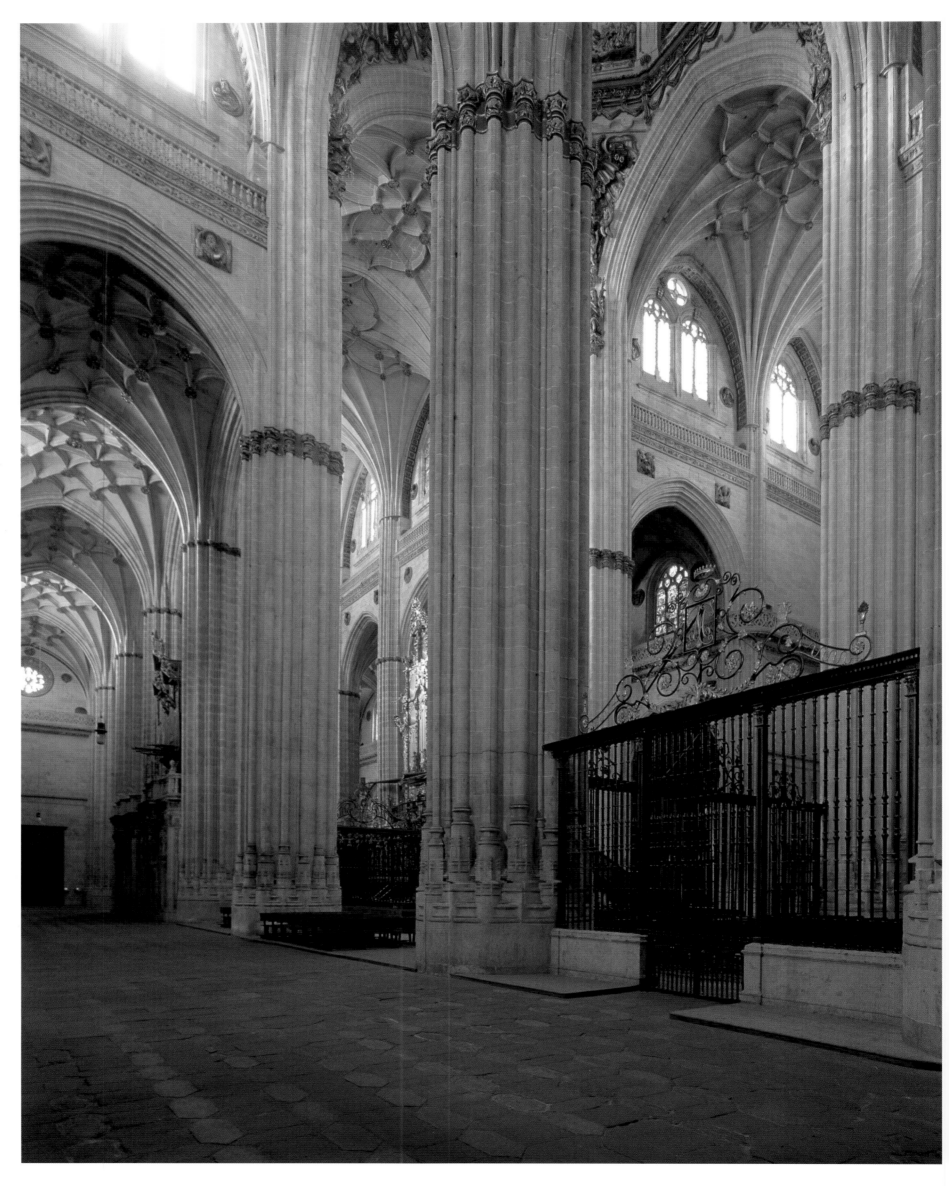

Salamanca, cathedral, begun 1513, crossing; view of the city and the cathedral

In Spain, sacred buildings were still erected according to Gothic rules in the 16th century. The cathedral of Salamanca is a bright building, richly decorated with fan and net vaults, yet still with a clear structure. Considering the relationship between the Spanish kings and German emperors, it might well have been influenced by the German late Gothic era.

RIGHT: **Segovia, cathedral**, begun 1525, choir

The three-aisle complex with a short transept has a choir ambulatory with seven radiating chapels. This disposition engenders harmonic steps on the exterior, accentuated by the buttresses with their massive pinnacles.

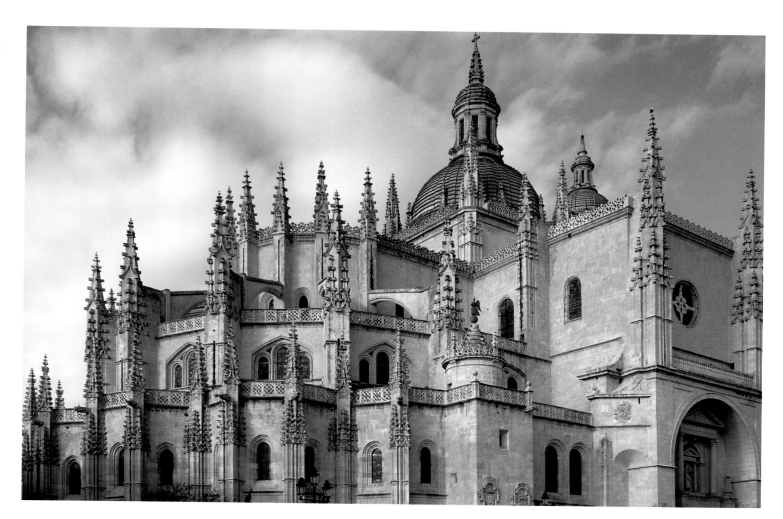

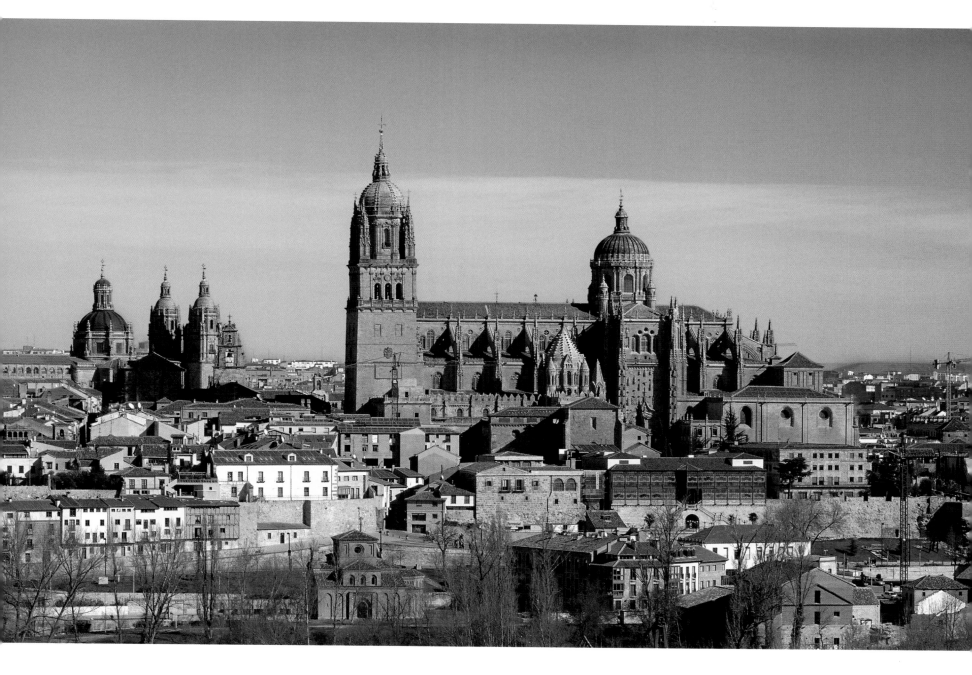

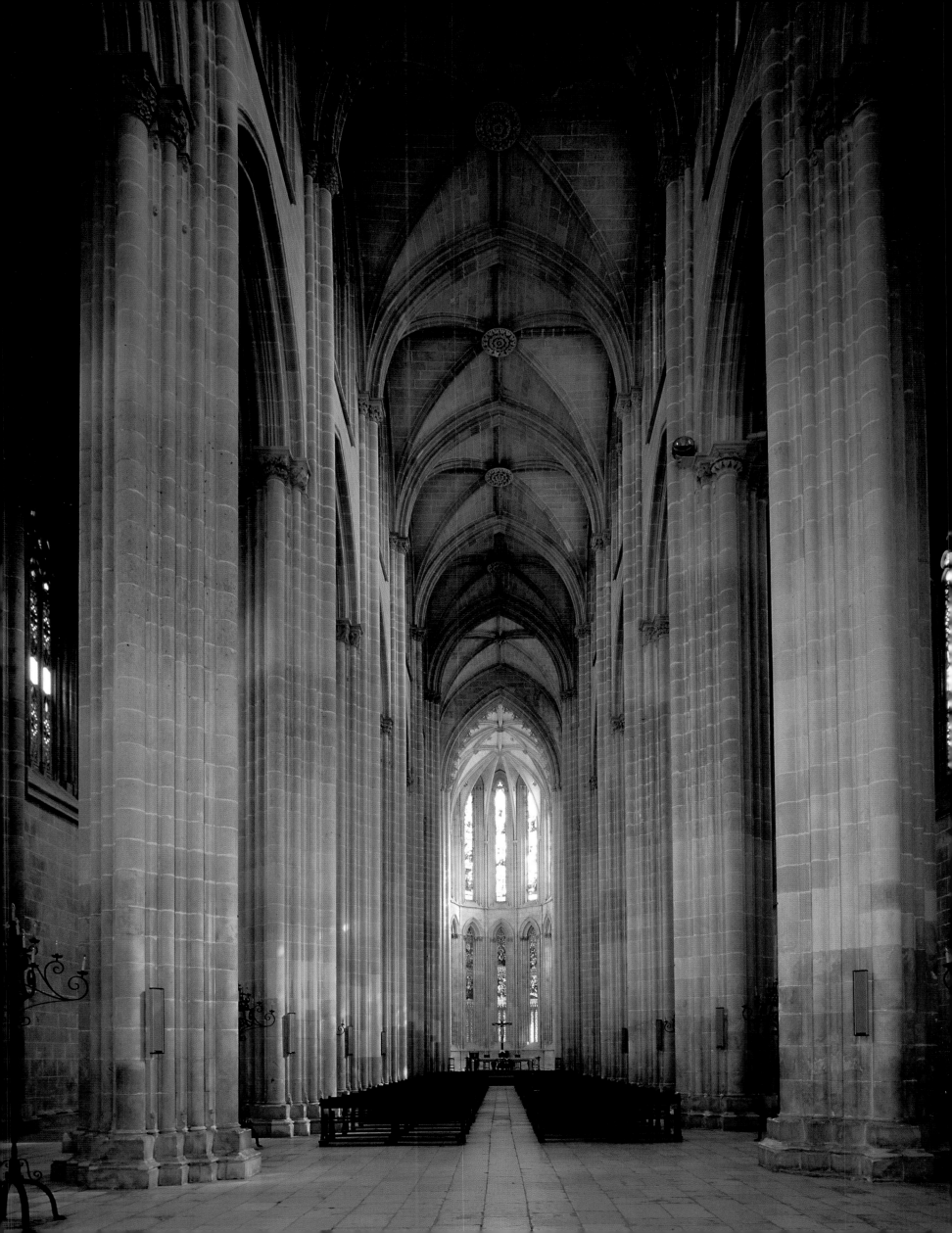

Batalha (Portugal), Mosteiro de Santa Maria da Vitória, begun 1388, vault 15th century, interior view of the church; fountain house; exterior

King João I had sworn to build a monastery after his victory over the Castilians in 1385. The Dominican convent also served as the burial site of the kings, and was thus a figurehead of the royal family. The large complex remained under construction until the 16th century.

The church transposes a type well known in the architecture of the mendicant orders into larger dimensions, as well as into new means of expression. The two-story, steeply proportioned fountain house is located at the head of the choir; its elegant and yet understated effect could hardly be further enhanced.

On the exterior, on the other hand, complicated tracery forms, the elaborate balustrades that crown the entire roofline, and pinnacles reaching upward like lancets determine the overall impression. The west facade is graced with a glorious portal.

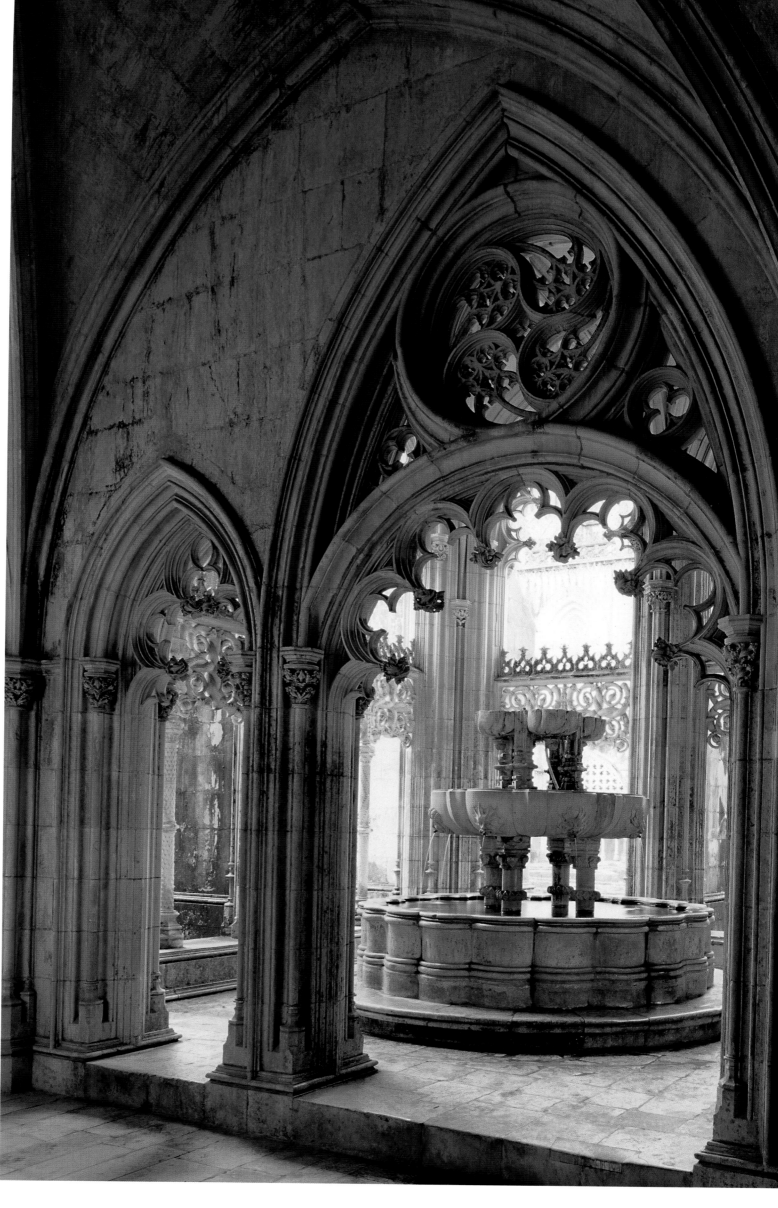

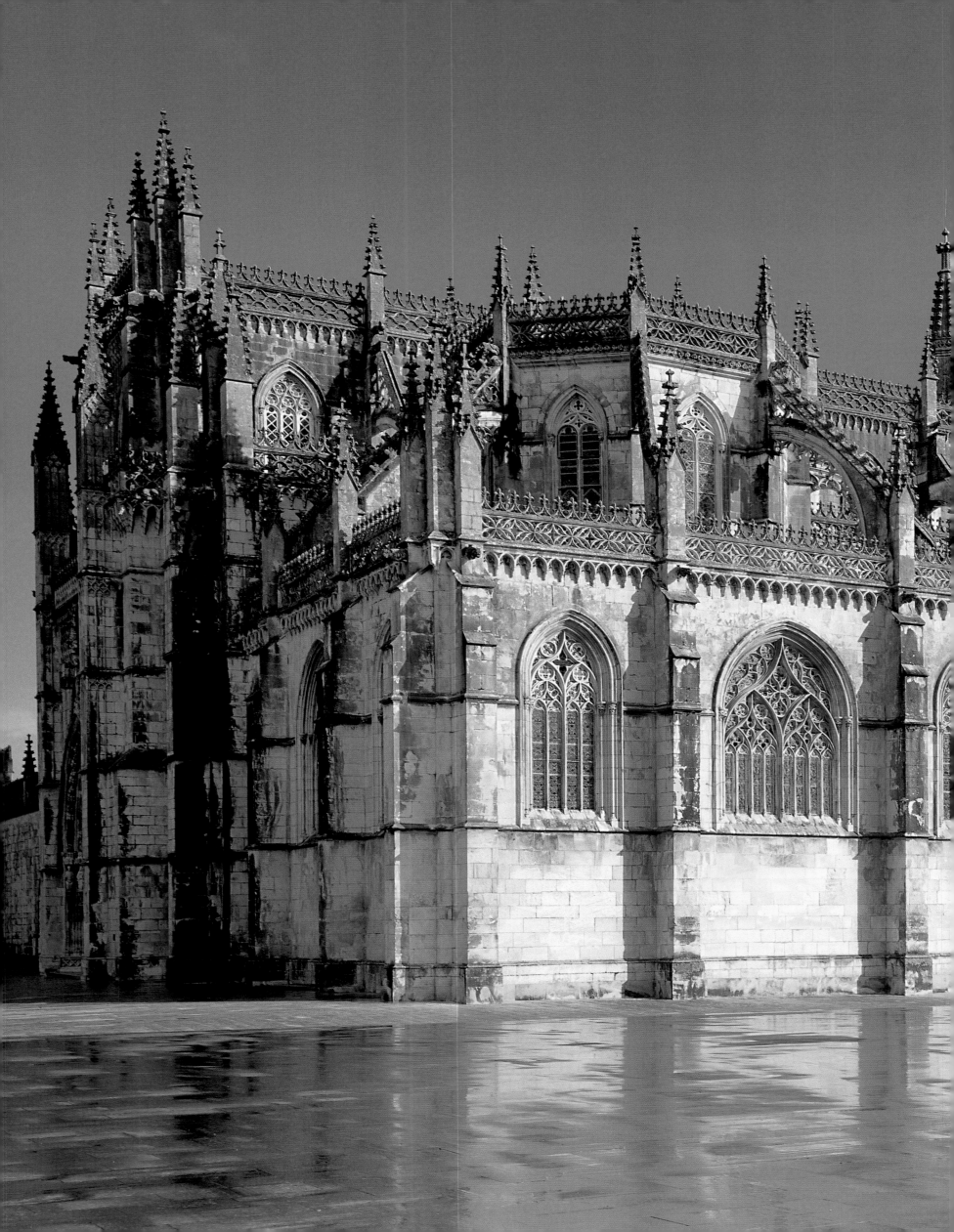

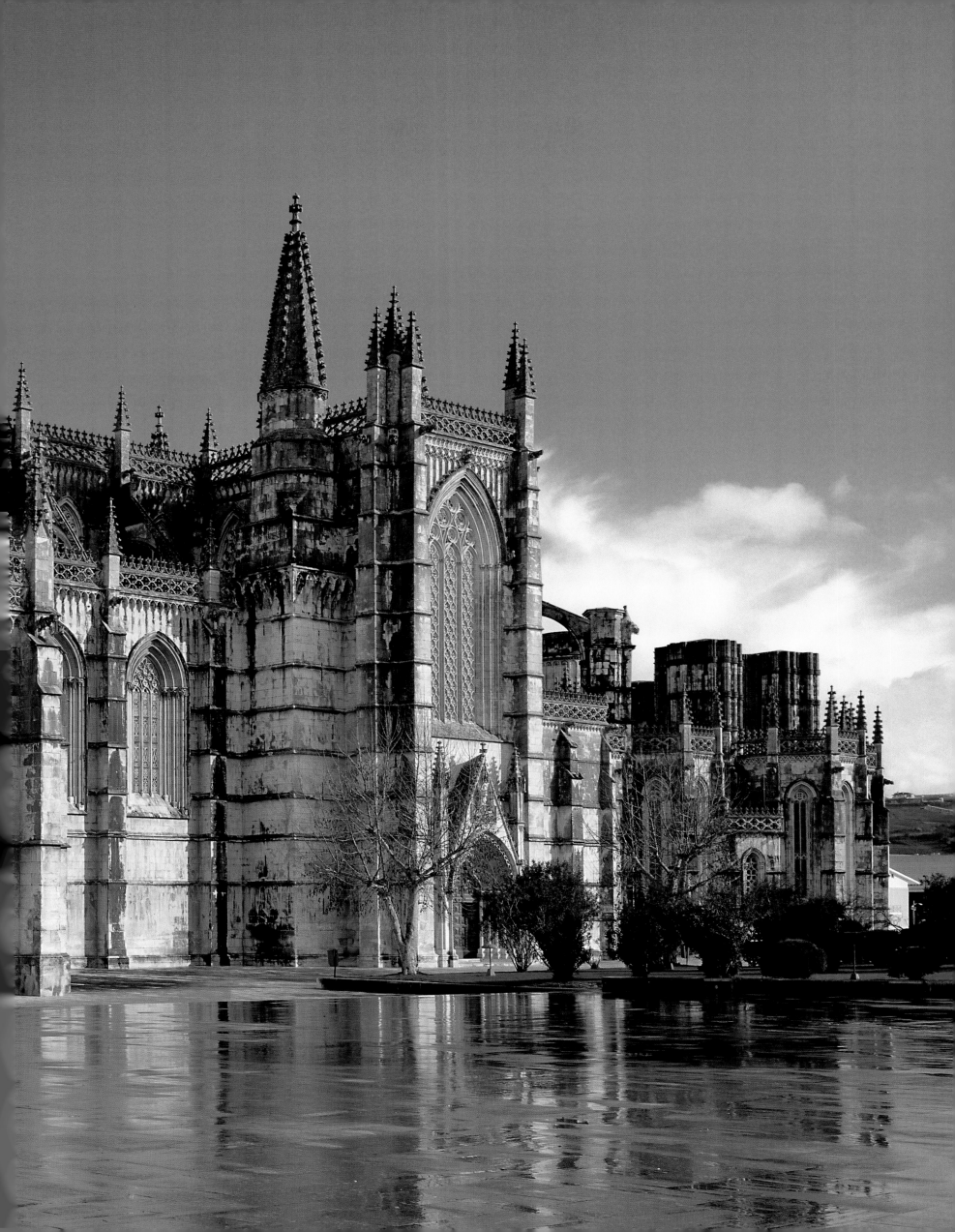

Secular Architecture between 1000 and 1500

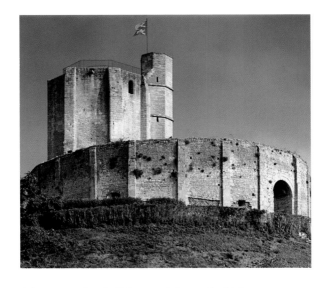

Gisors, castle: shell keep of the early 12th c., donjon ca. 1170

The farther back in time we go into the Middle Ages, the fewer secular monuments are preserved. For the late Middle Ages, in contrast, the examples are as numerous as the sacred buildings. In theory it would only be fair to cover them equally extensively, but doing so would exceed the scope of this book. The following pages are meant to provide at least a comprehensive overview of the intentions, types, forms and motifs, materials, and patrons that were operative regionally and internationally.

Secular architecture can be categorized in two groups. One is urban: residential and representative quarters in cities—among them houses, contors, and outbuildings such as storerooms and mews; residential towers, palaces, town halls and university buildings; city gates and walls, hospitals, armories, and mints. The second group includes architecture outside the cities, such as palatinates, castles, donjons, and palaces. Also belonging to this group are purely functional structures such as bridges, ports, wharfs, etc. These were commissioned by the nobility, clerics, and citizens as well as communes, co-operatives such as guilds, and other organizations.

Among the oldest preserved secular buildings is certainly the donjon of Langeais, built by Foulques Nerra toward the end of the tenth century, a rectangular tower with slim buttresses. This donjon constituted a major improvement over the motte, the traditional fortified living quarters. A motte is an artificial or natural elevation or a rocky protrusion set apart by ditches with a dwelling house made of wood, clay, or stones. Often a moat surrounded the area, which might be additionally protected by palisades and/or earthen walls. The motte was probably seen early on as a symbol of dominion. The Bayeux Tapestry (illus. below) shows the mottes of Hastings, Dol, Dinan, Rennes, and Bayeux; others have been excavated. In England there are well-documented mottes from the late eleventh and early twelfth centuries, which evidently were crowned by wooden towers. The oldest preserved stone tower is the aforementioned donjon of Langeais. This new building type proved to be exceptionally successful; it spread quickly and was combined with the motte. In England it was called a keep, in Germany a *berg-*

fried, and it was at first erected over the highest point of the complex. Starting in the late eleventh century, so-called shell keeps appeared, fortified ring walls that enclose the entire elevated area. The shell keep of Gisors, which was built in the early twelfth century (illus. right), is well preserved. Around 1170 Henry II Plantagenet had an octagonal donjon erected inside it that spectacularly crowns the concentric wall rings. Another octagonal donjon from the early twelfth century that possesses a highly complex defense system can be seen in Provins (illus. opposite). The forms of the floor plans now began to vary: round with apses in Houdan (illus. right), quatrefoil in Étampes (1130/1150), and circular in Châteaudun (early twelfth century) and in Paris/Louvre (around 1200). The existance of stone keeps since around 1070 has also been proven in England. The oldest are the rectangular tower of Chepstow and the only slightly more recent White Tower in London, an excellent example of the multiple uses of a donjon (illus. p. 256). The White Tower—a rectangular tower with a vaulted chapel—was a bulwark for the defense of London at its point of river access and a symbol of William the Conqueror's foreign rule. It served as stronghold, prison, royal palace, and treasury: in short, the seat of English royalty. As part of the construction of new city walls around Paris in 1190/1210, the Louvre was renovated to be one of the most modern fortresses, and also served to defend the city's river access. It, too, became a symbol for the power of the French king.

Over the course of the twelfth century, the English keeps take on more complex floor plans and basic forms, for example in Conisborough, where a round tower is crowned by slender angular turrets at regular intervals (illus. below right). The stone wall enclosure was built at the same time as the turrets. This was the beginning of castle construction. Castle types in Europe vary regionally. While the castles in Italy, France, and England established a uniform type by around 1200, the castles in German-speaking regions remained quite individual; the Staufen castles in Alsace and Swabia are impressive examples. They developed from purely functional structures in the twelfth century into complex compositions that

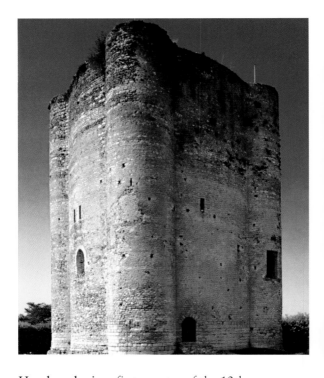

Houdan, donjon, first quarter of the 12th c.

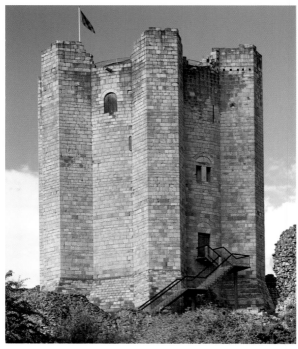

Conisborough, round donjon, reinforced with towers, 12th c.
OPPOSITE: **Provins, octagonal donjon,** early 12th c.

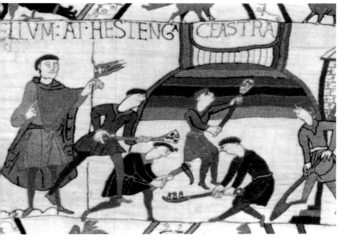

Building of the motte in Hastings, detail from the Bayeux Tapestry, between 1077 and 1082

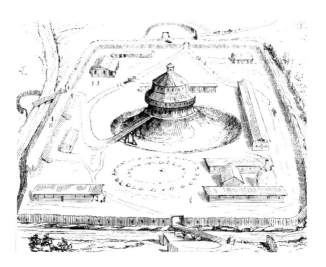

Motte "la Tusque" near Sainte-Eulalie-d'Ambarès, reconstruction according to Viollet le Duc

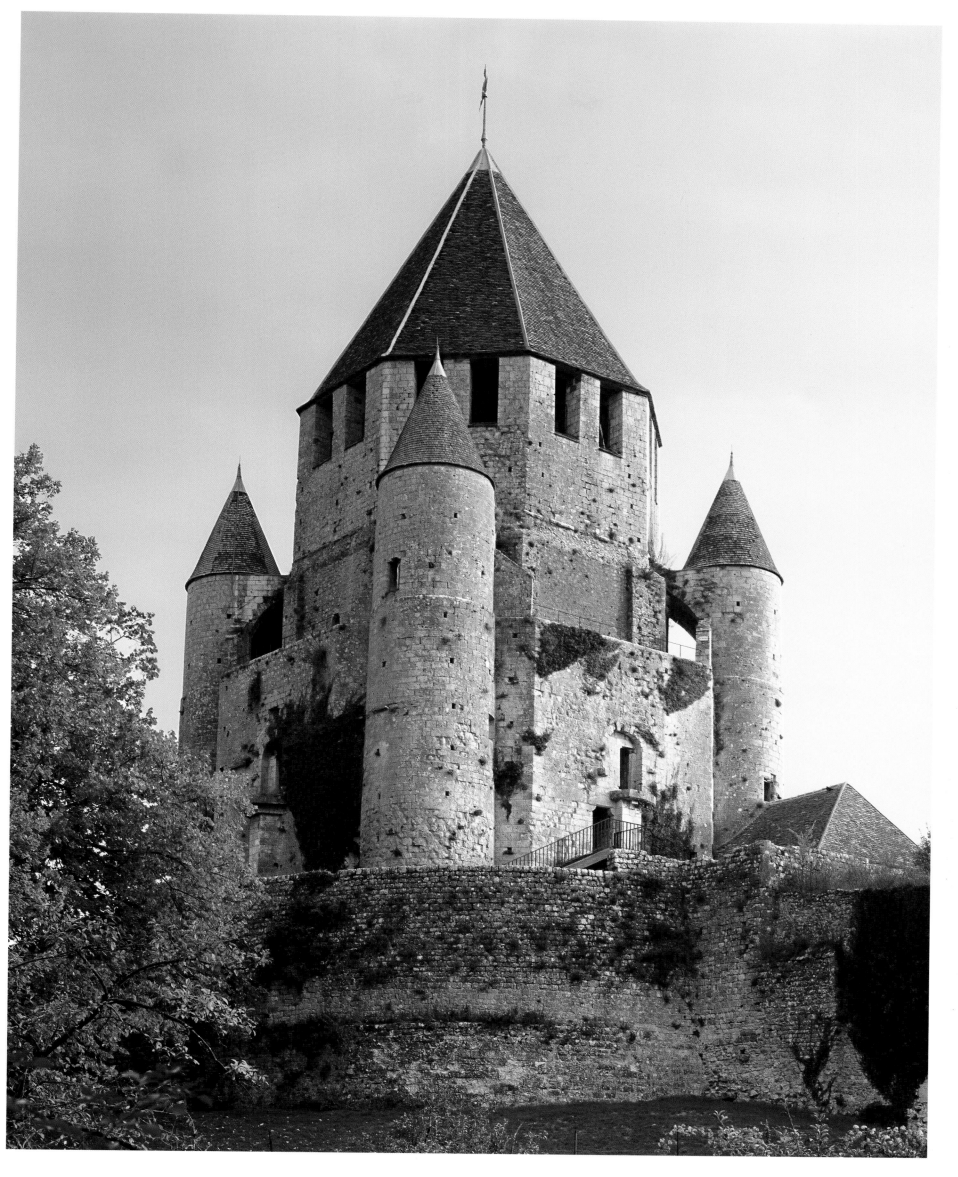

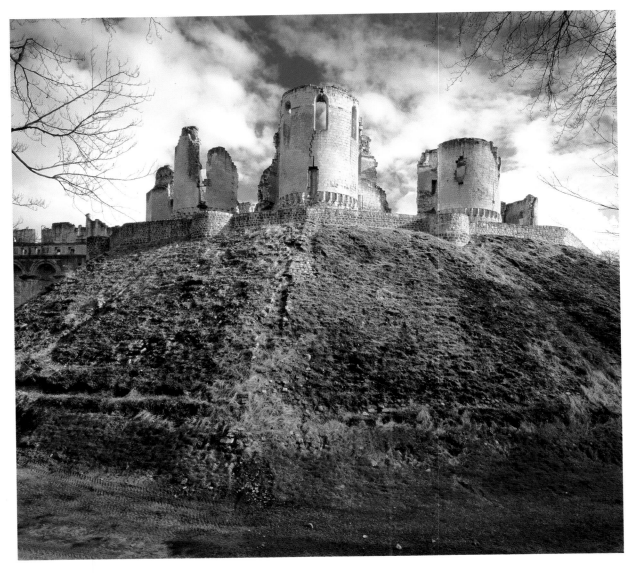

LEFT: **Fère-en-Tardenois, castle, ca. 1200**

LEFT CENTER: **Montségur, "Le Pog" (cliff) with castle, 1204**

BELOW: **Berzé-la-Châtel, castle, 12th/13th c. and 15th c.**

OPPOSITE TOP: **Druyes-les-Belles-Fontaines, castle, begun ca. 1200**

OPPOSITE BOTTOM: **Castel del Monte, begun ca. 1233**

that the motif of a gate flanked by towers became a particular symbol of authority. Almost all the castles of King Philippe Auguste include this feature. It appears that he also introduced the regular square floor plan in the construction of castles. This manifested itself from the beginning of the thirteenth century, when the nobility began to leave the inaccessible promontories and moved onto the plains. The earliest square castle in France built on flat ground is Philippe Auguste's Louvre. The corners were topped with round towers and a round donjon stood in the center surrounded by a wide moat. Competing with the Louvre, another square castle was erected on an extensive rocky plateau at Druyes-les-Belles-Fontaines, one with an impressive residential wing that has an entirely regular structure (illus. opposite top). In their succession the dukes of Burgundy, who belonged to a sideline of the royal family, covered their country with castles of this type that were located on plains. They may have been reserved for the high nobility. England also tended to adopt the regular structure in areas where castles were constructed on level ground: in Beaumaris Castle (1295), in Conwy (ca. 1280), in Rhuddlan (1277), in Flint (1277) and even in the high castle of Harlech (1283). Here, too, all the gates are framed by twin towers. Frederick II erected regular castles in southern Italy starting in the second quarter of the twelfth century. They are residences of strict mathematical regularity, each of which incorporates the beauty of the surrounding landscape into the architecture, including Castel Maniace in Syracuse (1230/1240), Ursino in Catania, and the famous Castel de Monte (illus. opposite bottom). Two additional, nearly regu-

by the French kings during their war against the kingdom of Aragon after the Cathar communities were brutally subjugated and their castles conquered between 1209 and 1244. Spectacularly located, they are erected on lofty, inaccessible rocky plateaus and served as refuge for the persecuted Cathars. The castle of Loarre in northern Spain (illus. p. 293) is also a representative of the early high castles. Beginning in the early thirteenth century, the walls and gates were equipped with flanking towers. It seems

united comfortable residential and representational buildings, all of which were protected by walls and towers, in impressive groups. In France, the prevailing feudal system led to the creation of a large number of elevated castles that consisted of a center with a donjon, dwellings, and outbuildings surrounded by concentric ring walls with pointed-arch gates. The castles of Châteauneuf-en-Auxois, Épinac, Montréal, Brancion, and Berzé-le-Châtel (illus. right) are well-preserved examples. Tragically famous are also the castles of the Cathars in southern France—Montségur (illus. above), Fenouillèdes, Peyrepertuse (illus. p. 263), Quéribus, Puylaurens, and Aguilar. The last five are the so-called *cinq fils de Carcassonne* ("five sons of Carcassonne"), which were renovated

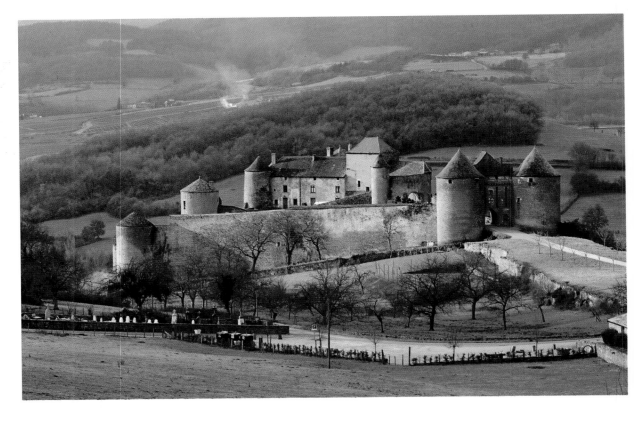

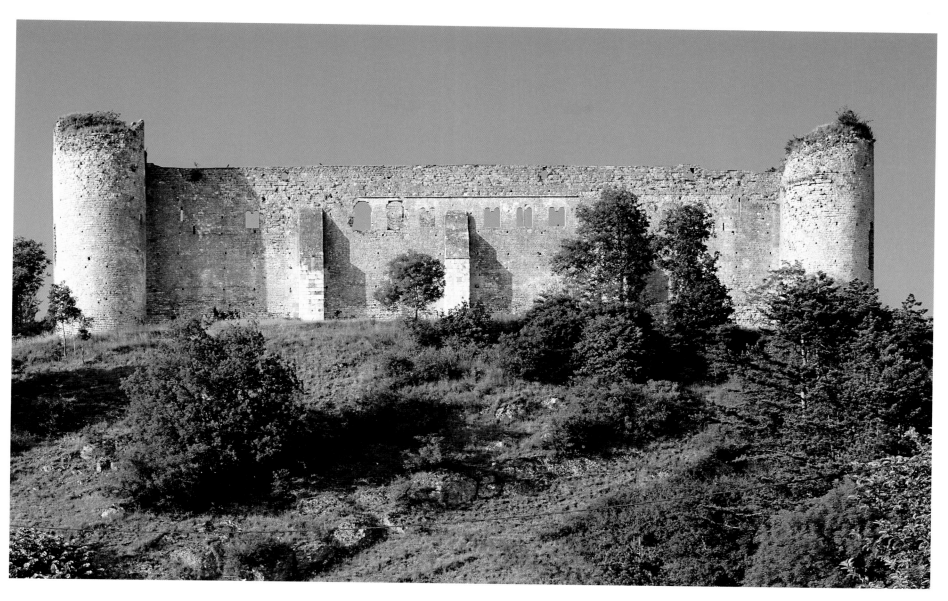

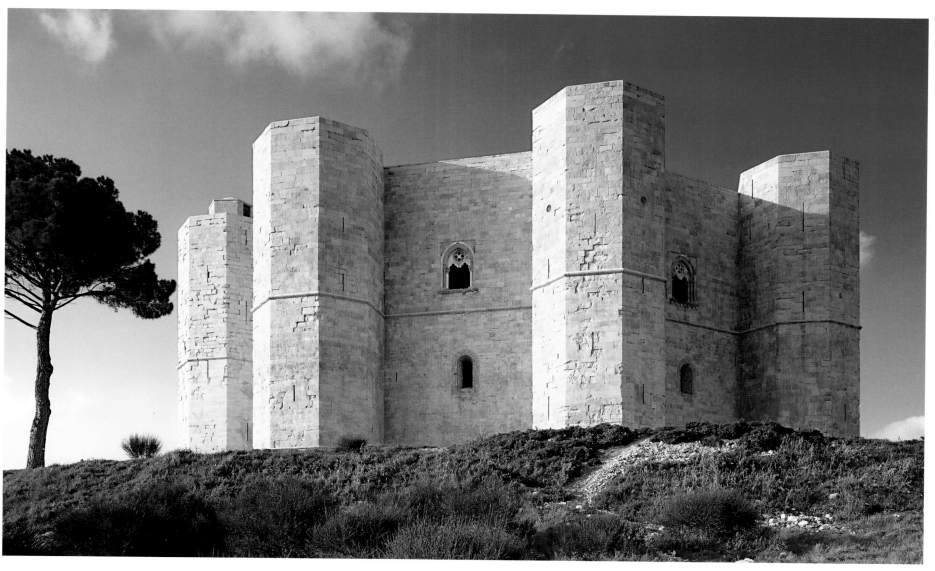

RIGHT: **London, White Tower**, from ca. 1078, fortress, palace, and seat of the government of William the Conqueror

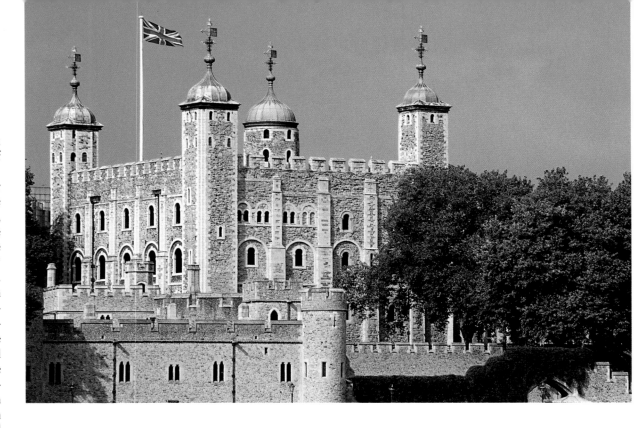

lar complexes are the fortresses of the Scaligers in Sirmione (late thirteenth century) and the castle of Fenis, built around 1340 (illus. p. 284).

Few twelfth- and thirteenth-century urban secular monuments remain. That is because at the time the cities possessed only very few stone buildings; indeed, they were places of continual change, both deliberate and unintentional. Nonetheless, a few dwellings have been preserved, for example the "Baumburg Tower" in Regensburg, a seven-story residential tower (illus. below right). Several two-story stone houses from the thirteenth century in Beaune, Vitteaux, and Saint-Julien-du-Sault with biforia or whole window galleries are also worthy of note. Apart from that, some representative palaces of bishops and abbots are still preserved—in Auxerre, Cluny, and Sens—whose arcaded facades illustrate their rank. No less representative are the city dwellings of the nobility, such as the city house of the Granolhets in Saint-Antonin (illus. opposite below left). Two early communal palaces in Italy are the Palazzo del Commune in Viterbo (begun 1281) and the Palazzo della Ragione in Milan, from the first half of the thirteenth century (illus. below), both wide rectangular complexes with an arcaded facade on the ground floor, lancet windows underneath stepped blind arches in the upper floor that simulate open galleries, and a crown of pinnacles (a more recent addition in Milan).

The first planned cities were built in France under Louis VII and Louis IX. One of them is Villeneuve-sur-Yonne, a walled-in rectangle with an isolated, round, rib-vaulted donjon. Another is Aigues-Mortes, also with a rectangular layout, walls fortified with towers and gates, and a rectangular grid of streets. It was from here that the French army set out on its crusades. Carcassonne is also a project of Saint Louis (illus. pp. 264/265). The pre-Roman Carcasso had been founded by the Tectosages and then taken over by the Romans. Over the centuries it changed hands from the Visigoths to the Arabs, back to the Franks, and finally to the counts of Barcelona and to Simon de Montfort, who turned it into a Cathar stronghold. In 1226 it fell to Louis IX, who in three stages (1228/1239, 1240 onward, and 1280/1287) erected a fortress covering 1,970 x 820 feet (600 x 250 meters) with two circular walls, gates, and a rectangular citadel.

With few exceptions, late medieval defense works superseded the city walls of the twelfth and thirteenth centuries, because the fourteenth and fifteenth

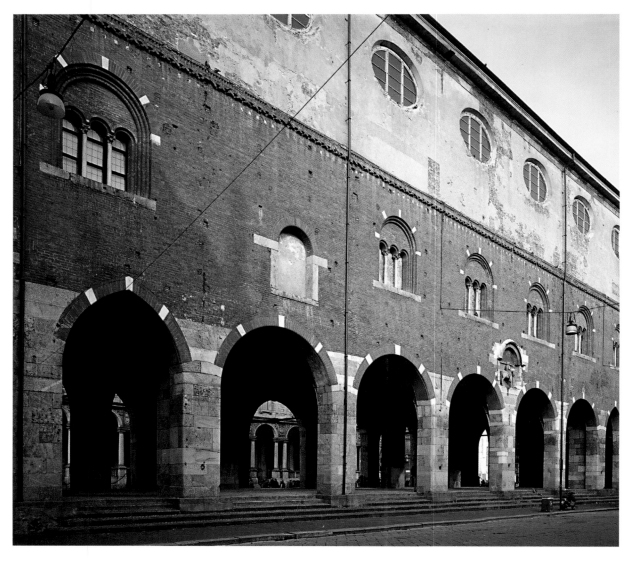

Milan, Palazzo della Ragione,
first half of the 13th c.

BOTTOM RIGHT: **Regensburg, "Baumburger Tower,"** residential tower, third quarter of the 13th c.

Mâcon, Maison du Bois (house of wood), early 16th c.

centuries were a period of major development for the cities. The towns had evolved from Roman forts, palatinates (illus. p. 274), kings' courts, castles, and bishops' seats or from market and trade locations. They often consisted of one main road and cross streets running perpendicular to it (as in Lübeck) or—as in Freiburg, Rottweil, and Villingen—of a crossroads. Cologne has basically preserved the rectangular grid of the Roman city in spite of later fundamental changes. Without exception, the cities were surrounded by walls that incorporated battlement parapets, towers, and especially, representative gates. Preserved examples include gates in Lübeck, Stendal, Neubrandenburg, the Osthoven Tor in Soest, the Rheintorturm and Schnetztor in Constance, the gates in Freiburg, the city gates in Flavigny-sur-Ozerain, Semur-en-Auxois, and many others.

In proportion to their gains in wealth and self-assurance, the bourgeoisie began to compete with the nobility and the clergy over the development of the cities. The Barri Gòtic in Barcelona is one of the few largely preserved city ensembles from the late Middle Ages. The cathedral and the king's and bishop's palaces can be found here in close proximity. Only a little later the seat of the government (illus. pp. 298/299), the city hall, buildings of the trade guilds and the stock market, hospitals, and palaces of the nobility came into existence. Here the medieval wharf complexes from the fourteenth century have also been preserved, eight parallel covered halls that replaced the older fortified squares that had been erected toward the end of the thirteenth century

by royal commission. The view of the city of San Gimignano in Tuscany is to this day characterized by its 72 residential towers, called "dynasty towers," which date from the first half of the thirteenth century and are as high as 167 feet (51 meters; illus. p. 287). Not until 1251, when a decree of the city of Florence limited the height to 85 feet (26 meters), was this development stopped. Residential towers are also known to have existed in northern cities, in France and in the German-speaking regions.

In the late Middle Ages, the town palaces of wealthy citizens defined the cityscape. They are preserved in Tuscany and Venice, in Dutch and Belgian cities, and along the Baltic Sea. Paris, which from the beginning of the rule of Charles V profited from the competition between the four Valois princes, sported a large number of *palais*, whose splendor and luxury are only known from historical records. An almost completely preserved example of such a city palace is the Maison Jacques Cœur in Bourges, erected around 1450 as a courtyard complex with several wings and richly decorated facades (illus. p. 270).

The pope's palace in Avignon is a defensive installation and one of the largest buildings of its time (illus. p. 268/269). Pope Benedict XII (1334–1342) tore down the palace of his predecessor John XXII and replaced it with an irregular complex of four wings, which Clement VI in turn enlarged with two more wings and a courtyard. The appearance of the papal palace is not at all typical for its time. It can only be explained by the situation of the pope and curia living far from Rome, a phenomenon as uncommon as the architecture of their residence.

In addition to the stone houses, half-timber and completely wood houses are preserved, particularly in the north, some of which attained considerable size (Strasbourg and Mâcon). Many cities still boast entire street sides (Strasbourg, Angers, Chester, and others). Regionally, there are completely brick buildings or combinations of brick and timber framing.

Beginning in the early fourteenth century, the rapidly growing population and increasing trade and production called for a more differentiated and extensive urban organization as well as a greater need for representation. The city hall, until then a purely

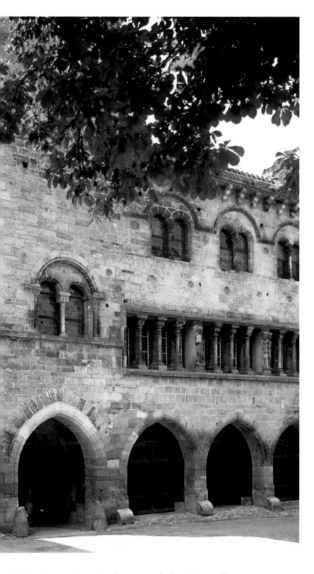

Saint-Antonin, city house of the Granolhets, second quarter of the 12th c., street facade

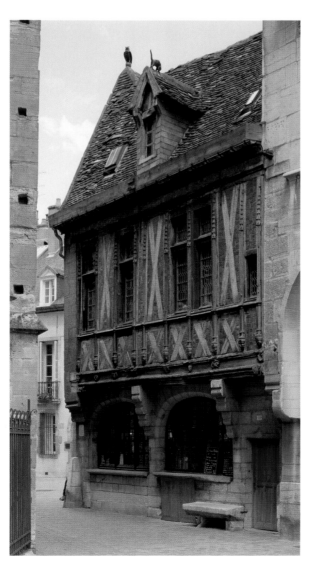

Dijon, Maison Millière, facade, 1483

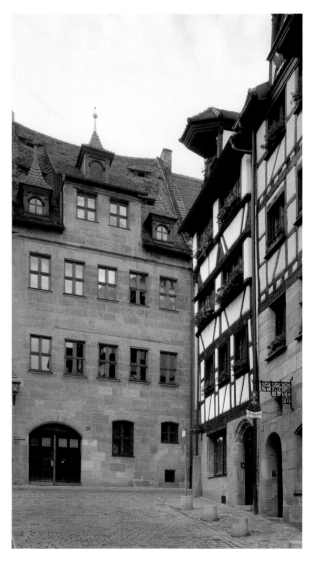

Nuremberg, house at Obere Krämergasse 12 (left building), 1398

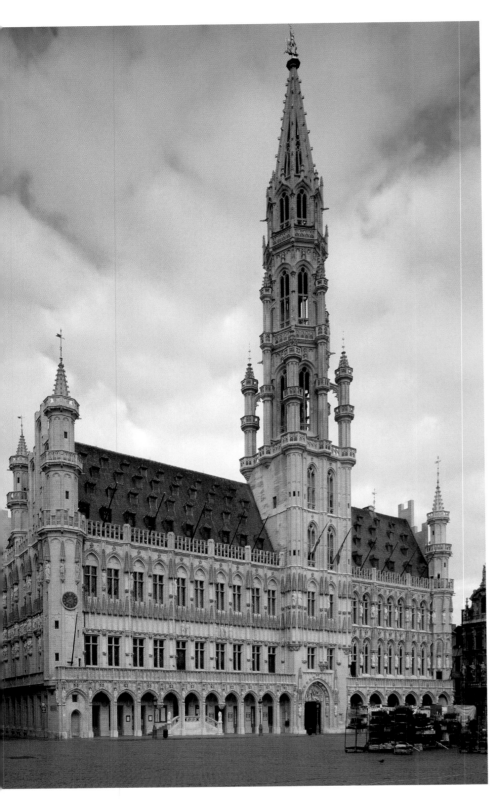

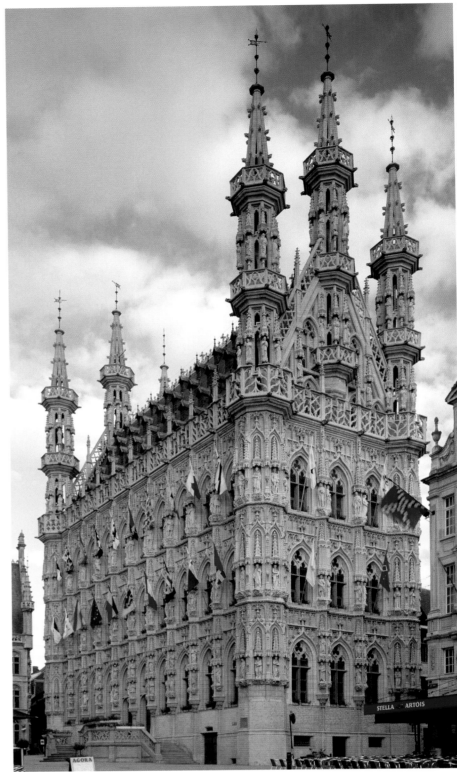

Brussels, city hall, begun 1402

Leeuven, city hall, 1448–1463

functional building, turned into a competitor of feudal and sacred structures, and its architecture incorporated motifs and status symbols from both types of buildings. Some especially impressive examples in Italy are the Palazzo Pubblico in Siena (illus. pp. 288/289), the Doges' Palace in Venice (illus. pp. 290/291) and the Palazzo Vecchio in Florence (illus. p. 286), each of which is combined with public squares that are jewels of city planning. Further north are the city halls of Brussels (illus. above left), Leeuven (illus. above right), and Arras (1450–1572) as well as the town halls in the proud cities of the Hanseatic league: Lübeck (ca. 1200–1442), Tangermünde (illus. p. 282), Stralsund (illus. p. 283), Hannover (from 1428), and Lüneburg (from ca. 1330), all with magnificent facades that emphatically demonstrate the political stance of the citizenry. By comparison, the city halls of Esslingen, a half-timber house from 1430, and Nördlingen (from the fourteenth century) seem rather humble. The fact that

substantial and magnificent city halls—many of them with a tower—were often erected directly adjacent to the bishops' churches clearly illustrates the competition that thrived. In addition, commerce required large halls, for example the cloth halls in Brussels (last third of the thirteenth century–1486) and the Gürzenich in Cologne (begun 1437).

Almost every medieval city had a hospital where not only the sick, but also the old, were cared for. They were founded either by patrons, rich citizens or nobles who wanted to ensure their salvation, or under the auspices of a mendicant monastery. In general, the hospitals were conceived as four-wing complexes around an inner courtyard. They consist of a huge hall for the sick, a chapel, a pharmacy, a kitchen and other functional rooms, as well as housing for the nuns who cared for the sick. Preserved are the hospitals in Tonnerre (illus. p. 272), Beaune (with an exceptionally rich endowment; illus. pp. 272/373), Chalon-sur-Saône, Mâcon, Barcelona, Lübeck and

many other places, some of which served their original purpose into the nineteenth century.

Education and formation were almost a monopoly of the church starting in the early Middle Ages. Monastery schools taught the fundamentals, while the cathedral schools trained the elite. These schools reached their peak in the twelfth century. The first universities were founded as far back as the twelfth century simultaneously in Bologna, Paris, and Oxford through the merging of free schools and student bodies. They were organized according to the model of city collectives, free from the estate system as autonomous bodies with their own statutes and privileges. Additional universities were founded in the thirteenth century, mainly in the cities of the Iberian Peninsula and in Italy: Palencia (1212/1214), Salamanca (1230/1243), Valladolid (1250), Seville (1254), Vicenza (1204), Arezzo (1215), Naples (1224), Vercelli (1228), Siena (1246), Piacenza (1248), Padua (1292); and in Toulouse (1229) and Montpellier (1289) in France.

In the fourteenth and especially the fifteenth centuries they also spread in the north. Cities profited from universities in many ways, and allocated them space. Interested monasteries did the same. Colleges are the first specific construction type of university buildings. At first without a specific shape, they came into existence as residential schools for poor students and were organized according to the model of the monasteries. A limited number of scholarship holders lived in a close community, supervised by a rector and deans. Slowly the colleges evolved into major teaching institutions with a growing influence on teaching as such. The Collegio di Spagna in Bologna (1364–1369) is considered the role model of the fully developed university. In Oxford and Cambridge, the colleges soon determined the character of the cityscape. New College in Oxford (1386) became the prototype for numerous small and large complexes. In general they also consisted of buildings with four wings around an inner courtyard. The chapel was an indispensable feature of the colleges, along with the hall that served as a meeting and dining room. Occupying three wings were the gatekeeper's lodge, apartments for the rector and the deans, the archive and treasury, kitchen, administration, library, and the living quarters of the servitors, or students. The pride of each college was its gate tower.

Outside of the cities, most of the new complexes built in the late Middle Ages were regular castles that slowly evolved into palaces, or the renovation of older complexes as a sign of high aspirations. The regular, square, or rectangular complex with towers remained the most common construction form. At this time, comfort and convenience were becoming more important. A significant group in late medieval palace architecture is the buildings of the Valois princes, the sons of John II of France and their offspring. Apart from Charles V, who commissioned Raymond du Temple to turn Philippe Auguste's Louvre into a representative city palace and began the palace of Vincennes as a programatic complex, his brothers Jean de Berry, Philippe de Bourgogne, and Louis d'Anjou, who cultivated a lively exchange on questions of art and architecture, undertook their own projects. The famous *Book of Hours of the Duke of Berry* shows twelve complexes, some recog-

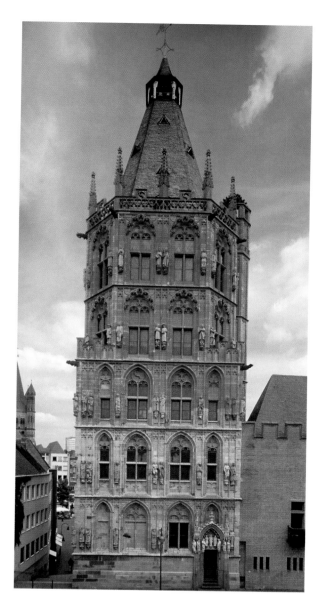

ABOVE: **Cologne, city hall tower**, 1407–1410

RIGHT: **Mellecey, Germolles palace**, begun 1380, former palace chapel (above); bedroom with late medieval painting: P stands for Philippe, M for Marguerite

BELOW: **La-Ferté-Milon, castle**, 1398–1407

nizable, among them the magnificent Mehun-sur-Yèvre, of which only ruins remain, the palace of Saumur, the Louvre, the palace of Poitiers, the donjon of Vincennes, and the Palais de la Cité. The existing edifices make clear how reliable the architectural depictions are. Indeed, the *Book of Hours* is an encyclopedia of different forms of secular architecture in the late Middle Ages. The buildings by the Duke of Burgundy are not shown, leading to the erroneous conclusion that there were none. Little remains of the extensive building projects of Philip the Hardy and his successors, except for parts of their residence in Dijon and the palace of Germolles in Mellecey (illus. above), a highly interesting complex with regard to cultural history. Germolles was the *villa rustica* of the Duchess Margaret, a kind of model farm, for the construction of which she hired the best architects and artists in France. This complex is also partially preserved, but late medieval paintings were uncovered in its interior only a few years ago that had previously only been known from astonishingly precise accounts. The nobility of Burgundy followed the duke's example and built country manors of two types: the castel and the donjon.

Representative palaces were also built by Louis d'Orléans, the younger son of King Charles V. La Ferté-Milon (illus. left), unfortunately unfinished, was one of his projects as was the Pierrefonds Palace, which was completed and (over-)restored by Eugène Viollet-le-Duc in the nineteenth century.

Apart from that, a plethora of small country manors have been preserved mainly in England, Germany, Holland, and France. Like the city dwellings, they were erected with materials typical for the region and adopted the ornamental motifs of sacred buildings.

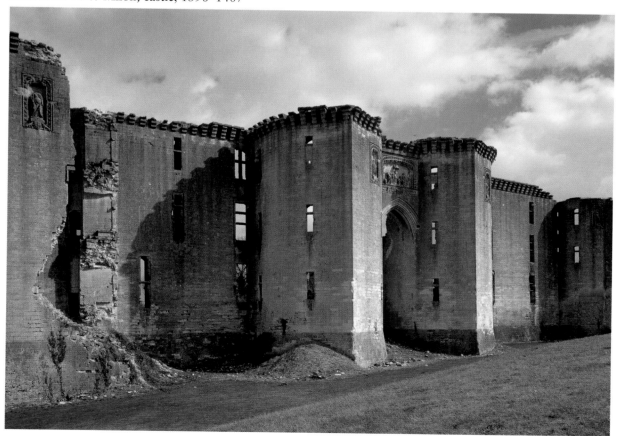

Forms in Secular Architecture

Nuremberg, castle

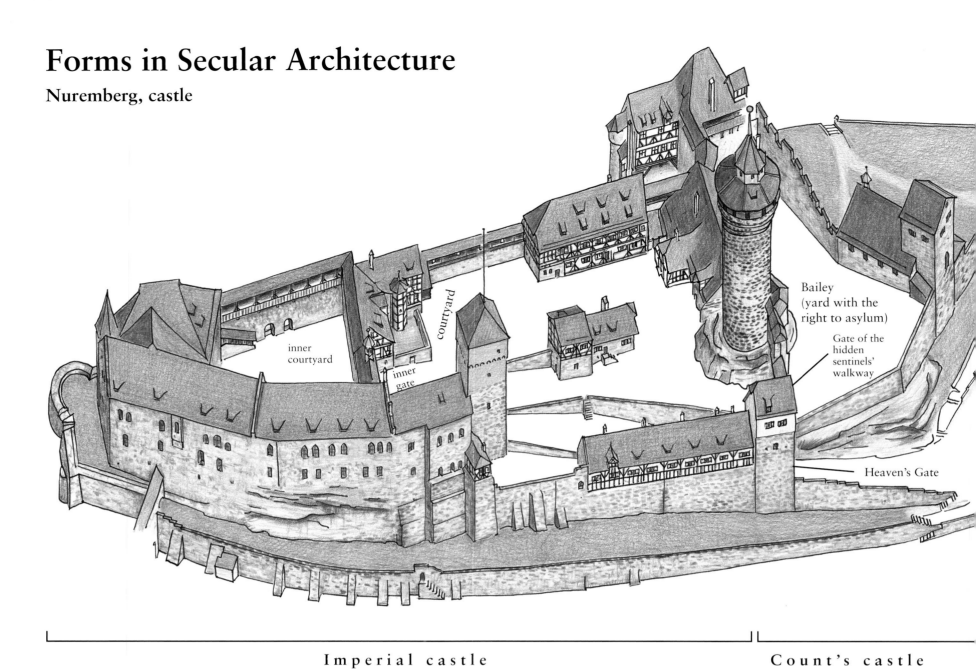

inner courtyard

inner gate

courtyard

Bailey (yard with the right to asylum)

Gate of the hidden sentinels' walkway

Heaven's Gate

Imperial castle

Count's castle

Half-timber house
(Esslingen, Plinsaustrasse 9, erected in 1286)

collar tie

cross brace

window

floor joist

strut

open ground floor

rafter

queen post

gable

brace

brace

corner post

bressumer

sill

joist ends

cellar

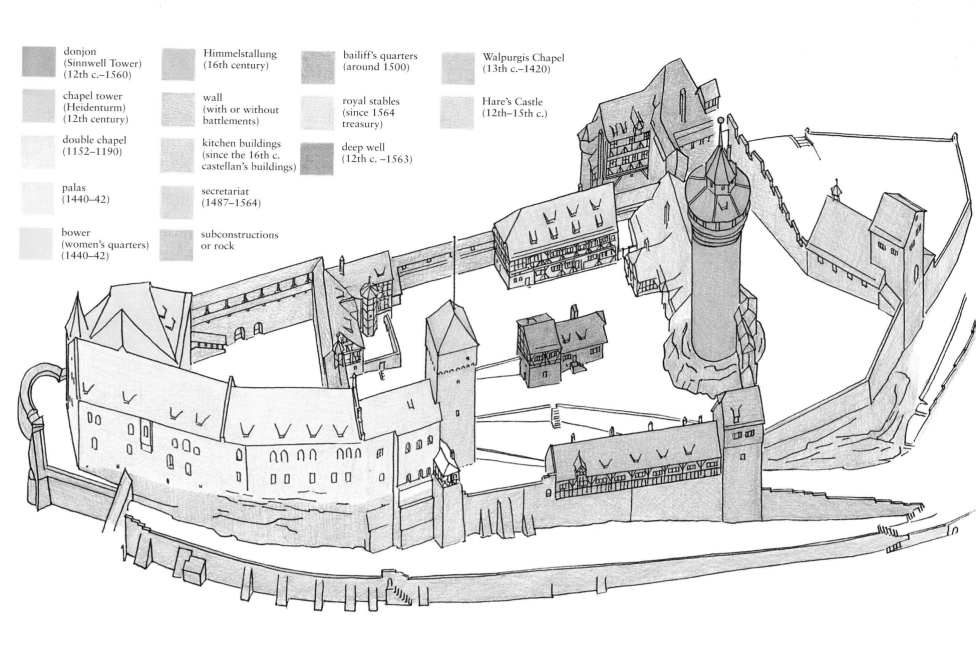

donjon
(Sinnwell Tower)
(12th c.–1560)

chapel tower
(Heidenturm)
(12th century)

double chapel
(1152–1190)

palas
(1440–42)

bower
(women's quarters)
(1440–42)

Himmelstallung
(16th century)

wall
(with or without
battlements)

kitchen buildings
(since the 16th c.
castellan's buildings)

secretariat
(1487–1564)

subconstructions
or rock

bailiff's quarters
(around 1500)

royal stables
(since 1564
treasury)

deep well
(12th c. –1563)

Walpurgis Chapel
(13th c.–1420)

Hare's Castle
(12th–15th c.)

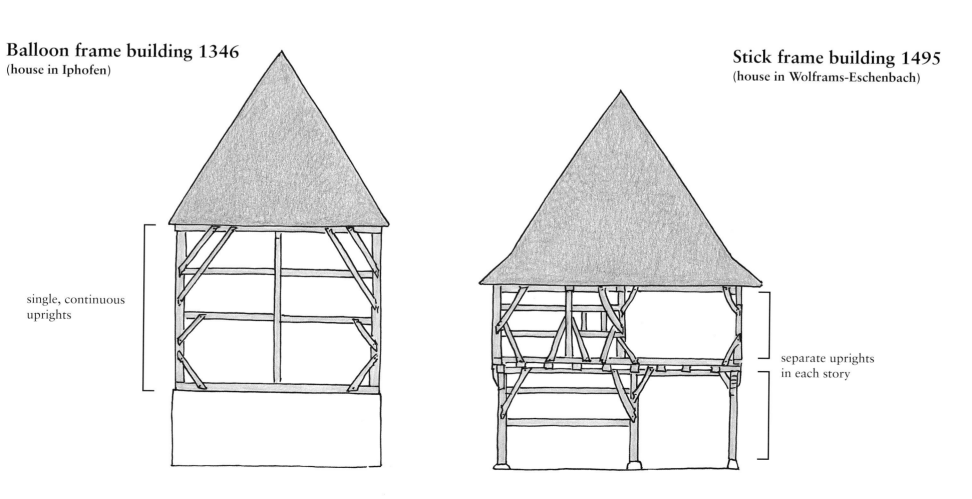

Balloon frame building 1346
(house in Iphofen)

single, continuous
uprights

Stick frame building 1495
(house in Wolframs-Eschenbach)

separate uprights
in each story

BELOW:
Lastours, castles, end of the 11th c., after 1230

The four neighboring castles of Lastours (Cabaret, Quertinheux, Tour Régine, and Fleur-Espine), which was originally named Châteaux de Cabaret, came into the possession of the French crown after the Albigensian Wars around 1230; they were then renovated.

OPPOSITE:
Peyrepertuse, castle, from 1239

Peyrepertuse is one of the "five sons of Carcassonne" that also fell to Louis IX, who expanded them as defensive positions against the kingdom of Aragon. As in Lastours, the structures (lower castle with chapel, staircase, and upper castle with its own defenses) are still quite easily recognizable.

PAGE 264/265:
Carcassonne, cité, 13th c.

This town, which has been continuously inhabited since the 1st century B.C., was turned into a castle for the king in three stages over the course of the 13th century. Eugène Viollet-le-Duc systematically added to it again and restored it starting in 1852 after the upper town had been used as a quarry in the early 19th century.

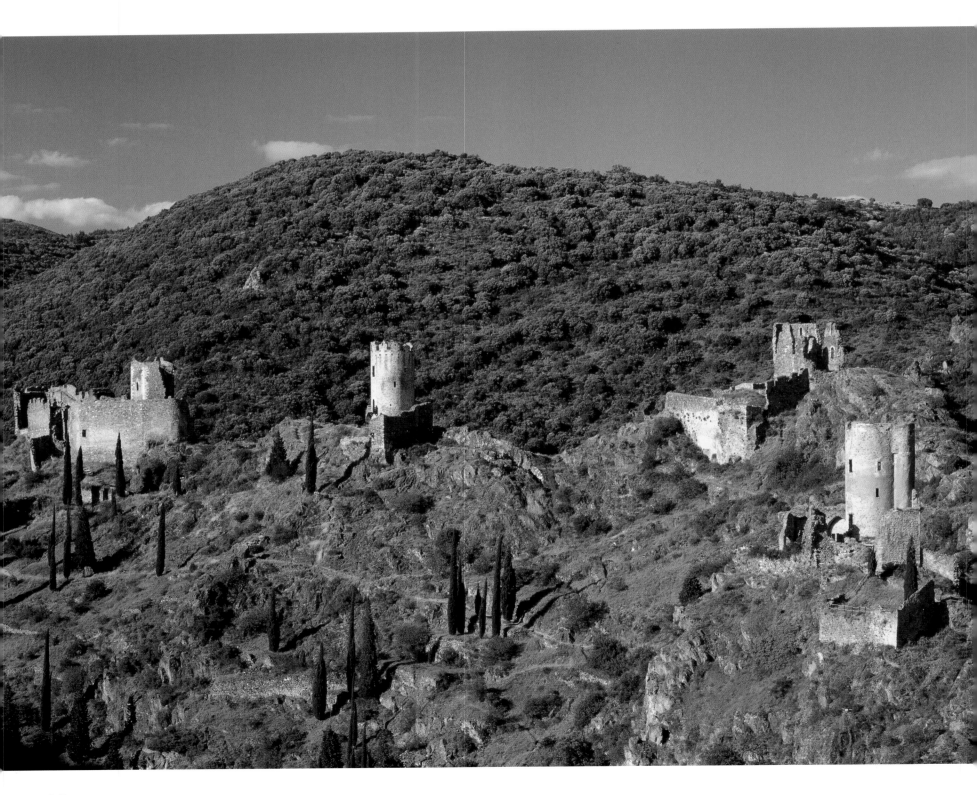

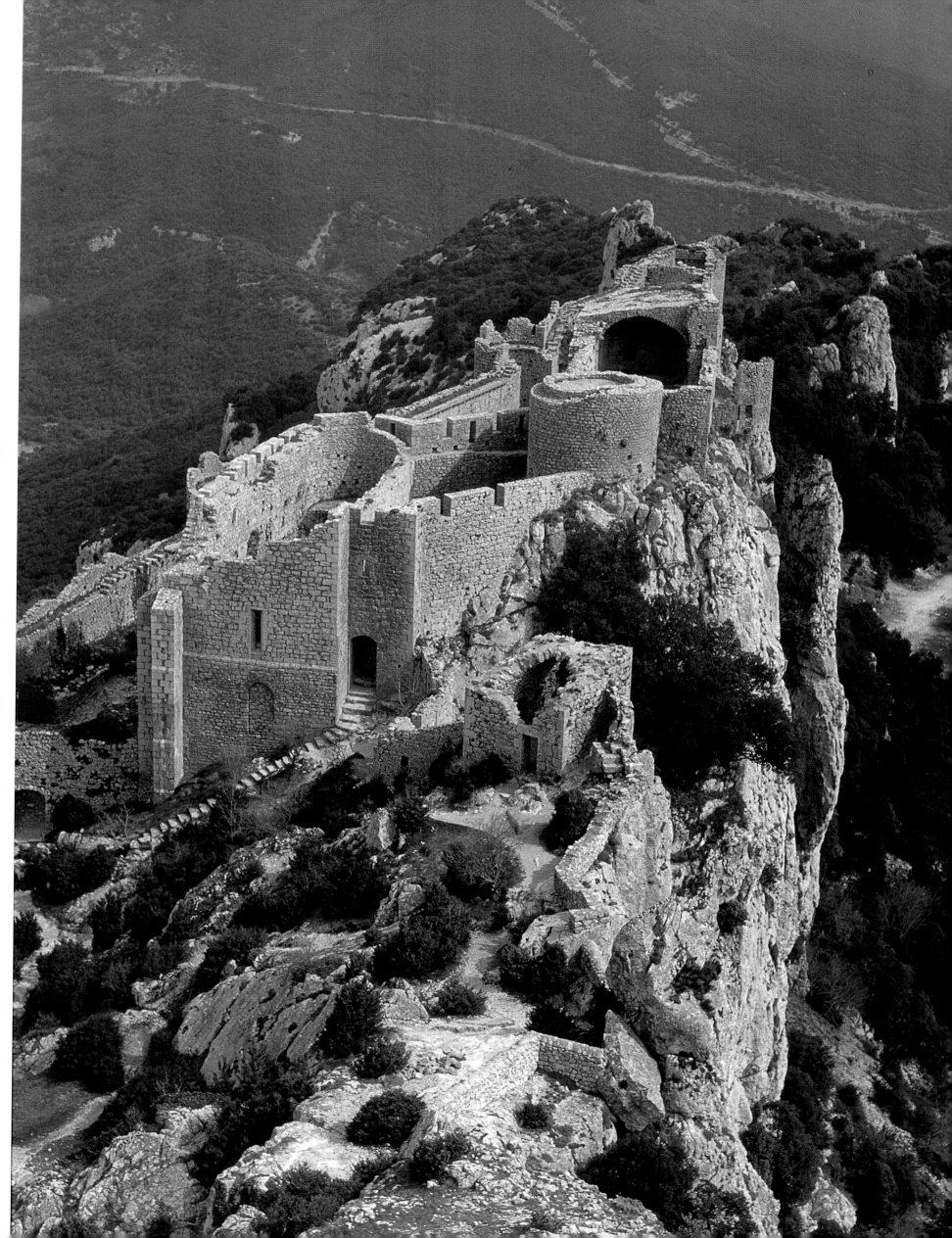

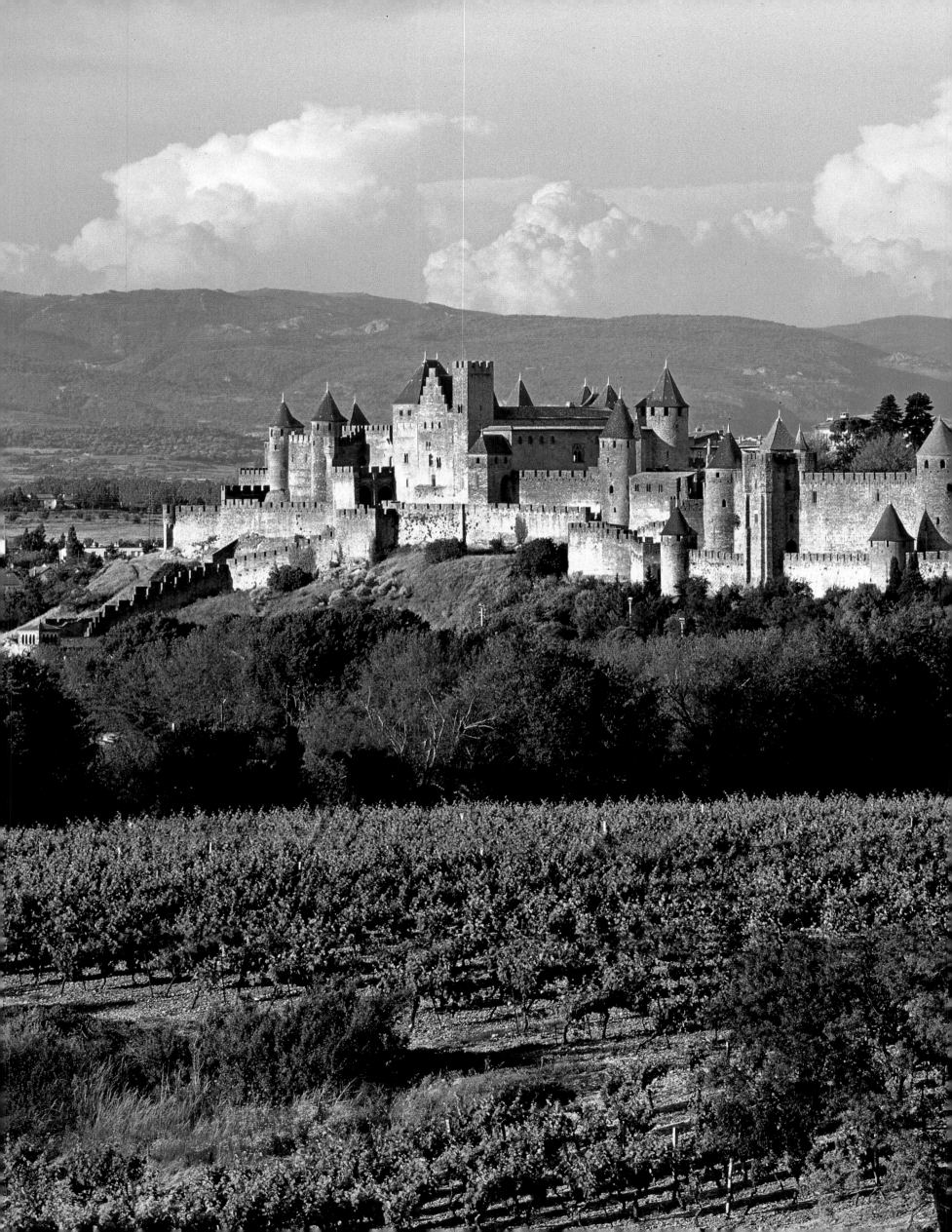

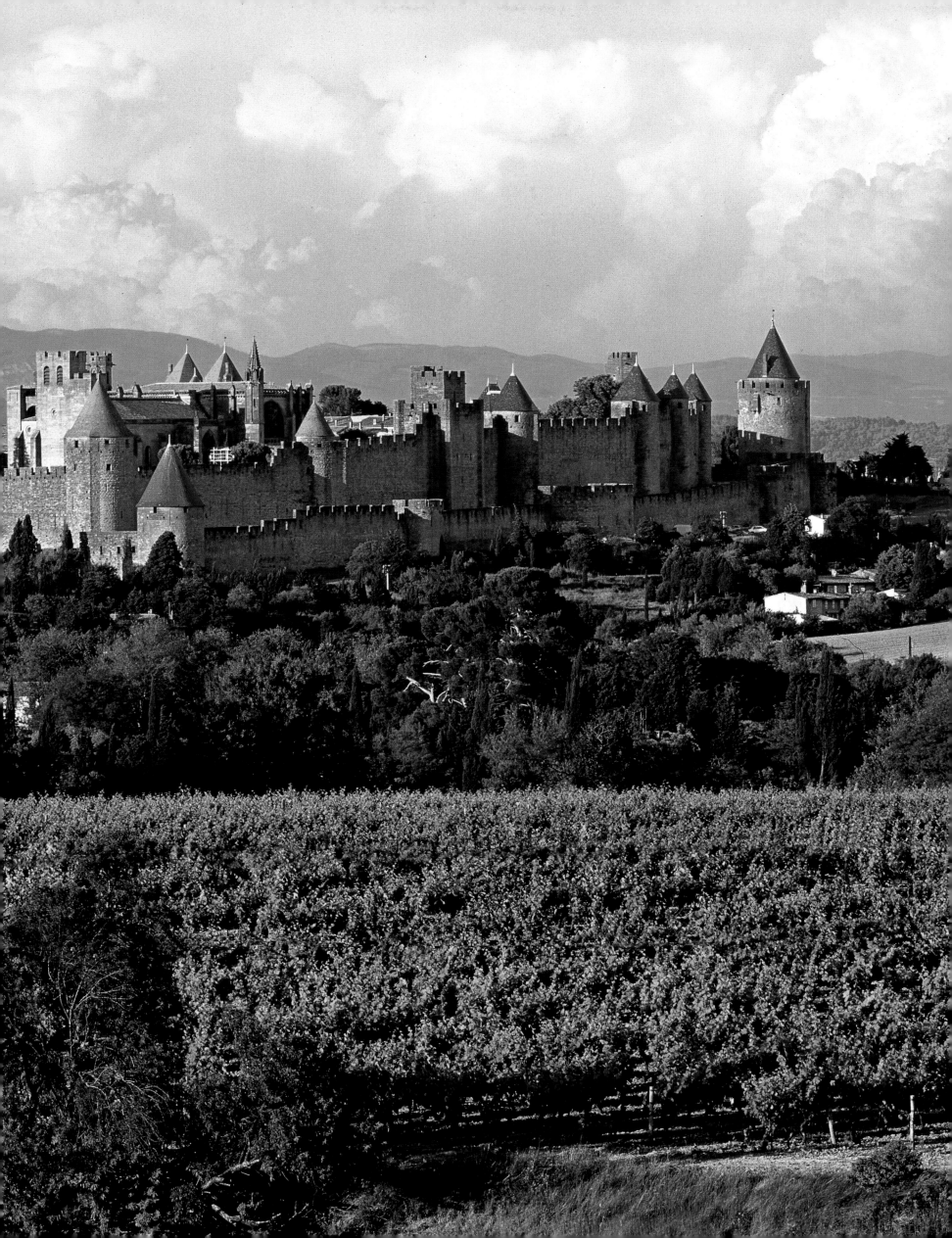

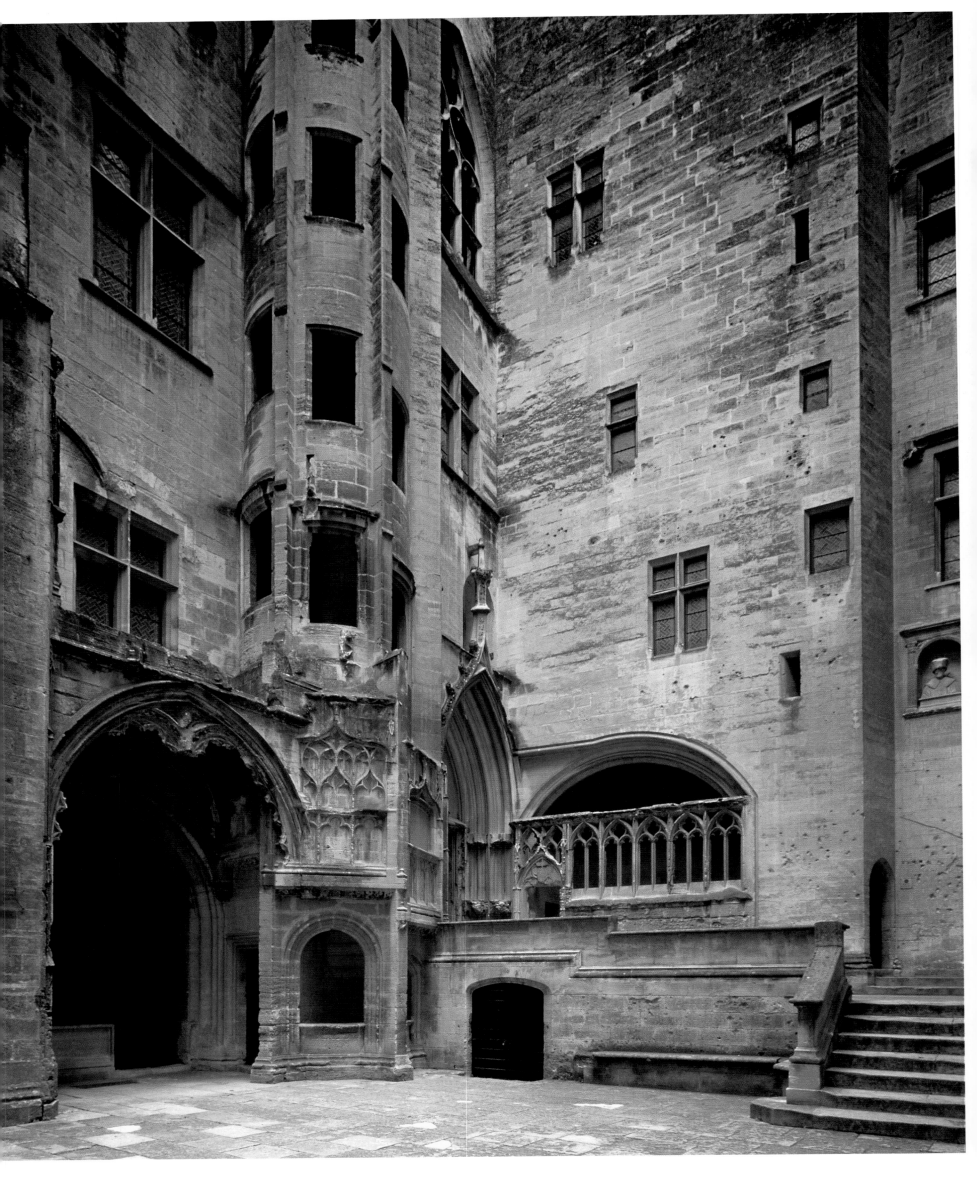

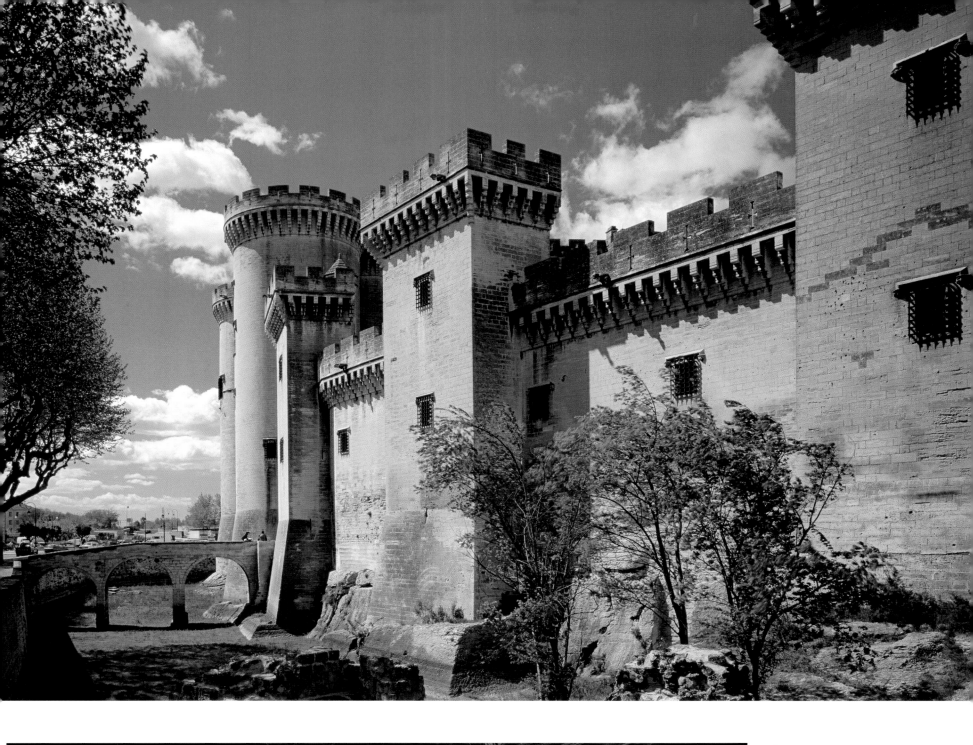

Tarascon, castle,
ca. 1400–1447/49

The Greek historian and geographer Strabo had already mentioned a settlement called Tarusco; from approximately 1040 there was a "castrum Tarascona." Louis II d'Anjou from the Valois family erected the castle around 1400 against the royal castle of Beaucaire, located opposite it. Jean Robert, Simon de Beaujeu, and Jacques Morel are known as its building masters.

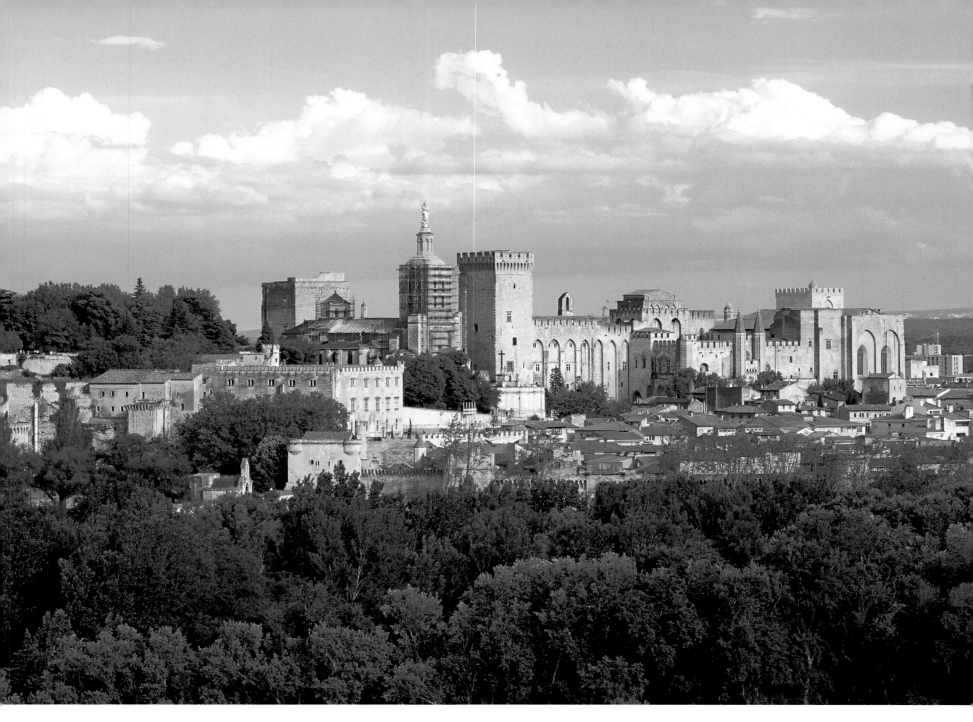

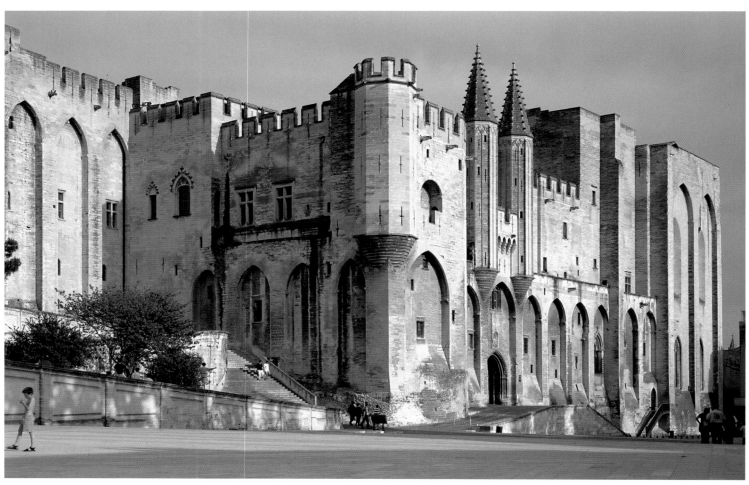

ABOVE, RIGHT, AND OPPOSITE:
Avignon, Palais des Papes,
14th c.

The extensive complex of
the papal palace towers like
a fortress over the old city
of Avignon. When in 1316
John XXII, the bishop of
Avignon, was elected pope,
he at first extended the
old bishop's palace. The
complex as it now stands
was created in several
stages under Popes Bene-
dict XII (1334–1342) and
Clement V (1342–1352).
The building masters were
Pierre Poisson from Mire-
poix for the northern sec-
tion and Jean de Louvres
for the southern section.

Matteo Giovanetti from
Viterbo was commissioned
with the interior decorations
in 1336. Frescoes have been
preserved in the chapels of
St John and St Martial, as
well as in the papal living
quarters.

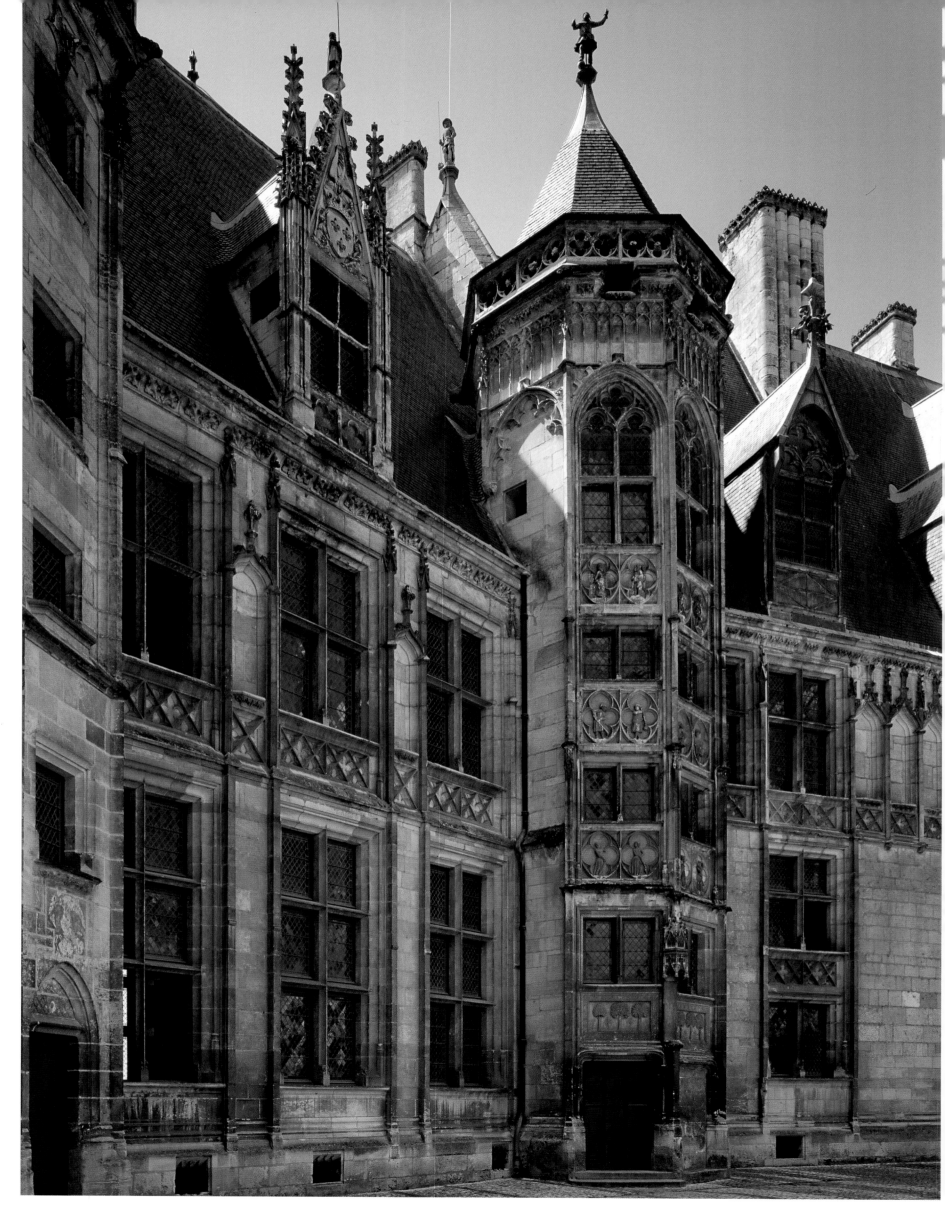

The merchant and banker Jacques Cœur, a "self-made man," supported the young dauphin Charles VII during his exile in Bourges. Cœur built his palace there, as well, a four-wing complex with galleries, staircase towers, and oppulent rooms.

Dijon, Hôtel Chambellan, end 15th c.

Other citizens also built resplendent palaces, such as the Hôtel Chambellan, whose owner had become rich serving the dukes of Burgundy. The inner courtyard, with its ogee arch windows and spiral staircase, is especially pretty.

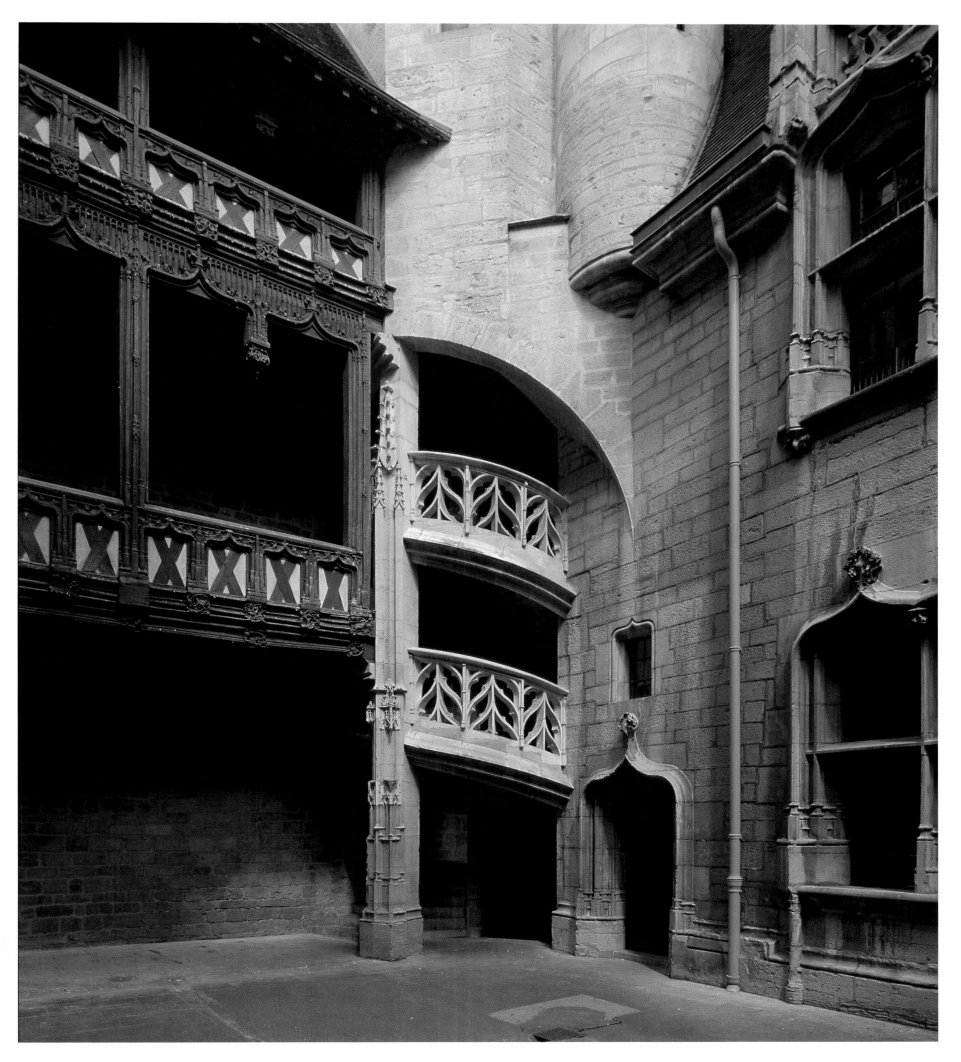

271

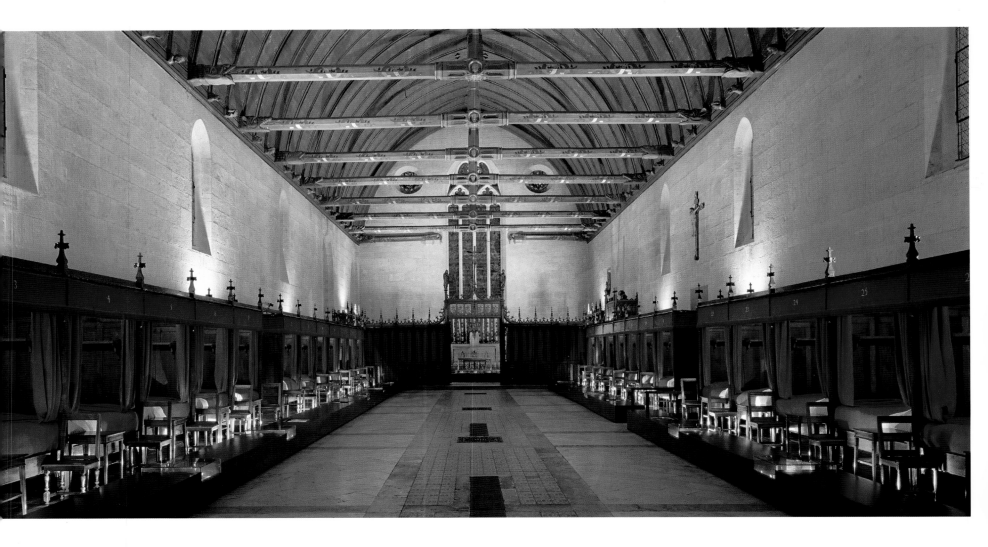

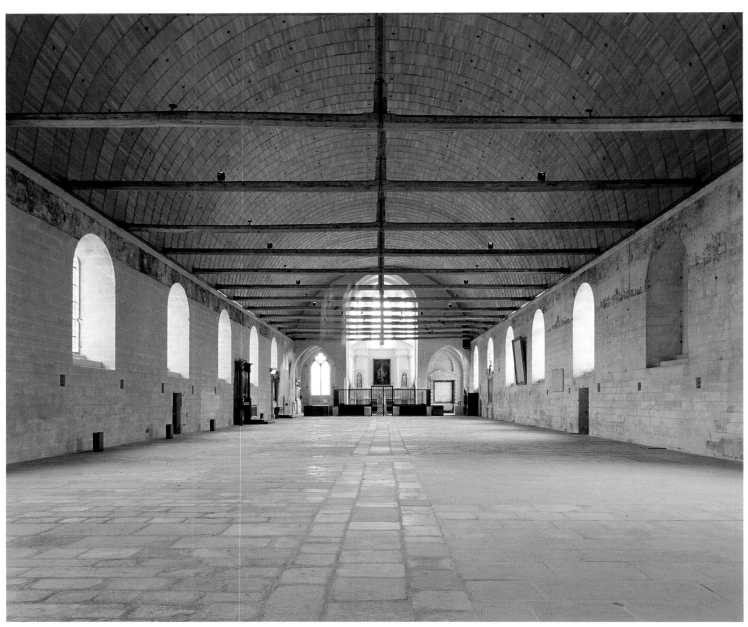

ABOVE AND OPPOSITE:
Beaune, Hôtel-Dieu,
after 1443

Nicolas Rolin, the influential chancellor of the dukes of Burgundy, and his third wife endowed a hospital in Beaune in 1443. At the time, there were already three such institutions, but none was as exemplary and as richly endowed as the Hôtel-Dieu. The main asset of the foundation, which still exists, consists of 800 hectares of vineyards, among them 52 hectares of the best vineyards in Burgundy.

RIGHT:
Tonnerre, Notre-Dame-des-Fontenilles Hospital, 1293

Notre-Dame-des-Fontenilles is one of the oldest preserved hospitals in France. It was founded by Margaret of Burgundy, the widow of Charles d'Anjou. The vast sick room that was completed in 1295 has been preserved almost without changes.

Gelnhausen, imperial palatinate, 2nd half 12th c.

Imperial palatinates were complex building projects of major importance from the 9th through the 13th centuries. These complexes, however, are little researched and preserved only in a few places. One of the few is the ruin of the Gelnhausen palatinate, where the elaborate display of architectural ornamentation that characterized an imperial residence can still be recognized.

OPPOSITE:
Goslar, former imperial palatinate, 11th–13th c.

An example of political dealings with architectural heritage in the 19th century is the imperial palatinate in Goslar, where the Kaiserhaus (emperor's house) was reconstructed in 1868–1879. The Hochkönigsburg in Alsace is also a complete reconstruction that was led by architect Bodo Ebhardt. His colleague Eugène Viollet-le-Duc did the same in France, for example in Pierrefonds and Carcassonne.

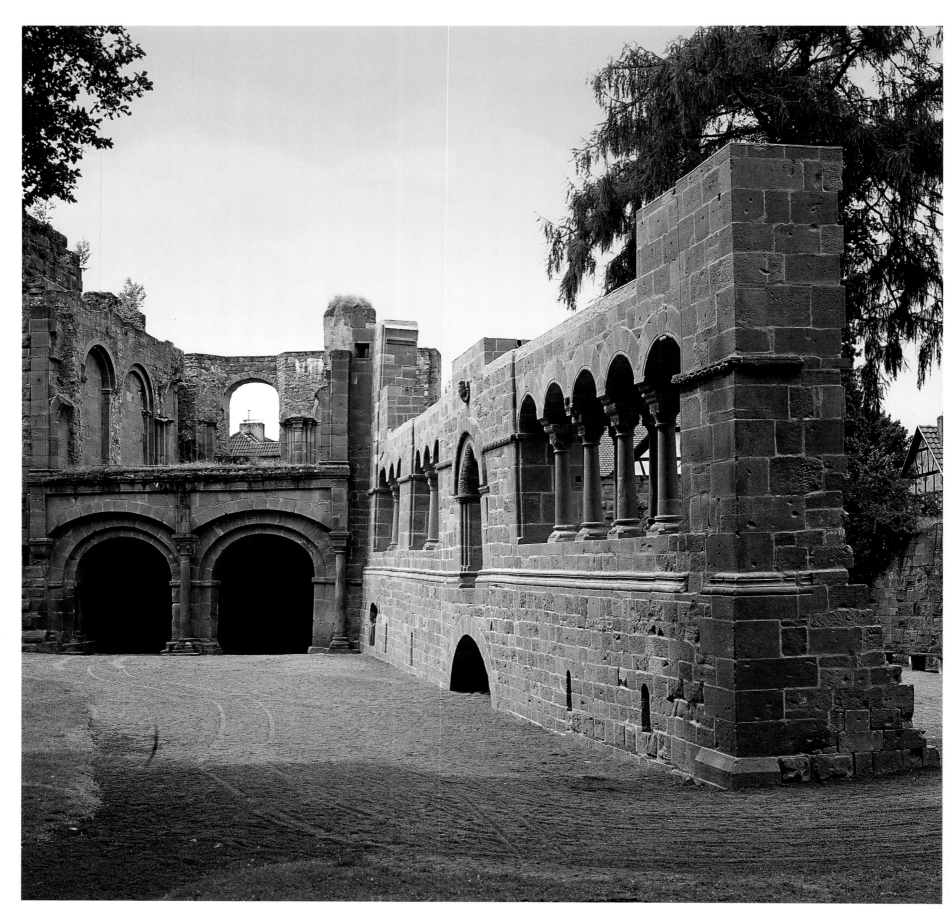

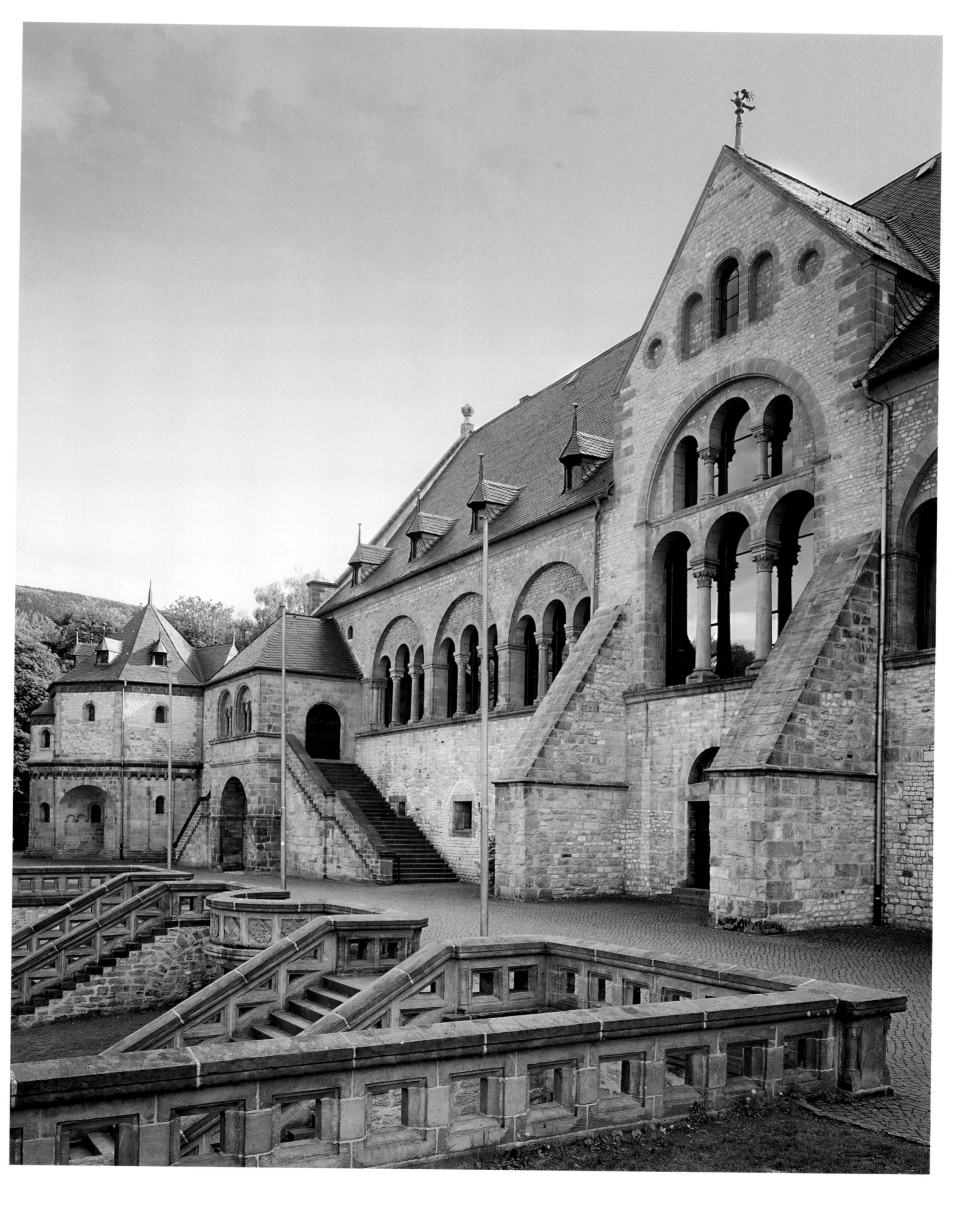

Ribeauvillé, Saint Ulrich, early 12th–13th c.

Saint Ulrich is one of the many Staufen castles in Alsace. Characteristic are the uneven stone blocks—which are especially evident on the donjon and the palace, and thus may symbolize dominion—the beautiful biforia on the residential wings; and the small apses of the castle chapel, decorated with lisenes and arched galleries, which protrude from the walls.

OPPOSITE TOP: **Landsberg, castle ruin,** mid-12th c.

OPPOSITE BOTTOM: **Ruin of the Trifels Castle**

Especially pretty samples of oriels are preserved in the castle of Landsberg, the family seat of Abbess Herrad of Landsberg, author of the famous *Hortus deliciarum*; and in the Trifels Castle near Annweiler, which is considered the noblest royal fortress of the Staufen period. It occasionally served to safekeep the imperial treasure.

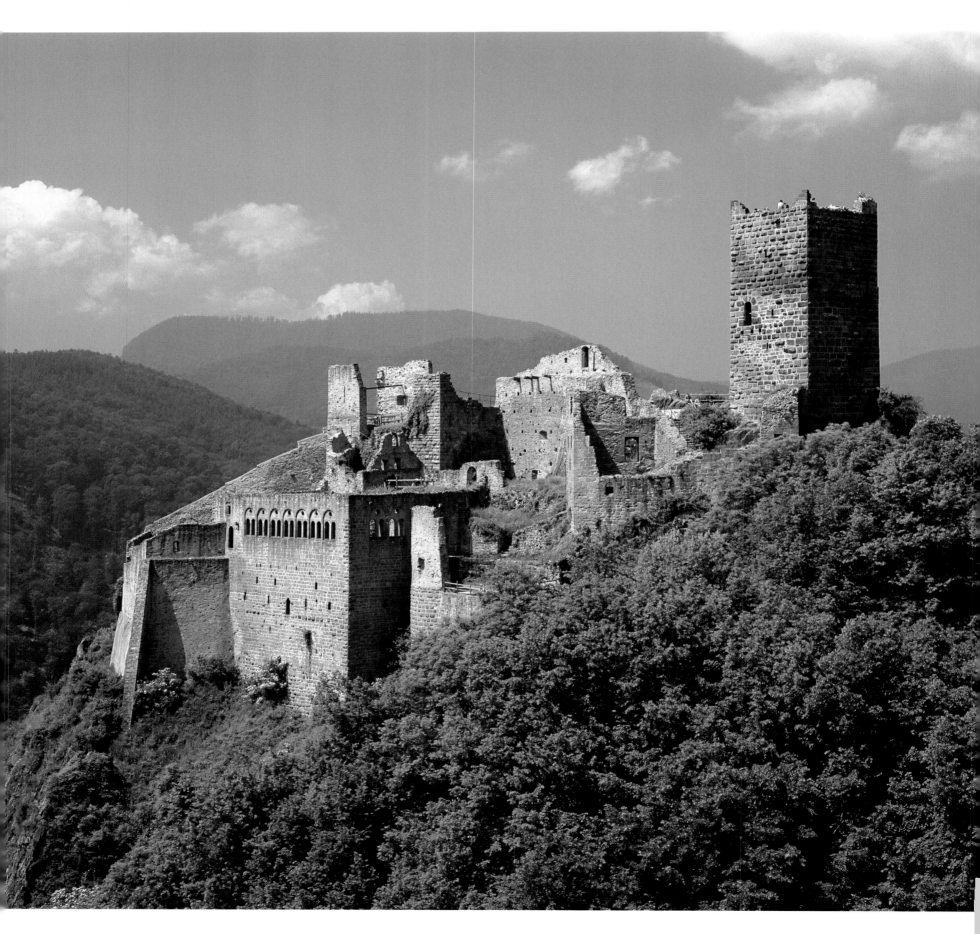

**Eltz, Burg Eltz, a
"Ganerbenburg,"** from the
13th c., exterior; inner
courtyard (below left); and
interior with late medieval
decorations

Burg Eltz belongs to the
type of the so-called "ring-
house castles," in which
the buildings are adjacent
to the walls or even replace
them in places. The term
"ganerben castle" signifies
that the castle was jointly
owned by a group of heirs
and that it was densely
inhabited by several
families, the "ganerben"
("all heirs").

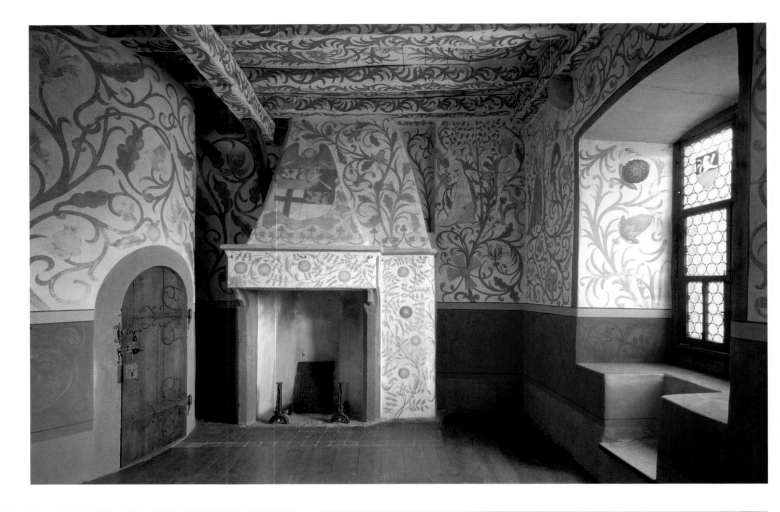

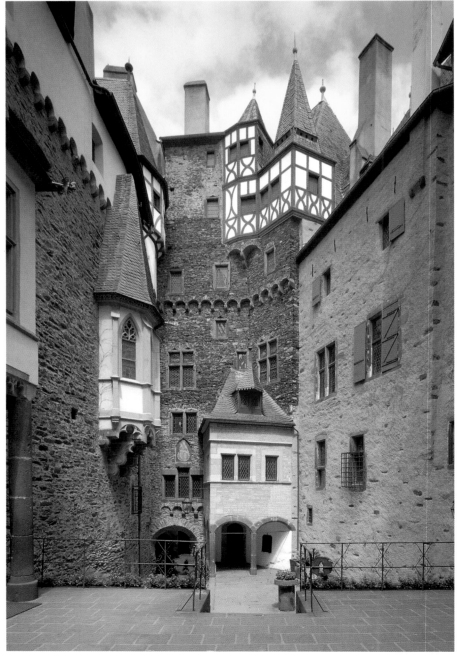

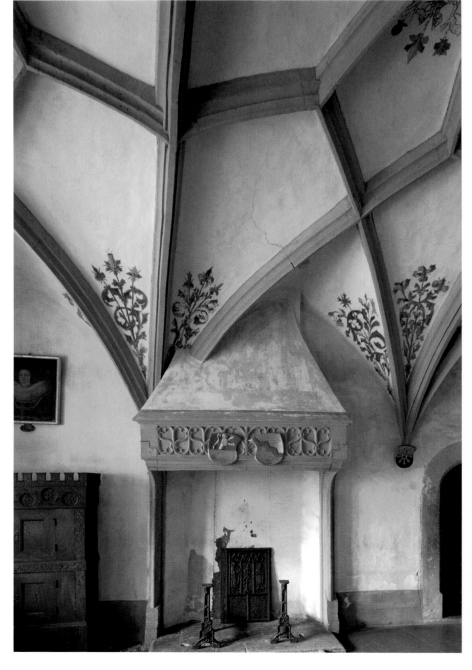

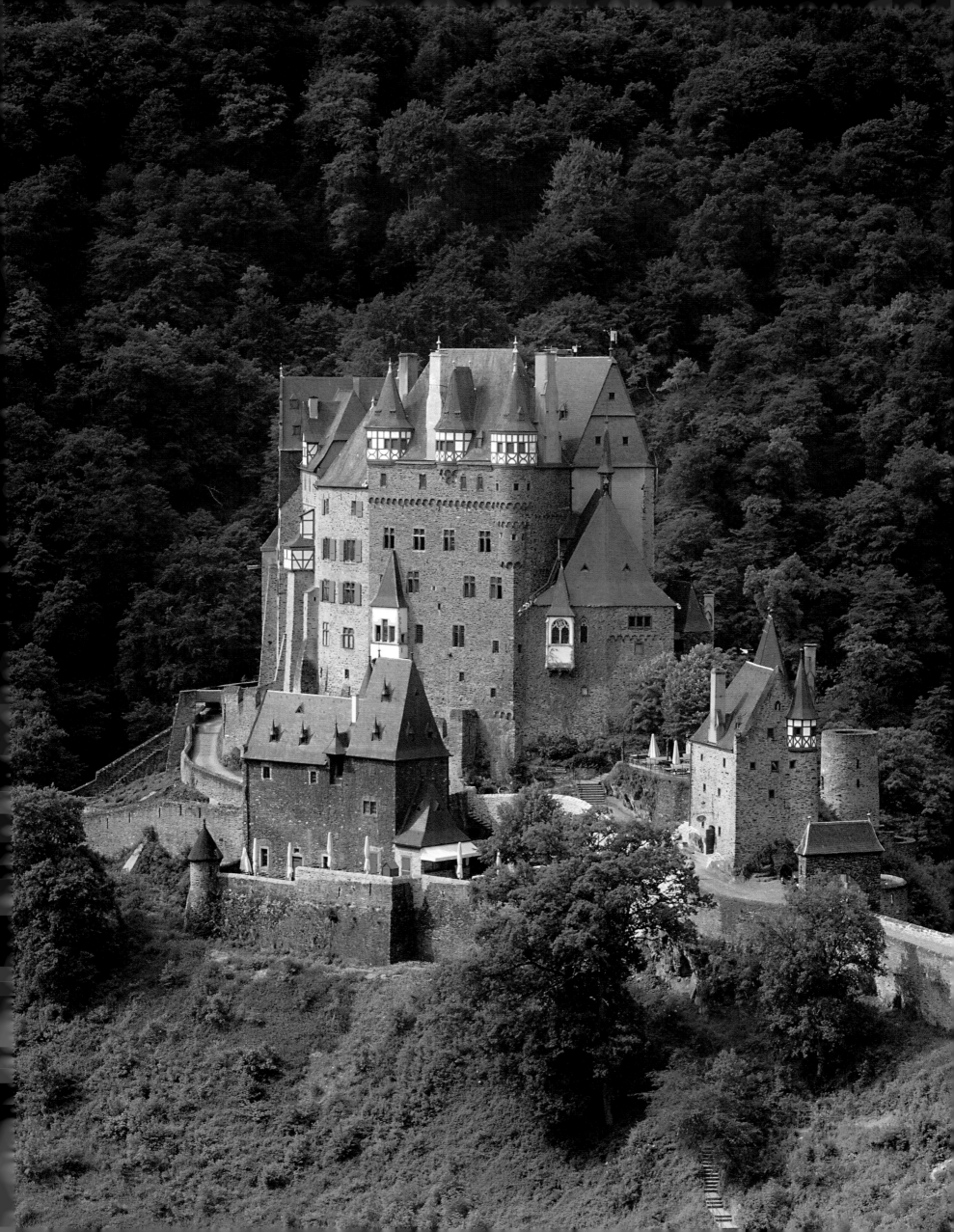

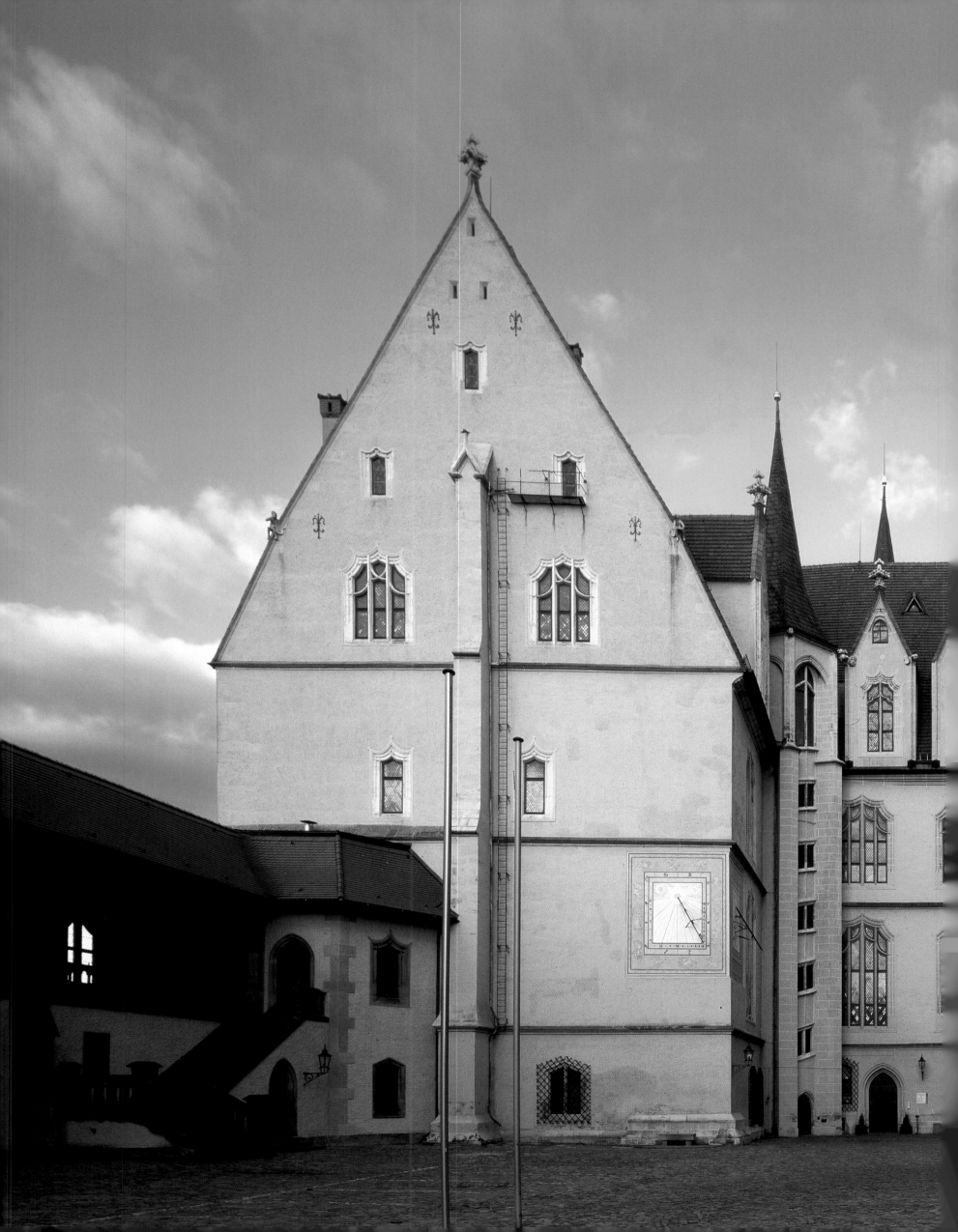

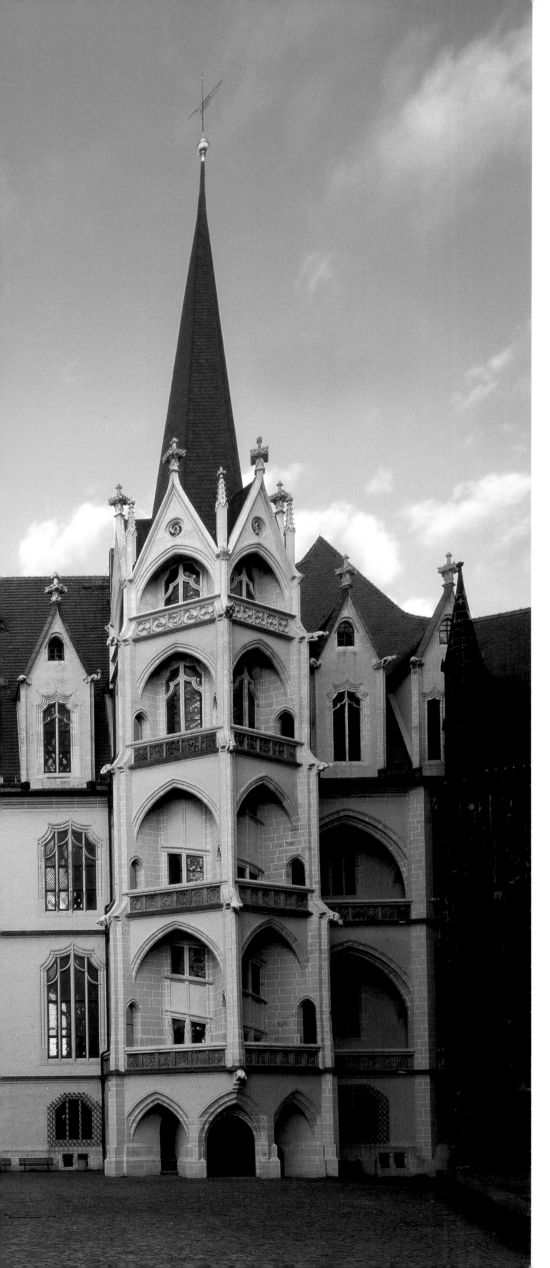

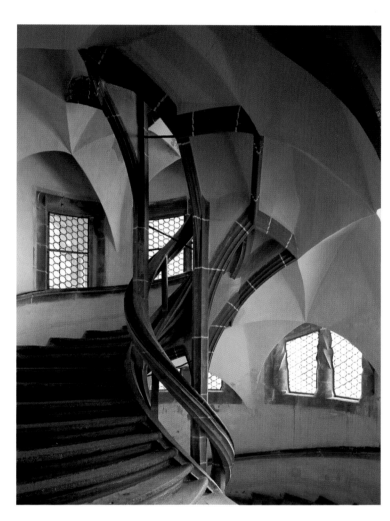

LEFT AND BELOW: **Meißen, Albrechtsburg,** begun ca. 1470, west or courtyard side (left); interior of the large spiral stone staircase (below); elector's chamber (bottom)

Arnold of Westphalia erected a residence for the brothers Ernst and Albrecht of Wettin starting in 1470. The result was not a castle, but a fortified palace. The main buildings form an angle in the corner of which a spiral staircase leads to the upper stories.

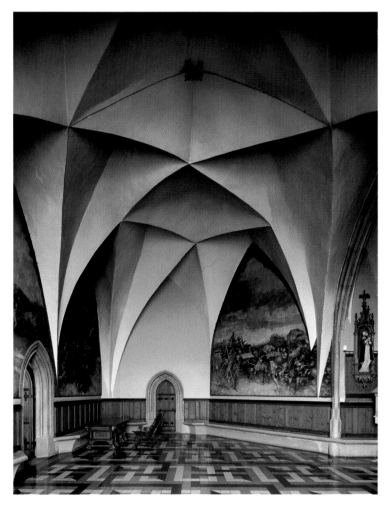

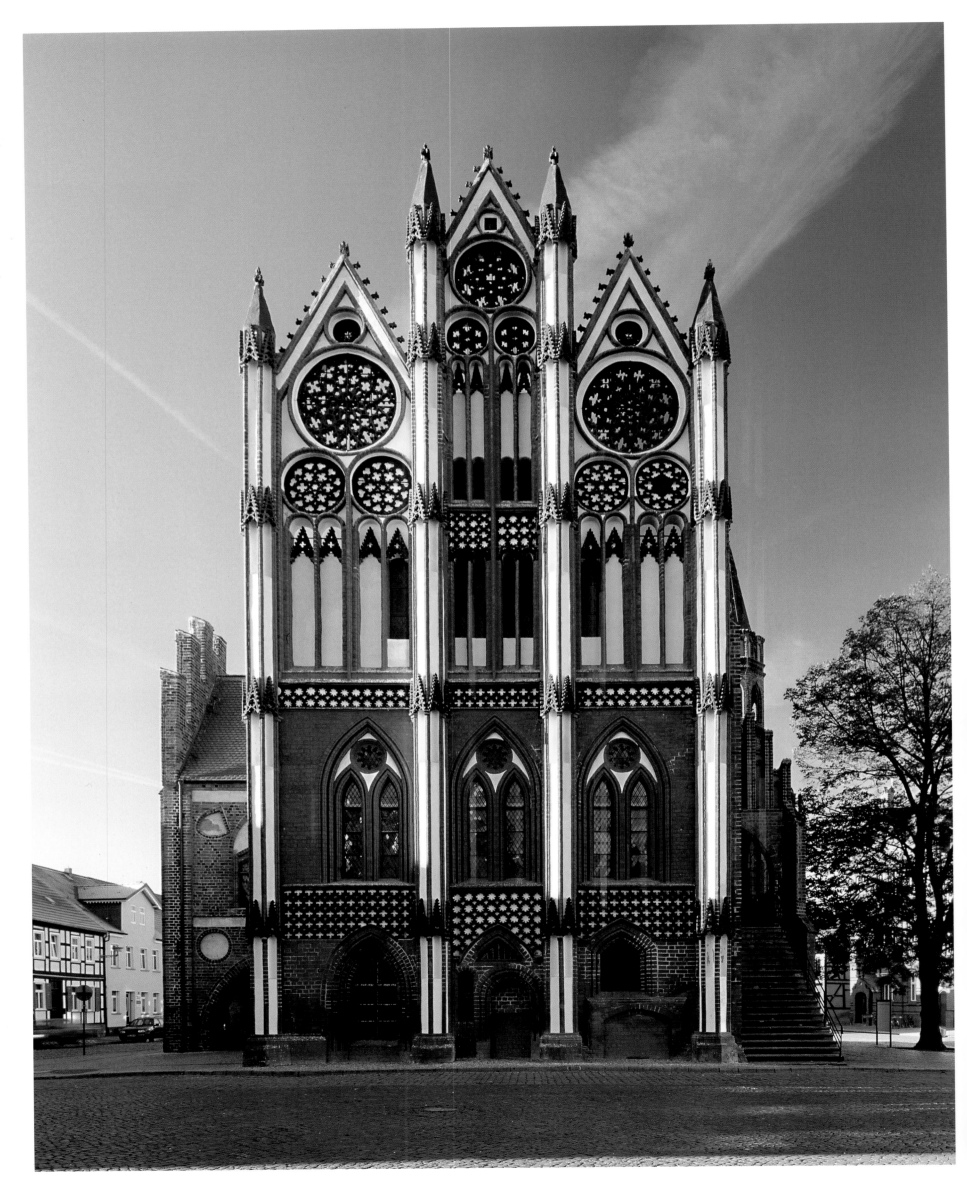

OPPOSITE: **Tangermünde, city hall,**
representative wall of the east wing, ca. 1430
The city hall of Tangermünde is a command-
ing example of the art of the Brick Gothic

facade. The facade of the east section is
attributed to Master Hinrich Brunsberg
of Stettin due to the characteristic lace-
like tracery.

Stralsund, city hall, 13th–15th c., facade facing
marketplace
As in other Hansa League cities, the city hall and the
church of St Nikolai intentionally form a coherent
portion of the cityscape.

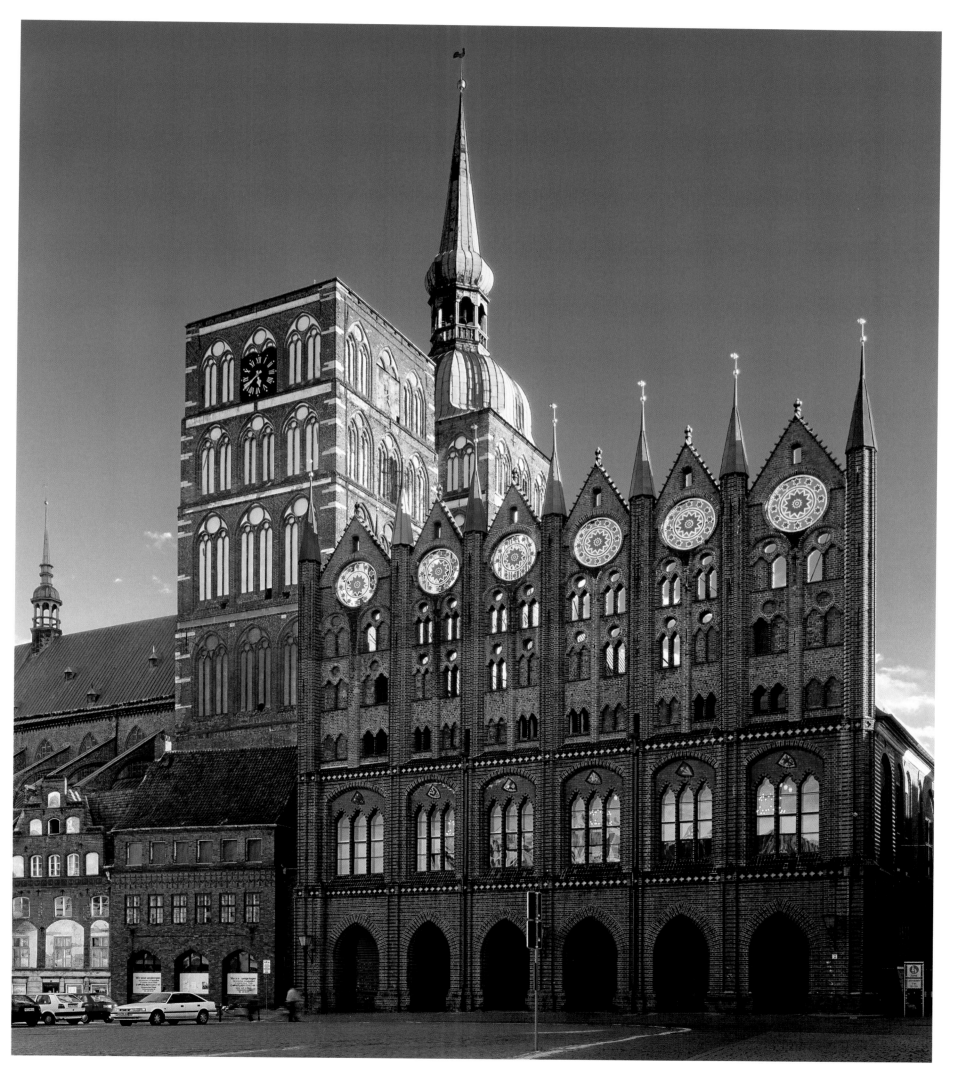

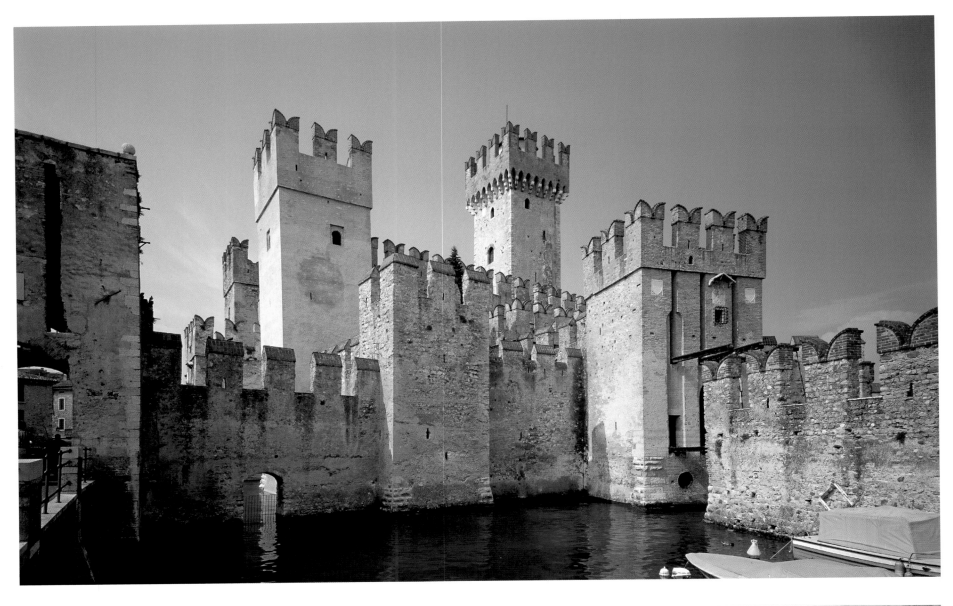

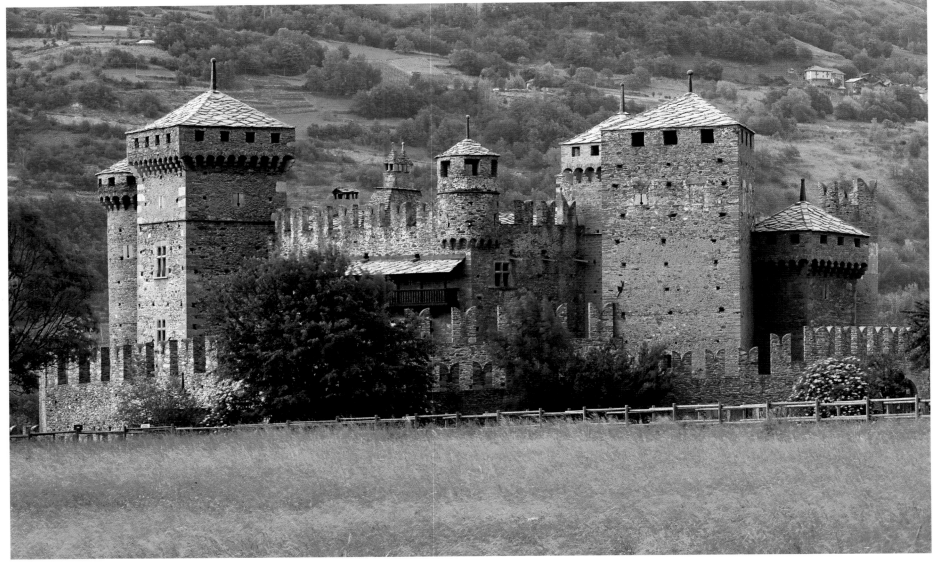

OPPOSITE ABOVE:
Sirmione, Scala Fortress, late 13th c.

The noble family of the Scalas, who ruled Verona from 1260 until 1387, erected this water castle on the southern shore of Lake Garda. Cangrande I was appointed vicar of the empire by Emperor Henry VII, and was the leader of the Ghibelline Party in Lombardy. The shape of the merlons displays that affiliation. Interestingly, on castles of those who opposed the Staufens, the Guelfs, the pinnacles formed a point.

OPPOSITE BOTTOM:
Fenis, castle, ca. 1340

This regular, almost symmetrical castle also displays the typically Ghibelline pinnacles. With one exception, all the towers are crowned by battlements above the machicolations that came into fashion all over Europe in the mid-14th century.

RIGHT:
Gradara, part of the medieval city wall

Since nothing of great significance took place in this town in the Emilia Romagna region, the past has remained very present here. The walls were never seriously put to the test; the city wall and castle provide Gradara with its very tangible medieval character.

285

The Palazzo Vecchio in Florence was built in direct competition with the Palazzo Pubblico in Siena. The Palazzo Vecchio, with its almost entirely solid plinth and protruding battlement, appears almost like a fortress with entrances that are hardly marked. The tower rises above the facade like a pointing finger.

San Gimignano, view of the town

The conflict between Guelfs and Ghibellines caused a war among the various noble families in Italy that lasted almost 200 years. The residential tower, called a "dynasty tower" in Italy, by necessity became the preferred seat of nobles in the cities. In the constant back and forth of conquering, destroying, and even more imposing reconstructions, these family towers characterized the cityscape of many medieval cities in Italy. However, it is only in San Gimignano that they are preserved as a total ensemble.

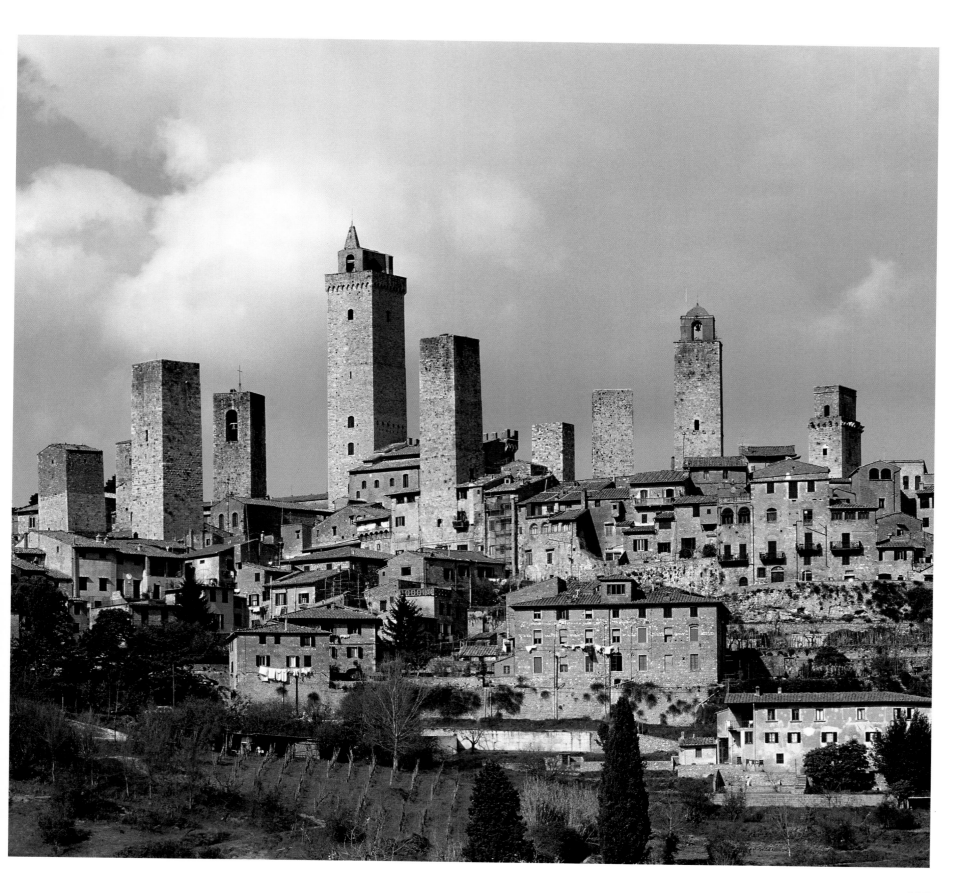

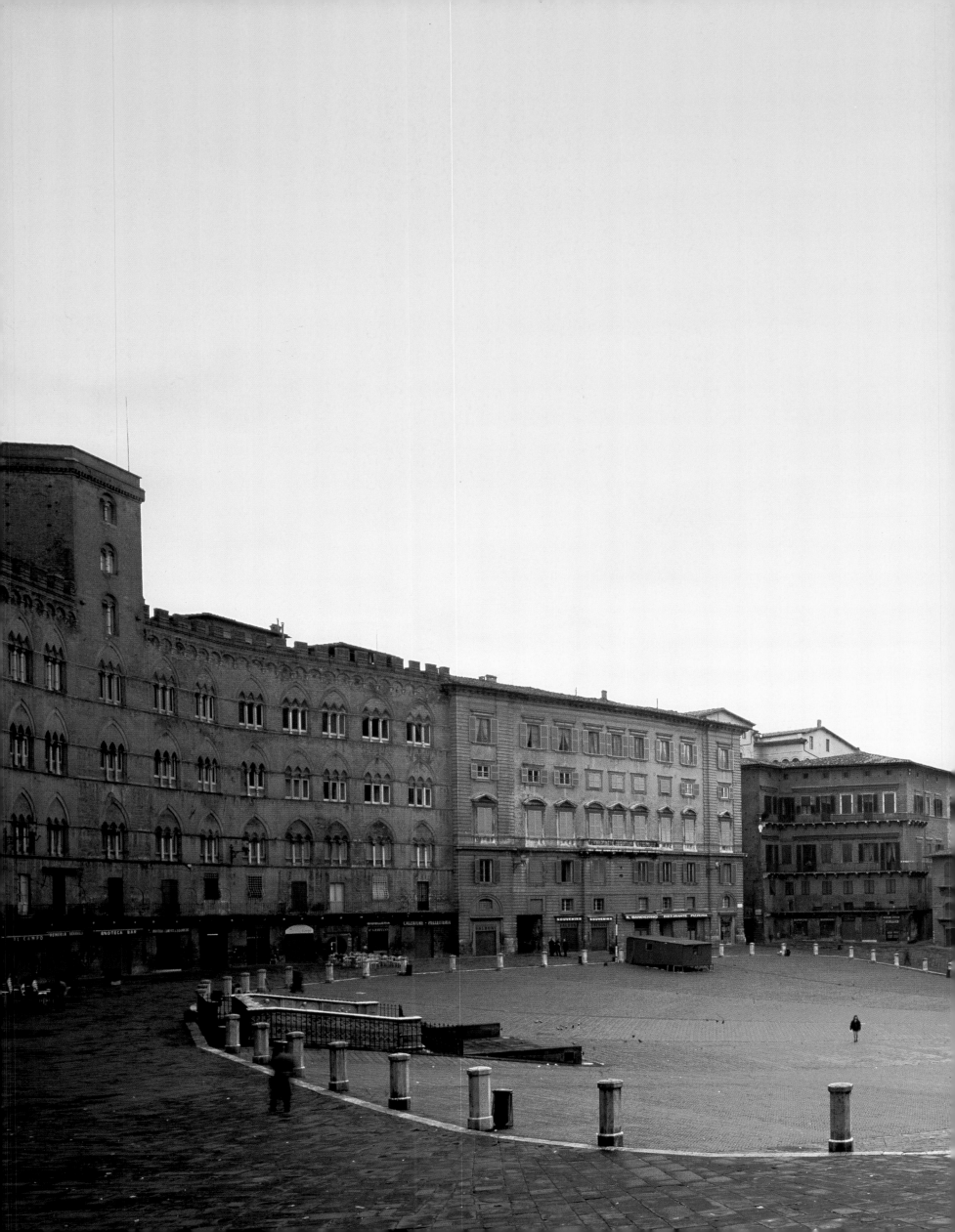

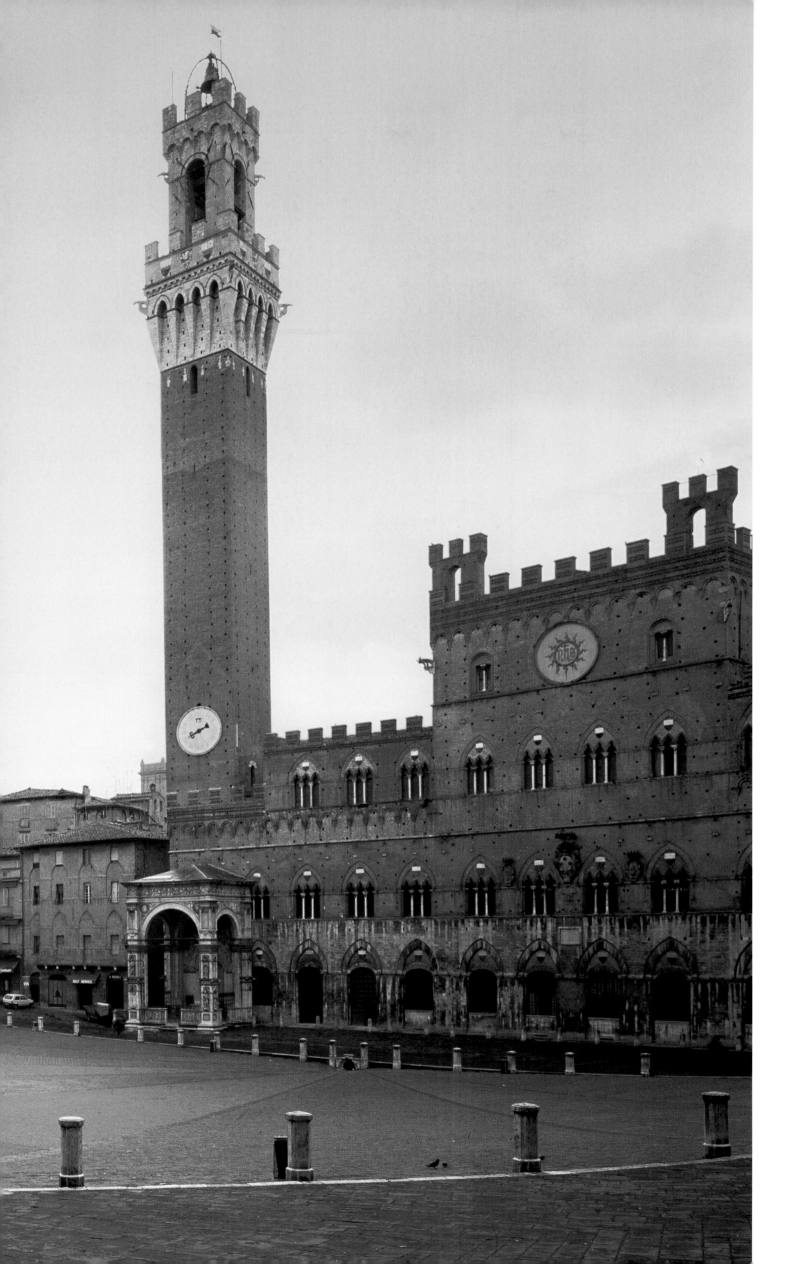

Siena, Palazzo Pubblico, begun 1297

The Palazzo Pubblico in Siena, unlike the communal palace (the Palazzo Vecchio) in Florence, is a representative building in the tradition of the public buildings of the 13th century. Arcades form the ground floor; above that is a symmetrical facade with an elevated center section. The pinnacles seem more decorative than defensive. Above the entrance hall, marked by its atrium, rises a slim campanile. The Piazzo del Campo, the public square in front of the palace, constitutes one of the most ingenious solutions of European urban architecture, reaching back to the model of the ancient amphitheater for its basic shape and effect.

289

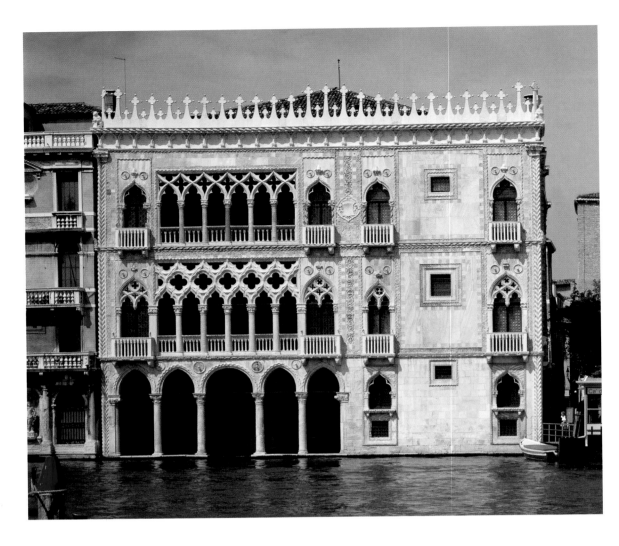

The exceptional position Venice enjoyed among the cities of the Middle Ages and early modern times was not only due to its topography. Thanks to its trade relations, for a long time the seafaring republic mediated between the Orient and the Occident culturally as well as economically and politically. The aristocracy and wealthy citizens determined the appearance of the city and the mainland along the Brenta River with their palaces and extensive villa complexes.

Mario Contarini commissioned the construction of the Ca'd'Oro—one of the most beautiful examples of the typically Venetian *palazzo*—which in this case is conceived entirely around the single facade facing a channel.

BELOW AND OPPOSITE:
Venice, Doges' Palace, begun ca. 1340, expansion and renovation 1424, facade and detail (portal area)

Like many other communal palaces, the ground floor of the Doges' Palace in Venice is opened by means of long rows of arcades, above which the second story, also open, has tracery lancets in a doubled rhythm. Above that is a solid block containing the council chambers and the lavishly decorated loggia for the doge's appearances. The models for the highly unusual design principles in both composition and decoration are undoubtedly from Islamic countries.

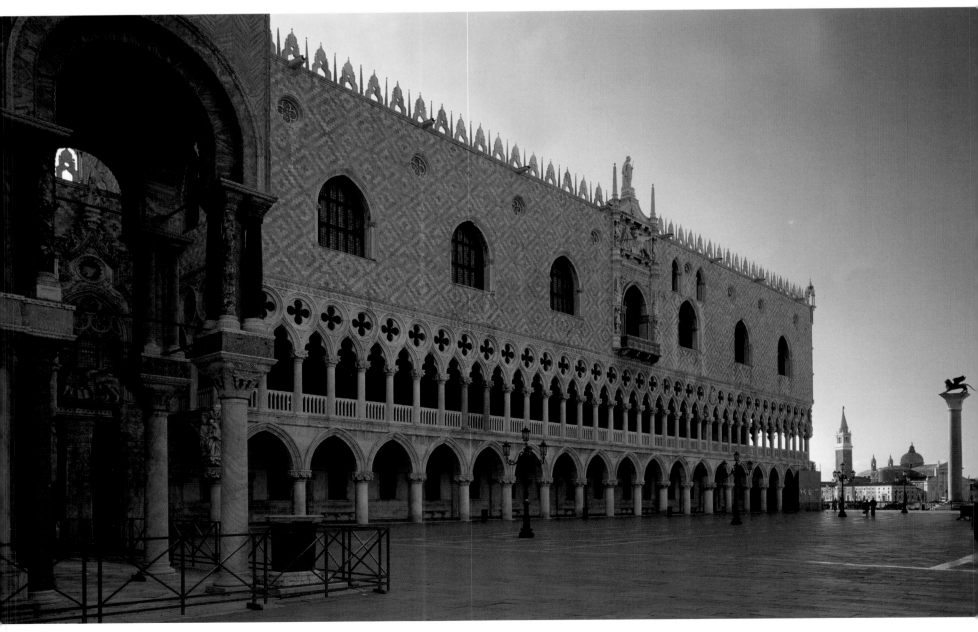

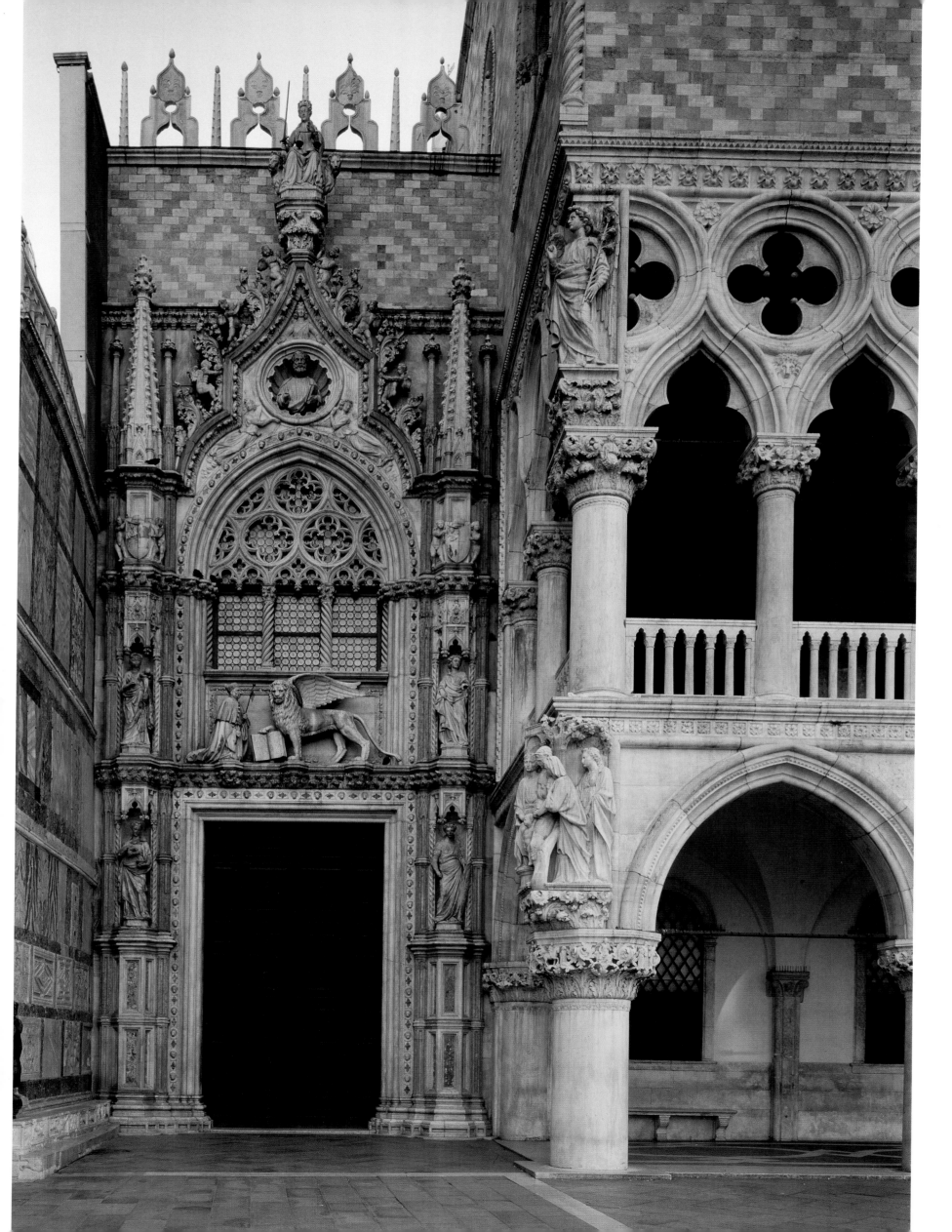

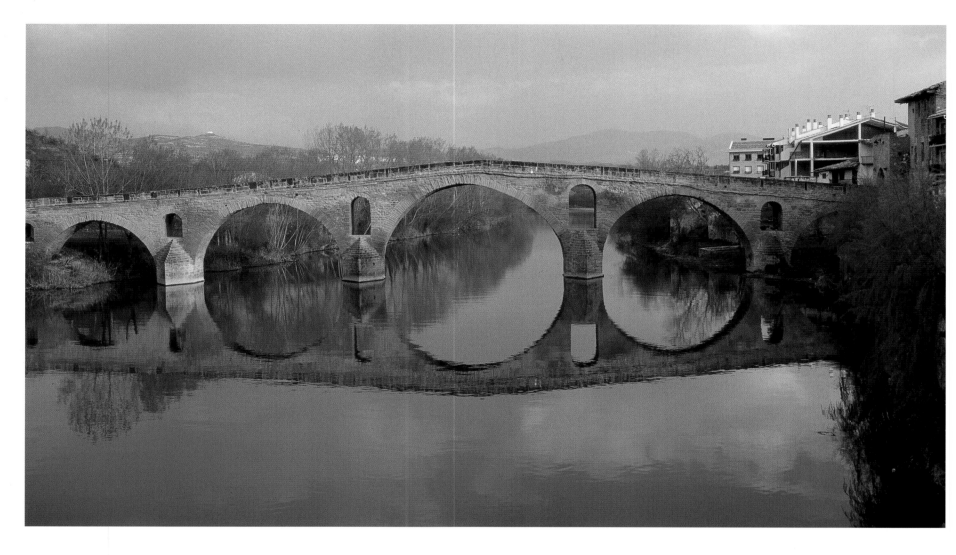

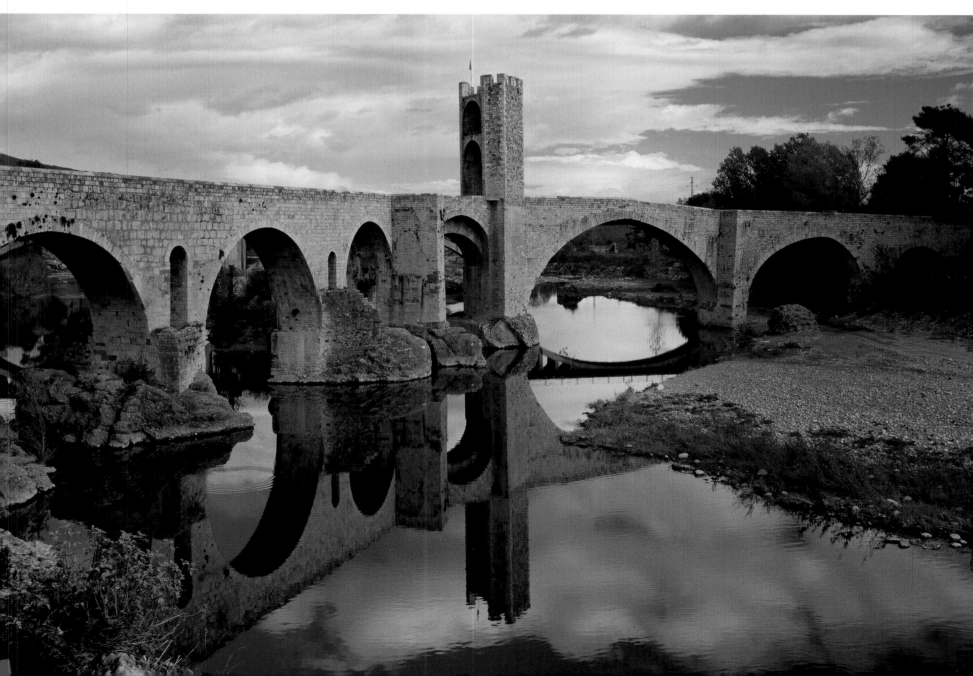

OPPOSITE TOP: **Puente la Reina, bridge,** 12th c.

The pilgrimage routes from the passes over the Pyrenes in Roncesvalles and Somport met in Puenta la Reina at the shore of the Rio Arga. Shortly after 1100, the queen of Navarra donated a bridge that was restored in the Gothic style in the 13th century.

OPPOSITE BOTTOM: **Besalù, bridge,** 14th c.

The bridge across the Rio Fluviá, where two foreign trade routes crossed, was rebuilt time and again since antiquity, most recently in the 14th century with Gothic forms. At its center stands a customs tower.

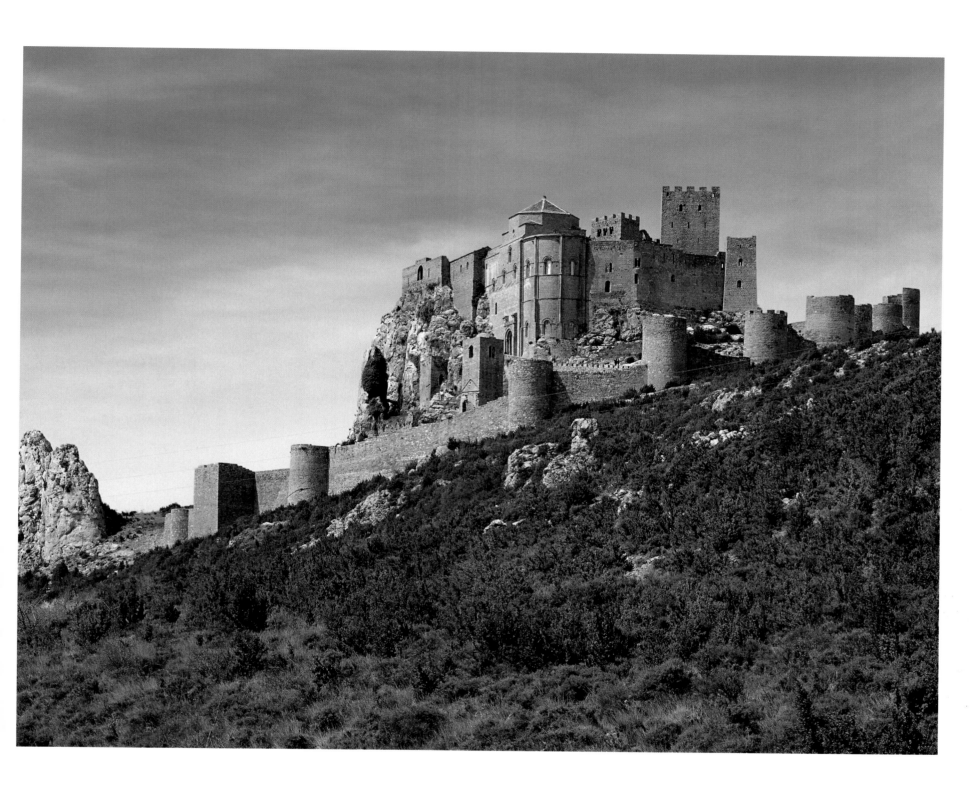

ABOVE: **Loarre, castle,** 1070 and following

Erected over Roman foundations, the castle was an important frontier fortress on the borders of the Arab-occupied regions as early as the 10th century. King Sancho Ramirez I started its expansion in 1070, eventually making it the most important high castle of his empire. The basic castle comprises three staggered residential towers, the palas with a high-lying hall for celebrations (biforium windows) and the barrel-vaulted castle church, built above a crypt (before 1096– ca. 1150), whose steeply rising apse is structured by responds. The castle church has verifiably housed an Augustine convent since 1071.

PAGES 294/295: **Castillo de Coca,** after 1453–ca. 1490

The Castillo de Coca, called Cauca by the ancient Romans, is one of Spain's most beautiful castles. The perfectly regular complex takes advantage of a strategic location above the confluence of the Rio Eresma and the Rio Voltoya in a castle quadrangle with Arevalo, Cuellar, and Olmeda. Alonso de Fonseca, the bishop of Segovia, had it erected in artistic competition with the castles of the kings of Castile. Building type and decoration clearly point to the confluence of Arabic traditions (star form of the watch towers, form and decor of the pinnacles) with the Occidental art of castle construction (type of the castel, donjon, moat, corner towers, machicolations), possibly influenced by Arab methods as early as the beginning of the 12th century.

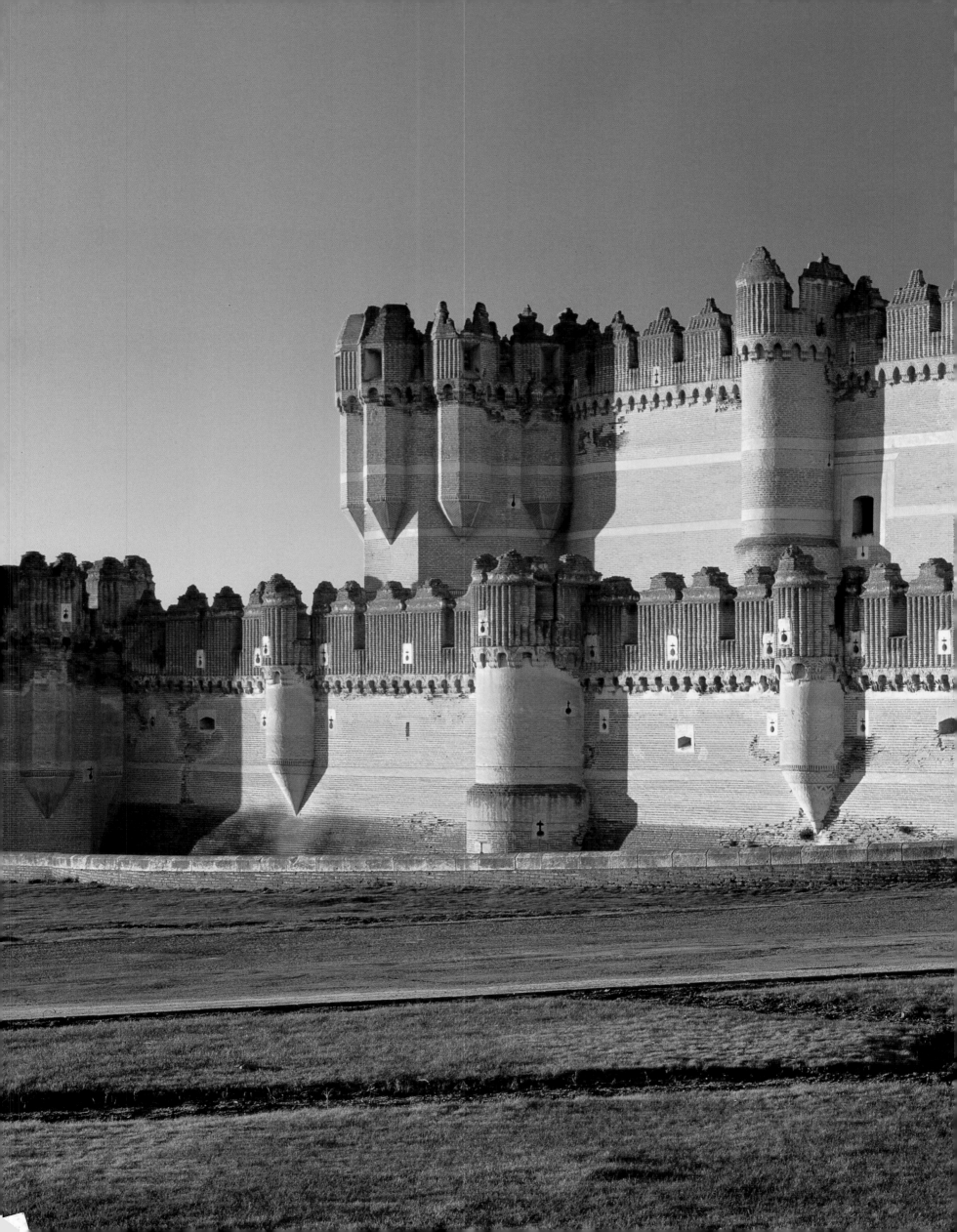

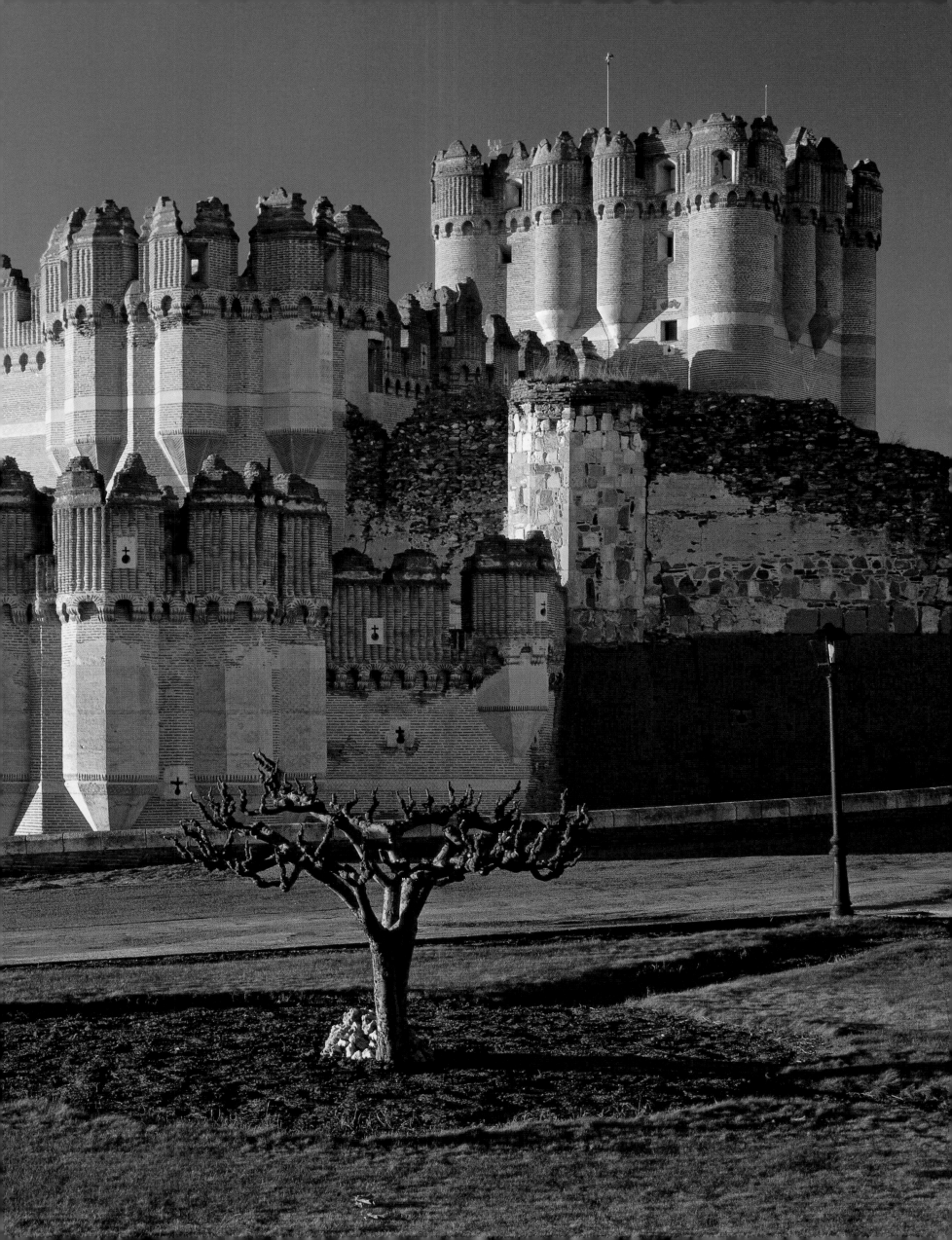

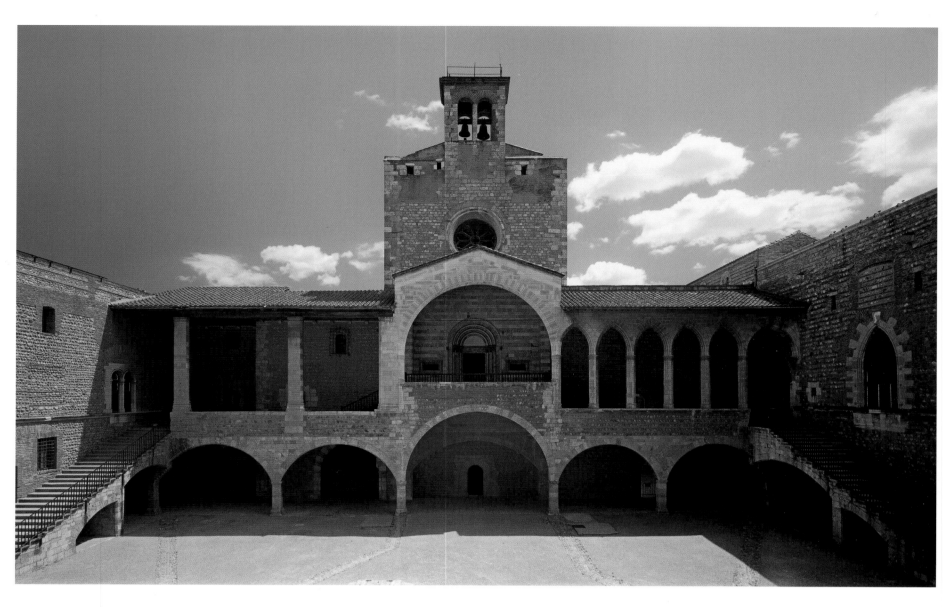

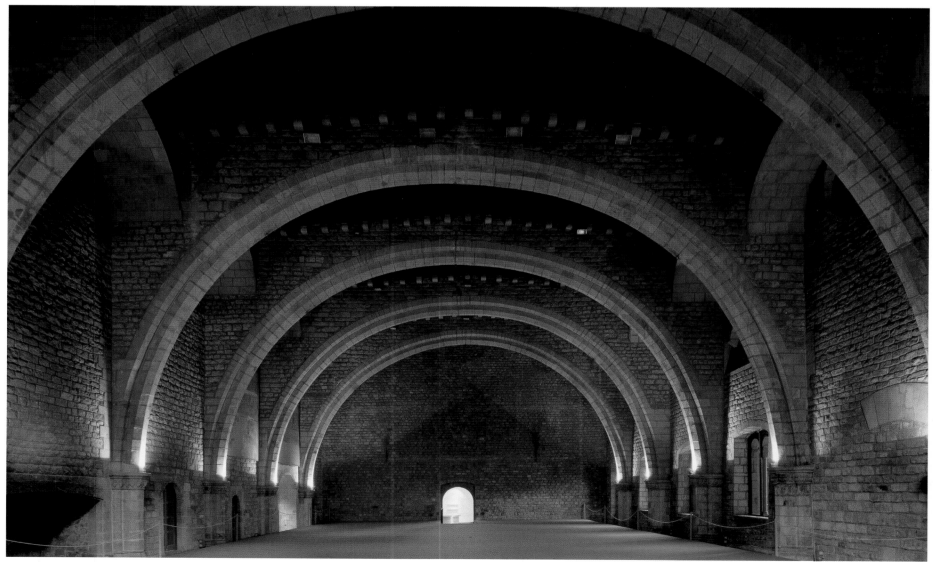

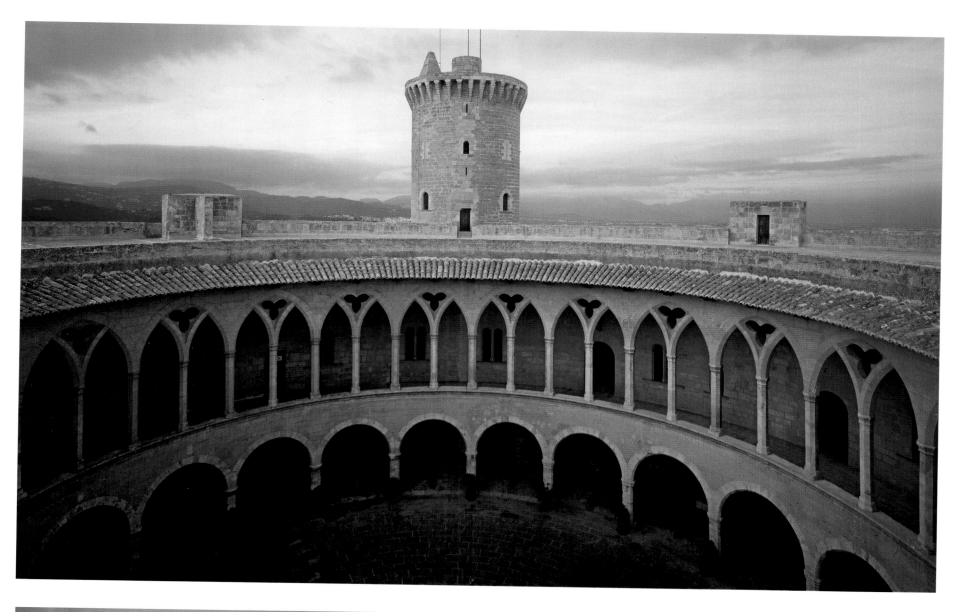

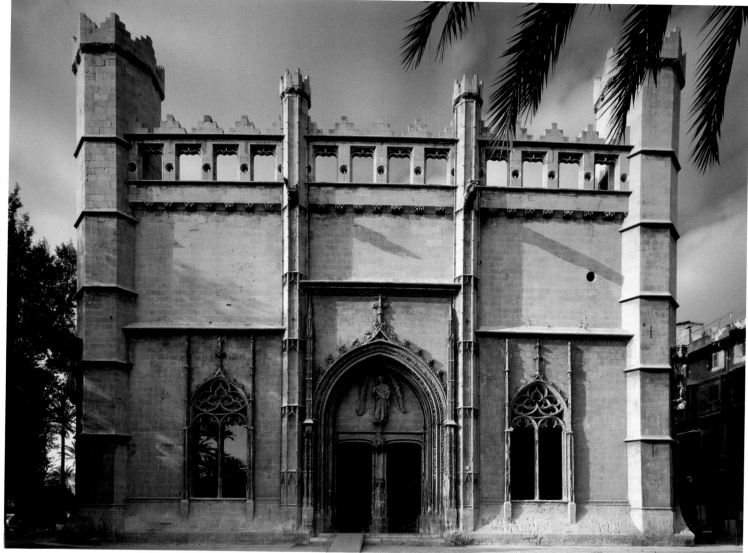

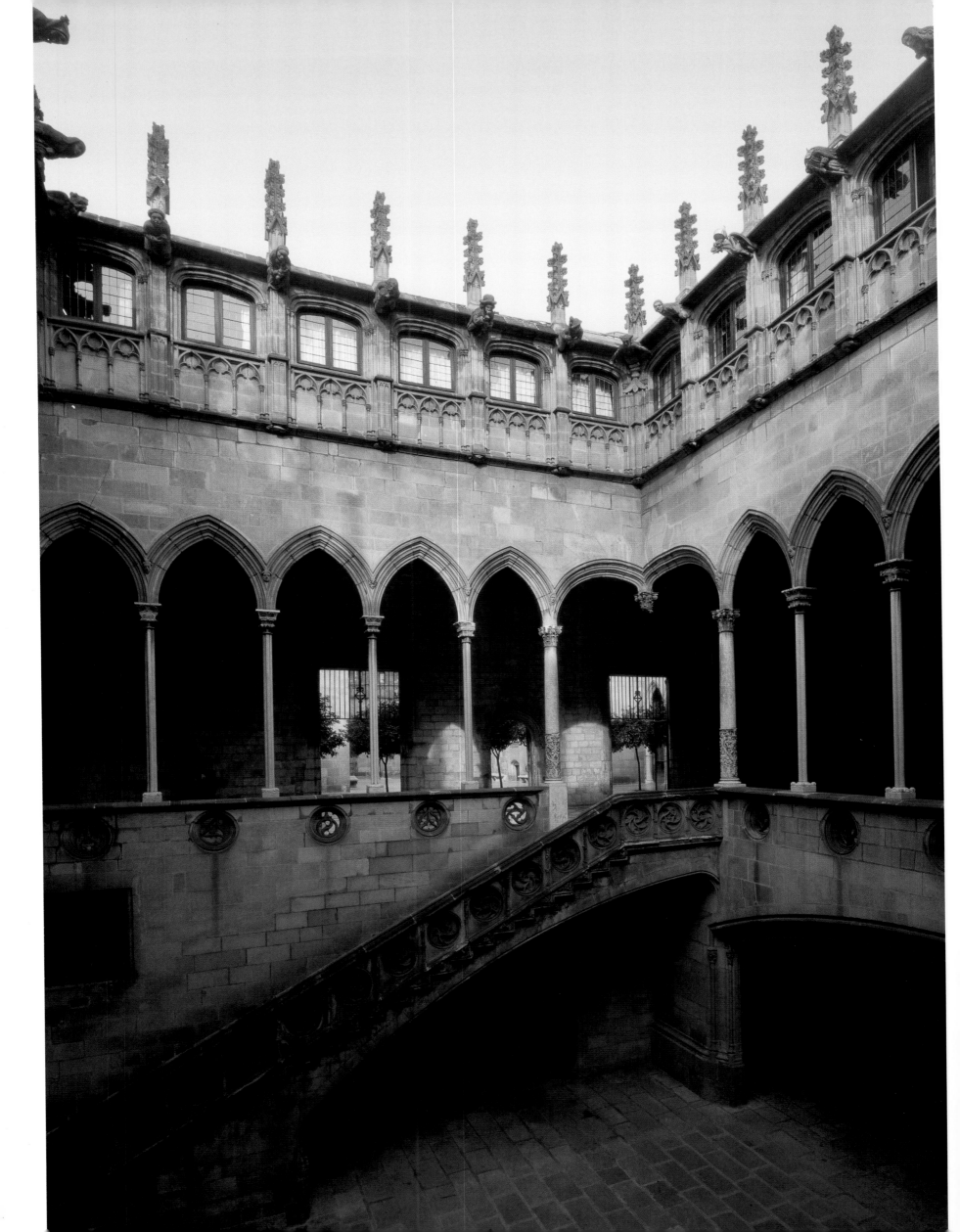

OPPOSITE AND BELOW:
Barcelona, Palau de la Generalitat, 1416–1630

The seat of the regional Catalan government, the buildings
were erected between 1416 and 1630 and are grouped around
several courtyards. Arcades on slim columns surround the
Pati Gòtic. Below is the Capella de Sant Jordi erected by
Marc Safont, whose facade is lavishly covered with flam-
boyant decor.

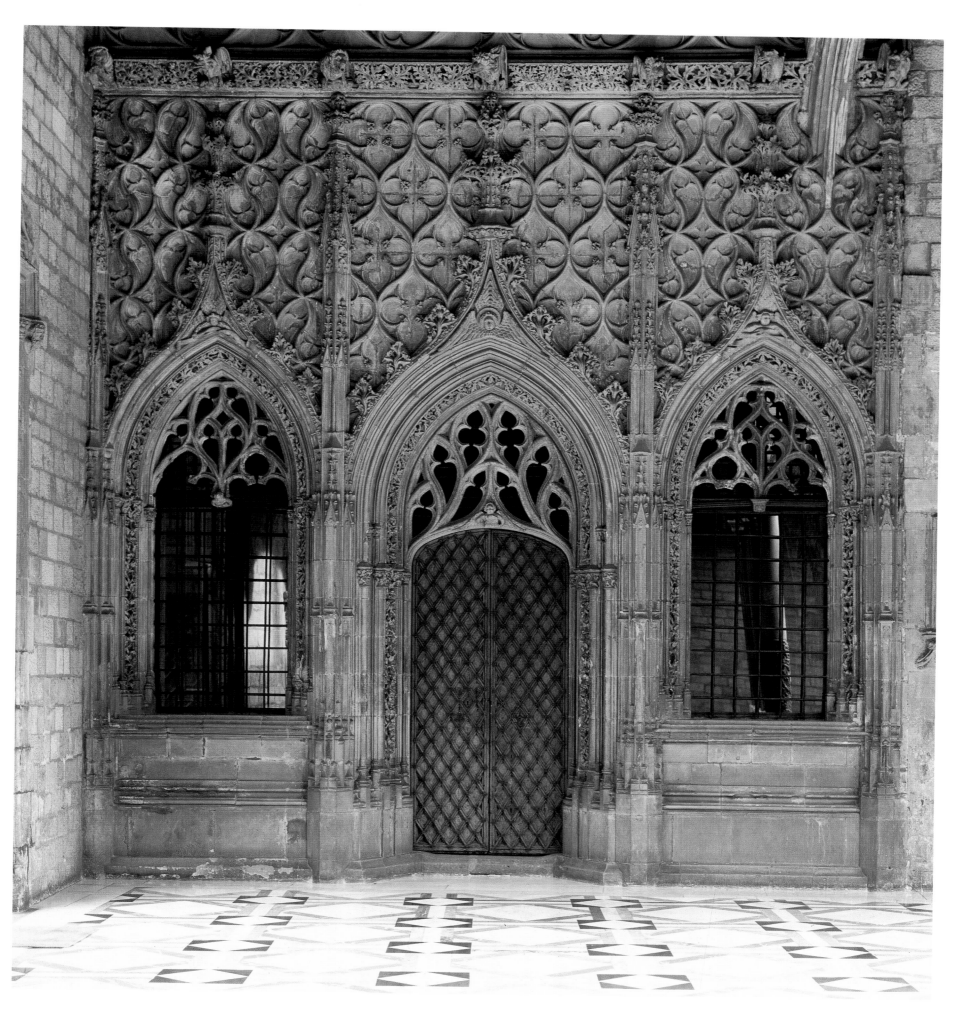

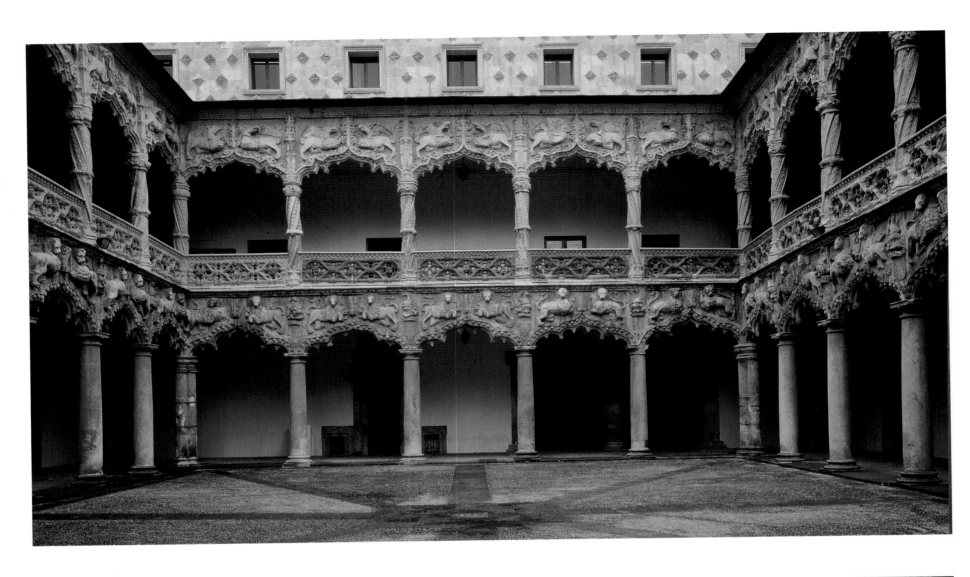

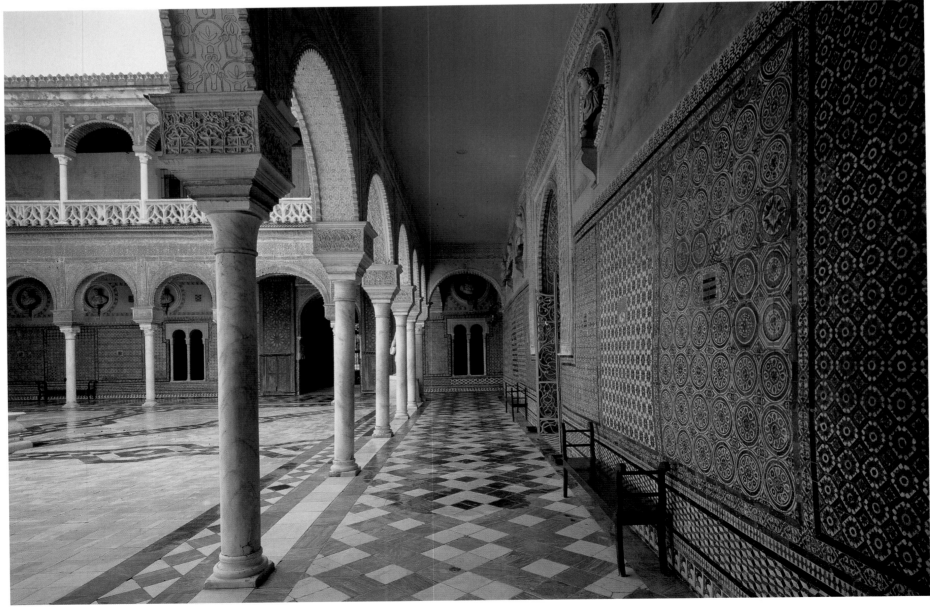

OPPOSITE TOP: **Guadalajara, Palacio del Infantado,** **1473–1483**

The Palacio del Infantado is considered the most famous secular building of Spanish late Gothic. It was initiated in 1473 by the duke del Infantado as an extension of a residence in the city that had been conquered by his ancestors in the 14th century.

OPPOSITE BOTTOM: **Seville, Casa de Pilatos,** ca. 1500

The inner courtyard of the Casa de Pilatos is decorated entirely with the forms of Mudéjar architecture (a style combining Arabic and Gothic elements). Patterns created with tiny pieces cover the back walls of the double-row of arcades almost like a carpet.

BELOW: **Lisbon, Torre de Belém,** 1516–1520

The Portuguese king Manuel I commissioned the construction of the Torre de Belém as a symbol of the capital city to be seen from afar by returning sailors. Francisco de Arruda built the small complex in the typically Manueline style, which combines the forms of late Gothic and the Renaissance.

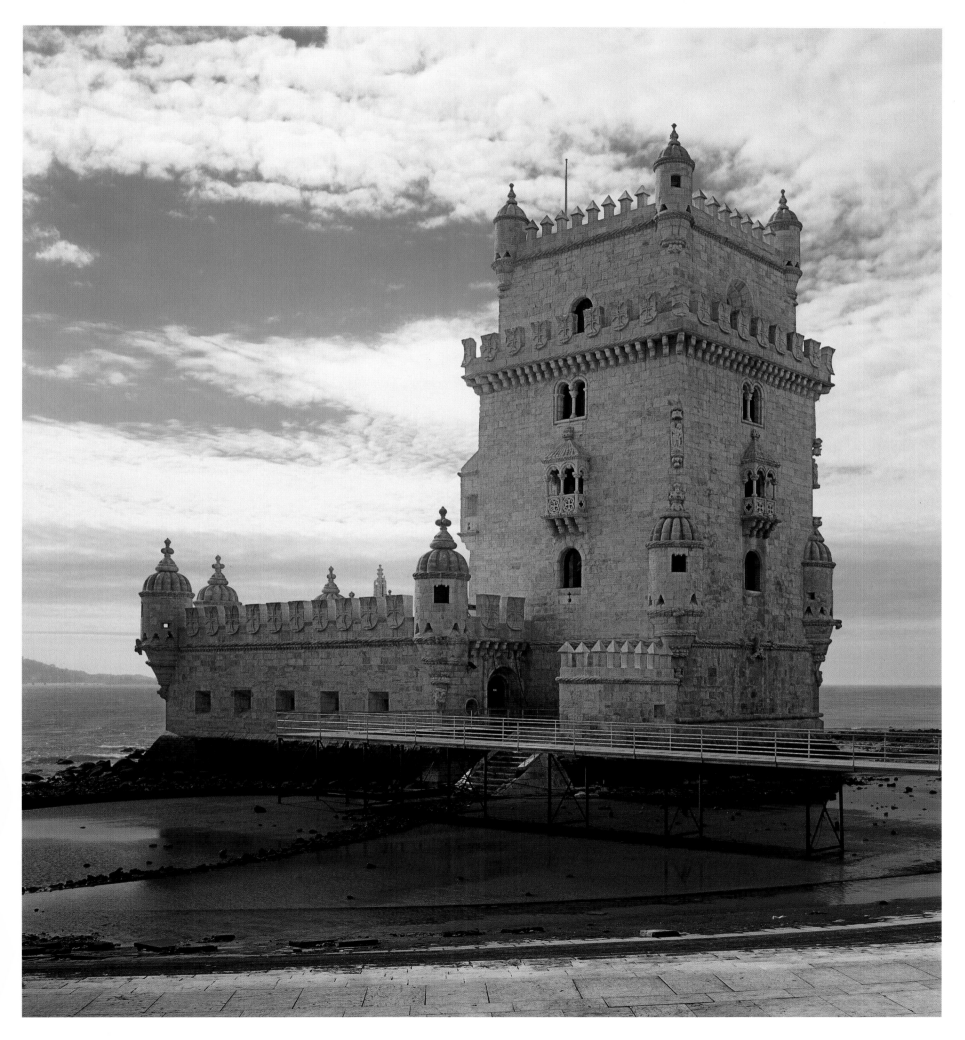

Index of Illustrations

Picture Credits